The Stained Glass of A.W.N. Pugin

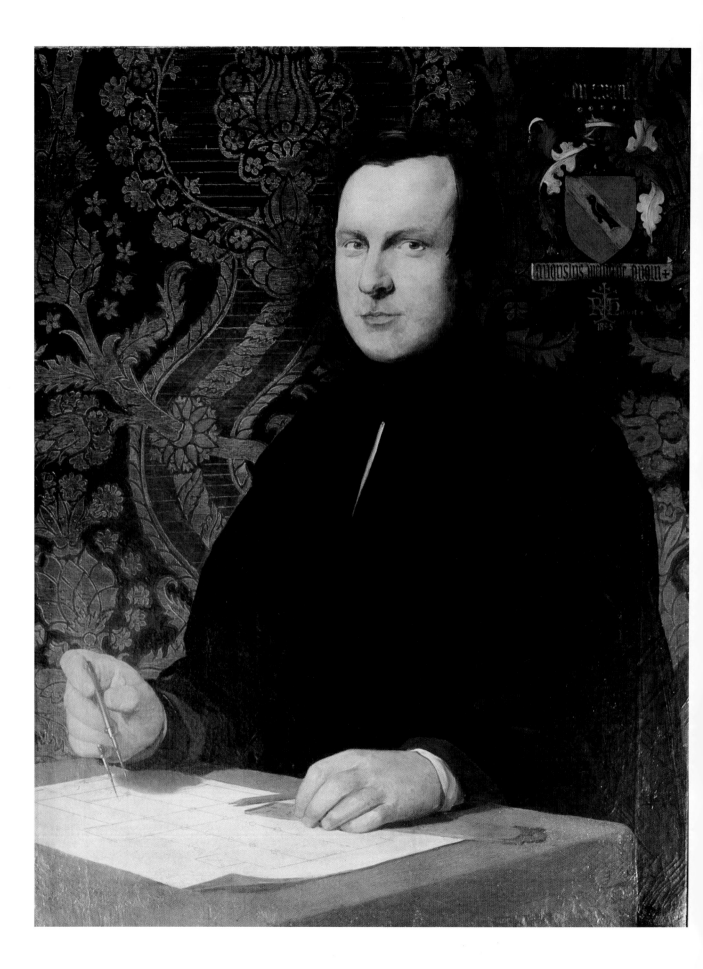

The Stained Glass of A.W.N. Pugin

Stanley A. Shepherd

With specially commissioned photography by

Alastair Carew-Cox

Spire Books Ltd

PO Box 2336. Reading RG4 5WJ
www.spirebooks.com

Spire Books Ltd
PO Box 2336
Reading RG4 5WJ
www.spirebooks.com

CIP data:
A catalogue record for this book is available
from the British Library
ISBN 978-1-904965-20-6

Designed and produced by John Elliott
Text set in Bembo

Frontispiece: Augustus Welby Northmore Pugin
by John Rogers Herbert, 1845
Copyright: Palace of Westminster Collection

Contents

Acknowledgements

My grateful thanks are due to the many priests and officials who allowed photographs to be taken in the buildings under their care.

Birmingham Archdiocesan Archives; Birmingham City Archives; the Borthwick Institute of Historical Research, York; Lord Coleridge; the House of Lords Records Office; Jesus College Cambridge; Oscott College; John Hardman Trading Co., Ltd; and the Trustees of the National Library of Scotland all very kindly allowed me to quote from letters, documents and records held in their collections. Birmingham Museums & Art Gallery; Jonathan and Ruth Cooke; English Heritage; the Dean and Chapter of Hereford and the Hereford Mappa Mundi Trust; Graham Miller; National Museums, Liverpool; and the Rev. Gordon Plumb kindly made available photographs for reproduction.

Alastair Carew-Cox entered into the project with great enthusiasm, producing the many excellent photographs which have enabled the book to be illustrated so impressively. Unless otherwise credited all photographs are by him.

The Paul Mellon Centre for Studies in British Art generously awarded me two most welcome grants.

Bigwood Chartered Surveyors, Birmingham, through the good offices of my brother, Arnold, very helpfully allowed me access to their office equipment whenever it was needed. Ann Bissell, Gill Brown, Perm Daley, Sue Edwards, Lesley Fowler and Karen Hegenbarth between them turned an untidy hand-written affair into an admirable typescript.

Professor Tim Barringer, Dr Margaret Belcher, the late Dr Chris Brooks, Martin Harrison and Alexandra Wedgwood greatly encouraged me to publish, once my Ph.D thesis had been completed. Lady Wedgwood has also subsequently given other helpful advice. Much-needed help and information was received from Paul Atterbury, Michael Fisher, Catriona Blaker, Gerrard Boylan, Canon Paul Iles, Steve Jones and Simon Gahan of Palm Laboratories, David Lawrence, Susan Mathews, Rachel Moss, Alyson Pollard, Douglas Schoenherr, Fr John Sharp, Joseph Spooner, Glennys Wild, Lesley Whiteside and, especially, Sarah Brown and Rosemary Hill.

Geoff Brandwood and John Elliott of Spire Books made helpful suggestions as did two anonymous readers of an early draft of the introductory chapters to the Gazetteer. In addition to his many other kindnesses David O'Connor, read a later draft. Any errors still present are wholly mine.

Sadly Professor Clive Wainwright, who supervised my Ph.D thesis, died early on in the project. His friendly presence and formidable scholarship were greatly missed.

Stanley A. Shepherd
Birmingham
January 2009

Abbreviations

BM&AG a.no. Birmingham Museums & Art Gallery accession number.

CoE Church of England.

f(f). folio(s).

Gaz. Gazetteer.

HLRO No. 304 or 339, House of Lords Record Office Historical Collection No 304 or 339. Both collections contain, on microfilm, letters held in private collections.

JHA John Hardman Archive – held in Birmingham Central Reference Library. The glass section of the archive is concerned with window-making and contains, amongst other items, the firm's: Order Books; First Glass Day Book; Cartoon Account Ledgers; Client's Letters and some from Pugin to Hardman. The items are not referenced but are stacked in date order. The First Glass Day Book runs from November 24, 1845 to January 4, 1854 and of the three order books, one covers the period 1845 to 1852 and the other two (books 2 and 3, numbered in the Gazetteer to indicate that there are two different books) 1852 to 1855.

RC Roman Catholic.

UA Unitary Authority.

Wedgwood (Pugin's Diary) Entries from Pugin's Diary as transcribed in Wedgwood, 1985.

Glossary

Apse
A semi-circular or polygonal end to a church chancel or chapel.

Canopy
The representation in stained glass of an architectural canopy or hood that projects over a niche usually containing the figure of a saint.

Cartoon
A full-scale design on paper for a stained glass window.

Cathedral glass
White or tinted sheets of glass.

Chiaroscuro
The use of light and shade in painting to portray the solidity of objects.

Crown glass
A flat disc of glass of about four feet diameter made by attaching the globe obtained by blowing (see pot-metal) to a 'pontil' rod and spinning it. A bull's eye knob is left at the centre of the disc after the 'pontil' has been broken away. The knob sometimes features as a decoration in leaded lights.

Diaper
Small repeated pattern. 19th-century use of the term might well have included all coloured, patterned-backgrounds.

Enamel
Metallic oxide as a colouring agent together with ground glass as a flux fired on to the surface of glass to achieve a coloured effect.

Emboss
Etching glass by means of acids.

Flashed glass
White glass with a thin layer of colour added during the blowing process, ruby being the commonest colour. The colour can be partially removed by acid or abrasion to reveal the white layer beneath and so create decorative effects.

Foil
A shape in the form of a lobe formed by the cusping of a circle or an arch. The number of foils created is indicated by a prefix as in trefoil (three), quatrefoil (four), etc.

Grisaille	Monochrome patterning of panels or windows of mainly white glass where the patterns are in the form of geometric or foliage designs.
Grozing tool	A tool hooked at each end and used to trim or shape pieces of glass, in effect, by nibbling away at the edges.
Jesse window	A window featuring a genealogical tree of the ancestors of Christ with Jesse at its root.
Lancet	A narrow pointed-arched window.
Light	Opening in a window bounded by mullions.
Mandorla	An almond-shaped line or lines surrounding a person endowed with divine light, usually Christ, or the Virgin Mary.
Mullion	A vertical post that divides a window into two or more lights.
Pot-metal	Glass coloured throughout its substance by a metallic oxide which has been added to it in its molten state. To manufacture sheets of pot-metal, the molten glass or 'metal', which is contained in a 'pot' or clay container, is gathered on a hollow tube and blown into a global shape of pre-determined diameter. The globe is swung pendulum-fashion over a small pit while applying repeated heatings and blowings until a desired cylindrical shape is achieved. The cylinder is opened up and flattened out into a sheet measuring some four feet by two and a half feet.
Quarry	A diamond or square-shaped piece of glass.
Quatrefoil	See foil.
Smear shading	Shading glass by applying thin washes of enamel paint to its surface.
Stipple shading	Shading glass by applying enamel paint as in smear shading and dabbing with the butt end of a brush to give a spotty texture which allows tiny points of light in through the paint.

Spandrel	The triangular space created between two arches or an arch and a wall.
Tracery lights	The small openings in the upper part of a window formed by ornamental intersecting work.
Transom	A horizontal, stonework bar across a window.
Trefoil	See foil.
Vesica	An upright almond shape.

Explanatory Notes

The Hardman First Glass Day Book is a record of the firm's completed windows and contains: the names and addresses of clients; the selling prices of windows in £. s. d. or s/d; the dimensions of the lights in imperial measure; the weights and measurements of the glass (except for the early windows) in imperial measure; and sometimes a mention of the subject matter.

The date a window is entered in an Order Book or the First Glass Day Book is a reliable indicator of when that window was officially ordered or finished.

A regularised transcription of the entries in the Order Books and the First Glass Day Book that appeared as an appendix in my Ph.D thesis was too long to be included here; however, the chronological order in which Pugin/Hardman windows were made, as given in the First Glass Day Book, is reproduced in Appendix 1.

Pugin's handwriting and that of some of Hardman's clients proved difficult to read so that where, in the extracts quoted from letters, there is doubt as to whether a word has been correctly made out, [?] has been added to the end of it; if it has not been possible to decipher the word at all, [?] has been used in its place. The original punctuation, abbreviations, spelling, use of capital letters and ampersands, etc. has been retained.

The captions to the illustrations give only an indication of what is contained in the windows. For detailed accounts of Pugin designed windows the reader is directed to the Descriptions sections in the Gazetteer.

Photographic credits:
All photographs are by Alastair Carew-Cox unless otherwise stated. Other photographers and those bodies requiring acknowledgement of permission to reproduce photographs are indicated in italics in the captions.

Introduction

Augustus Welby Northmore Pugin (1812-52) has always been respected as a stained glass designer of considerable merit. The quality of his work was applauded during his lifetime, as comment in letters and journals testify. At his death, the Catholic journal, *The Tablet,* mourning his loss, recalled the display in the 'Medieval Court' at the Great Exhibition of the previous year, in these words:

> In the department of stained glass he was unrivalled in Europe. The windows produced by Mr Hardman of Birmingham, under Pugin's superintendence have, in the opinion of the best critics left the works of all competitors far behind.[1]

Since that time, whenever nineteenth-century stained glass has been discussed – usually in a chapter that forms part of a general history of the subject since medieval times – Pugin's role has been recognised, particularly so in Martin Harrison's pioneering work *Victorian Stained Glass*, published in 1980, where Pugin is credited with laying the foundations for the successful revival of the medieval principles of stained glass design.[2] Even so, other than my brief chapter in Atterbury and Wainwright's, *Pugin: a Gothic Passion*, 1994, and Phoebe Stanton's unpublished Ph.D thesis, *Welby Pugin and the Gothic Revival*, 1950 (which although primarily devoted to Pugin's life and his work as an architect, gives more than a passing reference to his stained glass), comments have been restricted to no more than a few paragraphs. The present book is a reworking in effect of my Ph.D thesis 'The Stained Glass of A.W.N. Pugin *c.*1835-52', submitted to the University of Birmingham in 1997, and is an attempt to redress the situation.

Pugin was born in London on March 1, 1812. His father, Augustus Charles Pugin (1767 or '68-1832) was a Parisian artist and designer who fled Revolutionary France for England around 1792. His mother, Catherine Welby (1768 or '69-1833), was the daughter of an Islington-based attorney who practised in King's Bench in London.[3] Pugin's artistic ability was immediately in evidence. As Benjamin Ferrey, his fellow architect and first biographer noted: 'He had an almost intuitive talent for drawing, and as soon as he could handle a pencil, commenced sketching!'[4] His interest in all things Gothic, particularly architecture, started at an early age and was stimulated by his father who, once in England, began work for the architect John Nash and by 1796 had established himself as Nash's expert in Gothic details.

In 1821 and 1823 Pugin senior produced two volumes of *Specimens of Gothic Architecture* – measured examples of architectural details – having previously enlisted some pupils to help in the task. The pupils formed the start of an architectural drawing school that Augustus ran from his house and in which the young Pugin, then around the age of fourteen, participated, joining the pupils in their trips to sketch medieval sites in Britain and

France and making sketches for his father's books. The young man soon embraced different aspects of Gothic design. In 1827, through his father, he was commissioned to design and make working drawings for Gothic furniture at Windsor Castle and by 1829 he was working in the theatre, drawing on his knowledge of the medieval when painting some of the scenery and advising on the costumes for the ballet *Kenilworth*, performed in 1831 at London's King's Theatre. These were merely the beginnings of what was to become over the years a veritable torrent of work in Gothic design encompassing virtually the whole range of the applied arts, including: book covers and illustrations, ceramics, jewellery, metalwork, brasses, textiles and wallpaper.[5]

His interest in the historical past was complimented by his enthusiasm for collecting antiques which in turn benefited from another of his passions, a love of sailing, for he used his boat on a number of occasions to sail to the continent where he made many of his purchases. Like his father, Pugin produced books of designs and drawings which between 1835 and 1836 included: *Furniture in the Style of the 15th Century; Gold and Silversmith Work: Iron and Brass Work in the Style of the 15th and 16th Centuries;* and *Details of Ancient Houses of the 15th and 16th Centuries.* His most telling and influential book in terms of architecture in which he set out his rules of construction was published in 1841 under the title of *The True Principles of Pointed or Christian Architecture.* The title page indicates that the work emanated from two lectures he gave to the students of St Mary's College, Oscott, near Birmingham,[6] in his capacity as Professor of Ecclesiastical Antiquities, a post he had assumed in 1837. According to his diary he lectured on five occasions between 1837 and 1839, including once in 1838 on stained glass, but the relationship between the lectures and the book is not clear.[7]

It was his work as an architect that provided the main source of his income, at least until the late 1840s. His first building, in 1835, was St Marie's Grange at Alderbury near Salisbury, to house himself and his family. By then this consisted of Anne, a daughter by his first wife, Anne Garnet who died in 1832 shortly after Anne was born; Edward, his son by his second wife Louisa Burton whom he had married in 1833; and Louisa herself. By 1844, when he moved into the next house of his own design, the Grange at Ramsgate in Kent, his family had grown by the addition of a second son, Cuthbert, and three daughters Agnes, Katherine and Mary. Louisa died in 1844 and in 1848 Pugin married his third and last wife, Jane Knill who bore him two more children, Edmund (Peter, Paul) and Margaret.

Pugin's first church was St Mary, Derby, of 1837-9, and by the time he had finished his own church, St Augustine, Ramsgate, in 1850, the number had risen to around forty including three cathedrals. In all, his buildings numbered over one hundred[8] and in the process he had laid the foundations for a revived Gothic architecture correct in detail and conforming to the canons of the medieval builders.

Two significant and perhaps not unrelated events occurred in Pugin's

life when he was in his mid-twenties. To take them in reverse chronological order, in 1836 he published *Contrasts: or, A Parallel Between the Noble Edifices of the Fourteenth and Fifteenth Centuries, and Similar Buildings of the Present Day; Shewing the Present Decay of Taste.* This polemical piece of writing was intended not merely to portray modern day architecture in a poor light compared with that of the medieval past but was also a rejection of 'the increasing secularisation and materialism of the incipient Victorian period',[9] in favour of what he saw as a socially just society living under the benign influence of the Catholic Church. The critics either liked it or loathed it but did not ignore it. Sales were good and the book brought Pugin to national attention.

The other key event happened in the previous year when he converted to Roman Catholicism. Pugin found he had to defend himself against charges of insincerity from people who suggested that he joined the Church to gain favours in respect of restoring medieval art. In *A Reply to Observations which appeared in Frazers Magazine for March 1837*, he explained that as a result of becoming a student in ancient art he applied himself for upward of three years to liturgical knowledge to trace the fitness of each portion of 'those glorious edifices' to the rites for whose celebration they had been erected, and concluded:

> I therefore hope that in Christian charity my conversion will no longer be attributed solely to my admiration of architectural excellence: for although I have freely acknowledged that my attention was first directed through it to the subject, yet I must distinctly state, that so important a change was not affected in me, but by the most powerful reasons, and that after long and earnest examination.[10]

Roman Catholic art as a force leading to conversion was a significant factor in Pugin's link with John Talbot, the 16th Earl of Shrewsbury. Lord Shrewsbury, Pugin's patron from the start, was the premier earl in the English and Irish peerage and was leader of a group termed the 'English Catholics'. Few in number, they consisted of both hereditary Roman Catholics and converts and looked to restore the faith as it had existed in the medieval past. The earl together with Pugin and Ambrose Lisle Phillipps, the son and heir of a leading Leicestershire landowner, as leaders of the Catholic revival, aimed to do just that.[11] The overall decorative schemes Pugin devised for his churches in the early years, referred to in Chapter 4, should be viewed in this polemical light as much as in an aesthetic one.

The Gothic Revival was not, of course, restricted to Roman Catholic buildings. In his chapter headed 'Revival of Church Architecture', Charles Eastlake pointed out that, 'a strong desire began to manifest itself in this country for a return not only to, the ancient type of national church but to a more decent and attractive form of service',[12] and he outlined the roles of ecclesiology, the Cambridge Camden Society and its journal *The Ecclesiologist*,[13] in the revival of the medieval in Anglican services and architecture. Pugin

0.1a. St. Mary's College Chapel, Oscott, West Midlands, apse windows I, nII, sII (Gaz.182), Pugin/
Warrington, 1837.

influenced the ecclesiologists, and reaped the benefits with many orders for stained glass from Anglican patrons.

He started creating stained glass windows as an integral part of the buildings he designed as an architect. His work had an immediate impact. The installation in 1838 of the windows made under his supervision by William Warrington for the apse of St Mary's College Chapel at Oscott (**0.1a–e**), could be said to have marked the moment when the production in England of so-called 'picture windows' finally gave way to those made in accordance with medieval principles.

Picture windows reached their height of popularity in the last third of the eighteenth century when new works were made for the prestigious religious locations of New College Chapel, Oxford (*c*.1777-85), Salisbury Cathedral (*c*.1781-91), Lichfield

0.1b (*above*). St Mary's College Chapel, Oscott, West Midlands, central window of apse I (Gaz.182). Virgin and Child, with saints.

0.1c (*right*). Detail of 0.1b.

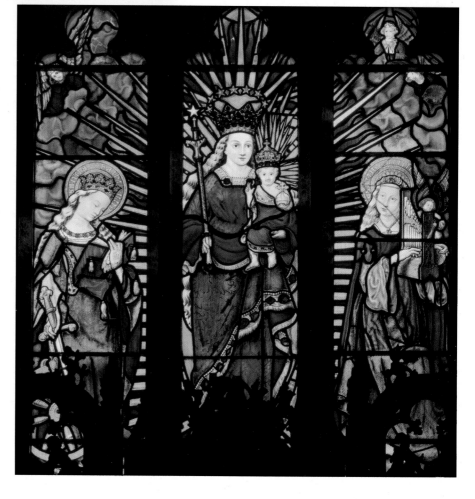

0.1d (*left*). St Mary's College Chapel, Oscott, West Midlands, north window of apse nII (Gaz.182), Pugin/Warrington, 1837. Apostles.

0.1e (*right*). St Mary's College Chapel Oscott, West Midlands, south window of apse sIII (Gaz.182), Pugin/Warrington, 1837. Apostles.

Cathedral (*c*.1795), and St George's Chapel Windsor (*c*.1786-89).[14] They were, in effect, multicoloured pictures painted in enamels on large rectangular panes of clear white glass which, put together, made up the finished windows. The results were akin to those of an artist painting on canvas, indeed, many designs were created by well-known artists, those for the above-mentioned locations being the work of Sir Joshua Reynolds, John Hamilton Mortimer, possibly Reynolds again, and Sir Benjamin West, respectively.[15] All of the artists' painterly qualities, including chiaroscuro and perspective, were faithfully reproduced by the glass-painter. The resultant images were naturalistic and three-dimensional and because the enamel remained on the surface of the glass the windows lost much of their translucency.

Medieval or 'mosaic' windows, on the other hand, were made up of a multiplicity of small, single-coloured pieces of

0.1f. Detail of 0.1e.

glass or 'pot-metal' held together by leads which in turn formed the outlines of the principal subject matter. Details of the compositions were painted in outline on the pot-metal and a minimum of shading or modelling in the flesh and draperies of the figures was introduced. Overall the effect was two-dimensional and, because the colour was an integral part of the pot-metal, light was enabled to filter through largely unimpeded. This type of window had been made in medieval times up until the later sixteenth century when it largely fell out of favour until the nineteenth-century, both because of the antipathy to religious imagery from the Reformation, and the early seventeenth-century discovery of how to paint whole works in enamels.

Pugin was contemptuous of post-sixteenth-century work. He regarded the New College window as being a 'vile composition' and all the worse because: 'to admit the insertion of this transparency, the whole of the ancient tracery of this once beautiful window was cut and destroyed'; as for an early nineteenth-century window in Hereford Cathedral, he thought it like a great transparency, 'yet more execrable than the window of New College'.[16] The problems created by picture windows were that the three-dimensional images and the use of perspective to create views in depth broke up the continuity of the walls in which the windows were contained, in other words they did not relate to the architecture, while chiaroscuro, together with the semi-opaqueness of the enamels, negated the windows' prime purpose – that of allowing light to pass through. These characteristics contravened Pugin's rules on structural integrity which required, 'that there should be no features about a building which are not necessary for convenience, construction, or propriety' and 'that all ornament should consist of enrichment of the essential construction of the building'.[17]

In contrast, the design and structure of medieval windows were wholly in accordance with these rules. The two-dimensional nature of their images allowed the flat surfaces of the walls to be left undisturbed, the pot-metal making up the windows was fully translucent, and the designs were not allowed to spread across the lights by appearing to pass behind the mullions so remaining fully-connected with the stonework of the window frames (although this was not the case at Oscott as will be mentioned later). The leads also complied, as Jim Cheshire has pointed out: 'the way in which the window is held together is there for all to see and is made beautiful by its contribution to the design'.[18] This last point, could not be applied to picture windows where the glass rectangles of which they were formed created a mesh of lines over the works that were completely unrelated to the designs, (**0.2a & b**), or, in Pugin's words: 'the subject is cut in every direction, as if a network was spread over it'.[19]

The shift from Georgian pictorialism to Victorian medievalism in glass design has been discussed at some length by Sarah Bayliss[20] and in a shorter form by Martin Harrison.[21] Suffice it to say here that it did not start with Pugin. Well before his time a revived interest in old glass itself had been stimulated by the activities of collectors, with Horace Walpole

and his Strawberry Hill collection in the 1740s, being, perhaps, the earliest. Up to the beginning of the nineteenth century collecting was mainly limited to scholars and aristocrats but then its appeal widened to include the middle classes. Interest and availability was fostered by men like John Hampp of Norwich, who, after the Peace of Amiens in 1802, imported glass from the continent on a commercial scale to be sold at public auctions in London and Norwich.[22]

Glass-painters became involved when they were called upon to restore and install such glass into suitable settings as decided upon by the collectors or the subsequent owners.[23] The most notable example of this practice occurred with the sixteenth-century glass from Herckenrode Abbey in Belgium which was brought over by Sir Brooke Boothby in 1802 and sold to Lichfield Cathedral. It was restored and installed there by John Betton of Shrewsbury (1765-1849) in 1803-14.[24] Betton, in partnership with David Evans (1793-1861), was also responsible for the celebrated 'restoration' of the fourteenth-century Jesse window at Winchester College Chapel. But when the partners came to inspect the window they found its condition so poor that it was beyond their capabilities to restore it. Their solution was to replace it in its entirety with a copy based on the original designs and to sell off or otherwise dispose of the original glass. The result of this, to modern eyes, rather bizarre treatment was widely praised by the critics of the day and it must have pleased the college too for they went on to commission the partners to deal similarly with the side windows of the chapel.

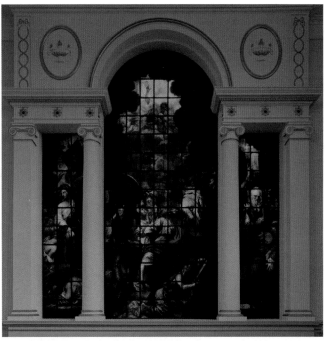

0.2a. St Paul, Birmingham, E window, Francis Eginton c.1799. Conversion of St Paul.

0.2b. Detail of 0.2a.

Sufficient of the original glass was later recovered to enable a window to be made for the west end of the chapel in 1951. The resemblance between it and the copy is close as far as the design is concerned but not so for the colours.[25] The experience gained by glass-painters such as Betton and Evans – Joseph Hale Miller (1777-1842) was another – in handling ancient glass brought them to a closer understanding of medieval window-making but pictorial ideas still dominated their designs. Even Pugin, at the start

0.3a. Malvern Priory, N transept, Coronation of the Virgin, *c.*1501-2. *Great Malvern Priory.: photograph Alastair Carew-Cox.*

of his career, used a substantial pictorial element in the apse window at Oscott in that the mandorla surrounding the Virgin in the centre light seems to pass behind the mullions before occupying parts of the two adjacent lights (**0.1b**). However, as an example of the medieval style it is far more convincing both in form and colour than that of its immediate predecessors[26] and was rightly regarded as a breakthrough even in its own time. One journal described it as 'equal to the best specimens of the earliest period',[27] and another as 'the cause of removing the prejudice or false notion which has so long possessed the public with an opinion that this art had become one of the *rerum deperditarium* of the ancients'.[28]

Why Pugin included this aberrant pictorial element in the work is not clear. Possibly he was influenced by his clients in this his first commission or it might have been that a visit to Great Malvern Priory in 1833[29] had remained in his mind when considering the design. He had rated the Malvern windows as 'among the finest specimens of English glass of the fifteenth century'.[30] The Oscott window is not dissimilar to a detail of the Coronation of the Virgin window of *c.*1501-2 in the north transept (**0.3a & b**) in which the Virgin Mary in one light is also surrounded by a mandorla which spreads into the two adjacent lights, and, as at Oscott, these lights contain standing figures with angels above. Although he regarded the introduction in the sixteenth century of windows, 'designed on an entirely new principle and rendered complete pictures unconnected in form with the stonework',[31] as being wrong in principle, Pugin nevertheless conceded that the windows produced were: 'exquisitely beautiful in design and colouring.'[32] Perhaps in the case of Oscott his admiration for the quality of the Malvern detail overcame his reservations as to its pictorial nature.

Until mid-1845 Pugin used William Warrington (1796-1869), Thomas Willement (1786-1871) and William Wailes (1808-81) to make the windows

he designed.[33] From then on, with two exceptions – at St Saviour, Leeds,[34] and Bolton Abbey[35] – all his windows were made by his friend and co-religionist, John Hardman (1812-67), in the stained glass department added, at Pugin's behest, to Hardman's Birmingham metal-works. This arrangement allowed Pugin the control that he desired over the whole of the window-making process, in the company of a manufacturer who was sympathetic to his views on working in accordance with medieval principles.

0.3b. Detail of 0.3a.

These principles could be applied reasonably successfully in practice, particularly if the works of the old masters were closely studied, as Pugin did on his many trips to the continent and around Britain. A big stumbling block preventing the windows from looking truly medieval, however, was the difficulty in producing pot-metal equivalent to that used in those times. The problems lay in replicating the colours of the old glass, its sparkling jewel-like quality – the result of light reflecting off its rough and uneven surface – and the degree to which it was translucent. Pugin, through Hardman, initiated a series of experiments, carried out by James Hartley (1810-86), a Sunderland glassmaker, in an attempt to find solutions but met with only limited success.

As Pugin's architectural commissions declined, he devoted more and more of his time to stained glass window design. Hardman's rapidly acquired a reputation for high-quality work in the medieval style and received orders for Roman Catholic and Protestant buildings alike, many of them commissioned by Pugin's architect friends and colleagues. Whilst he consistently looked to making the firm profitable, Pugin never lost sight of the windows' artistic nature and viewed with regret the general tendency to regard stained glass as being of a lower order of art. Two letters he wrote to Hardman illustrate these points. In one, relating to the east window for Nottingham Convent (**7.2**), he instructed:

> You must tell the Revd. Mother I cannot get the cartoons done – for some weeks – It is impossible….You better write and tell her I do my best to get the cartoons done but they expect a fine job and artists work cannot be knocked off like house painting[36]

In the other, concerning the west window of St Thomas & St Edmund of Canterbury, Erdington (**3.6**), he complained:

> We have been working incessantly at Mr Haighs windows if he is disappointed I cannot help it for no man can take greater pains or work harder that I do if a man was asked to paint the life of our Lord on Canvas it would be thought a great thing but on glass it is nothing.[37]

How far Pugin based his designs on particular medieval examples is a matter of conjecture. In general, but not always, he was more interested in the style than the content of what he saw, wishing, not to make copies, but to produce new work in the old way. For instance he undertook a special journey to see the windows in Chartres Cathedral before starting work in Jesus College, Cambridge. The result confirms that he was attracted to the nature of the Early style at Chartres rather than the content of what he saw. The correspondence reveals other instances of Pugin looking to medieval exemplars for his windows. These include Chichester Cathedral where the same Early style as at Sens and Chartres was to be used; St Chad's Cathedral in Birmingham, which included elements of the Decorated style from Tewkesbury Abbey and Bristol Cathedral; and Magdalene College Chapel, Cambridge, when a visit to St Mary, Fairford was made to gain an insight into the Late style. In all these cases Pugin's work survives and shows that the medieval style was his primary interest. In another instance, at St Stephen, Salford, an arrangement from Troyes Cathedral was used but the window has been lost so that it is no longer possible to see how much influence was exerted by the medieval work. Sometimes, however, Pugin did take up specific details for, as mentioned, the apse east window at Oscott seems dependent directly on work at Great Malvern Priory while the Apostles in the apse side windows are taken from lithographs in the Boisserée Collection in the Munich Alte Pinakothek.[38] Furthermore the crucified Christ at St Saviour, Leeds, may owe something to a window at St Patrice in Rouen,[39] and St George in a lost window for St George, Southwark, was taken from Cologne Cathedral. There may be other examples since Pugin regularly visited the continent where he observed windows in many of the cathedrals and churches. His comments, unfortunately, are often not sufficiently precise to pinpoint individual churches. For example, regarding the Cheadle windows, he wrote that he hoped to find, 'several glorious details' among the early work of Antwerp.[40] If he did, the windows affected and the sources he used have yet to be revealed.

Throughout his career Pugin had been plagued by illness[41] and his huge workload doubtless aggravated his condition which culminated in a severe mental breakdown in February 1852. The architect T.H. Wyatt certainly thought so, for he wrote to Hardman in March 1852:

> I cannot tell you how pained I have been to hear of this sad calamity which has befallen our poor friend Pugin. To see the wreck of so

intellectual, so active & as I believe, however much I have differed from him on many points, so honest a mind is most painful.

I have for some time anticipated it: and when we last parted at Ramsgate he was complaining of his head & I remember saying to him 'Pugin if you go on straining & driving that mind of yours like a steam engine you will have fearful breakdown mind & body'. Do they hold out any hope of recovery.[42]

Sadly there was no recovery and at the early age of forty Pugin died later in the year, on September 14 at Ramsgate.

1
Pugin's Window-makers

> My house is now nearly completed and is in every part a compleat
> building of the 15th cent. The minutest details have been attended to
> and the whole effect is very good.
> – Pugin on his new home, St Marie's Grange, near Salisbury, 1835.[1]

1.1. St Marie's Grange, Alderbury, near Salisbury, bedroom window (Gaz.192), Pugin/unknown maker, *c*.1835. *Stanley Shepherd*.

The pleasure Pugin took in the medieval effect of this, his first building, is reflected in its stained glass windows. They were probably the first made to his designs; the maker is unknown, though one or two suggestions have been made.[2] In emulation of the noblement of the past, one displays his acquired coat of arms and motto, and another quarries ornamented with his motto and monogram (**1.1**).

When, two years later, his stained glass came to public attention with the Oscott College windows, their maker William Warrington (1796-1869) shared in the acclaim.[3] Warrington, described as 'an artist but little known to the pictorial world'[4] worked from his premises in Berkeley Street West, London. How Pugin came to use him is not known but by his own account Warrington worked for the noted stained glass artist Thomas Willement[5] and this might have been the link. Apart from the fact that Pugin would have been familiar with Willement's work, the latter had been employed, in the early 1830s, by Pugin's patron Lord Shrewsbury to make windows for his house Alton Towers in Staffordshire (Gaz.147). Warrington too worked at Alton Towers – his windows for the lobby are still there but not those for the chapel – but whether he was subcontracted by Willement before 1837 or supervised by Pugin afterwards is not known. That Warrington was without an established reputation might have seemed advantageous to Pugin who had very firm ideas on stained glass design and would have wanted them followed without question.

The two continued to work together until some time early in 1841. Of the windows made in this period none had the impact of those at Oscott and only those at St Chad's Cathedral in Birmingham (**1.2**), perhaps the two now in the chancel of St Mary, Derby (Gaz.24), and the circular window at St Mary, Uttoxeter (Gaz.159) still remain. The St Chad's windows in particular, where the drawing of the hands of the figures is anything but good, suggest that Pugin spent less time overseeing the work than he did at Oscott. The break with Warrington came when Pugin asked Thomas Willement to make the east window for the Hospital of St John, Alton (**1.3a & b**). Writing to Lord Shrewsbury Pugin explained:

1.2. St Chad's Cathedral, Birmingham, apse windows I, nII, sII (Gaz.176), Pugin/
Warrington, 1841.

The reason I did not give Warrington the window at the hospital is that he has become lately so conceited, got nearly as expensive as Willement and the Newcastle man [William Wailes] had not turned up.[6]

According to Willement's ledger, the hospital window had been completed by May 1 1841.[7] So, assuming it took about three months to make, it would seem that Warrington's association with Pugin came to an end around January or February of that year.

Thomas Willement (1786-1871), unlike Warrington, was an artist of long-standing and considerable repute.[8] He made his first window in 1812[9] and like most of his work up until the 1840s it was heraldic in character, reflecting his absorbing interest in heraldry about which, between 1821 and 1834, he wrote a number of books. He became heraldic artist to George IV and artist in stained glass to Queen Victoria and, in the year before he began the Hospital of St John window he was commissioned to work on windows for St George's Chapel, Windsor.[10] Willement had in fact worked for Pugin earlier than at Alton because in 1840 he made the east window for the Convent of Our Lady of Mercy, Handsworth, near Birmingham.[11] It was, probably, of this window that Pugin wrote to Lord Shrewsbury:

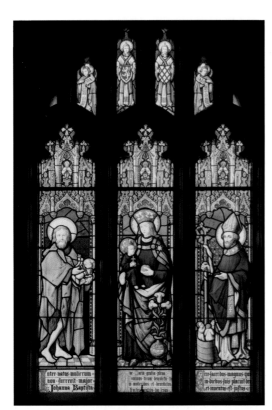

1.3a. St John the Baptist, Alton, Staffordshire, E window I (Gaz.148), Pugin/Willement, 1841. St John the Baptist, Virgin and Child, St Nicholas.

I cannot tell your Lordship how annoyed I have been with Willement for the stupid mistake about the hand of the Blessed Virgin at the Convent. I have called & written several times about it & he is at last preparing to replace it.[12]

Willement's reputation had never depended on his figure painting so the error was, perhaps, not surprising. With the Alton window, however, Pugin left nothing to chance as he later made clear when writing of the finished work, 'The figures are very devotional and well drawn', he added: 'I made full sized drawings of every detail'.[13] This additional work together with Willement's high prices[14] eventually became too much for Pugin, and some months after Alton had been completed he wrote to Lord Shrewsbury, 'I never will work with Willement again – for I have had imense [sic] trouble drawn everything out in detail and then at the last he charges twice as much as anybody.'[15]

Fortunately for Pugin, Wailes, 'the Newcastle man', had by then 'turned up'. William Wailes (1808-81) started out as a stained glass manufacturer in 1838, having previously failed as a landscape painter and a grocer.[16] His business grew rapidly and apparently within a few

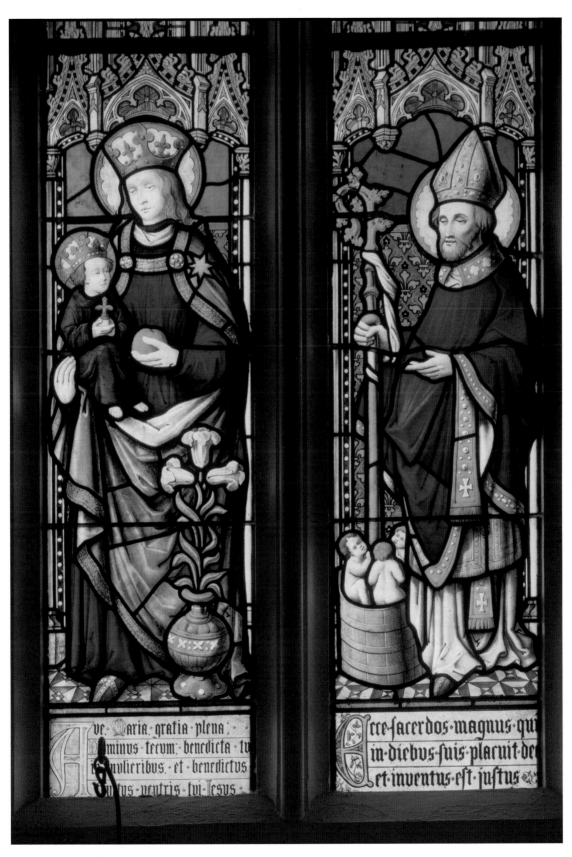

1.3b. Detail of 1.3a.

1.4. St Alban, Macclesfield, Cheshire, E window I (Gaz.16), Pugin/Warrington or Wailes, *c*.1841. St Alban.

years was employing a hundred men.[17] Even though his grandson William Wailes Strang, who ultimately succeeded to the business, claimed that his grandfather, 'excelled in delicate Indian ink, sepia, watercolour and pen and ink drawing',[18] there is no direct evidence that he designed any of the windows his firm made. Rather, he showed shrewd judgment in selecting artists to do such work for him,[19] no more so than when, according to the painter William Bell Scott (1811-90), he introduced himself to Pugin[20] and in the process gained the benefit of several large commissions.

Whether or not Wailes' first work for Pugin was the large east window of St Alban, Macclesfield (**1.4**), completed by the end of May 1841,[21] is open to question. In a letter to Lord Shrewsbury on Christmas Eve 1840, Pugin expressed great satisfaction with the stained glass in St Chad's in Birmingham and confirmed that Warrington would have it finished by the following March. Further on in the letter he informed the Earl; 'I find it quite impossible to get the window at Macclesfield executed under £150. I have got a contract for all the tracery and the centre light with the image of St Alban for £100. The other six lights will cost £50.'[22] There is no mention of Wailes or indeed that a change from Warrington was being considered so it seems reasonable to assume that he had been given the contract. However, Michael Ullman in his *St Albans, Macclesfield* observes that there is some evidence from Fr John Hall's account book that Wailes may have been used, although a search of the records in St Albans' presbytery failed to confirm this. Additionally the window is not included by Warrington in his list of some of the principal works carried out at his workshop.[23] Stylistically, arguments can be made in favour of either artist. The weighty figure of St Alban can be seen to be characteristic of Wailes' work but at the same time it could be argued that it is not unlike Warrington's Apostles in the Oscott window (**0.1d-f**).

Two other windows of this period, because they are so similar in composition to that at Macclesfield, although on a much smaller scale, add weight to the suggestion that the Macclesfield window was made by Wailes. These are the east windows at churches in Kenilworth (**1.5a & b**) and Banbury (**1.6a-c**). The first was unquestionably made for Pugin by Wailes,[24] whilst the second, also designed by Pugin,[25] is so close in the handling of the details[26] that it seems inconceivable that it could have come from any

1.5a. St Augustine, Kenilworth, Warwickshire, E window I (Gaz.168), Pugin/Wailes, *c*.1842. 'St Austen'.

1.5b. Detail of 1.5a.

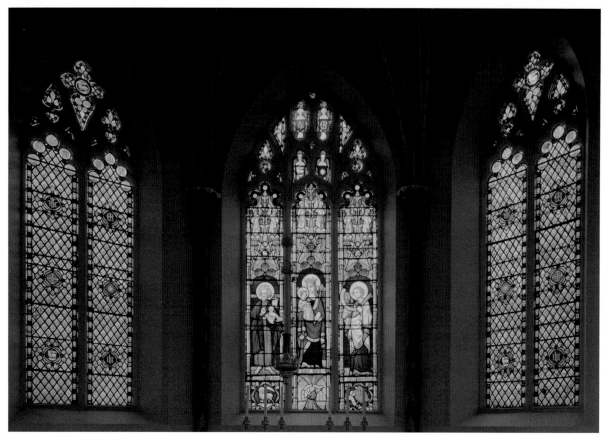

1.6a. St John the Baptist, Banbury, Oxfordshire, apse windows I, nII sII (Gaz.131A), Pugin/ Wailes(?), *c*.1841–2.

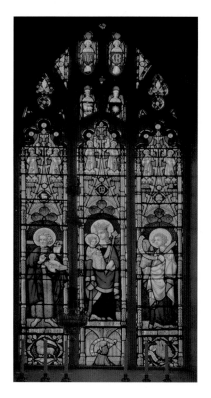

1.6b (*left*) and 1.6c (*above*). Details of 1.6a. St John the Baptist, Virgin and Child, St John the Evangelist.

1.7a. St Mary's Cathedral, Newcastle upon Tyne, E window I (Gaz.164), Pugin/Wailes, *c*.1844. Jesse.

other workshop than Wailes's. Both, as at Macclesfield, have the figure of the patron saint in the centre light and yellow silver stain patterned–quarries with inscribed geometrical bosses in the lights alongside.

Pugin and Wailes worked together harmoniously during the four years up to 1845. In this time the two men combined to produce religious and secular windows most of which were for buildings designed by Pugin.[27] Pugin was happy with the arrangement, particularly so as far as costs were

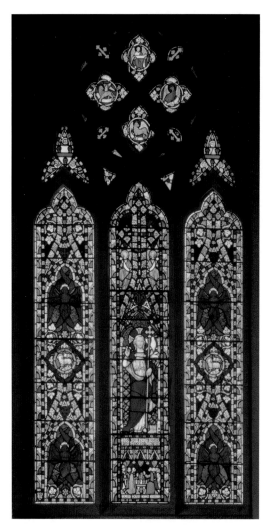

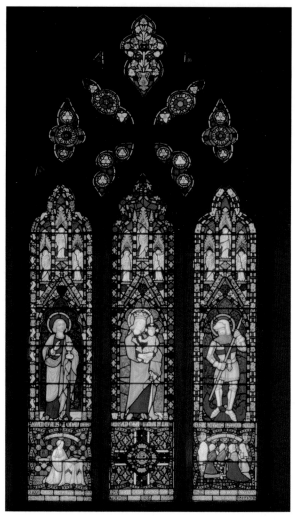

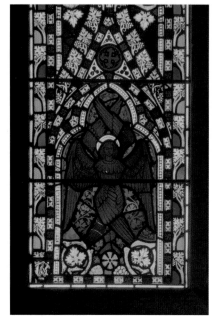

1.8a (*top left*). St Mary's Cathedral, Newcastle upon Tyne, E window N nII (Gaz.164), Pugin/Wailes, 1844. Christ with Seraphim.

1.8b (*left*). Detail of 1.8a.

1.8c (*top right*). St Mary's Cathedral, Newcastle upon Tyne, E window S sII (Gaz.164), Pugin/Wailes, *c.*1844. St John the Evangelist, Virgin and Child, St George.

concerned as he confirms in one of his letters: 'in the article of Stained glass alone, scince [sic] I have compleated [sic] my arrngmts with this northern man a saving of 60 per cent over Willements prices has in many cases been effected'.[28] For Wailes came the advantage of substantial contracts which helped him establish his business. Indeed, according to Pugin, Wailes at one stage relied entirely upon him for work: 'All Wailes men are occupied on Nottingham [Gaz.131], Cheadle [Gaz.151] and St Georges [Southwark: Gaz.63] and he has not a shilling capital

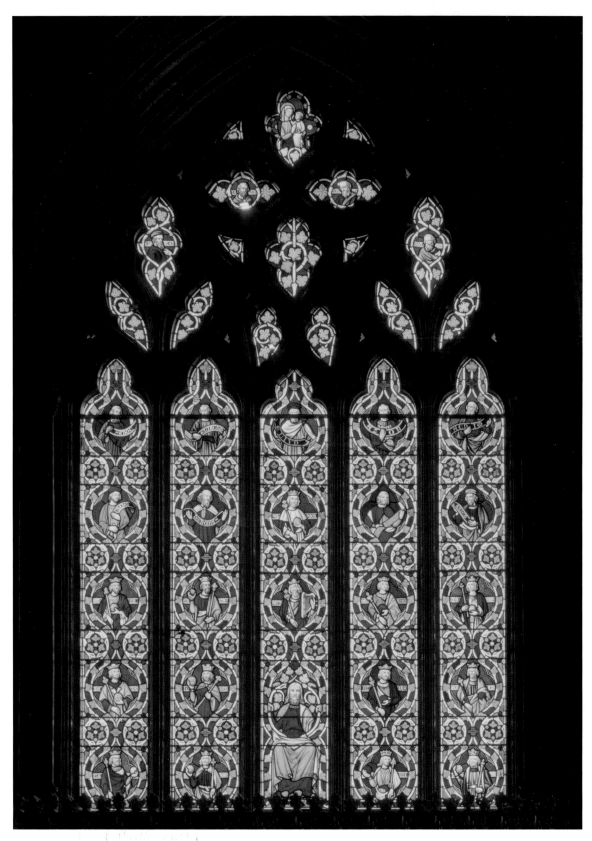

1.9. St Giles, Cheadle, Staffordshire, East window I (Gaz.151), Pugin/Wailes, c.1845. Jesse.

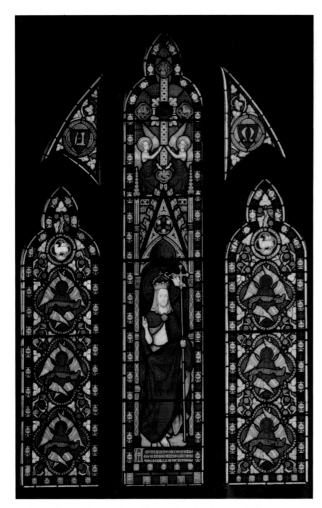

1.10a. St Giles, Cheadle, E window of the Blessed Sacrament Chapel sIII (Gaz.151), Pugin/Wailes, *c*.1845.

so I am obliged to keep up payments to get the work done.'[29]

Wailes produced a number of impressive windows for Pugin, such as those at St Mary, Newcastle upon Tyne (**1.7a – 1.8c**), Cheadle (**1.9-1.13**), and Kirkham (**1.14**), in which the drawing is beautifully executed, the colours bold and clean-looking and the designs skilfully interpreted. But Pugin became restless at his limited involvement in the whole manufacturing process. So far he had only created the initial design sketches, the drawing of the cartoons and the choice of glass being left in the hands of his window-makers. He had, of course, intervened when he was unhappy with their work, as with Willement's Handsworth Convent window, but he wanted to do more and when Wailes failed to satisfy with the windows for the Lady Chapel at St Cuthbert's College Chapel, Ushaw,[30] he seized the opportunity and persuaded his friend John Hardman to set up a glass workshop within the Ecclesiastical Ornaments metalworks that Hardman had established in Birmingham in 1838 and for which Pugin had been supplying designs.[31]

The move seemed to meet all of Pugin's needs. As his pupil to be, John Hardman Powell, put it:

[Pugin] was wishful to have his glass executed more immediately under his own care, and the direction of one (John Hardman) whose views for the progress of medieval art were entirely in accordance with his own, and whose energy and earnestness promised active cooperation in the work.[32]

Pugin made Hardman aware of his feelings probably some time during the first half of 1845, when he wrote: 'I have some great schemes in my head which I will tell you by & by. it does me good to scheme. I am scheming a stained glass shop. but this is only between ourselves'.[33] Whenever the letter was written, there is ample evidence that 1845 was the year in which the shop was established. Two large and two small easels with drawers, four grinding stones, two pestles and mortar, stain, sundries, colours and a cupboard were

1.10b. Detail of 1.10a.

1.11a (*left*). St Giles, Cheadle, N aisle window nIV (Gaz.151), Pugin/Wailes, *c*.1845. Seven corporal acts of mercy.
1.11b (*above*). Detail of 1.11a.

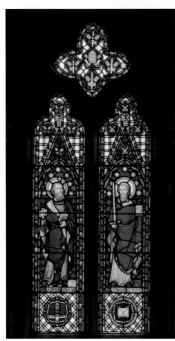

1.12a. St Giles, Cheadle, N aisle window nV (Gaz.151), Pugin/Wailes, *c*.1845. St Peter & St Paul.

purchased from A. Henderson of New Street, Birmingham, on July 19, and James Earley was paid for building muffles, altering a chimney, building a wall and sundry plastering jobs on August 4 while from July 16 onwards, quarries of cathedral glass and sheets of coloured and cathedral glass were purchased from William Perks Junr & Co., Smith & Pearce, and Lloyd & Summerfield, all of Birmingham. In addition Josiah Kempson of Birmingham supplied best bar lead, W.H. Pankhurst of Shelton, red and black colours (brown also from 1846) and Thomas Perkins of Birmingham, camel hair pencils and brushes and a badger hair foot.[34]

Hardman continued to mostly use the same glass and colour suppliers up to 1849, although the Newcastle Broad & Crown Glass Co., Stock & Sharp of Birmingham, the Cut Glass Co. of Birmingham, and William Henry Cope & Co., of Stourbridge were added to the list of suppliers for glass in 1847 and William Perks' firm became Perks & Rogers late in the following year. From 1849, James Hartley & Co., of the Wear Glass Works, Sunderland, became the main supplier of glass, and Francis Emery of Corbridge, Staffordshire, of colour.

Over the years other names to appear in the records included J. Bridgewater of Birmingham who provided in 1848 a circular iron window frame and two gothic casement frames and in 1849 three

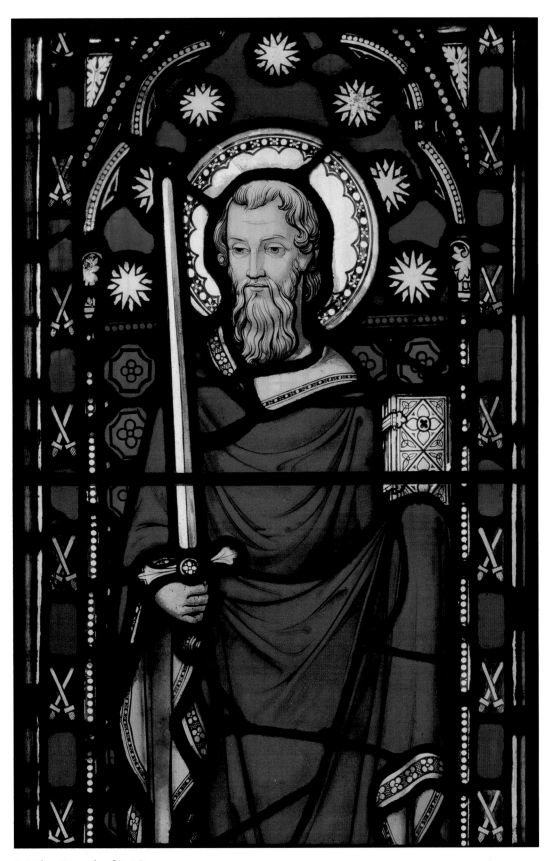

1.12b. Detail of 1.12a.

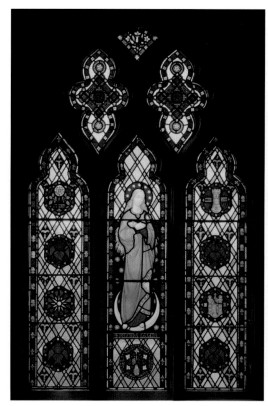

1.13. St Giles, Cheadle, S aisle window sVIII (Gaz.151), Pugin/Wailes, *c*.1845. Virgin Mary.

1.14. St John the Evangelist, Kirkham, Lancashire, detail of N aisle E window nIII (Gaz.92), Pugin/Wailes, *c*.1844. St Helen. *Stanley Shepherd*.

galvanised iron frames to order costing £25 for Cambridge (Gaz.9), and one large wrought-iron frame for £15. Also in 1849 eight cast-iron window frames were purchased from Smith & Hawkes of Birmingham, while Robert Field & Sons (Opticians) of Birmingham repaired and supplied compasses respectively in 1846 and 1847. William Perks provided two new diamonds (for cutting) in 1846 and one circle machine in 1847, and one small muffle came from from I. Marshall & Sons of Birmingham in 1849.

The first windows to be produced according to the First Glass Day Book, which is a reliable record of the completion dates of the firm's windows, was in November 1845. The first entry states: '1845 November 24 for windows at Ushaw [Gaz.40]'. The Pugin/Hardman stained glass business was under way.

2

Seeking the 'real thing'

I am determined to go to Rouen, Evereaux [sic] & c this month & have a good look at glass. I never troubled with that view before. I saw glass and drew it but not with the idea of <u>making it</u> & I am sure there is a deal to learn.

– Pugin writing to Hardman in 1849[1]

Pugin's letter to Hardman was written some four years after he became fully involved in window-making. Even so he was evidently not convinced that his efforts to emulate the stained glass windows of the medieval makers had been entirely successful. His misgivings were despite the fact that pre-Hardman windows, such as those at Oscott, Alton, Newcastle and Cheadle, had been very favourably received and that, with Hardman, he had already created the east (now west) window at Ushaw (**2.1a & b**) which he described as 'the finest work of modern times'.[2]

He was so conversant with the various processes that went towards making a window, that as early as 1838 (about a year after the Oscott window was completed) he was able, in a lecture to the students at Oscott to give brief and clear explanations of what was meant by cartoon-making, cutting, leading, painting and firing, and to familiarise them with some of the technical terms involved.

He also described five different styles of windows to be found from the seventh century onwards, designating them as 'first' to 'fifth', highlighting their distinct characteristics, giving the locations of where particularly fine examples of each could be found, and using large-scale transparencies to illustrate some of those mentioned.[3]

He was somewhat vague as to the precise period each style covered and in later years, when corresponding with Hardman, he reduced the five to three and referred to them as Early, Decorated and Late (Perpendicular), following the example of Thomas Rickman (1776-1841) in respect of Gothic Architecture. Rickman's timescales for these styles were respectively: *c.*1190-*c.*1300, *c.*1300-*c.*1390, and *c.*1390-*c.*1540.[4]

Supplementing this knowledge, was Winston's book, *On the Differences in Style observable in Ancient Glass Paintings with Hints on Glass Painting,* which appeared in 1847. Charles Winston (1814-65),[5] a barrister with a fondness for the fine arts and glass-painting in particular, meticulously analysed all the details of figures, draperies, borders, patterns, canopies, heraldry and lettering as well as the features and colours of glass that occurred in the various styles. He also included a series of drawings and engravings, taken from actual examples, to illustrate these features.

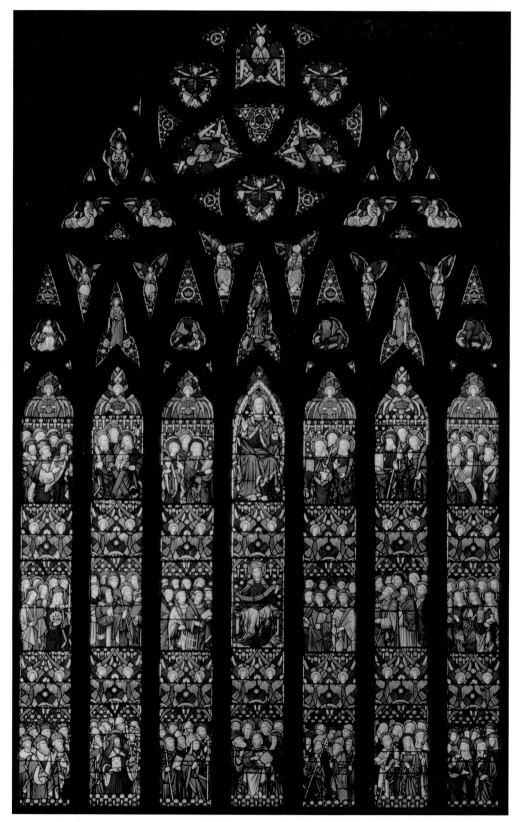

2.1a. St Cuthbert's College Chapel, Ushaw, Durham, W window wI (Gaz.40: originally the E window of Pugin's chapel but relocated to the W end of the new chapel of *c.*1884), Pugin/Hardman, 1846–7. Triumph of the Church.

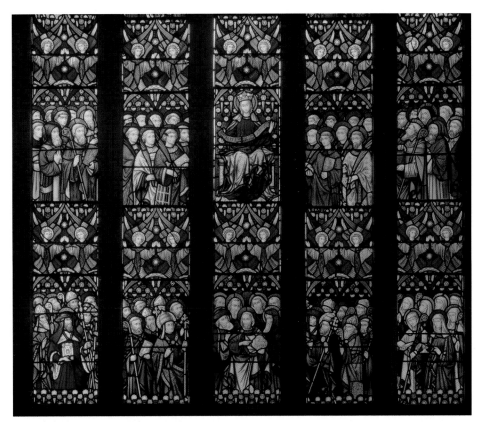

2.1b. Detail of 2.1a.

In theory, therefore, in the later 1840s Pugin was in a position to produce windows on a par with those of medieval times. Theory and practice, however, were two different things and in spite of all the analysis and his own work experience, he found it difficult to reproduce the effects that the old makers had achieved.

His response, to journey to France to study afresh the old glass, was typical. He had travelled in England and on the continent looking at, drawing and learning from, medieval buildings – including the stained glass where it occurred – since he was a boy under the tutelage of his father and now he would go to look again, paying particular attention to the techniques involved, in order to bring closer to the old style of work his figure drawing, grisaille, diaper, leading, painting, means of producing the colours and characteristics of the glass and the handling of the colours.

As far as figure drawing was concerned Pugin set limits to the extent to which he would follow the 'ancients'. He was not prepared to distort the proportions or features of the human figure beyond what were natural. Where this had occurred in medieval work, he thought it was due to the old men lacking modern-day anatomical knowledge and possibly the skill to draw what they could actually see. He wrote as much in a letter to the artist J.R. Herbert (1810-90) regarding the proposed School of Design:

No reasonable man would think of altering the proportions of the human

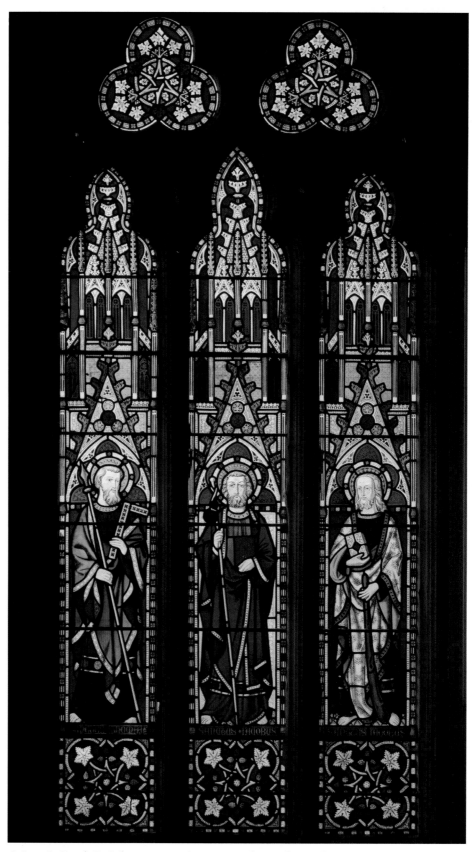

2.2a. St Paul, Brighton, East Sussex, S chancel window sII (Gaz.41),
Pugin/Hardman, 1849. St Thomas, St James the Great, St James the Less.

frame, so beautifully and wisely ordained by the Creator; but it is by the disposition and draping of the figure that the Christian artist obtains his effect … By draping a lay figure of natural proportions in stuff and vestments which were in use during the middle ages, the identical folds and forms are produced in reality which we see represented in a greater or less degree of perfection in the ancient works. The first productions of Christian art are the closest approximations to nature, and when they failed in proportion and anatomy, it was not a defect of principle, but of execution.[6]

This amounts to a rejection of deliberately apeing medieval distortions, a charge levelled at Warrington by *The Ecclesiologist* which accused him of elaborately reproducing 'Hands like a bunch of carrots hair something uglier than a rope mat – water elegantly reproduced by the heraldic wavy – and clouds literally nebuly.'[7] Perhaps this approach was part of the reason for Pugin dispensing with Warrington's services (reference has already been made to the badly-drawn hands in the windows at St Chad's, Birmingham). That he made full-sized drawings for Willement of every detail of the figures in the east window of the Hospital of St. John, Alton may also be significant in this respect. Apart from his failings as a draughtsman, Willement too, at least in his later work, was inclined to 'antiquate' or artificially age a window,[8] a procedure described by Martin Harrison as the 'application of matting paint to suggest the softening caused by ageing which is normally apparent in genuine medieval glass'.[9] This practice too was rejected by Pugin and noticeably so to the critic of the *London Illustrated News,* who, in 1851, reporting on the Pugin/Hardman glass in the Great Exhibition, commented: 'The whole of the glass has been painted in the old manner and without any attempt at antiquity, but left precisely in the same state as that of the old glass when originally executed'.[10]

Pugin's drawing also received critical acclaim. A footnote in the same issue of *The Ecclesiologist* that had criticised Warrington, praised Pugin and Hardman's glass for its purity of drawing, regarding it as exceeding anything yet produced in England.[11] The fact that Pugin was able to supervise the creation of the cartoons, once the Hardman workshop had been formed, had led to this high level of achievement, ensuring that figures and draperies were drawn in accordance with the principles he had outlined to Herbert and so, in his view, with those of the medieval artists. For the most part the cartoons were drawn

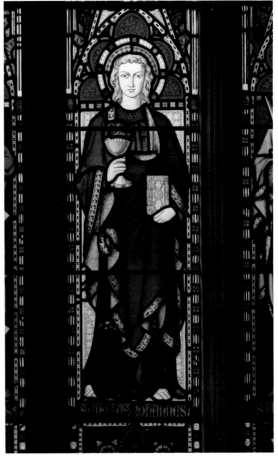

2.2b. St Paul, Brighton, East Sussex, S. Chancel window sIII (detail), Pugin/Hardman, 1849. St John the Evangelist.

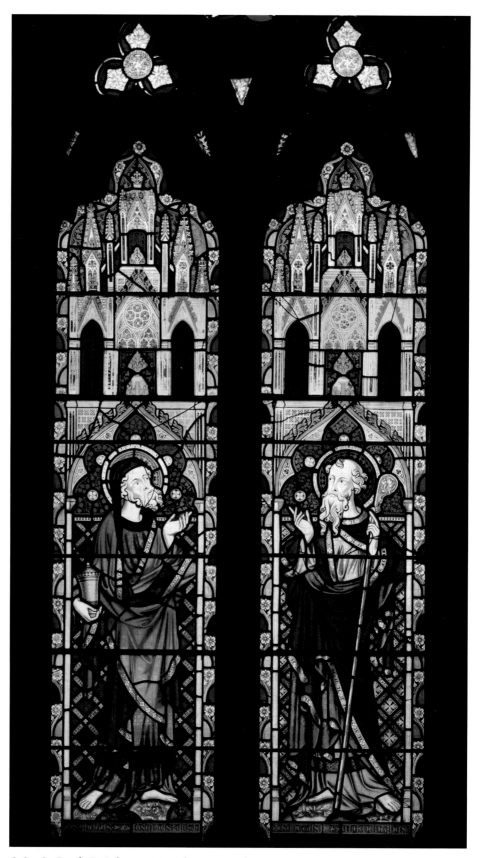

2.3. St Paul, Brighton, N aisle W window nVIII, (Gaz. 41), Pugin/Hardman, 1850. Includes much new work by Meg Lawrence to repair damage by vandals. St Joseph of Arimathea, St Clement.

at Pugin's home, The Grange in Ramsgate, by Hardman's nephew John Hardman Powell but some were submitted to him from London by Francis W. Oliphant and they caused him concern: 'being done away from me they really lose all the spirit of the drawing. he does them against his will & they are not near so like the true thing as what Powell does.'[12] An indication of what Pugin meant can be seen by comparing Oliphant's restrained and idealised – or 'academic' as Pugin would have it – Apostles in the chancel of St Paul, Brighton (**2.2a & b**), with Powell's vigorous and animated saints at the west end of the nave (**2.3**), always bearing in mind that the versions of the Apostles as they appeared in the windows would be much closer to Pugin's intentions than those originally sent him by Oliphant.[13]

Some months after Pugin made his visit to France in 1849 he had cause to complain about the appearance of the backgrounds in his windows; the grisaille (monochrome patterns of a geometric or foliage design on mainly white glass) at Chester, Ramsgate and West Tofts he wrote, 'wasn't half strong enough', and 'failed to tell'. Again the solution was to look at the old works and he resolved to send Powell 'to study – the foliage & c from the old things <u>real size</u> with the <u>real</u> strength of line that the old men used'.[14]

Diaper work created similar difficulties. Pugin's definition of diaper was probably not restricted to the familiar one of small repeated patterns, although these do occur, for instance, in the backgrounds of his windows at Ushaw (**3.12**), but included patterned, coloured backgrounds in general. The patterns could consist of: florets on stems as on the screens behind the saints in the windows at Great Marlow (**6.1a & b**); the foliage infilling of the lancets at Jesus College Chapel, Cambridge (**6.5a–c**); and the seaweed patterning on the screens behind the saints on the windows at Holy Innocents, Highnam (**6.11**). Analysing the problems Pugin wrote:

> I am sure our windows must be painted <u>stronger</u> especially in the diapers which in their present weak condition resemble various stages of the decline[?] of the small pox - & give no effect. I am sure the whole treatment is too small & poor[?] the old fellows leaded up simple & blacked in. I see a great improvement can be effected if we work[?] stronger but then we must have <u>tracings</u> of the old work <u>full size</u> to judge us.[15]

This simplicity of the leading was admired by Pugin not merely because it was the 'true thing' but because it was practical, looked good and contributed to a major saving in costs. Defects in Oliphant's work of which Pugin complained to Hardman, illustrate these points:

> It is a most extraordinary thing that Oliphant has no idea of practical leading. I had to take out half his lead instead of making[?] one piece of glass to fit into another like the old men he makes all sorts of pieces about this size [indicates with a sketch] making no end of expense and trouble I am sure by judicious leading the same effect can be gained at 50 percent less cost in Leading up & cutting – it is a great point[?]

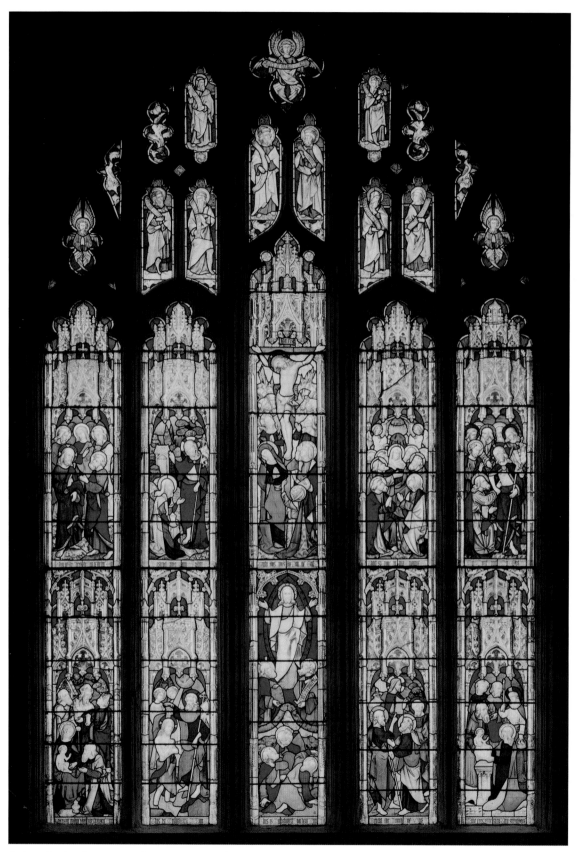

2.4a. St Andrew, Farnham, Surrey, chancel E window I (Gaz.162), Pugin/Hardman, 1851.
Events in the life of Christ.

to simplify the cutting & leading I have been examining the old work & I see they did[?] it everywhere & it looks better for it. I assure you I have taken at least half the Leads out of the cartoons & I feel certain I can make a reform in this input which will Earn you of half the Labour & loss in [?] & c.[16]

He explained in greater detail in a letter to Oliphant:

I must beg of you to be more careful about the leading of the cartoons you make all the 4 last groups I have been obliged to do half over again on account of you having made so many lead lines which could not possibly be worked. in the first place you make the lead about ¼ the real thickness [sketches a hatched lead line] consequently when the real comes [sketches a thicker lead line] half your drawing must be lost it is no use deceiving yourself by drawing these lead lines on the paper when as a practical man you must know that lead cannot be less than this to hold the glass and resist the weather [demonstrates with a sketch] & therefore your drawings are pure delusion & however beautiful are useless for all the form is lost in the leading you must keep your lead lines the full width & draw accordingly. the 4 subjects you have sent are completely spoilt for want of this. you have only allowed half the necessary space for the lead & in many cases not that so half your drawing is lost in the real lead & glass [PS] you allso [sic] make 2 many pieces so small that they would neither be cut nor leaded up.[17]

Improvements to the painting in his windows could not be achieved by Pugin simply looking more closely at the old glass, since, unlike the cartoons, the work was carried out by Hardman's men away from his supervision. The painter's main difficulties were, firstly, mastering the technique of scraping out, or removing the enamel paint to create highlights, and, secondly, to interpret correctly cartoons drawn in the Late style. Of the first Pugin wrote in some despair:

the old artists are the glass painters not the cartoon makers that is the secret & we might work 100 years on our system without doing anything, we cannot draw later glass painting in decorated work we can succeed but not in artistic work I shall light my furnace[18] & see what I can do on the glass….I had ladders up to the windows at kings [King's College Chapel, Cambridge] and it is all done by artists scraping out & c. we don't work on the first principles of the later men & you know it.[19]

The remark 'our system' no doubt referred to the unsatisfactory arrangement, from Pugin's point of view, whereby the painting was done in Birmingham, out of his sight in Ramsgate, to be seen by him only on visits to the workshop or, very late in the day, if he chanced to call on a site after a window had been put in place.[20]

It meant that he was in no position to pick up at an early stage adverse

effects of colour in the windows. His frustrations are revealed in two of his letters:

> Our great disadvantage is my never seeing the work in progress. I make the cartoons & that is all. but I am sure the old men watched everything & I predict that we shall never produce anything very good until the furnaces are within a few yards of the easel. the disappointing effect of the windows in execution[?] make me wretched they are optical delusions & & [sic] changes by juxtaposition of colour that no [?] can give[21]

and:

> I assure you I take every pain to prevent alterations I do indeed but I cannot see the effect in a cartoon not even a coloured one the transparent light changes the effect & deceives me altogether. It will be 20 years before I get sufficient experience to make[?] the cartoon….. how often painters alter the colour of pictures & you laugh at me when I say I ought to watch the work you work splendidly <u>to the</u> cartoons but you cannot alter them as they require it & there is the difficulty.[22]

The second difficulty of the painters, that of interpreting cartoons drawn in the Late style, was highlighted by Pugin about two years after his 1849 visit to France when, probably in early 1851, he wrote about the east window at

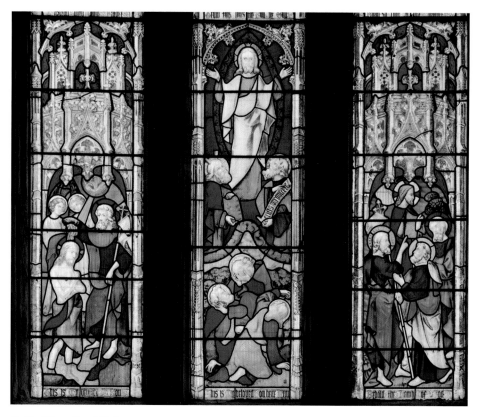

2.4b. Detail of 2.4a.

2.4c. St Andrew, Farnham, sketch by Pugin for 2.4a, 19.5cm x 33.9cm.
Birmingham Museums & Art Gallery, BM & AG a.no 2007-2728.7.

Farnham (**2.4a & b**) – a very ambitious project in the Late style containing ten multi-figured scenes under separate canopies. The problem underlined to him the importance of his being involved in the process:

The Farnham light is diabolical disgraceful. It is not the least like the cartoon they have put powerful shadows where there are half tints & half tints where there are strong shadows. It is a most infamous careless caricature of the cartoons & all painted with black instead of brown shadows which I have begged & prayed for but nobody in the place has the remotest idea of Late work … My dear Hardman if you don't turn over a new leaf about Late work the jobs may be given up at once. how I have exhorted for brown shadows in Late canopies - & they have altered the lines thinness they have made the lines the same thickness which are doubled & tripled on the cartoons. It is a most careless [?] production. I took the greatest pains with the drawings of the canopies & now the glass is not the least like it. you ought to put down so much for me to come here once for a week – where Late work is about for even you do not understand you [?] feel it yet the decorated is perfect but the Late is vile. There is not one line felt in that glass. It is execrable you will never do any good till you let have [sic] a man to educate for 3 months.[23]

With a very busy 1851 ahead, however, including exhibiting at the Great Exhibition and only about a year before severe illness would cause him to stop working altogether, the opportunity for Pugin to educate one of Hardman's men never arose.

If designing windows to medieval standards caused Pugin much heartache then attempting to replicate the colours, vibrancy and translucency of the old glass added considerably to his anguish.

During the 1840s Hardman purchased glass in a range of colours listed by manufacturers as stock items. These included in 1845, blue, and light blue, yellow, purple ruby, amber (two shades), dark and light green, brown green, blue purple and assorted colours, together with sheets of yellow stained, kelp (for staining) and cathedral or tinted glass. In 1846, flesh-coloured and grey were added and in 1847 variegated ruby, streaked ruby, flashed-green and flashed-blue. In 1848 red purple was introduced.[24] Warrington, Willement and Wailes seem to have been content to use glass from stock when working for Pugin. He on the other hand looked for something better. As early as 1842 he wrote to Lord Shrewsbury regarding the windows for St Giles, Cheadle: I will make the glass as rich as possible I have been much engaged in getting the real thick glass again I think I have succeeded at Last. This is the grand secret thick glass will alone produce richness.'[25] And a few years later, probably around the middle of 1845, in a letter to Charles Barry regarding the windows for the Palace of Westminster, he reported: 'I gave Wailes a good blowing up for his heavy glass and bad greens, and he has offered to finish another specimen on a different principle at his own cost, to which I have agreed.'[26] Eventually, according to Pugin, it was his dissatisfaction with the quality of the glass used by Wailes for the Lady Chapel windows at St Cuthbert's College Chapel, Ushaw, in early 1845 that caused him to persuade Hardman to set up his workshop.[27]

The glass available to Hardman during the early years of the workshop

must have been little different to the sort Pugin objected to when used by Wailes, so in 1849, he resolved to change matters. During his visit to Evreux he purchased a quantity of old glass which he determined to reproduce, writing to Hardman:

> I assure you we have hardly one of the old colours in our glass & I expect we shall have a deal of trouble to get them but at any rate we have now the patterns & I have several pieces of early sort so they can be analysed if necessary.... I have learnt an immense deal this journey & I feel certain we must start de novo to get the true thing – but I feel certain that I have now the key to whole system [sic] & by keeping the glass of the different periods distinct we can make every window If we accomplish the tints we shall be at the very pinnacle of glass painting.[28]

To help him achieve his ambitions, he instructed James Hartley, through Hardman, to carry out a series of experiments at Hartley's Sunderland works. Pugin's influence in this field has until recently[29] remained largely hidden, most of the credit being given to Charles Winston who arranged for chemical analyses to be undertaken of ancient glass specimens, and, ultimately, for the results to be used by Powell's of Whitefriars in the reproduction of old glass.[30] Winston acquired a reputation in his own lifetime for his interest in stained glass, *The Ecclesiologist* in 1853 describing him as an accomplished person who has bestowed an immense deal of time and study on painted glass.[31] The remarks were made in the context of a report on windows designed by him and put up in the round nave of the Temple Church in London, using the new glass which was described as being 'bright and clear'.

From Winston's own accounts it seems that his experiments started in the autumn of 1849. He gave some twelfth-century blue glass to a Mr Medlock of the Royal College of Chemistry for analysis[32] – this was a little after James Hartley began experiments to produce ancient ruby for Pugin/ Hardman – and the analysis was completed in Easter week 1850, although no glass was made. In a letter dated April 20, 1856 Winston refers back to the analysis of the blue glass and says that he subsequently got a pupil of Medlock to analyse many other specimens.[33] He then claims to have produced glass hitherto thought impossible to be made in blue, streaky ruby, several but not all kinds of green, yellow, white and a few shades of purple, but only in colours of the twelfth century. On the face of it, no Winston glass seems to have been made until after Pugin's death, when it was used in 1853 at the Temple Church, and none in any quantity or extensive range of colours until several years after.

Winston's approach was rational, methodical and analytical. In a paper read in 1849 to the Oxford Architectural Society and later published, he admitted he thought it problematical as to whether a material identical with that of the thirteenth and fourteenth centuries would ever be reproduced.[34] He argued that it was more difficult to go back, than to advance in manufacture and that the improvement of glass in clearness, purity and

equality of thickness, together with the more efficient furnaces used to fuse and amalgamate the materials, had made modern glass more transparent, more regular in thickness and freer from impurities in the substances of the glass and its colouring matter. The consequences were an evenness of surface and colouring resulting in a flatness of colour, in complete contrast to the sparkling gem-like qualities of medieval windows. At around the same time, Pugin was seeing these same defects in his own windows:

> I have been over to Cheadle today the window in the cloister of the convent looks – beastly <u>horribly modern.</u> I shall be in despair if we cannot get an older look to our windows – The arrangement of colours is bad which is my fault but I see all the ruby is as <u>clear</u> & <u>flat & equal</u> as possible altogether it makes me quite unhappy to see, pray get some of the Tofts [West Tofts, Gaz.120] tracery sent off that I may see the effect when I am there & get some comfort.[35]

Hartley's first major task for Pugin seems to have been to manufacture ruby glass with the characteristics of the old. His first attempts were anything but successful. In May 1849 he advised Hardman of the despatch of six sheets of sheet glass and six of rolled glass to be stained ruby, and also one sheet of each already stained. Included as well was some of the material to be used for staining, in a manner, 'precisely like silver stain'; as he explained:

> We do not profess to supply glass & Material for painters to make their own Ruby but only what may be required for the use of painters who require different depths of color [sic] on the same piece of Glass – you will soon see if you attain what is required in this respect.[36]

That Hardman's were favoured customers is evident from a letter Hartley sent three days later saying: 'You will please not inform anyone that we supply you with Glass & material for staining Ruby, as we have to decline to supply Wailes and other painters with it'.[37] Pugin was not impressed. The method seemed false and he wanted none of it:

> I dare say you think me a very miserable man but I am bent on getting the true thing in glass & I am quite certain we have not yet succeeded – we are just as far off the streaky ruby as ever – neither in Cambridge [Gaz.9] or Tofts [Gaz.120] is a single piece approaching the old. the Ruby is <u>shaded</u> with <u>brown stain</u> but you know that is a mere modern substitute. it is a most extraordinary thing that was <u>universal</u>[?] in Ruby cannot be attained with all our chemical knowledge.[38]

His reference to chemical knowledge in the above letter and to analysing some of the glass in the previously quoted letter from Evreux are intriguing. Was Hartley called upon to obtain chemical analyses similar to those which Winston commissioned? Before Pugin went to Evreux Hartley's were making glass for Hardman's from samples, with methods that were empirical rather than scientific, as one of his letters indicates: 'Our people have mislaid

your sample A – would you oblige us with another per return – we are making the glass and before we blow it we must have the sample to test the colour.[39] If he changed his approach Hartley makes no mention of the fact. Obtaining the equivalent to ancient ruby was particularly difficult. As early as 1847 Winston had published his conclusions as to the structure of old ruby noting that the glass was coloured only on one side of the sheet and that it varied in thickness according to its age. That of the twelfth, thirteenth and fourteenth centuries had the greatest thickness and most plainly exhibited the streaky appearance.[40] After tabulating the results he continued:

> The colouring matter of ruby glass, until the beginning of the fifteenth century when seen in section with the naked eye, seems to be collected into several thin strata, parallel to the surface of the sheet, of unequal thickness, and embedded in white glass, usually of a more yellow hue than that of which the rest of the sheet is composed. When examined however with a powerful microscope, the portion of white glass appears to be almost filled with an infinite number of the thinnest possible parallel laminate of colour, closer together in some places than in others, which produces the stratified appearance before mentioned… After the beginning of the fifteenth century, the ruby colour appears like a thin dense stratum on one side of the sheet, not thicker than a sheet of writing paper, which is sometimes…. covered with a thin layer of white glass… this stratum as in the earlier specimens being composed of a vast number of minute laminae of colour. The colour on modern ruby is equally thin and bears similar marks of construction. It is also sometimes covered with a thin coat of white glass… For these and other reasons I consider the modern ruby, and that of the fifteenth and sixteenth centuries, to be identical.

Pugin seems to have been unaware of Winston's work for writing to Hardman he shows himself knowledgeable as to the nature of early glass but confused as to the relative thinness of the glass of the fifteenth and sixteenth centuries:

> What a wretch you must be to deceive me at the 11th hour with that Ruby. after all my boasting about the revival of <u>thick rich looking</u> unequal glass you have sent me 2 smooth perfectly smooth, polished smooth pieces not so thick as I have drawn & the ruby all on the surface in a thin coat like the modern stuff when <u>mind</u> the specimen you showed me from Hartley showed it <u>mixed</u> in <u>with the white glass</u> like the old… the pieces you showed me from Hartley at first were the real thing this is only a streaky wash & not at all like the old & on such smooth polished glass that it must have come from Howell & James Windows in Regent Street … you know in your heart this is about as nearly like the <u>old rough rich glass</u> as if you took a piece of a claret glass [includes a small sketch of a goblet] … I see clearly it is as bad as ever <u>thin as paper</u> & <u>smooth</u> as a <u>mirror</u> & this for Early stuff whose whole beauty is in its rough rich look never was a greater piece of gammon than these 2 pieces thin smooth white glass with the

finest, truest, equal, precise, coat, of 16th century modern ruby.

After this came two sketches, one showing a cross section of a thin sheet of glass, identified as, '12 century ruby revived in 1850', and the other an uneven thick cross section labelled, 'a voice from Chartres, humbugs forbear'. But then he added:

> Since writing this [?] a whole packet of glass from the Cathedral at Tournay[?] has been sent here & hang me if a piece[?] is very like your beastly stuff and yet it must be old from the corrosion I send you a bit it must be 15 century.[41]

Hartley may or may not have read Winston but he did reach similar conclusions when writing at the end of 1849:

> All modern ruby contains but one thin surface of color [sic] whilst the old is mixed in innumerable stria through the metal. I enclose a sample somewhat approaching to it the colour you will observe is not on the surface but in the body of the metal like the old, the only difference being that in the enclosed sample there is only one or two layers whilst in the old there are hundreds, [he went on]: I have determined to make the article & have no doubt when I have succeeded it will appear so simple as to occasion surprise that there should ever have been any difficulty in the matter.[42]

He was prevented from continuing his work for some two to three weeks at the start of 1850 due to the coloured glass furnace needing to be rebuilt. At that stage he was sure he would succeed in his task, although concluding that the ruby would be more expensive, not from being charged more but from cutting up to such great disadvantage as compared with what is made on improved modern principles.[43] He sent samples which he regarded as good imitations of the old and Pugin was impressed, 'Hartley's ruby appears to me very sparkling & a great improvement', adding, 'but we want the streaky look', and then he became suspicious believing the samples to be real old pieces of glass: 'to see what I should say'.[44]

On February 15 Hartley complained that the colour could not be got 'solid' and that whenever the colouring matter was reduced to a certain point, 'it goes all away'.[45] He reasoned, therefore, that dark coloured glass needed to made and then lightened by flashing.

On March 1 he apologised for not yet having got any of the ruby and confessed that his initial success had been accidental.[46] A fortnight later, with the glass manufactured proving no more successful than that already returned by Hardman, he admitted:

> I am sadly puzzled in the matter and cannot give you any hope of being able to get what you want at present I shall continue to experiment with the Ruby in all its various forms but only get one pot per week on the large scale.[47]

It is worth interrupting, momentarily, the progress of these experiments to register the reaction of Charles Winston to Hartley's ruby at this time. Winston's views are recorded in an account of the *Proceedings at a Meeting of the Archaeological Institute* of May 3, 1850, which reported:

> In conclusion, Mr Winston called attention to a piece of modern ruby glass, made by blowing, in express imitation of some ancient glass of the thirteenth and early part of the fourteenth century, in March last by Mr Hartley of Newcastle [sic], at the instigation of Mr Ward, the glass painter. This was as Mr Winston believed, the first instance of such an imitation: and although the glass produced was not identical with the original model, yet it certainly came nearer to it than any other substitute.[48]

Whether Hartley copied a sample submitted by Ward or gave Winston an example of the work he had previously done for Hardman is not clear, but it is evident that Winston was impressed with the result.

Sometime after his low point of March 1, Hartley became convinced he had made the breakthrough, for on May 1 he wrote to Hardman: 'I send you a Box today with a sample of streaky ruby made precisely as the old ruby was made with which you will be pleased it is a perfect imitation with a brilliancy of <u>true ruby</u> which has never been attained', he continued:

> The burning of it will require considerable judgement the glass is first made white or nearly so a sample is in the case, and it is by applying a proper amount of heat for a given period that the colour is brought out, it will not stand firing neither will the old ruby in that barbarous affair the modern glass stainers kiln, a high temperature of five minutes is ample to flux any colour instead of the stewing for hours which it gets at present and ruins the best colour none of the old glass was fired more than from five to ten minutes – You will understand that the ruby sample is a portion of the white sheet, with a given amount of firing to bring out the colour you can heat pieces of it through your kiln & you will find it will come to the same colour if not overfired if too much fired it will go black the brilliant colour is obtained by subjecting it to a red heat for about 7 minutes – if for 15 minutes then all the colour goes – <u>Sample 1</u> in the case will show you the effect, at one end the glass is white at the other end it is overfired & all the colour goes at the junction of the two where there has been the proper amount of heat there is the brilliant ruby, this was done in the common fire in the office. [and concluded]: Now I fully understand the matter I shall soon be able to make it in any quantity and also find out the best mode of firing it – I enclose a small sample of the Ruby – however when you see the three sheets sent I think you will pronounce one of them to be the first sheet of true ruby you have ever seen of modern manufacture.[49]

Pugin's reactions to the ruby sent by Hartley during these months are difficult to assess since his letters on the subject are undated but perhaps the following refers to the glass made in February and returned to Hartley by

Hardman in March:

> these specimens of Ruby are vile they do not in the least resemble the
> old glass & if Hartley cannot make a better job he better cut it out
> once [sic]. they are to me execrable they look mean like bad water
> closet window glass than streaky Ruby why these are brick dust there
> is no sparkle or richness or anything about them… they are horrid,
> you must have seen them by candlelight good gracious I will take these
> pieces when we go to see old glass together & you shall make an act of
> contrition.[50]

And to that which so pleased Hartley in his letter of May 1: 'Hartley. Last
Ruby is very good but I want to see it in Quantities'.[51]

Hardman in spite of Hartley's guidance seems to have had difficulty in
bringing the colour out of glass sent to him in May and August,[52] albeit
that Hartley was completely satisfied that the process worked. There was no
change nearly a year later. In June 1851 Hartley wrote that he had made,
'The best streaky ruby … that I have seen',[53] and promised to send a crate
leaving Hardman to bring out the colour but on July 8 he found himself
writing, with perhaps a hint of exasperation:

> You had better return the crate and we will bring out the colour – we
> have sent you a Box today with some pieces of the same as sent you
> & the colour brought out you will notice one piece very cockled like
> horn this was done on a common shovel in the fire.[54]

In the succeeding months Hartley switched his attention from ruby to
matching the degree of semi-opaqueness of medieval glass, especially that
of white.

Charles Winston's tests with pieces of glass of the twelfth, thirteenth
and fourteenth centuries led him to the conclusion that if the glass was
to be sufficiently opaque so as not to appear flimsy or watery *in situ*, and
sufficiently clear to produce as brilliant an effect as the old, it must satisfy
two conditions. First, 'if the glass, held at arm's length from the eye, and at
the distance of more than a yard from an object, does not permit of that
object being distinctly seen through it, the glass will be sufficiently opaque';
second, 'if when held at the same distance from the eye, and at the distance
of not more than a yard from the object, it permits of the latter being
distinctly seen through the glass, it will be sufficiently clear and transparent.'
To some extent he attributed similar qualities to sixteenth century glass,
unlike Hartley who discounted age as being a significant contributing factor
and pointed to the importance of the composition of
the glass itself:

> Recent analyses have discovered the presence of at least one constituent
> of old glass [not named] which does not exist in the modern and on
> which being purposely introduced, produces the self same effect of
> solidity and richness which we perceive and admire in the old.[55]

Pugin had been visually aware of the special qualities of fifteenth-century white glass as early as 1848 when he insisted that the white in the side aisle window at St Mary's, Oxford must be given 'the milky look of old by an opaque tint'.[56] Two years later he still complained, 'our glass is bad from the foundations it is not the <u>white</u> the old men painted on',[57] but not until 1851 did Hartley make mention of it and then only in the general context of the non-transparency of old glass:

> I understand perfectly what is wanted, the defect in the glass of your windows in the exhibition [probably the Farnham Windows, Gaz.162] is quite apparent to me, they are quite spoilt by the great transparency of the glass & where the rough plate is used in the canopies of one or two it is no improvement for tho not transparent there is a dull opacity which is fatal –
> There is no doubt that part of the non-transparency of the old glass is the effect of time, this cannot be imitated not by the laying on of any substance which has often been attempted as it gives the windows a smudgy appearance, I expect to succeed by slightly diapering[?] the surface of the glass by the effect of <u>continuous heat</u> which has upon glass the same effect <u>as time</u> I have shown this lately to Dr. Lyon Playfair[58] in some imitations of glass taken out of the Egyptian Tombs. –
>
> In addition to the foging [sic] the glass must be made <u>to sparkle</u> this I have succeeded in so far as an experiment goes & have sent to you two sheets today one of streaky ruby which is a good sample of that sort of ruby & you will see it has a sparkling appearance; the other is a sheet of yellow tinted glass which in my view is all that can be desired you have there all the sparkling brilliancy of the old glass a little <u>more opacity</u> would have made it perfect... I propose carrying out the experiment in ordinary white glass if I succeed in which there will then be no difficulty in doing it with any of the colours.[59]

The experiment seems to have been successful for in the following month he wrote: 'We are now packing for you 8 or 10 sheets white glass that I think is just what you require I have succeeded in giving it that dull appearance or semi opacity of the old glass, you will probably write me when you have seen it.'[60] That Hartley was unable to attain a consistency of results in his experiments is evidenced by his letter of March 26, 1852:

> I was much disappointed the last time I experimented to get the semi opake [sic] glass you require & the importance of which I fully appreciate having as I imagined at one time fully succeeded its turning out such a failure was very annoying to me, however we will have another try... the semi opake samples enclosed in your letter are flint glass made with phosphate of lime glass of this description will not stand firing they would go quite opaque like a piece of pottery ware.[61]

On August 30 he wrote of the limits of his success, offered a new approach and reiterated the qualities in the old glass that he aimed to reproduce:

we can do very well on a small scale to making samples but I do not see my way clear on a large scale, is the window you speak of the large one at the end of Westminster Hall [Gaz.64]? If so it would be an inducement if you used <u>all our glass</u> for us to make almost every piece of glass as we do our samples – this no doubt is the way the ancient glass was made every separate piece was a study, the radical defect of the modern system is the having of large sheets of glass all of one plain colour – smooth surface – equal thickness & quite flat; & cutting this down as tho it were for plain glazing, irregularity of thickness non transparency, at the same time brilliancy of surface – crooked pieces & c are essential to produce the effect of old glass & which it is useless denying has never been equalled in modern times.[62]

He sent with the letter samples, one of which he believed to be a perfect imitation of the old glass, another of the same glass 'not so much dimmed …, but still very good', and a third of ordinary white glass with its surface rendered non-transparent by another process. He also included specimens of streaky ruby glazed which contained every variety of ruby to be found in old windows all of which were to some extent transparent except for one which was regarded as a perfect imitation of the old ruby in its non-transparency and brilliancy of colour.

A month later on September 21 he wrote a further account of his experiments and of their partial success and closed with a sad acknowledgement of Pugin's death a week earlier: 'I was much grieved to see the account of the death of Mr. Pugin he has left no one to succeed him.'[63]

Whilst ruby, white, and the general transparency of glass appear to have been the principal areas in which Hartley concentrated his experiments, in letters dated October 6, 1849, October 23, 1850 and November 7, 1851 he makes mention of work done in respect of other colours. The first concerned fifteen sheets of glass he hoped to sell even though, 'it is however too blue for your sample No.2', the second two samples of brown pinks, 'exactly the same as two of your Patterns,' and the third contained an acknowledgement that he could not match the flesh tint sample received.[64]

Although Hartley's work, prompted by Pugin, might have fallen short of reproducing consistently and in quantity glass with the qualities of the medieval, he undoubtedly did produce some that exhibited its essential characteristics. Whether he succeeded as well as Winston is open to question (Martin Harrison notes that the differences in quality between Pugin/Hardman windows and an early one by Winston would only be distinguished on close inspection by an expert)[65] but, as has been pointed out Hartley's glass was used in windows earlier and to a far greater extent that that of Winston who might have had as much difficulty in persuading Pugin that Powell's of Whitefriars glass was the 'real thing' as did Hardman with regard to Hartley's. Even in 1861 the architect William Burges could criticise a good deal of Powell's production:

2.5. St Augustine, Ramsgate, confessional window (Gaz.88), Pugin/Hardman, 1849.

I am very much inclined to believe that there is not much difference in the mere texture of Messrs Powell's glass and that of the old metal; for the former has been made from receipts furnished by Mr. Winston, who has devoted a great deal of time and care to the analysis of the old glass. Unfortunately Messrs Powell will persist in blending the colour too much with the metal, and the consequence is that the sheets for the most part come out all of a tint, instead of being streaky and clouded. What little does happen to possess the latter qualities, the firm very naturally keep for their own work, and thus the stained glass manufacturer cannot obtain what he most wants; for Mr Winston has hitherto limited the use of his receipts to Messrs Powell alone. Now as these latter gentleman are unable to produce a sufficient quantity of the glass in the right manner, I would suggest whether the time has not arrived to make these said receipts common to all the glassmakers, so that we may have a better chance of obtaining what we want.[66]

The 'receipts' seemingly were not passed on and glassmakers continued in their attempts to make 'antique' glass but it was not until the later 1860s that it became possible to match, consistently and in sufficient quantity, chosen medieval samples.[67]

Even if medieval-type glass had been wholly available to Pugin, he would still have needed the ability to match the old men in their handling of colours to produce windows of their quality. John Hardman Powell pointed to the subtleties the 'old painters' showed in this respect in a paper he read, some five years after Pugin's death, to the Worcester Diocesan and the Birmingham Architectural Societies on the subject of stained glass.[68] Noting how few colours they used, he mentioned: greyish blue for the backgrounds; rubies streaky and brilliant; green 'always quiet and used in large masses'; whites pearly or silvery (not thin and clear) and dispersed over the whole to give proper value to every tone; the brown purples used as a soft transition between the ruby and blue; and over all the golden yellow as, 'a tint of sunshine'. He observed that: 'These few colours, varied from the palest to the richest shade were sufficient for endless varieties of harmony in the hands of the old painters, the peculiar tint of each helping very much the effect of the whole.'

That Pugin had an equal grasp of colour harmonies was not doubted by Powell who, writing late in life about his years with Pugin, observed:

As a colourist he was supreme, not only for splendour and contrast, but on his knowledge of the juxtaposition of the tones and subtle harmonies, which even the old Artists, excepting those of the Renaissance might have envied. Seeing the glamour produced by time in the ancient Glass and that simple imitation would be crude he did not wait for his effect to come as a mere antiquary might but varied the whites and introduced transition tones, like a Genius.[69]

Pugin's mastery of colour and his understanding of its effect on design and harmony in windows was a major factor in the success of the Hardman

firm's work. His letters to Hardman contain endless comments on the need to use colours and tints carefully to produce good design and effects. Some of them concerning the windows in his own church at Ramsgate illustrate the point. With regard to white glass, for instance, he was captivated by the windows in the confessional (**2.5**) describing them as perfectly beautiful, 'the glass used in the quarries has the silvery look', and urged: 'be sure you make all leafwork of geometrical windows of this glass it is quite lovely',[70] But when the glass was used in the north aisle window he recognised that he had ruined it: 'not <u>you</u> but <u>me</u> in yellowing the Roses in the ground',[71] and explained:

> Remember I told you how beautiful the Confessional Windows looked now this same glass owing to the yellow has lost all the silvery effect it is wretched it looks like yellow – what experience it requires – but you must profit by this – in all you have in hand keep back the yellow'.[72]

On another occasion the St Louis figure in the quatrefoil tracery-piece of the chantry window (**10.18**) came in for much criticism, 'the white figure from below looks like a mass of dirty white',[73] and indicating in a small sketch that there was too much blue in the foils:

> Too much blue here it reduces the centre figure to nothing … I think I shall begin to <u>colour</u> the cartoons It is very costly but it is the only way of ascertaining the effect & I think it would be cheaper in the End.[74]

Blue he acknowledged as a key colour:

> It is a dreadful thing if our blues are too light – it will <u>affect all</u> the blues are the stumbling block & if they are not right we cannot get the old effect my traceries are all <u>ruined by blues</u> so much that if I can get any money I shall apply it to take them out.[75]

Wrong effects nagged away at him and he would go to great lengths to correct them:

> I go in & out of the Church in despair. It is the brown pink leaves on the blue that do all the mischief if you could substitute white I think it would do… the glass is built in the stonework what do you think about the possibility of substituting <u>white leaves</u> now it is <u>up</u>. I think the lead might be turned up & the white leaves inserted.[76]

Seeing the glass in St Augustine's several times a day when at Ramsgate, was a constant spur to his perfectionist nature and goaded him into changes which he regarded as experiments for the resolution of future problems: 'if I get my own windows right they will be of immense service in tying the combinations of colours'.[77] As a consequence the 'true thing' would become available to all who commissioned his works.

3

The Hardman Glass Workshop

everybody knows that I design the glass but double the applications
come through you than what I get. – Pugin to Hardman, *c.*1849[1]

Pugin's mock indignation partly reflects his frustration in running
a business with the two men based in different locations separated
by a considerable distance. It was not that Hardman concealed Pugin's
contribution from his clients – on the contrary, knowing he was essential to
the success of the undertaking Pugin's name was brought forward at every
opportunity. 'I am constantly making windows … from the designs of Mr.
Pugin under whose supervision the whole of my glass is executed,' Hardman
wrote to one client in 1846,[2] and this openness marked his dealings with
them all.

Working arrangements

The division of the various processes saw Pugin in Ramsgate creating
the sketches for the windows and supervising their translation into full-size
working cartoons, after which the leadlines were added and Pugin marked
in the colours that Hardman was to use. Once completed the cartoons were
posted to Hardman in Birmingham for use by the glass cutters, leaders and
painters whose work he oversaw.

These processes were described by Pugin in his Oscott lecture:

> A cartoon is extended on a flat surface, and the artist [glass cutter]
> proceeds to reduce the different pieces of glass, which are to compose
> the intended window, to their required shapes, by means of a diamond
> cutter and grozing tool, till they cover their destined places on the
> cartoon, allowing sufficient space between the joints for the insertion
> of the lead bands by which they will be finally fastened together….
> The various pieces being elevated against the light, with the cartoon
> behind them [see **3.1b**], the lines underneath are traced on the frosted
> [glass treated with a light greyish wash] surface of the glass, with a
> brown opaque colour, which is used also for the shadows and the
> lights are afterwards scraped out of the frosting with a sharp-ended
> hard piece of wood.[3]

The distance between the two sets of processes created annoying problems
for Pugin. Apart from being unable to oversee the work of the painters, there
was Hardman's aggravating failure to give proper attention to the paperwork,

3.1a. St Chad's Cathedral, Birmingham, N aisle window nX (Gaz.176), Powell/Hardman, 1853. St Luke, St Andrew of Crete.

something which was avoidable and led to wasted time and money. This caused Pugin to become confused by requests for work not linked to specific windows and he was often unaware of orders that Hardman had received:

> We have no earthly[?] idea what Castle Martin [Gaz.218] window is. the fact is you send bits of paper here without anything written on them. you ask for a sketch for a window by return of post without saying where or what is for [sic] I send back a sketch & in course of time it comes to me without any name I have several things in my book of which I <u>know nothing</u> & it is indispensable either for me to go to you or you to come to me with a list … why don't you keep a list of orders as they come & give me a copy.[4]

More seriously, because it directly affected the quality of the windows produced and could have led to the need for expensive alterations, was Hardman's failure to update the glass patterns kept at Ramsgate. These patterns represented the glass Hardman had available to him in Birmingham and were used by Pugin when marking in the colours, by code, on the cartoons. The code was alpha-numeric and consisted of the opening letter or letters of the colour together with a number that determined the colour's depth, as in the letter quoted below where y.5 refers to yellow of a particular intensity. That the updating lapsed is evident in that Pugin needed to write: 'you have no idea how confused I am about the numbers of the glass. I hope when you get the new colours right you will send me a current list numbered.'[5] And to highlight the consequences of such negligence, he used the east window of his own church, St Augustine, Ramsgate, as an example:

> I have just had a piece of the present y.5 comparing it with the old samples. It is [?] another colour. It is a sort of <u>modern orange</u> I thought the grapes in my east window looked very bad & this is it it is orange. now my dear friend if the glass used is quite different from what is marked we never can make a good result. I don't think you are aware of the main difference between my number of glass & what is new. This is very serious & again if your people put in this colour for Ruby borders what can we expect. Green 3 no more resembles my pattern than if had [sic] no reference to it. It is become a regular modern colour. I have been closely overhauling all these things & I implore you for the sake of an audit[?] to refuse these things or stop till

3.1b. Detail of 3.1a.

the old colours can be matched <u>or</u> give me notice of
the changes & then I could arrange something but as
it is I go on in the Delusion of the old colours & the
effect is quite different. I am <u>certain</u> this is the cause
very often with the blues that <u>look black</u> they must be
different from the pattern. pray reform all this. I think
more of glass than anything & we shall never do fine
things without a correspondence of colours between us.
we should have a pattern of shades of ruby mounted[?]
& marked nothing should be left to the men – I watch
everything or we shall never improve.[6]

His closing remark is indicative of the total control that Pugin sought to
exercise over the activities of the business. In this he was successful since his
views on every aspect of the firm's policy invariably prevailed. His advice
was even sought on relatively minor matters as for example when the Rev.
Newsham wrote to Hardman: 'I have often intended but always forgot to
ask you for the cartoons of the chapel windows [Ushaw, Gaz.40]. They will
at some future time become crucial materials in the College: I am anxious
to have them on that account.'[7] Hardman referred the request to Pugin,
who wrote back sharply, 'of course you will not send the cartoons to Ushaw
good gracious what an idea you supply <u>windows</u> not cartoons'.[8] So, in a
more emollient tone, Hardman explained to Newsham:

With respect to the Cartoons for the Chapel Windows

3.1c. St Chad's Cathedral, Birmingham, S aisle window sVI (Gaz.176), Pugin/Hardman, 1850. St George, Virgin and Child.

I cannot return them as they are part of my stock in trade & they are always kept at Ramsgate for reference & to make fresh Drawings by. Cartoons are never sent to the purchasers of windows as the windows themselves are the things sold & not the Cartoons which in most cases at the present day are used over & over again. There is not much danger of this in your case – But setting aside all this the Cartoons would really be of no use to you as they are all cut in pieces for the convenience of working and covered with dirt and nail holes from the use that has been made of them.[9]

The workforce

Only occasionally do we learn the identity of the window makers under Hardman's control. John Hardman Powell writing in 1866 on 'The art of stained glass in Birmingham', mentions the engagement at the outset of the two sons of Robert Henderson (a Birmingham glass painter who worked in enamel on domestic windows), who gave assistance, 'in the practical mixture of the yellow and brown stains, and in burning in the kilns', and also of Mr Hinkley, Henderson's chief painter, who had twenty-four years experience.[10] An invoice from Lloyd and Summerfield dated December 31 1845 includes a charge of 10/- a week for forty-nine weeks for the services of William Luckett, apprentice.[11] The First Glass Day Book entry on December 20 1853 (some eleven months after illness prevented Pugin from continuing to work for the firm and three months after his death) for the 'glassmakers' window at St Chad's, Birmingham (**3.1a & b**) identifies the working figures as: 'Cartooning E. Hendren; Cutting Thos. Grew; Painting James Jones; and Burning Saml. Jones'.

Letters in the archive from men seeking employment as glass painters include one dated March 1847 from Joseph Baguley who claimed fourteen years experience at Messrs Lowe & Son, Dublin, including the general run of ornamental work, the mixing and using of stains and the entire management of a kiln. Another in September 1849 from Thomas Hardy who worked four years for Wailes, principally at fine tracing and foliage work; and a third, February 1849. in which Robert Russell put himself forward for work in the lead glazing department, citing eight years experience with Wailes and Forrest of Liverpool. There is no evidence that their applications met with any success. Also in February 1849 John Tippin requested that his son,[12] who had been, 'at the Cuting [sic]', since he started with Hardman's, be 'Put at the Painting', as soon as convenient.

By contrast, Pugin's helpers at Ramsgate are readily

established. John Hardman Powell, a nephew of John Hardman, was already there helping with metalwork designs when the glass workshop was established, and so was Pugin's eleven-year old son Edward. Francis W. Oliphant was employed on a freelance basis from 1846 until the end of 1850. Sent at various times from the works in Birmingham to be trained under Pugin, were Edwin Hendren, Thomas Early and Frederick Hill.[13] Someone called Monaghan was paid by Powell through his cartoon account during 1850, but unlike Hendren, Early and Hill was not referred to by name in Pugin's letters. Enrico Casolani, a pupil of the Nazarene painter J.F. Overbeck, joined Pugin in 1847 and left, seemingly, in the same year.

John Hardman Powell (1827-95) arrived at Ramsgate when he was seventeen, probably in December 1844. In a letter of the previous month[14] Pugin anticipates Powell's arrival and sets out his terms for someone he was later to describe as his only male pupil.[15]

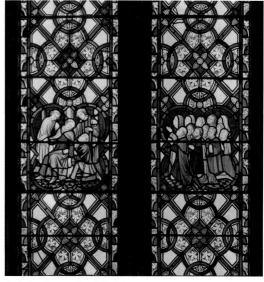

3.1d. Detail of 3.1c.

> I shall be ready for young Powell in about 2 weeks. It would be well for you to speak seriously to him before he comes for he is the only person I have ever consented to take as a pupil algh as you know I have been offered a deal of money to do so. I hope he will apply most earnestly to study. he will have immense advantages & if he seconds my endeavours & profits by the means in his power he will become thghly versed in Christian art. I will fund him in all things he may require for drawing & c free of cost & instruct him in all principles of the art but I do not expect he will run away from [sic] as soon as he gets to understand things or before he is 21. I may in progress of time instruct[?] him with business of trust & importance which he must execute faithfully & when he is of age I doubt not that he will be capable of Earning an excellent income. pray state all this to him & moreover especially explain to him that I have a very small establment in the way of servants & therefore he must in a great degree wait on himself for I dread Servants and will not have more than are absolutely necessary.

The decision to send Powell to Ramsgate seems linked with the anticipated heavy work load for the furnishing and decoration of the House of Lords with which Pugin had become officially involved during November 1844.[16] Possibly, even at that time, Pugin had in mind taking upon himself all aspects of stained glass manufacture, but Powell was used initially for modelling metalwork designs, in which he made good progress.[17] No documentation has come to light which determines absolutely when he started to assist with the cartoons for stained glass but it seems likely it was from the moment the

new business started. A letter postmarked DE 26 18 [4]5 shows Pugin eager to use Powell on some canopy work, implying that he was now sufficiently experienced. In the same letter he welcomes the anticipated arrival of a young man (Hendren?) to do the leadlines.[18] Undated letters from Powell to his uncle show him to have been involved with the Ushaw windows (Gaz.40) and by 1847 it is clear he was well established, although Pugin, as a letter of his shows, needed to supervise his work very closely:

> As soon as I go away everything stops. all done in the cartoon drawings will have to be altered so I shall not be able to send the Warrington windows [Gaz.17] yet it is a sad loss of time but it is wonderful how little judgement even Powell has when left to himself he is a competent man draws beautifully but he does not find[?] the telling points of arrangement. I must be at home as much as possible this summer & keep things going & for the future I will have everything done in my absence left in pencil till I return.[19]

Powell was working on figure drawing during 1847, as his letters to his uncle indicate.[20] One of them shows that towards the end of the year he was gaining in confidence: 'I am at work at Broughton [Gaz.66] hard. it is a very fine job for me and I improve very fast. I do believe in a little time I should be able to turn out very good figures but you will see these soon.'[21] Carelessness, lack of concentration and forgetfulness were the faults that Pugin levelled at him in these early years:

> he has got a most careless habit of doing without thinking the least of what he is doing I had taken immense pains that morning explaining to him the principles of tracery & a quarter of an hour afterwards he did just the same as if I never had spoken a word he says he acquired the habit of working without thinking at Elkingtons [Elkington & Co., Birmingham] & cannot get out of it. It is a sad thing for he can really do well when he tries.[22]

The same faults were still evident in 1849:

> It is a most curious thing I cannot get Powell to think at all about what he has done he makes beautiful drawings but they don't fit[?] the places they are intended to fill....You will hardly believe it after all my exhortations he let Ushaw library window [Gaz.40 Library west window] go to you without taking any memorandum of the colour of the heads and the quatrefoils though we had the centres[?] to do I assure you I have begged 100 times always to take a memorandum of unfinished windows that are sent off. it is very sad for he draws some things beautifully & with a little thought would be a first rate man.[23]

By 1850, however, things were looking up:

> Powells improvement is surprising[?] his figures for Beverly [St Mary, Beverley, Gaz.83] are far superior to Oliphants. his heads are full of devotion he will be a sterling example of what an artist can be without

going through the academy process of making one he deserves <u>every encouragement</u> in a short time he will be an excellent artist,[24]

and some lapses, it seems, could even be seen in a humorous light:

> On returning home I find Powell had put the following inscription for Cambridge [Magdalene College Chapel, Gaz.10] Sancta Maria Magdalene Virgini!!! & in answer he said he indicated that she became miraculously a virgin again this is a <u>new idea</u> and quite <u>original</u> & would I expect be condemned – it is a good thing we did not send it to Cambridge as[?] it would certainly have been considered as a <u>development</u>[?].[25]

In fact, by 1851 Powell had become indispensable: 'I do not think Powell can go away directly[?] the whole study may as well be pulled down if he does for nothing will be done – at all... all the others will go wild <u>quite wild</u>'.[26]

Two incidents involving Powell upset the rhythm of the work at Ramsgate. One occurred in January 1848 when Pugin sent him back to Birmingham after discovering that he aimed to leave; and the other in 1850 when he married Anne, Pugin's only child by his first wife, and left the Grange to live in his own house nearby. Of the first, Pugin wrote to Hardman:

> When I returned last night Powell told me that he intended leaving me altogether as soon as he was of age of course I have nothing to complain of in this he is quite right only It comes rather suddenly upon me & I am sorry you did not tell me when I was at Birmingham as he asked me if you had not informed me & seemed satisfied you had not. of himself I have not a suggestion[?] of anything but praise. He is the most trustworthy excellent person I ever knew & I had hoped for great things with him but like all other visions they fade at the touch. he will now turn his ammunition against me & I shall have to counter against another enemy. This is natural it is human nature & I do not complain for an instant (he that is not with me is against me) & however it will bring about one great change that I am not sorry for. I shall give up stained glass entirely. you have now an artist of your own who possesses accurate copies & tracings of every document from which I have been accustomed to work & you will be able to carry on the work independently of me & I trust make it pay which I have not been able to do. The cartoons for Winwick [Gaz.18] I shall finish myself but the other you must make the best of for I will not leave my other business to sprawl over yards of paper & I will not teach anybody else & therefore I will make it all over to you together & say Deo gratias. 1. I have been to Nottingham [Covent of Mercy Gaz.130] & I expect we shall be able to send [Thomas] Early there as soon as he leaves St. George's [Southwark, Gaz.63].[27]

Although Powell's twenty-first birthday was not until March 4,[28] once he had expressed a wish to leave, Pugin resolved not to keep him a day.[29]

According to his diary, Pugin had visited Nottingham on January 14, 1848 returning to Ramsgate the following day, so it seems likely that he packed Powell off to Birmingham on January 16, sending his things on later – one box went with Hendren who joined Powell, and one by goods train.[30] Pugin's immediate reaction was one of relief: 'I am now free from cartoon making it is quite delightful,'[31] but Hardman was upset on two counts. He thought that Pugin believed he was in some way to blame – something about which Pugin was quick to reassure him[32] – and he worried about how the work would be undertaken. Pugin suggested:

> that I supply you with the designs & details & c & that he [Powell] gets out the cartoons for them at your place with assistance – the best figures being done by Oliphant – you pay all expenses and allow me 10 percent on the work for the designs, by this means all will go on I shall be released from much trouble & anxiety – & I think it will be a mutual benefit.[33]

On the face of it it seems unlikely that these proposals were put into practice and that Pugin tided things over for the two months or so of the hiatus. The summary of cartoon costs held in the Hardman archive suggests that Powell and Hendren had resumed work at Ramsgate on cartoons for the windows for Oscott College (Gaz.182), entered as completed windows in the First Glass Day Book on June 24. For these and the one for Whalley church (Gaz.94), entered on June 30, to have been finished by the due dates (assuming a minimum of three months for the time between the receipt of the cartoons by Hardman and the completion of a window) would have required the young men's presence at the Grange at the latest by the middle of March. Once again assuming the lapse of three months between the receipt of the cartoons and the completion of a window, the cartoons for the windows (entered in the First Glass Day Book for 1848 to June 8 – the entry date for the windows for Winwick) would have needed to have been more or less finished before Powell left. Winwick, Pugin promised to complete himself, so that the only windows unaccounted for up to June 24 (the entry date for the Oscott windows) would have been the bedroom windows for Bilton Grange (Gaz.166), the cloister window for Nottingham Convent (Gaz.130), and the side chancel windows for St George's Southwark (Gaz.63) (all entered on June 8); from the correspondence, the first two named seem to have been handled by Pugin,[34] leaving only Southwark, as a candidate for the new system.

One other aspect of the affair that disturbed Pugin, and showed Powell's independence of mind (possibly influenced by Oliphant, something at which Pugin hints in his letters[35] and about which he complains bitterly at a later stage); was the discovery, chanced upon by Pugin, presumably when gathering together Powell's things, of proof that in his words, Powell was, 'A Pagan in heart'.[36] Promising to reveal all to Hardman when they met Pugin wrote:

I will tell you a good deal & show you the casts of the <u>Pagan Gods</u> the <u>venuses</u> & <u>apollos</u> he brought into my home <u>unknown to me</u> after all I have written & said on the subject he has disproved[?] my teaching. he left me for the sake of following <u>fake</u> art & I have done with him as a <u>disciple</u>. but in the way of himself with you & me we can go on & do everything.[37]

The sentiments in the last sentence and the warmth the three men felt for each other, as indicated in other parts of Pugin's letter, ensured that the rift was healed relatively quickly with no apparent adverse effects on the work in hand.

The second event, consequent on Powell's marriage on October 21 1850 created problems, affecting the routine in the cartoon room – or study as Pugin called it – at Ramsgate. Powell wanted to do more work at his own house,[38] and initially Pugin was understanding, although concerned that the output from and the discipline in the cartoon room would suffer as a result. By that time Powell was in charge during Pugin's absences, although Pugin still needed to approve the cartoons before they were sent to Birmingham. Explaining the difficulty Pugin wrote to Hardman:

> There is a matter of great importance that will require a perfect understanding. I <u>expect</u> I <u>imagine</u> that Powell intends to draw entirely at S. Lawrence[39] as soon[?] as the house is ready – now this is very natural but what is to become of all the other people & the study – even lately he returns only from the house to the study & goes back so that at least 13° [sic] of the day is passed on the Road. this may be only temporary owing to getting into the house but if it is permanent then this is an end to all we have been trying at. I actually went to see him & what is doing [sic] & he ought to look after the other people. It appears to me the beginning of a bad system – how singularly things turn out what we expected would[?] Lead[?] him to the mark[?] will be the means of taking him away from the study – & perhaps eventually forcing us to give up the glass windows from the inability of getting cartoons done – without the study it cannot be done.[40]

Once Powell began the new practice Pugin became much less sympathetic and saw Oliphant's influence behind the move:

> There is a system beginning which better be put an end to at once or else Powell better leave altogether. he has taken into his head to draw at home & I find the study left for hours together if this fine room which I have built at so much expense & fitted with such fine things is not good enough for him & if he does not like to work under my eye there is an end to everything if he is to begin the independent artist let him go to London & fight his way by himself for I will not have it & I am sure you will agree with me… if Hendren & the place is to be left in the middle of the day it is impossible to go on of course I have no power over him but while he is ostensibly with me I shall

insist on his working in my place & I am sure my dear friend you will join me in enforcing this point rely on it if there is something very bad beginning this is the first move – if he intends to go why not like an honest man say so & not back out by inches – I am very hurt at it … it is like an insult to leave my study which he has[?] to himself as fine a room as there is lighted[?] to draw in a Modern room with his infernal casts of gods. I know what he wants, he wants to be like Oliphant & live in London & come down to sketch & take the work away with him. but this shall never be – some think that I would do the work myself.[41]

After a flurry of letters the matter was not referred to again and the established routine in the cartoon room was resumed (in the following year Pugin referred to the disruption that would occur in the study should Powell be away for two or three weeks).[42] Probably the fact that Oliphant stopped working for the firm after 1850 was instrumental in restoring harmony. Pugin himself pointed to this: 'It is nothing to do with my alterations of Cartoons about Powell but I think Oliphant stuffs him with nonsense[?] about not being able to become an artist. he would starve in 6 weeks at that work. I am not sorry on the whole that Oliphant is giving up.'[43]

3.2a-b. St Catherine's Orphanage, Liverpool, E window, left- and right-hand lights (Gaz.109), Pugin/Hardman, 1846. Annunciation. On loan to Liverpool Museum. *National Museums Liverpool (Liverpool Museum)*.

Francis Wilson Oliphant (1818-59) doubtless came to Pugin's attention in Wailes's workshop where he was employed as the principal designer, having been trained at the Edinburgh Government Trustees' Academy under Sir William Allan.[44] He left Wailes to pursue an artistic career in London in November 1845[45] where it seems he began working for Hardman's on a freelance basis almost immediately, producing the cartoons for an Annunciation window at St Catherine's Orphanage Chapel, Liverpool (**3.2**), that was in place by April 4, 1846.[46] Pugin was particularly pleased with the figure of the Archangel Gabriel[47] and, perhaps, was referring to Oliphant, when he wrote to Lord Shrewsbury in February 1846: 'I have got an admirable artist with me to draw out the figures & I can provide angels with <u>sweet</u> countenances at last'.[48]

Oliphant restated the terms of his employment (in his words 'the old conditions') when in June 1850 he attempted to change them. He confirmed that apart from a small commission for a friend, he had done nothing for anyone but Pugin: 'considering it my duty to refuse all other work so long as I was sufficiently promised by you [Hardman]'. His travelling expenses, inclusive of time were £3; daily expenses 7/–; and for a day's work of eight hours £1.[49] The new terms that he asked for were: not to be bound as a

 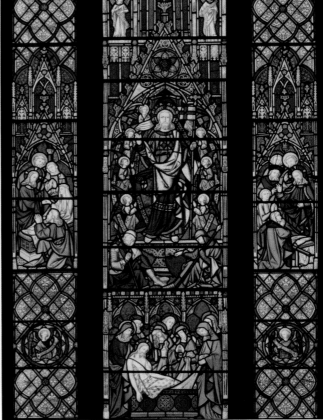

3.3a. Chester Cathedral, S aisle window sV (Gaz.14), Pugin/Hardman, 1850. Resurrection themes.

3.3b. Detail of 3.3a.

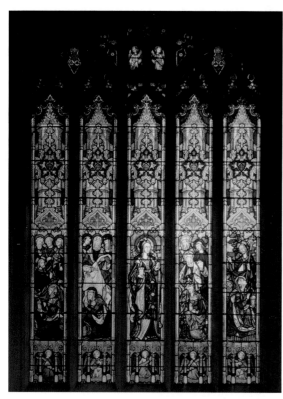

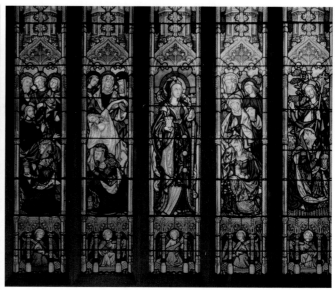

3.4a (*left*). Magdalene College Chapel, Cambridge,
E window I (Gaz.10), Pugin/Hardman, 1850.
Events in the life of St Mary Magdalene.
3.4b (*above*). Detail of 3.4a.

condition of employment to forward a supply of work on demand; travelling
expenses to be increased to £5; daily expenses to 10/-; and the day's work
of eight hours to £1 5s. 0d. These new conditions were almost certainly not
accepted. Apart from the fact that, as we shall see, Pugin already considered
Oliphant to be overpaid, he was genuinely concerned that his (Pugin's)
work might be used by other window makers:

> I can't imagine what he means by the old conditions pray have a good
> understanding what he means & intends it seems all mystery if he is
> going to turn general trader he shall not work for me for I am not
> going to supply him with drawings & documents for others.[50]

Hardman's call on Oliphant seems to have ended shortly after receiving
the new demands – the latter's last work being in connection with the
window for Hereford Cathedral (Gaz.75).

Although Pugin criticised him a good deal, there is no doubt that
Oliphant's contribution to the firm's output was considerable. Apart from
the east window for Hereford he was engaged on cartoons for windows in
more than twenty buildings.[51] These included some of the most notable that
Hardman's produced and caused Pugin to write of Wells Street,[52] Chester
(**3.3a & b**)[53] and Cambridge (**3.4a & b**)[54] as fine jobs and Brighton (**3.5a &
b**) and Erdington (**3.6**)[55] as first rate ones. Even with these works, however,
his frustration with Oliphant is evident, for his praise of the window at
Cambridge was qualified by the remark, 'I have knocked one fine job out
of Oliphant at last', and for Chester: 'I have got a fine job out of Oliphant at
last for Chester but I had a great fight for it and the entombment was done

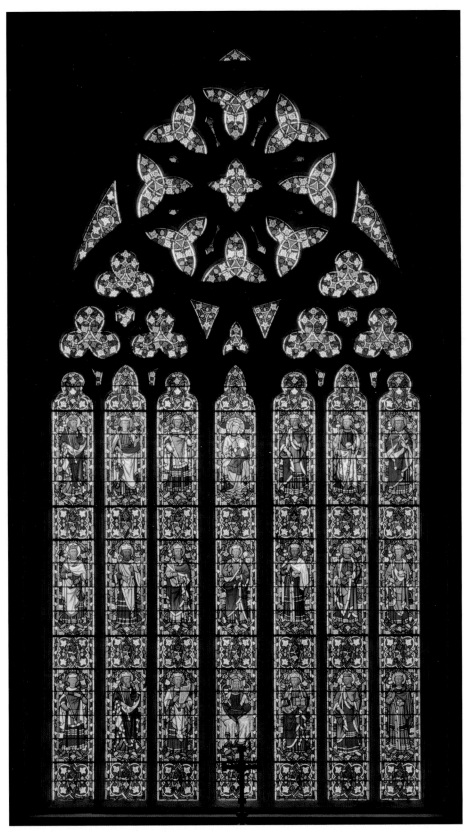

3.5a. St Paul, Brighton, E window I (Gaz.41), Pugin/Hardman, 1849.
Jesse. As seen after dark varnish which had covered the window had been
removed by David Lawrence.

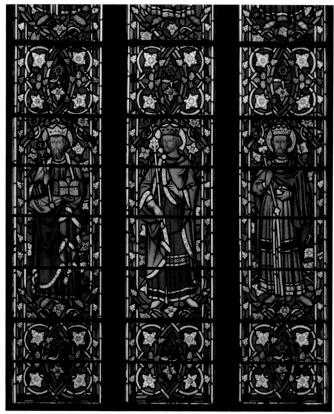

3.5b. Detail of 3.5a.

twice he grumbles dreadfully and says the work does not pay at all. I told him that was exactly what I said'.

The cost of Oliphant's cartoons and his perceived slow work-rate rankled with Pugin, as did the fact that he was unable to supervise directly most of his drawings. These were done in London (aided in part by Oliphant's brother) and sent to Ramsgate for approval, where a good deal of alterations were called for to eradicate what Pugin saw as the failings of an academic style. In spite of this, however, he recognised that if orders were to be fulfilled, Oliphant's help was required, and at times, as a means of improving matters, he would call him down to Ramsgate to work under his eye. Although on the one hand this was satisfactory to Pugin, on the other it caused him more anxiety for he saw Oliphant as a bad influence on the rest of the workers, particularly so with John Hardman Powell.

Pugin resolved his problems by reducing the work available to Oliphant, phasing him out as the young men at Ramsgate gained in experience and in the meantime using his greater artistic ability for work on the more complex windows. He wrote a number of letters to Hardman about his difficulties,[56] often repeating himself. An appreciation of his thoughts can be gained from the following representative quotes:

> I get more & more disturbed about Oliphant – the cost of his cartoons is <u>enormous</u> & being done away from me they really lose all the spirit of the drawing he does them against his will & they are not near so like the true thing as what Powell does I have every hope of doing all here if we had a young man of any ability he would soon be brought[?] to it of course Hendren [Edwin Hendren] is very useful but in an inferior[?] degree, I believe Edward [Edward Pugin] will very soon do fine things.[57]

> It is quite absurd to pay such sums as you mention [£] 130 for the cartoons of [?] windows & we have to do every bit of detail & to make ¼ size sketches first – it is too much it is impossible to make windows pay at that rate – I think it will be best to keep him just going & do all we possibly can ourselves.[58]

> I have got your letter Oliphant will not have to come to Ramsgate for the groups, but I am afraid if we do not give him more we shall never get through.[59]

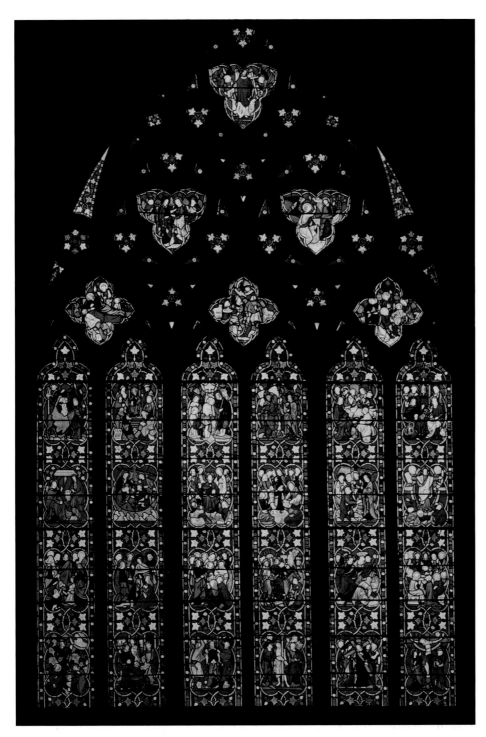

3.6. St Thomas & St Edmund of Canterbury, Erdington, Birmingham, W window wI (Gaz.177), Pugin/Hardman, 1850. Life of Christ.

Oliphant is here & that stops Powell. I shall be right[?] glad when he is gone but this East Window Erdington [**7.12a**] is a huge job & in the way he works takes a long time to draw out.[60]

(I hate to see Oliphant here) – he is coming on Monday – he will only do beastly things – everything is execrable that is done I hate the sight of his accademic [sic] groups & his hallallula [sic] saints.[61]

if we get any of the Large windows with groups they must be done by Oliphant but for single figures I think Powell is far the best.[62]

half the Sheffield [St Marie, **7.8a**] groups have had to be altered – they were beastly in parts & would not do … By infinite exertion I have got the Sheffield window done.[63]

In spite of the substantial help that Oliphant gave, Pugin became more and more disillusioned with him and finally was relieved to see him go:

all of the last lot of cartoons done by Oliphant with the exception of S. Mary Magdalene Cambridge [**3.4a**] are detestable. I cannot bear[?] this. I am very glad he has given up it is quite time to let him go – do you wish now pray to send me your figure man to improve him or is there [here Pugin sketches clouds of smoke][64]

From this last remark it seems that Pugin hoped to increase the numbers at Ramsgate but not, as a letter to Hardman indicated, from any source or at any cost:

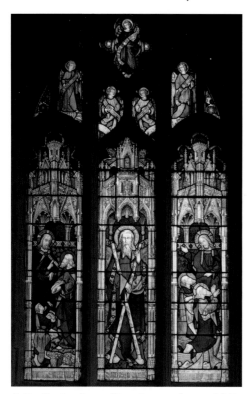

3.7. St Andrew, Farnham, chancel N window nII (Gaz.162), Pugin/Hardman, 1851. St Andrew and Christ's Miracles.

I enclose a letter from Oliphants brother, I am decidedly <u>against</u> engaging him. I will have no protestant in my studio & besides it would be a useless expense & we must work on things as much as possible amongst ourselves I will not have people in my study – who do not <u>belong to us</u> – & I think you will agree with me.[65]

Edward Welby Pugin (1834-75), Pugin's first child by his second wife Louisa Burton (*c*.1813-44), was eleven years old and living with his father at the Grange when the glass workshop was set up. He would, presumably, not have worked in the cartoon room initially other than, perhaps, fetching and carrying, but in 1847 Pugin commented that, 'he improves daily',[66] and in a letter to Hardman, post marked,'A P 30 1847', J. Hardman Powell explained: 'Edward is able to fill in the leads for me now so that I shall get on much faster. I ink in double lines for him and he keeps between them which saves a good deal of time'.[67] By 1849 Edward was judged competent enough by Pugin to produce leading designs, the latter writing to Hardman, 'Hendren [Edwin Hendren] can do little more than leading up Edward does nearly as well one of Mr Suttons windows [West Tofts, Gaz.120] is done entirely by him – but neither can help Powell in anything that is not mechanical'.[68] Two

years later, however, Edward had established himself, in Pugin's eyes, as a key member of the cartoon room personnel:

> Edward has now so greatly improved that he is really one of our best hands you will see a S.Peter that he has put in for Farnham [**3.7**]; & a great deal of the filling in of the Heraldry for the houses [New Palace of Westminster, Gaz.64] is by him. I think under the circumstances he is deserving of a better footing as he is [?] in life his time is accurately kept so that all the hours passed at his studies & the church & c & c is dedicated & I think you will say yourself – that it is only just & reasonable that he should rank on a higher footing. I believe he will soon become one of our best figure painters he is now doing the groups for alteration that is putting them in Sepia & if you examine them you will see what I say is true.[69]

Edward William (known as Edwin) Hendren (*c*.1831-94) seems to have arrived at Ramsgate as an assistant to Powell some time in 1846 for, in an undated letter to his uncle, Powell wrote:

> Hendren goes on very well but I cannot succeed in getting cheaper lodgings at all comfortable… he has been hard at work at the Parliament windows [New Palace of Westminster, Gaz.64] this last week will you keep account against the Governor [Pugin] for this work or shall I he has done a good 20 shills worth at the cartoons this week.[70]

In 1848 and 1849 he was regularly paid for work on cartoons for which Powell had the greater responsibility but during 1850 his involvement was considerably reduced. Pugin regarded him purely as a helpmate for Powell and at one time suggested getting another like him.[71] In 1849, as already mentioned, he remarked that: 'Hendren is very useful but in an inferior[?] degree'[72] and usually when he commented at all about him he tended to be critical.[73] After Pugin's death Hendren played a greater role in the workshop and is named as the cartoon maker in the 'glassworkers window' of 1853 in St Chad's Cathedral, Birmingham (**3.1a & b**).

Frederick Hill worked for Pugin at Ramsgate during 1847, for in Pugin's cartoon account he is credited, on September 28, with £9.15.0 for expenses, and time etc. going to Ramsgate to cartoon. The amount is subdivided into £2.8.0 for travelling expenses and £7.7.0 for time and his wife's expenses. The summary of cartoon costs for 1848, 1849 and 1850[74] reveals that only Powell, Hendren and Oliphant were involved in cartoon work in these years, but in 1851, Pugin's letters to Hardman show Hill being used on cartoons for windows in the Late style. For example,

3.8. St Peter & St Paul, Albury, Drummond Chapel (Gaz.161), detail of wall-painting, Thomas Early, *c*.1847. *Graham Miller*.

in respect of Sherborne Abbey, Dorset (Gaz.37) Pugin wrote, 'The cartoons for Sherborne are really come out very fine they are beautifully drawn in Late work – Hill is very good but Powell himself feels the defects in getting out canopies & geometrical work',[75] and for St Andrew, Farnham (Gaz.162): 'hill does not impress when I am away the Cartoons are beastly. The Farnham windows will be a disgrace I cant get out of my mind the horrid heads & c I saw painted up; they are only to be matched in the grisailles of Peckett [sic] of York AD1790.[76] Later he noted: 'Hill has recently improved the cartoons for – Farnham – if you were to see both groups together you would be impressed,'[77] and in a further letter concerning Stonyhurst College Church (Gaz.93), Pugin commented: 'I send you a rough sketch of the Stonyhurst window [north aisle] but it is sufficient to show what is intended it would make a fine job & just the sort of work for hill.'[78]

Thomas Early (1819-93) (sometimes spelt Earley) was in the first instance used by Hardman in painting and decorating but as this type of work declined, Pugin was disposed to using him to help out in the cartoon room. This is first indicated in a letter to Hardman written probably in 1846:

> I have written to Early to come home at once I have written a serious letter to Mr Drummond [Albury Chapel, Gaz.161] I am extremely offended at his conduct & will have nothing more to do with him. I think you should employ Early at glass painting he would do Quarries & borders extremely well & it would fill up time between jobs. I do not know what we will do with the other men.[79]

Early, however, was still at Albury in 1847 for he wrote to Hardman on May 2:

> I received the parcel of Gold yesterday I am going on very well with the job it is the most singular design for the wall I ever saw – the arrangement of the pattern making them appear exactly like curtains – the whole chantry appears like some large tent – the pattern is the field of the Drummond arms with his Crest a Black Eagle displayed thereon [(**3.8**)][80]

When he finished there, Early moved on to work for the New Palace of Westminster (Gaz.64) and at Ushaw (Gaz.40)[81] but in 1848 his position was again in doubt, with Pugin writing:

> I don't know what to do about Early – I have I have [sic] nowhere except Winwick [Gaz.18] to send him & that is my last job remember that – so I expect he will either have to take to some other trade or – be paid off like the rest – I don't see a chance of any work coming in from any quarter.[82]

Eventually, Early went to join Pugin at Ramsgate, who wrote: 'I am delighted to know about Early [?] It appears to me he will be able to help at the cartoons between whiles'.[83] Between whiles meant that Early would still be available to Hardman when required and he was used to fit completed

windows at various sites where local fitters were not employed. Initially Pugin was impressed with him: 'I consider Early is a very useful person he will do at cartoons he understands setting out.'[84] This, however, was not a lasting impression: 'I am afraid Early here is a Waster he is an idle fellow & takes no interest or delight in his work which has to be done twice <u>over always</u>',[85] and his days at Ramsgate seemed numbered when Pugin wrote: ' I think Early will very soon have to depart he has too much larking in him for me & I think the atmosphere of Birmingham would be more congenial to him however I have warned him & wait to see the result.'[86] It is likely that he returned to Hardman in Birmingham for he was still with the company in the autumn of 1851 when he was involved with the setting up of the Medieval Court at the Great Exhibition.[87]

Enrico Casolani, a pupil of the Nazarene painter J.F. Overbeck (1789-1889)[88] came to England in 1847 and stayed for four years. He brought with him letters of recommendation from his master to Lord Shrewsbury who introduced him to Pugin.[89] In turn, Pugin sent him to Hardman with the introductory note:

> the bearer of this is Mons Casolani a pupil of Overbeck a most distinguished Xtian artist. I need say no more to induce[?] you to get him a sight of everything good at Birmingham he is quite worthy of any attention <u>for he understands</u> the real thing. [beneath his signature, Pugin continued, 'give him a letter to Mr Logan Oscott][90]

Pugin wrote to Hardman of his great enthusiasm at the artist's arrival and the expectation that his contribution would be substantial:

> I have just settled on employing Casolani recently[?] he has finished a picture for me for £12 magnificent – & he will <u>a first</u> [sic] rate <u>cartoon</u> man for us.... he has improved imagery[?] beyond hope & his works are equal to the [?] of the antient [sic] men … I see a good opening with this. I shall make beautiful [?] my life is changed & I [?] to live at home, he is to teach Edward oil painting & Powell – as he works in the study.[91]

Seemingly, Casolini assisted with the cartoons for St Oswald, Winwick (Gaz.18)[92] and mention is made in a letter to Hardman of work for Oscott College which, perhaps, was not to do with stained glass: 'Casolani has made a really good job of 2 of the Panells [sic] for Oscott & he is going to do the other 2. I am glad of this we have got a right way with him. Powell draws them out full size and he <u>paints</u> them just <u>paints</u> them & that comes[?] well'.[93]

Prior to this, however, Pugin had been critical: 'of all the lazy people barring Casolani Oliphant is the worst',[94] and later on he complained about his slow workrate.[95] Casolani's eventual dismissal, apparently less than a year after he joined, was the result of his unsatisfactory work on the panels of the Stations of the Cross, intended for the chapel at Ushaw (Gaz.40). Pugin thought the cartoons, 'very poor productions', and the one finished picture:

'quite unworthy of the building'.[96] Writing, in late 1847, to Dr Newsham at Ushaw, Pugin explained how he had agreed with Casolani for the latter to accept the instalment he had received, as payment in full for all he had done. He added:

> upon this he [Casolani] expressed himself satisfied & even pleased but so far from holding out expectations of more possible employment I then paid him for some things he had done for me amounting to 14 or £15 for [?] I took a receipt in full of all demands & so was quit of him to my great satisfaction for he was not of the least use to me & what I paid for was only waste paper... he came to me highly recommended. I gave him a trial. found that his productions were not[?] of class that would be of service to me. I paid him what he asked for what he had done & got quit of him.[97]

On February 10 (presumably 1848) Pugin wrote to Casolani what were intended to be his final words on the affair. He opened with a resumé of the matter of the 'stations' and continued:

> I then wrote to your father & told him that I did not consider your prospects were likely to be improved by your Longer stay in England... I considered your interest required your speedy deportation from this country ... I shall not reply to any further communication that you may send me.[98]

Output

The stained glass windows produced by the firm were mainly for churches and chapels although those of a secular and heraldic kind, intended for public buildings and private houses, were not insignificant in number.[99]

It made no ornamental, embossed, or enamelled work suitable to be sold through dealers for general purchase, and even run-of-the-mill glazing such as plain glass windows and minor repairs were restricted to the properties of the firm and its personnel, and to Catholic schools and institutions, most of them local, with which Hardman and Pugin had special connections.[100] This is not altogether surprising, since Pugin's initial aim in setting up a glass workshop had been to provide windows, to a standard of which he approved, for churches and other buildings that he himself had designed. Even later on, when the business was expanding, it seems he had no desire to diversify into a wider range, for writing to Hardman towards the end of 1849 he maintained: 'I think we ought to do nothing but true kind of thing and decline general work & anything modern.'[101]

Pay

Although Pugin's decision-making affected all aspects of company policy his remuneration was strictly confined to his work in creating the designs and supervising the cartoons – at least until the beginning of 1848. This was established from the outset, as a letter from him to Hardman, probably in 1845, indicates:

There is every possibility of you seeing me next week. We will then arrange the best way of paying for the window drawings which is of course quite a distinct thing from the rest of the work. I think the same plan as I adopted with Wailes he pays so much for the drawings of each window which is counted as cost & then you take all the profit on the work but this we will settle.[102]

That Pugin regarded both designs and cartoons as window drawings is evident from the entries in his cartoon account. Up to the end of January 1848 he is credited with the full amount of the cartoon costs.[103] The system then changed – possibly as a result of Powell's return to Birmingham – and from the end of April 1848 only a memorandum entry of the full selling price of each window is recorded. A summary at the back of the Cartoon Ledger registered the selling prices of the windows along with their costs broken down into prime costs, cartoon costs – split between Powell, Hendren and Oliphant – and expenses. Perhaps at this stage Pugin changed to taking a percentage of the profits on the windows rather than being reimbursed for the drawing work alone.

Although Powell worked with Pugin at Ramsgate and Oliphant sent his cartoons there for approval, both men were paid by Hardman. Powell's cartoon account shows that his salary for 1848 was £100 per annum, increasing to £110 in 1849 and £120 in 1850. Hendren was paid 14/- a week for most of 1848 and 1849, Early a similar amount in 1849, and the combined wages of Hendren (26 weeks), Early (2 weeks) and the otherwise unmentioned Monaghan (4 weeks) in the first half of 1850 was £14.14.0. The same men for the whole of the second half of that year, plus Hill for 16 weeks, received £66.5.6.

An indication of the hours worked by the glass painters is given in a letter to Hardman from William Wailes, written in 1847. Wailes reveals the growing reputation of Hardman's and demonstrates his own reasonableness, which doubtless accounted in part for his lengthy working relationship with Pugin:

Will you be kind enough to let me know what hours are kept i.e. worked by your glass painters. I don't mean the ordinary men such as lead workers, glass cutters and tracers, but those who paint your figures and groups. Mine work 9 hours per day 9 am to 7 pm one hour for dinner. Now I believe I am the only glass stainer in the kingdom who does not work 10 – Cairney[?] of Glym[?] does. Ballintyne of Edinbro-Forest [sic] of Lpool & all those I know. I anticipate some little dispute with[?] two new men I have engaged & if I find I stand alone in these hours [?] maintain my ground & do as my neighbours. I need not say I suppose you are very busy for I hear of you all over. How is Mr Pugin?
If I find that I am in Birmingham I will be glad to call it was quite a piece of superfluous delicacy you declining to see my place because I was absent. So long as we do what is fair & honourable there is

plenty work for us all & I much regret there is so much jealousy & bad feeling amongst the generality of glass stainers – vide licet Warringtons remarks on my St. James window [see Chapter 6].[104]

Wailes, must have written in similar vein in 1850 about other workers causing Hardman to reply:

> I am duly in receipt of your letter & am sorry to hear that I have been paying considerably more than the sums you mention where my men are from home in fact I fear very much more than I ought to have done I must however try to reduce it. I shall be happy at any time to give you any information in my power.[105]

The hours and effort put in by Thomas Early in his role as a window fitter and the fact that in 1849 the need for cost saving had hit home, is illustrated in a letter sent by him to Hardman, from Wimborne, in that year:

> I received your letter and £10 this morning at 5 o'clock when I was in Bed. I had a queer job to find out Frith [sic] Church [Frieth, Gaz.5] you made a mistake about going to Henly [sic] on Thames, as it is 8[?] Miles from the nearest station, and 8 from Frith. I got out at Maidenhead and got a conveyance to take me to frith which was 15 miles off & call at Marlow Church [Gaz.7] – and arrived at Frith very late at night – & rose with the lark and having beautiful weather I got the whole of the window in safe and as very good finished it at 9 o'clock on Tuesday I had sharp work of it as I intended to spend a few hours at Oxford … From the description Mr. Bishop [one of Hardman's window fitters] gave me of the Glass and the kind of Fellows there are at Milton Abbey [Gaz.35] I thought to avoid any accident it was better to take my Brother with me as it is a deal more trouble to take out Glass than to put it in. I perfectly understand your letter and I think you will give me Credit for my expedition in getting down here within 15 miles of job [sic] – in so short a notice. I shall travel as economically as I possibly can to lighten the expense – I tramped 15 miles this morning with my back [sic] of Tools on my back from Frith to Reading as I could get no conveyance under a shilling per Mile besides Driver, Gates & c I shall look out for a Chapel in the Morning please God and if I fail to find one I must Join in intention – I shall go to Blandford by the Bath Coach at 8 in the Morning.[106]

Prices

As would be expected windows were priced according to their complexity and this is confirmed by quotations Hardman made to clients. In one he gave a statement of prices charged according to the style of a window:

> Early English Glass with geometrical patterns & bands of ruby & blue with borders & one figure in a panel can be executed for from 15/- to 18/- p. foot; Decorated windows for from 18/- to 28/- p. foot & perpendicular glass worth from 28/- to 35/- p. foot, [107]

and in another he is rather more specific:

> Figured quarries with border badges & c. from 10/- to 12/- per foot;
> Geometrical grisaille windows with borders & band of colours about
> 15/-; The same with figures & subjects in panels from 20/- to 25/-;
> But decorated Canopy glass with subjects & c. 25/- to 30/-; 15th
> Century Glass from 35/- to 40/- according to the treatment − single
> figures being less than groups.[108]

Turnover and profits

The amount of business generated through the glass workshop and its importance relative to metalwork is indicated by annual turnover figures compiled from the respective Day Books between 1846, the first full year of glass production and 1852 when Pugin died.

	Stained Glass £	Metalwork £
1846	1,542	9,028
1847	4,160	8,904
1848	3,980	12,126
1849	3,834	8,889
1850	4,615	10,626
1851	7,789	8,327
1852	5,149	8,207

These show that for the most part in just these few years window sales achieved around half those of metalwork and point to the eventuality of them becoming the more important of the two.

In the early years sales came in the main from one or two substantial contracts. For instance in 1846 St Cuthbert's College, Ushaw (Gaz.40) brought in £787, and in 1847 the New Palace of Westminster (Gaz.64) £1,218 and St Cuthbert's College a further £700. From then on the level of activity was spread over an increased number of jobs, some involving several windows, such as: St Paul, Brighton (Gaz.41) which brought in £610 in 1848 and a further £618 in the years to 1853; St Thomas & St Edward of Canterbury, Erdington (Gaz.177) £318 in 1848 and £415 in 1849; and Sherborne Abbey (Gaz.37) £511 in 1851 and £320 in 1852. The main reason for the increased turnover in 1851 was the work for the New Palace of Westminster which totalled £3,178 with £869 accruing in the following year.

The profits or losses which resulted from sales are difficult to gauge. The prime costs, in most cases of each window, are given in the cartoon ledger summaries for 1848 to 1850 and assuming that these comprise raw materials, direct labour, and direct expenses, the mark-up on them to cater for overhead expenses and profits in the selling prices can be computed.

The summaries are not complete but include windows made during the second half of 1848, the whole of 1849, and the first nine months of 1850. For the last three months of 1850 prime costs are not entered for nearly half the windows.

There appears to be no obvious formula for marking up, the percentages varying with each window. Perhaps there was a base figure which was adjusted by what it was thought individual clients could afford and then rounded up, in most cases to the nearest five or ten pounds. Marked discrepancies occur during 1848, with, for instance, in round figures, the heraldic windows at Oscott (Gaz.182) showing a 10 to 15% mark-up compared to that of Chirk Castle (Gaz.216) at 107%. Amongst church windows, 80% for St Edward, Clifford (Gaz.188) compares with 23% for the Convent of Mercy, Nottingham (Gaz.130). The overall mark-up for the windows recorded in 1848 was 51%, considerably higher than the 35% for 1849, when by and large, individual windows stayed closer to each other around the 30%, 40% and 50% marks. In 1850 the overall percentage dropped to 31%, made up of 27% in the first nine months and 40% in the last three (see Appendix 2).

Assuming that costs, at best, remained steady (more likely they rose – certainly the wages did) these figures indicate that prices were relatively high in 1848, constrained during the next eighteen months and then allowed to rise in the latter part of 1850. Pugin's letters to Hardman seem to confirm that this was the situation, and, at least as far as increases in 1850 were concerned, a consequence of his strategy.

The Palace of Westminster contract awarded in 1847 was a boon to the company but at the same time an embarrassment. Having only a small staff meant that if the Westminster deadlines were to be met, other smaller contracts would have to be delayed. For the first but not the last time Pugin came to realise that the customers could not all be kept happy at the same time. 'I begin to be sorry that I persuaded you to do the glass for Westminster it stops everything & I see clearly we shall disgust all the people.'[109] Nonetheless, when a big order was secured in the autumn of the same year he could hardly contain his excitement. 'I have just got a positive order for £4,020!!!! Of stained glass. £600 of which to be ready next summer all for one church an Anglican job of course'.[110] At this juncture he recommended taking on more staff: 'It appears to me that you might employ another cutter. I shall send you a great many windows this winter & I have a new one for Wells Street [St Andrew, Gaz.61] just ordered'.[111]

It was not just at Birmingham that there were difficulties in coping with the workload. In 1848, the cartoon output from Ramsgate slowed, when, seemingly, Pugin relinquished all but supervisory control over Powell in relation to figure drawing. He noted: 'This is a dreadful year. I wonder what 1849 will do…. Now it will be impossible to keep you supplied very quick for they will take a Long time – & it would be a perfect waste of time for me to do common work about cartoons.'[112] However, their clients kept faith with them largely because of the quality of the work and the firm's growing reputation.

There was a moment though when Pugin suggested there was a feeling against the firm, particular hostility being directed at Hardman, who doubtless bore the brunt of the complaints regarding delays, and the prices charged: 'there is a worse feeling against you than me. H.H.P.Hardman & High Prices is what they say & this idea has got such hold that nothing will undo it.'[113] Possibly there was some merit in the accusation for there was one occasion when Pugin took issue with Hardman on the subject in spite of the fact that seemingly, no complaint had been made:

> I went to the Catholic Church at Cambridge & to my horror found some execrable painted windows & on enquiring of them the priest told me you stained them at £20 each now there is not 4 feet of glass in them & you do not know what injury this has done. they are windows that could only admit of a narrow border & Quarries with an emblem in a circle £4 would pay well. I cant think how you came to make such a mistake for these things give such a handle against us.[114]

One would-be client made a fruitless attempt to separate Pugin from Hardman:

> A catholic gentleman whose name I have not learnt[?] [?] wishes to give a Large window to Newcastle [?] but on condition you do not make the glass – he would permit me to make a design for it. of course I declined the honour – but joking apart the thing is over.[115]

Pugin's unwillingness to design for other than Hardman is consistent, as is indicated below, with his reluctance to allow Hardman to make windows from other people's cartoons. It would seem that from the time it was set up, Pugin, with one exception, designed windows for the Birmingham workshop alone – Bolton Abbey (Gaz.126) was the exception with, perhaps, Pugin's special relationship with Crace[116] (through whom the order from the Duke of Devonshire was obtained) being the deciding factor.

The early part of 1849 saw Pugin in a pessimistic mood, high prices it seemed were losing them business:

> I think you better begin to work shorter hours everything is very bad. I am obliged to give up all windows in the London District because Dr [?] is led away to think Jackson & the Rowley [?] contractors are the men to mind getting cheaper [?] & I cannot work with such People.[117]

But the situation changed and as orders came in there was talk of obtaining more staff, 'it seems to rain windows we really shall want another hand here'[118] and when this, apparently, did not happen, Pugin wrote:'I have got your letter I quite agree with you we shall get into complete disgrace if we do not get on quicker. But how can I supply more cartoons with our present force – we have litteraly [sic] Powell.'[119]

There was even a suggestion that their prices had been too low:

> I really do very little else but design windows now – we have our glass
> all right which is the good point. & if we make a start in the right way
> we shall do. we have worked[?] at too low a price but now we can do
> first rate jobs we must get better. I assure you I don't think I have 5
> percent clear^nce & I am sure that cartoons cost you too much. we are
> not in a good system yet – we ought to do better at it for I know we
> can beat everybody else.[120]

By the end of the year, the feeling that prices should be higher became
stronger:

> I think we ought seriously to think about raising the prices of
> glass for the future I am sure that by standing out we could get a
> good price now we can do the work so well I believe now we can
> produce only fine windows & they must be made to pay the cost
> of supplying the study with materials is dreadful…. as the work has
> been lately I don't complain it has paid with you or me we must
> now begin a fine start for 1850, we have got our glass all right we
> know what to do & the work must be made to pay.[121]

Pugin's reference in the earlier letter to doing little else but design
windows seems to be a comment on his diminishing role as an architect,
something he still, presumably, had in mind when he wrote in 1850: 'there
is nothing but the glass. the year opens with miserable prospects'.[122] His
bitterness at the situation, particularly in being overlooked for the extensions
to St Wilfrid, Hulme (Gaz.67) is expressed in a letter of this period:

> are you aware that Large schools have been added to the church of
> S. Wilfrids I built at Manchester I think I am about the most mad[?]
> man in England. I finished all the altars of that church & c out of the
> margin[?] & this is the way one is treated. I shall work for the future
> entirely for my own church [St Augustine, Ramsgate, Gaz.88]. There
> is no justice I have just been made one[?] to batter down the wall for
> other people to walk in. There is nothing but the absolute necessity of
> having the means of finishing St. Augustines that makes me want to
> do what I am obliged to finish fine details for other peoples building I
> lay you any money that Hansom will keep all the credit of Mr Haighs
> job [St Thomas & St Edmund of Canterbury, Erdington, Gaz.177]
> when it is finished. In such a cause as that of building my church I
> would clean boots if it brought in money but for nothing else would
> I ever have submitted to the degradation I assure you it goes hard
> against the grain because I feel I am made a fool of.[123]

At the start of 1850 Pugin wrote to Hardman pointing out how important
to the business stained glass had become and stressing the need to make the
workshop pay:

> The cost of the cartoons is too great at present is not [sic] a shame

that Oliphant for doing a few groups in the year should get a great deal more than I do for designs & agreeing the whole thing these windows neither pay me nor you & they ought can be made to do both. Stained glass now becomes thanks to you the most important part of the business but the return is nothing look what I must do for £100 compared with what a [?] brings in & out of this [?] a huge deduction for expenses. if our glass concern was well managed & these rascally Expensive[?] cartoons done[?] away you & I ought to get double what we do & everybody well satisfied with the price of glass. I consider everything up to this <u>an experiment</u> we are now finaly [sic] starting. It is the beginning of another half century <u>1850</u> just the time for a start – increased[?] vigilance & care in every department & increased industry & increased skill, combined with rigid economy & then we shall get on.[124]

The following year, 1851, the year of the Great Exhibition, was extremely busy and found Pugin in buoyant mood, hopeful for the future although under considerable pressure: 'It rains windows… if our glass trade is well managed it may be made a real good thing in spite of all these terrible people at the Exhibition who do not consider our work even <u>worth notice</u>.'[125] This latter comment is odd considering the favourable reviews the Pugin/Hardman glass received, and may be related to Pugin's thoughts on Catholic journals about which he communicated to Hardman, 'The account in the journal of design is really very good. It is quite surprising what an effect this exhibition has produced but is it not shameful that not one catholic notice has appeared of these things. I do think we are the most degraded indifferent body existing'.[126]

The pressure continued relentlessly, 'I have several new windows come in this week I don't see at all how we are to get through at all',[127] and towards the end of the year he began to wilt: 'I am an example of a man who has lived [?] 60 years in 40 & is now suffering for it … there is no doubt but that we have got more glass then we can do anyhow & we can only do our best'.[128]

Although eager to acquire business, to control costs and to improve profits, Pugin, apart from on one notable occasion, put the quality of his work above these considerations. When he failed to do so in the case of the east window at Skipton, (Gaz. 128) he bitterly regretted the result, 'I expected what it would end in – It makes me furious I never will again have anything to do with windows for which there is not a sufficient price',[129] the window was subsequently altered, seemingly at the expense of the firm.[130]

Marketing the Products

Exhibitions afforded one of the ways for the firm to bring its products to the attention of a wider audience and in 1849 favourable reviews were received for its exhibits at the Birmingham Exhibition of Arts and Manufacture. In terms of windows, Hardman's showed: the two memorial windows (no longer extant) destined for St Nicholas, Copperas Hill,

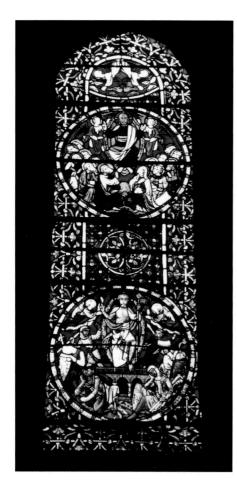
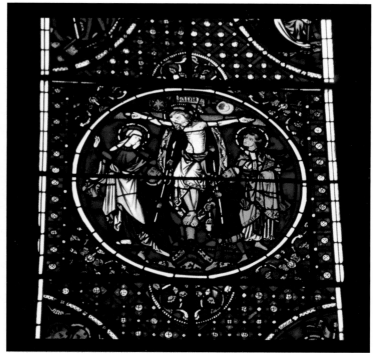

3.9a & b. Hereford Cathedral, chancel, E window remnants (now in E wall of the S transept), Pugin/Hardman, 1850. Ascension, Resurrection, Crucifixion. *The Dean and Chapter of Hereford and the Hereford Mappa Mundi Trust: photograph, Gordon Taylor.*

Liverpool (Gaz.111); one and part of another for St Augustine, Ramsgate (Gaz.88) (neither identified); and an armorial window for the hall of St Cuthbert's College, Ushaw, perhaps one of those for the refectory.

The *Birmingham Gazette* listed them and went on to say:

> The whole of the work is excellent, both in drawing and colour, and an extremely rich effect is produced by the elaborate diapering visible in the robes of many of the figures. Each of the figures has a high devotional character imparted to it; and in this respect, as well as in the appropriateness of the ornaments and the exquisite subordination into which these are brought to the subject, not only these windows, but Mr. Hardman's stained glass generally may be held up as almost unexceptionable models to all other window painters.[131]

Notwithstanding the enthusiastic reception, however, a suggestion by Hardman that the firm should exhibit on its own received short shrift from Pugin who wrote: 'as for a separate Exhibition you may rely on it that it would only be knocking down money at railway speed you would not get 50 people to go or take the least interest in it & would defeat all the object.'[132]

Naturally enough arrangements were made to exhibit at the Great

Exhibition of 1851. The exhibition, devoted to the 'Works of Industry of All Nations' was held in Hyde Park, London, in what became known as the Crystal Palace, designed by Joseph Paxton, the superintendent of gardens to the Duke of Devonshire. The structure was, in effect, a gigantic greenhouse inspired by the smaller version Paxton had erected for tropical plants at Chatsworth, the duke's ancestral home. Pugin was by no means enamoured with the showing conditions: 'since I have been to see the Crystal Palace I am quite out of heart It will be impossible to exhibit painted glass there It will be all light. It is only for plants the flat roof is a dreadful failure – wretched[?] the spaces appear very <u>Low</u> to show anything high or fine.'[133]

Having decided to exhibit, however, he looked to represent glass in all the different styles, writing, 'we ought to have something of each kind',[134] but anxious to avoid the added cost of making pieces specially for the exhibition he advised: 'you will only show windows ordered [which are not yet made or installed] and which will be paid for.'[135]

This limitation resulted in the Early style not being represented, as Pugin's efforts to obtain the light for the east window of Hereford Cathedral (**3.9**), 'it is a fine example of that style',[136] were denied by the Cathedral authorities, who were anxious to see their window in place without delay.[137]

Examples of the Decorated were readily obtainable and on show were: the two-light window (since destroyed) for St Edmund's College, Ware (Gaz.82), 'because we can have it & it is an easy subject 2 Large Saints under canopies';[138] three windows from Pugin's church, St Augustine, Ramsgate, comprising: the two for the south wall of the Lady Chapel (**3.10a & b**) and the one for the south aisle west; and a light, not identified which portrayed the Virgin Mary under a Decorated canopy.[139]

Glass in the Late style came from St Andrew, Farnham, and included, the chancel north window (**3.7**) and the two lights containing the Transfiguration and Crucifixion from the east window (**2.4a**). Pugin would have liked the south wall windows (no longer extant) of Jesus College Chapel, Cambridge, but the University refused to release them on the grounds of the delay that would occur before they were installed in

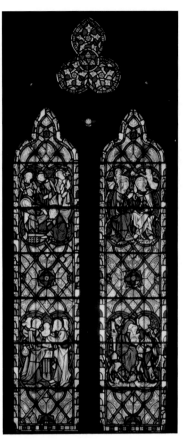

3.10a. St Augustine, Ramsgate, Lady Chapel window S wall sIV (Gaz.88), Pugin/Hardman, 1851. Scenes from the life of the Virgin.

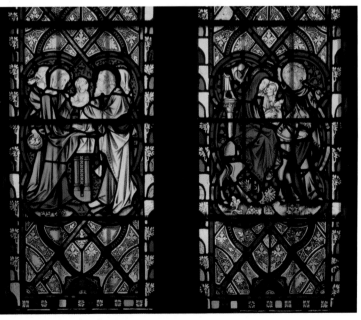

3.10b. Detail of 3.10a.

3.11. Alton Towers, Staffordshire, Great Dining Room, 'Talbot Window' (Gaz.147), Pugin/Hardman, 1851. Glass removed 1952, although some fragments remain. *English Heritage.*

the chapel and that windows executed for a church ought not to be shown in a secular manner.[140]

The firm's secular work was represented by the centre light of the Grand Talbot window of the dining room at Alton Towers (**3.11**), together with elements of the flanking lights, including the shields supported by Talbots.[141]

Most of the stained glass on display was arranged in the exhibition's north-east gallery but the Pugin/Hardman work was distributed about 'The Medieval Court'[142]. This was the name given to the space allocated to Pugin and his colleagues, Hardman, Herbert Minton, J.G. Crace and George Myers[143] who between them exhibited in the medieval style: furniture, the monumental tomb of Dr Walsh destined for St Chad's Cathedral, Birmingham; the Great Rood from the screen at St Edmund's College, Ware; the high altar, a niche with the statue of the Virgin and Child and the altar and reredos of the Lady Chapel, all from the Roman Catholic church of St David at Pantasaph; the font, tabernacle and part of the oak screen to the Pugin chantry from St Augustine, Ramsgate; a fireplace (ultimately set up in the Great Hall in Lismore Castle) and part of the staircase for Francis Barchard's house, Horstead Place, Sussex; and a number of items of ecclesiastical metal-work.[144]

According to the *Illustrated London News*, Pugin had, 'marvellously fulfilled his own intention of demonstrating the applicability of Medieval art in all its richness and variety to the uses of the present day',[145] but for the glass, he had made the viewing condition considerably worse than those that had so depressed him when he had first visited the Crystal Palace. In the words of *The Ecclesiologist*, the pieces were: 'barely visible from their internal position in the medieval court.'[146] In spite of this the journal placed Pugin and Hardman's glass in a class of its own[147] and the jury, although making some criticism, awarded Hardman's a prize medal for its work, stating in its report:

> In the window glass exhibited by this establishment in the Mediaeval Court, the true principles of the style [the Ecclesiastical style] have been faithfully observed; and the execution of the work is very careful. It may be noticed, however, as a defect in these windows, that the glass of the backgrounds between the figures is too transparent; they are consequently inferior in repose and harmony of colouring to the mediaeval windows of the best time.[148]

Placing windows in prestigious settings also appealed to Pugin as a means of attracting business, hence his enthusiasm for the order for Chester Cathedral (Gaz.14)[149] and his remarks in connection with St Andrew, Wells Street, London (Gaz.61):

> I hope you don't neglect the Wells Street window I should like that up I think it will do good in London anything in London is seen 10 to one & the season is coming on when that church is considered with the right sort of people. I think you should make an effort there.[150]

The idea of putting in a window to encourage funds for further commissions in the same building was followed at St Edward, Clifford (Gaz.188) although without success.[151] Something similar, that is putting in a single light to hasten receipt of the monies for the rest of the window, was mooted by the Rev. A.D. Wagner in respect of St Paul, Brighton (Gaz.41), when he wrote to Hardman: 'I shall be glad to know what part of the whole expense would be the painting the centre light of the West window. If painted soon it might I think lead to the completion of the whole window'.[152] The plan wasn't implemented, however, and the complete window was installed around a year later. But at St Andrew, Wells Street (Gaz.61), it was carried out on a grand scale with the first of the ten lights of the east window being put in in 1847, the second a year later and the last six in 1850. By then the lack of harmony between the second light and the rest was so great that it had to be replaced.

Competitions

Whilst he was keen to use installed windows as advertisements for furthering business, Pugin was completely against the idea of entering into competitions for the same purpose and he advised Hardman against the practice:

> I wish to caution you positively against all competitions I think when you are applied to you [sic] in this manner you should write to know wether [sic] it is intended to apply to other architect [sic] and if so to decline Willement always did and he gained by it.[153]

Designs by Others

Pugin was also very reluctant that the firm should generate profits by manufacturing windows to other people's designs. So when N.J. Cottingham, the architect in charge of the restoration of Hereford Cathedral (for which Pugin/Hardman were making

3.12. St Cuthbert's College Chapel, Ushaw, Durham, N wall window nIII (Gaz.40), Pugin/Hardman, 1846. Types with anti-types.

the east window [**3.9**]), wrote to Hardman in respect of the windows for the Lady Chapel, 'I have prepared the designs and cartoons for the five memorial windows to the late Dean and I will forward them in cource [sic] of a week or ten days for you to commence on',[154] Hardman replied that he would only work from cartoons prepared by Pugin.[155] Cottingham expressed his surprise: 'I certainly had quite: misunderstood the system on which you were executing glass being so exclusive', and pointed out that the designs and cartoons were prepared and approved by the Committee and ordered to be put in hand at once. He continued:

> I have generally hitherto made my own disigns [sic] and cartoons for the windows I have had placed in various works, and therefore naturally concluded you undertook commissions in like manner. My only reason in having the cartoons of the three east windows prepared by you was that at the time I was too full of work to get them done [?] here. I need scarcely say that these cartoons are all prepared in the most complete careful manner and therefore equally true to work from as your own.
> It only remains for you to say whether you wish to depart in this instance from your usual mode. I should like of course to have these windows executed by you, but it would be out of the question to throw aside an expensive and elaborate set of cartoons.
> I shall in future now that you have informed me, know that you prefer making your own cartoons, though it may occasion me difficulty with unreasonable parties as you will know which would not otherwise occur.[156]

Pugin, although ostensibly willing to leave the matter to Hardman, left him in no doubt as to what he should do:

> Think over Cottingham's [?] I shall be satisfied with whatever you do but we are really overwhelmed with work of all kinds & I don't like the idea of another mans drawings being seen in your place – it is not a good plan & may lead to a great deal that is very bad - & may be turned against us.... unless they intrust [sic] the work entirely it better really not be undertaken pray think this over... it is bad in principle & this will open the door to other people bringing drawings. I am afraid it really <u>will not do</u> don't accept it till I see you.[157]

Hardman clearly followed Pugin's line, for Cottingham later acknowledged his refusal, framing his words to allow for a change of heart:

> I am sorry at your determination as to the other windows as I should have liked them to be executed by you to harmonize with those you are doing, and as I then said, it need not have been precedent [sic] for any future work. I the more regret this matter as it may give reason for the employ of another for the other windows.[158]

The principle had been set, however, and Hardman adhered to it even

after Pugin had fallen victim to his final illness, as a letter to Frederick Preedy of Worcester confirms:

> I must decline working from Cartoons for which I am not responsible. I should be most happy to carry out your wishes respecting the treatment of any particular window & to allow you a percentage for processing the order but the Cartoons must in all cases be prepared by my own draftsmen [sic] who have been educated under Mr Pugin.[159]

The picture painted has been one of company policy being determined by Pugin with Hardman ever willing to acquiesce. Not necessarily always without resistance, however, for on one occasion, at least he touched a raw nerve in Pugin, when he, seemingly, compared Pugin's ability to man-manage unfavourably with his own. Perhaps the remarks occurred in discussions about coping with the volume of work for in one of his letters Pugin remarked: 'There is no parallel between Birmingham and Ramsgate you have a mass of people & me a most fluctuating set & very few.'[160] Whatever it was Pugin showed how sensitive he could be regarding his managerial capabilities, and he reeled off what was probably an exaggerated account of his youthful responsibilities for a theatrical production and the furniture made for Windsor Castle, and in more recent years of his work at the Palace of Westminster:

> & what do you mean about my being unfit to manage a manufactory have I not managed ten times the men you ever saw have I not had 180 men working day & night for Faustus had I not 700 men cabinet makers. Chair makers, inlargers [sic], carvers gilders & c & c for the Windsor job!! Did I not organise the concern at Thames Bank. I never heard so infamous and falacious[sic] a charge I could direct any number of men but not people working without tools & materials & inexperienced. It is the most shameful accusation that I am unfit to direct a factory. Shameful. Disgraceful why I have had more men to direct in my time than you have square inches in the factory. I never heard such an idea. Shameful. retract, retract.[161]

4

Windows for Churches and Chapels

The beautiful effect of wax tapers, of which a vast number were constantly burning in different parts of the churches, was greatly increased by the subdued light of the whole building: and it must be universally admitted, that such a softened and mysterious light as is produced in a building filled with stained windows, is well calculated to awaken those emotions and thoughts, in the hearts and minds of the worshippers, which they should feel and entertain, when within the temples, and before the altars of God.

– Pugin, lecture to Oscott College students, 1838.[1]

Thus Pugin impressed upon his Oscott students how stained glass could help establish the proper religious atmosphere in a church. He further emphasised his beliefs by describing the effect that the glass could have on ordinary daylight as it filtered through:

Nothing contributed in a greater degree to the solemn grandeur of the ancient churches, than the varied and modulated light admitted through the stained glass, with which both the lights and tracery of the various windows were filled etc. As justly observes an ancient and holy writer, the very light of day, by passing through so glorious a medium, became better suited to the sacredness of the place.[2]

More than anything, the magnificent, overwhelming and, to his eyes, harmonious schemes of colour and ornament decorating the old churches were his inspiration, and he berated those commentators who took a different view. Importantly, too, he regarded the stained glass as the key on which the whole panoply of colour in the churches depended:

The profusion of gilding and painting employed in the decoration of the old churches, and which modern ignorant critics condemn as tawdry ornament, was absolutely necessary to support a general richness throughout the edifice, of which the stained windows seemed to be the foundation. For when these glorious churches were in their full splendour, they presented an harmonious effect of the most surpassing richness. The vivid colours of the glass were recalled to the eye by the mosaic enamelled tile pavements, by the gold and colours which relieved the wood and stone carvings, by the painted pannels [sic] of the screens and altars, by the tapestry hangings, and

antipendiums of massive embroidery, by the shrines of gold and silver enriched with jewels, and lastly by the gorgeous vestments of the clergy, covered with imagery, pearls and precious stones.[3]

When, as happened in modern times, the church masonry was washed clean, he explained that the stained glass windows suffered by comparison and as a result were made to appear unharmonious:

> The effect of stained glass in churches which have been stripped of all these ancient beauties, is far too spotty; the contrast between plain walls and the most vivid colours is too violent; of which the present nave of York Minster since it has been <u>washed</u> is a most striking example – for more than half the beauty of the old windows is lost by the mass of whitened stone with which they are surrounded.[4]

Pugin had given practical effect to these thoughts in 1837, the year before he presented them to the Oscott students, when he designed the windows for the apse of their chapel.

The intense colours, the subdued light passing through and the richness of the surroundings in which they were set, is evidence of Pugin practising what he was to preach. The sanctuary of the chapel was decorated throughout. Its vaults were coloured blue and painted with gold stars, the walls were diapered and the floor tiled (**0.1a**) – the decorations have been much restored. That Pugin was at least partly successful in achieving the effects he sought, in this his first public venture, is suggested by a contemporary article in the *Staffordshire Examiner* reporting on the opening ceremony. Some of the expressions used such as, 'dim religious light' and 'ecclesiastical grandeur', come close to these expressed by Pugin himself but it is clear that to the correspondent, the lavishness of the décor and of the garments was somewhat overdone:

> The windows about the altar are beautifully executed in coloured glass, by Warrington of London; their effect being exceedingly rich as to colour, and well arranged in the disposition of the figures. The altar is covered with a profusion of gilding and there are some finely executed paintings in its panelling. In fact there is richness, perhaps displayed in too great a prodigality for our feelings. Notwithstanding the 'dim religious light' in which the coloured windows bathe the entire sanctuary … The gorgeous richness and number of the official dresses flickering with gold hues, contrasting with purple – these, the rich satin and snow white linen, crimson seats, a profusion of embroidery, the mitres and crosiers, and the altar, lit up with its massy candlesticks aside and above, presented an affluence of ecclesiastical grandeur – temple, taper, garment, censer, all in the freshness of workmanship – seeming to recall the worship the temple of Solomon must have exhibited rather than what we who differ in creed are accustomed to attach to the simplicity of the Christian.[5]

Pugin was unapologetic about this use of overall decoration and defended

the design principles behind it in an article in the *Dublin Review* of May 1841. He took a similar line to the one he had used in his lecture for justifying the profusion of gilding and painting – namely, that if colour was introduced into the windows all other decorative effects followed – but emphasised a little more the harmony and unity of such designs:

> It is not unusual for modern artists to decry the ancient system of decorating churches with much painting; but those who raise these objections seem to forget what is technically termed keeping, is quite as requisite <u>in a building as in a picture</u>. The moment colour is introduced in the windows, the rest of the ornaments must correspond – the ceiling, the floor, all must bear their part in the general effect. A stained window in a white church is a mere spot, which by its richness, serves only to exhibit in a more striking manner the poverty of the rest of the building.

> In old churches the azure and gilt ceiling, the encrusted tiles of various colours, the frescoes on the walls, the heraldic charges, the costly hangings of the altars, the variegated glass, all harmonised together, and formed a splendid whole, which can only be produced by the combined effect of all these details; – omit any of them and the unity of design is destroyed.[6]

It was not until 1845, when he completed the decorations for St Giles, Cheadle, designed for Lord Shrewsbury, that he finally achieved his goal of reviving the medieval mode of decoration for a complete and large church. In the meantime, because he needed to keep costs to a minimum, with the exception of the small church at Warwick Bridge (Gaz.22), he was only able to decorate in a sumptuous manner the sanctuaries of churches. He did this, for example, at St Mary, Derby (Gaz.24), 1839, and St Chad's Cathedral, Birmingham (Gaz.176), 1841, where initially, in each case, only the apse at the east end contained stained glass windows. The roof of St Chad's was decorated at a later date, being completed by 1847, when it caught the notice of *The Builder*:

> The roof has been diapered throughout, the groundwork being blue, and the prevailing colours crimson and green. The roof of the nave is adorned by a glowing geometrical pattern, and enriched with monograms. The aisles are powdered with stars between lines of trefoils. An inscription in gothic character forms a border to the whole.[7]

This programme no doubt would have been based on the work in the sanctuary, since the nave windows at that stage contained no stained glass. Also at St Barnabas, Nottingham (Gaz.131), *c.*1844, the patterned eastern chapel windows in particular, seems to have been designed as part of a greater decorative scheme, described in the *London & Dublin Weekly Orthodox Journal*:

The pavement of the choir and sanctuary, as well as that of the eastern chapels will consist of incrusted tiles of various colours, similar in design and composition to those used in ancient churches... Immediately behind the altar a rich perforated oak screen will extend across the Eastern extremity of the choir, enriched with gold and colours... it is proposed eventually to cover all the spandrils [sic] of the arches, walls & c with painted enrichments.[8]

With limited funds available, it was the small chapels, such as that at the Hospital of St John, Alton (Gaz.148), 1841, and Jesus Chapel at Ackworth Grange, near Pontefract (Gaz.191), *c*.1842, which gave Pugin the scope to produce overall decorative schemes, rather than the churches. Pugin relished the opportunity of describing in considerable detail the scheme for Alton, finishing with the windows, the essential element of this hugely rich design:

This portion of the building has been most carefully finished, and contains much decoration. The whole floor is laid with figured tiles, charged with the Talbot arms and other devices. The benches are precisely similar to those remaining in some ancient parish churches in Norfolk, with low backs filled with perforated tracery of various patterns; the poppy-heads are all carved representing oak and vine leaves, lilies, roses, lions, angels, and other emblems. The chancel is divided off by a rich screen, surmounted with a rood and images. The shields in the brestsummer are all charged with sacred emblems in gold and colours. The roof is also richly gilt. Each principal of the roof springs from an angel corbel, bearing each a shield or a scriptive; the braces, tiebeams, rafters and purloins [sic] of the roof are moulded, and the spandrils [sic] filled with open tracery. On each side of the east window is a niche with images of St. Katherine and St. Barbara. The reredos and altar are both worked in alabaster; the former consists of a series of richly canopied niches surmounted by an open brattishing; images of the apostles holding the emblems of their martyrdom, with our blessed Lord in the centre, occupy these niches. The altar itself consists of three large and three lesser angels seated on thrones bearing the lamb and cross. The sunk work is picked out in azure; the raised mouldings and carved ornaments gilt, and the remainder polished alabaster ... On each side of this altar silk curtains are suspended on rods. The cross is an exquisite specimen of ancient silverwork of the fifteenth century ... This precious relic of Christian art is parcel-gilt, and covered with ornaments and images of wonderful execution. A pair of parcel-gilt silver candlesticks have been made to correspond in style with this cross; they are richly chased, engraved and ornamented with enamels.

On the north side of the chapel is a three light window and in every light an angel bearing the cross, and the holy name [**5.5**]... In the east window are also three lights with an image of our blessed Lady with our Lord in the centre, St. John the Baptist with the lamb on the

right, and St. Nicholas vested as he used to say mass; with the three children on the left, all under rich canopies; and in the upper part of the window, angels with labels and scriptures [**1.3a & b**]. The side windows are filled with ornamented quarries and rich borders and quatrefoils, containing the emblems of the Four Evangelists [**5.4**], the annunciation of our blessed Lady, the pot of lilies with the angelical salutation entwined, and the holy name of our Lord [**5.3**].[9]

The Ackworth Grange Chapel has since been demolished but its sumptuous nature can be visualised from Pugin's description of a diapered panel roof, ceiling pricked out in gold and colour, the field painted azure and powdered with stars and suns, and the floors laid with incrusted tiles.[10]

St John the Evangelist, Kirkham, provides an isolated example of a church in which Pugin was able to extend the decorations outside of the limited area of the sanctuary. The ceilings and walls of the church were decorated with stars, roses, *fleur-de-lis* and emblems of St John – figured tiles being restricted to the floors of the eastern chapels.[11] The *fleur-de-lis* featured in the windows of the eastern chapels (**1.14**), as did the coloured diaper-patterned backgrounds that appeared on the walls. The appearance of features other than the colour in the stained glass indicates Pugin's use of the windows as the foundations for creating unified decorative schemes.

He came closest to achieving his ideal at Cheadle (Gaz.151). Of its general effect *The Tablet* reported: 'Bright and glittering colours, gorgeous decorations, beautiful paintings meet the eye on every side, till the senses become dazzled.'[12] In the same issue Pugin described the church, including details of its elaborate furniture at the same time revealing the extent to which his ambitions with regard to the enrichment of the fabric of the building had been realised. For instance, with regard to the nave:

> The ten arches are supported by eight detached and four engaged pillars, with richly foliated caps, all of different designs; these pillars as well as every portion of the roof, walls, arches & c are covered with gilding and painted enrichments. Over every arch are two circles containing heads of prophets, copied from ancient Italian frescoes … the floor is laid with encaustic tiles and stone alleys, with borders of inscription tiles. The [Blessed Sacrament] Chapel itself is entirely covered with gilding and decoration. The ribs of the groining which is of stone, are richly diapered. The spandrils are filled with passion flowers and foliage, and circles containing lambs, surrounded by running borders. The bosses are composed of vine leaves and grapes. The upper parts of the walls are powdered with crowns and rays, with crosses alternate; while the lower portion is diapered with a continuous pattern of vine leaves … The floor is laid with encaustic tiles, in appropriate patterns, such as the lamb and cross, with the word 'sanctus' repeated within a border.[13]

The windows in the church have, sadly, been mutilated, with much of the background diapering of those in the nave that would have related

to the ornament on the surrounding walls, having been removed (**1.11a–1.13**). The Blessed Sacrament Chapel itself, however, remains an excellent example for windows (**1.10a & b**) which form the base of an integrated, lavishly decorated and harmonious interior.

The importance to Pugin of unity in the interiors of his buildings is highlighted by an incident in respect of one of his later churches. In 1848 the *Morning Post*, reporting on the opening of St George's, Southwark (Gaz.63), had this to say:

> In a church where all the details and furniture are so correctly carried out, we are very sorry to perceive a number of very inferior pictures in ugly modern frames hung round the walls of the aisles and which greatly mars the unity of effect which otherwise pervades the building. It is but justice to Mr Pugin to state that he is in nowise answerable for this violation of good taste, as the pictures were hung in direct opposition to his advice.

The contributor of the pictures wrote in their defence, simultaneously criticising Pugin for his attitude to art from the sixteenth century on.[14] In reply, Pugin showed how strongly he resented the intrusion of alien elements into his designs and how sharp he could be with those he believed lacked an understanding of what he was trying to achieve:

> I am sorry to perceive, from the last week's *Tablet*, that a contributor has thought proper to write an article respecting his pictures in St George's Church, and that in rather an unbecoming manner. I will not attempt to refute his statement, but merely observe that he has attributed opinions to me which I do not hold, and that he neither understands my principles or the subject he has written about. As regards the paintings themselves, with two or perhaps three exceptions, they are very inferior, and utterly unfit for their position. I should have been the last man to have disturbed his happy delusion about them had he not intruded his purchases into a church of my erecting; and although I am quite willing to give him credit for those intentions, I really cannot allow the unity of my building to be destroyed without at least informing the public that I am not a consenting party to so glaring a mistake. I would strongly recommend him for the future not to interfere with church decoration, for which he has not the least vocation, but to amuse himself with hanging his pictures about his own residence, where they are certain to be in keeping with the surrounding objects and beyond the reach of my censure.[15]

When the Hardman workshop first started to produce windows, Pugin's outlook remained unchanged. Its earliest major project was for St Cuthbert's College Chapel, Ushaw (Gaz.40), 1846-7, where Pugin had designed both the building and its decoration. There was a profusion of ornament within the chapel that included panels of the choir ceiling covered with painting and gilding, and floors of patterned encaustic tiles.[16] The windows with their richly coloured biblical scenes and or saintly figures, against backgrounds of

4.1. St Osmund, Salisbury, chancel N window nII (Gaz.198), Pugin/Hardman, 1848. St Peter, St Paul.

coloured diaper or patterning (**3.12**) formed the basis of this harmonious scheme.

Windows similarly filled with colour were made for the chancels at Warrington, (Gaz.17), 1847-9, Broughton, (Gaz.66), 1846-9, and for the east end of St Edmund's College Chapel, Ware (Gaz.82), 1847-8, while richly coloured windows were introduced into the chancel at Winwick, (Gaz.18), 1848, where Pugin prevailed upon the rector to gild and decorate the ceiling.[17]

Changes become discernible in Pugin's design practices, however, in the years immediately prior to 1849. The backgrounds of his windows are no longer filled with coloured diaper-patterns. Instead, white or tinted patterned-quarries, as at Rampisham (**7.6**), 1847, and St Osmund, Salisbury (**4.1**), 1848, are used. Then in 1849 grisaille is introduced for the first time at Frieth (**4.2a & b**). From then on, the overall patterning, which had reached a peak at Cheadle, was restricted to the roofs, floors and furniture of the buildings, as at West Tofts (Gaz.120), and even in his own church of St Augustine in Ramsgate (Gaz.88). The same was true for smaller buildings such as the mausoleum at Bicton (Gaz.27), which appears restrained when compared, for instance, with the chantry chapel at Albury (**3.8**).

There are a number of possibilities that would explain why these changes came about in the late 1840s and they may be summarised as follows. In some Catholic circles opinion seems to have reacted against elaborate decorative schemes. There was a desire for more light to be admitted into buildings. A decline in Pugin's architectural commissions left him more dependent on private work which provided few opportunities for large-scale decorative projects and finally Pugin's interest in 'floriated ornament' – his book of that title was published in 1849 – might have led him to favour its introduction into his windows. It is worth exploring these issues in more detail.

Catholic reservations

Unease about elaborate decorations is touched upon in an article in *The Rambler* for 1849. Whilst stressing the distinctively Catholic features of the altar, the images, the pictures and the candles, it continued:

> Nothing is easier than to spoil a good church with painting and gilding. Miserable and cold as is a naked stone or plaster edifice... it is not so offensive as a church bedaubed with an innumerable variety of gaudy colours, and gold leaf laid on wherever the slightest pretence for gilding can be discovered... Decoration with colour ought to be conducted on the same principle as decoration in wood or stone. Its office is to <u>aid</u> the architectural effect, by bringing out its light and

shadows with additional distinctness, by treating the walls and flat surfaces as backgrounds from which the furniture and elementary features of the buildings shall (to use the <u>painters</u> <u>phrase</u>) <u>stand out,</u> and strike the eye without bewildering it.[18]

Pugin's defended himself in 'Some Remarks on the Articles which have recently appeared in the "Rambler" relative to Ecclesiastical Architecture and Decoration' which was published in *The Ecclesiologist* and which it is helpful to quote at length:

I am glad to have an opportunity afforded me of explaining my real views on the matter of church painting, for I have been long compelled to bear in silence an enormous amount of unmerited blame in this respect, and have witnessed with extreme disgust a great number of most vulgar perpetrations of colour which have been even introduced, in buildings designed by myself and without the least regard to style or propriety…. In most cases churches are commenced on a cheap principle, and when carried up and too late, some persons are anxious to improve the effect, and then gold leaf and colour are introduced to supply that richness which would have been far better produced in carved stone… this was the case in the side chapels of S George's [St George Cathedral, Southwark, Gaz.63]… This was also the same case at Cheadle, which was originally designed for a plain parochial country church, and it was quite an afterthought of its noble founder to cover it with coloured enrichment; hence there is a great anomaly between the simplicity of its walls and mouldings and the intricacy of its detail, but all this is the result of a chain of circumstances over which I had no control, yet I have no doubt that many people imagined is the ne plus ultra of my ideas on church decoration, and that I designed it on a carte blanche, when in truth it was originally planned to meet a very limited outlay… Do not let anyone imagine that I am deprecating the legitimate use of colour in church decorations, but it should be confined within proper limits, and applied with the greatest judgement and discrimination. Roofs are always susceptible of coloured enrichments – altars, panels, triptychs roods, & c., but colour will not remedy an original deficiency in the design of a building and its cost is far better expended in the improvement of the fabric in the first instance.[19]

4.2a. St John the Evangelist, Frieth, Buckinghamshire, E window I (Gaz.5), Pugin/Hardman, 1849. Crucifixion.

4.2b. Detail of 4.2a.

These views are very different to those expressed in his 1838 lecture and in the 1841 articles for the *Dublin Review*. His protested helplessness in the face of Lord Shrewsbury's demands for St Giles, Cheadle does not altogether ring true, particularly when his response to the noble lord in respect of the dining room at Alton Towers (Gaz.147), is considered:

> If I am not enabled to exercise my judgement and make use of my knowledge and experience, I am reduced to the condition of a mere drawing-clerk to work out what I am ordered, and this I cannot bear; and, so far from knuckling under, I really must decline undertaking the alteration, unless your lordship will consent to its being made worthy of your dignity and residence.[20]

Again, when, in 1846, *The Ecclesiologist* had chosen to criticise St Chad's in Birmingham (Gaz.176), and St Barnabas, Nottingham (Gaz.131),[21] Pugin had responded:

> nor does he even mention Cheadle, now rapidly advancing towards completion, and in which, although as I am well aware, there are some serious defects, having been commenced six years ago, yet very far exceeds anything in the way of ecclesiastical decoration that has been attempted in this country, and will not, I trust, disappoint those young Ecclesiologists who may have hope enough in me yet left to induce them to make a pilgrimage there in the ensuing summer.[22]

There is no suggestion here of the decorative designs having been forced on him against his will. Probably the manner of the decoration was a late decision,[23] and Lord Shrewsbury's concern that the windows at St Chad's should not want for colour[24] and his disquiet at the plainness of St Barnabas[25] show that his lordship was desirous of vivid effects. Pugin, however, would not have produced designs which ran counter to his own views on style and propriety.

Inconsistencies in Pugin's views are not, however, of prime concern. The examples of the new style of interior decorations given above, confirm, that for whatever reason, in the late 1840s he had shifted his ground. It may be that critical opinion had caused him to retreat from his preference for overall patterning, and in consequence, to maintain harmony within the buildings he had been obliged to change the background designs of the windows. Then again the reverse of that argument might equally have applied, as Pugin believed windows were the key to harmonious designs, changes in their background designs required the ornamentation in the rest of the buildings needed to follow suit.

Lighting

Another factor motivating change was almost certainly a reaction against the reduced lighting in church interiors caused by the filling of windows with diaper patterning. However appealing a subdued and mysterious light was to Pugin, for patrons and worshippers it had considerable practicable

drawbacks. Even in 1844 Pugin had been on the defensive over St Barnabas, Nottingham, asserting in a letter to Lord Shrewsbury: 'The effect is most solemn, some modern people complain it is too dark but it is just the thing, they are not used to solemn building'.[26] Eventually, in 1848, 1849 and 1852, the windows there were altered to allow more light to be admitted;[27] and it would seem, in 1846 similar attention had been given to the windows at Cheadle.[28]

Probably for the same reason Pugin used light-enhancing patterned quarries in 1847 and 1848 respectively, in the windows at Rampisham and St Osmund, Salisbury. He had designed the latter building, so, unlike that at Frieth, he could plan the overall decorative scheme. Possibly he thought the patterned quarries of the windows, would harmonise better with the painted, panelled ceiling and the encaustic tiles of the floor than would the grisaille he was to use at Frieth. Ironically, the donor of the window at Frieth would have preferred a diaper in red and blue or dark green but was dissuaded in favour of grisaille by Pugin, who also recommended that vine leaves be used for the motif rather than the requested oak.[29]

Floriated Ornament

Pugin's interest in Gothic foliage is another possibility to explain the changes in his window designs leading to the increasing use, from 1849, of patterned quarries and grisailles. That year he published *Floriated Ornament, A Series of Thirty One Designs*. In the introduction he explains how convinced he had become that Gothic foliage was natural foliage and that his main purpose in producing the book was to encourage modern artists to create designs that were in the same spirit as the old but new in form:

> The more carefully I examined the products of the medieval artists, in glass painting, decorative sculptures, or metal work, the more fully I was convinced of their close adherence to natural forms.
>
> At the beginning of this work I have introduced a plate of glass remains, taken from antient examples in the Kentish churches; and also a variety of painted enrichments from various churches in Norfolk and Suffolk which will fully justify this assertion. It is absurd, therefore to talk of Gothic foliage. The foliage is natural, and it is the adaption and disposition of it which stamps the style. The former disposed the leaves and flowers of which their design was composed into geometrical forms and figures, carefully arranging the stems and component parts so as to fill up the space they were intended to enrich; and they were represented in such a manner as not to destroy the consistency of the peculiar feature or object they were employed to decorate by merely imitative rotundity or shadow; for instance a panel which by its very construction is flat, would be ornamented by leaves or flowers drawn out or extended, so as to display their geometrical forms on a flat surface. While on the other hand, a modern painter would endeavour to give a fictitious idea of relief as if bunches of flowers were laid on, and, by dint of shadow and foreshortening, an appearance of cavity or projection would be produced

on a feature which architectural consistency would require to be treated as a plane; and instead of a well-defined, clear and beautiful enrichment, in harmony with the construction of the part, an irregular and confused effect is produced at utter variance with the main design.

He included in the body of the work, designs, as *The Ecclesiologist's* review put it, of: 'numerous plants, disposed in regular patterns on one plane, all more or less Cruciform.'[30]

His thoughts on foliage and nature had not just occurred to him in 1849. He had expressed them four years earlier in his previously remarked letter to the artist, J.R. Herbert,[31] when he had mentioned that he was preparing a book on the subject. Furthermore, it is clear from his 1838 Oscott lecture that he was perfectly aware of the use of foliated grisaille in medieval decorated windows. Perhaps the coincidence of the requirement for more light to be introduced into churches, and the completion of his book, impelled him to turn to foliage patterns as an alternative to diaper. As far as can be judged, Pugin preferred to use vine leaves in his patterns. As well as at Frieth, they also appear in the grisailles at Chester Cathedral; St Augustine, Ramsgate; and at West Tofts. Doubtless the symbolism was the overriding factor. In decorating items other than stained glass, however, he used a greater variety of motifs. Phoebe Stanton regarded West Tofts as being the most closely related to Pugin's book, and noted his drawings showed that the furniture of the chancel and the family pews in the nave were carved with animals – rabbits, quail, pheasants – and the plants of the neighbourhood.[32]

5

Windows for Palaces, Country Houses and Other Buildings

The windows, of those truly noble banqueting-halls of Westminster, Eltham, Hampton Court, Kenilworth, Warwick, Windsor, Christ Church, Crosby and many others blazed with the heraldic charges of their royal and noble founders.
　　　– Pugin, lecture to Oscott College students, 1838[1]

As his Oscott lecture remarks implied, Pugin still looked back to medieval precedent for his inspiration when considering designs for non-ecclesiastical buildings. Noble buildings of the size and quality mentioned were not everyday occurrences in Pugin's working life but the New Palace of Westminster (Gaz.64) and Lismore Castle in Ireland (Gaz.199), gave him opportunities not only to design secular stained glass windows in the medieval manner but also of incorporating them in rich decorative schemes of his making.

The New Palace of Westminster was far-and-away the largest and most prestigious secular building for which Pugin designed stained glass and he was still working on it when illness forced him to stop in early 1852 after which Hardman's carried on with the work for a number of years. The old parliament buildings had been destroyed by fire in 1834 and Pugin collaborated closely with Charles Barry on the design and decoration of the new.[2] As the Hardman glass workshop had not been established in 1843 it meant that the firm was unable to enter the competition for the windows of the House of Lords that was set up in that year by the Fine Arts Commissioners.[3] It was still not operating in early 1845 when the commission was awarded to the winners of the competition, Ballantine and Allen of Edinburgh. So, in spite of the fact that Pugin had worked with Barry on the project from the outset, it seemed he was to be denied a say in the design of the stained glass. The situation was not to last for long.

The commission comprised twelve, eight-light transom windows, with each light to contain a canopied-figure of a king or queen of England or Scotland. Ballantine and Allan's sketch designs were woeful[4] and in consequence Barry turned to Pugin to create cartoons from which the

Scottish firm could make the windows. An engraving in *The Builder*[5] gives a partial view of the interior of the House of Lords, including the position of four of the windows. Only one of them is shown to be filled with stained glass and this was the situation when the House opened in March 1847. This window, however, had *not* been made by Ballantine and Allan – in whom Barry seemingly, and with justification, had little faith – but by Hardman's who, as *The Builder* put it, executed the window: 'under the direction of Mr Barry for the latter [Ballantine and Allan] to work by, as to, colours, and general treatment'.[6] This 'specimen' window was entered in the Hardman First Glass Day Book on March 1, 1847, together with a note of alterations that cost almost as much as the window itself.[7] John Christian, quoting an early guidebook, describes the subject matter as William the Conqueror, William Rufus, Henry I and Stephen with their respective consorts.[8] The evidence from the Hardman archive is partially supportive for the First Glass Day Book has an entry for September 29, 1846 in respect of a light containing a representation of Matilda of Boulogne (wife of King Stephen), and in letters to John Hardman, I. Bishop and Thomas Early (Hardman's workmen) refer to Matilda of Scotland (wife of Henry I) and King Stephen respectively.[9] Early's letter dated February 26, 1847,[10] is in response to instructions from Barry to return the glass for alterations, and Barry's own letter of February 15[11] shows that this was, at least, the second time that the glass had been returned. A number of Pugin's sketches of kings and queens are retained in the Hardman archive.[12] One of them is colour-coded in a similar fashion to the way in which Pugin marked cartoons for Hardman and may be in respect of the specimen window.

For Ballantine and Allan to have matched Hardman in the other windows must have been an unsatisfactory, not to mention demeaning, way in which to work. To obtain anything like a reasonable correspondence, Pugin would have needed to have given Barry details of the colours and the glass that Hardman would have used, and, even then, differences in technique between the two firms would have been apparent. Perhaps in the end, a Ballantine and Allan production replaced the Hardman specimen in the interests of homogeneity. Barry apparently thought the windows were well executed,[13] but not all were similarly impressed. *The Ecclesiologist*, mistakenly believing the windows had been made by Hardman's commented:

> But Mr Hardman's colours are frequently very defective. Many of those in the House of Lords seem actually washed out. This mistake arises from the attempt to acquire transparency by a general washiness of tint, in place of a bold employment of <u>grisaille</u> balanced by strongly expressed colours in vigorous contrast.[14]

Unsurprisingly Hardman's were engaged to make all the stained glass

windows for the rest of the buildings comprising the New Palace of Westminster with Pugin providing the designs, which were of an heraldic nature.[15]

As with the churches at Cheadle and Nottingham, although, perhaps more to be expected, the Westminster stained glass met with resistance due to the buildings being made too dark.[16] Unlike the churches a religious atmosphere could not be put forward as a compensating factor, although Barry's ideas for decorating the buildings can be seen as the secular equivalents of Pugin's for churches with: historic events and personages replacing religious ones; heraldic devices supplanting sacred emblems; and the remaining surfaces being covered in coloured patterns. His aims were indicated in a report which he prepared for the Commission:

> With reference to the interior of the new Houses of Parliament generally, I would suggest that the walls of the several halls, galleries and corridors of approach, as well as the various public apartments throughout the building, should be decorated with paintings having reference to events in the history of the country…. All other portions of the plain surfaces of the walls should be covered with suitable architectonic decoration, or diapered enrichment in colour, occasionally highlighted with gold and blended with armorial bearings, badges, cognizances and other heraldic insignia emblazoned in their proper colours. That such of the halls as are groined should have their vaults decorated in a similar manner … That such of the ceiling as are flat should be formed into compartments by moulded ribs, enriched with carved heraldic and Tudor decorations. That these ceilings should be relieved by positive colour and gilding, and occasionally by gold grounds with diaper enrichments, legends and heraldic devices in colour. That the screens, pillars, corbels, harmonize with the paintings and diapered decorations of the walls generally, and be occasionally relieved with positive colour and gilding … That the floors of the several halls, galleries and corridors should be formed of encaustic tiles, bearing heraldic decorations[17]

These descriptions are similar to those of Pugin's for St Giles, Cheadle. Unlike Pugin, however, it would seem that Barry did not regard the windows as being the key to the colour scheme of the decorations, but simply as a means of controlling the light falling on them while at the same time blending in with the general décor:

> That the windows of the several halls, galleries and corridors should be glazed doubly, for the purpose of tempering the light and preventing the direct rays of the sun from interfering with the effect of the internal

decorations generally : for this purpose the outer glazing is proposed to be of ground glass, bearing arms and either heraldic insignia in their proper colours, but so arranged that foliage as diaper, and occasionally relieved by legends in black letter, should predominate, in order that so much light only may be excluded as may be though desirable to do away with either a garish or cold effect upon the paintings and decorations generally.[18]

Even for Pugin, the starting point of the decorative schemes for large halls and galleries may not have been the windows, as might be inferred from a letter he wrote to J.G. Crace (who was responsible for the decorative paintings at the Houses of Parliament) regarding the wallpaper for another large project, the Duke of Devonshire's Lismore Castle (Gaz.199) in Ireland:

> I will do the best I can for Lismore but it is very difficult for me to work without some data for armorial bearings, devices or badges which would give some character to the work …I wish to know something about the family and your advice about colours…I assure you I have no idea of what sort of paper to make…I feel quite in the dark about it. I am not in possession of any data.[19]

The final schemes for Westminster and Lismore were extremely lavish, with the heraldic windows, as is evident from illustrations of those in the Peers' Lobby of the former and the Banqueting Hall of the latter,[20] combining harmoniously with the decorations of the walls and ceilings.

Pugin's wallpapers and stained glass windows constituted most of the decorations in those large country houses that he worked on in 1847 and 1848, such as Bilton Grange, Warwickshire (Gaz.166); Burton Closes, Derbyshire (Gaz.23); and Oswaldcroft, Merseyside (Gaz.144). The heraldic nature of the decoration, personal to the owners, could be justified in Pugin's mind in that, as he pointed out to his students, in medieval times the mansions of the merchants were ornamented after the same manner as the royal residences.

At Bilton Grange, a large house that belonged to Captain J.H. Hibbert, now a school and much altered, vestiges of the decorations still remain, apart from the windows such as the encaustic tiles in the

5.1. Bilton Grange, Warwickshire, Gallery open side window G nIV (Gaz.166), Pugin/Hardman, 1847. *Bilton Grange School: photograph Alastair Carew-Cox.*

entrance hall. Also a specimen of the wallpaper that was used is stored in the Victoria and Albert Museum.[21] Lively heraldic motifs in the forms of shields, helmets and mantlings, with names inserted horizontally on scrolls beneath, against patterned-quarry backgrounds, are contained in the lights of the long gallery windows (**5.1**). Initialled badges and shields-of-arms, set amongst initialled quarries, and mottoes, make up the main dining room windows (**5.2a & b**), while above the gallery at the back of the room, patterned quarries replace the initials and mottoes, and foliated borders run round the lights. Presumably this last window was the one with the, 'bilious yellow', in the border that Pugin asked to be altered.[22]

Large entrance hall windows are in place at John Allcard's Burton Closes House – now a retirement home – and Henry Sharples' Oswaldcroft – now St Joseph's Home. At Burton Closes the window is made up of mottoes and initials against patterned-quarry grounds while at Oswaldcroft, heraldry, in the form of shields, takes up the top sections of the window and initials, rather than mottoes, are in the remainder. Burton Closes' dining and drawing room transom windows are, as at Pugin's house in Ramsgate, plain below the transoms, being so, as Pugin put it to John Hardman Powell, because it was 'A sin to block such views'.[23] Above the transoms, unlike at the Grange and Oswaldcroft where heraldic forms were used, there are roundels inscribed with monograms belonging to various members of the Allcard family.

In 1851, three large windows were commissioned by Sir John Guest through Charles Barry for his house Canford Manor, Dorset (Gaz.34), now a school. Two were for the great hall and each contained shields and diagonal lines of mottoes against flower-patterned quarry grounds. The third which lit the staircase leading out of the hall is similar to that in the dining room at Bilton Grange in that each light is filled with shields and lines of mottoes against patterned quarries.

The windows outlined above are very much in line with the description given by Pugin to his students of those to be found in medieval times:

> During the dynasty of the Tudors, shields-of-arms, surrounded by circular borders of heraldic

5.2a. Bilton Grange, dining room window DIR nII (Gaz.166), Pugin/ Hardman, 1847. *Bilton Grange School: photograph Alastair Carew-Cox.*

5.2b. Detail of 5.2a.

5.3. St John the Baptist, Alton, Staffordshire, N wall window nIV (Gaz.148), Pugin/Willement, 1841.

5.4. St John the Baptist, Alton, S wall window sII (Gaz.148), Pugin/Willement, 1841.

flowers, were frequently set in lights, filled up with the repetition of the motto, running <u>bendy</u>, with rows of quarrels between the scrolls, on which initial letters, or small badges, were generally painted.[24]

He further pointed out that lines in *Piers Plowman*, 'refer pointedly to windows of this description', and quoting them:

Wyde wyndowes ywrought ywritten ful thicke shynen with shapen sheds al skewen aboute with merkes of Merchauntes ymedeled betwene mo than twentie and two twyse ynombered. There is non heroud that hath half swich a rolle

He explained that 'merkes' were 'a sort of badges adopted by tradesmen and others who had no heraldic bearings.[25]

Probably his first executed secular design was of this type, made for the windows of his own house, St Marie's Grange, near Salisbury (Gaz.192), in about 1835. The lights included his own acquired coat of arms – although without the 'temple haunting martlet'[26] (perhaps this was included but has since disappeared) – and a shield with his monogram. The ground is filled with plain quarries containing the monogram, and repetitions of his motto 'En Avant'.

Not all secular commissions were for large country houses. There were a few run-of-the-mill orders, perhaps for friends or acquaintances, since, as has been seen, the firm was not looking to compete for general trade. Figured quarries were put into two small lights of a hall, for a Charles Iliffe (Gaz.173) and three bordered-lights with quarries, in a shop belonging to Messrs Lander, Powell & Co. (Gaz.174). Similar work was done for Michael Ellison of The Farm, Sheffield (Gaz.146), a client of the architect Matthew Hadfield, and for Oswestry School (Gaz.140).

A slightly more ambitious piece of work came through the architects Banks and Barry for a library and a staircase window for a Mr T. Field of Dornden, Tunbridge Wells (Gaz.91), where badges, initials and inscriptions were required, plus a coat of arms and a crest in the centre light of the staircase window. The crest of Mr Field was noted as being a hand in armour grasping a globe.

5.5. St John the Baptist, Alton, chapel N wall window nII (Gaz.148),
Pugin/Willement, 1841.

Perhaps the most interesting of these minor jobs was that for Major
Campbell of Montreal, Canada (Gaz.226), because it is an example of
Hardman's being recommended and the glass being sent abroad through the
agency of a Hardman client, Henry Sharples of Liverpool. It also indicates
the accessibility of Pugin and the firm's workshop to an interested customer,
as is revealed in an extract from a letter written by Sharples to Hardman on
December 3, 1851:'When the major was with his regiment in Warwickshire
he met Mr Pugin & was also at your works & in fact you have been named
to him for his stained glass.'[27]

5.6a. The Grange, Ramsgate, library S window L sII (Gaz.87), roundels of
undated provenance. Frame, probably by Pugin/Wailes, *c*.1844.

There were some buildings that could not be categorised as churches, palaces or houses where windows exhibiting scenes of major Christian themes, the history of the country or owner's noble ancestries would have seemed inappropriate. The buildings tended to be of a religious nature as for example with the school at the Hospital of St John, Alton (Gaz.148), the Bishop's House, Birmingham (Gaz.175), St Mary's College, Oscott (Gaz.182) and the choristers' school at Magdalen College, Oxford (Gaz.138). In these, religious inscriptions tended to replace mottoes, and shields contained religious rather than heraldic motifs.

The windows in the Hospital of St John school display the arms of the Midlands Catholic bishops, those of the Talbots and the initials of Lord Shrewsbury (**5.3 & 5.4**). In addition, a call for prayer for Lord Shrewsbury as founder, runs along the bottom of the lights. Today the school room has become the nave of a church, but in Pugin's time it was separated from the east end which was then a chapel. The windows were not meant to indicate the educational nature of the building but aimed at attracting and impressing visitors by their medieval character:

> I feel assured when your Lordship sees the glorious effect of the Glass
> in the school room you will not blame me. It is not for the urchins,
> but for the elite who will flock to see the building which should be
> in all respects a perfect specimen of the style.[28]

Those for the hall of the Bishop's House (since demolished), harked back to the nobleman/cleric of medieval times, linking both church and state, and for good measure including heraldic references to the benefactors:

> In the bay window of the hall are the arms of the four new vicars-
> apostolic, and in the window at the upper end, the arms of the
> present Queen, the Earl of Shrewsbury and the late C.R. Blundell, of
> Ince great benefactors to the buildings. The side windows are filled
> with ornamental quarries, rich borders and arms, with scriptures,
> vigilandum, and omnia pro Christo, running bendy.[29]

Heraldry appertaining to many of its dignitaries fills the windows along the corridors of St Mary's College, Oscott. Some were produced in Pugin's time and cut an equal dash with those for Captain Hibbert in the gallery of his house, Bilton Grange (**5.1**).

A pair of windows – now lost – were made for the east and west ends of the choristers' school room at Magdalen College, Oxford. They contained arms of religious dignitaries or sees. Pugin's close attention to interpreting the sketches that he was given for their design, is indicated in a letter written by Hardman to the commissioning architect C.A. Buckler:

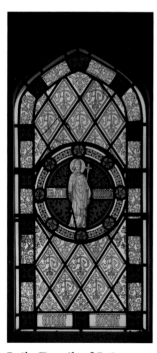

5.6b. Detail of 5.6a.

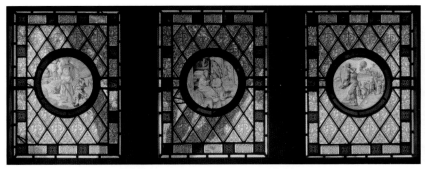

5.7a. The Grange, Ramsgate, library W window L wI (Gaz.87), Netherlandish roundels, probably in a Pugin/Wailes frame, *c*.1844.

> I am in great trouble about the glass for the Choristers School. Mr Pugin writes me that the cartoons have been drawn once that he was not satisfied with them & is having them done over again. Both of us have been abroad studying glass & my nephew who draws the cartoons, so that all our work is behind.[30]

Hardman clearly did not give similarly close attention to the work of his painters and leaders, who, not surprisingly, found difficulty in interpreting some of the individual letters and texts, as the client, was quick to point out:

> The glass for the head of the windows has arrived, and seems to be excellent in Execution and colour. I must however say that I am surprised at the want of some care in revising[?] the glass after it is leaded. The lights for the west window had several monograms inserted upside down – some the wrong side outwards – some omitted altogether, and some containing the wrong initials. That which has just arrived contains two inscriptions written thus, by transposition,
>
> Ne su sapiens <u>sicut</u> teipsum
> Justus germinabit <u>apud</u> lilium
>
> while another is twice represented as follows, omitting the words in brackets, which are necessary to make sense.
>
> sapientia aedificavit (sibi domum)
>
> The absurd effect which is given by all these blunders sadly diminishes the value of the windows which are otherwise very beautiful. I do not wonder that your journeymen

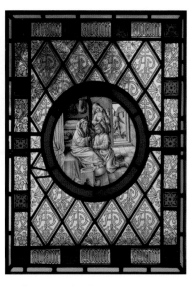

5.7b. Detail of 5.7a.

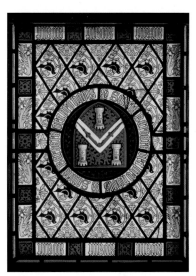

5.8. The Grange, Ramsgate, drawing room S window DRR sII (Gaz.87), roundel of undated provenance. Frame, probably by Pugin/Wailes, *c*.1844.

are not prompt at comprehending a Latin sentence or a mediaeval monogram, but it seems strange that their work should not be subjected to inspection before it leaves the premises.[31]

The letter was written in July 1852, after Pugin's illness had caused him to cease work for the firm, and doubtless he would have been pained by such oversights. Errors had occurred in the window in the dining room at Alton Towers (Gaz.147) (whereby the same names appeared under different shields-of-arms) during the previous year and had sparked off a series of letters from Pugin to Hardman which included the comments:

> I am dreadfully distressed and disgusted to find that in the alton window they have actually copied one set of Labels for the other light with 6 different shields so that the same Labels or names are under totally different charges…it shows a complete ignorance of Heraldry & these are arms which are well known[32]

> I am astonished that when the error & difficulty[?] was discovered at Birmingham that no application was made for the names & that such an act as repeated the names like a stencil to all sorts of arms could be perpetrated.[33]

Windows on a small scale which occurred in domestic buildings on the continent were referred to by Pugin in his Oscott lecture in the following terms:

> I am not acquainted with any examples of windows, filled up by inscriptions and quarries with shield interspersed, existing on the continent. The smaller windows of domestic buildings, both in France, Flanders, and Germany, mostly consisted of white quarries, edged with a narrow border of running foliage, and one medallion placed in the centre of each light, in which was a representation of a single figure, or a subject painted on white glass, relieved, by brown and yellow only, and generally surrounded by an inscription …Some of these small subjects were painted in the most beautiful and finished manner; nor did those great masters Albert Durer and Lucas Van Leyden, disdain the execution of them; for some fine specimens of these admirable artists are to be seen painted by their own hands, on glass medallions of this description.[34]

During his travels Pugin must have collected a quantity of these old 'medallions' or roundels, for one appears in a window of the former library at the Grange (**5.7a & b**) and others in the upper sacristy of St Augustine's (Gaz.88). None are surrounded by inscriptions, that in the library being

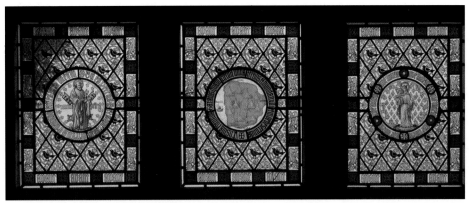

5.9. The Grange, Ramsgate, drawing room DRR wI (Gaz.87), roundels of undated provenance. Frame, probably by Pugin/Wailes, *c*.1844.

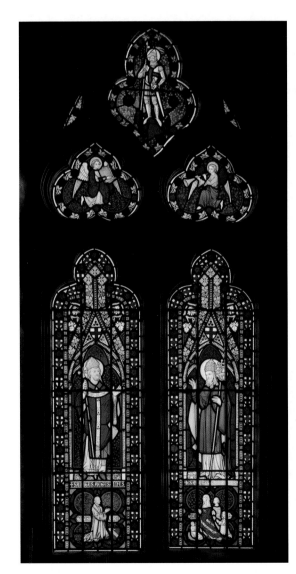

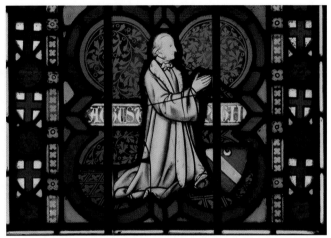

5.10a. The Grange, Ramsgate, chapel E window I (Gaz.87), Pugin/Wailes, *c*.1844. St Augustine, St Gregory.

5.10b (*above*). Detail of 5.10a. Pugin kneeling at prayer.

5.10c (*below*). Detail of 5.10a. Louisa (née Burton) with her stepdaughter Anne and her two daughters Agnes and Katherine.

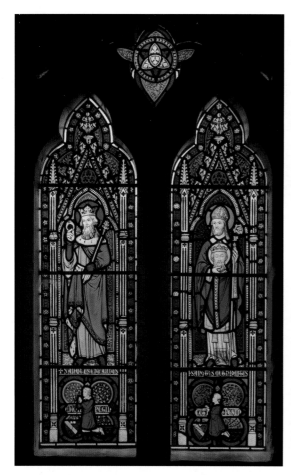

5.11a. The Grange, Ramsgate, chapel S window sII (Gaz.87), Pugin/Wailes, *c*.1844. Edward the Confessor, St Cuthbert.

5.11b (*above*). Detail of 5.11a. Edward, Pugin's eldest son.
5.11c (*below*). Detail of 5.11a. Cuthbert, Pugin's second son.

encircled by plain red glass and those in the sacristy by patterned blue. This glass is, presumably, Victorian. Only in the lower sacristy are the lights filled with plain white quarries and edged with a narrow border, but here there are no roundels and the borders are patterned with florets rather than running foliage. The library contains another roundel of unknown date and provenance (**5.6a & b**) featuring Pugin's patron saints surrounded by a circle of plain red glass and like the one already mentioned is set against a background of quarries containing Pugin's foliated monogram within borders which have part of his motto, 'avant', at the top and bottom and running foliage along the sides. More roundels of unknown date and provenance occur in the former drawing room. These are surrounded by inscriptions, and are set in quarries patterned with foliage and Pugin's emblem, the martlet (**5.8 & 5.9**). Again the upper and lower borders contain the part-motto, while those along the sides feature birds perched on foliage.[35] Three

5.12. The Grange, Ramsgate, dining room S window DIR sII (Gaz. 87), Pugin/Hardman, 1848.

of the roundels occupy the upper panels of a three-light window (**5.9**); two which enclose St Peter and the Virgin and Child respectively flank the third, in which is a map of the Isle of Thanet marked with some old churches. The last is mentioned by John Hardman Powell who does not suggest the glass is old, even though he described that in the library as comprising, 'beautiful roundlets of ancient glass'.[36] The grounds for all the undated roundels were mostly likely designed by Pugin and made by Wailes, for there is no record

5.13. The Grange, Ramsgate, dining room S window DIR sIII (Gaz.87), Pugin/Wailes, *c*.1844.

of them in Hardman's First Glass day Book and a letter from the Wailes workshop to Hardman (see Gaz.87) makes it clear that work of this nature was done at the Grange for Pugin in August 1844.[37]

Pugin also introduced into the Grange windows with a personal reference. In the dining room there are roundels containing coats of arms relating to his and his wife, Jane's, families (**5.13 & 5.12**), whilst in the chapel, images of himself, Louisa, his second wife, with Anne, Agnes and Katherine, his daughters, and his sons Edward and Cuthbert, are portrayed beneath those of their respective patron saints (**5.10a–5.11c**).

6

Some Aspects of the Styles

I am grieved to see you are prepared to sacrifice true Principles &
pander to the ignorance or bad taste of customers what an idea in a
decorated window to put an annunciation of the <u>16th century</u> with
perpendicular[?] interior & c I have written to Carpenter & shown him
the absurdity of the idea it is the <u>latest treatment of the subject</u> in a [?]
window, I don't believe any of them know the distinction of styles in
glass. – Pugin to Hardman, early 1850[1]

In this letter to John Hardman Pugin indicates that, although his 'true
principles' had set the standards for stained glass window design in
the early stages of the Gothic Revival, strict adherence to his rules was
not always followed, and at times even Hardman could be seduced into
accepting a mixture of the styles. In Pugin's eyes the Early, Decorated
and Late (Perpendicular) styles were categorically linked to the styles of
architecture that had evolved in the medieval past and on no account could
they be mixed.

This digression from Pugin's principles did not stand alone. Pictorial
windows – albeit made in leaded lights – gained a measure of support from
Pugin's erstwhile window-makers Warrington and Wailes as well as from a
number of other artists including Charles Clutterbuck (1806-61), Thomas
Wilmshurst (1806-80), and George Hedgeland who worked throughout
the 1850s. Chief among those who approved of such departures was Charles
Winston. Winston, as has been seen, had argued in 1849 that as it was
impossible in modern times to make glass with the characteristics of that
used in the thirteenth and fourteenth centuries – present day glass being
equivalent to that of the sixteenth century – the Early and Decorated styles
should not be used in contemporary work. He underlined this point in a
paper given in 1851, saying, 'nothing would be more miserable in effect,
than a work executed in the simple manner of the fourteenth century, upon
the comparatively poor material of the sixteenth', adding as a footnote to
the version he published many years later, in 1865, in his 'Memoirs': 'Messrs
Pugin and Hardman's imitations of thirteenth and fourteenth century glass
must fully prove the correctness of the opinion stated in the text.'[2]

It was not the only occasion that Winston showed his disdain for Pugin's
work. In his 1847 book, without mentioning Pugin by name, he quoted

chapter-and-verse from articles in *Punch* lampooning the medievalists, the illustrations to which were liberally sprinkled with Pugin's monogram and motto.[3] No comments on Winston's work by Pugin have so far come to light, although it is possible that the book purchased by Hardman's in early 1848 and noted by the bookseller as being *Wilson on Stained Glass*[4] was in fact Winston's publication.

In place of the Early style medallion windows Winston recommended that single figures should be put in each light or:

> Divide the window, if too large for this arrangement into as many parts as might be necessary for the reduction of the figures to a scale proportionable to the building; filling it with two or more figures placed one above the other, or with rows of figures placed under arcades; or else occupy the whole, or some part of it with a group of large figures.[5]

He was somewhat defensive about appearing to create a wholly new style, insisting that the ideas, except for the group of figures, had a basis in the ancient designs and he suggested using the deepest and most powerful colours, comprising those most resembling the ancient in tint.[6] He was also prepared to mix the bold and strong outlines of the Early style with the stipple and transparent shading of the Late, to give a greater degree of roundness to the figures, justifying the idea on the grounds that it accorded with the high relief of Early English carving.[7] His recommendations for the Decorated style, were broadly in line with those he had given for the Early, namely, that they should be based on ancient authorities but should preclude specific references to the style. Hence large single figures in each light were suggested, as was carrying a design across a window independent of the mullions.[8]

Winston was unashamedly enthusiastic about pictorial windows. He had nominated a pictorial addition to the Early, Decorated and Late styles calling it the 'Cinquecento' which he saw as having begun at the start of the sixteenth century and lasted for about fifty years, reaching perfection between the years 1525 and 1535, which he termed the golden age of glass painting. He brushed aside the reservations to it of the kind raised by Pugin.

> Designs extending over the whole of a window are common enough in the perpendicular style; nor is practically any ill effect produced, as might be anticipated, by their being cut by the mullions. Indeed it is surprising how little in reality the mullions interfere with the design. The eye traverses the picture without being caught by them; nor do I think that the appearance of the building itself suffers by reason

of the design of the glass painting not strictly coinciding with the architectural divisions of the window. Such pictures are, no doubt, best suited for the extreme ends of a building, where they are calculated to produce an agreeable variety when contrasted with the somewhat monotonous design of the figure and canopy windows at its sides. This circumstance, and the distinctness of their parts, owing to their size, are, I apprehend sufficient grounds of themselves to justify the use of designs, extended over the whole or a great part of a window.[9]

The Ecclesiologist was very critical of his approach:

'we hardly think Mr Winston serious in his – however cautious – hint that he is prepared to admit of a design being carried across a window independent of its monials', adding a pedantic note equating a light with a window and defining a six-light window as six windows fused.[10]

Although Winston continued to promote pictorial windows throughout the 1850s[11] Pugin's principles won out in the end. As Martin Harrison put it: 'by 1860 thoroughly pictorial glass had all but ceased to be made in England – the "battle of the styles" had been won by the Pugin-influenced medievalists.'[12]

The issues raised so far have been in relation to medieval buildings or new buildings built in the medieval style. A concern that was given much consideration in *The Builder* was what style of window was fit for a building erected in the classical manner.[13] The window in question, which no longer exists, was the east in St James, Piccadilly. Six artists were invited to compete for the commission: Willement, Ward & Nixon, Hoadley, Warrington, Gibbs, and Wailes. Their brief was that the design had to be in keeping with the interior. Willement, and Ward and Nixon, declined, ostensibly, because they had too much work to do but, probably, because they had no wish to take part – Willement as has been seen was against entering competitions. Wailes apparently replied that having devoted himself and his workmen exclusively to the production of glass adapted to Gothic structures, he hardly considered himself a proper person to execute a window for a church 'in the modern style'. He nevertheless gave his reasons for thinking that the stained glass of the Norman or Byzantine period was fitter for a Roman Church than copies on glass of Italian pictures. He thought Norman glass was the earliest style of glass painting known. Its use partook so strongly of the Roman character as to be called Romanesque and its use did not entail half the anachronism or incongruity that introducing copies of the works of modern painters (old masters) did, as these latter were removed six or eight centuries further from Roman architecture than was the Norman, and contained nothing

which at all approximated to Roman architecture. He also pointed out that the earliest Christian decorations known were to be found in some of the Byzantine churches in Sicily and had all the characteristics of Norman or Romanesque glass. Ultimately, a design by Wailes was accepted.

The Builder objected strongly that the style of the design he produced was Gothic and out of place, and took issue with him about the Roman character of the church, pointing out that it was, in reality, an Italian building based on the work of fifteenth-century revivalist architects who sedulously avoided anything Gothic. Warrington joined in with letters deprecating the window and supporting pictorial conceptions. Warrington's attitude upset Wailes[14] and brought the former a rebuke from Charles Mayhew, the Honorary Secretary of the Committee for the competition, who admitted to a personal preference for a pictorial production but had deferred to others 'more knowledgeable than himself'.

According to *The Builder*, the controversy had forced the committee to instruct Wailes to take out of his design 'everything Gothic'. Mayhew confirmed that alterations to the architectural details had been requested, but that Wailes' choice of subject matter and the mosaic style and character of the design had been retained. When the window was in place, *The Builder* reported:

> No Gothic outlines appear in the window as now executed; the vesica piscis forms, and the foils are omitted, the borders altered, and the figures made to approximate to nature rather than in imitation of medieval work. It has now a Byzantine rather than a Gothic character, and is less obtrusively objectionable than it would otherwise have been.

Winston, as might have been expected, thought the 'Cinquecento' style should have been used, referring to Wailes's design as a 'curious mélange' of a 'nineteenth century design, with ornamental details more resembling the Romanesque in character than anything else'.[15]

One might have thought the problem an irrelevance for Pugin, since he had no interest in, and indeed despised, classical churches, as evidenced by his Oscott lecture:

> and most fervently do I hope that all Ionic, Doric and Semi-Gothic conventicles, now used or erecting for Catholic worship, with sash windows, and square windows and dead walls without windows, may speedily be demolished, and edifices in their stead worthy of their holy purpose.[16]

He appears not to have joined in the discussions but at a later date

revealed that, unlike Winston, he would be prepared to put early medieval style glass in such windows:

> The window you speak of for the City would have to be treated very like the Early glass at Chartres, Bourges & c with good iron frame and subjects these [?] windows will always look well I believe a deal might even be done with St. Paul's [Cathedral] by early windows.[17]

In 1850 he was called upon to resolve a similar problem to that at St James:

> I send you the window for the Paladian [sic] Church, it would look very well but there is a deal of glass in these windows there is little short of 50 feet with the iron frames the window is worth £75 you must explain this that owing to the want of mullions the Quantity of glass is equal to a very huge gothic window.[18]

The church in question has not been identified. The design was probably never carried out, although, presumably, it would have been in the Early style, with no concessions to the Italianate nature of the building.

When it came to recreating the medieval in his own work Pugin was happiest when working in the Decorated style. The use of natural and heraldic motifs, the introduction of silver staining and the advent of architectural canopies were all new features of the style and gave Pugin more scope when creating his designs. Most importantly though, as he intimated to the artist J.R. Herbert,[19] he sought to represent the human form in its natural proportions, clothed in vestments of the Middle Ages worn so that the folds and forms represented were the natural results of the fall of the garments, or, as he put it: 'without any affected quaintness of outline'. That the Decorated style was more suitable to these aims than the Early is apparent from Winston's analysis of it, in which he noted in regard to the figures:

> A very considerable advance in the art of representing the human figure ... Its proportions are better preserved than in the former [Early] style, the figures in general not being too tall, or slender... an easy and graceful attitude is given to the standing figures, by slightly swaying the body backwards, and resting its weight on one leg, somewhat after the manner of the antique.[20]

The draperies, he concluded, 'are likewise treated in a broader more easy and natural manner,'[21] observing that they differed from those of the Early period, in that they 'are full of small folds, like the antique but are stiff, scanty,

6.1a. St Peter, Great Marlow, Buckinghamshire,
S aisle window sIV (Gaz.7), Pugin/Hardman,
1847. St Francis of Assisi, St Carolus.

6.1b. St Peter, Great Marlow, S aisle window
sV (Gaz.7), Pugin/Hardman, 1847. St Thomas
of Canterbury, St Osith.

and close. In the early specimens they are wrapped so tightly about the body,
as to appear as if they adhered to it.'[22]

In an article for the *London & Dublin Weekly Orthodox Journal* for 1838
Pugin had written on the appearances of vestments. Although a polemical
piece favouring the old against the modern, the article contained descriptions
which expressed what he sought to represent in stained glass:

> The dignity of vestments depends principally on their form. Without
> flowing lines and grand easy folds no majestic appearance can be
> obtained … The old chasubles, unpinched in shape, fell gracefully
> from the shoulders and folded over the arms … Dalmaticks [sic] and
> tunicks [sic] were likewise loose in their folds, with <u>ample sleeves</u>
> and rich tassels … Stoles and maniples were anciently very narrow,
> swelling out a little at the extremities, and embroidered with three
> crosses.[23]

Pugin's draped figures that appear in his windows of the Decorated
style follow the above precepts, being of natural proportions with an
unemphasised contrapesto stance and wearing full draperies with broad

angular folds as can be observed in the array of standing canopied-saints in the windows at Great Marlow of 1846 (**6.1a& b**), and St Paul, Brighton (**6.2**), 1849 and 1853, as well as the fourteen in the east window at St Edmund's College Chapel, Ware of 1847 and 1848, (**6.3a–c**), the sketch for which shows how Pugin with a few rapid strokes of his pencil, captured and highlighted the stance of the figures, the natural fall of their draperies and the angular nature of the folds (**6.3d**).

The Early style presented more of a problem to Pugin since the natural proportions and relaxed attitudes of the figures, prevalent in the Decorated did not feature. Instead a stiffness of movement was called for with the faces having strongly marked features and the hands unformed with fingers like, 'rakes or combs', as Winston put it.[24]

Pugin's attempt at the style in 1848, before he went to France to look at the windows in Chartres Cathedral as a precursor to designing those for Jesus College Chapel, Cambridge (Gaz.9), was in the windows for Clifford (**6.4a–c**) and showed how removed he was from the medieval. The windows are generally light in tone with yellow and a rather garish royal blue dominating instead of the rich sombre reds and blues of the old. The figures are in proportion, relaxed, meticulously and delicately drawn with refined faces and fully-articulated hands and fingers. The roughness and robustness of their medieval counterparts are missing – even the backgrounds are precise and delicate, the diamond trelliswork of which they are formed is exact and the infilling of foliated-crosses so consistent that the result looks mechanical. The circles forming the medallions are perfect shapes and their white-beaded outlines, which surround the similarly defined quatrefoils that contain the scenes, seem to act as precious ornamental frameworks rather than sparkling elements of light animating the windows, as would have been the case in their medieval exemplars. The only

6.2. St Paul, Brighton, S aisle window sVI (Gaz.41), Pugin (Powell)/Hardman, 1852. St Boniface, St Swithin.

125

6.3a. St Edmund's College, Old Hall Green, Hertfordshire, Chapel E window I (Gaz. 82), Pugin/Hardman, 1847-8. Virgin and Christ with saints.

aspect of the drawing in the Clifford windows which accords with the old, is in the draperies, where the heavy lines of the shadows, again as Winston described,[25] taper off to fine points. The garments themselves, however, unlike the old, are graceful and fall in a naturalistic fashion.

Pugin clearly learned from his visit to Chartres, for the drawing in the triple lancets at the east end of Jesus College Chapel, Cambridge (**6.5a-c**), finished some eighteen months after Clifford, is less refined. The figures are made to move in a stiffer fashion, and their features are more strongly marked, prompting *The Ecclesiologist* to comment that 'The drawing is however perhaps a little too archaic'.[26]

The blues in the backgrounds also bear a much closer resemblance to the medieval than do those at Clifford while the plain glass grounds of the medallions unlike the diapered at Clifford help to give a more austere effect to the work. Most importantly too, as with the medieval, Pugin strengthened the design by introducing ferramenta, that is ironwork, which not only helped to hold the glass in place, but also emphasised the outlines of the patterns of the medallions alternating with diamonds in the centre lancet, and ovals in the side.

Pugin mentioned this feature in a letter, probably to Rev. John Gibson of the University, together with other details of the design he intended to create:

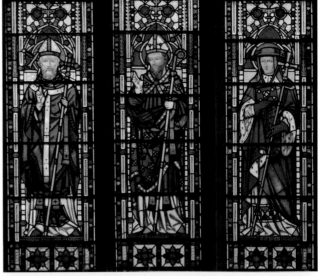

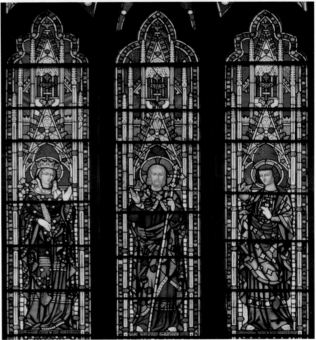

6.3b-c. Details of 6.3a.

> In a very few days I will forward you a sketch showing the arrangement I propose for the 3 East windows, of course it will be [?] as Early glass small subjects & rich borders & grounds – I can promise you something brilliant – the Real old thing we must have a <u>framework</u> of iron in a geometrical frame of iron as at Canterbury & c to define the pattern & secure the glass. The Early glass looks nothing without it poor & weak this must be made of galvanised iron which will not rust. I shall take great pains with this work - & try to produce something very good.[27]

6.3d. St Edmund's College, Old Hall Green, Chapel E window I, Pugin sketch, 32.9cm x 53.0cm. *Birmingham Museums & Art Gallery, BM & AG a.no. 2007-2728.4.*

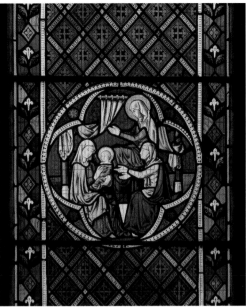

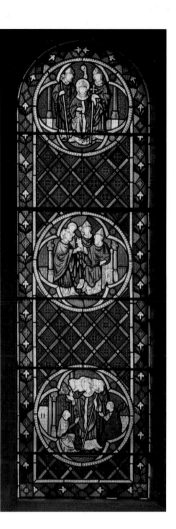

6.4a (*left*). St Edward, Clifford, West Yorkshire, N wall window nIII (Gaz.188), Pugin/Hardman, 1848. Life of St Anne.
6.4b (*above*). Detail of 6.4a.
6.4c (*right*). St Edward, Clifford, N wall window nV (Gaz.188), Pugin/Hardman, 1848. Life of William of York.

As a contrast to the severe lines of the framework and the austerity of the medallion backgrounds, the grounds of the lancets and of the diamond shapes are filled with foliage scrollwork and geometric foliage patterns respectively, the former set against red backgrounds and the latter blue. That Pugin made a special effort with these windows is clear from his letters. More than one factor motivated him. On the one hand the French glass maker Henri Gerente (1814-49) posed a competitive challenge to the firm in windows in the Early style as Pugin acknowledged to Hardman:

> I always thought Gerente was anxious to set up in England but do you mean he has got a place in Birmingham? He will do Early glass beautifully but not the later style at least I do not think he understands that so well – If he has plenty of cash – your men will be drawn off – but I don't think he has any money of his own.[28]

On the other, progress on an Early style window for St Patrick, Sydney, Australia (Gaz.224), was not going well causing Pugin to become disillusioned with the quality of the work at Birmingham and making

6.5a. Jesus College Chapel, Cambridge, E window I (Gaz.9), Pugin/Hardman, 1848 and 1850. Passion of Christ.

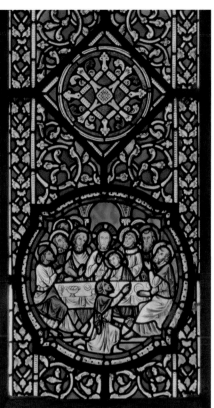

6.5b–c. Details of 6.5a.

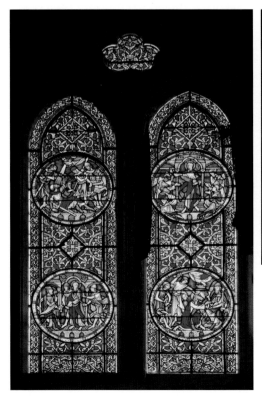

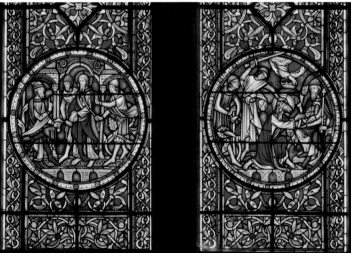

6.6a (*left*). Chichester Cathedral, West Sussex, S window St George's Chapel, sXII (Gaz.184), Powell/Hardman, 1852. Life of St Paul.

6.6b (*right*). Detail of 6.6a.

131

6.6c. Chichester Cathedral, S window St George's Chapel, Pugin sketch for 6.6a, 20.5cm x 43.0cm. *Birmingham Museums & Art Gallery, BM & AG a.no. 2007-2728.8.*

him particularly anxious about the likely reception that the Cambridge window would receive. All these reservations were expressed in a letter to Hardman:

> Powell gives me a most disturbing account of the Sydney window. I am afraid your men are getting to Paint (as Myers men carve) all styles alike. I am very miserable & dejected over our work. I am sure we don't advance … I am terribly anxious about Cambridge for if that is not very good we shall have all the critics down on us.[29]

Presumably the windows were received favourably by the University authorities, for within a month of their being installed, a further two were ordered. *The Ecclesiologist*, however, was not so enamoured, for while conceding that the design was good it thought the general effect rather pale and confused.[30] Certainly the overall effect of the windows is much lighter and more delicate than those of their medieval counterparts, and if anything the iron framework while giving the authentic look of the Early style, tends to emphasise this difference. Pugin himself recognised their comparative failure:

> I went to Jesus College. The windows like everything else are very disappointing I was quite astonished [?] they don't look as if if [sic] there was a powerful colour in them. our ornament is too faintly painted we are afraid of black.[31]

A practical difficulty Pugin faced in designing for commissions requiring the Early style was the relatively narrow widths of the lancets he was given to work on. It was a general point made in *The Ecclesiologist*:

> The narrow lancets of First Pointed [Early], and the contracted lights of Middle Pointed [Decorated], were fatal to complex subjects: except in the rarer cases, rare at least in England, where a light exceeds three feet in breadth. Medallion windows lasted much longer on the continent in perfection … because the lights, were relatively broader than in England. It is quite useless to think of a medallion window unless the lights, whatever the date and style, exceed three feet in width.[32]

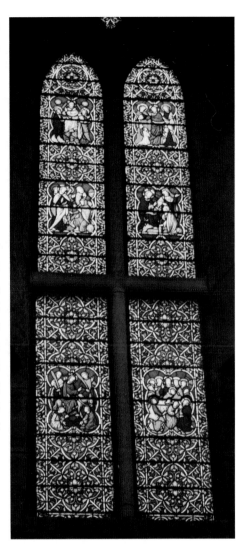

6.7. Bolton Abbey, North Yorkshire south wall sV (Gaz.126), Pugin/?, 1853. Transfiguration; Blessing the Children; Raising of Lazarus; Mary Magdalene anoints Christ's feet; Entry into Jerusalem; Last Supper. *Stanley Shepherd.*

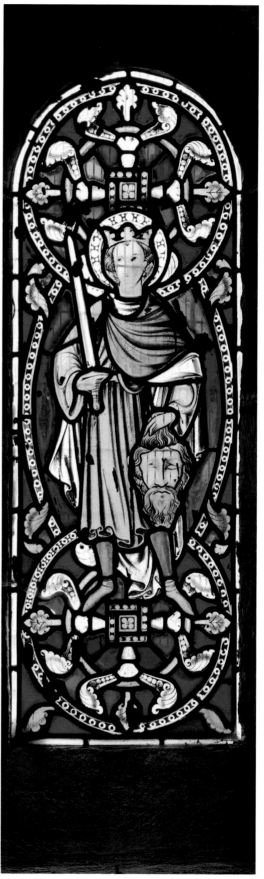

6.8a (*above left*). St Mary &
St David, Kilpeck, Hereford-
shire, apse window I (Gaz.76),
Pugin/Hardman, 1849. King
David.

6.8b (*above centre*). St Mary &
St David, Kilpeck, apse win-
dow nII (Gaz.76), Pugin/
Hardman, 1849. Agnus Dei.

6.8c (*far right*). St Mary & St
David, Kilpeck, apse window
sII (Gaz.76), Pugin/Hard-
man, 1849. David with head of
Goliath.

6.8d (*right*). St Mary & St
David, Kilpeck, apse win-
dow I (Gaz.76), Pugin sketch
for 6.8a, 21.0cm x 25.0cm.
*Birmingham Museums & Art
Gallery, BM & AG a.no.2007-
2728.3.*

134

Pugin had made the same point to Rev. Gibson in respect of Jesus College Chapel:

> [?] some time I forwarded you a rough scheme of the subjects for your east windows & also one bit to a Larger scale to show the proposed treatment of the Pattern the blue band shows the <u>iron frame</u> & by adopting this form I get the Largest space for the subjects [includes a sketch showing the medallions overlapping into the borders] like all my Lancet windows they are very limited for space the Foreign Lancets were often very Large & being with mullions afforded a fine [?] for glass. I think by the arrangement I propose, I shall get the subjects Large enough to be Effective.[33]

The width of the Cambridge Chapel lancets were 2ft 2ins for the centre and 1ft 9ins for the sides, and those at Clifford 2ft 3½ins thus falling considerably short of the more than three feet recommended in *The Ecclesiologist*.

Not long after completing the Jesus College Chapel windows, Pugin produced designs for a window high up on the east wall of Hereford Cathedral (Gaz.75). The centre light (the only one made) was 7ft 1in wide and ideal for a composition in the Early style – the glass was replaced in 1871 and presumed lost but substantial portions of it have recently been discovered in two of the Cathedral clerestory windows (**3.9**).[34] Pugin suggested that the Jesus College cartoons be used as a guide[35] and as in those windows the 'archaic' effect was sought in the form and manner of the figures. Pugin was delighted with the result: 'I have made a first rate design for Cottinghams[36] window it will look magnificent if it is carried out;[37] and he would have liked to have used the window, had it been possible, as an example of the Early style, in the medieval court of the 1851 Great Exhibition.

Two works still in place, are both ones where the windows are more-or-less of suitable widths. They are at Chichester Cathedral (**6.6a–c**) where the lancets are 3ft 9ins, and Bolton Abbey (**6.7**) with widths of perhaps between 2ft and 3ft. Pugin was enthusiastic about the proportions of Chichester[38] and produced designs of a form not markedly different from those he had used at Jesus College chapel. As the window was not completed until July 1852, he could not have taken any part in its execution and it seems unlikely that he was involved in the production of the cartoons. His design sketch (**6.6c**) shows that the medallions were intended to be contained within the inner boundaries of the borders of the lancets and that angels enclosed in segments of circles were to be placed along the inner boundaries, at the tops of the lancets and between each pair of medallions. The containment of the medallions within the borders made sense. There was no longer a lack of space, as there had been at Jesus College Chapel and the lancets were

6.9a (*left*). Our Lady, Upton Pyne, Devon, N aisle window nV (Gaz.31), Pugin/Hardman, 1851. Raising of Lazarus, Christ, Raising of Jairus's Daughter.
6.9b–c (*above*). Details of 6.9a.

virtually at eye level so that the scenes could be quite easily seen hence there was no need in the interests of clarity to use the whole width of the lights. The results of doing so, in what is presumed to be a reworking of Pugin's design by J.H. Powell, in the completed window (**6.6a & b**) – only the scene of St Paul's conversion has been retained - is that they become obtrusive, upset the balance of the composition by causing the patterned, diamond shapes between them and at the tops of the lancets to appear small and inadequate, and they conflict with, rather than supplement, the mosaic ground, thus reducing the overall rich appearance of the window and creating a lack of harmony which it is hard to imagine would have received Pugin's approval. Also, it seems unlikely that Pugin would have treated the spaces at the bottom of the lancets – left blank in his sketch, awaiting clarification – so oddly by creating what seem to be unnecessary panels of mosaic with a changed ground colour.

For Bolton Abbey windows, the cartoons were drawn under Pugin's supervision[39] and, like those at Jesus College Chapel, include scenes beautifully designed for containment within medallions – this time quatrefoil rather than circular – with figures which, although well-proportioned, incline to the stiffness of pose and the urgency of gesture found in early medieval windows. The windows (**6.7**) were not made by Hardman's, this being the only instance – as already noted – once the Hardman workshops had been

established, of Pugin allowing another glassmaker to use his designs. The inscription on the windows suggests that J.G. Crace made them, which is open to question,[40] but whoever the identity of the manufacturer may be the colours are more strident and less harmonious than those used by Pugin and Hardman.

Four other windows in the Early style, made in 1849, deserve mention. The first, for Brasted (Gaz.86), and commissioned by Benjamin Webb, editor of *The Ecclesiologist*, provided a moment when two notable figures of the Gothic Revival came together over the question of style. Webb asked for glass to fill a small Romanesque window assumed to be Saxon in origin and supposed that mosaic glass alone would be suitable. Pugin, determined to impress, pleaded with Hardman to 'use the <u>true</u> blue and streak the ruby with white and make a true little thing.'[41] The other three were for the apse of Kilpeck (**6.8a-c**) and indicate how important style was to the client and how practical considerations prevented its proper implementation. The Rev. Archer Clive noted in his order that the church was a very rude early Norman structure and asked that the windows should be of the earliest sort of glass. In direct contradiction to this, however, he also required them to be as light as possible, because they were the only source of light to the circular chancel.[42] Pugin's quite effective solution was to use in each window a single figure against the blue and red grounds of the Early style, and as much white glass as possible. Hence, white beaded-glass outlines the vesica-shaped central medallions that contain the figures, and also the patterned-roundels above and below; in addition the bulk of the foliage in the patterning is white, and a white fillet of glass separates the stonework from the stained glass. Pugin's sketch (**6.8d**), shows that his original intention was to contain the figure of King David (which appears in both the central and south windows) within its vesica, and to superimpose the vesica over the roundels; he also planned to have borders inside the white fillets. Doubtless, because the windows were so small (approximately 1ft wide and 3ft high), the borders were eliminated in the completed works, and to give maximum effect to the figures Pugin freed them from the vesicas by running the edges of the roundels behind their heads and feet and losing the vesicas' pointed ends in the foliage of the roundels. In the north window the depiction of the Agnus Dei within its vesica maintained the arrangement shown in the sketch – apart, that is, from doing away with the borders. This was done, presumably, because the design needed to emphasise and be contained on the vertical axis, which is marked by the crossed staff with banner, and also because the lamb within the vesica is recognisably a Christian symbol.[43]

Reference has already been made to the technical difficulties Hardman's painters experienced when faced with work in the Late style[44] and Pugin drew attention to these failings in 1850 when considering work on the east window for Magdalene College, Cambridge (**3.4a-b**). Suggesting to Hardman that they should visit St Mary, Fairford, he wrote:

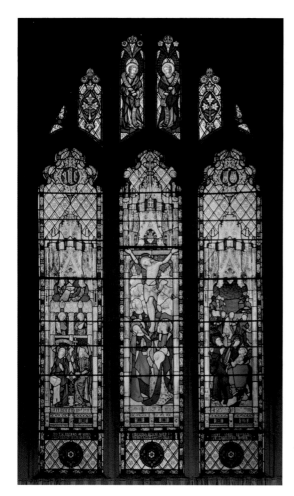

6.10a (*above*). St Mary, Hambleden, Buck-inghamshire, chancel E window I (Gaz.8), Pugin(?)/Hardman, 1853. Annunciation, Crucifixion, Flight into Egypt.
6.10b (*right*). Detail of 6.10a.

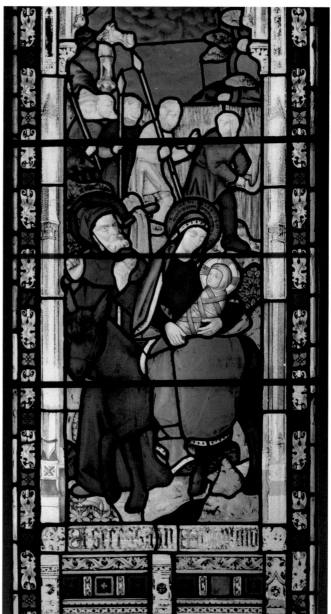

I should like to go to Fairford with you for that is a fine specimen of Later glass just what we want for Magdalene College Cambridge. I want to make a fine window of that but I don't <u>see my way yet</u> our late glass is not either drawn or painted like the old work.[45]

The window was completed that year in the Late style so that the canopies were shown in perspective as were the stepped bases on which angels variously sat, stood and knelt. That the figures are reminiscent of Early Netherlandish paintings is not surprising since the designs of the Fairford windows owe much to Netherlandish painters[46] and Pugin had asked Oliphant to work close to the Van Eyck School in the cartoons.[47]

Pugin went further than showing canopies in perspective in windows such as those in the north aisle at Upton Pyne, Devon (**6.9a–c**), and the east window at Farnham (**2.4a**). In these some of the scenes have backgrounds opened up to reveal landscape views but in other respects he was reluctant to move any nearer to a pictorial style. In 1851, around the time these windows were produced he wrote to Hardman: 'I have just returned from Cambridge – don't talk about <u>beating</u> Kings yet. there is a long way to go, but this late glass is in reallity [sic] a false system & the decline of the art'.[48]

There is just a hint here that however deleterious he thought the pictorial style was, the much-admired sixteenth-century windows of King's College, Cambridge, might in some way be emulated. Perhaps the scene of the Flight into Egypt in the east window at Hambleden (**6.10a & b**) was designed in this spirit. Split into foreground, middle ground and background, although the space is compressed, the scene comes closer to one in perspective that breaches the integrity of the wall than anything so far attempted. It is questionable however as to whether Pugin was involved. His original design in 1851 was for five scenes but, for reasons of cost, these were later reduced to three.

Hardman wrote to Captain Ryder (who was acting for Mrs Scott Murray in the commissioning of the window) on January 8, 1852: 'I think I could manage to get in the three subjects namely the Crucifixion in the centre light & the Annunciation & Flight into Egypt on each side if they were treated like the enclosed tracing'. This suggests an initial design sketch had been produced, and in the normal course of events it would have come from Pugin. Whether he would have been well enough to do it, is in some doubt, although in those early days of January he was still fully involved with the work. Letters written by him show that although very ill, business matters were still uppermost in his mind.[49]

In any event the window was not completed until a year after the initial design had been submitted and about five months after Pugin's death. This meant that plenty of time was available for changes unsupervised by Pugin to be made, and the whole of the glass painting was carried out after his demise. Any swing towards

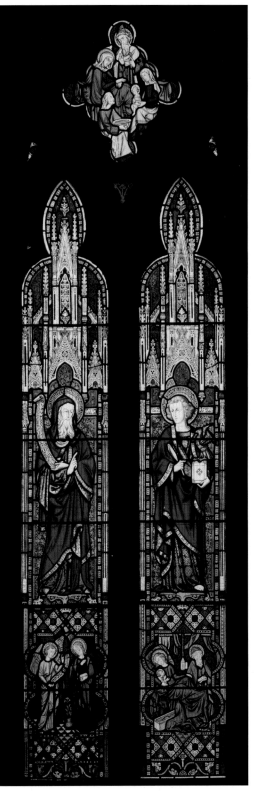

6.11. Holy Innocents, Highnam, Gloucestershire, S aisle window sVI (Gaz.48), Pugin/Hardman, 1850. Isaiah, St John the Evangelist.

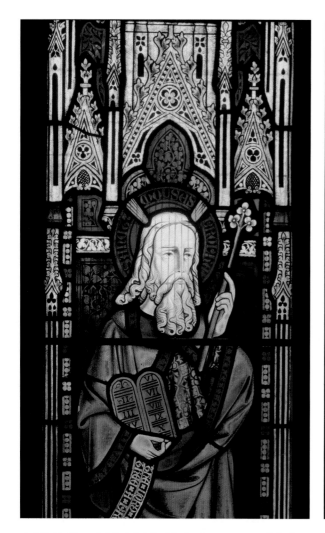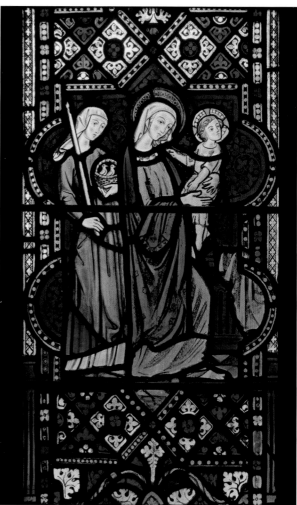

6.12 (*left*) - 6.13 (*right*). Holy Innocents, Highnam, S aisle window sVIII (details), Pugin/Hardman, 1850. Moses (*left*); Presentation in the Temple (*right*).

picture-making could, therefore, have come equally well from Hardman, working with Powell.

After some three years of working with Hardman, Pugin wrote of his frustration at their inability to make windows with the vibrant quality that was a feature of medieval work: 'As for windows I am burning to produce something sparkling and brilliant all our work is dead and heavy. we have never yet done a <u>brilliant</u> window and I am sure it can be done I shall come back to Birmingham I think of nothing else.'[50]

The need for glass of a sparkling jewel–like nature, as used in medieval times was a priority and the steps that Pugin took to obtain it have already been detailed. In addition he sought to enliven the overall appearance of his windows by the judicious use of white glass. His success in this latter respect did not go unnoticed.

In 1851 *The Illustrated London News* reporting on the Great Exhibition commented, 'In all the designs [of Pugin] a due proportion of white has

been introduced, without which it is impossible to attain a brilliant effect',[51] and in a paper read to the Ecclesiological Society in June 1852, G.E. Street commented:

> it would be ungenerous in the extreme if in speaking on such a subject one were to omit mention of the thorough appreciation shown by Mr. Pugin for the true principles of art in this as in other matters in the glass which he has of late been designing. I believe the brilliant effect of much of Mr. Hardman's manufacture is owing to the proper use of white.[52]

Street referred in particular to: the advantage of the white edge to all glass next to stone; the need to increase the amount of white used towards the head of a window, the inclusion of white canopies and supports; and the use of white foliage. Pugin's use of white in windows in Early style has already been mentioned when discussing the windows at Clifford and Kilpeck.

With the Decorated and Late styles the advent of a new motif, the architectural canopy, into stained glass window design gave greater scope for white glass to be used as a means of giving added sparkle.

In both these styles Pugin's mastery is best shown by comparing him with Wailes. In 1850 Pugin, with Hardman, was commissioned for the south aisle windows of Highnam (**6.11, 12 & 13**), and Wailes for the north (**6.14**). All the windows were in the Decorated style. Wailes' shortcomings in the use of white were highlighted, paradoxically, in *The Ecclesiologist* when it praised him for not using it in his window at St James, Piccadilly: 'In execution we think this window successful, and what in ordinary cases is so great a detriment to Mr. Waile's work, is here an improvement, the absence, we mean, of white, which serves to mark the window, and to contribute to its triptych-like effect.'[53]

6.14. Holy Innocents, Highnam, N aisle window, Wailes, 1850. Elijah, St James the Great, with Jonah and the whale above and raising of Jairus's daughter (*left*) and raising of the widow's son below (*right*).

6.15a (*left*). St Mary the Virgin, Oxford, S aisle E window sVII (Gaz.139), Pugin/Wailes, *c*.1843. Life of St Thomas the Apostle.
6.15b (*right*). Detail of 6.15a.

At Highnam, it is not completely excluded but where it appears, in the architecture, garments, scrolls and extremities of the figures, it is given a yellowish tinge; in addition the whole of the design is dominated by large areas of red, blue and green. The result fails completely to match the sparkle of Pugin's windows where white breaks up the colours making up the patterns in the lower parts of the lights, flickers around the edges of the garments of the main figures, dominates the black in the scrolls and enlivens the faces of the saints, above whom white canopies surmounted by superstructures, touched with yellow silver stain, shimmer in the heads of the lights. That these were not accidental results but were due to the application of design principles is confirmed by Hardman, commenting on the firm's practice, in a letter written to Lord Charles Thynne – probably about the latter's window at Longbridge Deverill (Gaz.195), since destroyed – a little after Pugin had contracted his fatal illness: 'white glass will be

6.16a (*left*). St Mary the Virgin, Oxford, S aisle window sIX (Gaz.139), Pugin/Hardman, 1848. Life of St Mary Magdalene.

6.16b (*below*). Detail of 6.16a.

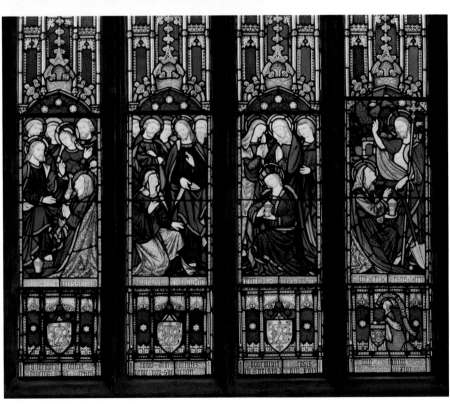

143

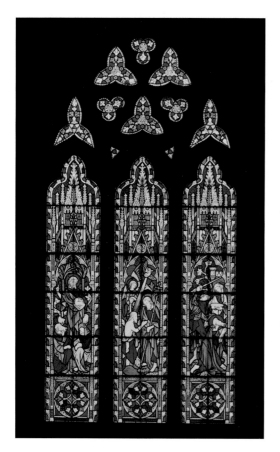

6.17a (*left*). St John the Baptist, Wasperton, Warwick-
shire, chancel E window I (Gaz.172), Pugin/Hard-
man, 1852. Life of St John the Baptist.

6.17b (*above right*). Detail of 6.17a.

6.18a (*right*). St Mary, Beverley, Humberside, N aisle
W window nXVI (Gaz.83), Pugin/Hardman, 1852.
Life of St John the Baptist. *Gordon Plumb*.

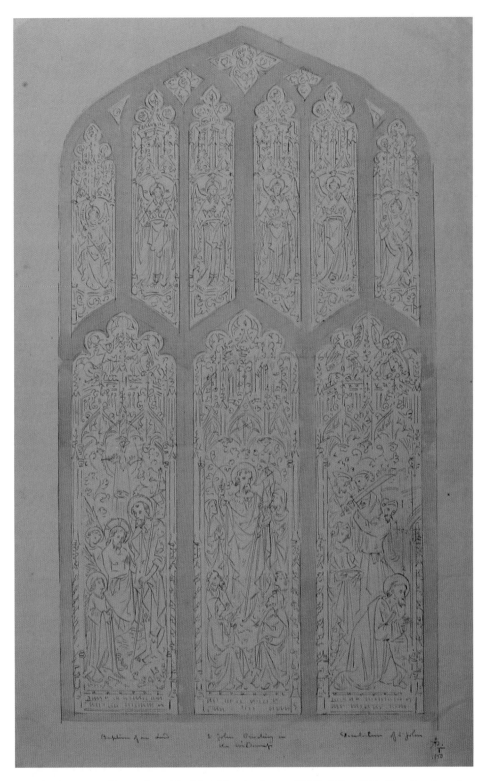

6.18b. St Mary, Beverley, N aisle W window nXVI (Gaz.83), Pugin sketch
for 6.18a, 1850. *Private collection*.

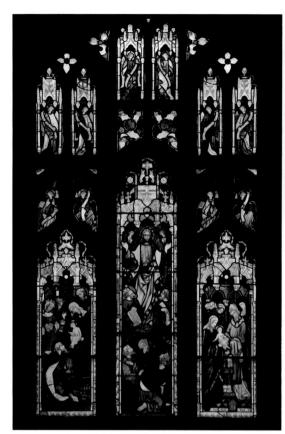

6.18c (*above*). St Mary, Beverley, S aisle W window sXXI (Gaz.83), Powell/Hardman, after 1853. Life of Christ. *Gordon Plumb.*

6.18d (*right*). St Mary, Beverley, S aisle W window sXXI (Gaz.83), Pugin sketch intended for 6.18c; window never made, 1850. *Private collection.*

6.18e-g (*top right*). Details of 6.18a.

dispersed about not in large quantities but sufficient to give brilliancy.'[54]

In the Late style comparison between the two can be made in respect of two windows at St Mary the Virgin, Oxford. The windows are not so completely at arms length as were those at Highnam. The one made by Wailes (**6.15a & b**), in 1844, was in fact designed by Pugin but as has been mentioned earlier he would only have supplied the design sketch and would not have produced the cartoons nor had any control over the choice of glass used. The Pugin/Hardman window (**6.16a & b**) was made four years later for the same patron, Mr George Bartley, and both windows are set in identical architectural frameworks.

Wailes' work is very subdued in appearance. There are large background areas of deep blues and reds and dark brown canopies overhang the scenes. The amount of light filtering through the window is as a consequence restricted and there is very little evidence of white glass. In the words of *The Ecclesiologist*: 'the whole effect is dingy'.[55] Although it lacks a vibrant quality, the window does exemplify the elements of the style in that the figures are made to stand on receding pavements and are set under three-dimensional, vaulted canopies.

By contrast in the Hardman window Pugin seems almost to revert to the Decorated style. The lower panels are reduced in size to allow for tall canopies and the general impression is one of flatness. There are no receding pavements, the shields in the bottom panels are aligned on the plane of the window, and in the one panel where there is a figure, the patron's daughter, she is placed in profile behind an altar the side of which is parallel to the window-plane. There is only a hint of three dimensions in the canopies with a suggestion that they are hooded and that the three white stars above each scene combined with the leads can be read as vaults. The scenes too, compared with Wailes' window, veer towards two dimensions with the figures occupying only very shallow spaces, other than in the panel containing a depiction of *Noli me tangere* where the background is opened up.

Unlike Wailes, Pugin has enlivened the window by breaking up the background colours into alternating patches of blue and red to make patterns on the window plane. These are bounded by the pinnacles of the canopies that are composed mainly of white glass. The resultant effect is to introduce lightness and brightness to the upper part of the window.

Winston points out that early in the fifteenth century some canopies were represented like the Decorated[56] but it seems likely that in this instance Pugin was more anxious to obtain a sparkling effect than to adhere strictly to the conventions of the Late style.

The two-dimensional Decorated style compared with the three-dimensional Late is well illustrated by two windows using the same composition. The Decorated version appears in the east window at Wasperton (**6.17a & b**) and the Late in the north aisle west window of St Mary, Beverley (**6.18a**). At Wasperton, the flatness and overall coloured-pattern-

effect of the scenes and canopies, reinforced by geometrical leaf patterns in the tracery and in the panels below the scenes, is marked. At Beverley, by contrast, patterns are secondary to solid forms. The eye is immediately caught by the white and yellow shadowed-canopies which overhang the scenes, while in the scenes themselves, slight changes in pose compared to Wasperton enhance the effect of figures set in space rather than on the surface of the window. For example, the Christ figure in the baptism scene at Wasperton is in profile, while at Beverley he is in three-quarter view and the same can be said in respect of St John the Baptist in the execution scenes. The figure of the executioner, at Wasperton has been flattened out (note particularly his right leg and the absence of any substance in the upper part of his body) whereas he is portrayed as a quite solid figure at Beverley. The scenery also underlines the change in style. The city gate in the execution scene at Wasperton is set parallel to the window plane, while at Beverley it inclines into the scene and forms a corner as the wall is turned. At Wasperton the water in the baptism scene forms stylised waves, more like patterns on the surface, whereas at Beverley it is marked with light and shade, conveys a sense of depth around Christ's legs, and recedes into the distance. The foliage at Wasperton fills the empty spaces with flattened forms in an irrational manner while at Beverley it seems to grow in the landscape. Finally, at Beverley canopy columns fill the extremities at the sides of the lights while at Wasperton the pattern effect is completed by borders of white leaves on yellow stems against red and blue grounds. Pugin's original design for Beverley was made in 1850 (**6.18b**) (he produced what was probably a later version which he mistakenly put in the framework of the south-west window).[57] It differs in some respects from the completed window and shows that Pugin initially intended to create more space around Christ in the Baptism scene, with an angel standing to his left in the foreground and another behind his right shoulder (this second angel is excluded in the sketch set in the south-west frame). St John the Baptist too is given greater prominence in the centre light by causing him to stand head and shoulders above the figures at his sides (this is amended in the sketch set in the south-west frame, which has the figures in similar positions to those that appear in the completed window). The figures in the Martyrdom scene are set in four planes: St John in the foreground; Salome behind him and to the left; the executioner to the right and behind Salome; and two figures behind the executioner. In the finished window the planes are reduced to three with Salome moved to the right-hand side as if entering the scene through the gateway (this is sensible, it relieves the congestion on the left- hand side of the composition, and in her original position Salome was in danger of being decapitated) and the two background figures replaced by trees and a turret. The composition as it appears in the completed window, is closest to that for Wasperton in respect of the side lights, and the sketch in the south-west frame for the centre light.

7

Subject Matter

I do not think any design would be so appropriate for the perpendicular windows as the doctors and Bishops you say you are tired of Canopied figures but where have you seen any new ones worth looking at.... I have not hitherto succeeded[?] in finding a fine canopy or figures of the Later period nor had I the means of so doing till my last journey to France … be assured single figures will be best for these windows & I really think I can produce the true thing as I have got the material for it.
– Pugin writing on designs for Jesus College Chapel, Cambridge, 1849[1]

Pugin's plea to Jesus College, towards the end of 1849, for his favoured canopied saints for the two south wall windows of the chapel – he recommended the Virgin and Child flanked by St John and St Radegunde for the one and St Cuthbert between St Margaret and St Katherine for the other – seemingly fell on deaf ears, for in a later letter he wrote: 'I have no objection to subjects though I should prefer Saints but it is quite immaterial to me only subjects will be more expensive.'[2]

Rebuffed on this occasion, as he would be later for the west window at St Marie, Sheffield and one in the south aisle of Ely Cathedral, Pugin would ultimately be able to reflect that canopied saints, designed much as they were in medieval stained glass when saints were among the most common subjects,[3] came to represent a substantial portion of his work.

The truth of this is confirmed by no more than a cursory inspection of the Gazetteer where saints will be seen to far outnumber all other forms of subject matter. This comes as no surprise since the natural choice of an individual donor, or the incumbent of a church tended to be that of his or its patron saint. Inevitably this led to the depiction of the same individual in many different windows but Pugin managed to steer clear of repeating his designs by introducing small differences between the figures, be it in pose or gesture, or in the colours of their garments or the manner in which they were worn.

Patronage was not the only reason for the inclusion of a representation of a saint. At Great Marlow (Gaz.7), for instance, two were selected because of their local associations, as Charles Scott-Murray, who paid for the church as well as the window in question explained:

I had wished to have had St. Thomas of Hereford & St. Osith, the latter having been born at Quarendon in this County, the former

149

being, as shown in the Bollandists in the Acts of his Canonisation born at Hambleden now my property, & situated a few miles of [sic] Marlow.[4]

Owing to some misunderstanding, St Thomas of Canterbury rather than St Thomas of Hereford was included, but local pride was swallowed and the figure retained because Scott-Murray thought it (**6.1b**) the most beautiful in the church.[5]

Again, although St George and the Virgin and Child (**3.1c**) featured as the principal subject matter for reasons of patronage in one of the windows of St Chad's Cathedral, Birmingham and St Luke and St Andrew of Crete (**3.1a**) in another, in both, a subsidiary panel explained why the windows had been presented. One illustrated the circumstances of the death of the husband of the donor (**3.1d**), and the other the working practices of Hardman's workshop, whose employees gave the window (**3.1b**). In the latter case, however, (as explained in Chapter 9), Pugin' designs differed from those of the final version of the window, which was completed in late 1853 after his death.

The dedication of a church, even though not that of the patron saint, was often the source of a window's subject matter. For instance, at Holy Innocents, Highnam (Gaz.48), subjects relating to children were introduced and at St Stephen and All Martyrs, Lever Bridge (Gaz.68), the martyrdom of saints was represented.

Memorial windows increased the demand for patron saints and Hardman, who took the opportunity of acknowledging Pugin's role in his window-making and of emphasising how experienced the firm was in producing such work, set out in a letter to Walter Blount of London the manner in which the figures should be organised:

> I am in receipt of a letter signed Mr. Moorcock[?] respecting a memorial window – I beg to say in reply that I am constantly making windows of this description from the designs of Mr. Pugin under whose supervision the whole of my glass is executed – <u>In windows of this kind it is usual to introduce a figure of the Patron Saint with the Effigy of deceased kneeling below in an attitude of supplication.</u>[6]

7.1. St Alban, Macclesfield, Cheshire, Lady Chapel window sIII (Gaz.16), Pugin/Hardman, 1846. Edward the Confessor, Virgin and Child, St John the Evangelist.

Pugin's words regarding a window at Macclesfield (**7.1**), a year before, had clearly sunk in. A donor, rather than a memorial window, Rev. John Hall had suggested that his patron saint be placed in one light and himself in another, an idea which Pugin

would not countenance: 'it will never do to have him in a whole light he must be kneeling under his patron saint'.[7]

Another design which included an effigy of the deceased kneeling in supplication, is mentioned by Pugin in a letter, partially preserved in the Hardman archive, addressed to the vicar of Gargave church (Gaz.127). A three-light east window of the church (since lost) contained in its centre light a representation of the figure of Christ. It was a memorial window and the vicar asked Pugin to suggest some means of marking this in the window itself. Pugin replied alongside a small sketch:

> now if you let me place a kneeling female figure under that of our Lord within a sort of pedestal & with the inscription Jesus Son of God have mercy on me. either in Latin or English I [sic] it would express the fact of its being a memorial window to a female. & this is the old way of representing it.[8]

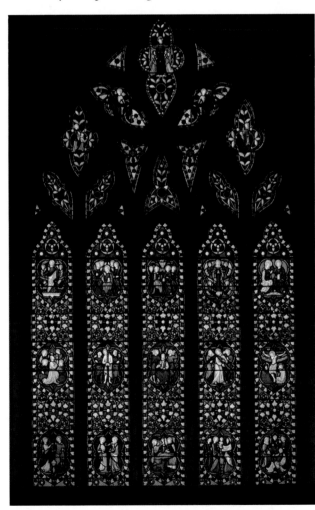

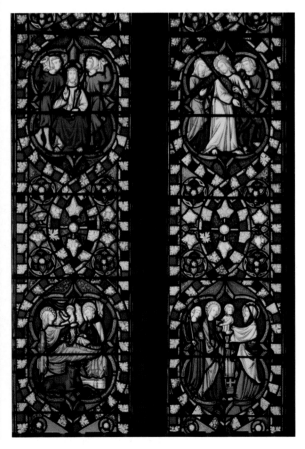

7.2a. Convent of Mercy, Nottingham, chapel E window I (Gaz.130), Pugin/Hardman, 1847. Mysteries of the Rosary.

7.2b. Detail of 7.2a.

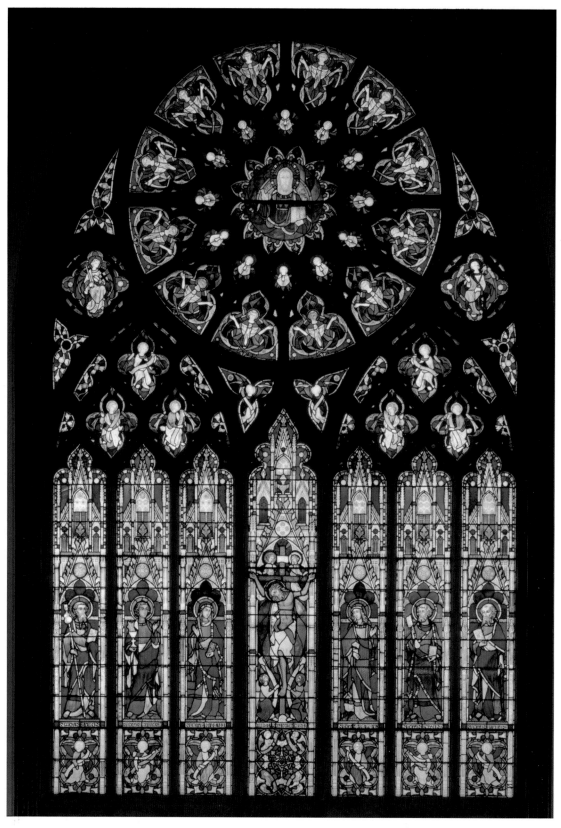

7.3a. St Mary Magdalene, Munster Square, London, chancel E window I (Gaz.59), Pugin/Hardman, 1851. Crucifixion with saints.

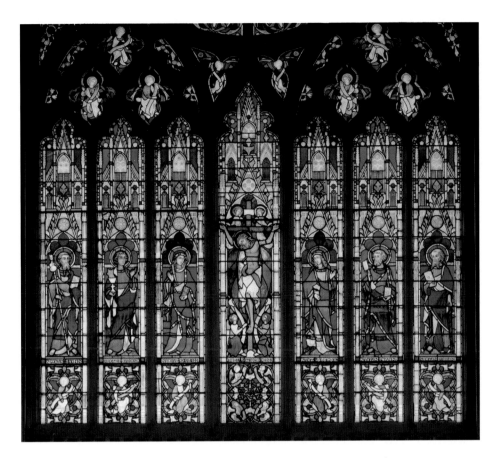

7.3b-c *(above & below)*. Details of 7.3a.

Pugin had already used his suggested arrangement in the centre light of the window at Leadenham (Gaz.107), although the Raising of Jairus's daughter – a theme found in a number of other memorial windows[9] was substituted for the figure of Christ. His closing remark – 'this is the old way of representing it', shows how keen he was that his work should be seen to be in accordance with medieval principles.

Images of Christ and the Virgin Mary and scenes of incidents in their lives formed the subject matter for a number of Pugin-designed windows as they had been in those of the Middle Ages. The most comprehensive and impressive of the life histories to be found in single windows are in the west window of St Thomas & St Edmund of Canterbury, Erdington for Christ (**3.6**), and the east of the Convent of Mercy, Nottingham for the Virgin Mary (**7.2**). The particular incidents in their lives most represented were Christ's Crucifixion and the Annunciation to the Virgin.

The Crucifixion sometimes appeared as one of a number of medallioned or canopied scenes that filled a window as for instance in that at the Convent of Mercy, Nottingham, mentioned above. In most cases, however, it was presented as the principal subject matter, occupying either the centre light

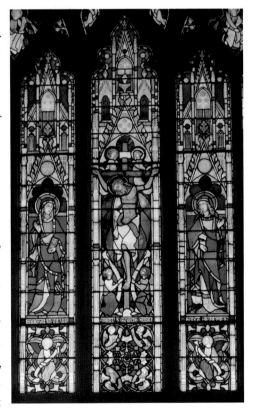

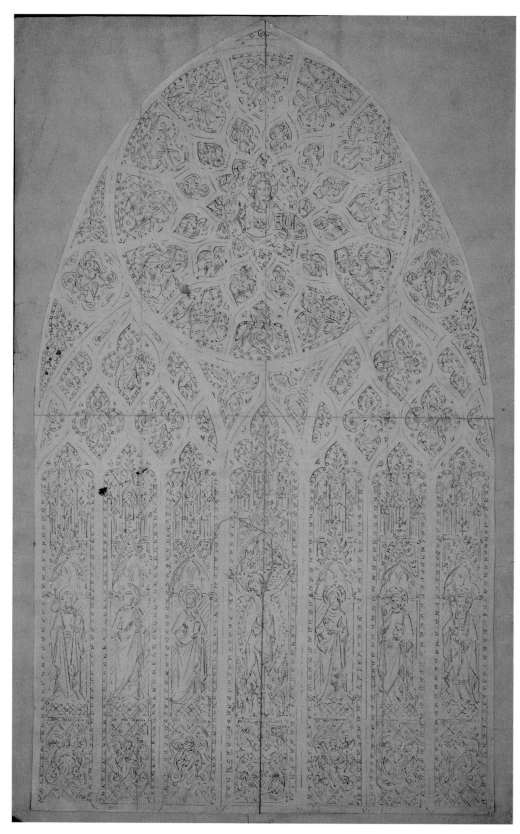

7.3d. St Mary Magdalene, Munster Square, chancel E Window I (Gaz.59), Pugin sketch, 30.3cm x 56.2cm. *Birmingham Museums & Art Gallery, BM & AG a.no. 2007-2728.1.*

of the window as at St Mary Magdalene, Munster Square (**7.3a–d**), or the whole of the window as at St Paul, Brighton (**7.4**).

As with repeat representations of saints, Pugin made minor changes in his compositions to avoid too much similarity, so that in some cases Christ's left foot is crossed over the right and in others the right over left while his arms could be either stretched out straight or bent. In those cases where the poses are virtually identical, such as at Grazeley (Gaz.4) and the clerestory of Ottery St Mary, (Gaz.29) or St Mary Magdalene, Munster Square (Gaz.29), and Algarkirk (Gaz.105), it could have been due to the influence of the patrons' architects, William Butterfield and R.C. Carpenter respectively. However, no such influences were at work in the windows for St John the Evangelist, Frieth (**4.2a & b**: completed 1849) and Upton Pyne (**7.5a & b**: completed 1851), where both compositions are very similar. Perhaps Pugin looked back at the Frieth cartoons when considering Upton Pyne or possibly the Frieth image had remained fixed in his mind at the time he produced that for Upton Pyne. Even in these cases, however, minor differences do exist, mainly in the stances of the supporting characters.

To prevent the occurrence of a pictorial effect when the Crucifixion was shown in three-light windows, the three principal figures, the Virgin Mary, Christ and St John the Evangelist were kept apart within their separate lights either enclosed in medallions or set under canopies. In addition Christ was usually contained within a mandorla or, as at Rampisham (Gaz.36), placed on a distinctive and separate decorative ground. Now and again, as at Skipton (Gaz.128), St Mary Magdalene was included kneeling at the foot of the cross. Although linked by glances and gestures, the separated figures resist becoming part of a combined picture, but apparently not sufficiently so in the window at the College church at Stonyhurst (**10.19**), where Pugin expressed his unease at the representation and wrote of his preference for the use of three subjects.[10] Given Pugin's rejection of pictorialism in his designs, it is surprising to find at St Paul, Brighton (**7.4**), each of the side lights filled with three overlapping figures all turned towards, and clearly participating in, the event featured in the middle light. The composition is unusual too in that it shows Christ with a crown on his head. Perhaps in these instances the preferences of Carpenter who gave the window prevailed.

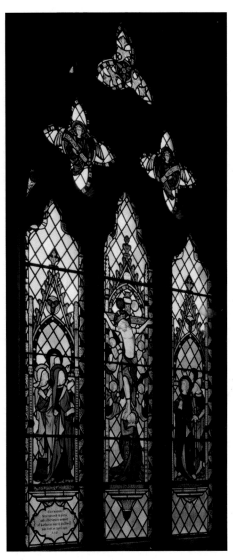

7.4. St Paul, Brighton, East Sussex, S aisle E window sV (Gaz.41), Pugin/ Hardman, 1852. The background to the window was removed, probably in the 1950s. Crucifixion.

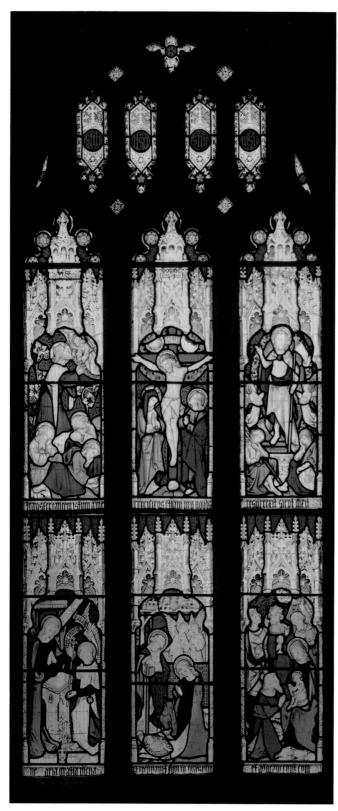

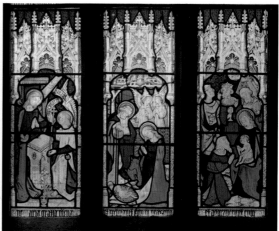

7.5b. Detail of 7.5a.

7.5a. Our Lady, Upton Pyne, Devon, N aisle E window nII (Gaz.31), Pugin/Hardman, 1851. Events from the lives of Christ and the Virgin Mary.

The Annunciation was most usually illustrated in two-light windows, one light containing the Archangel Gabriel and the other the Virgin Mary, as for instance at Great Marlow (**10.1**, Gaz.7). However, there are two instances where it appears in windows with three lights. One is at Cheadle (Gaz.151), *c*.1845, where the image of the Virgin and Child under a canopy in the centre light, is flanked by a representation of the Annunciation formed by a quatrefoil medallion in each of the side lights which contain representations of the kneeling Gabriel and the seated Virgin Mary, respectively. The other is at Rampisham (**7.6**), where elongated quatrefoils in the two side lights contain the standing figures of Gabriel and the Virgin Mary, with the vase of lilies – which at Cheadle was with the Virgin in the right hand quatrefoil – in a quatrefoil of its own in the centre light, between the figures.

Incidents from the New Testament in the shape of scenes from the Life and Passion of Christ and the lives of the Virgin Mary and the saints occur frequently in Pugin designed windows as much of the above has suggested. Scenes from the Old Testament, however, are by comparison, few and far

between. Adam and Eve and the Garden of Eden and Noah and his Ark feature in the side lights of a window at Winwick (Gaz.18); a south aisle window of Ely Cathedral (**7.7a & b**) is devoted to the history of David; and Old Testament kings and prophets were portrayed in the west window of Sherborne Abbey (Gaz.37: glass removed 1997).

There are, however, a group of windows designed by Pugin which portray biblical subject matter taken from both the Old and the New Testaments. These are typological, that is portraying figures or events in the New Testament foreshadowed by those in the Old. Such windows also featured among the works of the medieval artists, as Emile Mâle pointed out in his *The Gothic Image*: 'It early occurred to Christian artists to take as subjects a number of famous passages in the Old Testament which had been interpreted by the commentators as figures of the New … It is in glass that we find the most important works devoted by Gothic art to the concordance of the two Testaments.'[11] He cited

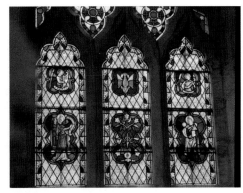

7.6. St Michael, Rampisham, Dorset, chancel S (sedilia window) sII (Gaz.36), Pugin/Hardman, 1847. Annunciation. *Stanley Shepherd.*

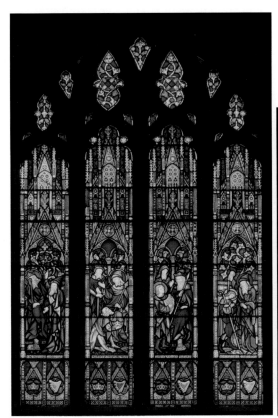

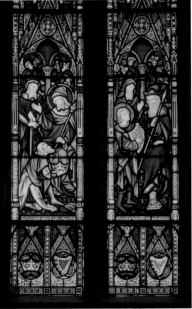

7.7a. Ely Cathedral, Cambridgeshire, S aisle window sXXIII (Gaz.12), Pugin/Hardman, 1852. Biblical scenes of David and Saul.

7.7b. Detail of 7.7a.

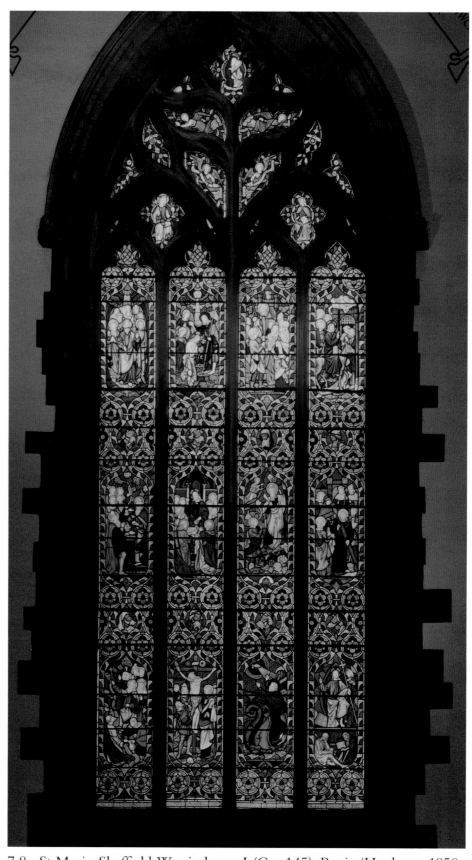

7.8a. St Marie, Sheffield, W window wI (Gaz.145), Pugin/Hardman, 1850.
Types with anti-types.

as examples, 'The famous windows at Bourges, Chartres, Le Mans, Tours, Lyons and Rouen'[12] of which Pugin had certainly seen those at Bourges, Chartres and Rouen during his travels. Pugin, however, did not follow the arrangements described by Mâle, for medieval windows in which central medallions containing events relating to the Passion were surrounded with medallions containing its Old Testament types.[13] Instead, at Ushaw, (**3.12**), anti-types – in the form of scenes and figures of the New Testament – were placed immediately above their types of the Old; at St Marie, Sheffield (**7.8a & b**) types and anti-types in the form of biblical scenes are paired across the window; while in the two-light windows at Highnam (**6.11**) they are presented as pairs of biblical personages with typological scenes above and below.

7.8b. Detail of 7.7a.

Although no documentary evidence has come to light as to who devised the programme for the windows at Ushaw, the scale and complexity of the project (apart from the anti-types and types along the sanctuary walls of the chapel there were also windows featuring British saints and the history of the church; the east window (**2.1a & b**) portrayed the Church Triumphant; and in the transepts, windows depicted scenes from the early life of Christ, types of the Virgin Mary, and scenes from her life) makes it very unlikely that Pugin would have been given a free hand and that at the very least he would have been required to consult with the then President of the College, Dr Charles Newsham who was, probably, responsible for the whole of the content.

In respect of Sheffield a broad appreciation of what was required was given to Pugin by the architect of the church, Matthew Hadfield. The proposed scheme was, as Pugin pointed out, far too ambitious for the money offered and he suggested as an alternative saints under canopies against backgrounds of geometric work. These, he thought, would not only be cheaper but would also look better than the asked for groups.[14] Presumably, the price was renegotiated for the groups were retained and in this case Pugin referred not to medieval windows for inspiration, but to manuscripts: 'I send a few types not arranged in order but in the class of subjects for the Sheffield window – I have taken them from old examples in the illuminated books of hours & I dare say a great many more may be found.'[15]

At Highnam the overall design for the south aisle windows (**6.11**) must have been communicated to Pugin by Henry Woodyer the architect who designed the church, at the behest of Thomas Gambier Parry (1816-1888),

7.9a. Milton Abbey, Dorset, S transept S window sXI (Gaz.35), Pugin/ Hardman, 1848. Jesse.

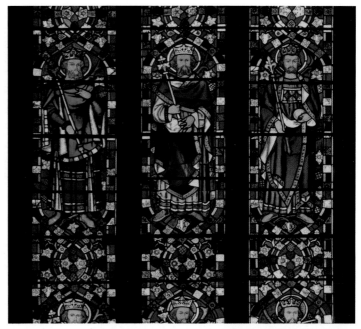

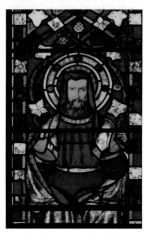

7.9b–d. Details of 7.9a.

artist, founder member of the Cambridge Camden Society and patron of the church. This follows since the subject matter in the windows of the north aisle (**6.14**) which were designed and made in the Wailes workshop is arranged in exactly the same manner.

Jesse windows are another group to link subject matter from the Old Testament with that of the New. There are many medieval examples and they illustrate the genealogy of Christ in accordance with the prophecy of Isaiah: 'And there shall come forth a rod out of the stem of Jesse, and a Branch shall grow out of his roots … And in that day there shall be a root of Jesse, which shall stand for an ensign of the people; to it shall the Gentiles seek: and his rest shall be glorious.'[16] Twenty-eight ancestors of Christ are listed in the opening chapter of St Matthew, something Pugin pointed out to Hardman, when he was asked to name kings for the east window at St Paul, Brighton (**3.5a & b**), and, according to Mâle, this genealogy was accepted in the Middle Ages.[17]

Five full Jesse windows were designed by Pugin and the Jesse tree formed part of the subject matter of a light in the now destroyed east window of St Andrew, Wells Street, London (Gaz.61). Of the five, three – all east windows – were made by Wailes in 1844/5, one each for St Mary, Newcastle upon Tyne, (**1.7a & b**), St George's Cathedral, Southwark (Gaz.63: since destroyed); and St Giles, Cheadle (**1.9**). The other two, the south transept south window at Milton Abbey (**7.9**) and the east window at St Paul, Brighton (**3.5a & b**) were made by Hardman in 1848 and 1849 respectively.

There are differences in the designs for the two glassmakers. For the Wailes windows, Pugin represented the figures seated at Newcastle and half-length at Cheadle, whilst in both of the Hardman windows they are full-length and standing. Jesse, as required by the format, is seated in all five windows. Again, in the Wailes' windows the Virgin and Child are placed at

161

7.10. St Mary, Ottery St Mary, Devon, E window I (Gaz.29), Powell/ Hardman, 1855. Te Deum.

the tops of the traceries whereas in each of Hardman's they are at the top of the centre light. The figures are, as required, enclosed by the stem of the vine in all of the windows but at Newcastle, the first of Pugin's designs, canopies are placed over them and, contrary to his views on pictorialism, the vine stem is made to appear to pass behind the mullions at the base of the window. Although only a small transgression it was not repeated in the other windows and neither were the canopies retained, although at Brighton the stem assumes the shape of a canopy as it winds its way around each figure. The stem in the Wailes' windows dominates, particularly so at Cheadle where a thick red band helps to emphasise its presence and although a similar band is present in the Hardman windows it becomes part of a floral-patterned border – there are no borders at Cheadle – is less obvious and allows the figures to be given greater prominence. That there is a similarity in the designs for the windows at Milton Abbey and St Paul, Brighton is not too surprising since the one was made not long after the other; Pugin asked for the cartoons of Milton to aid him with Brighton; and Oliphant drew them both. In the event the Milton figures were too large for

7.11a. Our Lady Star of the Sea, Greenwich, chancel E window I (Gaz.53), Pugin/Hardman, 1851. Virgin and Child with scenes from her life.

the cartoons to be used at Brighton,[18] although the forms of the Virgin and Child and the Jesse appear to be identical in both windows.

In other circumstances the previously mentioned west window of Sherborne Abbey with its portrayals of Old Testament kings and prophets alone, might have become a typological window featuring both types and anti-types. R.C. Carpenter, who was restoring the Abbey in stages, wrote to Hardman giving him details of the subject matter for the north aisle windows and advised: 'The treatment of the west window I have written to Mr Pugin about.'[19]

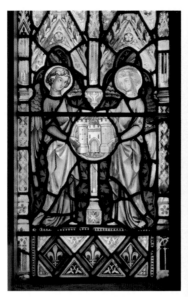

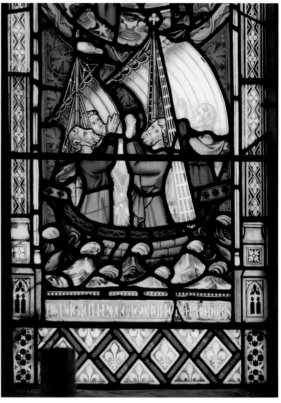

7.11b–c. Details of 7.11a.

Three years earlier Pugin had intended illustrating the four greater Prophets beneath the four Evangelists in the east window of the chancel at Winwick, thus bringing together the Old and the New Testaments, but he changed his mind, observing: 'I find from a very learned treatise on the porches of Amiens and other authorities that all representations of prophets and personages of the Old Testament typical of the new should be confined to the western portion of churches.'[20] It seems reasonable to conclude that Carpenter and Pugin agreed that in their 'treatment of the window' the types represented in the porches of the great French medieval cathedrals, should be introduced into the Abbey's English equivalent – the great west window.

Liturgical subject matter in the shape of the *Te Deum*, the ancient Latin hymn to the Father and the Son, was used by Pugin in two windows. One, no longer extant, was in the aisle of St Marie, Rugby (Gaz.170) and the other, is still to be seen in the south transept of Sherborne Abbey (Gaz.37). The hymn as represented in its simplified form in medieval stained glass showing angels holding scrolls inscribed with its verses,[21] seems to have been used by Pugin at St Marie's. The more complex version which brought together God the Father, ecclesiastics and sundry verses[22] formed the basis for the Sherborne window which comprises a complicated arrangement of figures made up of angels with scrolls in the tracery, and kings, queens, abbots, abbesses, saints and prophets, all with a text wound around them, in the lights below. Some two years after Pugin died, Hardman reverted to

7.12. St Thomas & St Edmund of Canterbury, Erdington, Birmingham, E window I (Gaz.177), Pugin/Hardman, 1849. Heavenly Jerusalem.

the theme when Powell designed the simple version for the chancel east window at Ottery St Mary (**7.10**).

The Seven Works of Mercy, the means of obtaining salvation through good works, was an enduring theme during the Middle Ages,[23] and appears once in Pugin's work, in a window that he designed for the north aisle at Cheadle (**1.11a**).

Rose windows were much enthused over by Pugin and he referred to them as: 'gigantic circles of light radiating and blazing with the most glorious effect'. According to him, giving as examples, Lincoln Cathedral and Westminster Abbey in England, and Amiens, Rouen, Rheims and Strasbourg on the continent, they reached their heights in the early part of the fourteenth century.[24] Because of their circular shape they lent themselves to subjects such as the Creation, the Last Judgement, and the Blessed Virgin in Glory, where complimentary scenes could be grouped around a spiritual centre.[25] Unfortunately for Pugin, he never had the opportunity to design for them on a grand scale, since English churches, as has been seen with Sherborne Abbey, tended to have large, multi-light windows without roses, at their extremities. He was nevertheless able to design for the small wheel windows which the multi-lights sometimes contained as part of their tracery.

The earliest of Pugin's wheels is to be found in the west (originally east) window at Ushaw (**2.1a**) where it is almost indistinguishable from the rest of the tracery due to the overall arrangement of colour patterns and figures, and where the emblem of the Trinity at its centre can easily pass unnoticed. His most impressive example is at St Mary Magdalene, Munster Square (**7.3a**), where he creates a dramatic effect of light radiating from the centre by surrounding a flame-encircled bust of Christ with two concentric circles of angels composed mainly of white glass. The opposite effect is achieved at Our Lady Star of the Sea, Greenwich (**7.11a**), where the angels converge towards a closed dark centre. Other examples are to be found at St Paul, Brighton (**3.5a**) which is leaf-patterned, and at St Thomas & St Edmund of Canterbury, Erdington where there are two. One, is in the tracery of the main east window (**7.12**). It is of a much more static design than at either Munster Square or Greenwich, consisting as it does of a large central roundel filled with a balanced representation of Christ and the Virgin Mary enthroned, surrounded by a circle of trefoiled-angels. The heaviness

7.13. St Thomas & St Edmund of Canterbury, Erdington, E tracery window SVII (Gaz.177), Pugin/Hardman, 1850. St Thomas of Canterbury (?).

of the stonework, adds to the solidity of the design. It contrasts with the second example, that of a tracery window close by (**7.13**), where a lighter and more dynamic effect is achieved by replacing the central roundel of the east window with a figured, star-shaped sexfoil surrounded by two concentric circles of trefoils. The inner circle is made up of large pieces containing angels, and the outer smaller pieces patterned with fleur-de-lis. There is some doubt as to whether the figure in the sexfoil is St Thomas of Canterbury who according to the First Glass Day book was the intended subject matter.

The window in Pugin's output closest to a rose is over the east end of the choir at St Barnabas Cathedral, Nottingham (Gaz.131). It originally contained a depiction of the Adoration of the Lamb, but the glass, made by Wailes, has since been replaced.

8

Client Relationships

if we are to work under dictation as to the way of treating the glass and what colours to use there is an end to everything.
 – Pugin to Hardman, 1849[1]

S uch was Pugin's reaction to Captain Ryder's specific instructions regarding his window for St John the Evangelist at Frieth in Buckinghamshire (**4.2a & b**). The captain had not only described the attitudes that the main figures should adopt, but had also specified his preferred background design and given directions as to the colours to be used:

> We shall like the groundwork to be as much as possible of the <u>Red</u> and <u>Blue</u> colours. <u>Very dark green</u> if required we shd not object to – but <u>light green</u> & <u>yellow</u> unless they cannot be avoided are colours which we cannot fancy will look well in the window … we have a strong feeling of preference for a <u>very narrow</u> white Border round the stained glass.[2]

In the event Pugin declined to carry out some of the details regarding the figures and was unhappy about producing a red and blue composition.[3] Ryder was unusual in requesting the amount of detail he had. As a rule, as seen in the previous chapter, the client would decide on the general nature of the subject matter, Pugin would submit for approval a sketch of the design and normally this was given subject to minor alterations. Sometimes everything would be left to Pugin, as for example with the first window made for Mr Bartley in St Mary the Virgin, Oxford (**6.15a & b**), the background to which is recounted by Benjamin Ferrey in a story that highlighted Pugin's prolific design capabilities and speed of execution:

> On reaching Oxford, Bartley went to the church where the incumbent was waiting his arrival, expecting momentarily the artist whom he wished to design the window for Bartley's approval. It was then within a few minutes of the time for morning service … when in rushed Pugin … 'It is too late now' observed the clergyman; 'we must defer the consideration of this matter till after the service':
> 'Why not now?' exclaimed Pugin looking at his watch. 'There is

plenty of time – ten minutes or more to spare'. Then pulling out his sketchbook, began addressing Bartley. 'Now what is your son's name? Thomas? Ah Thomas: subject, incredulity of St Thomas, & c' asking with his usual rapidity, a number of other questions, sketching all the time. In less than a quarter of an hour he had made two or three masterly sketches for the subject of the window, to the astonishment of all present.[4]

The rapidity at which Pugin worked on designs is confirmed by two other observers. One was William Bell Scott reporting on a visit to Wailes's workshops (possibly at around the time the Bartley window was being made):

> I met Welby Pugin who made in ten minutes the sketch for a large window, the slightest possible pencil suggestion of both ornament and picture, but with the aid of the young experts to be found there, enough to come out as a large window with great success a few months afterwards.[5]

The other was John Hardman Powell writing about Pugin at work:

> The pace at which he worked would be incredible to anyone not seeing it. His few implements were at hand and his design was in his brain distinct even to the detail, so without hesitation he pencilled or penned or brushed it in; he never rubbed out or altered, all was as easy as talking, he used any quick method, ruling in straight lines, sketching in arcs with compasses; 'What does it matter how the effect is produced, the result is the thing'. He was just two hours making a large pen and ink interior of the Chapel of St Edmunds College [Gaz.82], with stalls, glass and decoration. He always worked with steel pens, and Woe to anyone who carried off an old one!!! A coloured design for the East Window of St Mary Mag College, Oxford[6] was asked for one morning post, it was posted by eleven a.m.[7]

After clients had decided on the subject matter, Pugin would challenge their choice if he thought it unsuitable. He did not always get his way as has been seen with the windows at Jesus College, Cambridge, and St Marie, Sheffield, and another instance occurred at Ushaw. Here Pugin appears to have raised no objection with Dr Charles Newsham about the intricate programme for the chapel, but he did regarding the windows overlooking the staircase leading to the library, which had been donated separately. He protested at the inclusion of St Thomas Aquinas in one of the windows on the grounds that he thought him 'too stout' for the narrowness of the light.[8]

Newsham was unimpressed: 'St Thomas Aquinas is the patron saint of the person who gives us the staircase windows of our library & he wishes to have that saint in preference to any other. No doubt Mr. Pugin's ingenuity can contrive to make the figure suitable to the size of the glass.[9]

Again, at Ely Cathedral Pugin thought the width of the lights made them suitable only for saints under canopies and not for the proposed biblical scenes.[10] The Rev. E.B. Sparke writing on behalf of the donor was respectful but firm:

> as I before stated I have the highest opinion of Mr. Pugin's good taste & judgement & were the window in question in any other position or had not the scheme been so far carried out figures would be very effective – but as it is we must confine ourselves to groups.[11]

In both these instances Pugin was obliged to give way but it was not always the case. When the donor of the four-light east window of St George, York (Gaz.129), wanted the Crucifixion and the Resurrection in the two inner lights Pugin was insistent that it could not be done:

> both the subjects he mentioned are <u>central</u> subjects. You cannot put the crucifixion as a pendant to anything. I have therefore introduced 2 subjects relative to the restoration of the dead by Our Lord when on earth & the 2 subjects he wanted. It is the best thing I can propose.[12]

Pugin's views prevailed here as they did when Stafford H. Northcote gave Hardman his ideas as to the treatment of the east window for Upton Pyne church, Devon (Gaz.31): 'My own fancy is to have 9 (or 6) circular subjects each taking up the greater part of two of the present panes. I do not know whether the window is large enough to admit of these being representations of scriptural scenes containing more than one figure.'[13] Hardman passed them on to Pugin who responded:

> That must be a very foolish man about the window how would he imagine we would get 9 scriptural subjects in such a space as that why they would look like German medallions in one piece it will not do I send you a sketch in character for 6 subjects I have taken 3 joyful & 3 dolours but you can explain it to him & can have any 6 subjects that do not require too many figures the 9 medallions cannot be done.[14]

Northcote ultimately agreed that the window should be filled with scenes under canopies (**7.5a & b**).

Pugin was regarded with considerable respect by some clients, as with the Rev. Leveson Lane who, regarding the east window for Wasperton (**6.17a & b**), diffidently asked for a particular colour to be included in the design:

I like the design for the East Window much & I hope that you will do the <u>best</u> you can for me at the price named : if Mr Pugin introduces some pale blue in his draperies I shall be better pleased but I do not like to interfere with men so well qualified for the task as yourselves; & rely with great confidence on your better Judgement,[15]

John Allcard on the other hand although equally compliant, was less deferential when overruled by Pugin in his plans for his house Burton Closes in Bakewell, Derbyshire (Gaz.23):

I always thought the small diamond Glass for the 3 windows in the side entrance to my new House would look <u>poor</u> and I wish to put in one pane only in each opening of <u>plate Glass</u> there being no quarre [sic] glass about the House excepting these 3 windows – but Mr P. would not hear of it, & would have the windows as you have the order – I therefore think you must adhere to <u>his</u> plans, I do not think the word 'Economy' ever entered his mind, & I am sure, when I have the pleasure of introducing you under my Roof, you will think so yourself – For my own part I should not object to your addition of coloured Glass, of the <u>most</u> transparent colour & light figures, but I think we must get leave of our <u>Master</u>. It has been my desire to let <u>his</u> fine & correct taste prevail yet I must confess I am not a little astonished at the Beauty & grandeur of our doings.[16]

The Rev. Hartopp raised an issue of a different kind with Hardman when, in respect of St James, Little Dalby, Leicestershire, he pointed out one of the differences between Anglican and Catholic ideas on religious representation:

I return the Cartoons, with which I am especially pleased with the exception of the Design for the wheel at the top. Any representation of God the Father in a Human form is repugnant to Protestant feeling and could not be admitted into one of our churches. Some other design must therefore be substituted and I really know not what to suggest.[17]

In the early years of Hardman's existence, work had been mainly for Roman Catholic buildings for which Pugin had been the architect.[18] From 1849 onwards, however, the situation changed. Pugin's architectural commissions were on the wane and the growing reputation of the firm led to Anglican churchmen wishing to have examples of its stained glass in their buildings. Prejudice against the firm for being a Catholic business does not seem to have been a major issue, indeed, initially, if Captain Ryder is typical, the view may have been held that it had no interest in attracting

171

work from non-Catholic sources. In his letter to Hardman of January 13, 1849, after giving details of what he required in his east window at Frieth, Ryder concluded: 'Mr Scott Murray of Danesfield[19] assured Captain Ryder that Mr Hardman would have no objection to making a window for an Anglican Church.'[20] There were occasions, however, when Pugin's work was suspected of being a means of bringing Roman Catholic imagery into Protestant surroundings. St Mary the Virgin, Oxford was a case in point, when under the heading, 'Proposed Stained Glass Window in Oxford', *The Builder* in its issue of March 21, 1847,[21] reported:

> Some excitement has been caused in Oxford by the refusal of the vestry to allow a stained glass window, executed under the direction of Mr. Pugin, to be set up in ST. MARY'S. It was conceived that the tendency of such windows was to withdraw the mind from the Creator to the creature, and the vestry were unanimous in considering, that the attempt on the part of the committee (embracing the vicar, the principal of Brasenose, and the master of the University) to set up the window, was an endeavour to Romanise the church without their knowledge or consent.

In the end all was smoothed over and the window was installed (**6.16a & b**). On the face of it, it would seem that the vestry were either unaware that three years previously a window designed by Pugin (**6.15a & b**) had already been installed in the church, or they had concluded that the work of Hardman's was likely to be more Romanist in character than that of Wailes. In this context it might be noted that Hardman's had not been averse to making windows for the church at Stoneyhurst College, albeit it came under the auspices of the Society of Jesus, an institution founded in post-medieval times. Pugin had previously designed the high altar for the Society's Farm Street Church in London – although, curiously, the original altar window made in 1849 was by Wailes[22] – and also, later, a window for their church St Francis Xavier, Liverpool (Gaz.115). Possibly the fact that both Hardman and Lord Shrewsbury had been educated at the college[23] encouraged acceptance of these particular commissions, but designing gothic windows for gothic churches was the firm's business and generally they were grateful to have it regardless. This did not apply, however, when it came to the Oratorians – the Oratory of St Philip Neri founded, as was the Society, in the sixteenth century – as John Henry Newman recalled in a letter to Bishop Ullathorne:

> Mr Pugin however, who, when at Rome poured contempt upon the very notion which I suggested to him of Building a <u>Gothic</u> Oratory, because an Oratory is not a Medieval idea and

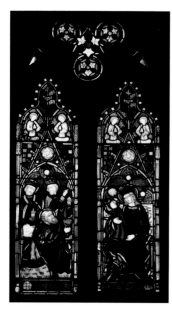

8.1. St John the Evangelist, Broughton, Greater Manchester, chancel S window sII (Gaz.66), Pugin/Hardman, 1848. Adoration of the Magi. *Jonathan and Ruth Cooke.*

who told me that St. Philip's Institution was nothing more than a mechanics institute.[24]

Perhaps the most serious incident of prejudice to occur was when in late 1850 Dr James Prince Lee, Bishop of Manchester from 1849 to 1869, criticised a number of aspects regarding the chancel added to St John the Evangelist, Broughton, Greater Manchester, in 1846, as examples of, 'symptoms' in the English Church 'encouraging to Rome'. One his objections was that the Virgin Mary was crowned in one of the stained glass windows[25] – the window in question (**8.1**) had been executed by Hardman's in 1848.[26] This caused W.L. Clowes to write to Hardman in December 1850, stating that the window had been put in for his late brother the Rev. J. Clowes and that in view of the Bishop's objections, could the window be altered with the offending crown being replaced?[27] Hardman replied that since he no longer had the cartoons the alteration would be troublesome to make and also he objected in principle to removing the crown: 'as it is in accordance with the traditions of art in all nations.'[28] Possibly that would have been the end of the matter but for the negotiations with Hardman's concerning the east window of St James, Rochdale. I. Nield wrote to Hardman pointing out that he had been advised to apply to the Bishop of Manchester either for a faculty or for his sanction, and that the Bishop had expressed his willingness to dispense with a faculty but would not give his sanction before seeing in more detail, the figures and subjects proposed to be put up. Nield continued: 'He requires this in consequence of a window having been put into a Church in this Diocese having a crown on the head of the Virgin Mary. He required its removal, but the Artist declined on religious grounds – I <u>think</u> you were the artist.'[29] In a later letter, Nield referred Hardman to a 'semi-official' article in the *Manchester Guardian* which alluded to the Broughton window.[30] Pugin drafted a long reply to the editor of the *Manchester Guardian,* defending his artistic principles, emphasising his reliance on ancient authorities and styles, and insisting on convention and symbolism to create beauty and edification in church decoration. The full text read:

> To prevent misconception I beg to state that the principles on which I objected to remove the crown from the image of the Blessed Virgin at Broughton, were <u>artistic</u> and not <u>religious</u>. The church has never laid down any fixed rules for such matters nor would any theologian ever think of attaching the least importance to the retention or omission of the ornament. but as I have always laboured to reproduce the style of the ancient glass painters in all its integrity, & having excellent authority from many of the finest examples examples [sic] of medieval work for what has been done I certainly did object to make any alterations especially as the glass had been executed <u>some</u> <u>years</u> & had met with

for the most part entire approbation not only of the donors but also of the late respected[?] incumbent [?] from the account in your paper it appears that the Bishop himself had frequently assisted at Divine Service seated in the chancel & as it most probable that the glass on these occasions was concealed[?] by drugget his Lordship must have had full opportunity of inspecting the same & I must be excused for saying that had it not been for the occurrences of recent ecclesiastical arrangements the window would not have been considered in any way offensive. It is indeed painful to find such very immaterial details made the subject of grave & ever acrimonious dispute continuing[?]. In reviving[?] the solemn ecclesiastical architecture of the medieval period, the traditional & symbolical art of that period is naturally retained[?] with it. – now this is utterly opposed to what is termed the natural school, it surrounds the sacred mysteries of the holy scriptures with a halo of glory & majesty which was the result of Christian feelings & ideas in representing the saintly history of our blessed Lord after his divinity was recognised. These representations do not profess to be accurate illustrations of costume & [?] but rather devout & brilliant conceptions of Christian artists to suit the glorious fabrick they were to decorate. Everything is glorified & shown in an ideal medium calculated to present to the people the majesty of the Godhead & the glories of the celestial kingdom surrounding our blessed redeemer as though[?] his painful[?] purpose through this life. Unless Christian art is viewed under this light it must be abandoned altogether for Church decoration & in lieu of ruby mantles, azure tunics & the jewelled nimbus we should have the torn garments of poverty & the dirt of travel. Painted glass to be either beautiful or edifying or indeed suited to one of the most important objects the adornment of the temples of god must be treated after a conventional & symbolical manner & we must accept the ancient traditions in all their integrity if the objection against the coroneted figure at Broughton was presented to its full extent we should not have a fragment of fine costume or a nimbus left. I trust this will be considered as a satisfactory explanation & my reasons for refusing to make the alteration in the glass & that the objections were based on artistic & not any religious or Theological reasons.[31]

The window was never altered and still exists in the church complete with the Virgin's crown (**8.1**). The reverberations continued as far as the Rochdale window was concerned and ultimately Nield wrote to Hardman:

Much to my disgust but not contrary to my expectation the Bp. Of Manchester has found out something to object to in your design for the window at S. James. The circlets round the heads of the Saints are

what <u>he</u> strongly objects to, and after a rather lengthy correspondence he still persists in his objection. Regarding the matter as so very trivial and paltry, I declined to have them altered and therefore threw up the whole affair and have retired from office. I don't think the Bp, could have prevented me from putting in the window even without his consent, but had he not countenanced the Scheme I could not have raised the funds.[32]

The window was a ten-light one with tracery and Pugin included episodes from the life of St James in three of the lower lights and Christ's Passion in the rest. He worked hard to produce the design (**8.2**) but never felt confident that the window would be completed.[33]

The Master of Jesus College, Cambridge, had raised similar reservations in mid-1850 regarding the jewelled nimbus of the Virgin in one of the proposed windows for the south wall of the college chapel, but was eventually persuaded by Hardman's reasoning, and work on the windows went ahead.[34]

Worries about the perceived intrusion of Roman Catholic imagery increased towards the end of 1850 with the announcement by Pope Pius IX in September of the re-establishment in England of the Catholic hierarchy. To prevent such an occurrence taking place, the Ecclesiastical Titles Bill was introduced into Parliament and its passage provoked a good deal of bitter debate.[35] Certainly Bishop Prince Lee's reaction to the work in the chancel of St John, Broughton, which had been in place without adverse comment for from two to four years (indeed in 1849, *The Ecclesiologist* had regarded the whole project with pleasure),[36] seems to have been prompted by a strongly worded letter on the subject from the Prime Minister Lord John Russell to the Bishop of Durham, published in the *Manchester Guardian* for December 14, 1850.[37] Similar unease had occurred in respect of Pugin's rood cross – minus the images of Christ, the Virgin Mary and St John[38] – set up high in the Medieval Court at the Great Exhibition, which resulted in a complaint being forwarded to Lord John Russell and Prince Albert. As a consequence Lord Granville, the President of the Board of Trade needed to explain:

> The only thing that has been brought into this court is a Cross, not a Crucifix… An intimation was sent to Mr Pugin that it could not remain there at a height which was inconsistent with the regulations [Pugin's response, Lord Granville explained, was that a foreman had placed it in this position to save room, as a result of which it was at an elevation that prevented the wood carving from being well seen. That it had been taken down and that he (Pugin) proposed to put it in a corner]… One side of this Court will be hung with Ecclesiastical ornaments, the other three sides with Domestic furniture, and in the

8.2. St James, Rochdale, Greater Manchester, Pugin sketch, 30.2cm x
49.2cm. Life of St James. *Birmingham Museums & Art Gallery,* BM & AG
a.no. 2007-2728.10.

middle there will be a mixture of Fonts, stoves, flowerpots, armchairs, sofas, tables & c & c, which I hope will give it a sufficiently secular character.[39]

Henry Cole, one of the executive committee of five which, under the personal direction of Prince Albert was entirely responsible for carrying the Exhibition into effect,[40] writing in the *Journal of Design and Manufacturers*, also absolved Pugin from attempting to Romanise the exhibition:

> On the south side of the Central Avenue will be the Medieval Court, which will excite great notice… The accompanying diagram shews the arrangement of this court, and will remove the erroneous impression that Mr. Pugin intended to erect a Roman Catholic chapel in the exhibition.[41]

It seems unlikely that Pugin set out to cause controversy with his work and his remarks in the proposed letter to the *Manchester Guardian* about the window in St John's, Broughton, should be taken at face value. True, as mentioned in the Introduction, he, the Earl of Shrewsbury and Ambrose Lisle Phillipps looked to Roman Catholic art as a force leading to conversion, but that was in respect of the churches built for the Earl in the 1840s during the early stages of the Catholic revival. By 1850 Pugin and Hardman had established a window-making firm respected by both Roman Catholics and Anglicans alike. When called upon to work for the latter, apart from not wishing to turn away valuable business, his aim was to produce art that was in accordance with medieval principles and not to engage in religious propaganda, although sometimes the line between the two could appear somewhat blurred.

As Pugin's architectural commissions fell away, the role of his fellow architects in bringing business to Hardman's became very important. The firm's work for Charles Barry (1795-1860) at the Palace of Westminster was in this respect the most substantial commission.

Pugin's letters to Hardman concerning Westminster[42] show him always ready to defer to Barry although there is no suggestion that he was prepared to carry out that of which he did not approve – on the contrary he was in complete agreement about the many alterations Barry required.[43] Hardman, however, was discomfited by these changes, so that Pugin, while putting Barry in the right, needed to justify matters to him on economic grounds:

> it is no use moaning on the alterations in the Commons glass. they will be paid for which is a great point & I assure you they are necessary to make a profit with Remember I always troubled for the Dark lions I knew & felt they were wrong. The rest of this glass in the mantling &

c is perfection but Mr Barry is quite right & in so great a work I think the expense is well laid out [44]

Barry also commissioned Hardman's for the stained glass windows for Canford Manor (Gaz.34) the home of Sir John Guest and a letter to Pugin shows how he sought to impose his views on the general layout of the design:

> I enclose tracings of the Design of the windows on which I have pencilled the treatment I should wish to be adopted in the glass. The ground a clear glass and plenty of <u>white</u> throughout. – A very simple pattern on the quarries in <u>yellow</u> or white would I think look better & give more effect to the positive colours of the Heraldry than a <u>pearl</u> colour[45]

In another letter Barry suggested how the elements of the heraldry might be arranged,[46] the details of which needed to be given more precisely by the client. He had noted in the letter quoted above, 'I have written in the tracery all the information I have as yet received as to the Heraldry from my <u>Lady</u> client who is vastly curious in such matters', and he later required the glass to be held until his client, Lady Charlotte Guest, had agreed that all was correct in the drawings.[47] It seems likely that for Canford Pugin prepared the design sketches from Barry's written information and then supervised the cartoons.

Another architect, C.A. Buckler (1824-1904), acting for the Master of Magdalen College, Oxford, regarding the heraldic windows for the new choir school (Gaz.138), made the preliminary sketches himself. He was insistent that his handling of the details of the designs was in accordance with that of ancient heraldry and instructed Hardman: 'Be very strict in yr: injunctions that no departure from the design is to be made by the Cartoon draughtsmen.'[48] His belief that this would enable the cartoons to be produced more speedily did not take into account Pugin's attention to detail and when Hardman later informed him that, 'Mr Pugin writes me that the cartoons have been drawn once that he was not satisfied with them & is having them done over again',[49] Buckler replied in exasperation: 'the sketches were made to so intelligible a scale that it should not have taken much time or rare genius to have <u>enlarged</u> them.'[50]

Whilst Pugin was happy to work with Barry's perfectionism, he found the interventions of William Butterfield (1814-1900) and his clients not at all to his liking. Initially, all was well, as Pugin's letters to Hardman show. In one he commented:

> I got a letter from Butterfield & went to him this morning he says our glass is most admirably designed & drawn & coloured but he says

8.3. St Mary, Ottery St Mary, Devon, N transept E window nVI (Gaz.29), Pugin/Hardman, 1850. Adoration of the Lamb.

he thinks that the lines are too faintly painted & want black & power. he was really kind & he told me that he quite relied on my doing everything & I took him to Westminster to see the glass there with which he was delighted. he says it is far the best he has seen & he was astonished with the detail of the work.[51]

In two others, he noted, 'I have 2 more windows from Butterfield since I wrote last he says we beat everybody else hollow',[52] and, 'I hope you will do all in your power to please Butterfield for he is one of our best customers & a man who appreciates a good window'.[53] The large amount of stained glass the firm was called upon to produce during 1850 and 1851, however, meant that Pugin was overstretched, and he could not deal with Butterfield as he would have liked: 'I had another letter from Butterfield today about some more windows I told him Exactly how we are situated about the quantity

of the work in hand & the only conditions on which I would consent to do his glass was that of <u>unlimited</u> time.'[54] He agonized: 'We use Butterfield very bad we do nothing for him & I have 7 windows ordered by him.'[55] One of the windows, however, caused Pugin to think a little less of Butterfield, and he wrote to Hardman of his irritation:

> I only sent you Butterfields Letter to show how hopeless it was to please people. that was the best drawn window indeed it was <u>the first</u> window that was drawn in the true way for glass & I say it was excellent but you see nobody appreciates or scarcely anybody you don't suppose I send it as a critticism [sic] but to show what fools there are & how disgruntled people are even with good things.[56]

The east window at St Mary Magdalene, West Lavington (Gaz.186: since replaced) had been criticized in a letter to Hardman from the incumbent, the Rev. James Currie,[57] who, citing the views of the architects Woodyer and Scott, wrote that the central figure of Christ on the Cross was not religious. Pugin had been enthusiastic about the cartoons for a window at the church, describing one group, as 'the first true thing that has been accomplished'.[58] This is similar to the language used in his letter quoted above, making it probable that the east window was the one in question.

Butterfield could be very persistent in his requirements, and the combination of his client the Hon. Justice Coleridge and himself, in respect of the north transept window at Ottery St Mary (**8.3**), tried Pugin's patience to the limit. The treatment of the subject matter for the window was altered a number of times. The contrast in tone of Pugin's letters to Coleridge with those to Hardman is marked. To the former, after detailing the arrangement he had followed, he continued politely, 'But of course I have no other desire than to meet your wishes & I will willingly prepare fresh cartoons of the heads,'[59] while to the latter he fumed:

> I have had so much trouble with everything on Mr Coleridge window – there is hardly 8 inches of room & he wants all sorts of saints & things – I am worn out with it we have had to alter all the heads again after they were done. I assure you the letters have taken me double the time of the designs with troublesome people the letter writing is immense – I am sick of him he is humbug [sic][60]

and:

> The heads for Mr Coleridges window have been done 3 times & after we changed them the Last time he writes today that he would keep my original arrangement in preference to anything else!!! It has hindered us sadly[61]

Butterfield's added request came near to being the last straw:

> Butterfield wants me to send a <u>coloured</u> sketch of the Lancet windows for Ottery St. Mary !!!!!!!!!! to judge colours by & you have the size send it me by return. I assure you if there is so much bother I shall soon cut his work. I am sick of all this already.[62]

Pugin's relations with R.C. Carpenter (1812-55) seemed to proceed more harmoniously. He may have been associated with Carpenter's work at Kemerton (Gaz.49) as early as 1846 but his acquaintanceship with him started long before that, as apparently he introduced him to the Cambridge Camden Society around 1841.[63] The first major commission that came through Carpenter was for the windows in St Paul, Brighton (Gaz.41). A project that continued from 1849 until a year or so after Pugin's death in September 1852. The correspondence appears to indicate that the main discussions concerning subject matter and its presentation were with the incumbent of the church Rev. A.D. Wagner, but significantly, Hardman's letter of May 8, 1849[64] quotes Carpenter as having requested the designs to be submitted to him first, and for the east window of the south aisle – which Carpenter donated – Pugin was told precisely what it was he wanted in terms of the composition, style and effect.[65] The continual toing and froing of letters concerning recommended changes that characterised the relationship with Butterfield and Coleridge, is not to be found, although Carpenter was not averse to commenting if he thought it necessary. When he did, his remarks were generally thoughtful and could be favourable as well as critical. Hence, with regard to the east window of St Mary Magdalene, Munster Square, (**7a-e**) (which Pugin described as, 'the finest thing done since the finest of the old time')[66] he wrote to Pugin on April 17, 1850:

> I duly received this morning the sketch for the East window of St. Mary Magdalene Church which I admire very much. I suppose in introducing the cherubim it would not be necessary that they should be entirely red, for I do not fancy the windows I have hitherto seen in which they are so represented. The lower lights I think will be very fine and also the Majesty; the crucifixion comes as a nice centre & breaks up the line most satisfactorily. I have, in reflecting upon the window since I first suggested the subjects, sometimes thought whether S. Thomas would not be a better subject than S. Paul; the penitence of S. Thomas having a nearer relation to the circumstances of Our B. Lord's passion & the great facts in the life of S. Mary Magdalene with reference thereto. I will shew the sketch to Mr. Stuart [the incumbent] and then forward it to Hardman.[67]

His strictures regarding red cherubim were taken account of, but St Paul retained favour over St Thomas. In the same letter he continued with some informed observations on the now lost window for the chapel of Campden House, Gloucestershire (Gaz.44):

> I saw the little window at Campden yesterday it looks very well & I consider the chapel by no means to [sic] dark with the one window. Lord & Lady Campden are well satisfied – There is something queer in the drawing of the right hand of the B.Virgin – Crace, [J.G. Crace] who was with me, suggested whether the apparent deformity about the wrist was occasioned by a departure from the <u>shading</u> as given in the cartoon – I have a tracing shewing the form of the hand & the leading of the Glass which I enclose[68]

Delays over the south transept window for Sherborne Abbey (Gaz.37), caused friction between the two men[69] with Pugin threatening to end the association – although not directly to Carpenter. His remarks were made to Hardman (to whom in one of his letters he referred to as his only safety valve when making complaints)[70] when he wrote:'I don't like this Sherborne window & I don't think after it is done we can do any more windows for Carpenter... I don't like it at all & <u>after the windows are in</u> I don't think Carpenter cares a bit about them.'[71]

Carpenter's letters to Pugin and Hardman clearly shows this remark to be wrong, and was one that Pugin would probably not have sustained had he continued in work. The south transept window was not installed until April 1852, some two months after Pugin's final breakdown, and seems to have been the last window for Carpenter with which Pugin was seriously involved – another major work, the east window at Algarkirk, Lincolnshire (Gaz.105) had been completed before the end of 1851, and the windows in the chancel for Old Shoreham, West Sussex, remained as the subject of a letter from Carpenter to Pugin, dated September 20, 1851, until the east window was finally made by Hardman's in April 1854, having been designed by J.H. Powell.[72]

If Barry, Butterfield and Carpenter were the architects for whom Pugin did the most work, he obtained significant commissions from several others.[73] With these, his dealings seem to have been mainly through the incumbents or clients, but not in the case of N.J. Cottingham, to whom he gave short shrift. Cottingham chose to air his knowledge of stained glass, in connection with the Hereford Cathedral window (Gaz.75), managing in the process to appear somewhat patronising. In a long letter to Hardman, he issued specific instructions, including:

> I should wish you to keep as <u>blue</u> & <u>silvery white</u> a tone as possible in the general effect, avoiding the coarse <u>purple</u> ensemble so often

occurring in the diaper grounds of modern glass of this style – as for example that in the Temple Church, (good as it was for the time it was done). But little yellow and rarely any of that salmon tint which Wailes and others are so fond of ever occurs in Early glass, but a vast deal of a fine <u>silvery</u> <u>opaque</u> <u>white</u> and a <u>scarlet</u> flashed ruby.

The windows, particularly the last one placed in Ely Cathedral by my friend the late Mr. Gerente were the nearest approach to the true feeling of the old <u>work of this period</u> that I have yet seen, & I should much like you to give them a careful examination before commencing these for Hereford … The contrast with those by Wailes in the same building is immense the one all feeling the other the most packaged forms of "popular Early English Glass" which is in other terms "all wrong"[74]

Pugin's withering response was short and to the point:

What a foolish letter that is of Cottinghams it is all travels I should just tell him that you had seen the way <u>some colours</u> [?] [?] that we used for the early glass that you have matched them most carefully, that the composition & arrangement of the colours are taken from the first rate examples at Chartres & Churches & more cannot be done.[75]

Ready as he was to accept the informed criticism of the likes of Barry, Butterfield and Carpenter, he was not prepared to be lectured to on matters with which he was more than familiar.

9

After Pugin[1]

Pugin was too ill to work from late February 1852 until his death on September 14 later that year[2] and as a consequence his role of creating designs for windows and overseeing the drawing of the cartoons fell to John Hardman Powell. The cartoons continued to be produced in Ramsgate until around mid-1852 when the workforce was relocated to the Hardman workshop in Birmingham.[3]

Pugin's influence continued to exert itself on the firm for some time after he had gone. He seems to have completed designs for most of the windows made in 1852 and some in 1853, for these windows were entered in the order book some months before his collapse. The correspondence suggests that such entries would have been made only after the designs had been submitted and agreed upon.

It is probable too that Pugin had supervised the drawing of the cartoons for those windows made in the early part of 1852 for there was usually a lapse of at least two to three months between the receipt of a cartoon in Birmingham and the completion of a window. Windows for the Bicton Mausoleum, Algarkirk, and West Lavington serve to make the point for all had been made by early April 1852 and Pugin's letters to Hardman confirm his involvement with the cartoons.

Even when Powell created the designs there were still good reasons to continue working in the Pugin mode. One was continuity, for example the scheme of windows for St Paul, Brighton, was still to be completed, and the windows remaining to be done needed to harmonise with those already installed. Also Hardman had the reputation of the firm to consider. Clients who were aware of Pugin's contribution might have been concerned that the high standards achieved could not be maintained without him and those who were unaware might be less enthusiastic about the firm's work should it be perceived to have changed. In the first category, perhaps, comes Thomas Thorp, rector of Kemerton, who wrote: 'I meant to ask whether Mr Hardman has not got some cartoons of Mr Pugin's from which he Cd work so as to supply some of the windows in my church, now that poor Mr Pugin is [?] for work',[4] while Dr W. Masfen represents the most extreme example of a client wanting a window of Pugin's design. He funded one in St Mary, Stafford (**9.1**), to be made from a Pugin sketch of 1851, his request coming as late as 1871.[5]

Someone in the second category, who may not have been aware of

Pugin's role in the business and was reluctant to see any change in what he had come to expect of a Hardman window, was the Rev. William Wells of St John, Wigan, who, short of funds, wrote:

> I want to inquire what you wd charge per foot for a stained glass window …St Peter & S Margaret in 2 outside lights & S Raphael Arch-Angel in centre … I make this inquiry (in confidence) because it is proposed that Wails [sic] shd execute it & if you will tell me the lowest charge you cd make to complete such a window in a style that wd not detract from your well deserved laurels, & if this charge shd be moderate I have little doubt that I may exercise influence enough to alter the proposed arrange[nt]. I am very anxious to get one of your windows in my ch. I should regret (for my own sake) if your terms shd prove the obstacle.[6]

A further reason that Pugin's style was likely to continue was the influence that he had had on Powell over the years the two had worked together. Repeatedly he had spelled out his principles of design and criticised Powell's work, requiring it to be re-done if it failed to meet his expectations and now if Powell was at all uncertain as to how to proceed, he had all of Pugin's sketches, and the finished cartoons, to which he could refer. This was a point Pugin himself had made at the time Powell left Ramsgate for Birmingham in 1848, when he wrote to Hardman explaining:

'I shall give up stained glass entirely you have now an artist of your own who possesses accurate copies & tracings of every document from which I have been accustomed to work & you will be able to carry on the work independently of me.'[7]

Nevertheless, however closely he worked to Pugin's style, Powell was not Pugin, and differences can be observed. At Brighton for instance, the single figures of saints under canopies contained in the windows in the north aisle are very Puginesque, but the elongation of the figures and the sweetness, or charm, of the colours deviate from Pugin's natural proportions and subtle colour harmonies. Again, when it came to portraying figured scenes, Powell tended to be drawn towards distracting, albeit very appealing, narrative detail and he lacked Pugin's skill in composing simple and harmonious arrangements that accorded with the geometrical shapes within which they were to be contained.

The lower panels of the lights of the two-light 'glassmakers' window, finished in late 1853 for the north aisle of St Chad's Cathedral, Birmingham, offer a good example of the different approaches of the two men. Pugin's design – no longer extant, but referred to in one of his letters to Hardman[8] – included scenes of the painters making the window and offering it, all enclosed in quatrefoils like those of the scenes in the 'Wareing' window

9.1. St Mary, Stafford, N aisle W window nXIII (Gaz.156), Powell/Hardman, 1871. To a Pugin design of *c*.1851. St John the Evangelist. *Stanley Shepherd.*

opposite (**3.1c & d**) (completed December 1850), which it was intended to complement. Powell's new design dispensed with the quatrefoils, thereby avoiding having to fit the composition within the curved boundaries created, included beautifully drawn scenes that recounted the various tasks involved in making a window – drawing, cutting, painting and firing – but had no concluding scene of the offering of the completed work (**3.1a & b**). The awkwardness of Powell's designs, particularly in the panel containing illustrations of painting and firing, where the two main figures are placed back-to-back and effectively split the panel in two, compares unfavourably with Pugin's balanced and simply composed scene within a quatrefoil – showing George Wareing collapsing and dying while assisting at High Mass, in the 'Wareing' window.

Another two windows, one in the Lady Chapel of St Augustine, Ramsgate (**3.10a & b**) and the other on the south wall of the chapel of the Blessed Sacrament at St Thomas & St Edmund of Canterbury, Erdington (**9.2**), further point up Pugin's superiority over Powell in window design. At Ramsgate he uses quatrefoils to contain his scenes, the poses and placements of the figures reflecting the curves of the foils. The quatrefoils themselves give an added liveliness to the window as they expand across its width and come to rest on the lines marking the inner boundaries of the border. A year earlier he had used the same arrangement in the lower panels of the south aisle windows at Holy Innocents, Highnam (**6.11**), although there he had allowed the foils to extend right across the borders and up to the windows' edges. His enthusiasm for the form outweighed even his previously expressed regard for canopies, as he explained to Hardman: 'they are far better than all images under canopies, they increase the size of the window … the groups fill the quatrefoils perfectly.'[9]

Powell also uses quatrefoils in his Erdington window and as with Pugin sets them on the inner lines of the border. In general, however he ignores the curved shapes of the foils when arranging his figures and unlike Pugin, who elongated the form by adding a central section bounded by complementary curves, uses the straight lines running along the insides of the borders to achieve the same purpose. These together with his elongated figures

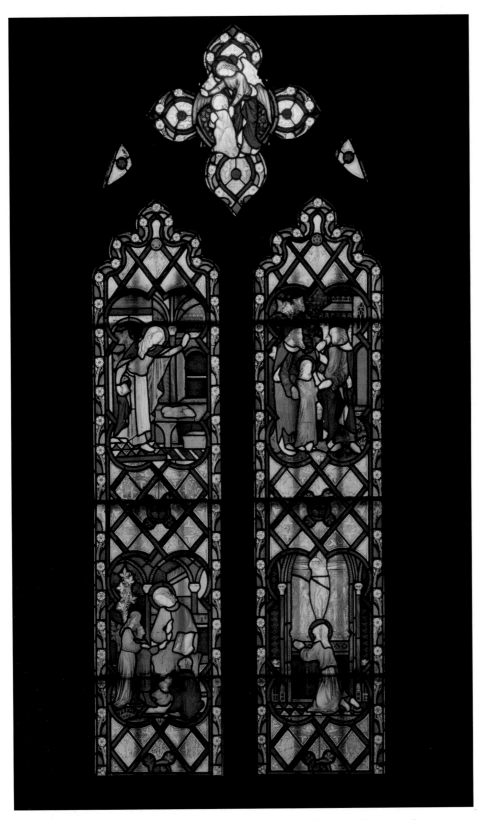

9.2. St Thomas & St Edmund of Canterbury, Erdington, Birmingham, Blessed Sacrament Chapel. S wall window (Gaz.177), Powell/Hardman, *c*.1854. Life of the Virgin.

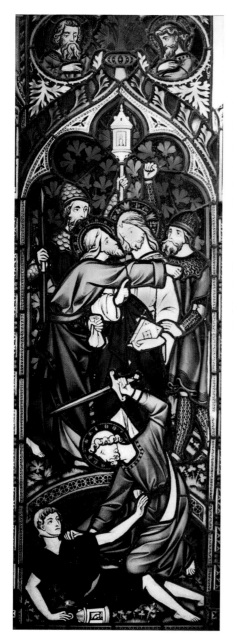

9.3. St Mary the Virgin, West Tofts, Norfolk, detail of chancel E window (Gaz. 120), Powell/Hardman, *c.*1855. Kiss of Judas. On loan to the Ely Stained Glass Museum. *Diocese of Norwich: Stanley Shepherd.*

create a rather static and uncoordinated effect with the emphasis almost wholly on the vertical, in contrast with Pugin's dynamic, compact and harmonious designs.

In addition, Pugin integrates his scene-carrying quatrefoils into the background decoration by seamlessly linking the points separating the foils, with the red diamonds that form part of the geometrical grisaille filling the rest of the window. Powell also creates a link with a diamond shape but because he introduces a trelliswork feature the effect is one of quatrefoils separated by bands of unrelated decorative detail.

Powell's attitude to figure-drawing differed from Pugin in ways other than in his elongation of forms. He put a different gloss on perceived imperfections in the work of the medieval draughtsmen. Whereas Pugin explained: 'When they failed in proportion and anatomy it was not a defect of principle, but of, execution,'[10] Powell argued:

correct drawing, though necessary to a perfect work, is not so important as an expressive design … So, even defective drawing receives in the old glass painting a sort of reverence, from its use in explaining grand religious ideas; not that the faulty part of it should be imitated now, merely because it is so inseparable from the talent of old masters … The truth is, that our forefathers laid as much stress upon the intention of their work as we do upon our correct drawing – they on great conceptions and ideas, we on mere correct forms. But very much of this want of natural drawing is to be defended on true principles; thus as perspective and foreshortening are not admissible, it follows that limbs must be displayed and flat – the feet shown in full or sideways – the eyes nearly full, hair painted by lines, fingers stretched out, visibly; in fact a sort of heraldic treatment throughout … Glass drawing, however, actually requires exaggeration of action, and parts of the figure varying in strength according to the distance from the eye; thus, the meaning you could convey to a friend a few inches off by a look, requires at a few yards the movement of a finger and at a still greater distance the violent gesture of an arm. So in glass, according as the window is removed from the eye, an executioner swings his sword with more than the usual circle, and St John preaches with stronger movement than natural.[11]

So, while rejecting imitating of the so-called defects of

the old masters, to achieve an ancient looking effect, Powell, nevertheless, in contrast to Pugin, was prepared to follow what he saw as their more expressive compositions. The exaggerated gestures of many of the figures in his east window of the new chancel at West Tofts, executed *c*.1855 could be taken as illustrations of his ideas (**9.3**).[12]

Pugin's influence through Hardman and Powell and his architect colleagues lived on quite strongly at least until the mid-1850s. Of his two main colleague/clients R.C. Carpenter and William Butterfield, Carpenter survived him by only two years. Significantly, however, Martin Harrison notes that in that time Carpenter took up designing for stained glass and: 'His first windows were executed by Thomas Ward and their quiet simplicity owes a debt, predictably enough to Pugin as much as to Carpenter.'[13]

Butterfield continued to use Hardman's for his windows during the twelve years after Pugin's demise. In the first instance this was because of the need to complete the series of windows at Ottery St Mary (Gaz.29), but then the two seemingly established a good working and personal relationship and many more commissions were forthcoming.[14] Unsurprisingly Paul Thompson finds that the designs for these were very like those designed during Pugin's time;[15] Pugin can also be said to have left his mark on those glassmakers with whom he worked in the early years. Willement, who was most noted for his heraldic windows, seems to have gained much by working with him during 1841 at the Hospital of St John, Alton. (Gaz.148). For in terms of his figure subject windows Martin Harrison writes:

> As to the compositional organisation of his windows Willement seems still to have lacked the confidence or inclination to attempt a complex figure subject; his invariable method of filling a given window space was to place single, standing figures under architectural canopies, a practice which continued until what appears to have been a major turning point in his career as a designer in 1842-3. After 1843 his work became much more accurately medieval, and his handling of multi-figure subjects showed much greater assurance.[16]

Wailes continued to be Puginian in his approach for many years after Pugin's death,[17] although his compositions and use of colour still lacked Pugin's flair and on numerous occasions he was prepared to break with the 'True Principles' and make a pictorial window.[18]

Warrington, perhaps, benefited least from working with Pugin, in spite of his early success in 1838 with the apse windows at Oscott. Apart from his window in the Lady Chapel at St Chad's Cathedral, Birmingham (Gaz.176), which is very Puginesque, his output generally fell short of Pugin's example both in drawing and composition and his advocacy of pictorial windows not only broke with Pugin's principles but also gained him the hostility of

the ecclesiologists.[19] In spite of this he thrived as a stained glass artist until his retirement in 1866.[20]

Hardman's continued in business as a family firm until 1936 when, for the first time its list of directors did not include a Hardman. It still traded as John Hardman & Co., however, as it does to the present day.[21] In the years immediately following Pugin's death, the firm maintained its position, the *Building News* commenting in 1858 that 'it [Hardman's] grew up under the auspices of Pugin, has advanced steadily and deservedly, and is now fairly and most justly established'.[22] However the outstanding reputation acquired in Pugin's days, when it was at the forefront of stained glass window-making, did not continue through the 1860s. Its decline is indicated in a letter of 1867 from the architect G.F. Bodley to the Dean of Jesus College, Cambridge regarding a window for the nave of the chapel:

> Heaton & Butler are not to be thought of – their glass is not worthy of a place in your Chapel. Hardman's glass is getting worse & worse – Pugin's influence started them well, but it is a great risk now what you get – the windows I have seen lately are terribly bad in *colour & drawing*. Clayton & Bell have so much to do they cannot give that attention to the work that glass demands. I still think you [had] better get a sketch from Morris.[23]

The pendulum was moving from Gothic Revival glass in the direction of what Martin Harrison has described as William Morris & Co.'s 'original nineteenth-century manner.'[24]

Putting to one side Pugin's widespread influence, his contribution to the Gothic Revival in stained glass was considerable. He realized the importance of restoring the medieval qualities of texture and colour to the glass itself. He had an understanding of the medieval principles and practices involved in drawing and painting and of the use of white glass and leads to enhance a design. Allied to his considerable talents as a draughtsman, designer and colourist, these factors ensured that the windows for which he was responsible were of very high quality, harmonious in colour and composition, and redolent of the glass of the old Christian artists that he was so anxious to emulate.

Gazetteer

This Gazetteer contains all the windows that are known to have been designed by Pugin. The completeness of the Hardman business records, covering the whole period of Pugin's association with the firm, makes it almost certain that every window made during their collaboration has been included here. For windows made before Pugin's involvement with Hardman's the sources are more limited. William Warrington's records are restricted to the list in his manuscript (see Sources) while Thomas Willement noted clients' names rather than those of any designers in his ledger and 'List of Principal Works' (also see Sources). William Wailes's records have not survived. Knowledge of Pugin-designed windows made by these manufacturers is therefore gleaned from other sources (detailed under *Literature* for each site) and for Warrington and Willement their records serve to confirm that such windows were made by them. Unfortunately, therefore, it cannot be said with complete confidence that all the windows by these three makers, particularly Wailes, to Pugin's designs have been identified.

Windows by Hardman's in 1852 and 1853 without Pugin's involvement (because of his illness and eventual death) have also been included. These are identified as 'Window(s) designed by J.H. Powell'. The reasons for their inclusion are a) for completeness sake (the First Glass Day Book, the only one in the Hardman Archive up until 1863, runs to the end of 1853) and b) to indicate those windows which may look to be by Pugin but were in fact designed by Powell working in the Pugin tradition. Information concerning them has been limited to their dates and descriptions as contained in the Order Book and First Glass Day Book.

Each Order Book entry is for all the windows contained in a project together with any additional information such as inscriptions etc., while the First Glass Day Book entries are for individual windows and/or repairs and alterations carried out.

Window numbering

The *Corpus Vitrearum* system of window referencing has been used throughout this Gazetteer and indicates the position a window occupies in a building. The system is designed primarily with churches in mind. The windows are numbered using upper case Roman numerals which progress in sequences along both the north and south sides, counting from the E window which is given the number I. The letters n, s, e, and w are used to indicate north, south, east and west. The first window on the north side from the east window (which is designated as I rather than eI when there is only one) thus becomes nII, the second nIII, and on the south side sII, sIII and so on. The upper case N, S etc refer to clerestory windows. A main W window is designated here as wI. Adaptations have been necessary for various non-church buildings and a prefix (such as L for library, DIR for dining room) has been added to avoid any confusion.

Dimensions of windows

Overall dimensions of windows have been expressed in metres with width preceding height. Window measurements are approximate and are based on the widths of individual lights (those made by Hardman's have been taken where available from the First Glass Day Book) used in conjunction with extrapolations from photographs to give the dimensions quoted. Where it was not possible to obtain photographs of individual lights measurements are given in Imperial units, as recorded in the First Glass Day Book.

Numbering and location of sites

The numerical sequence used in the Gazetteer in my Ph.D thesis has been retained for consistency, resulting in the additional entries of St John, Banbury; Holy Trinity Chapel, Radford; and All Saints, Leigh being numbered 131A, 139A and 153A, respectively (11A for Elsworthy parsonage did appear in the thesis). Similarly the classification by counties designated in 1974, cross-referenced, where appropriate, to those which existed before has also been kept, with references to the Unitary Authorities introduced in the 1990s being added.

Descriptions

Descriptions of all Pugin-designed windows visited have been included in this Gazetteer. For those made by Hardman which have not been visited (including all those outside England) or which are no longer in existence, the descriptions as contained in the First Glass Day Book have been taken. In all other cases contemporary accounts have been used.

Letters

Extracts from letters commenting on the design and progress of, and satisfaction with the windows, have been set out, as far as possible, in date order by correspondent. Pugin's letters are almost all undated, which meant using references in the letters themselves (or in clients' letters) to arrive at a likely chronological sequence. Where this was not possible they were arranged in the order in which they appeared to make most sense. Hardman's replies to Pugin are non-existent since, according to John Hardman Powell (Wedgwood, 1988, p. 181): 'Every letter he [Pugin] received he answered at once and burnt'. In his letters to Hardman Pugin often separated and numbered the various points he was making, which is why many of the extracts included here start with what might appear to be an unrelated number.

References to Pugin sketches

The references given in my Ph.D thesis Gazetteer for Pugin sketches held in the Birmingham Museums & Art Gallery are no longer applicable. New accession numbers (a. nos) have been given to those illustrated here, whilst the remainder which are mentioned in the Gazetteer and were illustrated in the thesis – my photographs were not of publication standards – have been referenced 'a.no. not allocated'.

ENGLAND

AVON

1 Clifton (Bristol UA), St Catherine's Convent (RC)

1852. Window designed by J.H. Powell.

Office records. Order Book, 1852, f. 171, Mar. 4. *First Glass Day Book*, 1852, f. 148, Jun. 12: 'To A Stained Glass Window/of 3 lights and Tracery/for side window of Chapel/£30/3 lights 6'8½" x 1'9¾" …/8 Tracery pieces … Subject/In centre light St Theresa//In side lights St Thomas/Aquinas & St Phillip [sic] Neri'.

2 Clifton (Bristol UA), private chapel

1850. Client: Rt Rev. Dr Hendren. Supervising architect: Charles Hansom.

Office records. First Glass Day Book, 1850, f. 103, Nov. 9: 'For Private Chapel 3 Trefoil pieces of Stained/Glass Tracery …/£2.16.0'.
Literature. Wedgwood (Pugin's Diary): Pugin visits Bristol, 1850, Sep. 4.

BERKSHIRE

3 East Woodhay, St Martin (CoE)

1850. In Hampshire but addressed as Berkshire in the First Glass Day Book. Client: Rev. T. Douglas Hodgson, presumably the son of the Rev. Hodgson mentioned in the inscription below.

Chancel S window	sIII	2-light	1.0m x 2.3m	£20

Description. sIII. 2-light window and tracery. A blue foliage diaper, figured medallion in the middle of each light with grisaille covering the remaining areas. *Noli Me Tangere* is depicted in the left-hand medallion and St Mary Magdalene tending to Christ in the right. The grisaille is of white leaves (vine(?) and grapes(?)), attached to trailing yellow stems on black-hatched grounds. It is overlain by a vertical series of large and small red-outlined diamonds. The borders are patterned with white flowers on red and green grounds. The single tracery-piece comprises a large circle with five smaller circles on its circumference, all filled with leaf decoration. A brass plaque beneath the window contains the Latin

inscription, as recorded in the First Glass Day Book: 'In honorem SSmae Trinitatis/fenestram quae supra est/poni atque fieri curavit/desideratissimae conjugis/memor Thomas Douglas Hodgson/huius Ecclesiae Rector.'

Office records. *Order Book*, 1850, f. 114, Sep. 22. *First Glass Day Book*, 1850, f. 104, Nov. 9. Oliphant's Cartoon Account, 1850, Jun. 26, records a charge of £4 for: '2 Groups. Resurrection and Ascension @40/-'. It seems the subject matter was changed and Oliphant's cartoons were not used (see letter from Hodgson, 1850, Aug. 27, below). *Cartoon costs per ledger summary*: Powell £'2.10.0'

Letter. *JHA: Hodgson to Hardman*, 1850, Aug. 27: 'Mr Wyatt had unfortunately left England before your sketch arrived. I am hardly able to gauge from the sketch the exact text to which the subject Apertains and I am not sure that I quite like it ... The inscription I should wish altered from In honorem <u>Dec</u> & c to In honorem S.S. Trinitatis & c.'

4 Grazeley (Wokingham UA), Holy Trinity (CoE)

1850. Client: Miss E. Hulme, Sunbury, with William Butterfield acting as her agent.

Chancel E window	I	2.4m x 3.9m	3-light	£100

Description. I. 3-light window and tracery. A crucified Christ, with an angel at either side of his head, midriff and feet, all contained in a large blue diaper medallion, fills most of the middle and upper parts of the centre light. Below is a small red diaper quatrefoil medallion containing a half-length angel in a green-lined, yellowish-white mantle over a red robe, who holds an inscribed scroll. A seated Evangelist with his symbol at his feet is contained in a red diaper medallion at the top and bottom of each of the side lights. The left-hand light top shows St Matthew in a green-lined, blue mantle over a red robe, holding a quill in his right hand; and the angel. The bottom has St Luke in a purple-lined, yellow robe, holding a quill in his right hand; and the ox. The right-hand light top shows St John the Evangelist in a blue-lined, green mantle over a brown robe, holding a quill in his left hand; and the eagle. The bottom has St Mark in a green-lined, pinkish-white mantle over a blue robe; and the lion. Between, above and below the medallions in each light are quarries patterned with white oak leaves on yellow stems, against black-hatched grounds, all overlain by a diamond trelliswork, red in the centre light and red and blue in the side lights. The borders are patterned with white leaves on vertical yellow stems against red and blue grounds. The three main trefoil tracery-pieces each contain a half-length angel holding a text. The other pieces are patterned with white leaves and yellow and green rosettes. The text inscribed in white on black at the base of the window is in line with that shown in the Order Book up to 'Christo' (see below), but then deviates to read 'sua LVIII D.D.Filae [?] die Feb IX AD MDCCCXLV'.

Office records. *Order Book*, 1850, f. 94, Jul. 19: 'Inscription on glass to be: D.O.M. Patri Filio Spiritus Sancto in memoriam Georgii Hulme A.M. Presbytere qui obdormivit in Christo die Feb 9 AD MDCCCXLV Oct. sua LVIII D.D. Filiae'. *First Glass Day Book*, 1850, f. 97, Aug. 30. *Cartoon costs per ledger summary*: Powell £7.10.0.

Letters. *HLRO 339*: Pugin to his wife, Jane, letter no. 245: 'I am mad the great window for Grazely Church is just 3 feet too long the finest window we have ever done & now to be cut to pieces at a loss of £20 – everything follows one on the other Losses mistakes. Errors & [?] – It appears that the angel[?] drawing[?] was torn off & Powell finished it in one evening. I see nothing but loss misfortune every day brings something further I will never trust Powell without verifying everything but I will have a close examination & see whose fault it really is & by whom the paper of the Light was pasted on the other ... [PS] I am not certain that Powell pasted the drawing on the top so don't accuse him of it. but it is a dreadful loss'. *JHA: Butterfield to Hardman*, 1850, Apr. 25: 'I return the Grazeley window (sketch) which we like. I should however be glad to have the figure of Our Lord more square with the light – i.e. turning due west in a stiff severe manner'. May 2: 'when you receive Cartoons of a window for Grazely Church with a Crucifixion and 4 Evangelists from Mr. Pugin will you proceed with it as quickly as possible It is wanted the beginning of July.' Jul 20: 'will you send the sketch Mr. Pugin made and which is of course at Ramsgate to Miss Hulme at the address she gives. Pray let me hear whether Mr. Pugin has returned and what is doing. This delay should not have happened <u>after what I said</u>. All other windows which I had ordered should have been delayed till this was done.' Aug. 12: 'I have received the enclosed inscription which Miss Hulme wishes put at the bottom of the Grazeley Wd but without any cross at the beginning or end [the inscription is as recorded in the Order Book, f. 94] Miss Hulme much wishes to know when the window will be finished will you write to her at Sunbury at once. I hope that the figure of Our Lord is a more full front figure than shewn in the sketch. I mentioned this point to Mr. Pugin.' Sep. 10: 'Miss Hulme writes to me about a mistake in the length of the glass sent to Grazeley. I hope it will not interfere with the figures or throw them out of proper proportion when the length is corrected.' Sep. 13: 'The mistake was not mine. I never saw the church as Mr. Ferrey is the Architect The Mason made this blunder I always make figures end where templates begin ... They write me ... that the window has borne it remarkably well & looks well.'

Newbury, Marlston, church, see WILTSHIRE
Brighton & Hove, see EAST SUSSEX
Bristol, see AVON

BUCKINGHAMSHIRE
5 Frieth, St John the Evangelist (CoE)
1849. Client: Captain Ryder, Hambleden, Henley-on-Thames.

| Chancel E window | I | 2.1m x 3.4m | 3-light | £90 |

***Description.* I.** 3-light window and tracery (**4.2a & b**). Two blue diaper medallions (the upper smaller than the lower) are contained in each of the lights. Depicted in the medallions are: centre light, upper, two facing angels; lower, Crucifixion; at the top of the light, in a red roundel, is the Holy Dove. Left-hand light, upper, a kneeling angel holding a text; lower, Last Supper. Right-hand light, upper, a kneeling angel holding a text; lower, St John on Patmos. The borders are patterned with yellow leaves on blue grounds. The tracery contains in each piece immediately over the side lights, an angel in prayer, and leaf decoration on blue diaper ground in the rest. A brass plate beside the window is inscribed 'This window was presented/to the church in memory of Edward L. Ryder by his brothers and sisters./He was the seventh son of hn/Ryder D.D. Bishop of Lichfield/and Coventry and died at Columbo/in the Island of Ceylon on the 1st/of May, MDCCCXLVI aged XLVII/June Vth MDCCCXLIX.'

Office records. *Order Book*, undated, ff. 46-7: 'Crucifixion centre light, B.V. & St. John, the idea/being that our Lord has just uttered the command to take the B.V. as his Mother and this idea to be expressed in the attitude of the Figure./ Left-hand light, Last Supper, St. John leaning on bosom of Our Lord, this to be expressed in a very/reverent way, so as not to convey any idea of familiarity./Right-hand light, St. John in the island of Patmos see Corregio's fresco at St. John's Church, Parma./St. John sitting and looking for inspiration and/Eagle holding pen in beak./2 Angels over crucifixion 1 Angel over groups in side lights. Inscription of bottom light "In Honour of GOD and St. John"'. *First Glass Day Book*, 1849, f. 59, May 12. *Cartoon costs per ledger summary*: Powell £5.0.0, Hendren £2.0.0, Oliphant £6.0.0. Oliphant's account records that the payment was in respect of: '3 cartoons of Crucifixion, 3 Figures, Last Supper & St. John in Patmos @ 40/-'.

Letters. *HLRO 304: Pugin to Hardman*, letter no. 16: '6. I send you a sketch for the window. tell Captain Ryder that the ground work of the window should be <u>vine</u> leaves not oak & on a geometrical pattern'. No. 267: 'I send you a sketch for the Ryder window which is for[?] the subjects.' No. 100: 'I fully expected to send off the whole of the Frieth Window today but we can only send off the pinnacles[?] & tracery & the groups tomorrow. This window will require very careful treatment & I don't think it is any use bringing it unless you are well[?] enough to look out the pieces of Ruby and mind[?] the diaper part must not be left altogether transparent as it will look thin & poor & it should be a greenish white glass ... This window must not go off without my seeing it.' No. 91: 'the cartoons for Captain Ryders window are very fine indeed'. No. 172: 'as regards Captain Ryders window you can substitute ruby if you like but it will not be half such a job all the geometrical windows in which the subjects are in medalions [sic] or Quatrefoils are white grounds & they look beautiful. the only fear is your white which is very bad it is nasty modern white I have a white bottle an old wine bottle with a green shade that is beautiful just the thing we must have a good white it is too white. It is quite impossible to make the blessed virgin & St. John joining hands under the crucifixion it is a monstrous idea & absurd for the text is not telling [?] moment that S. John took the B. Virgin Bodily away I represent as well as one can Our Lord addressing the words to them it is an excellent crucifixion – the window ought to look very well. if you manage the ruby & c if we are to work under dictation as the way of treating the glass & what colours to use there is an end of everything if you make a ruby ground you will see the job will be a complete failure It would require an entirely new design – the sketch I sent him showed a geometrical window exactly like what has been done nothing can be more painful than a composition of red & blue look at <u>nottingham</u> [Gaz.130 or Gaz.131] they were all colour & you remember how much they were improved by white.' No. 173: 'If you are really going to change Captain Ryders window you better try a bit first to see how the ruby works.' *JHA: Ryder to Hardman*, 1848, Jan. 13: encloses a sketch: 'The subjects have been sketched in merely to give an idea of the size of the figures & the general outline ... Captain Ryder has seen the windows that Mr. Hardman has put into the Church at Marlow [Gaz.7] and was much gratified by the effect of the faces in white glass – Captain Ryder would decidedly prefer that there should be no Tabernacle work – he supposes that a good pattern of rich coloured glass say in oak leaves – or diaper work – would fill the vacancy between the small and large subjects in the long lights without it being necessary to have recourse to Tabernacle work'. Undated, in Feb. bundles: 'I dont think I mentioned to you that we shall like the groundwork to be as much as possible of the Red and Blue colours. <u>Very dark</u>

green if required we shd not object to – but <u>light green</u> & <u>yellow</u> unless they cannot be avoided are colours which we cannot fancy will look well in the window ... we ... have a strong feeling of preference for a <u>very narrow</u> white Border round the stained glass ... An angel should be be substituted for the figure of the Blessed Virgin in the right-hand small upper light – we should like all the upper lights in rich colouring. The only points which we leave undecided is the inscription at the bottom.' Jun. 5: expresses pleasure with the window and requests a brass with an inscription: 'First letter to be large in blue & gold, an ornamental cross above the inscription.'

Literature. The Builder, 7, 1849, p. 296: consecration and notes the E window was executed by Hardman.

6 Great Marlow, Danesfield
1852. Window designed by J.H. Powell.

Office records. Order Book, 1852, f. 192, Aug. 31. *First Glass Day Book,* 1852, f. 156, Sep. 25: 'To 4 Lights/ Stained Glass of 2 quarries/ Each Light 4'0" x 1'5½'".

7 Great Marlow, St Peter (RC)
1846-7. Client: C. Scott Murray.

Chancel E window	I	2.3m x 2.8m	3-light	£40	1846
Chancel S window	sII	1.7m x 1.9m	3-light	£25	1846
Chancel S window	sIII	0.3m x 1.1m	1-light	£5	1846
N aisle E window (**10.1**)	nII	1.3m x 2.5m	2-light	£30	1846
W window	wI	1.3m x 2.3m	2-light	£25	1847
N & S aisle windows (**6.1a**)	nIII, sIV	1.3m x 2.4m	2-light	£25	1847
N & S aisle windows (**6.1b**)	nIV, sV	1.3m x 2.4m	2-light	£25	1847

Descriptions. **1.** 3-light window and tracery. St Peter in a green-lined, yellow mantle over a red robe, holding a key in his right hand is depicted standing in the centre light in front of a light blue diaper screen. An angel in a yellow robe holding a text is in a white-outlined quatrefoil at the top and bottom of each of the side lights. Vine leaves and bunches of grapes on intertwining yellow stems against red diaper grounds fill the remaining areas of the lights. The borders are patterned with alternating yellow keys and red crosses on black grounds. The three quatrefoil tracery-pieces form a triangle. The piece at the apex contains two crossed keys and each of those at the base a kneeling angel holding a crown. The window is blocked by a new church building and is illuminated by artificial light.

sII. 3-light window and tracery. The lights are made up of black-hatched quarries patterned with three leaves (oak?) attached to a single stem. A red roundel is contained in the upper section of each of the lights. The roundel in the centre light contains a yellow chalice surmounted by a white cross; that in the left-hand light, candles, a book and a censer; and in the right-hand light, two pitchers.
The borders of the left-hand light are patterned in yellow, blue, purple and green. In the centre light yellow chalices alternate with green and blue leaves. In the right-hand light yellow and white pitchers alternate with blue, purple and green patterns. The two main tracery-pieces are blue diaper quatrefoils each containing a blue-winged angel in a yellow robe, holding an undulating inscribed scroll.

sIII. 1-light window made up of black-hatched quarries patterned with a foliated capital letter P outlined in black. A blue diaper quatrefoil medallion is at the top of the light. It contains a scene of St Peter, in white, holding the keys while standing in the prow of a purple sailing ship, with a crowd of tiny figures in white in the stern. A similar quatrefoil medallion containing a figure in a red mantle over a yellow robe, kneeling in prayer, is at the bottom of the light. The inscription 'PETER COOP'[1] bisects the medallion and runs behind the figure.

nII. 2-light window and tracery depicting the Annunciation. The Archangel Gabriel in a green-lined, yellow mantle over a white robe stands against a white diaper ground, in the left-hand light. The Virgin Mary in a blue mantle over a red robe, holding a book in her left hand, against similar ground, is in the right. Above each is a bust-length angel playing a harp. The borders are patterned with touching red rosettes and yellow *fleur-de-lis* (on black diamond grounds). The topmost of the three tracery trefoils contains the Holy Dove and each of the two lower ones an angel (in green on the left and blue on the right) holding a book.

wI. 2-light window and tracery. Each light is composed of white, leaf-patterned quarries and has a geometrically patterned roundel at its top, middle and bottom. The borders are patterned with almond-shaped yellow leaves on undulating white stems, against red grounds. The tracery-piece is a red, blue and yellow geometrically patterned quatrefoil.

nIII, nIV, sIV, sV. 2-light windows and tracery. Each light contains a standing saint under a yellow-crocketed and finialed, ogee-arched canopy behind which rise yellow-crocketed, gabled towers. The saints are respectively: nIII: St Elizabeth of Hungary in a red-lined, patterned, brown mantle over a green robe, holding white roses in the fold of her mantle: a beggar kneels at her feet; St Cecilia in a green-lined, yellow silver stain flower-patterned mantle over a blue robe who presses the bellows of a blue portable organ with her left hand and touches the keys with her right; nIV: St Winefride(?), crowned and in a red-lined, yellow silver stain flower-patterned white mantle over a blue robe, holding a book in her right hand and a crozier in her left; St Edward the Confessor, crowned and in a green-lined, white mantle patterned with yellow silver stain capital letters E surmounted by crowns, holding a ring in his right hand and a sceptre in his left; sIV: St Francis of Assisi in a white-lined, purple robe; St Carolus (Charles Borromeo) in a white-lined, red mantle over a yellow robe, holding a book in his right hand and a sceptre in his left; sV: St Thomas of Canterbury in a yellow mitre, red-lined, white chasuble over a green dalmatic and a white alb and the pallium around his shoulders. He holds a crossed staff in his left hand and a sword passes through his head; St Osith, crowned and in a green-lined, yellow silver stain flower-patterned, white mantle over a purple robe, holding a crozier in her right hand and a downward-pointing sword in her left. Borders: nIII: alternate red and green rosettes separated by white and yellow patterns: nIV: left-hand light, blue capital letters W alternating with yellow patterns; right-hand light, alternate floriated green and red capital letters E separated by yellow-on-black floral patterns: sIV: left-hand light, red letters IHC in small roundels alternating with yellow crosses with white hearts over their centres and white marks of the stigmata in their interstices; right-hand light, floriated red letters C in small roundels alternating with white leaf patterns. sV: left-hand light, illuminated red capital letters T alternating with yellow mitres; right-hand light, alternating red and yellow foliage patterns. Tracery: nIII, nIV: single large quatrefoil pieces containing shields carried by angels: sIV, sV: smaller quatrefoils filled by shields with two pieces below filled with leaf and stem patterns.

nV. 1-light window (not in First Glass Day Book) of plain glass quarries, containing a leaf-patterned roundel at the top and bottom of the light.

Office records. Order Book, undated, f. 1, cost of cartoons: I £8; tower £1; sII £5; sIII £1; nII £6; wI £5; nIII and sIV £5 each; nIV and sV £2.10. each.. *First Glass Day Book*, 1846, f. 4, Jul. 4 (I): '2 small Lights for Tower ... with 2 Centres in each, £6', f. 5, Jul. 4 (sIII), Jul. 14 (nII); 1847, f. 14, Jul. 1 (wI), f. 17, Oct. 11 (nIII, sIV), f. 21, Dec. 22 (nIV, sV); 1848, f. 28, Apr. 3: '2 New Shields in 2 Tracery pieces'. *Pugin sketch*, BM & AG a no. not allocated: 'S. Werburgh' and 'S. Cecilia'; and 'S. Claire' and 'S. Ethelreda'; not used for a completed window.

Letters. HLRO 304: Pugin to Hardman, letter no. 37: 'I did the Borders and canopies for Great Marlow the cartoons of the figures will soon go'. No. 381: 'Cartoons will go off on Sunday night post'. No. 638: 'tomorrow I go to Gt. Marlow Mr Murray there is a regular Row there'. No. 887: 'the Lady Chapel window for Mr Murray [nII] get it <u>in hand at once</u> you will not have much time – It is a very fine job – I should like the same Diapering as for the angel Gabriel at Liverpool [St Catherine's Orphanage, **3.2a & b**] for the angel and I send a diaper for the B. Virgin'. No. 890, postmark '24 JY 1846': 'I do not[?] remember ever receiving any money from Mr. S. Murray for windows it is just possible & if so I will send it you immediately but I do not think so.' *JHA: P. Coop to Hardman*, 1847, Mar. 8: 'Can you inform me when the stained glass will be ready for our Church? Will it be ready for putting in before Easter? Having had now for seven months, only canvas in the windows, we have been obliged to fit shutters to them for security ... I wrote to Mr. Pugin on the subject in the beginning of November, and he said they might be done in about 8 or 10 weeks. Neither Mr S. Murray nor Self had any idea that they would not be completed before Winter'. *Scott Murray to Hardman*, 1847, Sep. 20: 'I am surprised to find you charge £25 for the West Window Mr Pugin's estimate having only been £20 & it contains so very little design or colouring I hope you will soon send down Lord Lovats [nIV] & Mrs E. Petres [sV] windows as the long delay has caused me great disappointment & inconvenience'. 1847, 'St. John's Day': confirms nIV and sV were, 'in on Christmas Day', and considers them 'decidedly the handsomest of the whole'. Points out that the St Thomas (sV) should have been of Hereford and not Canterbury but in view of the figure being, 'the most beautiful to my mind in the church', does not ask for a change; mentions that the 2 coats of arms of Lovat and Petre were not sent and will send another drawing if necessary; asks that the Transcription of S. Osilla be changed to S. Ositha (sV). Is much pleased with the effect of the glass, believing St Francis (sIV) to be the only one not quite good, 'it being poor in colouring, contrasted with the richness of the others'. *Powell to Hardman*, 1847 bundles, undated: 'Enclosed you will find templets [sic] of all the windows I have seen for Great Marlow 5 in all ... also the cartoons for tracery of West Window'. Undated: 'I send you some figures for side windows Great Marlow ... when you see Mr. Pugin please ask him about the other ones. S. Thomas of Hereford one of the Bishops you have is to be made do. also please ask what pavement he will have underneath the figures'. *Powell to Mr Burton(?)*, postmark 'MR15 1847': requests details of size of figures for side windows mentioning, 'they started from here on Friday night, there are two more to be drawn and Mr Pugin has not got the size.'

196

Literature. *Tablet*, 6, 1845, p. 406: forthcoming laying of the foundation stone; 6, 1845, p. 438: details of the ceremony, and background to the establishment of the church. No details of the proposed window design. Wedgwood (Pugin's Diary): Pugin visits Marlow, 1845, Feb. 27, Sep. 2; 1847, Sep. 29; 1851, Jun. 24.

8 Hambleden, St Mary (CoE)

1853. Client: Mrs Scott Murray. Chancel E window (**6.10a & b**) I

The history of the window can be traced through a series of letters, given below, from early July 1851, when Pugin designed five scenes (two in each of the side lights and one in the centre), to February 1853, when the window was finally installed. The five-scene window would have cost £160, and Mrs Scott Murray, not being prepared to pay more than £100, suggested alterations to reduce the cost; these Hardman declined to do and the matter fell into abeyance for some months. In January 1852, Captain Ryder (see Frieth, Gaz.5), on behalf of Mrs Scott Murray wrote to Hardman, who agreed to make a three-scene window as described below for £100 (possibly Pugin did the design sketch for this window – it may have been the tracing referred to in Hardman's letter to Captain Ryder of Jan. 8, 1852). The general effect of the window proved disappointing to Mrs Scott Murray who suggested alterations, and these Hardman agreed to do, subject to her willingness to pay the extra cost involved.

Description. **I**. 3-light window and tracery. Subject matter as set out in the Order Book below. The scenes are under canopies, not dissimilar to those at Farnham (Gaz.162) – with the rest of the lights made up of white, flower-patterned quarries. There is a two-line, white-on-black inscription, beneath the scenes: 'TO THE MEMORY OF ANNA/ SUSANNA NIXON AGED 72/OBIT APRIL 12th 1821/ERECTED BY HER DAUGHTER/AUGUSTA ELIZA SCOTT MURRAY OF HAMBLEDEN HOUSE'.

Office records. *Order Book*, 1, 1851, f. 157, Oct. 27. *Order Book 2*, 1851, ff. 42-3, Oct. 27, f. 46: 'Church is dedicated to St. Mary – to be a memorial window. Subject centre light Crucifixion/side light Annunciation/do. do. Flight into Egypt/ The above window to be altered and the extra cost to be charged to Mrs Murray.' *First Glass Day Book*, 1853, f. 172, Feb. 4: '3 Lights & Tracery for/East Window of Church/3 Lights 11'3" x 2'4"… 6 pieces Tracery … £100'.

Letters. HLRO 304: *Pugin to Hardman*, letter no. 121: 'I send you the design for Mr Murray window anything above the crucifixion will have raised the window setting[?] – but by double subjects in the side lights & the important one above in the centre a good effect will be obtained pray explain that & stick to it. it will make a fine & brilliant window & give great satisfaction'. *JHA: Letter Book, Hardman to Mrs Scott Murray*, 1851, Jul. 10: 'I now enclose a design for the East Window of the Church at Hambledon [sic] in which the subjects you mention are introduced except that the Ascension is put into one of the side lights instead of being over the Crucifixion it not being usual to represent anything over the Crucifixion in the same light. This design has been made by Mr. Pugin whom you are probably aware executes all the cartoons for the windows I carry out – you may therefore depend upon its being an artistic work'. 1853, Jul. 17: 'I am sorry to hear that you are disappointed in the general effect of the window but it really is <u>not my fault</u> & to show that it is not I must beg to draw your attention to the correspondence that passed respecting it'. Hardman then quotes from his letter to her of Jul. 10, 1851 and to Captain Ryder's of Jan. 8, 1852 and Captain Ryder's letter to him of Jan. 5, 1852 to show how against his better judgement and to accommodate her wishes for a cheaper window the design had been changed, he goes on: 'I now enclose a copy of one light of the drawing I sent & you will perceive that I have carried out the Window according to the drawing & agreement, & that the cold effect of which you complain is there shewn just as much as in the window itself I cut out the work to meet the price you fixed & regret exceedingly that I did not stand by my first resolution to decline the window altogether as I have a great objection to have work complained of. I will be happy to make the alterations you suggest providing you will pay the expense of them'. *Hardman to Captain Ryder*, Jan. 8, '1851' (must be 1852): agrees to do all he can to meet Mrs Scott Murray's views and encloses a tracing showing a treatment of the three subjects, viz, those recorded in the Order Book and proposes that: 'the work above & below the subject to be a sort of diaper, & the centre subject would take more space than the other two'. He mentions that the window is of the perpendicular period and therefore requires most careful drawing and treatment, something of which he has had so much experience lately, and he gives the three windows at St Andrew, Farnham (Gaz.162), as examples of his work. *Letters, Mrs Scott Murray to Hardman*, 1852, Jan. 18: having received information from Capt Ryder, she agrees to put the window in hand but asks for a coloured sketch of the new design, and sets out aspects of the St John the Evangelist, Frieth (Gaz.5), window that she would not like repeated at Hambleden, such as, the diaper to be not so green, the general colouring not to be preponderantly blue, and the preponderence of the passion flower to give way to a greater variety of emblems. She notes that the design would need the approval of the Rector Mr Bidley(?) and the sanction of the Bishop, and asks that the figure of the Blessed Virgin be represented kneeling and without any crown.

Jan. 31: wonders why she hasn't heard from Hardman, since in his last letter he had said that he 'should soon see Mr. Pugin and send me the Drawing', but then answers her own question: 'you say you shall require the first sketch to make the second by that this may be the cause of the delay'. Requests that the white borders of the window be made a half or a third the breadth of those at St John the Evangelist, Frieth, and that the ground work be of a grey grisaille. She asks for a little piece of glass to see the colour. Mar. 15: likes the drawing very much but with the following reservations: too many figures in the central compartment – suggests dispensing with the soldiers in the background; emblems instead of mere ornament needed in the upper part of the side compartments and in the little compartments on either side of the Angel in the tracery; the Virgin, in the Annunciation, to be more obviously kneeling, with the Angel standing. Asks for a sketch showing the alterations. Mar. 26: 'I return the design & think the alterations you have made in the last sketch a great improvement. I must however trouble you still further by saying that I wish the Light & Dove over the Virgin's head in the left hand compartment (viz. in the Annunciation) to be omitted also in the also upper part of the window I should prefer some other Emblems in place of the Crown surmounted with a Lily, viz a Lily alone on one side & the Pelican pecking her breast on the other [the Lilies surmounted by crowns remain in the window]. Below this I very much admire the monogram but instead of repeating the same monogram in the corresponding compartment on the other side I should suggest Alpha and Omega [the finished window shows that this request was carried out]'. 1853, Feb. 18: 'contrary to my particular request you have introduced the Light into the subject of the Annunciation as well as the Almighty's Hand. I am sorry to say these alterations must be made to meet the wishes of our Bishop wh. I am sure you will readily do. I think it would be more satisfactory to all parties if you cd. see this window just as it is ... It has struck me you may be coming to Danesfield [Gaz.6] on business regarding my Lous [sic] Chapel, [the finished window shows that no change was made]'. John Wheeler & Sons, masons, to Hardman, 1852, Jan. 22: 'send the size of the window'.

CAMBRIDGESHIRE

9 Cambridge, Jesus College Chapel

1848-53. Clients: Rev. John Sutton (I); J. Wallace (sVI, sVII).

E window (**6.5a-c**)	1	1.5m dia. rose	£30	1848
		0.7m x 5.9m centre		
		0.5m x 5.4m side lancets	£150	1850
S wall windows	sVI, sVII	2.2m x 3.1m 3-light	£200	1851
S wall windows (**10.2**)	sII–sV	0.5m x 3.9m single lancets		1853
sII–sV designed by J.H. Powell				

Descriptions. **I.** 3-lancet window with a cinquefoil rose above. The Passion is illustrated in the lancets by scenes contained in blue circular medallions. The medallions alternate with geometrically-patterned roundels framed by diamonds in the centre lancet and oval medallions containing angels in the side. The background in all three lancets, outside of the medallions, is of white leaves on yellow stems against red grounds. The scenes depicted are from the top down: left-hand lancet – Agony in the Garden, Flagellation, Christ before Pilate, Judas and the Elders: centre lancet – Mary at the Sepulchre, Entombment, Deposition, Crucifixion, Last Supper: right-hand lancet – Christ bearing the Cross, Christ mocked, Pilate washing his hands, Betrayal of Christ: the cinquefoil rose contains the Agnus Dei surrounded by angels. **sVI, sVII.** Windows removed and replaced *c.*1914. They consisted of three-light windows, with scenes depicted in the Late style. The Adoration was in one and the Dispute with the Doctors in the other. *The Ecclesiologist*, 1853, described the canopies as being drawn in perspective, very translucent and well relieved with white and gold; the drawing, as bold but naturalistic; the tinctures fine, but the glass too thin and translucent. Of the 'Doctors' window it remarked: 'Our Lord is seated in the middle light and there are two doctors in each of the other lights, with the Blessed Virgin and S. Joseph behind. There are curtains of heavy colour as a background, up to the shoulders of the figures; above there is blue sky and landscape.'

Office records. *Order Book*, undated, ff. 45-45A (I); 1850, f. 79, Mar. 26 (sVI, sVII). *First Glass Day Book*, 1848, f. 48, Dec. 9 (rose); 1850, f. 80, Feb. 12 (I); 1851, f. 128, Oct. 24 (sVI, sVII); 1853, f. 204, Dec. 31 (sII–sV). *Cartoon costs per ledger summary*: rose window, Powell 6s.8d, Hendren 6s.8d; I, Powell £9.10.0. Oliphant's account re sVI & sVII: '1850

Sep 16 3 Light Cartoons for Jesus College @ 65/-, offerings for the Magi 9 15 0
Nov 11 3 Cartoons for a Large Window of 3 openings, for Jesus College
 Cambridge. "Jesus in the Temple with the Doctors" 9 2 0'

Letters. **I.** *HLRO 304: Pugin to Hardman*, letter no. 996: 'Mr Sutton is very anxious to have something at Cambridge.' No. 988: 'I shall be very glad if we get the 3 East Windows of Jesus College'. No. 425: 'I thought you could estimate the

Iron frames for Jesus College from those we had done for Sydney [St Patrick, Gaz.224] & c but I send you a scheme of the 3 windows by which you will see the arrangement of the principal bars – you must retain it for I shall want it for the cartoons'. No. 406: 'Powell gives me a most disturbing account of the Sydney window. I am afraid your men are getting to Paint (as Myers men carve) all styles alike … I am terribly anxious about Cambridge for if that is not very good we shall have all the critics down on us'. No. 1022: 'they are anxious to begin at Cambridge'. No. 140: 'I don't mean to say we cannot do as well as Gerente in practice but we have as yet few examples of this Early style if things keep quiet I will go to Chartres & get some sketches'. No. 962: 'I have got the 2 lights of Jesus College marked so you can get on with all but the subjects.' No. 955: 'I have just got one of the groups for Jesus College finished perfectly to my satisfaction if you get the old tints matched we shall make a splendid job [repeated in no. 815]'. No. 893: 'I have also sent the centre light of Jesus College I want you to lead up a bit to try the effect with various blues & c. so as to make a real good job.' No. 835: 'the 5 centre Groups for Jesus went yesterday'. No. 836: 'The whole of groups for Cambridge will go tomorrow so you will be able to finish off these windows.' No. 171: 'I send you Mr Suttons window & with it the full size of the iron frame in which it is fixed … pray make a fine job of this window make it look like the old very rich it will want stippling for it must not look thin & poor. I do think it will be very rich. I am very anxious to make a good job of this'. No. 634: 'I am very thankful to hear so good an account of Jesus Col glass.' No. 761: 'The news about Cambridge window is too good to be true let me go and see'. No. 686: 'I went to Jesus College The windows like everything else are very disappointing I was quite astonished they don't look as if if [sic] there was a powerful colour in them. our ornament is too faintly painted we are afraid of black.' *Jesus College Archives*: The letters commencing 'Rev & Dear Sir' are suggested by Belcher, 1987, p. 363, to have been written to John Gibson and those 'My dear Sir' to Sutton. *Pugin to 'Rev & Dear Sir'*, undated : 'In a very few days I will forward you a sketch showing the arrangement I propose for the 3 east windows. of course it will be [?] as Early glass small subjects & rich borders & grounds – I can promise you something brilliant – the Real old thing. We must have a <u>frame work</u> of iron in a geometrical frame of iron as at Canterbury & c to define the pattern – & secure the glass the Early glass looks nothing without it, poor & weak this must be made of galvanised iron which will not rust. I shall take great pains with this work – & try to produce something very good.' 'Mon in Easter week', year not stated, (1849[?]): '[?] some time I forwarded [?] you a rough scheme of the subjects for your east windows and also one bit to a Larger scale to show the proposed treatment of the Pattern the blue band shows the <u>iron frame</u> & by adopting this form I get the largest space for the subjects like all my Lancet windows they are very limited for space the Foreign Lancets were often very Large & being with mullions afforded a fine [?] for glass [?] I think by the arrangement I propose, I shall get the subjects Large enough to be Effective. I think these windows should be made as closely in imitation of the ancient glass as possible as the whole is a restoration of an old work … you will see by the scheme I get the 5 principal mysteries in the centre light – & then the 8 others in the sides'. 1849, Apr. 28: 'if you have got the sketches for the East window please return them to me – as I have no copy of them [?] & want to refer [?] it before I pass you the estimate.' 1849(?), Dec. 5: 'the cartoons for the East Lancet window 3 times [sic] & then they would not have been the thing if I had not gone to Chartres to match the old cartoons'. *Pugin to 'My dear Sir'*, undated: 'I have just returned from Chartres where I have been for the express purpose of examining the early windows for your chapel & I have not only got most accurate details but actually a lot of the real glass from a glazier – & Mr Hardman is going to match the tints exactly so I have every expectation of providing the <u>real thing</u> I have had my cartoons done over again for there is a peculiar treatment about this Early Glass which is exceedingly difficult to attain we shall now get on very fast & I can assure you that every exertion shall be made to complete the 3 windows as speedily as possible but I must be perfectly satisfied before I let them go [quoted in Belcher, 1987, p. 363].' 'Xmas eve' [1849]: 'the East windows for Jesus Coll far advanced they will be finished only I have delayed them to procure some more varied Ruby'.

sVI, sVII. The letters indicate that two sets of designs for the windows were produced. The first, probably in 1849, were for figures under canopies, upon which no progress was made. In May 1850, designs of scenes of the Adoration, and Christ in the Temple, were accepted, and the windows were completed in late 1851. They were replaced *c*.1914 by those presently in place. An appeal document, dated May 1913 (in the College archives) called for their replacement, on the grounds that: 'The two existing windows are not memorial windows. They were put up in 1852 and are an undoubted eyesore, disfiguring the beauty of the chancel and out of harmony with the series of windows in the nave and transepts.' *HLRO 304: Pugin to Hardman*, letter no. 964: 'I have got an order today for 2 more windows'. No. 712: ' I wish you would write to Jesus College to know if their windows are to be done or not – for they will let it go on & then expect them all in a hurry.' No. 848: 'This is the very first moment I had any idea that sketches were to be made for Jesus College I thought it was an idea merely under consideration but I will be pleased to make them as soon as possible & send them to you'. No. 856: 'I can swear you told me that the Jesus College fellows could <u>not agree on the subjects for the side windows</u> or I should have done the sketches long ago.' No. 983: 'I find you have not sent the Book of Tournay[?] that

Mr. Moore[?] sent me it would be most useful in these Cambridge Windows beyond measure useful & I find you have kept it back!!!!!!!!!!!! pray let us have for [sic] we are going to design the subjects for the side windows & it is exactly what we want too bad too bad'. No. 940: 'these Cambridge windows after making 3 designs no end of letters have died out all your good window jobs all Die out [see letter, Jesus College Archives, Pugin to 'my dear Sir', Jan. 15, 1850 regarding the delay]'. No. 856: 'I send you the 2 windows for Cambridge but you must tell Mr Gibson we need time & money to carry them out. I think they are worth £100 a window – the cartoons will be tremendous and to make a very fine job. Powell ought to go to Cologne this summer and make studies of the fine glass in the nave. I think I could astonish people with these windows.' No. 571: 'I have been overhauling the cartoons for the other Jesus College window regular failures no principle no system no understanding of drapery when Powell returns there will have to be a great deal done to alter them. they are not to compare with the others for the East window.' No. 899: 'I am very anxious about the ruby bands in the Cambridge windows. I fear these will be stippled[?] & I shall find a dead unbroken surface of red like Mr. Webbs light [St Martin, Brasted, Gaz.86] without this unequal ruby-streaky and brilliant our Labour is vain [SIC] your painting my drawing design all is nothing without it it is the soul and life of the effect of the old glass but to my grief I don't see we approximate to it in the least'. No. 498: 'Jesus College windows are pressing'. No. 507: 'It is all for the good that the windows have been delayed I have done my best & more I cannot do. you should say there is no blame allocated[?] to you that the whole responsibility rests with me that you could have painted the windows twice over if I could have let you have the cartoons that they have already been done twice that I was still disappointed and am finishing a third set that if it would be any satisfaction to them they can see the 2 sets done & the great improvement in the 3rd. that of course this diminishes if not destroys any profit in the work but that I have been most anxious to supply a fine thing. that later windows of this style cannot be done like earlier ones they they [sic] are pictures and works of art'. No. 642: 'I have got a letter from Sutton he says the windows are in and promised by all to be equal and by many to be superior to Kings but I cannot consider it possible that the bars are inside for Heavens sake [?] to Bishop & everybody connected with it to have the bars outside why the windows will be Ruined good gracious me ... our work is ruined till this is altered'. No. 735: more in the same vein concerning the bars and Bishop's ineptitude. No. 659: quoting from a meeting of the Fellows: 'it was determined not only to have bars outside but everything was to come from Hardman and moreover it was proposed and carried unanimously that the remainder of the windows of the chapel should be glazed in glorious design by Hardman. Hardmans gifts great applause Hardman he would say (great applause) the first real reviver of the glories of antient [sic]glass painting. 5 more lancets for Hardman , Hardman for ever. pray pray forgive me the rest'. No. 665: postmarked 'No. 20 1851': 'I have just returned from Cambridge – don't talk about beating Kings yet. there is a long way to go but this late glass is in reallity [sic] a false system and the decline of the art'. *Jesus College Archives: Pugin to 'Rev & Dear Sir'* [late 1849(?)]: ' I do not think any design would be so appropriate for the perpendicular windows as the doctors & Bishops you say you are tired of Canopied figures but where have you seen any new ones worth looking at ... I have not hitherto succeeded [?] in finding either a fine canopy or figures of the Late period of glass. nor had I the means of so doing till my last journey to France now I have reason to hope that I am position[?] to make a fine work of the time and I send you a rough sketch of what I propose but I should like to make a light first one figure & canopy & have it offered up in the window if you will send me the size. I will let you know the cost of this. be assured single figures will be best for these windows & I really think I can produce the true thing as I have got the material for it [A sketch of one light with a Bishop under a canopy is held in the College archives]'. Dec. 5 [1849(?)]: I have just returned home & found your letter with the templets. I really think the dedication of the old religious house should be included in the windows now certainly the Blessed Virgin in the centre with the infant Jesus 1 [sic] and S. John & S. Radegunde on the sides would make a beautiful window. S. Radegunde is always represented in a royal mantle – powdered with *fleur-de-lis* – there is a fine example at Poictiers [sic] – S. Margaret & S. Katherine are all that a glass Painter could desire they are usually represented as [?] in gorgeous attire with jewill [sic] orphreys to their mantles & c & the wheel & dragon form capital accessories – & in the centre a bishop – say S. Cuthbert who is [?] old English Saint – now these will make subjects for windows worthy of S. Gothard. The lights are wide & will admit of good unstinted design. I should like to start with S. Margaret. I have every reason to believe we should succeed but it is a very difficult thing to work up to the old men & it may take some little time before I am satisfied the cartoons for the East Lancet Window 3 times [sic] & then they would not have been the thing if I had not gone to Chartres to match the old colours. I do not hesitate to say that the colours generally used by modern glass painters are very dissimilar to the old & have a harsh glowing appearance. & all my aim is to obtain that richness & harmony which is the distinguishing Characteristic of the 15 century glass painters [quoted in Belcher, 1987, pp. 363-4, who appears to link it with the E window. A sketch for the window referred to in Pugin's letter and depicting, St John, the Virgin and Child and St Radegunde is held in the College archives].' *Pugin to 'My dear Sir', 'Xmas Eve'* [1849(?)]: 'I have no objection to subjects though I should prefer

Saints but it is quite immaterial to me only subjects will be more expensive'. 1850, Jan. 15: 'Can you tell me anything of Mr Gibson I expected to have heard from him before this – your fellows are extraordinary men for long deliberations – & between that & the time it takes to create the glass a very considerable period elapses between the conception of an idea and its realization'. Jan.[?] 21: 'what is the difficulty now about the side windows I thought from Mr. Gibsons last letter that one window was decided'. Gibson to Osmond Fisher, 1851, Nov. 27: 'The two S windows are in their place in the Chapel and await Hardman's man to finish ... Pugin came to see them being summoned to determine the controverted points of the inner or outer bars. I[?] with Salter took the part of the old bars and Pugin completely confirmed our view'. *JHA: C. Smyth to Hardman*, 1850, May 15: 'I am glad to be able in answer to your note to request that you will put both the designs for our windows in hand as soon as possible ... there are two or three things he [the Master of the College] wishes to be altered. In the design for "The Adoration" he objects to the <u>Jewelled</u> nimbus about the head of the Virgin, "which he fears is expressive of her being Queen of Heaven." If Mr Pugin can state that such is not a necessary deduction from the design the Master will be content to let it remain as it is, otherwise he wishes a common nimbus substituted like that on St. Joseph. In the "Christ in the Temple"...The central figure does not please him. He thinks our Lord should be represented in an attitude of <u>respectful attention</u> (I use his words as "hearing & asking questions") & not in the position of a Teacher which he maintains is not warranted by Scripture ... Once more he objects to the Head-dress of the Virgin in the design as too <u>monastic</u>. I suppose he does not like it being brought so far forward over her face. I would now humbly suggest one slight alteration in this last design on my own authority. At the same time I would not with to see it adopted without Mr Pugin's entire concurrence in its correctness. Would it not lend to the dignity of the central figure (which is necessarily small) if the more distant figs of the Virgin and S. Joseph were a little reduced in size or at any rate not so much raised above the heads of the Doctors'. Undated: 'I send you the designs for the windows. After reading your note [Hardman, May 16] to the Master, he was perfectly satisfied with regard to the jewelled nimbus; so the Cartoon for that window "The Adoration" may be proceeded with at once. I think the design for that window is perfect, with reference to the design "Christ teaching in the Temple" He will not I fear give way at all. He still objects to the attitude of teaching as unwarranted by Scripture, tho all art ancient & modern represented Our Lord in that position. You will see now what I alluded to in this design, with regard to the figures of the B.Virgin & S. Joseph. But I am so <u>moderately</u> acquainted with art, that I cannot insist upon my objection for a Moment if it is not responded to elsewhere ... I shall be glad to receive Mr Pugin's remarks on the design & the Masters objections.' Nov. 2: 'will you kindly sent a line to inform me of the progress of the two windows for Jesus Chapel and when you think they will be completed. I should be glad too if I might be allowed to have the small drawings designed by Pugin for these windows after they are done with, I presume this is not an <u>out of the way</u> request.' *Hardman to C. Smyth*, 1850, May 16 (replying to Smyth's letter of 15th inst): 'as soon as Mr. Pugin returns from the continent where he is gone to study glass & which will be in the course of ten days I will forward your letter to him requesting him to put the Cartoons in hand & answer the objections the Master has made – I will just observe that with respect to the nimbus no such construction can be put upon it – The Blessed Virgin is always Crowned when represented as the Queen of Heaven – the jewelled nimbus can only refer to superior dignity when other saints are represented at the same time with plain nimbuses ... It will certainly be very difficult to alter the Figure of Our Lord in the Temple without detracting from the dignity of it and I should have thought the mere words of Scripture would warrant such a representation for it says "And all that heard him were <u>astonished</u> at his understanding and answers", thereby implying that he spoke with authority – In all representations of this subject that I have seen this interpretation is put upon it and our Lord is shewn rather as the teacher than the listener or learner. – However I should prefer your having Mr. Pugins Opinion in these matters. Your own objections I cannot understand without seeing the drawings which it will be necessary for me to have that I may take tracings from them – please therefore return them & I shall let you have them back in a few days.' *J.S. Gammell to Hardman*, 1850, Dec. 14: 'I have delayed answering your letter of the 22nd Nov till I could ascertain the general feeling of the gentlemen who have subscribed to put in the Windows which you are making for our chapel – The result is that I regret I cannot accede to your request to allow them to be sent to the approaching exposition [the Great Exhibition, 1851] – I am sorry that you should not have the opportunity of Exhibiting so good a specimen of the progress of the art as I expect (both from what you say of them & from the specimen which we have lately seen in the window in Magdalene College [Gaz.10] that these windows will be – [?] tho' the reasons are various in the minds of the different subscribers the conclusion they draw from them is the same – Many are unwilling that these windows executed especially for a church & so in a manner already consecrated shd. be made objects of exhibition among a collection & in a manner so purely secular. Others object to the time that would elapse before they could be placed in the chapel & some even speak of withdrawing their subscriptions if they are not to see the first of them before they leave College'. 1851, Mar. 15: queries when windows will be ready. 'Though these windows are not to appear in the Exhibition I

suppose you will exhibit other specimens of glass staining tho' in such a flood of reflected light as there will necessarily be in the building I should fear it will be be at considerable disadvantage seeing their full beauties.' *J. Wallace to Hardman*, 1851, Apr. 9: 'In the absence of Mr Gammell (who has forwarded your letter of the 21st ult) it becomes my duty to address you on the subject of the windows for this College, and to express the excessive annoyance amongst the subscribers at the unlooked for nature of your communication – some months since you wrote attributing the previous delay to Mr. Pugin, and requesting permission to send the windows to the Exhibition. It was plain, <u>then</u>, at all events, that there was no further need for delay … answer was made to you that we were unwilling to have them exhibited but most desirous for their immediate completion …you have suffered us to remain awaiting their certain arrival at the present time, and now suddenly give us to understand that they have been left almost untouched. You have broken your faith with the College … the effect has been, That those who took so warm an interest in the matter having closed their academical career and now leaving and will have no opportunity of seeing the works to wh. they contributed so long ago. That others have intimated their intention of withdrawing their subscriptions … our hopes of proceeding with additional windows are seriously damped. It now therefore becomes my duty to seek for some distinct understanding as to the earliest time when by your utmost exertions they can be put up, & whether you are inclined so to expedite them… The delay would obviously be indefinite if we were to allow of argument that time brings improved manufacture'. Apr. 16: 'I have to acknowledge the receipt of your letter of the 11th inst. Mr. Pugin has likewise written exculpating you in a good measure from the charge of neglect. … I would urgently beg of you therefore to use your <u>best exertions</u> to get the first window put up before the end of May that we may see it before the Long Vacation. The second you might delay until the latter part of September if necessary as it appears that simultaneous completion of both is impossible'. Sep. 9: I regret extremely to be forced to address you another letter of remonstrance with regard to the non-appearance of the windows of Jesus College Chapel … Now in May last, you promised one <u>certainly</u> in June, and the other before October. It will therefore be highly satisfactory … to hear some definite information relative to your intentions. Do not send the old excuse of Pugin having broken up the cartoons: that has served more than once: and it stands to reason that if six months will make a window to do your firm credit at the Exhibition, 18 will not disgrace a collegiate Chapel'. Nov. 10: 'I beg to acknowledge the arrival of the windows: You shall hear more at length when they have been up'. 1852, May 17: queries charge of £200: 'In no manner did you hint to him that the price of the windows would exceed £140 – that the price originally proposed was £100 but on the change of the design from figures to groups you then informed him that the work could not be done under £140 i.e. £70 each [this could be a reference to the canopied figures design mentioned in Pugin's letter to Gibson – see *Jesus College Archives*]'. *Sutton to Hardman*, 1851, Apr. 15: points out that the windows were commissioned by students – hence the anxiety for their completion: 'Smyth the chief mover in the matter has left excuse the impatience of young people between the ages of 17 and 20'. I. Bishop to Hardman, 1851, Nov. 15: 'I have fixed the windows at Cambridge; I never saw parties so well pleased before but had a difficulty in pleasing them with the bars I had the windows in and out two or three times'. *J. Gibson to Hardman*, 1851, Nov. 24: 'Mr Pugin paid us a visit last week and strongly recommended us to replace the <u>old</u> bars in our windows and to fasten the windows to them … Much satisfaction is expressed on all sides with the windows, the colour is particularly admired and the effect in the Chapel is admirable: to my mind the effect will be much enhanced when the bars are in their place again – an essential feature to give solidity and reality to the work and to remove the transparency effect. The Undergraduates are raising money for four of the South lancets and I hope it will not be long before the subscriptions are sufficiently advanced to enable them to enter upon this undertaking'. (Re sII–sV, although interest was expressed in these windows in late 1851 (see *Letters, JHA, J. Gibson to Hardman*, Nov. 24 and *HLRO 304, Pugin to Hardman*, letter no. 659), by Jan. 17, 1852 (see L.N. Rate's letter to Hardman below), very close to Pugin's final illness, the intention seems to have been to have geometric designs. The subject windows now in place – not ordered until mid-1853 – can reasonably be attributed to J.H. Powell). *Rate to J. Hardman & Co.*, 1852, Jan. 17: enquires about price of filling four lancet windows on S side of choir with glass of: 'the best possible quality and colour, the design geometric' (Order Book 3, 1853, f. 90, Jun. 30, describes the windows as subjects in medallions, 3 in each light). *Letter Book, p. 180, Hardman to Rate*, Jul. 2 1853: 'I have this evening sent the roll of Drawings containing … a portion of one of the Lancets for the south side of the College Chapel. They are not quite finished but they will enable you & Mr. Gibson to judge.'

Literature. *The Ecclesiologist*, 12, 1851, p. 324; 14, 1853, pp. 370-1. R. Willis, 1886, pp. 152-3: note 1 stating that the glass of sVI and sVII was exhibited in the Great Exhibition of 1851 is incorrect – see letter from J.S. Gammell to Hardman, Dec. 14, 1850, above. I. & G. Morgan, 1914, pp. 311-14. Wedgwood (Pugin's Diary): Pugin visits Cambridge, 1847, Oct. 15; 1848, Feb. 29, Aug. 24, Oct. 19; 1849, Apr. 26, Oct. 17-18; 1850, Apr. 4; 1851 Nov. 20.

10 Cambridge, Magdalene College Chapel
1850. Client: Randall Burroughs.

 E window (**3.4a & b**) I 3.3m x 5.1m 5-light £200

Description. **I.** 5-light window and tracery. St Mary Magdalene in a green cloak over a greenish-white gown and a reddish-brown robe stands under a canopy, in the centre light, holding an ointment jar in her right hand and its lid in her left. Scenes from her life, under canopies, are depicted in the other lights. From left to right they are: St Mary Magdalene at the feet of Christ (together with an unidentified saint, St Peter holding the keys and St John the Evangelist); St Mary Magdalene at Christ's tomb (with the Marys behind); the Deposition; and *Noli Me Tangere.* The canopies are in shallow perspective and have white-finialed, vaulted heads. Behind the finials are three-sided conical-topped towers rising into the tops of the lights. Below each scene an angel holding a text kneels within an open series of columns and arches that support the base of the canopy. The two tracery-pieces immediately above the centre light each contain a standing angel holding a text. The two over the inner mullions of the outer lights contain alpha and omega respectively while the remainder are filled with red and blue leaf patterns, diaper, and small leaf-filled circles.

Office records. Order Book, 1850, f. 71, Feb. 28 (I). *First Glass Day Book,* 1850, f. 98, Oct. 3 (I). *Cartoon costs per ledger summary*: Powell £5.15.0, Oliphant £17.10.0. Oliphant's account records that the payment was in respect of: '5 Cartoons 4 Large groups & Figures S.M. Magdalene @ 70/'.

Letters. HLRO 304: Pugin to Hardman, letter no. 791: 'This Cambridge window is a very difficult one indeed I don't see how it is possible to make a design without going in to see the East window he speaks off [sic] for where there is old glass already in one window it is indispensible to assimilate the new . I think you better write & tell him that I will take an early opportunity of going down to look at the original window the scale of the figures & c & will then prepare a design – you should also let him know that this glass is the most expensive as being the most artistic & I do not think this window could cost less than £150 as there are 80 feet in it – but how is all this to be done?' No. 818: 'The Cambridge design tomorrow I hope it will get us the job'. No. 862: 'If I do not get the templates for Magdalene College soon I shall never get it done. it is <u>indispensible</u> that Oliphant should draw it out here under my eye. I <u>leave at Easter</u> so don't reprimand[?] me if you have not the cartoons [these comments are repeated in No. 686] ... 4. The coloured sketch for Magdalene College window'. No. 819: 'I send you the Cambridge window nothing can be so appropriate as the life of St. Mary Magdalene'. No. 688: 'I should like to go to Fairford with you for that is a fine specimen of Later Glass just what we want for Magdalene College Cambridge.' No. 692: 'I have knocked one fine job out of Oliphant at last the S. Mary Magdalene window for Cambridge. I have made him work close to the Van Eyck school'. No. 777: 'Hereford [Hereford Cathedral (Gaz.75)] & S. M. Magdalene Cambridge are the next cartoons you will receive.' No. 693: 'those [groups] for Cambridge were most magnificent'. No. 758: postmarked 'OC 13, 1850': 'I was very glad to have so good an account of Cambridge window S. M. Magdalene'. *JHA: Burroughs to Hardman,* 1850, Feb. 21: 'Mr Burroughs begs to inform Mr Hardman that the design which he sent for the East Window at Magdalene Chapel has been approved by the College and that they have decided on leaving the execution of it in his hands ... The design has met with universal admiration.' Mar. 15: 'the colours are approved and [Mr Burroughs] wishes Mr. Hardman to begin the window directly'. Oct. 18: requests account for painted window in the Chapel. 1851: 'I need hardly add that your window gives the most universal satisfaction to all who come to see it, I only wish I could persuade the College to put painted glass into the other windows [an undated letter from Randall Burroughs in the 1850 box, gives authority for the side windows in the chapel to be 'done over with the Composition you proposed doing them with', but this seems to have come to nothing]'.

Literature. The Ecclesiologist, 12, 1851, p. 325: describes the window. For Pugin's visits to Cambridge see Gaz.9, *Literature.*

11 Cambridge, St Andrew (CoE)
*c.*1845.

Literature. London & Dublin Weekly Orthodox Journal, 14, 1842, p. 177: illustrates exterior and interior; p. 178: refers to Pugin as the architect but there is no mention of stained glass. Wedgwood (Pugin's Diary): Pugin visits Cambridge, 1841, Jul. 21; 1842, May 2, 'began church'; 1845, Jan. 27: 'Wailes for Cambridge £20'. Wedgwood, 1985, p. 87, note 2, observes that the church was removed to Huntingdon where it survives.

11A Elsworth Parsonage.
1853. Window designed by J.H. Powell.

Office records. Order Book 2, 1853, f. 101, Sep. 3. *Order Book 3*, 1853, f. 73, Sep. 3. *First Glass Day Book*, 1853, f. 193, Oct. 29: 'Quatrefoil piece/of stained glass for Study/Subject = St. Peter seated.'

12 Ely Cathedral (CoE)
1852. Client: Rev. E.B. Sparke.

S aisle window (**7.7a & b**)	sXXIII	2.2m x 2.9m	4-light	£75

Description: **sXXIII**. 4-light window and tracery. A biblical scene, under a multi-pinnacled and gabled canopy is depicted in each light. From left to right the scenes are: Nathan reproving David; the crown of Saul brought by an Amalekite; David playing before Saul; Samuel anointing David. In the bottom panels beneath each scene are pairs of blue diaper roundels each containing a crown and a harp respectively. Yellow-crocketed gables, mirroring those of the canopies above, surmount the roundels. The seven main tracery pieces contain leaf and stem patterns in red, white, green and blue.

Office records. *Order Book*, 1851, f. 139, Mar. 7 (sXXIII). *First Glass Day Book*, 1852, f. 139, Mar. 22 (sXXIII).

Letters. *HLRO 304: Pugin to Hardman*, letter no. 504: 'I have examined carefully the sketch you have sent me of the Ely window & the width of the lights are so narrow & unsuited to the subjects purpose that the window if designed on that principle must be a complete failure and I must address you on no condition to attempt it – for if it was ever so beautifully executed it will go for nothing in that great church that window is only suitable for 4 saints under fine canopies upon a grand scale with fine drawing & detail which would suit the Cathedral then indeed we might have a truly effective work & gain us much credit unless the design & parts of the glass are on a scale with the stone mullions & tracery the effect must be detestable if I am called to treat the window in the way I propose I can promise a fine work but subjects in 1.5 lights must be failures'. No. 460: 'It is not the least use committing ourselves at Ely by making a set of little paltry subjects in such lights I enclose you a letter you can send to Mr Sparke on the subjects if they don't give us a good chance[?] I would not do anything the idea is preposterous. it is a <u>decorated</u> window not a later one as you said & 4 fine images with plenty of [?] & fine canopies would make a grand job in <u>1.5½ you cannot make groups</u> it would be a great injury to us'. No. 180: 'It is exceedingly difficult to interpret[?] that Ely window from the sketch which is very bad & therefore you must explain to Mr. Sparke that if I have mistaken the date it is the fault of the sketch sent. It is a most unaccountable[?] window with Lancet heads under what looks like a 4 centred arch. pray explain this to him for I have made the glass compared[?] to <u>what I consider this style</u> of the mullions & tracery. I hope to send the sketch of the Ely window tomorrow evening but you must explain the case to Mr. Sparke about the date of the window we must have a better drawing or templates before we can do the glass.' No. 501: 'has the Ely window dropped through the mullions into Chaos'. No. 508: 'I send you herewith the sketch of the Ely window the 4 subject [sic] are [as described above]. The spaces are small but I will do my best & I must have the exact date of the window before begin [sic]'. *JHA: Sparke to Hardman*, 1851, Feb. 13: 'I am commissioned by some Ladies who propose giving a window to Ely Cathedral to enquire whether you are disposed to furnish a design & estimate for it another artist is going to do so ... It is proposed to fill the window with eight subjects selected from the history of David'. Feb. 18: 'I beg to acknowledge your letter which I have shewn to some ladies at Ely. We are doubtful about your meaning as to entering into competition for as I informed you in my first letter we have already engaged one Artist to send a design & estimate so that you will have one competitor – I think it better to draw your attention to this circumstance in order that there may be no misunderstanding'. Feb. 22: 'am very glad to find we shall have an estimate & design from you...I forward to you eight subjects that have been selected in order that you may consider the best way of illustrating them'. Mar. 8: 'I beg to acknowledge your letter with the opinion of Mr. Pugin [see *HLRO 304*, letter no. 504]: I entertain the greatest respect for his correct views on these matters – but unfortunately this window is one of a series that is dedicated to the history of the Old Testament so that if the scheme is not carried out of having subjects there will be a link wanting in the chain – The only way I see in which the difficulty could be overcome would be by introducing figures of David, Solomon, Nathan & Samuel. However I have sent both your and Mr Pugin's letters to Mrs Farwell who will consult the other ladies interested in this matter ... I admire Mr Pugin's advice to give up the window if you do not think it will be satisfactory – If all artists would but adopt the same manly course we should not see so many monstrosities perpetrated – However in some instances I do not think Professional taste better than that of Amateurs – '. Mar. 27: 'as I before stated I have the highest opinion of Mr. Pugin's good taste & judgement & were the window in question in any other position or had not the scheme been so far carried out figures would be very effective – but as it is we must confine ourselves to groups'. Nov. 9: seeks progress on: 'the Ladies window at Ely'. Nov. 22: 'when can we expect the window?' 1852, Apr.: 'I have twice seen your window since it has been fixed in the Cathedral & regret very much to be under the necessity of informing you that it does

not equal my expectations for I hoped it would be as good as that in the Chapel of Magdalen Coll [Gaz.10]: which I consider decidedly your best work ... Independently of the detail & drawing not being up to the same quality there is a want of harmony between the upper & lower parts of the window . The portions of the tracery are small & the sight[?] line between the coloured glass & the stone is too broad & conspicuous – '. Aug. 17 'I think the groups very good but the blue in two of them is not a correct decorated blue, it turns inky and heavy in the twilight the canopies are also good in design but there is too much yellow – the only way to subdue[?] it is to introduce a very considerable proportion of black if there were only four crockets instead of six & the intermediate spaces increased & filled with black sometimes there would almost be too much yellow. The great blots in the window are in the tracery & the unnecessary sight[?] lines which seem only an after thought to fill up the openings'. Undated 'I was at Ely on Wednesday last and saw the window which is certainly improved by the alteration of the lower part & by the introduction of more black in the canopies. The leadpaint on the sight[?] line of the glass in the tracery has produced little or no effect for the white is still glaring & predominates too much so that there is a want of harmony between the upper & lower parts of the window'. Nov. 8. 'I have for some time been in expectation of hearing from you what alterations you intend making in the Ladies window in Ely Cathedral'. *Letter Book: Hardman to Sparke*, 1851: f. 5, Apr. 14: Identifies the subject matter. f. 79, Aug. 18: 'I have been abroad studying old glass & that the Cartoons for the window have been delayed but I will now get them in hand. I trust I shall succeed in making a fine window but the width of the lights is rather against me. I am glad to hear that you are pleased with the St. Mary Magdalene Window [Magdalene College Chapel, Cambridge, Gaz.10].'

Literature. *The Ecclesiologist*, 14, 1853, p. 7, reports: 'a Pointed insertion of four lights has been filled by Mr. Hardman of Birmingham, with the History of David. It has a good deal of merit of a certain kind, and is very like an old window of a late though not debased style. Its drawing is good, and most of the faults of modern glass are avoided. But its tinctures are somewhat washy, and its groups confused; and above all, the tracery though elaborate is quite unsuited to the character of the architectural tracery of the window and indeed it almost overwhelms the groups beneath'. Wedgwood (Pugin's Diary): Pugin visits Ely, 1842, May 3; 1848, Aug. 24-5; 1849, Apr. 25-6.

CHESHIRE

13 Appleton, (Halton UA) St Bede (RC)

1851, 1853. Client: Rev. George Fisher.

S aisle E window	(**10.3**)	sII	1.3m x 2.5m	2-light	£35	1851
			E window for Blessed Sacrament Chapel per First Glass Day Book			
S aisle window		sIII	1.0m x 1.8m	2-light	£15	1851
			Side of chapel per First Glass Day Book			
N aisle E window		nII	1.4m x 1.9m	2-light	£25	1853
			Ordered Oct. 13, 1851, re-ordered a year later, designed, seemingly, by J.H. Powell			

Descriptions. **sII.** 2-light window and tracery. The Last Supper is depicted in the left-hand light and the Israelites in the Desert receiving Manna, in the right. Both scenes are under canopies surmounted by yellow-crocketed gables. Superstructures in the form of Gothic windows under yellow-crocketed gables rise above the canopies. The borders are patterned with white leaves on undulating yellow stems against purple and blue grounds. The main tracery-piece, which is filled with white diaper, has at its centre an encircled white star surrounded by six white leaves, all contained in a red diaper sexfoil.

sIII. 2-lancet window and tracery. Each light contains a figure standing beneath a yellow-crocketed, gabled and finialed canopy. Behind each figure is an orange diaper screen. St John the Evangelist in a blue-lined, green mantle over a red robe is in the left-hand light. He holds in his left hand a chalice from which a red demon is emerging. St Margaret of Antioch in a red-lined, white mantle over a green robe is in the right-hand light. She holds a crossed lance in her right hand and a book in her left. The lance is plunged into the mouth of a red dragon lying at her feet. The borders are patterned with white florets on yellow stems against red and green grounds. The quatrefoil tracery-piece is filled with white grisaille and has a geometrically-patterned roundel at its centre.

nII. 2-light window and tracery depicting the Annunciation.

Office records. *Order Book*, 1850, f. 99, Jul. 27 (sII, sIII); *Order Book*, 1851, f. 149, Oct. 13 (nII), re-entered in Order Book 2, 1852, f. 24, Oct. 13. *First Glass Day Book*, 1851, f. 120, Aug. 8 (sII, sIII); 1853, f. 181, Jun. 3 (nII).

Letters. HLRO 304: Pugin to Hardman, letter no. 782: 'you have mixed up the B.S. Chapel at Appleton & that one I took the memorandum of at Handsworth ... I have included the manna in the desert & Last Supper in the E window. *JHA: M.E. Hadfield to Hardman*, 1847, May 7: 'The enclosed is a sketch for the window at St. Bede, Appleton – Can you do

it for us by July or thereabouts and at about what price? I am anxious to have some of your work as we shall bye and bye have a great deal to do.' *Letter Book: Hardman to Fisher*, 1850, Jul. 8: '2 stained glass windows the one near the Altar containing the Manna & the last supper or our Lord at Emmaus the side one the Patron Saints of Donors'. *JHA: Fisher to Hardman*, 1852, Oct. 11: 'I have not had an opportunity of shewing the sketch of the window to the gentleman who has partly agreed to pay for the same. I shall see him tomorrow & then I will return it'.
Literature. Wedgwood (Pugin's Diary): Pugin visits Appleton, 1851, Aug. 20.

14 Chester Cathedral (CoE)

1850. Client: Rev. J.B. Bloomfield, canon of Chester Cathedral. Memorial window to G.E. Anson, late Privy Purse to H.M. Prince Albert.

 S aisle window (**3.3a & b**) sXXIV 3.5m x 5.1m 5-light £170

Description. **sXXIV.** 5-light window and tracery. The central and upper parts of the wider middle light are filled with a depiction, under a canopy, of the Resurrection, and the lower part, the Entombment. The central parts of the other four lights, contain under canopies, from left to right: the Raising of Lazarus; the Raising of Jarius's Daughter; the Raising of the Widow's Son; and Noli Me Tangere. The upper and lower parts of these lights are filled with a grisaille of white leaves on yellow stems against black cross-hatched grounds. The grisaille is overlain by red-outlined quatrefoils which in turn are over and underlapped by diamonds outlined in blue-beaded glass. In the middle of each of the upper portions and contained in one of the blue diamonds is a red circle enclosing: in the outer lights, a red lion on a gold ground and a gold lion on a red ground, respectively; and in the inner lights against blue grounds, green leaves on yellow stems and a harp, respectively. In the middle of each of the lower portions, again within a blue diamond, is a red-rimmed roundel containing a half-length angel holding a text, against a blue quatrefoil ground. The canopies are surmounted by yellow-crocketed and finialed gables. That in the centre light has a superstructure of Gothic windows flanked by yellow-winged angels in white, under canopies. The flanking angels are not included in the superstructures in the other four lights. The main tracery-pieces consist of nine circles made up into three separate triangles each with a smaller circle at its centre. Green and white leaves on yellow stems encircled by white-patterned glass fill the nine circles while a coat of arms is contained in the topmost of the three smaller ones and a yellow crown in each of the remaining two.
Office records. *Order Book*, undated, f. 68 (sXXIV): 'G.E. Anson is described as keeper of the Privy Purse and second son of the Dean of Chester'. *First Glass Day Book*, 1850, f. 88 (sXXIV), Apr. 25, f. 91, May 18: 'To making Alterations in/ window South Aisle of Choir/taking to [sic] pieces & introducing/New Glass & releading do/sent April 25 1850 fo. 88'. *Cartoon costs per ledger summary*: Powell 15s.0d, Oliphant £15.15.0. Oliphant's account records that the payment was in respect of : '6 Groups for Resurrection do. [window]'.
Letters. HLRO 304: *Pugin to Hardman*, letter no. 903: 'before I begin this you must realy [sic] run[?] down & see the situation of this window and wether [sic] it receives sky light or has a blank wall a few feet off & also see what Wailes has done we must assured[?] on all these points – now is the time to do something transcendent or be for ever failures'. No. 898: 'I will send a sketch of the Chester window tomorrow there appears to be about 110 feet of glass in it. I should tell them if you find it can be well done for 150 or 60 they shall have it. but that in including a binding estimate you are obliged to provide for contingences – now if you take my advice you will go to Chester by the express in 2½ hours & see the situation of this window & see what Wailes window is that he speaks of opposite my dear friend be assured we ought to know the position of this window a good deal will depend on the windows we do for <u>Cathedrals</u> they are seen by thousands. I would strain every nerve in such a job as this. The idea of filling the side lights by a scroll[?] is detestable but I will arrange something good & send it by day mail tomorrow.' No. 896: postmark 'DE 5 1849', 'I send you the Chester window The centre subject contains the entombment & the resurrection in the side lights the raising of the widow's son. Jairus [sic] daughter. Lazarus & the appearance of our Lord in the garden to St. Mary Mag. The Royal Badges would be appropriate & they are in the upper circles. Mr Ansons arms ought to be in the top trefoil ask about them it would make a fine window.' No. 846: 'when I came home I found the centre light of Chester all set out wrong & have had to cut it to pieces to bring it in now mind our decorated glass is painted on a wrong principle. I am quite satisfied in broad bands in architectural work [Pugin demonstrates with a sketch] as in the sepulchre in this window the <u>whole glass</u> was covered with a tint then[?] black lines & lights scraped out if you leave these broad bands plain glass they look thin & miserable – our diapers require more strength the borders of diaper also, more black. The windows would look as rich again.' No. 224: 'got all the subjects for Chester marked in colour'. No. 930: 'I have got a fine job out of Oliphant at last for Chester but I had a great fight for it & the entombment was done twice he grumbles dreadfully & says the work does not pay at all. I told him that was exactly what I said.' No. 939: 'It is quite impossible to [?] half the

Quarterings of Mr. Ansons coat for the window at Chester they would be like a miniature can you get to know what is the distinguishing bearing of his familly [sic] for that is all that can be done.' No. 859: 'The Chester window goes off today. I am in some doubts about the heads of the angels surrounding Our Lord wether [sic] they should be done in pale ruby or white – what would be best is a pale pink like the old men in that glass that came from Paris'. No. 693: 'I am very sorry to hear so bad an account of the Chester lights I have no doubt you are right the grisaille is miserable it is so at Tofts [West Tofts, Gaz.120] we dont do it half strong enough. I want Powell to go this year to study – the foliage & c from old things <u>real size</u> with the <u>real strength of line</u> that the old men used.' No. 713: 'I have just got your letter – now take my advice & alter the grisaile [sic] at Chester at once it is another temporary sacrifice for future credit. I assure you in my little church [St Augustine, Ramsgate, Gaz.88] it was <u>invisible</u> even near as every window is depend on it the window altered do us great credit if this was done but as it is <u>it must be a failure</u> you better [?] it at once. It is not a great job but it should be done to save our credit. I assure you my north window looked like white glass <u>plain white</u> & if it does so then what must Chester be. in such a place above all we should be transcendent for heavens sake don't sacrifice our reputation in such a place have it done <u>without loss</u> of time put on fine lines & hatch the ground get the darkest pieces of glass you can find & it will be a grand job.' *JHA: Bloomfield to Hardman*, 1849, Nov. 29: requests a sketch for a memorial window in the S aisle of the choir of the Cathedral for Mr. G.E. Anson, late keeper of the Privy Purse and second son of the Dean of Chester, 1850, May 10: 'I think all persons concur in entire approval of the general design & of the execution of the pictorial parts of the window which exhibit some excellent harmonies of colour and admirable execution. But the effect is much impaired by the dominance of white glass in the upper spaces of the portion of the window. This gives a glaring effect to the whole which takes the attention off the pictorial representations & kills them as we say. Two circumstances may possibly contribute to produce this effect its position on the south & sunny side of the Church and its proximity to the darkly coloured window Wm. Wailes executed. The contrast is not agreeable. If the foliated portions of the white glass had been darkened I think it would have looked better.'

Literature. Wedgwood (Pugin's Diary): Pugin visits Chester, 1836, Mar. 13-14; 1841 Mar. 29; 1848 Sep. 12, 13-14; 1850 Nov. 18-19; 1851 Aug. 25.

15 Liscard, St Alban (RC)

1853. Window designed by J.H. Powell.

Office records. First Glass Day Book, 1853, f. 189, Oct. 4: 'Stained glass East/window of 4 lights &/Tracery/. Subjects in Groups from/Life of St. Alban/4 Lights 10'2" x 2'3".../20 pieces Tracery'.

16 Macclesfield, St Alban (RC)

1841, 1846. Clients: Lord Shrewsbury (I); Rev. John Hall (sIII).

E window (**1.4a**)	I	5.0m x 6.3m	7-light	£150	1841
Lady Chapel window (**7.1**)	sIII	1.5m x 2.6m	3-light	£50	1846

Descriptions: **I.** 7-light window and tracery. In the centre light, St Alban in a white mantle over a purple robe stands in front of a red screen, under a vaulted canopy. The canopy is shown in perspective and has a four-sided tower rising above its head. The saint holds a large downward-pointing sword in his right hand. Beneath his feet is a badly worn inscription reading: 'St. Alban, proto-martyr of England pray for us'. The remaining six lights are made up of yellow silver stain-patterned quarries (the patterning in many is worn). Each light contains a vertical series of five roundels. The top, centre and bottom roundels are each overlain by four yellow leaves on stems, the stems forming a blue concave-sided diamond at the centres, the others each contain a yellow M surmounted by a crown. The main tracery-pieces contain standing angels, in white, holding variously, yellow, blue, green and purple scrolls inscribed with extracts from the scriptures and portions of the Gloria and Te Deum. Yellow letters IHC on red, and M on blue are inscribed on shields beneath the angels' feet. The initials T and S, shields with yellow lions rampant on red grounds, and white foliage patterns fill the remaining pieces.

sIII. 3-light window and tracery. The Virgin (in a green-lined, red mantle over a blue robe) and Child in the centre light, are flanked by St Edward the Confessor, crowned and in a red-lined, yellow silver stain-patterned white mantle over a green robe and St John the Evangelist in a green-lined, yellow silver stain-patterned, white mantle over a red robe, in the side lights. St Edward holds a ring in his left hand and a sceptre in his right. St John holds a yellow chalice, from which issues a green demon, in his left hand. Both stand against white diaper screens. The panel beneath the Virgin and Child, contains white lilies and green leaves on yellow stems in a yellow and white-patterned vase, against a red diaper

ground. That beneath St Edward, a group of figures at prayer, in profile and looking to the right; and beneath St John, the kneeling figure at prayer of the Rev. John Hall in a green-lined yellow silver stain-patterned robe, in profile and looking to the left. At the top of the tracery are two white, yellow-ornamented bishops' mitres over a yellow R(?) on red ground, while the red letters IHC and MFA contained in yellow roundels, alternate across the bottom.

Office records. Order Book, undated, f. 4. *First Glass Day Book*, 1846, f. 9, Dec. 3 (sIII).

Letters. **I.** *Wedgwood, 1985, p. 102, letter 21, Pugin to Lord Shrewsbury*, 'Xmas Eve 1840': 'I find it quite impossible to get the window at Macclesfield executed under £150. I have got a contract for all the tracery & the centre light with the image of St. Alban for £100. The other 6 lights will cost £50 ...What shall I do about the window. I fear the 6 plain lights will quite put out the stained glass, but is is a very large window and I could not make the £100 do more by any contriving.'

sIII. *JHA: Hall to Hardman*, 1845, Oct. 29: 'I am perfectly satisfied with the design suggested by Mr. Pugin for the window in the Lady Chapel, with the exception of the side lights which I do not thoroughly understand. I am anxious to know what kind of emblems he would put in them for I think it would be much better to have a proper understanding at the beginning. As the window is in the Lady Chapel would it not be better to have the Blessed Virgin in the centre light & the figure of St. John my Patron Saint in one of the others & self kneeling in the third light. initials under: or my Patron Saint with self kneeling in the second light & some other figure in the third. You can name it to Mr. Pugin & he will give his opinion about it.' 1845 (in 1847 box), Dec. 18: order confirmed. Nov. 30 1846 (in 1847 box): 'I am proud to hear that our window is finished.' Dec. 7 (in 1847 box): 'it is a very rich & most beautifully executed work & that the design surpasses anything they have ever seen before.' Dec. 14 (in 1847 box): £50 paid by order. *Pugin to Hardman*, undated, marked '1845 box': 'do write yourself to Mr. Hall about the glass. his patron saint in the centre light with himself kneeling under. his initials in the Quarries with borders & emblems in the side lights worth about 25s a foot altogether'. Undated, marked '1845 box': '2. [?] your Mr. Hall. I should of course prefer the 3 figures if he can stand the expense but it will never do to have him in a whole light he must be kneeling under his patron saint & another Saint in the other light. S. Oswald was a good saint in that part of the country & a king with crown as well. if he does not approve of S. Oswald he can select some other saint, say St. Edward.' Postmark 'DE 14 1845': '4. Mr. Halls glass must cost £50 for there are 33 feet in it & a deal of work. [P.S.] I have calculated Mr. Halls window for rich canopies & c if less than that would do of necessity[?] I could make a simple design.'

Literature. Catholic Magazine, 3, 1839, pp. 337-41: reports the foundation stone laying. Pugin, 1841, p. 328: describes window I. *London & Dublin Weekly Orthodox Journal*, 12, 1841, pp. 347-8: describes the church, including window I. *The Tablet*, 7, 1846, p. 427 (reports on a testimonial to the Rev. J. Hall and refers to his resolve to donate window sIII); 13, 1852, p. 74: opening of the chancel after a restoration. Wedgwood (Pugin's Diary): Pugin visits Macclesfield, 1838, Sep. 21, Dec. 13; 1839, Feb. 25-6, Apr. 1-2, Jun. 4-5, Aug. 19, Oct. 30; 1840, Jan. 14-15, Apr. 30-May 1, Jul 6, Aug. 26, Sep. 5; 1841, Mar. 30-1, May 6-7, 21-2, p. 50 '[End papers at front of book] [d] For Macclesfield window 150.0.0'; 1843, 1846 no diary; 1849, Oct. 12.

17 Warrington, St Elphin (CoE)

1846-9. Clients: Rev. Horace Powys (W circular window); Rev. John T.V. Bayne (sIII); John Allcard, Stratford Green (I tracery); William Allcard, Warrington (I lights); Hon. and Rev. H. Powys (nII, sII).

E window	I	3.2m x 4.3 m	5-light (tracery)	£30	1846
			(lights)	£200	1847
Chancel S sedilia window	sIII	2.1m x 2.7m	3-light	£74	1846
Chancel N window	nII	2.1m x 2.7m	3-light	£80	1848
Chancel S window	sII	2.1m x 2.7m	3-light	£80	1849

The windows have, unfortunately, suffered damage in the past. During the 1930s the backgrounds of those in the N and S walls of the chancel (nII, sII, sIII) were removed and replaced by plain glass quarries to admit more light, while the lights of the E window were blown out during bombing in the Second World War, at which time further damage was inflicted on the other windows.

The W circular window referred to in the First Glass Day Book and in the letters, is no longer in existence and was probably lost when the nave was remodelled in the 1850s.[2]

Descriptions. **I.** 5-light window and tracery. The centre light originally contained a representation under a canopy of the standing figure of Christ in a red-lined, yellow silver stain flower-patterned white mantle over a brown robe and holding a crossed staff in his left hand. The Agnus Dei appeared, seemingly, in a quatrefoil within the gable over the canopy. The

Evangelists were portrayed standing, with their symbols in blue quatrefoils arranged in the superstructures over their canopies, in the remaining lights. From left to right were St Matthew in a purple-lined, green mantle over a red robe, holding a quill in his right hand and a book in his left (above, a kneeling angel in white); St Mark in a white-lined, red mantle over a blue robe, holding a quill in his left hand and a book in his right (above, a winged-purple lion); St Luke in a brown mantle over a green robe, holding a quill in his right hand and a book in his left (above, a winged-brown ox); St John the Evangelist in a blue-lined, red mantle over a green robe, holding a quill in his left hand and a book, on which is perched a small eagle, in his right − the stained glass is missing at his left shoulder and just above his middle − (above, a brown eagle). All that remains of the stained glass are the five figures (their heads seemingly restored) and the symbols, the rest having been replaced with plain glass quarries. There is much evidence of the breakages that have occurred. The tracery appears to be intact. All the pieces are filled with patterns of white vine leaves and green bunches of grapes on yellow stems against red grounds. Each of the two main pieces contain, in addition, a kneeling angel in green who holds a text − the combined texts read: 'Glory be to God on High and Pastor on Earth'. The centre and topmost pieces each contain the letters IHS.

sIII. 3-light window and tracery. The centre light contains in the upper panels a scene under a canopy in which Christ in a green-lined, blue mantle over a mauve robe and St Mary Magdalene in a white lined, red mantle over a brown robe are the principal figures. Beneath the scene in a blue diaper quatrefoil is a kneeling figure in a white mantle over a blue, hooded robe (possibly the donor) who has his hands raised and together in prayer. Each of the side lights contains in a blue diaper medallion, a standing figure of a saint, with a scene from his life in an elongated blue diaper quatrefoil below. In the left-hand light is St John the Baptist(?) in a yellow silver stain floral-patterned, green mantle over a brown robe, holding a crossed staff in his right hand and a red book in his left. The Baptism is portrayed below. In the right-hand light is St Stephen in a red-lined, yellow silver stain floret-patterned, white mantle over a blue robe, holding a book in his right hand and a palm in his left. The stoning of the saint is portrayed below.

The three main tracery-pieces contain seated angels in red-lined, white mantles over yellow robes. Their feet rest on bands of blue, stylised clouds and they hold texts.

nII. 3-light window and tracery. At one time the Wise and Foolish Virgins were depicted in the lights which now contain one small standing figure each. That in the left-hand light is in a white mantle over a blue robe and in the right, a white mantle over a yellow robe. Both wear white head-dresses and carry in their left and right hands respectively a lamp with a red flame. The figure in the centre light is in a purple mantle over a white robe and wears a head-dress. Unlike the other two, she has no halo and carries no lamp but brushes a tear from her eye with her right hand. A lamp with a red flame is depicted hanging at the top of the light. The three main tracery-pieces contain angels in red roundels on blue grounds. The one at the top in an orange-lined mantle over a green robe holds a text. The one on the left, in a red-lined, white mantle over an orange robe, holds a crown in his outstretched hands and the one on the right in a white-lined, red mantle over an orange robe, holds a torch in his right hand.

sII. 3-light window and tracery. Christ blessing the Children, under a yellow-crocketed and finialed canopy is represented in the centre light. Christ is in a green-lined red mantle over a yellow robe and the two children in yellow silver stain floral-patterned white robes. Beneath the scene is the text: 'Suffer Little Children to come unto me'. The side lights each contain two blue diaper, figured quatrefoil medallions; those on the left depict: Christ with his parents(?) (top) and the Dispute in the Temple (bottom). The corresponding ones on the right: the Nativity and the Presentation in the Temple. Above, between and below the quatrefoil medallions are roundels containing red diaper quatrefoils with yellow-patterned centres except for the two middle ones which have monograms, perhaps PCN and PC, at their centres.

The three main tracery-pieces each contain a seated angel holding a text. The one at the top is in a yellow-lined, green mantle over a pale yellow robe and the two below in blue-lined mantles over green robes.

Office records. *Order Book*, undated, f. 4 (sIII) cartoons £20, f. 6, cartoons £50, f. 41 (nII); the other items do not appear in the Order Book. *First Glass Day Book*, 1845, f. 1, Dec. 11: '1 Trefoil Tracery piece/...centre piece of West Circular Window'; 1846, f. 2, Feb. 13: 'A Figure Tracery piece of/St Matthew being the Top/piece of West Circular Window', f. 3, Jun. 6 (sIII), f. 6, Sep. 13: '12 Large Tracery pieces for/East window Warrington/10 Small Tracery pieces do.do. £50... repairing Figure Tracery of St. Matthew/2 Large Tracery.../4 Tracery pieces...above for West Circular Window £11'; 1847, f. 18, Nov. 4 (lights I & bars); 1848, f. 37, Jul. 8: 'Tracery for West Circular Window/3 Evangelistic symbols of/St Mark St Luke & St John/2 Long ogee pieces...£8/4 Small triangular pieces...£3'; f. 45, Nov. 8 (nII); 1849, f. 63, Jun. 19: 'To Altering & Repairing/Tracery pieces for Side Window [nII]'; f. 67, Sep. 10 (sII). *Cartoon costs per ledger summary*: nIII, Powell £2.13.4, Hendren £1.0.0; sIII, Powell £6.0.0, Hendren £1.6.8.

Letters. *HLRO 304: Pugin to Hardman*, letter no. 885 (re W window?): 'the pieces of glass we sent to Warrington look wretched there is an optical delusion by which all the white glass appears chrome yellow owing to a reflection & it

spoils it completely.' No. 887, re sIII: 'The glass is a present from Mr. Baynes to Mr Powys so you write to Mr. Baynes at Broughton Nr. Manchester & tell him the glass is ready & ask him how it is to be sent'. No. 169, re nII: 'The following cartoons go off tonight one light of the wise & foolish Virgins window for Warrington.' No. 1021: 'Mr. Powys doesn't seem to think much of the Virgin window. I expect it is the north light – that alters the effect.' The following letters seem to be concerned with the chancel S side windows. No. 148: 'The rest of the Warrington window goes tonight it will be a fine job – pray get it done.' No. 874: 'I will get something drawn out for Mr. Powys as soon as I get his templates.' No. 1020: '4. I believe I have the cartoons of the subjects Mr. Powys wants shall I send them to him?' No. 5: 'As soon as I go away everything stops. all done in the cartoon drawings will have to be altered so I shall not be able to send the Warrington windows yet.' No. 38: '4. I have had a very unpleasant letter about the Warrington window. I cannot tell you how it cuts me up to find anything fail in this way. It makes me despair I shall begin to think I cannot do it & yet I take all possible pains. It appears that the leading in of the lines[?] is greatly objected to. so you must <u>not do it for Winnick</u> [Winwick, Gaz.18] mind this but in [?] the effect was beautiful perhaps it is the vastness of the building that alters the appearance of the windows but it makes me very unhappy indeed.' No. 122: 'Mr. Powys is going to have another church window – same size as the last.' No. 1015: 'side window Warrington £80.' No. 1030: 'I have found the old estimate for side window Warrington it is as I said £80.' No. 1027: 'The Warrington window was contracted at £80 – & you should have stuck to what I said I am always right.' *JHA: Powys to Pugin*, 1846, Jun. 27: 'As to my round window ... I also return to him [Hardman] the top light which you condemned.' 1849: Jan. 2: notifies the death of Rev. Bayne: 'Your sketch of a memorial window [sII] is approved of & will I feel be executed. So you may proceed with the full sized cartoons. Let me know when you wish to have the paper templets [sic].' *J.H. Powell to Hardman*, 1847 box, undated: 'Notice the head of Luke for Warrington [sic] Uncle it is my most successful attempt certainly there is more character and good drawing'. Undated: 'I do not think the Governor [Pugin] has marked any colours on the Warrington window tracery. I can manage all the ornament and believe I could colour it to the Governors satisfaction but if you think there will be risk we had better wait.' Postmark '1847 Sep. 9': '3 figures for Warrington shall start tomorrow ... They belong to the east window St Edmunds [Ware, Gaz.82] but you will see a few alterations to turn them into Evangelists marked red. I am not sure about the coloured grounds they are upon you will see if they are correct.' Undated: 'I send 3 figures for Warrington there are one or two things to explain 1. the 3 figures are drawn and altered for Old Hall [Ware, Gaz.82] the alterations to make them do for Warrington are marked in red. 2. St. Peters Hair must be altered for S. Mark lined over the scalp. the colour I will send. 3. Our Blessed Lords Hair I think must be leaded in but this I will ascertain. His mantle for Warrington will be yellow with a stained pattern. no lead around them.' Postmark '1847 OC 1': 'the Warrington figures shall start on Monday'. Postmark '1847 OC 5': 'In the sketch you sent of evangelists for the Governor to work from St. John has some small squares let into his ruby mantle of white stained. this colouring was marked for St. Edmunds [Ware, Gaz.82] and the colours for Warrington was marked differently. his mantle was to be diapered with birds a loose pattern that went by same post none of the Warrington figures were to be very rich even Our Lord has stained ornament instead of having them leaded in.' *Powys to Hardman*, 1845, Nov. 12: 'I am directed by Mr. Pugin to send for his design for the centre compartment of a circular window which I am <u>very</u> anxious to have executed as soon as possible. It is a west window, immediately opposite to my pulpit, through which an inconveniently strong light shines, therefore I wish to have the colouring as much shaded as possible. When I have the requisite funds at my command it is my intention to complete the whole window according to Mr. Pugin's design.' 1846, Jun. 7: 'Mr [?] has requested me to write to you of the safe arrival of the stained glass window for the sedilia window in my church [sIII]. It has been put up without damage or accident of any kind & is in my opinion, a work of very great merit. The only <u>fault</u> that can be found with it is, that the wire guards show too plainly through the transparent parts of the glass, more especially the face of our Blessed Lord. What am I to do with my round window? Has Mr Pugin said anything to you about it? He pronounced it to be 'beastly' & said 'he never was so deceived in his life'. When he pointed out to me the defects I was struck by them, & now dislike the window more & more. I have no doubt that the evil might be easily remedied by taking out the border, & perhaps some of the small pieces of glass & substituting pure white for yellow. The yellow tinted cathedral glass now looks like one blaze of bright yellow.' 1847, Aug. 24: 'The fault must lie on your workmen as regards the circular window. The St. Matthew compartment was so altered in size that we had to cut the stone to get it into the place which it fitted well before it was returned to you...you will find that I ordered two more lights viz the emblems of St. Mark & St. Luke.' Nov. 11: 'The Glass is safe in my East window & I admire it very much ... Mr. Allcard entirely approves of it ... Have you the cartoons in your [?] for the Memorial window completed & for the rose window unfinished in my church'. 1848, May 4: 'Are you now in condition to go on with the remaining lights of my round west window? ... I have Mr. Pugin's design for the North Chancel window [nII] & shall send him the templates in a day or two.' Undated: 'The remaining lights are fixed in the circular window ... when may we expect to have the North Chancel window.' Sep. 26: 'Many weeks ago

I read a letter from Mr. Pugin in which he says your chancel window is alright & Mr. Hardman will get it finished off for you, so there is no necessity for you doing anything to the window.' Nov. 14: 'The window is in its place & looks very well. I hope soon to be able to send an order for another ... Have you preserved the full sized cartoons of the first memorial window? I particularly want the medallions to make from them patterns for worsted work in my girls school.' Nov. 23: refers to the cost of the chancel North window as £70 to £80 and the remainder of the West window as £30 to £40. Nov. 24: 'I am expecting that you will [?] long have an order through me for another memorial window.' Jan. 8: requests the cost of the memorial window 'of which I sent you Mr. Pugin's sketch'. Jan. 9: Settles the account of the late Rev. Bayne: 'The remaining window will I think be completed by the members of his Congregation'. Jan. 12: 'The templates for the memorial window are in hand ... when you can get the cartoons from Mr. Pugin please to hurry on the execution'. May 17: 'Are you at work upon the memorial window for my Chancel yet? This has been a much longer time on the stocks than was promised.'

Literature. Wedgwood (Pugin's Diary): Pugin visits Warrington, 1837, Mar. 30; 1848, Mar. 2.

18 Winwick, St Oswald (Warrington) (CoE)

1848. Client: George Myers, London; Rev. J.J. Hornby (alterations, I and tracery).

E window	I	2.7m x 5.4m	8-light
Chancel N & S windows (**10.4**)	nII, sII, sIV	1.5m x 3.1m	3-light
Chancel S window	sIII	1.0m x 1.5m	2-light

Descriptions. **I.** 8-light transom window and tracery. Four of the Apostles are depicted in blue, white-outlined, medallions in the top lights and the four Evangelists in similar medallions in the bottom. Above each Apostle is a red roundel containing an angel holding a text. Below each Evangelist would have been his symbol but due to a measuring error these had to be removed (see *Letters*, JHA, Pugin to Hardman below). Geometrical leaf patterns fill the remaining areas. From left to right the Apostles are: St Paul in a white-lined, red mantle over a green robe holding a book in his right hand and a downward-pointing sword in his left; St Peter in a white-lined, red mantle over a yellow robe holding the keys in his right hand and a book in his left; St James the Less in a purple-lined, yellow silver stain-patterned, white mantle over a yellow robe holding a club in his right hand and a book in his left; St Jude in a red-lined, orange mantle over a green robe holding a lance in his right hand and a book in his left. Each Evangelist holds a quill in his right hand and a book in his left. From left to right they are: St Matthew in a white-lined, red mantle over a green robe; St Mark – as for St Matthew; St Luke in a green-lined, purple mantle over a yellow robe; and St John in a white-lined, green mantle over a purple robe – an eagle perches in left-profile on the top of the book he is holding. The Agnus Dei is portrayed in the quatrefoil at the top of the tracery and a red-winged seraph in each of the two outer middle pieces. White leaves on yellow stems against blue grounds fill the remaining pieces.

nII, sII, sIV. 3-light windows and tracery. Each light contains a frontally-posed figure standing against a blue ground – those in the centre lights under canopies, and in the side lights in medallions. Over the canopy heads in sII and sIV are yellow-crocketed and finialed, red diaper gables that have an angel at either side of the apices. The angels are replaced in nII by a yellow-crocketed, finialed and gabled, red diaper Gothic window superstructure. A haloed hand is at the top of the centre light of sII. The top sections of the side lights contain scenes in blue diaper quatrefoil medallions. The tracery in each of the windows is comprised mainly of three geometrically-patterned, white diaper quatrefoils. The figures and scenes are as follows:

nII. Centre light: Christ in a white-lined mantle over an orange garment and green robe, holding an orb in his right hand and a rainbow topped by cloud(?) in his left. Left-hand light: Adam in a pale green-lined, purple mantle over a red robe, holding a spade in his right hand. Above, Adam and Eve flanking the tree of knowledge around which the serpent is entwined. Below, the Garden of Eden. Right-hand light: Noah in a blue-lined, mauve mantle over a green robe holding a sceptre in his left hand. Above, Noah kneeling before an altar. Below, Noah and the Ark.

sII. Centre light: the Transfiguration. Left-hand light: Moses in an orange-lined, white mantle over a red and green robe holding the tablets of stone in his right hand and a sceptre in his left. Above, Moses receiving the tablets of stone. Below, Moses kneeling before a vision of God. Right-hand light: Elijah in a white head-dress and a red-lined, white mantle over a brown robe holding a downward-undulating inscribed scroll in his left hand. Above, Elijah kneeling before an altar. Below, Elijah in a chariot of fire.

sIV. Centre light: Christ in a green-lined chasuble over an orange dalmatic and white alb, holding a chalice with Host in his left hand. Left-hand light: Abraham in a white-lined, red mantle over a brown robe, holding a knife in his right hand. Above, the Birth of Isaac(?). Below, the Sacrifice of Isaac. Right-hand light: David, crowned and in a green-lined,

red mantle over a brown robe, holding a harp in his left hand. Above, David the Shepherd. Below, David kneeling over the prostrate Goliath.

sIII. 2-light heraldic window and tracery. Each light contains three shields of arms, with name plates below, on red grounds. A yellow-on-black inscription is at the bottom of each light. The tracery-piece contains a further shield of arms on a red ground.

Office records. Order Book, undated, f. 24: 'Cartoons £50 [I]', '£45 [nII, sII, sIV]', '£15 [sIII]', 'Mr. Hornby to pay £28 for alterations.' *First Glass Day Book*, 1848, f. 33, Jun. 8 (I, nII, sIV, sIII), f. 35, Jun. 24: 'Alterations in glass/made in mistake [see Pugin's letter to Hardman below, except that Myers not Mr Hornby paid £28 for the alterations], f. 36, Jun. 30 'fixing bars [I]', f. 41, Sep. 22: 'To Altering tracery pieces/for Winwick Church/New ground Ruby to yellow/5 Roses'; 1849, f. 63, Jul. 6: 'To Altering 9 pieces of/Stained Glass Tracery/2 feet of Ruby glass used/½ foot of Blue 5'.

Letters. HLRO 304: Pugin to Hardman, letter no. 58: 'The cartoons for Winwick I shall finish myself.' [See Chapter 3 p. 67 for fuller quote]. No. 436: 'There are 3 Hebrew inscriptions for the side windows Winwick I have written the letters in English get Mr Morrow[?] somebody to look at a Hebrew Alphabet for them. The East window goes off tonight The side windows soon[?] one you will receive from Mr Hornby he has had it to look at.' No. 378: 'all the tracery for Winwick will go off tomorrow.' No. 806: '5. keep the tracery for Winwick till the lights are fixed which you will have this week. They must harmonise ... 10. I shall send you the N window of Wymeswold [Gaz.104] and the E window this week.' No. 321: 'The side windows go by post 3 figs you will receive from Mr. Hornby & the small groups as far as possible 6 are done.' No. 29: 'you will have all the Winwick cartoons in a few days.' *JHA: Pugin to Hardman*, undated, marked '1848 Box': 'if anything could add to my present distress it is the subject of the enclosed letter from Winwick this is Myers figuring I have got his own drawing it is figured 7.2 to the springing he sent drawing this [Pugin here sketches one of the lower lights of I and marks the distance from the base to the springing as 7.2] & it only [sic] 5.11. I am wild about it. I have written to Winwick to say that they must send back the 4 lower lights to you. then you must send me one of the lower cartoons & I will see how it can be reduced of course all the beautiful emblems of the evangelists must be cut out. but I think we ought to give them to Mr. Hornby as the quantity of glass was estimated for at a good price & Myers must pay for the alteration it is monstrous – I am wild about it.' *Hornby to Hardman*, 1848, May 25: 'The East window is come, and Piddock is filling in the tracery. It promises to be glorious. He will go on with the Apostles. But there I regret to say he must stop. There is a serious error in the Evangelists. The figures & emblems together are 2ft 2ins longer then the space – figures alone 4in shorter. What is to be done.' *M. Piddock to Hardman*, 1848, May 30: 'The Rev. Hornby wishes me to stop to put the glass in the side windows & therefore I shall be obliged to you to forward all or part as soon as possible.' *Powell to Hardman*, undated, 1847 box: 'I send you ... 3 side windows Winwick also 1 piece for small window Winwick containing a set of arms.' *Wickham (1907)*, p. 152, quotes from Pugin's letters to the rector, the Rev. J.J. Hornby, pointing out that in one of them Pugin originally proposed to put into the E window [I] the 'four greater Prophets under the Four Evangelists – then we shall have the Old and New Testament,' but that in another dated Aug. 21, 1847 he changed his mind, writing, 'I am anxious to make an alteration in the east window of your chancel for reasons which I will endeavour to explain. I find from a very learned treatise on the porches of Amiens and other authorities that all representations of prophets and personages of the Old Testament should be confined to the western portion of churches, and chancels should be decorated with personages and subjects exclusively from the New Testament. This appears to me most beautiful in principle – particularly applicable to an east window. I am proceeding with the Evangelists, and have now the assistance of Overbeck's best pupil [Enrico Casolani], who has arrived in England recommended to me by Overbeck himself. I have also some very splendid Authorities for the other saint, which I got in my last journey, and if you will allow me to introduce them, we shall have a very glorious window.' In his footnote 2, Wickham quotes from a letter Pugin wrote from Florence on May 17 1847 which includes: 'I have been collecting a vast number of splendid authorities of stained glass from ancient examples, and I think I can promise you such an east window ... as has not been seen since the old times ... I am quite astonished at the immense quantity of Gothic work, of the finest design, in Italy. I never saw any stained glass so beautiful as that at Perugia.' Further letters quoted by Wickham are: 1847, Nov. 1: 'Your east window pleases me and therefore I am sure you will be satisfied, for I am much more difficult to please than you are – the Evangelists are coming out gloriously.' 1848, May 26: 'The window will fortunately not be spoiled but we shall lose the emblems of the Evangelists, which is a great pity. I never took so much pains with a window in my life ... You must find some place for the emblems of the Evangelists in another window of the church. They are too fine to be lost.' Jun. 7: 'I have arranged the alteration in the glass. I do not think it will be perceived but the general beauty of the window is certainly diminished.'

Literature. Wickham, 1907, pp. 132-60. Wedgwood (Pugin's Diary): Pugin visits Winwick, 1847, Mar. 11-12, Jul. 19, Sep. 14; 1848, Mar. 2, May 4, Jun. 23; 1849, Apr. 16, Aug. 15, Nov. 28.

19 Woolston, St Peter (Warrington) (RC)

1852. Windows designed by J.H. Powell.

Office records. Order Book, 1852, f. 163, Jan. 30. *First Glass Day Book*, 1852, f. 160, Oct 23: 'To A Stained Glass/Window of Single/Light (Window of Mrs/E.M.I. Nicholson)/1 Light 10'4" x 2'6½" .../Subject: Figure of B.Ladye/representing the Immaculate/Conception in Centre, above/& below Groups of the "Annunciation"/& the "Assumption"... To a 'Stained Glass Window/of Single light (Window/of W.I.A. Nicholson Esq)/1 light 10'4" x 2'6½'"'.../Subject: Figure of "St. Joseph"/in Centre, above & below/ "The Flight into Egypt" and "His Death"... To A 'Stained Glass Window/of Single Light/1 light 10'4" x 2'6½".../Subject: Figure of "St. Edward"/with kneeling Figure of/Mr Statham underneath/ being Memorial Window/of Edward Statham'.

CLEVELAND

20 Stockton-on-Tees, St Mary (RC)

The elevation illustrated in Pugin, 1841, suggests that stained glass windows may have been installed in the church, but no further information has been obtained. This is perhaps artist's license.

CUMBRIA

21 Cockermouth, All Saints[3] (CoE)

1853. Windows designed by J.H. Powell.

Office records. Order Book 2, undated, f. 69. *Order Book 3*, undated, f. 45. *First Glass Day Book*, 1853, f. 202, Dec. 31: 'To A Window of Stained/Glass of 5 Lights and/Tracery, .../being/Wordsworth Memorial/Window/5 Lights 12'7" x 2'1".../27 pieces Tracery... the fixing & c done in January 1854'.

22 Warwick Bridge, Our Lady & St Wilfrid (RC)

Warrington, '1855(?)' records making the E triplet for chapel at Warwick Bridge and ten other windows for the N, S and W sides of the chapel: these do not seem to have survived. Pevsner considers the side windows in place in early 1967 to be by Hardman after Pugin's death, and judging from the early 1990s photograph (kindly given to me by Paul Atterbury) it seems doubtful that the E triplet contains the original Warrington glass.

Literature. London & Dublin Weekly Orthodox Journal, 13, 1841, p. 398: reports of the opening of the church, designed by Pugin, and includes a brief description, but with no mention of stained glass. N. Pevsner, *The Buildings of England: Cumberland & Westmorland*, Harmondsworth, 1967, p. 198. Warrington, '*c.*1855'(?), p. 7.

DERBYSHIRE

23 Bakewell, Burton Closes House

1847. Client: John Allcard ('Alcard' in the First Glass Day Book).

Entrance hall window	EH wI	2.9m x 3.0m	5-light	£25
Library E window	L I	1.6m x 0.5m	3-light	
2 windows recorded for library; that for SE no longer in place				
Dining room window	DIR I central section	1.4m x 0.6m	3-light	
	side section	0.9m x 0.6m	2-light	
Drawing room windows	DRR I, DRR sII as for DIR I			
Drawing room window	DRR sIII as for DIR I (central section)			

The entrance hall and library windows together cost £25, and the remainder a total of £54.

Descriptions. **EH wI.** 5 long rectangular lights with 3 smaller ones above, all made up of yellow silver stain-patterned quarries. Each of the the larger lights contain four yellow silver stain-patterned, white quatrefoils separated by diagonal mottoes reading 'INDUSTRIA ET SPE'. The two outer smaller lights both contain a similar quatrefoil and the centre one a roundel inscribed with the yellow silver stain initials JA.
L I. The three upper panels of the window are made up of yellow silver stain-patterned quarries. The outer panels contain a central roundel inscribed with a yellow silver stain monogram combining the initials of members of the Allcard family. The roundel in the middle panel contains a yellow silver stain floral pattern.

DIR I, DRR I, DRR sII, DRR sIII. Similar to L I with varied monograms and flower patterns.

Office records. Order Book, undated, f. 18. *First Glass Day Book*, 1847, f. 19, Nov. 4 (DIR, DRR, L); f. 22, Dec. 24 (Hall); 1848, f. 31, Apr. 22: '8 Quarry Lights for/Library Window of House/of Figured Quarries & Borders/4'1" x 4'½"/£28; f. 40, Aug. 8: '3 Squares of Plate glass/2'11½"x 9½" £1.7.3 Squares of ground Plate glass/3' 9" x 8" £1.8/ 2 pieces of Yellow Stain £2.15'; 1849, f. 58, May 3: '21 Light Coloured glass Rosettes for Window in Dining Room'; f. 59, May 13: '20 Rosette pieces of Ruby glass for Hall window'. *Pugin sketch*, BM & AG a. no. not allocated, of detail of EH wI.

Letters. JHA: Allcard to Hardman, 1847, Aug. 26: 'Mr. Pugin was here yesterday [letter addressed from Bakewell; according to his diary Pugin travelled from Rugby to Exeter on Aug. 25, he was, however, in Derby on Jul. 31-Aug. 1] he approved of the Glass being ground tinted the same as the Pattn herein returned, but not of any deeper color [sic]'. Undated, in 1848 bundles: 'I always thought the small diamond Glass for the 3 windows in the side entrance to my new House would look <u>poor</u> and I wish to put in one pane only in each opening of <u>plate Glass</u> there being no quarre [sic] glass about the House excepting these 3 windows – but Mr P. would not hear of it, & would have the windows as you have the order – I therefore think you must adhere to <u>his</u> plans, I do not think the word 'Economy' ever entered his mind, & I am sure, when I have the pleasure of introducing you under my Roof, you will think so yourself – For my own part I should not object to your addition of coloured Glass, of the <u>most</u> transparent colour & light figures, but I think we must get leave of our <u>Master</u>. It has been my desire to let his fine & correct taste prevail yet I must confess I am not a little astonished at the Beauty & grandeur of our doings.'

Literature. Wedgwood (Pugin's Diary): Pugin visits Burton Closes, 1847, Nov. 24-5. N. Pevsner & E. Williamson, *The Buildings of England: Derbyshire*, Harmondsworth, 1978, corrected 1986, p. 79, says 'Hardman glass from Burton Closes service wing (demolished 1849) is in The Mullions, off Barlow Road.'

24 Derby, St Mary (RC)

*c.*1839.

E, N, S windows of apse	I, nII, sII	1.8m x 6.2m	3-light

Descriptions. **I, nII, sII.** The apse windows, made by Warrington, *c.*1839 (the church opened Oct. 10, 1839), are described in part in the *London & Dublin Weekly Orthodox Journal* for July. The centre window (I) is reported to depict the immaculate Virgin standing arrayed in beams of glory, supported on one side by St Alkmund and on the other by St Werburg. The etching of the interior, in the *Catholic Magazine*, supports this arrangement and also suggests that the side windows (nII, sII) each portrayed in the bottom sections of the windows, three large standing figures, while smaller figures, encircled by foliage, covered the rest, and figures of angels filled the tracery pieces. The windows as they appear today reflect some of these ideas; the central window depicts the Virgin and Child standing in rays of glory, although the supporting saints are absent, and the side windows have the three standing figures in their lower sections and smaller figures encircled, 'Jesse-like', in branches and foliage in the remainder of the glass. Whatever the similarities, however, it would appear that the original windows are no longer in place. In Oct. 1855 *The Builder*, reporting on the near completion of structural and decorative changes to the church, commented: 'The three east windows are of perpendicular glass from Messrs Hardman & Co. of Birmingham. The whole of the works have been carried out from the design of Mr E.W. Pugin assisted in the decoration by Mr. J. Powell, who is also the designer of the glass.' Although the paragraph might be read as referring to Powell's design for the window of the new Pieta Chapel (E end of the S aisle) there seems little doubt that the E windows were replaced. Hardman's Order Book 4, Jan. 27, 1854 records, among others, an order for 3 E windows (Jesses) of 3 lights, and cost sheet No. 76 for 1854 details 3 E windows of 3 lights and tracery, and includes calculations of the quantity and cost of the glass required, together with the costs of cutting, painting and leading etc. as well as that of the cartoons. It seems Powell's designs were influenced by the earlier windows; there is no indication in the documentation that he retained any of the original glass.

Office records. *First Glass Day Book*, 1853, f. 198, Dec. 9: 'To 10 Lights of Cathedral/tinted glass/ 9'0" x 1'8" each.../29 Pieces of Stained/glass Tracery'. W window designed by J.H. Powell.

Literature. *The Builder*, 13, 1855, p. 513. *Catholic Magazine*, 3 1839, pp. 629-30: illustration and description of interior. *London & Dublin Weekly Orthodox Journal*, 7, 1838, pp. 37-8: laying the foundation stone: report from *Derby Mercury*, Jun. 13, 1839; pp. 385-7: illustration and description of exterior; Jul. 13, 1839, pp. 17-20: illustration and description of interior. Warrington 'c.1855(?)', p. 8, records: 'Romanist Chapel, Derby.' 3 Chancel /1 East end of North Aisle and 1 East end of South Aisle': The two latter windows may have been moved as a result of the above changes and could now be the two chancel south side windows, one of which includes Lord and Lady Shrewsbury in the donor positions, in the bottom panels of the window. Wedgwood (Pugin's Diary): Pugin visits Derby, 1837, Sep. 5, Nov. 23-4; 1838, Feb. 20-1,

Apr. 26-8, Jun. 13, 25-6, Sep. 17-18, Nov. 28-9; 1839, Feb. 8-9, Apr. 5-6, Jul. 2, Aug. 8, Sep. 3, 14, 27, Oct. 5-10, p. 44 '[end papers at back of diary] [a] [list of expenses]' Warrington, Derby 64.10.0; 1840 Aug. 10, Oct. 22; 1841, May 7-8, 19; 1842 Apr. 3-4, Sep. 6; 1844, Jun. 11, Aug. 5-6, Sep. 28-9, Dec. 2-4; 1845, Jun. 26-7, Sep. 3-4; 1847 Jul. 31-Aug. 1; 1848, Oct. 11-12; 1850, Apr. 8-9; 1851, Nov. 26-7.

25 Elvaston, Church.[4]
1853. Window designed by J.H. Powell.

Office records. Order Books 2 and 3, 1853. *First Glass Day Book*, 1853, f. 192, Oct. 15: 'To A Stained Glass/Window of 3 Lights/& Tracery being Memorial/Window of a deceased/Child/Centre light 6' 6½" x 1' 4" .../2 Side do 6' 1½" x 1' 4" .../2 pieces Tracery'.

DEVON
26 Alfington, St James & St Anne (CoE)
1852. Client: Hon. Mr Justice Coleridge, Ottery St Mary, Devon.

 E window (**10.5**) I 0.4m x 2.6m (centre lancet), 0.4m x 2.3m (side lancets) £35

Description. **I.** 3-lancet window depicting the Crucifixion. A blue medallion containing Christ on the Cross within a red mandorla bounded by yellow flames is in the centre light and red medallions containing the Virgin in a green-lined, blue, hooded mantle over a purple robe, and St John the Evangelist in a blue-lined, light-green mantle over a green robe, are in the left- and right-hand lights, respectively. Above Christ in a smaller blue medallion is a half-length St Andrew in a red-lined, brown mantle over a light green robe, holding a small diagonal cross in his right hand and a book in his left. Below in a similar medallion is a half-length St Peter in a green-lined, yellow mantle over a red robe, holding the keys in his right hand and a book in his left. Similar medallions above the Virgin and St John contain half-length figures of St James the Great in a red mantle over a green robe, holding a staff (flask attached) in his right hand, and St Paul in a purple-lined, green mantle over a red robe, holding a sword in his left hand and a book in his right, respectively. Most of the paintwork has gone from the faces and hands of the figures. Quarries patterned with a grisaille of oak leaves outlined in black on black hatching fill the remaining areas of the lights. The grisaille is overlain by red trellis-work in the centre lancet and single large red-outlined diamonds crossed by yellow diagonals in the side.

Office records. Order Book, 1851, f. 158, Oct. 27. *First Glass Day Book*, 1852, f. 144, May 14.

Letters. Pugin to Coleridge (held at Chanters House, Ottery St Mary),[5] undated: 'I have your triplet already set out [a drawing of the design is with the letter].' *JHA: Butterfield to Hardman*, undated, the first page is missing: 'I also want some glass to be ready by Easter for a narrow triplet window near Ottery in a temporary church'; Butterfield sketches the lancets, numbers the medallions, and gives their positions and subject matter – all as appear in the finished window. He notes: 'They exceedingly wish St. Peter with or upon his cross but I have negated it in favor [sic] of the keys. Do not you agree? I enclose the templates – you will be a little puzzled by their narrowness. They wish them of the character and tone of the St. Stephen and S. Lawrence windows at the end of the Ottery aisle [Ottery St Mary, Gaz.29].' 1852, Oct. 19: 'with the Alfington windows I am disappointed. The grisaille & subjects are oddly put together and I cannot understand your motive for such an unattractive arrangement.' Oct. 25: 'You had better charge a usual price for Alfington ... I believe no price was named.' *Henry T. Coleridge to Hardman*, 1852: Apr. 1: enquires on behalf of his father, Mr. Justice Coleridge, and himself as to the state of things with the windows for Ottery church and: 'the little church in the neighbourhood, for which you are making an E. window. We have heard with the greatest concern of the affliction which has rendered Mr. Pugin unable to attend to such things.' *J. T. Coleridge to Hardman*, 1852, Nov. 22: 'I enclose a cheque for the Alphington [sic] window ... I believe Mr. Butterfield spoke to you about it – you know how pleased we were with the two [?] windows for the Ottery Chancel Clerestory this window is certainly very inferior – especially as regards the principal figure the Crucifix, which of course one is most desirous to have very well done.'

Literature. For Pugin's visit to the area see Ottery St Mary (Gaz.29).

27 Budleigh Salterton, Bicton Mausoleum
1852. Client: Rt Hon. Lady Rolle, Bicton, near Sidmouth.

 E, W windows I, wI 1.6m x 2.8m 3-light £95

Descriptions. **I.** 3-light window and tracery. The Resurrection is depicted in the centre light under a yellow-crocketed,

pinnacled and gabled canopy. Over the canopy is a multi-pinnacled, yellow-crocketed and gabled superstructure. Three blue diaper quatrefoil medallions containing half-length angels holding texts are in each of the side lights. The remaining areas of the side lights are filled with quarries patterned with a grisaille of oak leaves overlain by a red diamond trelliswork. The borders in the side lights are patterned with leaves on undulating stems. The five main tracery-pieces are filled with green, white, yellow and blue geometrically arranged leaf patterns.

wI. 3-light window and tracery. A biblical scene under a canopy surmounted by yellow-crocketed and finialed gables is contained in each of the lights. The top and bottom panels are filled with a grisaille of white oak leaves outlined in black against a black-hatched ground, overlain by red-outlined quatrefoils crossed by yellow-beaded diagonals. From left to right the scenes are: Raising of Jairus's daughter(?) (inscription beneath: 'Intravit et tenuit Manuum et [?]'); Raising of Lazarus ('Lazare veni foras [?]'); and Raising of the Widow's Son ('Adolescens Tibi dico surge'). The five main tracery-pieces are filled with patterns of white flowers on intertwining yellow stems, against red grounds.

Office records. Order Book, 1851, f. 156, Oct. 27. *First Glass Day Book*, 1852, f. 141, Apr. 6.

Letters. *P. Stanton, thesis catalogue, Pugin to the Earl of Shrewsbury*, 185(?): 'I went to Bicton, I found Lady Rolle a very cheerful happy sort of woman but with dreadful ideas on architecture. She actually suggested a sort of Turkish morgue with light coming in from the top for a <u>mausoleum</u>. however I managed so well that in half an hour she consented to call it a mortuary chapel, to have 2 stained glass windows and a proper ceiling with armorial bearings.'

HLRO 304: Pugin to Hardman, letter no. 111: 'you will receive the cartoons for Lady Rolles in a few days'. No. 530: '2. Lady Rolles windows cartoons are going tonight pray remember <u>galvanised bars</u> for both must go with the glass.' No. 679: 'you will have to prepare the bars for Lady Rolles Church windows upright & horizontal & as you will have the cartoons you will be able to decide this properly make a note of this.' No. 642: 'I have to go down to Exeter by the express about that unfortunate Lady Rolles Chapel her cartoons are just done pray knock off the windows.' No. 659: ' I have just received the most insulting letter from Lady Rolles [sic] ever written to an artist'. No. 524: 'I got a kind letter from Lady Rolles [sic] at last. She begins to be pleased.' *JHA: Thomas Early to Hardman*, 1852, Apr.: 'I have had a deal of Trouble with Lady Rolles [sic] she is very hard to please or deal with she has just been with me and is furious about the Glass. I told her it was in hand and that you would forward it as soon as you possibly could. She made a great many Ill natured remarks about Mr. Pugins veracity and almost called him a liar. I will strive to conciliate this Antiquated Old Lady and make her pass the work. as to pleasing her that I think is out of the question'. Apr. 5: 'please to Direct the Glass to me at Bicton Church. To be left at Exeter Station till called for … Do not let it trouble you the Least about any unkind remarks L. Rolles [sic] may have made concerning poor Mr. Pugin as she is a person utterly devoid of every feeling that elevates human nature from the Beastly creatures.' 'Easter Monday': 'The glass arrived at Exeter station on Saturday night. I have been at it since 5 this morning. There is a bad job. The Bars of Windows come across the faces of figures so I am compelled to remove them to suit the glass. I have a mason from Sidmouth to do this.'

Literature. Atterbury & Wainwright (1994), p. 204, contains an illustration of wI. For Pugin's visits to the area see Ottery St Mary (Gaz.29).

28 Ilfracombe, Church[6]

1852. Tracery designed by J.H. Powell.

Office records. Order Books 2, 3, 1852, Sep. 18. *First Glass Day Book* 1852, f. 164, Dec. 9: 'To A piece of Stained/Glass Tracery set/with Figure of Angel'.

29 Ottery St Mary, St Mary (CoE)

1850-5. Clients: Rev. R. H. Podmore (nIV, sIV, NIII), J.D. Coleridge, Heaths Court, Ottery St Mary (nVI), Mr Digby, builder, Ottery St Mary (SIII), F.G. Coleridge, Ottery St Mary Court, (NII, SII, oratory), Hon. Mr Justice Coleridge (NIV, SIV, NV, SV). Supervising architect: William Butterfield.

E windows, N & S aisles (**10.6**)	nIV, sIV	0.2m x 0.7m	2-light	£24	1850
N transept E window (**8.3**)	nVI	1.9m x 2.5m	5-light	£47.10	1850
Clerestory windows	NII, SII	2.1m x 1.9m	3-light	£15	1850
Clerestory windows	NIII, SIII	2.7m x 1.9m	3-light	£60	1850
W wall, quatrefoil windows	NVIII, SVIII	c.0.7m x 0.7m			c.mid-1850
Clerestory windows	NIV, SIV	2.7m x 1.9m	3-light	£60	1852
Clerestory windows	NV, SV	2.7m x 1.9m	3-light		1853
Clerestory windows	NVI, SVI	2.7m x 1.9m	3-light		1854

Clerestory windows	NVII, SVII	2.7m x 1.9m	3-light	1855	
E window (**7.1**)	I		8-light	1855	

Windows NV–NVII, SV–SVII, I designed by J.H. Powell

Descriptions. nIV. 2-lancet window. The lancets are made up of a grisaille of white flowers on yellow stems with each containing a figured-red medallion. St Lawrence in a blue-lined, white robe stands in the left-hand medallion holding a book in his right hand and a gridiron in his left. The martyrdom of the saint is depicted in the right-hand medallion.
sIV. 2-lancet window, as for nIV. St Stephen in a white robe stands in the left-hand medallion holding a book in his left hand and an incense burner in his right. A large stone rests on the top of his head. The light had been restored in recent years. The martyrdom of the saint is depicted in the right-hand medallion.
nVI. 5-lancet window. The two outer lancets each contain four angel-figured medallions, the two inner lancets, six, red figured medallions and the centre lancet five, blue. The rest of the lancets are made up of panels of white, yellow silver stain leaf-patterned grisaille. The figures in the medallions are from the top down: centre lancet: Blessed Virgin, St Joseph, Agnus Dei, St John the Baptist, St Augustine. Left-hand, inner lancet St Agnes, St Mildred(?), St Peter, St Benedict, St Edward, St Oswald(?): right-hand, inner lancet St Catherine, St Etheldreda, St Paul. St Bernard, unidentified, St Thomas Cant(?).
NII. 3-light window made up of yellow silver stain-patterned quarries, with a line of alternating leaf-patterned red and blue roundels down the middle of the centre light and yellow roundels down the side lights. The borders are of red, yellow, blue and white glass.
SII. 3-light window. The stained glass has been replaced by plain.
NIII. 3-light window depicting Christ on the Cross with angels around the top of the cross in the centre light. The Virgin Mary in a green-lined, blue, hooded mantle over a purple robe is in the left-hand light and St John the Evangelist in a light-blue-lined, greenish-blue mantle over a purple robe in the right. A white grisaille overlain by quatrefoils and diamonds outlined in red and blue respectively, fills the remaining areas of the lights. The borders are patterned with white flowers on undulating yellow stems against red and blue grounds.
SIII. 3-light window. As for NIII except that Christ in Majesty with two of the emblems of the Evangelists holding texts, above his head and the other two beneath his feet, is depicted in the centre light, and kneeling angels holding texts in the side lights.
NVIII, SVIII. Single quatrefoil windows containing depictions of the Archangels Michael and Gabriel respectively, on red grounds. These windows are not recorded in the First Glass Day Book but are attributed to Pugin by J.D. Coleridge in *The Ecclesiologist*, Apr. 1852 (see *Literature* below): Pugin mentions them in one of his letters (see HLRO 304, Pugin to Hardman, letter no. 693 below).
Office records. *Order Book*, undated, f. 71 (nIV, sIV, NIII); undated, f. 70 (nVI, SIII), re SIII: 'Inscription to read: "Presented by Tradesmen of this town & date" to be sent to Mr. Digby, Mason, Ottery St Mary'; undated, f. 57 (NII, SII); 1851, f. 159, Oct. 27 (NIV, SIV), re SIV 'Inscription to read "To memory of his dear Parents by J.T. Coleridge 1851"'; 1853, Book 2, f. 64, re NV, SV 'In both above windows Our Lord to be alone'; Book 3, f. 38 (NV, SV), f. 162, 1854, Mar. 15: ' 2 windows of 3 lights [NVI, SVI]. Order Book 4, 1855 Jan. 9: '2 remaining windows of series: Chancel Clerestory: Epiphany and Circumcision'; May 8: 'E window 8 lights – Te Deum – Hon. Mr. Justice Coleridge.' *First Glass Day Book*, 1850, f. 80, Feb. 12 (nIV, sIV), Feb. 26 (NIII), f. 81, Mar. 6 (nVI, SIII), f. 89, May 9 (NII, SII),. 1852, ff. 154-5, Aug. 6 (NIV, SIV, subjects – the Ascension of Our Lord & the Buffeting of Our Lord), f. 155, Aug. 27: 'To A stained Glass Window/ of one light for Oratory/1 light 4'10" x 1'0" Subject – "The Crucifixion"'; 1853, f. 192, Oct. 15 (NV, SV, subjects – 'The Scourging of Our Lord & The Resurrection'). *Cartoon costs per ledger summary:* NIII, Powell 15s.0d, Oliphant £4.12.6; nVI, Powell £4.15.0, Hendren £1.5.0; SIII, Powell £3.15.0; SIV Powell £1.0.0. Oliphant's account records the payment was in respect of: '3 Cartoons for Crucifixion Window'.
Letters. nIV, sIV. *HLRO 304: Pugin to Hardman*, letter no. 282: 'what a man you are the 2 saints Ottery are in the East windows of the chapels. & the 2 martyrdoms North & South'. No. 226: 'as regards the order of the Ottery Windows, the 2 saints to the East thus [indicates St Stephen and his martyrdom to the left, and St Lawrence and his martyrdom to the right]'.
NVI. *6 letters (5 undated) held at the Chanter's House, Ottery St Mary. Pugin to Mr Justice Coleridge*, 1849, Nov. 9: 'Mr Welby Pugin by desire of Mr. Butterfield the architect has enclosed a coloured sketch of a [?] light of an East window in the church of S. Mary Ottery for Mr. Justice Coleridges approval. The lights are unfortunately very narrow & will necessarily require a great mixture of grisaille or they would produce too dark an effect. The present design has been arranged to meet this difficulty & also to suit the contracted width.' Undated: 'I can assure you the arrangement I proposed for

the saints was based on a regular plan. If you remember in a former [?] letter you expressed a wish to realise as far as possible the <u>adoration of the Lamb</u> – & in this subject – the various orders and dignitaries[?] & [?] should be represented – hence S. John the precursor. on the highest[?] Our Blessed Lady. S. Peter & Paul for the Apostles. S. Katherine [sic] & S. agnes virgins S. Benedict & S. Bernard Religious Orders S. Mildred[?] & S. Etheldreda Do & Queens S. Edward & S. Edmund[?] kings S. Oswald & S. Thomas Bishops york & canterbury But of course I have no other desire than to meet your wishes – & will willingly prepare fresh cartoons of the heads. The only priest to which I find an objection is that of St. Francis of Sales. he had nothing to do with this country & he flourished at a time when ecclesiastical costume was so debased that it is surely impossible to introduce a representation of him without having an absurb appearance. the french mitres of the 17 century will ill accord with the grandeur of Ottery S. Marys built in the [?] time – so I hope you will substitute some older saint more in character with this kind of window. I can easily manage the inscription in the bottom of the centre light & if this new arrangement of saints is in accordance with your wishes please to let me know & I will finish the window accordingly I trust you will see that my arrangement was not one made at hazard but based on your original proposition – for which it was quite appropriate but the new arrangement is very good. only I am sorry to lose S. Edward the Confessor as he was connected with the church of Ottery. Do you object to substitute him for S. Benedict?' Undated: 'The heads are all done for your window. They consist of The B. Virgin, S. John the Baptist, S. John evangelist, St. Peter, S. Paul, S. Katherine, S. Edward, S [?], S. Bernard, S. Benedict & 2 Queens – In stained glass the effect must be produced by strong lines – to tell at a distance it is quite impossible to make glass from Prints or finished drawings they would look tame & miserable – I fully intend to introduce the inscriptions on the labels held by the lower angels – there is no space at the bottom & to make one we should be obliged to prepare fresh cartoons of the whole as nothing can be cut off a geometrical window ... I should imagine the whole window will be completed in 6 weeks.' Undated: 'I am very glad indeed to find you are pleased with your window. I cannot offer you the least explanation about the line[?] of the medalions [sic] they were certainly lined[?] in the cartoons or appeared so & I took the greatest pains in their adjustment if I saw the window with you I should be better able to speak on the matter but I cannot conceive how the irregularity can be produced.' *HLRO 304: Pugin to Hardman*, letter no. 836: 'Butterfield wants me to send a <u>coloured</u> sketch of the Lancet windows for Ottery St. Mary to judge!!!!!!!!!!! colours by [?] & you have the size send it to me by return I assure you if there is so much bother I shall soon cut his work. I am sick of this already.' No. 977: 'I will send you the Ottery window tomorrow I know the church. his suggestions will not do. it must be something very simple for such narrow lights. it is impossible to get subjects or anything of that kind.' No. 972: 'There is only one way of treating the window of S. Mary Ottery of which I send you a sketch. a geometrical pattern with circles & angels with inscriptions one of the circles in the centre light can have a Lamb if they wish it. the holy saints would be ridiculous for a Lad 15 years of age. I was a regular scamp long before that. they are quite inappropriate after 2½ or 3 at outside ... they will look very well as I propose them if you have nice white glass. No. 908: 'I have had so much trouble with everything on Mr. Coleridge window – there is hardly 8 inches of room & he wants all sorts of saints & things – I am worn out with it we have had to alter all the heads again after they were done. I assure you the letters have taken me double the time of the designs with troublesome people the letters written is immense. – I am sick of him he is humbug.' No. 917: 'The heads for Mr. Coleridges window have been done 3 times & after we changed them the last time he writes today that he would keep my original arrangement in preference to anything else!!!' No. 856: 'I send you a letter of Mr. Coleridge I dont know what he means about the medallions [see *J.D. Coleridge to Hardman*, 1850, Mar. 22, and Pugin's second undated letter to Mr Justice Coleridge]'. *JHA: J.D. Coleridge to Hardman*, 1849, Sep. 25: 'My brother & sister & myself wish to make it [sVI] in some degree a memorial window of a brother who died some years ago at the age of 15 we had thought of small figures of [?] saints in medallions with the figure of the Blessed Lord as a child in the centre ... Mr Butterfield & Co is restoring the church seemed to prefer a number of little angels in medallions. He was of the opinion the way to treat the window was in <u>bands</u> of colour with a great deal of light glass between the bands It certainly should not in my judgement be a dark or very rich window & I think Mr. Butterfield is of the same mind. It occurred to me whether it might be made an <u>Innocents</u> window – spotless Lamb in the centre as in Van Eyck's great picture at Ghent.' 1850, Mar. 22: asks for the amount of indebtedness for the window: 'The only point I regret is that the medallions <u>below</u> the Lamb in the centre light are not in line with those in the side lights – This could <u>not</u> be the case with those above the Lamb but I think the effect would have been better if it had been so with those below ... In all other respects I admire the window very much ... It is far the best window in the church & has a very good position.' **NIII, SIII.** *HLRO 304: Pugin to Hardman*, letter no. 895: 'I am afraid we have got into a great mistake[?] about the Clerestory windows at Ottery St. Marys. I estimated them for the size originally set out but now we have got the real templates. The side lights are only <u>1.6</u> wide & <u>2 feet</u> to the spring so that we must correct our estimate. I should think £30 plenty for each window. I have got an order for a third window of the same kind. I wish you to write to Butterfield

about it for our first price must appear tremendous for the size.' No. 899: ' I am very glad you wrote to Mr Butterfield. I assure you when the windows were set out they looked ridiculous the spandril [sic] I thought a fine Large open space only a triangle of 3 inches.' No. 934: 'I find the tradesmen give the the [sic] <u>majesty</u> window for Ottery & not the crucifixion.' No. 642: 'There is also that window at Ottery St. Mary of the ascension that is very important.' *JHA: Butterfield to Hardman*, 1850, Mar. 25, asks for accounts for: NIII, SIII, nVI, nIV, sIV, nII, SII and the oratory window; to be sent to the various people (as indicated in the First Glass Day Book and listed as clients above).

NII, SII. *HLRO 304: Pugin to Hardman*, letter no. 859 (see also no. 693 below): 'you better send me the dimensions of the 2 clerestory windows for Ottery that are to have only grisaille and I will get them set out.' No. 856: 'you have sent me the window Mr Butterfield sent you for Ottery to be filled in with geometrical work only – have you heard anything of the other windows are they fixed & what is the result? You must tell me everything about the work'. No. 699: 'they are making the cartoons now they are only <u>quarry</u> windows with a border & c.' *JHA: Butterfield to Hardman*, 1850, May 2: asks when the two grisaille clerestory windows will be sent to Ottery.

NVIII, SVIII. *HLRO 304: Pugin to Hardman,* letter no. 693: '2 Quatrefoils for Ottery S, Mary go off tonight they are badly wanted. it is a new order and then if possible with the Quarry windows [NII, SII]'. *JHA: Butterfield to Hardman,* 1850, May 2: queries when the two quatrefoils with the Archangels will be sent to Ottery.

Not identified to specific windows. *HLRO 304: Pugin to Hardman*, letter no. 958: 'I had a letter from Butterfield today ordering 4 more windows for Ottery S. Marys. It appears to me that we shall be great[?] window makers if we do something transcendent.' No. 822: 'I got settled with Butterfield for all his windows & also Mr. Coleridge so that it is a good job.' No. 938: '2. The Ottery window goes tonight.' No. 937: 'I have told Powell to finish off the Ottery window & send it to you.' No. 846: 'The Ottery windows convince me that we cannot <u>draw</u> on a <u>cartoon</u> what is required to make a good decorated window it should be done on the <u>glass</u> & till you have somebody who can do this we can do <u>nothing</u> I know how it should be done now but it cant be rendered in a cartoon'.

Literature. J.D. Coleridge, 'Restoration of Ottery S. Mary Collegiate Church', *The Ecclesiologist*, 13, 1852, pp. 79-88. Wedgwood (Pugin's Diary): Pugin visits Exeter, 1841, Jul. 11-12, 14-15; 1844, Oct. 16-18; 1847, Aug. 25-6; Oct. 4-5; 1850, Feb. 28-Mar. 1; 1851, Dec. 1-2.

30 Stoke Canon, St Mary Magdalene (CoE)

1850. Client: Ralph Barnes, Bellairs, Exeter.

S aisle window (**10.7a & b**)	sII	1.7m x 2.8m	3-light	£70

Description. sII. 3-light window and tracery. Christ in a green-lined, red mantle over a white robe, holding a crossed staff in his left hand, is depicted frontally-posed, against a blue diaper ground, in the centre light. He stands under a vaulted canopy above which is a crocketed and pinnacled gable and a conical topped tower (shown in perspective). Four members of the Barnes family, one above the other, kneeling in profile against alternately red and blue diaper grounds, are portrayed in each of the side lights. A scroll inscribed with name and year of death arcs behind each of their heads. A further figure – Ralph Barnes's wife – kneels against a red diaper ground below Christ. She was included late in the design which is, perhaps, the reason that she disturbs the symmetry of the window (see *Letters*, Ralph Barnes to Pugin, Mar. 28 1850, below). Each of the four main tracery-pieces contains a representation of a standing angel against a red diaper ground, holding a shield inscribed with the yellow silver stain letter B – of a monogram in which the other letters, in black, are alternately r and c. In the bottom margin of the window there is a Latin inscription commencing 'in memoriam' and on a plaque beneath the window one in English reading: 'Sacred to the Memory of Augusta second daughter of Ralph Barnes of Exeter. Died 15th October 1901 aged 90. I will lay me down in peace and take my rest'.

Office records. Order Book, 1850, f. 96, Aug. 4. *First Glass Day Book*, 1850, f. 105, Nov. 19. *Cartoon costs per ledger summary*: Powell £7.10.0.

Letters. HLRO 304: Pugin to Hardman, letter no. 732: 'Ralph Barnes Esq window for Exeter is finished It is a first rate job at last.' No. 112: 'It is just possible that I told you £100 for that Exeter window as I see my figures in 2 places but it is very important I made an estimate & I wish you had charged 70 & seen what turned up. it appeared to me a small window very narrow lights [inset at the top: 'if you have not sent the bill to Exeter charge £70 & try it on']'. *JHA: Barnes to Pugin*, 1850, Mar. 28: 'My friend the Revd. Willm Mallock corresponded with you some years ago, as to a design for a Memorial Window, intended to be put up in the Parish Church of Stoke Canon to the memory of my 8 children. I have since lost my wife, their mother, and I am desirous of completing this work ... I approve of your design – that is I think the only figure in the centre of the 3 lights, is just what I like and prefer it to the Virgin. How to record or portray the memorial of my wife, I am at a loss to say I wish for your suggestions therein. There <u>could</u> be an inscription on brass

beneath, but I do not inquire, how to have any special regard to it in the Window yet I would, if I well could. [P.S.] In this change of circumstances, you are not confined to this design. I would wish to judge of the Colours as far as possible. Instead of Shields, Christian symbols.' *Anna Barnes to Hardman*, 1850, Nov. 21: 'This day we have seen the window in the Stoke Canon Church which you executed for Mr Pugin and beg to inform you that we are very much pleased – the colours are very rich and sober and the whole effect beautiful'. (Another letter of the same date also mentions seeing that day the 'memorial window' and expresses pleasure with the design. It begins 'Dear Sir' and was, perhaps, to Pugin. Extracts from this letter are as follows: 'The execution of the colours is also most pleasing – and the expressions of the countenances also – particularly that of the second on the left, as you look at the window – There is only one omission, that of our late mother's first name – the scroll bears this 'A Charlotte' instead of 'Augusta Charlotte'. The violet robe on this figure is peculiarly happy – and the deep red robe on that of our Lord – The whole effect is good in the Church and gives size to the window – The letters of memorial at the base are too crowded to be very legible this might be avoided another time – Mr. Barnes would feel obliged by your Account.').

Literature. Wedgwood (Pugin's Diary), for Pugin's visits to Exeter see Gaz.29.

31 Upton Pyne, Our Lady (CoE)

1851. Client: Sir Stafford H. Northcote, Bart, Exeter.

N aisle E window (**7.5a & b**)	nII	1.6m x 3.0m	3-light	£60	
N aisle window (**6.9a–c**)	nV	1.3m x 2.5m	3-light	£50	

Descriptions. **nII**. 3-light window and tracery. Each light contains two scenes under canopies, one above the other, depicting, against blue diaper grounds, incidents from the lives of Christ and the Virgin Mary. From left to right those in the upper sections are: Agony in the Garden, Crucifixion, Resurrection and in the lower: Annunciation, Nativity, Adoration of the Kings. An identifying Latin text is inscribed in black-on-white in the margin beneath each scene. The canopies are vaulted, in perspective, and similar to those for Stoke Canon (Gaz.30) except that the tops of the towers in the upper canopies are domed rather than conical. The four main tracery-pieces are lozenge-shaped, filled with white floral diaper and each contains a roundel inscribed in red-on-black with the initials SHN. A plaque at the side of the window reads: 'This window was erected in AD1850 in memory of Henry Stafford Northcote Esq of Pynes. Born Mar 18th 1792 died Feb 22nd 1850. The Eternal God is thy refuge'.

nV. 3-light window and tracery. Christ in a dark blue-lined, red mantle over a light-blue robe, holding a crossed staff attached to which is a red, yellow-crossed banner and with an inscribed scroll undulating down from over his right wrist, is depicted standing in the centre light against a green diaper screen. The Raising of Lazarus is depicted in the left-hand light and the Raising of Jairus's Daughter in the right. The four main tracery-pieces are lozenge-shaped and are filled with red flower patterns around white rosette centres, flanked by white scroll-like leaves all on blue grounds. A plaque at the side of the window reads: 'This window was erected in 1851 in memory of Sir Stafford Henry Northcote Bart of Pynes. Born Oct 6th 1762 died March 17th 1851. My flesh shall rest in hope'.

Office records. *Order Book*, 1850, f. 8, May 23. *First Glass Day Book*, 1851, f. 125, Sep. 8.

Letters. **nII**. *HLRO 304: Pugin to Hardman*, letter no. 714: 'That must be a very foolish man about the windows how would he imagine we would get 9 scriptural subjects into such a space as that why they would look like German medallions in one piece it will not do I send you a sketch in character for 6 subjects I have taken 3 joyful & 3 dolours but you can explain it to him & can have any 6 subjects that do not require too many figures the 9 medallions cannot be done I should think the window would be worth about £50 that is about 25 feet.' *JHA: Letter Book, Hardman to Northcote*, 1850, May 8: 'I cannot get in more than six subjects as it would not do to introduce them in circles in a window of this date.' *Letters, Northcote to Hardman*, 1850, May 3: 'Being desirous to put a memorial window in a country church I have been advised by Mr Justice Coleridge [see Ottery St Mary, Gaz.29] to apply to you for a design. My own fancy is to have 9 (or 6) circular subjects each taking up the greater part of two of the present panes. I do not know whether the window is large enough to admit of these being representations of Scriptural scenes containing more than one figure. Whatever is introduced should be very simple and intelligible, as the congregation is a poor and uneducated one, and the inscriptions should be easily legible. A few texts which occur to me as appropriate, if texts are introduced are 'Blessed are the dead that die in the Lord' – 'Blessed are the meek'. 'Blessed are the merciful' But you will be the best judge whether the introduction of texts is suitable. May 22: 'I like the design very much, but should prefer the Resurrection to the Descent from the Cross for the last subject and perhaps you will make this alteration. I will have a brass plate engraved with the inscription and placed underneath it will be very short merely recording the name and age, and a single text of scripture. I will tomorrow send you the bearings for the four shields'. May 25: 'I sent you yesterday four coats of arms

for the four shields in the window at Upton Pyne. The first were the arms of my Grandfather Sir Stafford Northcote (impaling Baring), the second those of my father impaling my mother's arms (Cockburn), the third those of my father impaling his second wife's arms (Robbins), and the fourth my own and my wife's (Farrer). I have since however thought that I should like to put the arms of my father and those of both his wives in one shield, and to put my son's arms in the fourth shield, as it is not often that four generations are in existence together as in our case. I do not know how my boys arms ought to be given: strictly speaking I suppose there should be a label on my father's, a double label on mine, and a third label on his, but this is rather awkward to draw. As my mother was an heiress I might quarter the Cockburn arms, and my son might bear my arms, quartering Cockburn, with a label for difference. But probably you will understand these things better than I do, and I will leave it to you to arrange them. I have sketched my idea of them on the other side.' Aug. 16: 'as the shields are too small for them [the arms] they cannot be introduced, and I will leave the filling up of the shields to your judgement. If initials are introduced they might be S.H.N., H.S.N., S.W.N., and W.S.N. to correspond with the proposed bearings: but I think that such small shields had perhaps better be plain and of a single colour. [The shields probably appear in the bottom sections of the lights which are obscured by the reredos]'.

nV. *HLRO 304: Pugin to Hardman*, letter no. 118: 'I think we have made a good [grand(?)] job of S. Stafford Northcotes window it is gone tonight. if well carried out it will be <u>brilliant</u>.' *JHA: Northcote to Hardman*, 1851, Mar. 26: asks for a window to be made in memory of his grandfather Sir Stafford Northcote in addition to the one being put up in memory of his father and for subjects to be proposed: 'It will be next to the one in memory of my father, but the aspect is North instead of East, and the size of the window is rather greater'. Apr. 5: 'Sir Stafford Northcote presents his compliments to Mr. Hardman and will feel obliged by his proceeding with the design for the second window'. *Letter Book, Hardman to Northcote*, 1851, Apr. 1: suggests for the subject matter: 'Our Lord in centre – raising of Lazarus & Daughter of Jairus on sides'.

nII, nV. *JHA: Letters, Northcote to Hardman*, 1851, Aug. 9: asks when he may expect windows. Sep. 20: 'I understand from my Uncle that the windows have been put up in Upton Pyne Church and he expresses himself much pleased with them.'

32 Zeal Monachorum, St Peter (CoE)

1851. Client: Rev. Edward Cooper. Agent: F.W. Oliphant.

E window	I	2.0m x 3.6m	3-light	£61

Oliphant is recorded in the First Glass Day Book in the same way as the supervising architects for other windows, hence he has been described here as an agent. It is possible that by the time the window was ordered, Oliphant had left Hardman's employ. There is nothing to indicate that the usual procedure of Pugin producing the initial design sketch was not followed, but the information in the Order Book taken with Oliphant's letter to Hardman of Aug. 21, 1851 (for both, see below), seems to suggest that Oliphant's cartoons were not supervised by Pugin.

Description. **I.** 3-light window and tracery. Christ in a green-lined, red mantle over a blue-green robe, holding an orb in his left hand, is depicted standing under a canopy, in front of an orange diaper screen in the centre light. Over the cinquefoil canopy head is a yellow-crocketed and finialed gable behind which rises a pinnacled and gabled Gothic window superstructure. The margin at the bottom of the light is inscribed: 'Thou art King of Glory O Christ'. St Peter in a green-lined, red mantle over an orange robe holding two keys, one yellow silver stain, the other white, in his right hand and a book in his left is portrayed standing under a canopy in front of a blue diaper screen, in the left-hand light. St Paul in a white-lined, purple mantle over a green robe holding an upraised sword in his right hand and a book in his left is posed likewise in the right. Both canopies are similar to the one in the centre light. The main tracery-piece is a circle containing a blue-winged, angel in a green mantle over a white robe holding a text. Attached to the circle are six lobes, each containing an angel. Below the window is a brass plaque inscribed: 'To the Glory of God. In memory of Caroline Matilda Robins & John her brother. Jesus Mercy Amen'.

Office records. *Order Book*, 1851, f. 136, Jul. 5: 'For Captain Cocks & Mrs Cooper. £M[8] to be paid to F.W. Oliphant Esq for cartoons'. *First Glass Day Book*, 1851, f. 122, Aug. 27.

Letters. *JHA: Oliphant to Hardman*, 1851, Aug. 15: 'am very glad the window is completed.' Aug. 21: 'I have a note today from Capt. Cocks from Ledbury – he says window is to be sent to Mrs. Cooper, Zeal Monachorum, Crediton, Devon & the account also to be sent with it – it was arranged with Mr. Pugin for £53 and £8 added to my part of the cartoons making in all £61.' *Edward Cooper to Hardman*, 1851, Sep. 25: 'The stained glass windows you sent to me by direction of Capt. Cocks arrived quite safe.'

Literature. Wedgwood (Pugin's Diary) for Pugin's visits to Exeter, see Gaz.29.

DORSET

33 Beaminster Church, St Mary[7]

1852. Client: Mrs Peter Cox, Beaminster, Dorset.

The order date for the window would appear to rule out Pugin's involvement, although Anne Cox's letters (see below) could mean that he produced the initial design sketch.

Office records. Order Book, 1852, f. 165, Feb. 20: 'Inscription: 'In memory of Peter, only son of Peter & Anne Cox, who died at Bekfeya on Mount Lebanon 11th September 1850 aged 23.' *First Glass Day Book*, 1852, f. 152, Aug. 6: 'To A Window of Stained Glass/of 2 lights & Tracery for/South side of Chancel/2 Lights 7'1" x 1'6" .../& Tracery piece .../.../Memorial window to Mr/Peter Cox/Subjects in Medallions/1. "Resurrection". 2. "Ascension". 3. "Our Lord speaking to Martha". 4. Our Lord healing the/Nobleman's Son" £38.10.0', f. 162, Nov. 15: 'To 2 pieces of Stained/Glass for Heads of Lights/upper part of 2 light window £2.10.0'.

Letter. JHA: Anne Cox to Hardman, 1852, Apr. 28: 'It is with much regret we have heard of the illness of Mr. Pugin, although not known personally to us the interest he has taken in a window he has been superintending ... Mr. Pugin has always written to our friend the Revd RF Meredith of Leuscombe Rectory[sic]'. Jul. 13: confirms window completed. Jul. 29: 'we regret that we cannot have the pleasure of offering Mr. Pugin our thanks for so beautifully carrying out our wishes as to the subjects of the window.'

34 Canford Manor, Poole. Now Canford School

1850. Client: Sir John Guest, Bart. Supervising architect: Charles Barry.

E window of hall	I	5.0m x 3.3m	7-light	£132
Staircase window	nII	3.7m x 4.1m	5-light	£61
W window of hall	wI	5.0m x 3.3m	7-light	£132

Descriptions. **I, wI.** 7-light windows and tracery. Each light is made up of yellow silver stain floral-patterned quarries and contains two shields of arms, one above the other, in roundels surmounted by crowns (the crown is missing from the bottom roundel in the light on the extreme right of wI). Above and below the bottom shield in each light is a diagonal strip inscribed with a motto. The borders are patterned with crowns, lions and *fleur-de-lis*. Each of the tracery pieces contains a coloured motif in a roundel.

nII. 5-light window and tracery. Each light is made up of yellow silver stain patterned quarries and has a shield of arms in its upper section. Beneath each of the shields are three diagonal strips inscribed with mottoes. The rectangular panels containing shields of arms beneath each light, including that with a portrait of Queen Victoria in the centre one, appear, on stylistic grounds, to be later additions.

Every tracery-piece contains a motif which reading across and from the top down includes: two feathers(?), a shell, a cross, a king's head, a lion, a beehive, a red hand, a swan, a bolt, a crown, a shield and a bird.

Office records. Order Book, 1850, f. 120, Oct. 25. *First Glass Day Book*, 1850, f. 110, Dec. 26 (I, nII & wI); 1851; f. 118, Jun. 28: 'Making small sized draw/ings for inspection of all the Shields in above Windows [I. nII & wI]; £9.10.0' Jul. 12: 'Alterations in Shields East & West Windows of Hall/& Staircase Windows [I, wI, nII] New/Glass & c'. *Cartoon costs per ledger summary:* I, nII, wI, J.H. Powell £20.

Letters. HLRO 304: Pugin to Hardman, letter no. 740: 'I have sent all the [?] iron work for Canford full size & the documents Mr. Barry sent so you can make the best of them.' No. 483: 'You must return instantly all the documents for the Canford Windows for they [?] our cartoons are not like them let me have them by fast train I am wild with all this'. No. 482: 'no Canford Cartoons have arrived and I have to meet Mr. Barry tomorrow like a fool without anything to say Powell now says that the small sketches dont resemble the cartoons – that he put g for gules & Hendren thought it was green & coloured it so, & all sorts of similar things so I can do nothing if the cartoons had been sent out by a fast train I should have had a triumphant case[?] but as it is I can say nothing & look like a fool this is our most stupid job – Queen Adalaide [sic] was over on the wrong side of the impalement.' *JHA: Barry to Pugin*, 1850, Oct. 2: 'I have contrived after much trouble to secure out of my Dorsetshire Client an allowance of £325 for three painted windows provided they can be got ready for Christmas. I wish Hardman of course to do them if he can for the sum which I think he can from what he said to me about price when last in Town and I enclose tracings of the Design of the windows on which I have pencilled the treatment I should wish to be adopted in the glass. The ground a clear glass and plenty of white throughout. – A very simple pattern on the quarries in yellow or white would I think look better & give more effect to the positive colours of the Heraldry than a pearl colour. I have written in the tracery all the information I have as yet

received as to the Heraldry from my <u>Lady</u> Client who is vastly curious in such matters. The remainder I am to receive from her in a few days.' Oct. 9: 'Herewith I send to you the data[?] for all the Heraldry for the Canford Windows which I have just received – The [?] across the Lights may take the mottoes where there are any, but where they are [?] the names of the party to whom the arms belong. The border round the lights may be, the Lion of England and the Fleur de Lys alternately. The Head of the window might be fitted in provisionally with badges of the owners of the arms below where they are given such as 'Swan feathers' Cross moline, Palm tree the badge of the Family ancesters and cyphers of C & J G the present owners of the House.' Barry to Hardman, 1851, Jan. 7: 'I am again earnestly importuned by Lady Charlotte Guest for the drawings of the arms for the Canford Windows which I trust are in hand & far advanced towards completion I am going to Canford towards the end of the week and should much like to take them with me – Do therefore make an effort and let me have them together with the authorities if they should be with you and not with Pugin, from which they were sketched for the Cartoons – let me know also in what state the Glass is at present and when it will be ready for delivery which must not however take place until Lady Charlotte is satisfied that all is correct from the Drawings which she requires – '. *Letter Book, Hardman to Barry*, 1851, Jan. 8: 'I did not lose a moment after I left you in making arrangments about the Drawings of the arms for Canford and they are being done at Ramsgate. ... I have sent a copy of yours down to Mr. Pugin by this morning's post & have requested him to forward them to you as soon as possible.'

35 Milton Abbey (CoE)

1848. Client: Lord Portarlington.

S transept S window (**7.9a-d**)	sXI	5.5m x 7.3m	7-light	£400

Description. sXI. 7-light Jesse window and tracery. Each light contains representations of three of the ancestors of Christ. At the bottom of the centre light is the seated figure of Jesse and at the top, that of the Virgin and Child. The ancestors are crowned and stand, in frontal poses, holding sceptres in their right hands (five hold them in their left) apart from David (alongside Jesse) who holds a harp. They are in mainly green, red, orange, purple and yellow robes with touches of white and blue. The Virgin is in a purple-lined yellow robe and the Child a red robe. Jesse wears a blue head-dress and is in a green-lined, yellow mantle over a red tunic. Each figure is enclosed in a blue lozenge. Yellow stems with white vine leaves and green bunches of grapes attached, emanate from around the figure of Jesse and from the heads of the bottom row of figures. They climb up the lights, wrap around the lozenges containing the ancestors, and fill the empty spaces within and around them. All the tracery-pieces are blue and each has a red roundel at its centre with green and purple vine leaves and bunches of red grapes, on yellow stems, filling the remaining areas.

Office records. *Order Book*, undated, f. 39: the complete order for Milton Abbey (of which only the Jesse window above was commissioned), comprised:

	£
'South Transept	
4 Windows ea. £100	400
1 Great Window 7 Lights being Jesse Window	400
4 Upper Windows @ £100	400
2 Smaller do. @ £50	100
N Transept	
1 Great Window	450
2 Small do. @ £30	60
Choir	
8 Upper Windows @ £100	800
4 Smaller do. @ £50	200
E Window	250
Aisles	
6 Windows	700
2 Smaller do. £65	130'

(Total £3,890, instead of Pugin's £4,020 – see *Letters, Pugin to Hardman*, 1847)

First Glass Day Book, 1848, f. 45, Nov. 2, f. 48 (sXI), Nov. 25 (fixing window); 1849, f. 67, Sep. 10: 'to remove Iron Bars & c from Jesse window'. *Cartoon costs per ledger summary*: Powell £1.6.8, Hendren £1.0.0, Oliphant £47.5.6. Oliphant's account records that the payment was in respect of:

		£. s. d.
'1848 April 7	1 days work at Ramsgate @ 20/-	1 0 0
August 10	6 Cartoons figures, 4 ft. high – @ 50/-	15 0 0
August 21	Expenses to & from Ramsgate including time	3 0 0
August 21	5 days work at Ramsgate @ 20/-	5 0 0
August 21	Expenses at Mr. Pugin's at Ramsgate 5 days @ 3/-	15 0
	Inn expenses 5 days @ 4/-	1 0 0
August 28	3 Cartoons figures @ 42/6 ea	6 7 6
August 31	3 do do @ 42/6 ea	6 7 6
September 15	3 do do @ 42/6 ea	6 7 6
September 15	Cartoons of BVM & Our Lord @ 48/-	2 8 0'

(Total £47 5s. 6d.)

Letters. *HLRO 304: Pugin to Hardman*, letter no. 1027: 'also all those for Lord Portarlington but I have only set down those which are actualy [sic] ordered windows <u>positive</u>. No. 1032: 'The milton figures will next come in – they are too Large. the window could be done well I should say for £350 or 360.' No. 432: 'I have no doubt that Lord Portarlington will go on as soon as I send his window. the kings are all in hand but Oliphant does so little.' No. 171: 'I have had a letter from Lord Portarlington he is very glad to hear that the window is nearly finished.' No. 1005: 'I cannot find the address of the glazier at Lord Portarlington anywhere you must write to his Lordship directing your letter – Milton Abbey Blandford to be <u>forwarded immediately</u> & state you are ready & want to know if the scaffolding is fixed for you to send over your man.' No. 381: 'I believe the Milton Abbey job is put off owing to the impossibility of getting any rent in I do not think it will affect the glass only the building.' No. 173: 'I don't think Lord Portarlington will do any more like everybody else he is hard up.' Letter Nos: 987, 1022, 1025, 1033 refer to attempts to obtain payment from Lord Portarlington. *JHA: Pugin to Hardman*, 1847, Oct. 1 (addressed from Weymouth and postmarked 'Birmingham OC 2 1847'): 'I have just got a positive order for £4,020.0.0!!!! of stained glass £600 of which to be ready next summer all for one church – an anglican job of course.' Oliphant to Hardman, 1848, Aug. 28: 'I have to inform you that I have sent off this morning to Ramsgate 3 more things for the Jesse, ... another 3 shall be sent on Thursday – that will make 12 leaving me only 4 on hand, 5 of the figures are to be repeated with a different arrangement of color [sic] – there being 21 figures in the window, while I am making but 16 cartoons if you could learn from Mr. Pugin which are to be repeated that might give you out of the 12, 4 more, so with the 3 I have sent off and the 3 to be sent on Thursday you could have 10 to go on with.' Sep. 15 – 'I have sent off to Ramsgate this day the last 4 cartoons for the Jesse window.' *M. Cork(?) to Hardman*, 1848: Nov. 10: 'the glass has arrived and placed in the Abbey Church.'

Literature. Wedgwood (Pugin's Diary): Pugin visits Milton, 1847, Sep. 30 (and Weymouth on Oct. 1).

36 Rampisham, St Michael (CoE)

1847. Client: Rev. Frederick Rooke.

Chancel E window	I	2.5m x 3.7m	3-light	£70
Chancel S (sedilia) window (**7.6**)	sII	1.6m x 1.9m	3-light	£20
Chancel N window	nII	0.9m x 1.9m	2-light	£15

Descriptions. I. 3-light window and tracery. Christ on the Cross with a pair of angels flanking his sides and a corresponding pair beneath his feet is depicted on a red diaper ground under a white-crocketed and finialed ogee-arch-headed canopy in the centre light. The Virgin Mary in a green-lined, blue mantle over a red robe, holding a book in her right hand, is portrayed standing under a similar canopy, against a white diaper screen, in the left-hand light. An unidentified female saint in a brown pattern-lined, dark green mantle over a red robe holding a book in her right hand is similarly posed in the right. A pair of standing angels, one above the other, are represented over each of the saints in the side lights. The borders are patterned with white leaves on red grounds. The main tracery-pieces consist of three white diaper quatrefoils above three red diaper trefoils. The topmost quatrefoil contains a green-patterned roundel surrounded by red rosettes while the five other pieces contain representations of seated angels. The two uppermost angels hold symbols of the Passion and the other three, texts.

sII. 3-light window and tracery. Each light is made up of white quarries patterned with alternating rows of *fleur-de-lis*, and flowers outlined in black, against black cross-hatched grounds. A large blue diaper medallion is centrally placed in each light and a smaller one – that in the centre light is red diaper – towards the top. The Annunciation is depicted in the large medallions – St Gabriel on the left, lilies in a white vase in the centre, the Virgin Mary on the right – and angels

playing a harp and a mandolin(?) left and right respectively with the Dove centre between them in the small. The borders are patterned with white leaves on yellow undulating stems against red and green grounds. The main tracery-pieces are patterned with red and blue rosettes and white and green leaves on white diaper grounds.

nII. 2-light window and tracery. The lights are made up of white quarries, each patterned with a leaf outlined in black on a yellow silver stain stem against a black cross-hatched ground. The left-hand light contains a figured red diaper medallion portraying St Peter in a green-lined, orange mantle over a yellow robe, standing, holding a yellow key in his right hand and a book in his left. The similar medallion in the right-hand light features St Paul in an orange-lined, yellow mantle over a green robe holding an upright sword in his left hand and a book in his right. The borders are patterned with white florets on blue and red grounds. The main tracery-piece is patterned as those in sII.

Office records. Order Book, undated, f. 15, cartoon costs, £20 (I), £5 ea. (sII, nII). *First Glass Day Book*, 1847, f. 14, Jul. 13 (I); f. 17, Sep. 8 (tracery, I); f. 22, Dec. 24 (sII, nII), f. 23, Dec. 24 (window bars).

Letters. HLRO 304: Pugin to Hardman, letter no. 381: 'I will forward you a lot of glass next week – I am very anxious to get the east window at Rampisham done.' *JHA: Powell to Hardman*, undated, 1847 box: 'I have started … 2. Rampisham east window.' Postmark 'NO 27 1847': 'Rampisham shall be with you in a day or two.' Undated 1847 box: 'Rampisham is all ready but no colours marked.' *Rooke to Hardman*, 1848(?), Jun. 12: confirms the arrival of the glass which he likes: 'the better for the faces being rather darker.'

Literature. Wedgwood (Pugin's Diary): Pugin visits Rampisham, 1845, May 15; 1847, Oct. 2.

37 Sherborne Abbey (CoE)

1851, 1852. Supervising architect: R.C. Carpenter. Clients: R.C. Carpenter, 4 Carlton Chambers, Regent St, London; the Earl of Digby (sX).

W window	wI	6.2m x 7.0m	27-light	£301	1851

The Pugin/Hardman glass was replaced in 1997 by stained glass of modern design and is now in the keeping of the Worshipful Company of Glaziers in the City of London.

N aisle windows	nVII–nX	2.3m x 2.6m	4-light	£280	1851
S transept S window	sX	6.5m x 9.0m	8-light	£320	1852

Description. **wI.** 27-light window forming three rows of nine lights each and tracery. Each light contains a depiction of an Old Testament king or prophet whose name is inscribed in black and yellow-on-white in the bottom margin of the light. From left to right they are: top row – Isaiah; Isaac; Jeremiah; Noah; Abraham; Melchizedek; Ezekiel; Jacob; Daniel: middle row – Hosea; Joel; Amos; Moses; Joshua; Aaron; Obadiah; Jonah; Micah: bottom row – Nahum; Habbakuk; Zephaniah; David; Jesse; Solomon; Haggai; Zachariah; Malachi. Apart from Jeremiah, who has a full head-dress, Melchizedek and Aaron, mitres, Solomon, a crown and Moses, from whose head two horns protrude, the figures wear coloured turbans. All are in mantles over robes in various combinations of red, green, purple, yellow, blue and orange. Inscribed scrolls undulate around their bodies as they stand, for the most part, frontally posed against diaper screens of mainly red or blue with some that are green, orange, and white. They are empty handed except for: Isaac who holds a staff in his right hand, Noah a model of the ark in both hands, Melchizedek a chalice in his right hand and a loaf of bread in his left, Jacob a staff in his right hand, Amos a crook in his left hand, Moses an open book in his right hand and a staff in his left, Joshua a sword in his right hand and a lance with banner attached in his left, Aaron a staff in his left hand, David a harp in his left hand, Jesse a staff in his left hand and Solomon a sceptre in his left hand. The tracery-pieces contain either white-rimmed red roundels on blue grounds or yellow on red.

nVII. 4-light window and tracery. A scene from Christ's Passion is depicted under a canopy against a blue ground in each of the lights. From left to right they are: Agony in the Garden, Entry into Jerusalem, Carrying the Cross and Kiss of Judas. Pairs of crocketed and pinnacled gables in white glass touched with yellow silver stain surmount the round heads of the canopies and behind them rise conical-headed towers on pitched roof structures. Most of the paintwork has gone. The tracery-pieces contain geometrically patterned red roundels on white grisaille grounds.

nVIII–nX. 4-light windows and tracery. Each of the twelve lights contains a depiction of an Apostle. They stand in frontal poses under cinquefoil headed canopies surmounted by yellow-crocketed and finialed gables with towered superstructures, as in nVII. The Apostles are in mantles over robes in colour combinations of red, blue, white, green, orange and purple. They hold their appropriate attributes and stand in front of screens which are coloured either red, blue, green or yellow. The tracery-pieces are as for nVII.

sX. An 8-light transom window and tracery illustrating the *Te Deum*. Each light contains six pairs of figures placed one above the other – three pairs above the transom and three below. The figures are of: kings, queens, bishops, abbots,

abbesses, saints and prophets and they hold a variety of attributes including: swords, banners, crosses, croziers and palms. A text winds around each of them. The background to the lights is blue but the principal colours come from the garments worn, and include: red, blue, yellow, purple, brown, orange and green. Most of the tracery-pieces contain a representation of an angel holding a text.

Office records. *Order Book,* 1850, f. 81, Jul. 13, re wI: 'Subject Kings & Prophets.' *Rough Day Book,* 175/36/2, p. 202, Oct. 1866, records 'Faces, hands & feet of 12 apostles to be restored (not to be charged)'.

First Glass Day Book, 1851, f. 118, Jun. 12 (wI), f. 119, Jul. 23 (nVII, nVIII, nIX, nX: note – nVII is recorded as being: 'for South Transept'); 1852, f. 143, Apr. 19 (sX).

Letters. **wI.** *HLRO 304: Pugin to Hardman,* letter no. 712: 'I have written my anxiety [?] to Carpenter I have told him we shall be delighted to do his work provided he allows <u>sufficient time</u> but if not we must decline it. 3 months for a <u>great west window</u> of an abbey is ridiculous & I obliged to be away a deal from here at this time of year if we get it done by the autumn of 51 would be very good. It is no use for us to promise what cannot be finished[?]. The tracery and one window.' No. 157: 'the upper Row [?] of W. window Sherborne went today.' No. 793: 'It appears between hill [Frederick Hill] & Powell [John Hardman Powell] that they have at the Sherborne Prophets all manner of <u>heights</u> for the same window. I repeatedly told Powell I was certain they did not look the same size & was repeatedly <u>informed</u> by him that they were all done to the same dimensions Exactly at Last I determined on Laying the window out on the floor & then out came the truth & half must be torn and redone. Now this is a case of [?] & shameful inattention. I told them to make a base line & a horizontal line for the eyes & to work to that ... here is a waste of time & money & all through my trusting Powell to such a simple thing as this'. No. 159: 'some of the Figures are on <u>white</u> ground this must be well covered or it will look thin.' No. 637: 'The cartoons for Sherborne are really come out very fine they are beautifully drawn in Late work.' *JHA: Carpenter to Pugin,* 1850: Apr. 17: 'You shall hear in a day or two about Sherborne'. 1851: Sep. 20: 'let me tell you how much I like the Sherborne glass: in the West window the effect is much injured by a row of red stars which glare unfortunately & the people say look like railway signals. I have spoken about this to Hardman who says an alteration shall be made.'

nVII–nX (inc). *HLRO 304: Pugin to Hardman,* letter no. 575: 'I also send the remaining cartoons side windows Sherborne.' No. 488: 'Powell also says that he believes & I believe that the tracery for the side windows Sherborne were sent some time ago to you.' *J. Staples to Hardman,* 1851, Jul. 24: 'Mr. Carpenter was here last night and informed me that the glass was ready for the North Aisle windows.'

wI, nVII–nX. *JHA: Carpenter to Hardman,* 1850, Mar. 30: 'I have an order for you for five windows for Sherborne Church which I was authorized by the committee to give you on the 27th inst. This work will require your immediate attention as the part of the church now in progress of restoration will be completed fit for service by the end of July when it will be re-opened. I enclose tracings of the windows ...The Great West Window tracing will speak for itself. In three of the 4 [light] windows the 12 Apostles are to be introduced and in the other subjects relating to the Baptism (in panels as the figures) The treatment of the west window I have written to Mr. Pugin about. I shall want an estimate for this work in the course of the next week say by the 6th April.'[8] 1851, May 9: 'I am going to Sherborne on Monday please write me a line here addressed to the Kings Arms Hotel to say which day the glass for the West Window will arrive. Mr. Pugin has written to me to say the work makes a splendid job.' Aug. 11: 'I have just come back from Sherborne ... I will write to you about the glass...altogether it is very fine.' *J. Staples to Hardman,* 1851, Aug. 21: 'You will be pleased to send me your a/c for the Glazing of West & North Aisle windows to the church and I will forward a check [sic] for same.'

sX. *HLRO 304: Pugin to Hardman,* letter no. 271: 'we have no template for the Te Deum window Sherborne.' No. 178: 'we are going to begin the Te Deum window for Sherborne as that appears the one now most wanted.' (also see letter no. 179). No. 609: '1. I have simplified the work in Sherborne window it would have been dreadful as set out first.' No. 631: 'more than ½ Sherborne window is done.' No. 108: '[?] work hard at that Sherborne Te Deum window. I have been working manfully[?] at the glass for the last four days you will have a great lot of cartoons & <u>fine job</u>. No. 614: 'The Te Deum window was partly drawn in but my dear Hardman Powell had altogether mistaken my intentions & it was something execrable nothing particular must be done when I am away.' Delay in completing the window led to some acrimony between Pugin, Hardman, Crace and Carpenter as the following letters suggest. *Carpenter to Pugin,* 1851, Sep. 20: 'we are also[?] anxious to have the Digby window now & among other reasons for fear of the Old Lord's decease which might as far as £.s.d are concerned place us in an awkward position. I should hope to talk with you some day about this.' *HLRO 304: Pugin to Hardman,* letter no. 764: 'I dont at all see how any glass is to be done for Sherborne. it is now 2 months since we were at Carpenters Chambers & we are no further forward'. *JHA: Crace to Hardman,* 1851, Dec. 6: 'when I saw Mr Pugin I could not refrain from mentioning that the whole of the restoration of the Chancel at Sherborne Abbey was endangered by the delay & that I was present when Mr. Carpenter was obliged to equivocate

when Lord Digby asked him if the window was fixed in – '. *HLRO 304: Pugin to Hardman*, letter no. 182: 'I wish you would let me know what you want about the Sherborne window for I never was so attacked in my life as by Crace he said I <u>was</u> the <u>ruin</u> of Carpenter's successful prospects.' No. 672: 'I return your Crace letter. If Carpenter had shown the cartoons to the Earl & explained to him that the single figures according to the original design had all been changed into groups with extra expenses'. *JHA: Carpenter to Hardman*, 1851, Dec. 30: 'It is now getting on for two years since the Digby window was ordered! I mention it without a desire to revive old grievances, but only by the way in telling you that the transept is sustaining so much injury from exposure to the atmosphere at this season that I have been compelled to order the window openings to be made weather tight & that the Committee will look to you for the cost of this.' In a series of letters, Pugin emphasises to Hardman the time taken to mark the colours – seven to nine days – and that they were doing it too cheaply; these include HLRO 304, letter nos 617, 620, 639, 640, 655 and 672 of which a quote from no. 672 gives the flavour: '9 & not 8 days in marking the colours & trying the effect of the colours … I never took greater pains with anything & that without hope of [?] return'. *HLRO 304: Pugin to Hardman*, letter no. 661: 'I don't know what colours to mark for the armour in this Sherborne window so I have left off marking you have great experience & you know what comes[?] best. I don't like a <u>blue</u>. I think the rubies[?] do it better pray let us examine this point carefully when I come down & select what is best. It will save a deal of trouble & effort[?] this is a most important one settle [sic] we should always know[?] what to use[?] I expect to finish this Sherborne window tonight Remember 7 full days nothing else doing – for me me [sic] don't bring another of that sort here for it <u>cannot do</u>. I am disappointed again in the Sherborne window. the lower groups were done in the middle of all this uncertainty & distress and are very inferior to the upper ones Powell sees it as much as I do & we are going to change them they ought to look up the higher the level[?] they get but some of them were looking across the window & at once disadvantaged the lines[?] we shall get it right in a few days but upper part <u>above the transom</u> will be sent to you immediately as they are all right & it is only the <u>lowest group</u> of each low light that wants altering the 2 upper groups of each of the the [sic] lower lights is very good & all right but I am particularly anxious that what is close to the eye should be perfectly painted & bears inspection.' No. 672: 'I don't like this Sherborne window & I don't think after it is done we can do any more windows for Carpenter. we have taken immense pains with all his windows none of them have ever failed the E. window of S. Mary Magdalene [Munster Square, Gaz.59] is the finest thing done since the finest of old time it is disgraceful why did they not fill the window with plain quarries till the painted glass is ready I have never taken greater with [sic] any window than this too much so. I dont like it at all & <u>after the windows</u> are in I don't think Carpenter cares a bit about them he has got a fine job cheap [?] & [?] all right'. No. 175: 'The Sherborne window is a failure after all we ought to have 2 years & £200 to prepare the cartoons for such a window – it is impossible[?] to make fine things in the way we do this each image wants redrawing it is disheartening to look at it. *JHA: Staples to Hardman*, 1851, Nov. 28: 'I shall be glad to know when we may expect the <u>glass</u> for S. Transept'; 1852, Mar. 4: 'The glass for Tracery of South Transept window arrived safe and is all fixed; but my foreman says there are 6 pieces missing'; Apr. 14: 'The glass for South Transept Window is just come to hand you will be pleased to send a man to fix the same as soon as possible.'

Literature. *The Ecclesiologist*, 11, 1850, p. 205; 12, 1851, p. 435, comments on the progress of the restoration work in the church. *The Builder*, 9, 1851 p. 534: re-opening of church after completion of restorations including brief comments on the W and aisle windows. Shepherd, 1994-5, pp. 315-22. Wedgwood (Pugin's Diary): Pugin visits Sherborne, 1845, May 15.

38 Stapehill, Holy Cross Abbey (Stapehill Convent: RC). Now a crafts and gardens centre

1850, 1853. Client: Rev. Fr Hawkins (I): sII donated by John Hardman.

E window	I	2.5m x 3.4m	3-light	£60	1850
S aisle (nuns' choir) E window	sII	2.5m x 4.0m	3-light	£60	1850
N aisle E window	nII	1.0m x 2.2m	2-light	£6.10	1850
N aisle W windows	nIII–nVII	1.0m x 1.7m	2-light	£20.10	1850
S aisle (nuns' choir) windows	sIII–sVI	0.4m x 0.7m	2-light	£17.12	1850
	wI	2.6m x 3.4m	3-light		*c.*1853

Descriptions. **I.** 3-light window and tracery. The Virgin and Child under a canopy are depicted in the centre light and an unidentified saint under a canopy in each of the side lights. The Virgin is crowned, seated, and in a green-lined, blue mantle over a purple robe. The Child is in a red-lined, white mantle over an orange robe. The saint in the left-hand light is in a purple-lined, white mantle over a blue robe and holds a crozier in the crook of his right arm. The saint in the right-hand light is in a yellow-lined, white mantle over a green robe and holds a book in his left hand and a crozier in

his right. There are yellow-crocketed and finialed gables over the canopy-heads. Blue rectangular towers with pinnacles make up the canopy superstructures in the side lights to which a red diaper gabled and crocketed Gothic window mounted on a pitched roof structure is added in the centre light. The top and bottom panels of the lights are filled with a grisaille on white glass of leaves and berries outlined in black on black hatching, overlain by red-outlined quatrefoils crossed by blue diagonals. The borders are patterned with leaves on vertical yellow stems against red and green grounds. The two tracery-pieces are filled with green, white and yellow leaves on curving yellow stems against red grounds.

sII. 3-light window and tracery. The stained glass, which according to the First Glass Day Book featured the Virgin in the centre light, has been replaced with plain glass.

nII. 2-light window and tracery. The Deposition is depicted in a blue diaper medallion in the middle panel of the left-hand light and the Pieta in the right. The remaining panels are filled with a grisaille of leaves outlined in black and yellow silver stain berries on yellow silver stain stems, overlain by blue-outlined quatrefoils, crossed by red diagonals (much of the grisaille pattern has gone). The borders are patterned with white leaves on vertical yellow stems against red grounds. The quatrefoil tracery-piece contains at its centre a blue roundel inscribed with the yellow letters IHC. White leaves interspersed with bunches of grapes on a red ground fill the remaining areas.

nIII–nVII. 2-light windows and single quatrefoil tracery pieces. Each light is made up of plain tinted quarries and has in its centre panel a yellow or red-rimmed, white roundel within a red or yellow-rimmed quatrefoil. Each roundel contains a yellow silver stain emblem or pattern as follows (that in the left-hand roundel is given first). nIII: a crown above a rose, and a crown above the letter M: nIV: a crown above a star, and a flower motif; nV: a crown above a star, and a crown above a rose; nVI: a flower motif, and a crown above the letter M; nVII: a flower motif in each light (the roundel has no rim and is enclosed in a concave-sided octagon instead of a quatrefoil). The borders are patterned with red flowers on yellow and green grounds except for nVII which is similar to those in the S aisle. Each quatrefoil tracery-piece is filled with four yellow leaves on circular stems, alternating with red rosettes, around blue centres on white grisaille grounds.

sIII–sVI. As for nIII to nVII with the quatrefoils in the lights moved through ninety degrees and given pointed rather than rounded foils. The motifs in the roundels are: sIII – The letters IHC, and a crown of thorns; sIII – the letters IHC, and the robe with dice; sV – the letters IHC, and scourges; sVI – head of Judas(?) with coins, and the letters IHC. The borders are patterned with white leaves on vertical yellow stems against blue and red grounds.

wI. Cathedral glass fitted in 1850 and costing £5 was replaced by stained glass designed by J.H. Powell – still *in situ* – that was ordered in late 1853 (see below) and not completed by the end of that year.

Office records. Order Book, 1850, f. 77, Jan. 29: 'Tower window with emblems and border; East Window [I] as per Mr Hansom sketch' per Order Book 2, 1853, f. 95: 'A west window [wI] of 3 lights. Subjects St. Patrick, St. Joseph, St. Bridget, Figures under Canopies, Centre light from sill to spring 8'0¹/₈" side lights do. 6'3"'. *Order Book 2,* 1853, f. 95, Sep. 7. *First Glass Day Book,* 1850, f. 100, Oct. 24 (organ loft, chancel, nII, nVII, sIII to sV, nIII to nVI, tower), f. 101, Oct. 24 (I, wI, sII). *Cartoon costs per ledger summary:* I, Powell £1.5.0, Oliphant £4.15.0; sII, Powell £3.10.0, others £2.5.0. Oliphant's account records that the payment was in respect of: '3 do[cartoons] of B.V. S.Anne & an Abbot. East Window'.

Letters JHA: Letter Book, p. 228, Hardman to Hawkins, 1850, Jan. 22: 'I should strongly recommend you either to do the west window [wI] properly at the price I have named with 3 figures in it at £55 or merely glass it with plain Cathedral glass. You are more likely to get it given hereafter if it is kept quite plain than if it was partly ornamented – I have reckoned the plain glazing to be done with thick Cathedral glass & very thick heavy strong lead which will stand for a hundred years without repairing – Groups of figures are very troublesome to do and more expensive than single ones under Canopies besides being less effective particularly at the height your windows are from the ground.'

DURHAM
39 Durham Cathedral (CoE)

*c.*1842. Panels from Ackworth Grange, West Yorkshire (Gaz.191). Chapter House entrance wall: the window left of the entrance door contains two panels (0.2m x 0.3m), one with the Crucifixion and the other a shield of arms with lions couchant and *fleur-de-lis* in the quarterings. Both panels have been badly damaged and subsequently put together using remnants from other work.

The window on the right of the entrance door also contains two panels (0.2m x 0.3m), one made up entirely of remnants in the form of two medallion-like shapes on a white background, and the other, two blue, red-rimmed, quatrefoil medallions, the top one containing a depiction of a half-length, yellow-haloed, golden-winged, white-robed angel facing the front and holding a text between outstretched hands; and the other, a yellow-haloed, golden-winged, lion-like creature in profile, facing to the left. The rest of the panel is made up of white, flower-patterned quarries. In the borders, yellow *fleur-de-lis* alternate with blue rectangles.

Galilee Chapel W wall: window no. 40 (as numbered in Norris): bottom row, three panels 0.5m x 0.5m, each containing a yellow-rimmed, blue quatrefoil medallion in which a red-haloed, yellow-winged, red seraphim is depicted, facing the front, balanced on a small red wheel . The rest of the panel is made up of black-outlined, leaf and stem grisaille, with borders formed of pieces of glass decorated with a yellow leaf on a white stem combined with red pieces, to give the effect of an undulating stem with leaves, against a red ground.

Literature. N. Pevsner, *The Buildings of England: County Durham*, Harmondsworth, rev. E. Williamson, 1983, p. 193. Norris, 1984, p. 11, window no. 40.

40 Ushaw, St Cuthbert's College (RC)

1845-53. Clients: Revs Charles Newsham, Thomas Witham (LS I, LS wI). Supervising architect: Joseph Hansom (L I, L wI).

E window	I	3.7m x 5.5m	5-light	£210	1847, tracery 1846	
Apse & N wall windows (**3.12**)	nII, nIII	2.2m x 4.28m	6-light			
Apse & S wall windows	sII, sIII	2.2m x 4.28m	6-light			

The glass for nII, nIII, sII, sIII came partly from the old choir windows (see below); the windows were made in 1846-7 at a cost of £85 each.

N & S wall windows	nIV, sIV	2.2m x 4.28m	6-light			

The glass for nIV, sIV came partly from the old choir windows (see below); the windows were made in 1847-8 at a cost of £85 each.

W window (**2.1a & b**)	wI	4.6m x 6.9m	7-light	£320	tracery 1846, lights 1847	
Ante chapel N & S windows	nX, sXII		8-light	£295	1846	
Ante chapel SW windows	sXIII, sXIV		2-light	£40	1846	
Lady chapel S window	sXI	1.0m x 2.1m	2-light	£30	1846	
Lady chapel E window	sX		2-light	£25	1846	

Pugin's chapel of 1847 was replaced by the present one designed by Dunn & Hansom and completed *c.*1884. Much of Pugin's work was preserved and incorporated into the new building. In the case of the stained glass: wI was the old E window and I the old W; the tracery and the three lights above the transoms of nII, nIII and sII belonged to those of the old S choir (the lower lights were newly designed as was sIII, apart from the tracery); nIV and sIV are made up of tracery and lights with figures of saints from the old N choir, together with newly designed scenes from the lives of the saints beneath them. nX and sXII were the old N and S transept windows and sXIII and sXIV the windows of the W walls of the old transepts (the latter two windows were enlarged by the addition of canopies and bases in new glass). Pugin's Lady Chapel, with windows sX and sXI, was adapted to the new church.

Refectory windows (cost £102):

Long side wall	R nII–R nVI	1.0m x 3.5m	4-light		1846
	R nVII, R nVIII	1.6m x 3.5m	6-light		1846
Library:					
E window	L I	2.6m x 4.4m	4-light	£70	1850
W window	L wI	4.0m x 6.1m	5-light	£120	1850
Staircase windows E and W (**10.8**)	LS I, LS wI	1.5m x 2.8m	3-light	£40	1851
St Joseph's Chapel E window		3.5m x 5.1m	5-light	£150	1853

Original design by Pugin – see Atterbury, 1995, p. 319, for illustration – altered by Powell in the completed window – see Shepherd, Ph.D thesis, 1997, plate 270.

Descriptions. **I.** 5-light window and tracery. St Cuthbert is depicted beneath a canopy, in the centre light. He holds the head of St Oswald in his right hand and the pastoral staff in his left. The saint's soul being received by the eternal Father, is represented in the upper part of the light and the kneeling images of the President and Vice-President of the college in the bottom panel. Eight incidents from the saint's life are illustrated beneath canopies in the inner and outer side lights, the bottom panels of which contain (reading from left to right), alternate blue and red medallions, enclosing depictions of: the donors and their patron saints in the outer lights; and alumni of the college in the inner. The figures are mainly in blue robes (those in the centre light, mainly white) with touches of green, orange and yellow. The upper tracery-pieces contain depictions of angels in green, red and yellow robes holding torches, and the lower, geometrical patterns in red, green and blue and yellow against white grounds.

nII. The upper three lights contain historical types of the Old Testament beneath their anti-types in the New. From left

to right the images are: Christ as King above David anointed by Samuel; the Church and Heresy above the Judgement of Solomon; and St John the Baptist above Judas Maccabeus. The borders consist of alternating red and white squares. The tracery-pieces are filled with red and green geometrical patterns.

sII. The upper three lights are concerned with the history of the church and from left to right depict in their upper sections: the Discovery of the True Cross; Christianity proclaimed at Rome; and the Vision of Constantine; and in their lower sections: the Baptism of Lucius, St Augustine preaching before St Ethelbert, and Coiffe hurling his spear. The borders and tracery are as for nII.

nIII. The upper three lights continue the theme of types and anti-types with, from left to right: Christ on the Cross above the Sacrifice of Abraham; Christ rejecting the Jews and blessing the Gentiles, above Isaac blessing Jacob; and Personifications of the Church and the Synagogue, above Jacob blessing Euphraim and Manasses. Borders and tracery are as for nII.

nIV. 6-light window. Each light contains a depiction of a frontally posed saint standing under a crocketed and finialed, trefoil-headed canopy against a white diaper screen. They represent the holy patrons of learning and the arts, and from left to right are; in the upper lights: St Aldhelm in a white-lined, blue chasuble and a brown dalmatic, holding a book in his left hand; St Bede in a red-lined, white mantle over a blue robe holding a book in his left hand; St Alcuin in a green-lined, brown mantle over a white alb, holding a book in his right hand and a crozier in his left; in the lower lights: St Catherine in a red-lined, white, yellow silver stain-patterned mantle over a brown robe, holding a wheel in her left hand and a downward-pointing sword in her right; St Barbara in a green-lined, white mantle over a purple robe holding a tower in her left hand and a book in her right; St Cecilia in a green-lined, white mantle patterned with yellow silver stain over a blue robe, cradling a blue organ in her left arm. The borders are made up of alternating white squares and rectangles. The tracery is similar to that for nII.

sIV. 6-light window. Each light contains a depiction of a British Saint similarly posed as the saints in nIV. From left to right they are; in the upper lights: St Augustine in a green-lined, white mantle over an orange robe; St Thomas Becket in a purple-lined, white chasuble over a green dalmatic; St Edmund of Canterbury in a green-lined, white robe; in the lower lights: St George in a green-lined, yellow silver stain-patterned cloak over armour, with a red-crossed shield fastened to his left forearm and a lance held in his right hand – the lance is thrust into a red dragon at his feet; St Andrew in a red-lined, white mantle over a blue robe holding a large green diagonal cross in his hands; St Patrick in a red-lined, white, yellow silver stain-patterned chasuble over a green dalmatic holding a processional cross in his left hand. The borders and tracery are as for nIV.

wI. 7-light window and tracery, illustrating the Triumph of the Church. Christ in Glory (he stands surrounded by a red diaper mandorla, in a green-lined, yellow mantle over a red robe, holding an orb in his left hand) is depicted at the top of the centre light with two angels in the panel below. Beneath the angels is the Virgin Mary enthroned, crowned, and in a green-lined mantle over a red robe, holding a text in her outstretched hands. Another pair of angels separate the Virgin from a group of figures below in which the central one is St John the Baptist. This compositional arrangement is repeated in the other six lights to produce across the window three rows of groups of figures alternating with two rows of pairs of angels, all on a blue diaper ground. A single half-length angel holding a crown is depicted at the top of each of the six lights. In the top row of figures, the twelve Apostles arranged in groups of three occupy the four inner lights and groups of patriarchs and prophets (King David plucking his harp is conspicuous in the left-hand group) the two outer. The middle row contains groups of virgins martyrs, monks and abbots; and the bottom, popes, cardinals, bishops, abbots, abbesses, kings and queens. At the centre of the tracery pieces that form a wheel at the top of the window, and enclosed in a trefoil, is the emblem of the Trinity. Represented in the wheel and amongst the other tracery-pieces are the nine orders of angels and the symbols of the four Evangelists.

nX. 8-light window and tracery. The top four lights contain depictions under trefoil-headed canopies of the four Evangelists holding their respective gospels. From left to right they are: St Matthew, St Mark, St Luke and St John (a yellow eagle perches on his shoulder). In triangular formation about the head of the canopy, at the apex, is the relevant symbol of each Evangelist and at the base, two chalices. The bottom four lights contain depictions of the Doctors of the Church seated, writing under trefoil-headed canopies. They are from left to right: St Jerome in a red cardinal's hat, a red mantle over a blue robe and accompanied by a lion; St Augustine in a white mitre, a yellow-lined, blue mantle over a red robe, holding a crozier in his left hand; St Ambrose in a red mitre, a yellow-lined, green mantle over a red robe, holding a crozier in his left hand and St Gregory in a papal tiara, a green-lined, red mantle over a blue robe and accompanied by a dove. All the figures appear against white diaper screens. The borders of the bottom halves of the lights, which also act as the sides of the canopies and turn in to form ogival-curves around the heads of the figures, are patterned with yellow leaves on stems against red grounds. The tracery-pieces are filled with multi-coloured geometrical patterns, except

for the single large quatrefoils positioned immediately above and between each outer and inner light, which contain allegorical representations of the church and the synagogue. The former on the left, seated against a blue ground, is a female figure, crowned, in a yellow mantle over a red robe, holding a sceptre in her right hand and a chalice in her left. The latter, on the right is also female but is seated against a red ground. She is blindfolded, in a yellow mantle over a blue robe, holding a broken staff in her right hand and the tablets of the law, which are slipping from her grasp, in her left.

sXII. An 8-light window and tracery. The scenes in the upper lights are concerned with the early life of Christ. Set beneath trefoil-headed canopies against white diaper screens, from left to right they are: Nativity, Adoration of the Wise Men, Presentation in the Temple, and Flight into Egypt. Those in the lower lights representing types of the Virgin Mary are: Aaron holding the Flowering Rod, Moses kneeling before the Burning Bush, Gideon and the Golden Fleece, and the Vision of Daniel of a stone detached from the mountain without hands. At the top of each upper light is a representation of an angel holding a symbol of the Virgin which from the left are: the sun, a star, a rose and the moon. The borders are patterned with yellow *fleur-de-lis* on red grounds alternating with green pieces of glass. The tracery is similar to that in nX, with two triangular shapes each containing a half-length angel holding a text, in place of the two quatrefoils.

sXIII. 2-light window. St Edward crowned, in a green-lined, white, yellow silver stain-patterned mantle over a brown robe, holding a ring in his left hand and a sceptre in his right, stands under a canopy against a pale blue screen in the left-hand light. St Edmund crowned, in a similar mantle to that of St Edward over a blue robe, holding a sceptre in his right hand and an arrow in his left, stands under a canopy against a red screen, in the right.

sXIV. 2-light window. St Oswin in a green-lined, white, yellow silver stain-patterned mantle over a yellow robe stands on the left under a canopy against a blue screen, St Oswald in a similar mantle to that of St Oswin over a yellow-and-blue robe stands on the right under a canopy against a red screen.

sX. 2-light window and tracery illustrating under double-headed, yellow-crocketed, pinnacled and gabled canopies, the Coronation of the Virgin. Christ, enthroned, in a green-lined, white, yellow silver stain-patterned mantle over a yellow robe is in the left-hand light. An angel floats horizontally above his head. The Virgin, enthroned, in a similar mantle to that of Christ over a red robe is seated in profile turned toward Christ, in the right. An angel floating above her, places a crown on her head. Crowds of angels outlined in black on blue grounds fill the spaces bounded by the tops of the thrones and the canopy heads. The tracery is filled mainly with blue and white geometrical patterns, and the letter M is inscribed in yellow in the middle of the topmost piece.

sXI. A 2-light window containing under triple-headed, pinnacled canopies a depiction of the Annunciation. The Archangel Gabriel in a white, yellow silver stain-patterned robe holding a sceptre in his left hand, half-kneels in profile in the left-hand light. The Virgin Mary in a blue mantle over a red robe holding a book in her left hand sits in the right. An angel playing a musical instrument is at the top of each of the lights. The tracery-pieces are filled with red rosettes on white grisaille.

R nII–R nVI. 4-light transom windows and tracery. Each light is made up of plain quarries, with the middle panels of the sections above the transoms containing a shield of arms within a quatrefoil.

R nVII–R nVIII. 6-light windows and tracery. As for R nII to R nVI.

L I. 4-light window. Each light is filled with a leaf and stem grisaille outlined in black on plain quarries, overlain by a vertical line of yellow-outlined diamonds. The diamonds contain, alternately, small geometrically patterned centres and large geometrically patterned quatrefoils. The tracery is patterned with white and green leaves and flowers on red grounds.

L wI. A 5-light window. Each light is made up of four-part-leaf-patterned quarries, the leaves being outlined in black and enclosed by black lines which form a white border within each quarry. The arrangement of overlying diamonds as in L I is followed but the diamonds are now outlined in red and the quatrefoils become part of the main design, no longer being contained within the diamonds. Each quatrefoil contains the bust of a religious or historical figure, (see Order Book, f. 13 below for the names). St Thomas of Canterbury is depicted in the centre light, standing under a canopy, in a mitre, the pallium, a green-lined, white chasuble over a blue dalmatic and white alb, holding a crozier in his right hand. A sword pierces his head. The canopy has a cinquefoil head over which is a yellow-crocketed and finialed gable. Above the gable is a red grisaille four-light Gothic window superstructure surmounted by a yellow-crocketed and finialed gable. A shield of arms is contained in a red quatrefoil beneath the saint's feet. The tracery is filled with patterns of white leaves and green grapes on yellow stems against red grounds.

LS I, LS wI. 3-light windows and tracery. The centre light of each window contains a depiction of a saint standing under a trefoil-headed canopy over which is a tall yellow-crocketed and finialed gable. The Venerable Bede in a white-lined blue mantle over an olive-green robe, holding a book and a quill in his right hand and a crozier in his left, against

a red diaper ground is in the centre light of LS I and St Thomas Aquinas in a greenish-white habit dotted with yellow stars, holding a quill in his right hand and a book in his left, in L swI. Beneath each of the saints, in a quatrefoil, is a red shield emblazoned with the arms of the Rev. T. Witham. The side lights of both windows are made up of plain quarries. Each light contains three symmetrically placed, patterned roundels including in the centre ones a yellow silver stain bird among leaves and branches. The borders are patterned with red florets on black grounds. The tracery is patterned mainly with white leaves on red grounds.

Other windows:

St Joseph's Chapel E window. 6-light window with tracery. Each light, apart from the middle one, contains two scenes from the Life of St Joseph, one above the other. St Joseph occupies the whole of the middle light except for the bottom panel which is almost totally obscured from view. In Pugin's sketch St Joseph and all of the scenes are contained beneath elaborate canopies. In the completed window Powell had removed them from over the scenes using medallions instead. He has, however, retained that over St Joseph although in a much simpler form. Pugin's compositions, whilst unfinished, are clear in conception, comprised generally of only two or three figures and free of extraneous detail. Powell's on the other hand seem much busier, involve larger groups and contain background items of only incidental interest.

Side windows of library. 4-light transom windows and tracery. Only the two lights above the transom in each window contain stained glass which is comprised of black-outlined, leaf-patterned quarries. The borders are patterned with yellow, red, green and blue florets. The main tracery-piece is a white grisaille quatrefoil with a patterned centre.

Cloisters. 2-light windows, some with plain quarries, stained borders and patterned tracery, others with yellow silver stain-patterned quarries, stained borders and no tracery. These latter types contain a roundel with a depiction of one of the instruments of the passion. Also three-light, plain quarry windows, with stained borders and roundels that contain symbols of the Virgin including the letter M, a star and a rose.

Exhibition room. These window were not seen as they were covered with blinds at the time the room was visited (see, however, *HLRO 304, Pugin to Hardman*, letter no. 837 below).

Office records. Order Book, f. 13, cartoon costs: cloister windows; nX £25, sXII £25, refectory £2, S choir 6 windows £120, antechapel £20 & sX £6, cloister gable £15, sXI £6, I £50, wI £60, screen £10, upper N 5 windows £60. 1850, Apr. 4: Library East [should be W] window: 1. St. Thomas Aq. 2. Ven Bede 3. St. Anselm 4. St. Aldhelm 5. Alcuin 6. King Alfred 7. Bennet Biscop 8. Aelfric 9. Lanfranc 10. Gerson 11. St. Bonaventura 12. St. Theodore of Cant. The arms of the 8 benefactors introduced'. 1850, f. 105, Aug. 27 re LS I & LS wI: 'with the Arms of the Donor introduced into each'. *First Glass Day Book*, 1845, f. 1, Nov. 24 (cloister), Dec. 27: '1 sexfoil Trace/2 small Tracery pieces/1 Iron bar with 3 Arms £8'; 1846, f. 2, Jan. 13 (I tracery), Mar. 28 (nX, 1 light), f. 3 Apr. 31 [sic] (nX), Jun. 23 (sXII), f. 6, Sep. 8 (refectory & 2 for choir), f. 7, Sep. 29 (wI tracery), Oct. 22 (2 windows antechapel and sX), f. 10, Dec. 10 (cloister & sXI); 1847, f. 13 May 8 (I lights), , f. 16, Sep. 8 (wI lights), f. 19, Nov. 4 (screen), f. 20, Dec. 2 (3rd choir), f. 21, Dec. 13 (4th choir), f. 22, Dec. 22: 'To Repairing Light of/South side choir window £11.9.0', Dec. 24 (fitting wI), f. 23, Dec. 24 (5th & 6th S choir), f. 24, Dec. 24 (tracery upper N windows); 1848, f. 32, May 19 (lights for 5 upper N. windows, 'New Tracery & Alterations/South Transept Window [sXII] £15', f. 44, Oct. 25: '10 yellow pieces of Stained/glass/3 Border Pieces with Crowns/painted on/ 7 Plain Ruby pieces'; 1849, f. 72, Oct. 19 (library), f. 74, Nov. 24 (exhibition hall/; 1850, f. 84, Mar. 15: '1 New Shield of Arms & c/ in window for Exhibition Hall', f. 108, Dec. 26 (L I & L wI); 1851, f. 117, May 26 (LS I, LS wI); 1852, f. 164, Dec. 13 (cloister & oratory); 1853, f. 180, May 25 (St Joseph's Chapel), f. 182, Jun. 13 (St Joseph's Chapel), f. 198, Dec. 12 (St Joseph's Chapel). *Cartoon costs per ledger summary:* R nII–R nVIII, Powell £6.0.0, Hendren £3.0.0; Exhibition Hall, Powell £1.0.0, Hendren 6s.8d; L I, Powell £2.15.9, Hendren £1.10.0; L wI, Powell £7.0.0. *Pugin sketches*, BM & AG a. no. not allocated, for Exhibition Room and St Joseph's Chapel E window.

Letters. HLRO 304: Pugin to Hardman, letter no. 870, postmark 'JA 1846': 'you must take the window from Ushaw it would have paid well at the original design but the new one is very full of Difficult drawing the glass will not be difficult but the cartoons will be very Long[?] to make.' No. 362: 'The Ushaw people insist on having the tracery of N Transept window done again but they are prepared to pay for it. make the glass very strong & thick for my Cloister windows.' No. 867: 'I have sent off by this post a lot of work 1st the canopies borders & c for the N transept Ushaw Oliphant is doing the figures over again & you will have them this week.' No. 881: 'I expect by this post to send you the borders & tracery for 4 side choir windows Ushaw which will give you a deal of work the figures I get done by degrees.' No. 876: '1. With this I send the remaining cartoons for the N Window Ushaw which I hope you will get done as soon as you can for I want to show something good. there are so many attacks on me and I also send you all the bordering & canopy work for the South Transept window the Images are in hand'. No. 436: 'The last North window for Ushaw tonight.' No. 887: 'The Ushaw windows with the types will be splendid they are all drawn & the East window is in hand. Dr. Newsham

must send you some money. the moment you have despatched the South Transept write for £250.' No. 394: 'the East window for Ushaw is nearly finished. the finest work of modern times & so you will say.' No. 258: 'I did 2 heads for Msgr Gibson for the W. window Ushaw.' No. 12: 'The west window Ushaw goes off ready[?] tonight. Powell completely drains me. He came in ½ an hour before post time on <u>Tuesday</u> I saw he was getting the window ready for the post. I said let me see it first & seriously[?] there were 2 days for <u>him & me</u> for me on it [sic] do you see what trusty people I have – If my eyes go I shut up everything directly.' No. 948: 'I send you the arrangement of the windows for Ushaw with the subjects just get Mr. Horne[?] to put them in latin in the simplest manner one line to each.' No. 531: '10. what I send you is nothing to what I do I have great orders[?] from Dr. Newsham of Ushaw.' No. 837: '3. as regards the Ushaw glass the date of the presidents should be in Roman numerals mdccc. The saints will not come well at all in the Exhibition Room Windows. they will not go with anything else but that is no affair of ours get all you can spoil the Philistines Powell has done the other shields.' No. 867: '2. the refectory windows are all double & their [sic] 7 of them [Pugin sketches the format of the window] 4. Dr. Newsham complains of the colour of the faces of the angels in the W Window [see JHA below C. Newsham to Hardman, 1846, Jan. 26] 'it is too deep we must not use any more for the purpose. Cant you get a few samples of the light pink glass for me to choose when I come [written at the top of the page] I have seen in a pattern sheet of glass that Wailes sent me some excellent flesh tints, of Pale pink – & yet not <u>pink</u> you should get some of these. The bordering for the refectory windows at Ushaw. it is a plain easy job but will do for the inferior Lads at odd times.' No. 797: 'I send you the 2 sketches of the Ushaw Library windows I would suggest in the 5 light window to have ¾ lengths of the great ecclesiastical writers Bede alcuin S. Thomas Anselm Gerson & c & c – on Ruby & blue grounds this would give life and and interest to the glass. I have a good proportion of Quarries in the lights to keep down the cost the tracery is entirely composed of small pieces but there are about 20 feet in each light – so I don't think the Large window could be done under 80 or £90 that you will judge but we must not make too cheap nor yet go for too much [?] I would not do them unless they brought in something – for they will be effective though I think having[?] glass & all very much out of character for a library it must look very like a church'. No. 401: I shall have to design new quarries & c for the Ushaw lights. You will have to get the shields of arms of <u>the Benefactor</u> & c especially – it is good to have this sort of work it fills up.' No. 717, postmark 'AU 16 1850': 'I send you a sketch for the Ushaw Windows. I object to S. Thomas Acquinas as being too stout for so narrow a light. I hope they will have 2 long[?] Northumbrian Bishops or Kings or a King & a Bishop. Some of the Northern Kings were great patrons of learning. S. Oswald & c. The quarries might be plain with a few centres like Merton [Merton College Chapel, Oxford] to give them a character.' No. 771: 'one of the Ushaw library lights will leave tomorrow.' No. 488: 'Powell says we have no templates or sketches or anything belonging to the staircase windows for Ushaw I remember designing them but I never saw the sketches come back, let me know about them by return. *HLRO 339: Pugin to Rev. Newsham*, letter no. 124, postmark 'Ramsgate AU 22 1847': 'as regards the glass what you say disturbs me very much. I am sure both Mr Hardman & myself have made every effort to make all the windows for St. Cuthberts as perfect as possible – but I never agreed for a moment that you expected the works at Birmingham to have been entirely confined to them. or they might have been shut up Long ago. to keep such a business going it requires a great variety of work to suit different hands & abilities & in first rate windows half the ordinary workmen would be idle waiting for the best men finishing the heads & c. – windows I really would not undertake to design faster that I have done. – I admire them as works of art & they cannot be put on the same footing as mechanical productions – allow me to draw your attention to the peculiar circumstances under which these windows have been executed they were estimated by me to be executed by Wailes in the best way we then had. I made the designs his men finished the cartoons for them & the glass was crown not flint – the Lady Chapel was a signal failure I was as anxious as yourself to do something very good & I induced[?] Hardman to set up furnaces & begin here[?] was my first loss. I paid Wailes £55 & I would gladly take £5 for the Lady Chapel windows – then I found flint glass was indispensable for richness of colour, Crown glass was cut by a diamond flint had to be ground by a tool. this added at least 20 per cent on the labour but I did not hesitate a moment in adopting it. then it was suggested to change the design for the East Window [wI] & I <u>am delighted it was done but</u> the estimate was made for 12 figures & here are some hundreds all at the same price. The cartoons alone were doubled in cost besides the creation of the glass. The other day you wanted me to change the tracery of the west window [I] & I agreed with you it would be an improvement but do you think that by the time it is sent to Birmingham taken to pieces, new glass painted & leaded up again the alteration will be effected under £20 in addition to all this I can show you a great roll of rejected cartoons for your windows all of which I have had to pay for. so that altogether I expect the execution of your glass will be attended with a considerable loss of solid cash all this I should not mind or regret as long as you are satisfied & gain us credit for our exertions but when you say <u>disatisfaction</u> [sic] <u>is far too mild a term</u> to use rejecting us I feel inclined to pull up – & stop. The East window is just completed & will be fired by the time the gilding will come to the altar but I shall most gladly assent to

postpone the other windows if you either wish or will agree it and I am quite willing to lose all that I have paid on the cartoons for them. remember I am like a Thermometer & rise & fall with the atmosphere when I have your sunshine I go up & will do anything but if you send me a chilling blast I sink below zero I really am a most zealous son of S. Cuthbert & do my very best & you ought to have have faith in me I know you have had great difficulties to collect the means for this church & I have made every exertion to get you the most done for your money & to produce a fine work. – but while I am carrying on these things for you. Con amore I must do something for other places that will bring in a little money. & keep matters going all the best men are constantly at work for you. – & more I cannot do. I feel assured that if you reflect on all the circumstances I have stated you will not only acquit me of any blame but give me some credit – I wish you could go & see the new chapel of the missionary college at Canterbury. built at the expense of Mr. Hope with an unlimited outlay. underline – & see what a miserable thing they have produced – & I believe I am quite correct in saying that their small East window has cost more than yours & it is a dead [?] failure – I am doing the windows for the Screen, I can postpone them if you wish but I fear we shall never attain that great increase of skill which is predicated [?] – I only wish it may come to pass. I expect to be at S. Cuthberts early next month & will bring the gilding with me.' *JHA: Pugin to Hardman,* undated, marked '1847 Box': 'I herewith send you the 4 evangelists for the N. Transept Ushaw the 4 Doctors will come in a few days – other 4 Evangelists go at top.' Undated marked '1847 Box': '2. My eye does not get any better I have very little pain but the sight does not improve – quite dim. I am something like spent ammunition.' '3. Oliphant has been painting a lot of things & he sketched in while I was blind – vile they must all be torn up – I never saw anything like it. this is the 3rd time portions of the East window at Ushaw have been drawn.' *Powell to Hardman,* undated, '1847 Box': 'I send the twelve groups Ushaw. the scheme shall come on Sunday for they have altered the arrangement since the first design.' Undated, '1847 Box' (with May letters): I send 3 more Groups for Ushaw and hope you can manage untill [sic] the Governor [Pugin] returns for the others as he has not coloured them and they are mostly religious orders which require more management than I shall get through.' Undated, '1847 Box': 'The window you received for Ushaw is one of the 2 screen windows, the other figure for centre light shall come soon. both windows have the same Angels with same colours on each side so that the only difference is in the the middle lights, I send tonight … an Angel for East window Ushaw.' Undated, '1847 Box': 'The shields you mention for the tracery of the south Chancel Ushaw. I think went to you … In hand are these windows 1st Lady Chapel Ushaw. two windows … 5 East window Ushaw 6. West or St Cuthberts window Ushaw … No. 1 will be with you on Friday … 5. is in Oliphants hands this will be a long time before it is complete and the west window longer. If you are waiting for work there is one light of East window complete but I know the Governor will better like to send it all together. besides these there are some more side windows Ushaw in progress so that there is no chance of a standstill.' *Thomas Early to Hardman,* 1847, Sep. 12: '4 out of the 7 lights Ushaw East Window are 2 inches too long. Mr Pugin has been here today he has devised a remedy for the glass – I had the whole of the East Window in for him to see. it has a glorious effect he is much pleased with it … it will take me and Lads [sic] 3 days more to complete the East Window it came here without a single crack which is something extraordinary in so large a quantity of Glass.' 1847: Sep. 17: 'I have got the East Window in and have commenced painting the High Altar. I have also 3 men at work at the windows around the Church painting them.' 1847 'Thomas Day' [Dec. 29 if Thomas Becket]: 'Dr. N is much pleased with the Glass all of which is now in except the Baptism of Lucius.' *Rob Tate to Hardman,* 1847, Aug. 22: 'The East window looks beautiful and the figures are elegantly drawn & designed.' Aug. 23: 'In the 4 South [?] lights you have the arms of the three districts – the lions of Durham, the Keys of York & the 4 mitres of Chester. What for the 4th window? Surely the College arms – St Cuthbert's cross on a shield azure or Mr. Gibson's, 3 white pelicans with wings extended & heads side each on a shield gules.' Sep. 14: 'The Chancel windows arrived some days ago and also the lower lights of the refectory windows, but the 4 south windows & the upper lights of 5 of the other 7 windows of the refectory have not yet come.' *C. Newsham to Hardman,* 1846(?), Nov. 19: 'The glass of the two west windows & of the east Lady window is most beautiful when you were here I told you I thought you would never equal the north antichapel [sic]; I think I remember you were yourself of the same opinion. I am very much inclined to prefer the two west windows to it & to anything you have yet sent us – even to the Lady Chapel windows. However others are not of my opinion. Some prefer the Lady Chapel window to any. They are all excellent. I have a fault to find with the drawing of the hand, in St. Edmund, that grasps the sceptre. It is stiff & clumsy In all other aspects they are all admirable.' 1846(?): Jan. 26: 'The glass of the west window [I] is now in its place [this must refer to the tracery] we all like it very well. I object to nothing but the darkness of the countenance of the angels. I think they would have looked far more beautiful & angelic had they been bright. Mr Pugin some time since gave us a drawing of the great east window & the price was stated at £320. We did not quite approve of the general conception, & we induced him to draw another. This he has now done; & on forwarding it[?] to me he expresses a fear that it cannot be done for the original price specified Now we very much dislike any change in the price originally fixed. It has been a

troublesome thing to raise the money for this window: & in fact not more than two thirds was raised. I think you could execute it for £320. If so, we will give it to you.' 1847, May 13: 'The glass of the North antichapel [sic] window is now in place. 1847 file: 'I understand from Mr. Pugin that he has finished the cartoons of the Lady Chapel.' 1847, Jul. 11: 'The west window is very beautiful but the tracery does not correspond. It is much too dark & pimply. I expect Mr. Pugin here on Saturday & we shall then hear what he thinks of it.' 1847, Sep. 16: 'We are all delighted with the East window [wI]. It is really magnificent.' 1848, Apr.11: 'I am convinced you can make a good job of the west window tracery [?] patching. Mr. Pugin told me distinctly that he would give a <u>new design.</u> I still hope that this will be done.' Postmark 'MR6 1849' (copy letter signed 'C. Newsham') 'I am requested by Dr. Newsham to forward this enclosed outline to you for a design & estimate of windows for the Exhibition room to Ushaw College [includes a sketch of a six-light, transom window]. They are to be similar in character to those you put in the Refectory. Please [?] to have a sketch made to a larger scale & send it with estimate for me [?]. There are 8 or 10 windows.' 1850, Apr 22: 'I have decided on adopting the sketches proposed by Mr. Pugin for the east & west windows of the library.' Aug. 24: 'St. Thomas of Aquinas is the patron saint of the person who gives us the staircase windows of our library & he wishes to have that saint in preference to any other. No doubt Mr. Pugin's ingenuity can contrive to make the figure suitable to the size of the glass. As you say that both windows can be done for £40 I wish you do both in the same way – only in the window towards the west let the figure be that of St. Bede, while the figure towards the east must be as I have stated that of St. Thomas of Aquinas. As you say nothing about the shields for the great east window of the library I take it for granted that Mr. Pugin has designed something else. I hope he has for shields will not do well for that window there would be an impropriety in introducing them, as all is done by one individual. The person who gives the two staircase windows is the Rev. T Witham. I believe you have his shield which must be introduced into both these windows.' 1851, Jun. 21: 'I wish from my heart that you were here that I might <u>speak</u> with you, instead of <u>writing</u> about the glass that has been sent for the library. However as I fear I cannot have the pleasure of seeing you I will state plainly as to a friend what I feel on this subject. The glass is really quite unworthy of your manufactory & will most certainly, if allowed to remain, do irreparable damage to your credit in this branch of your business I have always considered you not only at the head, but far in advance, of all others whose glass I had seen in this country. My journey through Belgium & many parts of Germany & Italy served only to confirm me in my opinion with the exception of two or three specimens of old glass I look upon your glass as the very best I have ever seen in <u>any</u> country. In the exhibition although your glass is unfavourably placed, yet there is nothing there in my opinion at all equal to it. Within the last three weeks, before my arrival at Ushaw, a friend of mine told me that he was most strongly solicited to give the order for some glass he was about to get, to Wales [sic] of Newcastle. I earnestly remonstrated with him, I told him I should consider him mad if he allowed any solicitations to induce him to employ a man so infinitely inferior to you. In fact in all places & to all persons I have whenever occasion offered recommended you as the only fit person to be intrusted with figured glass. Will you allow me to speak plainly out? This glass of ours had quite shaken these strong feelings of your superiority. I can hardly remember to have seen what appears to me worse. I have seen glass by Wales [sic] far superior. Were my friend <u>now</u> to say what he said not 3 weeks since I could not honestly use the language to him I did <u>then</u>. Observe I speak of the figures only I wish you were here to see them. I am certain you would be ashamed of them. No person on seeing the glass in our chapel & this glass in our library would believe that they come from the same manufactory. I much dislike all the figures at least the heads – : but those in the west window are the worst. There is another thing I complain of in the west window. There is a repetition – merely reversed of the same figure. Of all the heads there are only 6 <u>distinct</u> figures. The others are mere repetitions reversed. Now this is not in my opinion (& I believe all would agree with me) a window with a stated number of figures. Of course I meant distinct figures. I never should have thought of or consented to repetitions. There is something so poor & unpleasant in the effect that it strikes everyone at first sight I must observe that all at Ushaw express to me the same opinion & feelings I here convey to you I think therefore it is absolutely necessary to replace the heads of the figures by something different & better [Hardman has noted on the letter: '4 figures reworked']'. *Hansom to Hardman*, 1850, Sep. 26: in this letter Hansom discusses the costs of various designs for the side windows of the Ushaw Library and includes a sketch to make his points. Originally, it was intended to include the bust of a saint, within a quatrefoil, in each of the upper lights of the windows, and the head of a saint in a circle at the centres of the quatrefoils in the tracery. Hansom queries what the reduction in cost would be if the busts were omitted , a reduced price having already been offered if the heads were left out. On the basis of the windows now *in situ* it would seem that agreement was reached to exclude both the busts and the heads, leaving the windows comprised of figured quarries and coloured borders only. Peter Leed to Hardman, 1850, Oct. 10: passes on a request from Mr Hansom for the E & W windows of the library to be expedited. C. Gillow to Hardman, 1850, Dec. 28 (in 1851 box): 'I was very much surprised to hear that the templets [sic] of the two windows had not been sent. I have requested Peter Leed to forward them without delay. I

think that Mr. Pugin made some objection to introduce the figure of St. Thomas of Aquinas. As the donor particularly writes to have the figure of his patron saint in the window we must not omit it. When you were last here, you spoke of having plain quarries in the two windows. I am afraid that the donor will not be satisfied with them. We must therefore have figured quarries.' *James Chadwick to Hardman*, 1847, Feb. 7: 'If you have a list of subjects of St. Cuthberts life contained in the glass for the West Window [I] I would feel very thankful for a copy of it, as I want it for a purpose'.
Literature. *The Tablet*, 9, 1848, p. 675: description of opening ceremony with an indication of the chapel layout. Chadwick, 1848. Gillow, 1885. Wedgwood (Pugin's Diary): Pugin visits Ushaw, 1840, Aug. 29-31; 1841, May 2; no diary 1843; 1844, Feb. 24-6, Jun. 8-9, Aug. 6, Sep. 27-8; 1845, Apr. 12-14, Sep. 18-19; 1846, no diary; 1847, Jul. 10-11, Sep. 11-12, Nov. 27; 1848, Mar. 18, Sep. 5, Oct. 9-11.

EAST RIDING OF YORKSHIRE, see HUMBERSIDE.

EAST SUSSEX
41 Brighton (Brighton & Hove UA), St Paul (CoE)
1849-53. Clients: Revs A.D. Wagner, H.M. Wagner (I). Supervising architect: R.C. Carpenter.

Chancel E window (**3.5a & b**)	I	4.6m x 7.6m	7-light	£370	1849
Chancel N & S windows (**2.2a & b**)	nII, sII–sIV	1.7m x 3.7m	3-light	£240	1849
N aisle W window (**2.3**)	nVIII	1.2m x 2.3m	2-light	£35	1850
S aisle E window (**7.4**)	sV	1.6m x 3.4m	3-light	£65	1852
S aisle windows+ (**6.2**)	sVI–sVIII	1.1m x 2.7m	2-light	£75	1852
W window★	wI		5-light	£250	1852
S aisle windows+	sX, sXI	1.1m x 2.7m	2-light	£50	1853
N aisle windows+	nIII–nVII	1.2m x 3.0m	2-light	£125	1853
Vestry window+			2-light	£18	1853

 ★ initial design by Pugin but probably redesigned by J.H. Powell
 + initial designs by Pugin, final designs almost certainly by J.H. Powell

The letters show that after the E window (I) had been ordered by the vicar of Brighton, the Rev. H.M. Wagner, in Jan. 1849, his son, the Rev. A.D. Wagner, the incumbent of St Paul's, became adminstratively responsible for the scheme, which he outlined to John Hardman, on Mar. 24, 1849. Apart from changes to some of the saints named for the W window (wI) and the window for the W end of the N aisle (nVIII), this arrangement was followed and the work was completed by Nov. 12 1853.

Pugin produced the initial sketches for the chancel windows (I, nII, sII–sIV) and supervised the cartoons for them which were drawn by F.W. Oliphant. He performed a similar task for the W window of the N aisle (nVIII), although in this case the cartoons were prepared by J.H. Powell.

The E window of the S aisle was ordered on Oct. 27, 1851 after R.C. Carpenter had corresponded with Pugin about the design in the previous month. It seems likely that Pugin produced an initial design but whether it was carried out is uncertain. The window was not finished until May 25, 1852 (nearly four months after Pugin stopped work because of illness) and the arrangement of three overlapping figures in each side light, turned inwards and participating in the event portrayed in the central light is more pictorial than Pugin's usual work, which tends either to portray the whole scene in the centre light[9] or to isolate the figures in their separate lights, within medallions,[10] or under canopies.[11] Possibly Powell, who was more inclined to introduce narrative detail into his designs, produced a new design in 1852.

The W window (wI) was also ordered on Oct. 27, 1851. Hardman's letter to the Rev. A.D. Wagner dated May 8, 1849 refers to Pugin's designs for the window. Since it was not finished until Dec. 13, 1852, Pugin would not have been involved in its manufacture and as the revised list of saints was not received until around Aug. of the same year, the same applies to the cartoons. Powell could have used Pugin's initial designs, assuming they were returned to Hardman, altering them to give effect to the changes of personnel, or produced his own, close to Pugin's style because of the need to harmonize with the windows already completed. Also at this early stage of Powell in Pugin's role, the latter's influence would still have been considerable.

The aisle windows (sVI–sVIII, sX, sXI, nIII–nVII) and the vestry window come into the same category as the W window (wI). However, Pugin's initial designs for the aisle windows which were of saints in medallions against backgrounds of diaperwork were abandoned, although the window for the vestry retained this form, with the Rev. A.D. Wagner looking to have canopied-saints as in the window at the W end of the N aisle (nVIII). As recorded in the First Glass Day Book and inscribed in the windows (apart from the vestry window), the saints comprise: St Boniface and St Swithin (sVI);

St Edmund & St Edward (sVII); St Dunstan & St Alphege (sVIII); St Anselm & St Edward King (sX); St Hugh & St Richard of Chicester (sXI); St Etheldreda & St Bede (nIII); St Augustine of Canterbury & St Chad (nIV); St David & St Gregory (nV); St Helen & St Alban (nVI); St George & St Nicholas (nVII); St Chrysostom & St Augustine of Hippo (vestry window). Designs for these, apparently, were not produced by Pugin. Powell's work is again close to that of Pugin, although the elongation of the figures – particularly those in the N aisle – and a certain sweetness or charm in the colours, might point to the former's preferences. A restoration of the windows was undertaken, in the early 1990s, by Lawrence & Co. of Canterbury, including the removal of 19th-century overpainting , applied with the intention of toning down the colours, from the E window (I) and alterations to the W window (wI) as mentioned below.

Descriptions. **I.** 7-light Jesse window and tracery. Each light contains representations of three of the ancestors of Christ, who combine to form three rows of figures across the window. Jesse in a blue, hooded headdress, and a green-lined, white mantle patterned with yellow silver stain, over a red robe, is seated at the bottom of the middle light. The Virgin in a white-lined, yellow head-dress and a blue-lined, yellow mantle over a brown robe, with the Christ Child in a red robe holding an orb in his left hand, on her lap is seated, at the top of the same light. The remaining figures, who are all crowned and in garments variously coloured red, blue, green, yellow, orange and purple stand against a background of blue foliage diaper holding sceptres in their right hands, except for the figure in the middle light between the Virgin and Jesse who holds one in his left hand, and David, on Jesse's right, who holds a harp in his left hand. Red quatrefoils with a white vine leaf in each of the foils fill the panels at the bottom of the lights and between the figures. The leaves are attached to yellow stems which emanate from the bottoms of the lights, proceed vertically up the borders and form lozenge shapes around the figures. The borders are patterned with green and white vine leaves that are attached to the climbing stems. The tracery consists mainly of a wheel formed by eight trefoils with a quatrefoil at its centre. It is positioned between two sets of three trefoils that form triangles over each set of three lights to the left and right of the centre light. The pieces are all filled with patterns of white vine leaves and green bunches of grapes on yellow stems, against red and blue grounds.

nII sII, sIII, sIV. 3-light windows and tracery. nII was blown out in 1987 and was filled with plain glass when visited. It has since been restored and reinstated[12] (see *JHA Letters* below for subject matter).

An Apostle is depicted standing under a canopy in each of the lights of the other three windows – those in the side lights of sII and sIII against red diaper foliage screens, and in the centre lights against white. The colour scheme is reversed in sIV. The canopies have cinquefoil heads over which are yellow-crocketed and finialed gables. Above and behind the gables are superstructures formed of red and blue Gothic windows surmounted by white-crocketed and finialed gables. From left to right the Apostles are:

sII. St Thomas in a red-lined, green mantle over a wine-coloured robe, holding a builders square in his left hand and a lance in his right; St James the Great in a purple-lined, blue mantle over an orange robe, holding a staff with flask attached in his right hand and an open book in his left; St James the Less in a green-lined, white mantle patterned with yellow silver stain, over a brown robe, holding a club in his left hand and a book in his right.

sIII. St Philip in a green lined, blue mantle over an orange robe, holding a crossed-staff in his right hand; St John the Evangelist in a white-lined, red mantle over a green robe, holding a chalice, from which emerges a devil, in his right hand and a book in his left; St Bartholomew in an olive-green lined, blue-green mantle over a brown robe holding an upturned-knife in his right hand.

sIV. St Simon in a green-lined, red mantle over a blue robe, holding a saw in his left hand: St Matthew in a green-lined, green mantle over a wine-coloured robe , holding a quill in his right hand and a book in his left; St Jude in a red-lined, white mantle over a green robe, holding a lance in his right hand and a book in his left.

The windows all have three trefoil tracery-pieces filled with patterns of white vine leaves on yellow stems against red grounds.

nVIII. 2-light window & tracery. St Joseph of Arimathaea in a wine-red hood, a wine-red-lined, blue mantle over an orange robe, holding a green, conical-orange-topped jar in his right hand, is depicted in the left-hand light standing under a cinquefoil-headed canopy over which is a yellow silver stain-crocketed and finialed ogival-arch. Above the arch is a crocketed and finialed multi-gabled green, white and red Gothic window superstructure. Behind the saint is a yellow-beaded, diamond trellis screen with red diaper infill. St Clement in a blue-lined, red mantle over a green robe, holding a crozier in his left hand stands under a similar canopy to that of St Joseph, and in front of a similar screen, except that the diaper infill is green, in the right-hand light. The borders are patterned with white roses on yellow undulating stems against red and green grounds. The three main tracery-pieces are filled with yellow silver stain-patterned white grisaille roundels surrounded by white vine leaves on red grounds.

sV. 3-light window and tracery depicting the Crucifixion under canopies. Christ on the Cross with an angel at either side of his waist and legs and St Mary Magdalene in a white head-dress, a brown-lined, red mantle over an olive-green robe, half-kneeling at his feet, is in the centre light. The Virgin Mary in a white-lined, blue, hooded mantle over a purple robe, with two other female saints, is in the left-hand light, and St John the Evangelist in a white-lined, red mantle over a green robe, with a soldier and another man, is in the right. The backgrounds have been removed and replaced with green-tinted quarries. All that remain of the canopies are the columns, the lancet arches of the heads and the yellow-crocketed and finialed gables over them. The main tracery-pieces are a leaf-patterned trefoil at the top of the window and two quatrefoils, each containing a half-length angel holding an inscribed scroll, positioned symmetrically below.

wI. 5-light window and tracery. Each light contains two figures under canopies. The backgrounds to the figures were removed, probably in the 1960s, and when the window was restored, during 1990-2, new backgrounds based on examples of Pugin's work, were introduced. Also some of the original faces and hands of the figures, which had lost much of their paintwork, were replaced. According to Hardman's order book the arrangement of figures, reading from left to right, was as follows: upper tier: St Luke, the B.V. Mary, Our Lord, St Joseph, St Mark; lower tier: St Timothy, St Barnabas, St Paul, St Matthias, St Titus. The same names, listed as 1 to 8 (those corresponding to the even numbers accord with the upper tier and those to the odd, with the lower tier), are given in the First Glass Day Book.

Office records. *Order Books*, undated, f. 53 (I, nII, sII–sIV); undated, f. 52 (nVIII); undated, subject matter given as St Joseph of Arimathea and St Clement, f. 59 and 1851, f. 150, Oct. 27 (sV, wI), f. 151, Oct. 27 (sVI–sVIII, sX, sXI); Book 2, 1852, f. 14, Nov. 25; Book 3, 1852, f. 16, Nov. 25 (nIII–nVII & vestry). *First Glass Day Book*, 1849, f. 63, Jun. 19 (I), f. 68, Oct. 9 (nII, sII–sIV); 1850, f. 103 Nov. 2 (nVIII); 1852, f. 145, May 25 (sV), f. 161, Nov. 8 (sVI–sVIII), f. 165, Dec. 13 (wI); 1853, f. 175, Mar. 19 (sX, sXI), f. 195, Nov. 12 (nIII–nVII and vestry window). *Cartoon costs per ledger summary*: I, Powell £6.0.0, Hendren £3.0.0, Oliphant £27.10.0; nII, sII–sIV, Powell £6.0.0, Hendren £3.0.0, Oliphant £18.5.0; nVII, Powell £3.5.0, Hendren £1.0.0. Oliphant's account records that his the payments were in respect of:

			£.s.d.
'1849	Mar 3	Expenses to & from Ramsgate	3.0.0
		18 days Inn Expenses @ 7/-	6.6.0
	April 3	14 Kings for Jesse Window @ 22/6	15.15.0
		13 of them sketched at Ramsgate	
	" "	Cartoon of B. Virgin for do @ 35/-	1.15.0'
		(Difference with ledger summary	14.0: total £27 10.0.)
	'May 18	3 Figures Apostles @ 35/-	
		Sketched at Ramsgate	5.5.0
	July 16	9 Cartoons, Apostles 3ft 6in @ 29/-	13.0.0'
			(Total £18.5.0)

Letters. *HLRO 304: Pugin to Hardman*, letter no. 100: 'The next window will be Brighton East Window.' No. 134: '1 . you better send me the cartoons of Lord Portarlingtons window [Milton Abbey, Gaz.35] they will be helpful[?] in the Brighton window. 4. I will send you the nave windows for Brighton tomorrow.' No. 1032: 'I am just able to send you the drawing of the window for Brighton the milton figures [Milton Abbey, Gaz.35] will not come in – they are too large'. No. 143: '1. I send you the nave windows for Brighton I should think they would be done at £30 a piece or perhaps less if there are many of them. 2. It is very difficult for me to make out the tracery of such windows as this last Brighton window without any tracery or general scheme of the window – they ought to send me back the sketch I made to work by. It is impossible to remember all these things – you must look out & send the general sketches with the templates.' No. 99: 'I return you [sic] the sketches of the Brighton windows. I do not at all approve of the idea of altering the tracery. it is a Jesse window & in all old examples the vine runs through the top angels & Lamb it would be very good in a window of general design – but they would be quite innappropriate [sic] in this case & I hope you will persuade Mr. Wagner not to have it. [See *JHA, A.D. Wagner to Hardman*, 1849, Jan. 29 below].' No. 228: 'Mr. Wagner is here from Brighton he thinks my East window tracery very fine indeed.' No. 55: 'I do not underestimate about Brighton – the 12 apostles will be in windows alike – & similar to the one I already have in hand – what is intended to be in the East window of S. aisle which you have now sent 2 – I hardly know what to say about the amount time [sic] for finishing these windows the East window is my fault unless[?] we may be able to send it off to you this week. For the Apostles we have to depend upon Oliphant & he does very little himself I will do my best I should think you will get all the Chancel

windows in by the mid of June.' No. 382: '2. The cartoons for the Brighton window could be done in 6 weeks if Oliphant will work.' No. 950: '3. I think the Brighton windows can be ready by the time.' No. 991: ' I send you the sketch for the side window Brighton. I think you may promise with the east window.' No. 54: 'Oliphant is making a first rate job both of the Brighton & Erdington [Gaz.177] windows.' No. 314: 'Oliphant has not made a good job of the apostles for Brighton we shall have to make many alterations – I am working at them. Pray do not forget my iron for the top quatrefoil of my east window [includes a sketch]'. No. 986: 'I am very unhappy about the side windows at Brighton – the heads are rascally'. No. 971: 'I am very much distressed about the heads of the Brighton Apostles. It is a sad job & there is too much light gone I am afraid we shall not get any credit by them & unless we do something <u>very good</u> soon we shall never get any credit ... I have made a great mistake in using a very pale green in the Brighton window canopies ... It is a dreadful disadvantage for us to work so far apart. I have only an occasional opportunity of seeing the effect & very often too late to improve'. No. 984: '5. I have arranged a new canopy for Brighton which I hope will come well.' No. 731: 'I find the canopy for Mr. Minton's friend [?] comes just the size for Brighton so we shall use it for that also. Powell is now doing the 2 images & you will have the whole window. Powell has done a <u>magnificent</u> image of Joseph of Aramathea [nVIII]'. No. 955: 'The Brighton tracery goes off by this post I have taken the colours which produce the best effect <u>everywhere</u> the tracery in decorated work is kept light – & is so on principle –to define the form of the mullions. in late work it is different & then the masonry was sacrificed to pictorial effect. I hope the new canopies for Brighton come well. they ought to look bolder than the others.' No. 398: 'There are great complaints about the Brighton window [I] they say it looks poor & almost <u>white</u> in the upper part. I mean to go & see it.' No. 407: 'I will go to Brighton before I say anything about the tracery if <u>it is light</u> I expect it is just the thing I wish my tracery [St Augustine, Ramsgate, Gaz.88] was light. I will have a talk with Mr. Wagner about it.' No. 966: '5. I went to Brighton yesterday [1849, Oct. 20]. the glass on the whole looks very well. the great defect is in the blues but the East tracery is capital twice as good as the blue & I think the last canopy a great improvement on the former I am sure we shall now be able to do some good jobs the thick white glass in the canopy looks exceedingly well we must always use that. – The Church is no great thing bad[?] crossing[?] vile – but a good proportion. I think it is rather dark.' No. 833: 'Mr. Wagner spoke to me about the crucifixion for the E. aisle window but I don't think that I have not [sic] got the templates.' No. 780: 'It appears we have never had the templates of the East window at Brighton the lights are set out from a similar[?] dummy but no tracery, will you see to this.' No. 424: 'We can do without the East window tracery for a little while – don't neglect Brighton on any account I think I shall be able to send the other 2 apostles making one side window complete.' No. 423: 'I send you the sketch of the other Brighton window for which I hope you will get an order.' No. 49: 'I am getting the Nottingham windows [Convent of Mercy, Gaz.130] & the side Brighton next. By the way what an absurd idea about you sending the names of the Kings in the East window [I] if they look up the first Chapter of St. Matthew they will find them all & they can take those that suit them best.' No. 164: '4. I want my sketch of the East Brighton window [I] to work by pray get it for me. 5. The 3 apostles are drawn for the side window & is a fine job.' No. 401: 'these are the dimensions of the Brighton window [makes a sketch of sV]. you will have the design of the west window by the Early post tomorrow. I will do my best to get on'. *National Library of Scotland: Pugin to Oliphant*, MS 23204, f. 3, undated: 'I am quite determined to turn over a new leaf in the arrangement of our figures or Rather to turn back to an old one. when you come down I will point several things that require amendment especially the position of the feet which are foreshortened but which wont come down on the ground [includes a sketch]. I have [?] this everywhere & it gives great variety of [?] whereas ours are flat & innefective [includes a sketch]. I am studying very hard these old things & by working more on the old principles we will improve immensely. I am sure you will see the truth of these remarks. we must come to a more conventional means of representing figures for glass – more ageless Draperies some of the apostles for Brighton dont come well. They look so coarse & the drapery is broken & wrinkled[?]. they looked[?] very well when sketched in but some how or other they have lost in the drawing. & I fear[?] I cannot [?] them by any [?] or [?] they don't look like your hand [drawn by Oliphant's brother, perhaps] for the first 3 we had were admirable. however we shall see. I get very miserable over my work we are so far behind the old men can you not tell. you have forgotten the [?] head of S. Paul with the tuft of hair on the forehead & the long beard [includes a sketch] you have given him a full head of hair & it just alters the look'. MS 23204, f. 14, undated: 'I think the general arrangement of the apostles very good but in future you must take more pains with the heads which are too coarse[?] for windows so near the eye & I do not believe the old men ever put in the eyes black except at a great height – there is also great attention required in the disposition of the hands & fingers which do not come well in most of these figures. they have a lumpy look which the old men avoided I have just been going about to look at old glass & I see enormous[?] room for improvement in details next time you come we will have a <u>fresh start</u> everything falls short of the true thing. I cannot please myself in anything. Can you not tell'. *HLRO 304: letters from Powell to Hardman*, postmark 'PM JY 22 1849': 'Oliphant has finished Brighton side windows.' *JHA: A.D. Wagner to*

Hardman, 1849, Jan. 29: 'The window I wish to have painted is the south east window of the Chancel, I mean the most eastern of the three [sII] that under which the sedilia are. It should represent according to the plan proposed the apostles S.S. John, Philip, Bartholomew (St. John occupying the eastern most light) [The saints proposed were included in the middle window sIII with St John appearing in the middle light, while those proposed for sIII (see below) appeared in sII].' Mar. 12: re NE window of chancel (nII) 'The Three Apostles to be represented ... are St. Peter, St. Andrew & St. James (St. Peter of course being in the light nearest to the West end and St. James in that nearest the East end [St Paul replaced St James in the finished window, St James the Great replacing St Matthew in the Wagner-designated second window [sIII], see below]. I suggested to Mr. C[arpenter] that some alteration should be made in the manner of breaking the ceiling of the great East window [treatment of the tracery?]. I think there should be Angels in each of the compartments and a representation of Our Lord in the centre. I should suggest the figure of a Lamb. See Apocal V 8 [this idea was not pursued: see *HLRO 304, Pugin to Hardman*, letter no. 99 above]'. Mar. 24: 'When I wrote to you a few days ago I did not think that I should have been able to give an order so soon for the remaining two windows of the Chancel, containing six other apostles. I should be obliged to you to put these now in hand & to sign & return the enclosed agreements ... As it is not impossible that some other persons may desire to present a window to the Church, I should be glad if you would let me have a design for the Great West Window [wI], for which you have already sent in the estimate (in £210). I think that it would be better that there should be two saints in each light, else the figures would be too large, & out of character with the rest of the painted glass and further a larger number of saints can then be represented. I think the Saints that would be represented on that window would probably be SS. Paul, Luke, Barnabas, Mark, Stephen, Philip, Philomena, Onesimus, Timothy, Titus. I have not of course arranged them in any order [changes were made and in the finished window, the B. Virgin, Our B. Lord, St Joseph and St Matthais, replaced St Stephen, St Philip, St Philomena and St Onesimus]. (2) Further I should be glad to have an estimate for the window at the west end of the North Aisle [nVIII] containing two saints (probably S. John Baptist & S. Joseph of Arimathaea [St Clement ultimately replaced St John the Baptist]) (3) Also for that at the East end of the South Aisle [sV], with three lights containing a representation of the Crucifixion with S. Mary & S. John. (4) And lastly an estimate for one of the 10 aisle windows, all of which are of the same dimensions and of two lights – each light should contain a Saint which will be decided upon afterwards probably the ten windows will be fitted with 20 of the English Saints [asks for estimate of each item and a sketch]. It is not improbable I may get some of my friends to put in one of the smaller windows. I need hardly say, that the glass should be of good execution & in the best style of art. I had rather have no painted windows at all, than have any of a second rate description [at the bottom of the letter Wagner named the saints to be depicted in the two remaining chancel windows as follows] '2nd window [sIII], S. Thomas, S. Matthew, S. James; 3rd window [sIV], S. Jude, S. Simon, S. Matthias', a number of the changes made before the windows were finished, have been mentioned above, in addition to these, St Matthew replaced St Matthias in (sIV), appearing in the middle rather than the end light, with the latter saint ultimately appearing in the west window (wI)].' Apr. 28: 'I shall be glad to have at your convenience the agreement for the last two windows of the Chancel, and also to know, as near as you can tell me, the time by which they will be finished. I am also desirous to have the prices for the other windows of the Nave, as I may be, & have been asked what the cost would be. I saw Mr Carpenter the other day, and he agreed with me in thinking that the figures of the Aisle Window in your design were too small. He told me, he should speak to you on the subject, which I suppose he has done.' Jun. 8: 'I am glad to know the East window [I] is well nigh complete. I suppose your men will be able to put it up by Saturday the 23rd, if they commence on the morning of Monday the 18th.' Undated: 'I send another note just to say that the two Saints I wish to be represented in the West window of the North Aisle [nVIII], are S. Joseph of Arimathaea & S. Clement I forgot whether I told you this before. Have you a list of the figures in the Jesse window [see Pugin's response, *HLRO 304*, letter no. 49 above]? Should any of the Aisle windows be ever painted I can give you a list of the Saints I desire to be represented'. Jun. 16: 'I enclose as you desire the drawing for the window at the End of the North Aisle [nVIII]. Part of the glass for the window [I] arrived this afternoon, and is now in the Church ... I have suggested to your man that it would perhaps be desirable to deaden the light of the Gt. West Window [at this time it was filled with plain glass] but I can better judge of this when I see the [?] of the [?] so done.' Jun. 20: 'I was quite unaware that I had made an alteration in the subject of the Aisle window [nVIII] I think I should prefer the original subject i.e. S. John the Baptist S. Joseph of Arimathaea. I have not quite decided on the list of saints to be represented in the other windows of the Aisle. If anyone will present any of these windows I can then send you the subjects. There is also a small window in the Vestry, which I hope one day to see painted ... the window might be diapered, with a small figure of a Saint in the centre. I like very much what I have yet seen of the Jesse window, but it is hardly fair to judge of it till all is put in ... Mr Carpenter has forwarded me a sketch of some lights – but I fear our fund will not admit (for the present at least) of ordering them'. Jun. 21: 'I am just on the point of leaving Brighton for the day, & so have only time to say that I have seen the whole of

the window [I], now put up, & like it, as a whole very much. The part I least like is the upper portion containing the foliage. The colours in this seem to be hardly deep enough, but I suppose time & dirt will improve this. I think it would be well to insert some rather different subject in the summit [tracery] of the other windows of the Chancel. Could not Angels, or some small figures be represented in the circles [?] surmounting the lower lights [this idea was not pursued]'. Jun. 25: 'The other day when I wrote I was on the point of leaving Brighton and had hardly time to say all I wanted. I am very much pleased with the window [I] as a whole, and think it is the best modern window I have seen. I should be glad if you would tell me what would be the difference of cost between painting the Aisle windows in a similar manner to the Window last ordered [end of N aisle (nVII)] and in the manner you first proposed with a diaper. I cannot say I quite like the design I should like larger figures. The price you mention for the window is £25. I should therefore be glad to know how much more it would cost to execute them in the manner I have described.' 1851, Oct. 14: 'I have been in communication with Mr. Pugin respecting the painting of two or three more of the windows of S. Pauls Church & hope before long to give an order for all. The first window I wish put in hand is the East window of the South aisle [sV]. Mr Carpenter has offered to give the centre light himself. I am therefore to be responsible for the remaining two lights & the tracery ... The Great West window was to cost £240 ... & each of the side windows of two lights £30 each if done in the same manner as the last windows put in. I should be glad to know what part of the whole expense would be the painting the centre light of the west window. If painted soon it might I think lead to the completion of the whole window.' 1851 bundles, undated: 'I think it would be better for your man to take a copy of the windows in the nave of S. Pauls, as I hope to be able to order several, and I am afraid I shall not do it with sufficient accuracy myself. Mr. Pugin said he would go on with the Cartoons if they were sent to him at once – Your man had better take a copy of all the windows & then, I can order them, as I have sufficient funds to enable me to do so.' Nov. 9: enquires as to the entire cost of finishing all the remaining 12 windows of the Nave of S. Pauls (sV, ten aisle windows, wI) 'I thought that the expense of painting the 12 windows would be less than if they were painted at intervals and that you might be willing to make some reduction on the earlier cost. Would you let me know whether you would do this. Of course you may depend on my paying ready money if you consent to this arrangement. I enclose a list of the saints I wish to be represented in 12 windows.' Nov. 12: 'I do not quite understand the manner in which you propose to treat the aisle windows. I did not at all like the sketch you sent me some two years ago. The Figures were not nearly large enough & [?] the windows looked mean & poor. However, I will give an order at once for all the 12 windows at the prices you mention ... I can write to Mr Pugin about the side windows, & explain to him what I want.' Dec. 18: 'Has Mr. Pugin finished the cartoon of the East window [sV]? I am afraid there is not sufficient space in the little windows [aisle] for grisaille work to look well. I think I should prefer Canopies. But I must see Mr. Pugin on the matter. I hope you will get on with the windows this winter as I find peoples interest flag, if they see nothing done & I have a good deal yet to collect.' 1852, Mar. 23: 'I shall also be glad to know the probable time, when I may expect the first of the Painted Windows.' Apr. 26: 'I should like the windows in the Aisle on the south side of the Church to be proceeded with before the rest, as three of them [sVI–sVIII] have been given by different parties who will expect to see them. I suppose before long I may expect the East window containing the Crucifixion [sV]. Jul. 8: 'will you let me know whether you have still got the list of Saints for the West window and their position.' 1852 bundles, undated: 'I return (with a few alterations) the list of Saints to be represented in the West window of S. Pauls. I shall be glad if you can get it finished by the beginning of October. Would you please let me have a sketch of the small side windows I am sorry that you did not understand that I had ordered all the remaining windows I suppose I must have written about it to Mr. Pugin. I hope he is better than he was.' Oct. 25: 'I should be glad to know when I can expect some of the windows. I have been looking for the west window every day the last fortnight, as some time ago you promised it me the last week in October.' Undated: 'I like the window [wI] on the whole very much. I think the figures a little too large'. Nov. 11: 'The wire work and all the tracery arrived yesterday, so that we have just had here to get the three windows [sVI–sVII] put in by tonight. I like them on the whole very much. They add greatly to the beauty of the Church and make one look forward to the time when all will be finished. I should like you to execute a painted window for the Vestry. It is a small two light window – you have I think the templet [sic] & once gave me an estimate for it. The two saints I should like represented would be S. Chrysostom with Greek vestments & S. Augustine (Hippo)' 1853 bundles, undated: 'I should be much obliged to you if you would let me know when you think the remaining windows of S. Pauls are likely to be completed. Could you get the remaining windows in the south aisle [sX, sXI] finished before the others? I am making a covered way and it will be difficult to get at the windows when that is finished ... I was not in London last week as I should have gone to the sale of Mr. Pugin's Library [the sale took place Jan. 27-9, 1853].' Undated: 'I ought to have written last week to say that the windows were opened & had arrived without injury [sX, sXI]. I think the two last are superior to the other three which you sent last Autumn.' Nov. 12: 'I like the new windows [nIII–nVII and vestry] very much better than the five corresponding windows on the

south side and the vestry window the best of all'. *H.M. Wagner to Hardman*, 1849, Jul. 26: Confirms receipt of Hardman's account, 'It [I] is very generally admired. Thousands of persons have seen it and & I hope it will add to your Fame.' Aug. 10: Confirms that the consecration is postponed to October 18 ('Festival of St. Luke' with the aquiescence of the Bishop, 'I earnestly hope that your windows may be fixed before that time, when Brighton will be overflowing with visitors & thousands may have an opportunity of admiring them and I the more rely upon your kind attention to this matter having originally understood (I presume mis-understood) that several of the windows would have been fixed before the Festival of St. Peter the 29th June long past'. *I. Bishop to Hardman*, 1851, Nov. 9: 'I have seen Mr. Wagner Junr he says he should like the center [sic] opening of the West window filled he says if he had that in he would fill the other sooner Mr. Pugin would not let me stop to finish.'. *Oliphant to Hardman*, 1849, Mar. 24: 'I expect to get all the cartoons for the Brighton Jesse sent off to Ramsgate on Tuesday week.' *Carpenter to Hardman*, 1849: Jan. 9: confirms 12 Apostles as subject matter for the four chancel side windows. Carpenter to Pugin, 1849, Jan. 8: 'I enclose a tracing of the Chancel side windows four in number in which it is proposed to introduce the 12 Apostles what would be the cost of such a work' Feb. 10: 'Respecting the time for completion of the work, I would urge upon your consideration the necessity of having this window [sII] together with the east window [I] fixed by the day on which the Church is to be consecrated, viz the festival of S.S. Peter & Paul [Jun. 29], "All the world" will be there then and it would be a pity both for your sake, the Vicar's and mine that the Church should not on that important day have the benefit [of] so striking a decoration.' 1851, Sep. 20: 'I have been staying for my health at Brighton but left last week & before doing so obtained a commission from the Wagners to order glass for the East window of the So. Aisle of St. Pauls [sV], a window <u>wh</u> will tell well. It is to be a crucifixion window. Our Lord on the Cross in the centre light with angels with thuribles at A.A. [sketches a cross with the positions of the angels marked accordingly] and in the first and third lights the B. Virgin & S. John. The whole under canopies & occupying the entire height of the lights. The tracery I suppose <u>wd</u> be like that to the Mid[dle] P.[ointed] windows at Sherborne [Gaz.37] the effect of which in the short windows is beautiful. Perhaps you would make a sketch I enclose a tracing showing the size & arrangement of the lights & tracery.' *Hardman presumably to A.D. Wagner although headed to Carpenter*, 1849, May 8: 'I have by today's post sent to Mr. Carpenter the designs for the remaining windows for your Church & on the other side you have the estimates for them the costs quoted on "the other side" are as follows: West Window 10 figs £250, East end of South aisle £65, windows in aisles with a saint in ea. light £25. Mr Carpenter tells me he is to be at Brighton on Saturday & as he expressed a wish the last time I saw him to have the designs previous to their being submitted to you I have forwarded them to him accordingly – On measuring up the templates taken by my workman I find that the West Window is very much larger that I had estimated it from a tracing of small size sent to me by Mr. Carpenter in the first instance & also I had calculated on merely putting in 5 figures with long canopies & geometrical work [?] whereas you wish to have 10 figures which will increase the expense of the cartoons & also the painting I trust therefore that you will allow me to increase the price to £250 ... I am working hard at the East window & trust that it will turn out such a work as will quite satisfy you.' *Letter Book: Hardman to A.D. Wagner*, 1852, Mar. 25: notes that the templates used for the E window of the S aisle (sV) were wrong – 'nearly twice the size' and therefore the cartoons would have to be withdrawn.

Literature. *The Ecclesiologist*, 7, 1847, pp. 153-4: progress report on the building of the church; 10, 1849, pp. 204-7: description of church, including the following comments on the chancel windows: 'The east window, of seven lights, contains the Radix Jesse, which we like the least of the set. The white borders to the tracery openings being rather exaggerated, give a somewhat spotty appearance to the whole. Still the work, both in design and execution is vastly superior, not only to the yellow tawny Radix Jesse by Mr. Wailes, in S. George's, Lambeth [Gaz.63] but also to the one which he has recently put in the altar – (but the north), window of the Jesuits church, in Farm-Street Mews. The three three-light side windows on the south and the one to the north contain The Twelve Apostles. With those we are excessively pleased; and these together with the windows in S. Wilfrids (R.C.) Church, Coton Hall, Staffordshire [Gaz.152], which they greatly resemble are the works of the Pugin and Hardman fabrique which have struck us as the best of those which we have seen. They are a most valuable practical exemplification of the canon contained in our last number of the advantage which single figures possess over groups. The colours are good with occasional experiments, which we do not like – a certain purply blue for instance, and a dingy olive green, which once or twice occur we have said that these windows contain the twelve Apostles. However St. Paul, as the patron saint, occupies the place which ought to belong to S. Matthias. We really think that so great a deviation from tradition ought not to have been allowed. The twelve Apostles should have been depicted as the Church has always represented them, and the west window given up to S. Paul where he might have occupied the central light, supported by S. Barnabas, St. Luke, S. Timothy and S. Titus his companions. Is it too late to shift his effigy there, with the necessary alterations and to supply his place in the church by the rightful owner? It may also be hypercritism, but in case the idea should be reproduced, we should

venture to question whether making the same series include the windows both of the sanctuary and the chancel proper, was of the most perfect symbolism … The builders of the church are determined to fill all the windows with painted glass; the sound aesthetic system of single figures being carried throughout the building'; 13, 1852, pp. 60-3: description of a service in the church); 15, 1854, pp. 215-16 (further progress report on the building work, including: 'All the nave windows have been filled with painted glass by Mr. Hardman; the side lights, figures of British saints under canopies, and the west window a selection of figures without reference to nationality. Altogether the series throughout the church is one of the most successful masses of English glass we have seen, and the result of the substitution of painted glass in the nave for the plain windows with which the church was originally opened, has been materially to increase its apparent magnitude'. Wedgwood (Pugin's Diary): Pugin visits Brighton, 1836, Mar. 4; 1842, Jun. 28-9; 1844, Sep. 12-16; 1849, Oct. 20; 1850, Nov. 9. O'Loughlin & Elleray, 2000, pp. 29-43 (Shepherd, 'The Pugin/Hardman Stained Glass'), and pp. 44-51 (Lawrence, 'The Restoration of the Stained Glass Windows').

42 Hove church.[13]
1853. Window designed by J.H. Powell.

Office records. *Order Books*: 1853, Book 2, f. 66, undated; Book 3, f. 40, undated. *First Glass Day Book*, 1853, f. 199, Dec. 16: 'To Λ Window of Stained/Glass of 5 Lights and/Tracery/5 Lights 10'9" x 1½" …/29 pieces Tracery/…/ Subject 'In centre Light, Figure of St. John the Baptist & in side lights Medallions of his life.'

GLOUCESTERSHIRE
43 Bussage, St Michael & All Saints (CoE)
1852-3. Client: Rev. R.G. Swayne.

Chancel S window	sII	1.1m x 3.1m	2-light	£35	1852
S aisle W window	sVIII★	0.5m x 2.5m	1-light		1853
	★designed by J.H. Powell				

Description. **sII.** 2-light window and tracery. Christ in a blue-lined, red mantle over a white, patterned robe (much of the patterning has worn away) enclosed in a blue foliage diaper medallion, is depicted, rescuing a sheep from the thorns, in the left-hand light. He is shown, in a similar medallion, wearing a green-lined, red mantle over a yellow robe, carrying the sheep across his shoulders, in the right-hand light. The remaining areas of the lights are made up of quarries covered by a grisaille of white leaves outlined in black against black hatching, overlain by a vertical series of red-outlined diamonds. The diamonds are over and underlapped around their vertical points by yellow-beaded circles and around their horizontal points by blue.

The borders are patterned with white leaves attached to vertical yellow stems on red and blue grounds.

The three tracery-pieces are filled with leaves around red rosettes on a white grisaille similar to that in the lights.

Officer records. *Order Books*, 1851, f. 160, Nov. 27 (sII): 'Inscription in Latin to be introduced in Centre light. "O ye followers of me, even as I also of Christ". Inscription at bottom of window "D.O.M. In Memoriam amici hujus Ecclesia Presbyteri 1851."' 1852, Book 2, f. 29, undated; Book 3, f. 29, undated (sVIII). *First Glass Day Book*, 1852, f. 156, Sep. 11 (sII), f. 159 Oct. 23: 'To Altering 2 lights for/Window in South Side/of Chancel sent 11 Sep/52'; 1853, f. 179, May 3: 'To A Stained Glass Window/of Single Light and/Tracery piece/1 Light 7'0" x 1'6" …/1 Tracery piece… [sVIII] Subject Our Blessed Lord & Little Children'.

Letters. *JHA Letter Book*, *Hardman to Swayne*, p. 95, 1851, Nov. 20: 'I regret that I shall not be able to send you a sketch of the window for probably a fortnight as Mr Pugin is from home. I am afraid the single figure of Our Lord as the Good Shepherd or as rescuing the Lost Sheep from the thorns will not accord well with any group of figures. It would be far better to have two single figures or two groups. Please let me have therefore what miracles or events in Our Lords life you would suggest as any might be represented.' p. 96, Dec. 17: 'In consequence of Mr Pugin's illness I have not been able to get the designs of the window before I now enclose it with Our Lord represented as described in your last letter.'

Literature. Wedgwood (Pugin's Diary): for Pugin's visits to Gloucester see Gaz.48.

44 Chipping Camden, Campden House
1850, 1853. Client: Viscount Campden. Supervising architects: R.C. Carpenter (1850 window), Charles Hanson (1853 window). Chapel demolished, window lost.

Office records. Order Book, undated, f. 66: 'Figure to be a large one, window to be sent to Mr. Mills, Builder, Stratford on Avon, being the only window in the Chapel must be treated light.' *First Glass Day Book*, 1850, f. 83, Mar. 12: 'An East Window of/2 Lights, 'The Annunciation'/£24/2 Lights 4'7" x 1'4½"/&3 Tracery pieces'; 1853, f. 197, Nov. 26: 'To A Window of Stained/Glass of 2 Lights with/Initials & c introduced/A window of do.do. of/2 Lights with Initials/for South Window/of Sanctuary/2 Windows of do.do. of/2 Lights ea with/Initials for sacristy/8 Lights 3'10" x 1'4½"…/& 4 Wrought Iron Casement/Frames [Window designed by J.H. Powell].' *Cartoon costs per ledger summary*: Powell £1.10.0, Oliphant £2.5.0. Oliphant's account records that the payment was in respect of '2 cartoons for Annunciation window'.
Letter. JHA: Carpenter to Pugin, 1850, Apr. 17: 'I saw the little window at Campden yesterday it looks very well and & I consider the chapel by no means to [sic] dark with one window. Lord & Lady Campden are well satisfied – There is something queer in the drawing of the right hand of the B. Virgin – Crace who was with me, suggested whether the apparent deformity about the wrist was occasioned by a departure from the <u>shading</u> as given in the cartoon – I have a tracing shewing the form of the hand & the leading of the Glass which I enclose.'[14]
Literature. D. Verey, *The Buildings of England: Gloucestershire, The Cotswolds,* Harmondsworth, 1979, p. 160.

45 Gloucester, St Mary de Crypt (CoE)
1853. Window designed by J.H. Powell.

Office records. Order Book 2, 1852, f. 8, Oct. 27; *Order Book 3*, 1852, ff. 10-11. *First Glass Day Book*, 1853, f. 188, Sep. 12: 'To 4 Windows of Stained/Glass of 2 Lights each, & Tracery; being the/Upper & Lower windows/on North & South sides/of Great Window/ Obituary windows/of the late R. Fletcher Esq… 4 Lights 6'4" x 1'8½"…/4 do 5'8" x 1'8½" …/2 pieces of Tracery'.

46 Gloucester, St Michael (CoE)
1851. Client and supervising architects: Fulljames & Waller. Church demolished and E window lost.

Office records. First Glass Day Book, 1851, f. 115, Apr. 12: 'A Stained Glass East Window/of 3 lights 11ft 4 by 2ft 0½/& 13 pieces of Tracery/£90/ Subject the nine orders of Angels, St. Michael in Centre'; 1853, f. 171, Jan. 21: 'To 9 Pieces of Copper Wire/Lattice for East Window/£5.15.0/'.
Letters. JHA: Fulljames & Waller to Hardman, 1851, Jan. 18: asks when the E window will be ready. Apr. 11: 'We are pleased to hear that the window for St. Michaels Church is ready & you will oblige by sending it on Saturday directed to Mr. Eastcourt at St. Michaels Church Gloucester'. Apr. 28: 'The window you have sent us for St. Michaels Church and which is now fixed has a remarkably good and rich effect.'
Literature: Wedgwood (Pugin's Diary) re Pugin's visits to Gloucester see Gaz.48.

47 Hasfield, St Mary (CoE)
1852. Client: Rev. James Servier. Supervising architects: Fulljames & Waller.

Chancel E window	I	1.6m x 2.8m	3-light	£35

Description. **I.** 3-light window and tracery. Christ as Salvador Mundi, in a green-lined, red mantle over a green-patterned robe, holding a processional cross in the crook of his left arm is depicted standing under a canopy in the centre light. St Peter in a blue-lined, red mantle over a yellow robe, holding the keys in his right hand and a book in his left and St Paul in a red-lined, blue mantle over a yellow robe, holding a book in his right hand and a downward-pointing sword in his left, stand under similar canopies in the left- and right-hand lights, respectively. The canopy-heads are cinquefoil in the centre light and trefoil in the side. Over them are yellow-and-white-crocketed and finialed gables behind which rise, buttressed, white Gothic window superstructures. The top and bottom panels of the lights are filled with a grisaille of white floral patterns on black-hatched grounds overlain by a vertical series of red-outlined quatrefoils which are over and underlapped by yellow-beaded diagonals. The borders are patterned with white leaves on undulating yellow stems against red and blue grounds. The tracery-pieces are patterned with red, blue and white leaves. The window was restored *c.*1957 (church guide [n.d.]).
Office records. First Glass Day Book, 1852, f. 141, Apr. 6.
Letters. JHA: Waller to Hardman, 1850, Nov. 1: 'The window designed by Mr. Pugin containing Our Lord, St. Peter & St. Paul is to be placed at <u>a</u> [a sketch of the chancel shows A as the E window and B on the S wall]. The new window and which is to be put up in place of a most detestable old Georgian Monument is to be placed at <u>B</u> [it would seem that

this latter window was not made]'. *O. Eastcourt to Hardman*, 1851, Apr. 28: 'How long will it be before the East window for Hasfield Church arrives as well as the Design for the small two light monumental [?] window for the same church [these queries are repeated in letters dated Jul. 12 and Oct 22].'

48 Highnam, Holy Innocents (CoE)

1850. Client: Thomas Gambier Parry, Highnam Court, near Gloucester. Supervising architect: H. Woodyer.

E window of S aisle chapel	sIII	1.3m x 3.1m	2-light	£55
S aisle windows (**6.11–6.13**)	sVI–sIX	0.9m x 3.0m	2-light	£120

Descriptions. sIII. 2-light window and tracery. Each light contains a scene depicted against a blue diaper ground, under a trefoil-headed canopy over which is a yellow-crocketed and finialed gable. A superstructure rising behind and above the gable is made up of red and white Gothic windows surmounted by crocketed and finialed gables. The scenes are: the Scourging of Christ in the left-hand light and the Agony in the Garden in the right. The main tracery-pieces contain a seated Christ in Glory surrounded by six angels.

sVI–sIX. 2-light windows, each with a large tracery piece, quatrefoil in sVI, cinquefoil in sVII and star-shaped in sVIII and sIX. Each window contains a depiction under a canopy of an Old Testament figure (type) in the left-hand light and an answering figure from the New (anti-type) in the right. The canopy-heads are flanked by yellow-crocketed and finialed gables and there are similar gables over the heads themselves. The superstructures above consist of green-patterned, trefoil-headed niches topped by yellow-crocketed and finialed gables. The figures stand in front of diaper screens, orange in sVI, green in sVII and red in sVIII and sIX. In the panels immediately below them enclosed in red diaper quatrefoil medallions, are scenes from the Gospels (anti-types) while in the tracery above, against a red diaper ground, is a connecting scene from the Old Testament (type). From left to right the figures and scenes are:

sVI (6.11). Isaiah in a purple hood, patterned-green-lined, red mantle over a blue-patterned robe, holding an upward-curving text in his left hand. St John the Evangelist in a patterned-blue-lined, red mantle over a green-patterned robe, holding a quill in his right hand and a book – on which perches an eagle – in his left. Below, the Annunciation, and the Nativity. In the tracery, the birth of Isaac.

sVII. David in a hooded, wine-coloured mantle over a blue-patterned robe holding a harp in his right hand which he plucks with his left. St Matthew in a blue-lined, red mantle over an orange-patterned robe, holding a quill in his right hand and an effigy of an angel in his left. Below, the Adoration of the Magi, and the Visit of the Shepherds. In the tracery Abraham paying tithes to Melchizedek.

sVIII (6.12, 6.13). Moses in a violet-lined, yellow mantle over a green-patterned robe and with two yellow horns protruding from the sides of his head, holds the two tablets of the law and a downward-curving text in the crook of his right arm and a flowering rod in his left hand. St Luke in a red-lined, green mantle over a blue-patterned robe, holding a book – on which is seated an ox – in his right hand and a quill in his left. Below, the Presentation in the Temple, and Simon and Anna. In the tracery, the Sacrifice of Isaac.

sIX. Malachi in a purple-lined, blue mantle over a green-patterned robe holding a downward-curving text in his right hand. St Mark in a green-lined, white mantle dotted with yellow silver stain flowers, over an orange-patterned robe, holding a quill in his right hand and a book – on which sits a lion – in his left. Below, Pentecost, and the Baptism of Christ. In the tracery Moses interceding against Amalek.

Office records. *First Glass Day Book*, 1850, f. 104, Nov. 9 (nIII, sVI–sIX). *Cartoon costs per ledger summary*: nIII none; sVI–sIX, Powell £4.10.0, Hendren £2.0.0.

Letters. *HLRO 304: Pugin to Hardman*, letter no. 693: 'You will shortly receive a set of cartoons for a church by Mr Woodyer about which I am very anxious as I believe the other aisle is done by Warrington [it was done by Wailes] & I think it is a good opportunity to annihilate the beast. I have taken great pains with them they must be in by the end of June at latest before the consecration.' No. 778: '2. The window for Mr. Gambier Parry is among the other cartoons sent to you for Mr Woodyers Church it is an east window [sIII] with 2 subjects ... you can say it is nearly done & that he will have it with the rest.' No. 722: 'I hope you will put deeper green in Mr. Woodyer's windows – I am anything but delighted with them they are complete failures in the design & the <u>orange yellow</u> will <u>damn everything</u>' No. 733: '1. pray but – know if anything has been done to alter that Baptism of Our Lord in Mr. Woodyers window [sIX] I assure you I think of it constantly for it is dreadful.' No. 721: 'from what Powell says I fear you intend to shirk altering the Baptism in these windows for Mr. Woodyer. It is dreadful.' No. 711: 'Myers is here there is every reason to fear there is some error in Mr. Woodyers dimensions ... the cartoons will have to be altered.' No. 713: 'as regards Mr. Woodyers windows it is impossible to lengthen them at bottom [sic] – The donor has a sort of rabid dislike of horizontal lines cutting the

window ... they are everywhere avoided ... it is their fault they must pay for it. I never saw anything like it.' *JHA: Woodyer to Hardman, 1851*, Oct. 10: 'I am getting together a summary of the Highnam Church costs, and shall be glad if you will send me the sum that the windows & Lamps supplied by you amounted to.'

Literature. *The Ecclesiologist*, 13, 1852, pp. 263-5. T.J. Fenton, 1985, from which the identification of the scenes in the tracery have been taken, as well as those of a more obscure nature, among the lower scenes. Wedgwood (Pugin's Diary): Pugin visits Gloucester, 1850, Jul. 29-30, Nov. 20-1.

49 Kemerton, St Nicholas (CoE)

1852. Now in Worcestershire. Windows designed by J.H. Powell. Client: Archdeacon Thomas Thorpe. Supervising architect: R.C. Carpenter.

Chancel S window	sII	1.0m x 2.1m	2-light, 3 tracery-pieces	1852
Chancel S window	sIV	0.4m x 1.7m	1-light	1852

windows designed by J.H. Powell.

Office records. *Order Book*, 1852, f. 188, Aug. 31. *First Glass Day Book*, 1846, f. 7, Sep. 29 refers to a window for Kemerton church of '2 lights, with Stained Quarries/ and 2 centres in each / 3 tracery pieces'. The client was Ferdinand Eyston of Kemerton and the cost £10.10.0. If this window was for St Nicholas, it no longer remains *in situ*; 1852, ff. 158-9 Oct. 23 'To a Stained Glass window/for South side of Chancel of/ 2 lights & Tracery/ ... 5'3½ x 1' 5"/ 3 Tracery pieces/ subjects: St Austin of Hippo/ & St. Andrew/To a Stained Glass Window/for South side of Chancel/of 1 light/ 5'5" x 1'4"/ Subject: St. Nicholas & the 3 children'. Of other windows in the chancel, sIII appears in Order Book 2, 1852, f. 4, Oct. 22; nII and sIII (again) in Order Book 2, 1854, f. 166, Mar. 18.

Letters. *JHA: Thorpe to J. Hardman & Co.*, 1852, Mar. 4: 'I meant to ask whether Mr. Hardman has not got some cartoons of Mr. Pugins from which he Cd work so as to supply some of the windows in my church, now that poor Mr. Pugin is [?] for work.' *C.T. Heartley to Hardman*, 1852, Oct. 11: 'Mr. Carpenter & Mr. Crace will be here on Thursday Morning early. The windows are come – I am particularly anxious to have them put in before Mr. Carpenter & Mr. Crace come as this will be their <u>final</u> professional visit.'

50 Lydney, Church[15]

1853. Window designed by J.H. Powell.

Office records. *Order Book 2*, 1852, f. 11, Oct. 27. *First Glass Day Book*, 1853, f. 178, Apr. 27: 'To A Stained Glass Window of 2/Lights & Tracery/2 Lights 6'6" x 1'3"…/1 Tracery piece…/ Subject Memorial Window with Subjects'.

51 Shurdington, Church[16]

1852. Client: Rev. S. Wright. Supervising architects: Fulljames & Waller. Window designed by J.H. Powell.

Office records. *Order Book*, 1851, f. 131, Jun. 13: 'with Badges & bands of colour'. *First Glass Day Book*, 1852, f. 136, Feb. 21: '3 Windows of Stained/Glass of Single Lancet/Light each/£12.15.0/ Each Light 4'8" x 1'1"…/Geometrical Grisaille Glass/with Badges'.

GREATER LONDON

52 Clapham, Our Lady of Victories (RC)

1851, 1852. Client: Rev. F. de Held. Supervising architect: W.W. Wardell.

Chancel E window (**10.9a & b**)	I	3.7m x 5.9m	6-light	£250	1851
Lady Chapel S window	sII	1.9m x 3.7m	4-light	£80	1852

The glass for the E window of the Lady Chapel and a side window in addition to sII as recorded in the First Glass Day Book is no longer *in situ*. The subject matter of the latter window was given as '1. St Joachim 2. St Mary Magdalene 3. St Thomas of Canterbury 4. St Edward 5. St Anne 6. St Barbara 7. St Augustine of Canterbury 8. St George Martyr'.

Descriptions. I. 6-light window and tracery illustrating the Coronation of the Virgin. Christ and the Virgin, enthroned under canopies, are depicted in the upper sections of the two middle lights. The equivalent sections of the other four lights each contain, under a canopy, a representation of a kneeling archangel over whom hovers a censer-swinging angel. A female saint, standing under a canopy, in front of a red diaper screen, is depicted in each of the lower sections

of the lights. The upper canopies have cinquefoil-heads above which are yellow-crocketed and finialed gables. Rising up behind the gables in the two middle lights are superstructures in the form of three Gothic windows surmounted by crocketed and finialed gables. In each of the other four lights there are only two such windows – a half-length angel behind the parapet of a tower replacing the third. The cinquefoil heads of the lower canopies are surmounted by yellow-crocketed and finialed ogee arches. From left to right the archangels are: St Michael, holding a sword in his right hand and a shield emblazoned with a red cross on a white ground attached to his left forearm; St Raphael from whose right hand a fish hangs vertically; St Gabriel holding a sceptre in his right hand; and St Uriel(?) holding a disc marked with yellow silver stain in his left hand. The female saints are: St Agnes(?) holding a lamb in her right hand; St Catherine holding a wheel in her right hand and a downward-pointing sword in her left; St Cecilia holding a harp in her left hand while plucking it with her right; St Lucy holding a dish containing her eyes in her left hand; St Barbara holding a white tower in her left hand; and St Apollonia holding long-handled pincers upright in her left hand and a book in her right. The tracery is filled variously with green and white leaf patterns, red rosettes and red roundels containing leaf patterns.

sII. 4-light window and tracery. Each light contains, one above the other, two saints under canopies. Those in the upper sections stand in front of screens – red and blue in the left and right-hand outer lights, and green in the two inner ones. The canopies have trefoil-heads surmounted by yellow-crocketed gables, behind which, in the lower compartments, a series of white, Gothic windows are depicted, and in the upper, superstructures of double-turreted towers separated by crocketed and pinnacled niches. From left to right the saints are: upper – St Stanislaus Kostka in a white mantle over a blue robe, holding a book in his left hand; St Patrick in a white mitre, a white-lined, green chasuble over a red dalmatic and white alb, holding a crossed-staff in his left hand while trampling a red serpent underfoot; St Philip Neri in a white mantle over a blue robe, holding a book in his left hand; St Catherine of Alexandria in a red-lined, hooded, white mantle over a green robe, holding a book in her right hand and a green palm in her left. Her face has been badly damaged: lower – St Aloysius Gonzaga in a blue mantle over a green robe, holding a large crucifix in his right hand; St John Nepomuk in a white-lined, red mantle over a greenish-white robe holding a book in his left hand; St Francis Xavier in a red-lined blue mantle over an olive-green robe, holding a flowering rod in his left hand, and a white crucifix tucked into the white band that encircles his waist; St Francis Girolano in a green-lined, white mantle over a greenish-white robe, holding a book in his left hand. The tracery-pieces are filled mostly with red and white diaper, two main dagger-shaped pieces having small green-patterned roundels at their centres.

Office records. *Order Book*, 1850, f. 113, Sep. 17, per E window of Lady Chapel 'Subject: St Alphonsus, St Joseph, St Theresa and Brother Gerard Magilla'. *First Glass Day Book*, 1850, f. 106, Nov. 23: 'To Plain Quarry Glass/for S.Marys Ch.Clapham/9 Windows for Aisle of 3 Lights/ea. 5'8" x 1'0½"…/12 Windows for Clerectory/24 Lights/of 2 Lights ea. 4'6" x 10½"…/West Window over Door/of 5 Lights 4 – 14'11" x 1'2½"…/1-16'10½" x 1'8½"/& Tracery for do/6 Windows in Sacristy/& Oratory/12 Lights/of 2 Lights ea. 3'10" x 1'0½"…/2 Windows in Tower/4 Lights/of 2 Lights ea. 4'0" x 10½"…/2 Windows in Chapel/8 Lights/of 4 Lights ea. 9'0" x 1'2½"…/8 Lights for Passages/ea.2'6" x 0'8½"…/' Dec. 26 (wire mesh); 1851, f. 116, Apr. 21 (I & tracery sII and another side window); f. 119, Jul. 12: 'For East Window of Ladye Chapel/- A Window of Stained Glass/of 4 Lights 9 feet by 1ft 2½ins/£80/& 14 pieces of Tracery'; 1852, ff. 143-4, Apr. 29: lights for sII and another side window; 'Loss on Plain Glass in West/& other windows of Church exchanged for lighter tinted/Glass/£10'; f. 156, Aug. 28: 'Taking Out Window &/Repairing same at St./Mary's Church'; f. 157, Oct. 16: 'To 4 Lights altered with/New Glass & Lead for/East Window of Ladye Chapel/Sent 12 July 1851'; 1853, f. 201, Dec. 20: 'To Alterations in Stained/Glass Window in Chapel…/removing portions of Windows &/Substituting New Glass'.

Letters. HLRO 304: *Pugin to Hardman*, letter no. 459: '3. the [?] at Clapham is despatching'. No. 468: 'we are ready at Clapham.' No. 586: 'I heard our East window at Clapham most [?] beastly [?] and soundly attacked[?] today as an exagerated [sic] Medieval production.' No. 464: 'The Clapham East W is fine [?] a very fine job indeed'. *JHA: Wardell to Hardman*, 1851, Jan. 3: 'Father de Held has arranged with me about the subjects for the side lights. The only question is (& it is one you must determine) whether you can get single figures under canopies in the lights – say two figures in each light one over another. I should very much prefer this if it can be managed & so would Father de Held. If it cannot we must adhere to the old intention of illustrating S. Alphonsus life. Jan. 6: 'Many thanks for the prompt reply to my letter of Saturday. The following is the list of Saints Father de Held wishes to be represented & the order in which they are to be arranged [these are as they appear on f. 143 in the Day Book: as they appear in situ, St Patrick and St Philip have changed places with St Stanislaus and St Catherine]. Sep. 2: 'Father de Held wishes me to write to you on the subject of the Altar window of S. Alphonsus Chapel [recorded as Lady Chapel on f. 119 of the Day Book] two of the lights or compartments of which, he wishes you to be good enough to have altered at your earliest convenience – viz that representing Brother Gerard & that of St. Theresa as they are not accurate in their representations. S. Theresa he desires should be without the Crozier & the Crown & should have the shoes worn by the order. Br. Gerard also should be in the Redemptorist dress & should have shoes.'

53 Greenwich, Our Lady Star of the Sea (RC)

1851. Client: Rev. Dr North. Supervising architect: W. W. Wardell.

Chancel E window (**7.11a–c**)	I	3.3m x 4.6m	5-light	£190
Chancel N & S windows	nII, sII	3-light (tracery only)		★
B.S. Chapel E window	sIII	1.5m x 2.6m	3-light	£34
B.S. Chapel S windows	sIV, sV	0.4m x 1.3m	1-light	£14
N & S aisle windows	nIII–nVIII, sVI–sXII	2-light (tracery only)		★
	wI	4-light (tracery only)		★
Eight clerestory windows		3 quatrefoils each		★

　　★ Inclusive price £51.2.6

Descriptions. **I.** 5-light window and tracery. The centre light, taller and wider than the others, contains a depiction of the Virgin and Child under a canopy above a scene of a sailing ship on a stormy sea, with four disproportionately large men aboard, praying to her for the storm to be stilled. The middle and upper sections of the other four lights contain, under canopies, scenes depicting events in the Life of the Virgin; while in the lower portions, pairs of angels under simple crocketed and gabled canopies, hold, between them, emblems of the Virgin. She is crowned, has a white head-dress and is in a blue-lined white mantle, patterned with yellow silver stain flowers, over a purple robe. She stands on a white crescent moon, in front of a red foliage diaper screen, surrounded by white stars, holding a white rose in her right hand and cradling the Christ Child in her left arm. The canopy above her has a cinquefoil-head over which is a yellow-crocketed and finialed gable flanked by two standing angels holding texts. A superstructure made up of a green Gothic window flanked by pinnacled buttresses and surmounted by a yellow-crocketed and finialed gable rises up from behind the gable over the canopy-head. From left to right the scenes portrayed are: the Annunciation, Nativity, Assumption of the Virgin, and Coronation of the Virgin. The emblems held by the angels are: a *fleur-de-lis*, a rose, a tower, and a twin-towered gate. The canopies over the scenes have cinquefoil heads surmounted by two white, yellow-crocketed and finialed gables. A further series of white, yellow-crocketed gables over, red Gothic windows in the outer lights, and blue in the inner, make up the superstructures that rise behind and above the gables of the canopies. Six angels holding texts, plunge, rise, and hover horizontally in the main tracery-pieces that form a wheel above the central light. A further angel stands holding a roundel containing a monogram, in each quatrefoil positioned above the mullions that separate the two pairs of inner and outer lights. A note entered in Hardman's 1946 Day Book and dated Aug. 2 1946 reads: 'damaged stained glass removed from East window of 5 lights & tracery after bomb damage and sent to Webb's Studios, Brookers Yard, West Street, East Grinstead, Sussex to pack and return to Hardman Studios. Remaining glass removed and sent to J. Hardman Studios. Lights stripped, repainted where necessary, repaired, re-leaded and returned to church. Refixed by Hardman's complete with new saddle bars!'

sII. 3-light window and tracery. Christ as the Good Shepherd, in a white-lined, red mantle over an olive-green robe, holding a sheep in his arms and a shepherd's crook in his left hand, is depicted standing under a canopy in front of an orange diaper screen, in the larger centre light. Along the trefoil-head of the canopy is a line of yellow crockets and there is a short finial at the apex. A superstructure consisting of a two-light red-patterned Gothic window flanked by pinnacled-buttresses and surmounted by a yellow-crocketed and finialed gable, rises behind and above the canopy head. A blue foliage diaper medallion containing a depiction of Melchizedek offering bread and wine to Abraham is in the left-hand light, and a similar medallion containing the Sacrifice of Isaac is in the right. The panels at the top and bottom of the centre light are filled with a white foliage grisaille overlain by a red-outlined quatrefoil which is over-and-under-lapped by yellow-beaded diagonals. The grisaille in the corresponding panels of the side lights is made up of white leaves and berries on stems, outlined in black, against black-hatched ground. It is overlain by red-outlined diamonds over-and-under-lapped by yellow-beaded quatrefoils which are linked to the medallions. The borders of the side lights are patterned with green and white flowers on red grounds. Those of the centre light are comprised of the columns of the canopy, apart from the pieces at the top and bottom which follow the patterning of the side lights. The tracery is filled with a white and yellow silver stain floral grisaille and red-rimmed roundels containing yellow flowers and blue, red and green rosettes.

sIV, sV. 1-light windows & tracery. The stained glass of sIV has at one time been replaced with plain glass.

sV. Contains a depiction of an angel standing in front of a red foliage diaper screen, under a trefoil-headed canopy surmounted by a yellow-crocketed and finialed gable, holding an undulating inscribed scroll in his right hand. The borders are patterned with white leaves on red and green grounds. The tracery is filled with white, red, green and yellow leaf patterns. The tracery in the other windows is varied in shape, and is filled with leaf and flower patterns main in

white, red, green and yellow. The glass in the lights is plain except for later stained glass in sVII, sVIII, & nIII–nVIII. The quatrefoils in the clerestory windows are now filled with plain glass.

Office records. *Order Book*, 1850, f. 84, Apr. 23. *First Glass Day Book*, 1850, f. 102, Oct. 24 (plain glass: aisles, wI, side chapel, gables over I and wI); 1851, f. 123 Sep. 8 (fixing 2 windows per f. 102), f. 124, Sep. 8 (stained glass for: tracery in clerestory, aisles, wI, side chancel, small chapel, side chapel clerestory; I. sIII–sV).

Letters. *HLRO 304: Pugin to Hardman*, letter no. 690: 'as for the window at Greenwich [I] I do not see how it can be treated differently but 150 seems very little too little. you better send this design & tell him if they will not give more the canopies must dwindle[?] into geometrical work.' No. 740: 'what a vile window is that Greenwich East when we examine[?] the templates there is hardly a space as large as the palm of your hand. it is impossible to get any design in all that is Effective[?] I dont think there are 10 feet of glass in the whole tracery. every space is different by inches how the window has ever been put together puzzles me. it is a wretched job the tracery will bear no proportion to the lights. No. 570: 'Powell says we have no templates for the side windows of Chapel B. Sacrament Greenwich what are we to do this will be a great delay for there is no one to take them. I was quite certain we had them but Powell denies it. They have made a famous job of the Greenwich group it is quite a fine work far exceeds my expectations & will do us much credit it is a real fine thing harmonious in colour & will quite delight you.' No. 213: 'I have found the Greenwich template & I am working at them you shall have this window.' No. 561: 'I yet live in hope of the side lights Greenwich on which Hendren & Early are working & they were drawn out last night.' *JHA: North to Hardman*, 1850, May 21: refers to Wardell having given him (Hardman) the commission for Chancel & B. Sacrament Chapel windows in stained glass. Oct. 24: 'Mr. Wardle [sic] has now nothing to do with our church – He cast me adrift because I accepted of an altar for B.S. Chapel of Pugin's design'. 1851: Jan. 27: 'you could [?] let us have the tracery of the aisle windows it would impart to the church somewhat of a look of finish.' *Wardell to Hardman*, 1850, May 1: 'The altar window to the side chapel is to be in honour of St. Joseph. I should suggest the subjects for the three lights should be No. 1 The Espousal of the B.V. & St. Joseph – the Centre light a large figure of St. Joseph with Our Lord & the Lily – No. 3 the Death of S. Joseph.' May 12: 'with regard to the smaller window Mr. North insists upon the `Pastor Bonus' for the middle light so we must let it be so.' Oct. 1: 'I enclose herewith the sketch for the Great window of Greenwich Church & am directed by Mr. North to say he will feel obliged by your having it done as soon as possible ... Could you manage to keep the Angels and Emblems at the bottom a few inches higher as I am afraid the reredos of the Altar may partially hide them. Also will you provide a small space for the egress of the condensed stream & breaths. [regarding this latter point Wardell in an undated letter asked for the bottom of the window to be left about 1/8 of an inch from the top of the sill as at S. Edmund's College, Old Hall Green, Gaz.82: Hardman thought this objectionable].'

Literature. *The Tablet*, 12, 1851 p. 821: short description of the church, including the windows, on the occasion of its opening. Wedgwood (Pugin's Diary): Pugin visits Greenwich, 1851, Aug. 18, Dec. 3.

54 Hammersmith, Convent of the Good Shepherd (RC)

1849. Client: Madam De Regaudiat(?). The convent has been demolished (Wedgwood, 1985, p. 96, note 20). Windows presumed destroyed.

Office records. *First Glass Day Book*, 1849, f. 52, Feb. 15: 'A Circular Stained Glass/ Window of Figures & c & c/ of 15 pieces of Figure Tracery/ 35 pieces without Figures £100. To Tracery for 7 Choir Windows/of 3 pieces for each, making/21 pieces in all £14'; f. 69, Oct. 10: '12 Small pieces of Ruby/glass for Eyelet holes in/Stone Work East Window/sent to Mr. George Myers. [see *HLRO 304*, letter no. 971 below]'. *Cartoon costs per ledger summary*: round window, Powell £1.6.8, Hendren 13s.4d; tracery, Powell 6s.8d, Hendren 3s.4d.

Letters. *HLRO 304: Pugin to Hardman*, letter no. 1027: 'The Hammersmith window is finished' No. 762: 'I have just posted the Covent window for Hammersmith – I think it is a first rate job.' No. 714: 'Powell has not yet got to know what are the 2 saints for the Convent sedilia window at Hammersmith the cartoon is done all but this!!' No. 1011: 'The aisle window at Hammersmith will be ready in a few days'. No. 990: 'you better send the window directed to the Revd. Mother of the Convent of the Good Shepherd Hammersmith I dare say she has got the money from the donor.' No. 296: 'send the glass up to Hammersmith the tracery is in [?] no wire work is necessary there is a wall 25 feet high in front of the window.' No. 293: 'I have just been to Hammersmith and although the nuns are delighted with the window I am not at all satisfied with the effect it is dark & heavy & I find it is owing to the blue.' No. 971: 'there are 12 small spaces of the Round window at Hammersmith that have no glass if you will send Myers up a few bits of Late ruby he will fix them & get them cut to the shape'. *JHA: (M. de Regaudiat[?] to Hardman)*, 1849, Apr. 10: 'we have the pleasure to write to say that the Oriel window is placed and looks quite beautiful. The effect is grand – and the predominant colour blue it

is so in keeping with the mysteries represented. The designs are chaste and elegant, and the richness of the colours give great value to the whole. We hope some of these days you will yourself see it [see *HLRO 304*, letter no. 293 above]'.
Literature. Wedgwood (Pugin's Diary): Pugin visits Hammersmith, 1848, Jul. 21, 23; 1849, Feb. 8.

55 Hammersmith, Holy Trinity (RC)
1853. Window designed by J.H. Powell.

Office records. Order Book 2, 1852, f. 9, Oct. 27; *Order Book 3,* 1852, f. 12, Oct. 27. *First Glass Day Book,* 1853, f. 185, Jul. 13 'To An East Window of/Stained Glass of 6 Lights/& Tracery with subjects/of the Passion of our Lord in groups.../6 Lights ea 11'8 x 1'8½".../48 pieces Tracery'.

56 Hillingdon, St John the Baptist (CoE)
1850, 1851, 1852. Client: Rev. B.P. Hodgson. The windows as detailed below were destroyed by a bomb blast in the Second World War.[17]

Office records. Order Book, 1850, f. 87, May 12 (E window); 1852, f. 137, Jul. 5 (chancel memorial E window and side window of chancel), inscription: 'To God and the Church, In memory of the/Revd. Robert Hodgson D.D. thirty years Vicar of this Parish/from AD. 1810 to AD. 1840, Died October 9th AD 1844/Aged 72 years.'. *First Glass Day Book,* 1850, f. 110, Dec. 26: 'To A Stained glass East Window of 5 Lights/£180/4 Lights 9'3" x 1'10".../1 centre do 9'7" x 1'10".../& 19 pieces of Tracery to do'; 1851, f. 114, Apr. 10 [fixing E window]; 1852, ff. 146-7, May 25: 'To A Stained glass Window/ of 3 lights & Tracery for/East Window of Chancel/£95/3 Lights 8'10" x 1'9½".../7 Tracery pieces.../ Subject/Memorial window to Rev/R Hodgson D.D/Resurrection in Centre Light/& in 2 side lights Angels in groups/ bearing Texts'. 'A Stained glass Window/of 3 Lights & Tracery for side/Window of Chancel/£33/3 lights 4'7½" x 1'3½".../7 Tracery pieces.../ Subject – Figures of St. John/St. Peter, & St. James.' *Cartoon costs per ledger summary*: E, Powell £10.10.0, Hendren £2.5.0.
Letters. HLRO 304: Pugin to Hardman, letter no. 691: 'I send you the tracery of the Hillingdon window I suppose £160 will do. you may add nicodemus S. Joseph of Aramathea to the figs in the crucifixion but I should prefer subjects.' No. 703: 'I send you the Hillingdon window pray explain that the tracery is filled with Angels bearing the emblems of the Passion & appropriate texts (but in Latin) under the subjects.' No. 119: 'I send you all the sketches for the windows at Hillingdon which should make a fine job.' *JHA: Hodgson to Hardman,* 1850, Apr. 4: 'Mr G.G. Scott recommends Hardman for an East Window.' Requests the Crucifixion for the centre. Apr. 23: 'it would be better to introduce in the side lights subjects connected with Our Lords Passion: those you propose The Agony in the Garden, the Scourging, the Crowning with Thorns & the Carriage of the Cross are very sensible'. May 16: accepts design of window: 'the colouring appears a little faint & from what I hear of your windows I think I may safely ask you to put in your richest colours without risk of making it dark & gloomy. I have no objection to the texts being in Latin'. Dec. 31: notes that although the window was promised for the end of the year accepts that April or the week <u>before</u> Passion would be acceptable. 1851, Apr. 2: 'I think it right to express my extreme satisfaction with the principal part of it, but cannot say I am equally pleased with the lower compartments, which certainly appear to me to be a little too colourless'. Aug. 11: 'all the difficulties in the way of the Memorial Window at Hillingdon have been resolved, & I can now request you to commence them both without loss of time & without fear of any further alterations. *Letter Book: Hardman to Hodgson,* 1850, May 8: 'At the bottom of each subject will be a text relating to it & the Angels in the tracery holding implements of the Passion & appropriate texts which I should propose to put in Latin unless you prefer them in English.' 1851: Jul. 7 (p. 77): 'I now enclose your designs for the two windows ... the Resurrection in the Centre Light & Angels in Groups bearing texts in the 2 side lights ...The small side window in which are represented St John, St Peter & St James will be fixed at the same time. *I. Bishop to Hardman,* 1851, Apr. 1: 'I have got the old window out & the Iron work the Iron was very heavy & cut across the faces. I shall use some round inside ... Mr. Hodgson likes all of it very much but thinks the bottom part rather to [sic] light it is first rate window [sic] the best of any yet the colour harmonises beautifully.' *G.G. Scott to Hardman,* 1852, Oct. 12: 'I saw your windows at Hillingdon the other day. I think that which commemorates Dr. Hodgson and the small one in the <u>side</u> of the chancel are among the <u>very best</u> windows I have seen but I do not much like the Great East Window it is too thin and transparent; you can see the trees through it from the other end of the church. The two first named however are <u>perfection</u> to my notion, did poor Pugin design these himself?'

57 London, design for Mr Walter Blount

1849.

Office records. First Glass Day Book, 1849, f. 56, Apr. 26: 'To a Design for Stained Window/10s 6d'.
Letter. JHA: Hardman to Blount, 1846, Dec. 14: 'I am in receipt of a letter signed M Moorcoch[?] respecting a Memorial window – I beg to say in reply that I am constantly making windows of this description from the designs of Mr. Pugin under whose supervision the whole of my glass is executed – <u>In windows of this kind it is usual to introduce a figure of the Patron Saint with the effigy of deceased kneeling below in an attitude of supplication</u> – According to the description of the window given to me the glass in it would be about 37 square feet but I am inclined to think there must be some inaccuracy. Glass of the best kind is worth about 40/- a foot – Waiting your further command I remain'.

58 London, Architectural Museum, Cannon Row

Office records. First Glass Day Book, 1853, f. 182, Jul. 8: 'To 3 Specimens of Stained/Glass leaded up showing/styles of Quarry Glass'.

59 London, St Mary Magdalene, Munster Square (CoE)

1851. Client: Rev. Edward Stuart. Supervising architect: R.C. Carpenter.

Chancel E window (**7.3a-d**)	I	4.9m x 6.6m	7-light	£400

Description. 7-light window and tracery. Christ on the Cross with a pair of angels flanking his shoulders, and another pair holding texts, his feet, is depicted under a canopy in the larger centre light. In the panel below, the emblems of the Evangelists are contained in the foils of a blue diaper, leaf-on-stem-patterned quatrefoil – the angel and the eagle in the top foils and the ox and the lion in the bottom. The other four lights each contain a representation of a saint under a canopy standing in front of a coloured diaper screen (the left-hand screen is blue and the others are alternately green and blue). The canopies have cinquefoil heads surmounted by yellow-crocketed and pinnacled gables behind and above which rise superstructures formed of green Gothic windows (red in the centre light) in turn surmounted by yellow-crocketed and pinnacled gables. Left to right the saints are: St James the Great in a white-lined, red mantle over a green robe, holding a staff to which a flask is attached, in his right hand and a book in his left; St John the Evangelist in a white-lined, red mantle over a blue robe, holding a chalice – from which a green devil emerges (the detail has worn away) – in his right hand; Virgin Mary in a white-lined, purple, hooded-mantle over a blue robe, holding a book in her left hand; St Mary Magdalene in a purple-lined, hooded, orange mantle over a white robe, holding an ointment jar (detail worn) in her right hand; St Peter in a red-lined, orange mantle over a blue robe, holding a key in his right hand and a book in his left. In each of the bottom panels, immediately below the saints, an angel holding a text, set against a blue diaper roundel, is enclosed in a green diaper quatrefoil medallion. The tracery contains a large wheel which has at its centre a red roundel rimmed with yellow-patterned tongues of flame, which contains a bust of Christ in a red robe holding an open book in his left hand. Twelve angels form a ring around the roundel and a further twelve are enclosed in trefoils arranged symmetrically around the inside of the circumference of the wheel. Ten of the tracery pieces outside the wheel also contain angels; two who are enthroned and hold a crossed-staff and a sceptre respectively are in quatrefoils on each side of the lower part of the wheel; the other eight hold texts and are in six quatrefoils and two trefoils placed just above the lights. The remaining pieces are filled with leaf and stem patterns on red grounds.

S aisle E window sII. From the letters (see below), it would appear that work on this five-light window (including, possibly, the preparation of the cartoons) took place under Pugin's supervision. The window, however, is not recorded in the First Glass Day Book and seems not to have been executed by the end of 1853.

Office records. Order Book, 1850, f. 103, Aug. 14. *First Glass Day Book*, 1851, f. 127, Oct. 3 (I). *Pugin sketch*, BM & AG a no. 2007-2728.1, of I (**7.3e**).

Letters. HLRO 304: Pugin to Hardman, letter no. 632 (written from London): 'I am going to make a desperate effort this morning to see the window at S.M. Magdalene I assure you Earlys account has quite frightened me if it has so lack an effect it certainly must be altered [and included below the signature] I see by your other letter you are painting[?] another cartoon image for S.M. Mag this is capital I am delighted to hear it.' No. 604: 'I have just been to S.M. Mag I think the window quite glorious the centre image is not so offensive as I was led to believe but it will be better three[?] times lighter[?] though I believe we have this old colour this window will do immense good all the rest are nothing & it will be well seen. It is a first rate job & one which does our heart good & animates to fresh exertion what is the true style – <u>of glass</u> –'. No. 626: 'I shall be very glad to hear that the colour of our Lords image is changed at S.M. Mag. all the

rest is <u>perfect.</u> It is a first rate work.' No. 672: 'the E window of S. Mary Magdalene is the finest thing done since the finest of the old time.' No. 665, postmark 'NO 20 1851': 'The other window S. Mary Magdalene is unfortunate the position is dreadful.' *JHA: Carpenter to Pugin*, 1850, Apr. 17: 'I duly received this morning the sketch for the East Window of S. Mary Magdalene Church which I admire very much. I suppose in introducing the cherubim it would not be necessary that they should be entirely red, for I do not fancy the windows I have hitherto seen in which they are so represented. The lower lights I think will be very fine and also the Majesty; the crucifixion comes as a nice centre & breaks up the line most satisfactorily. I have in reflecting upon the window since I first suggested the subjects, sometimes thought whether S. Thomas would not be a better subject than S. Paul; the penitence of S. Thomas having a nearer relation to the circumstances of our B. Lord's passion & the great facts in the life of S. Mary Magdalene with reference thereto. I will shew the sketch to Mr. Stuart & then forward it to Hardman.'[18] *G. Corley to Hardman*, 1851, Jan. 25: On Carpenter's instructions forwards patterns of E window of S aisle for St Mary Magdalene's church, St Pancras District. Sep. 5: 'Am I to understand that at present you are only engaged upon the East window of Chancel and the E window of S. aisle is not commenced or is the latter window finished?' Sep. 9: 'Mr. Stuart desires to ask you how far advanced the East window of the South Aisle is at the present time; and also to inform you that he wishes this window to be stopped for a time as he contemplates some alterations in the figures & c.' *Stuart to Hardman*, 1852, Jul. 6: refers to the 5-light window for the church and notes that the cartoons are made but the glass not begun; mentions lack of funds prevents going ahead but when ready asks for the costs of five other figures in place of St Alban, St Augustine, St Anselm, St Paul and St George. *JHA Letter Book, Hardman to Stuart*, 1853, May 21, p. 162: 'I am sorry to have been so long answering your last letter but until today I could not put my hands on the cartoon of the East window of the South Aisle. It is a long time since they were made & in removing to my new work [cartooning was removed from Ramsgate to Birmingham in mid-1852] they had got mislaid. However I have now found them. The centre light & tracery will be worth £72 – & the window complete was taken at £200. I do not know the exact sum that was to be allowed by Mr. Carpenter for the window in the South Aisle but I remember that I did not consider it sufficient for the size of the window. He will no doubt tell you how much he will allow toward the centre light & tracery. I hope you will be able to raise sufficient to finish the window at once.'

Literature. The Ecclesiologist, 13, 1852, pp. 167-8: description of the church, including the subject matter of window I, which at that time was the only one in stained glass, and the comment: 'this is a very successful specimen of Mr. Pugin's designs and Mr. Hardman's execution; though we might find some fault with some of the flesh colours and some of the tinctures'.

60 London, Osnaburgh Street Church[19]

1853. Window designed by J.H. Powell.

Office records. Order Book, 1852, f. 190, Aug. 31. First Glass Day Book, 1853, f. 175, Mar. 16: 'To A Window of Stained/ Glass of 3 Lights and/Tracery for East Window/£60/2 Side Lights 8'0" x 2'6"…/1 Centre 6'3" x 2'6"…/1 Large piece of Tracery 4'8" x 4.8" … 7 small pieces do.'

61 London, St Andrew, Wells Street (CoE)

1847-50, 1852. Clients: Rev. James Murray, 208 Castle Street, Regent Street, London (later, 70 Welbeck Street) (I); A.J.B. Hope, 1 Connaught Terrace, Hyde Park (clerestory).

St Andrew's, Wells Street, was relocated at Kingsbury, Middlesex, in 1934. The 10-light E window, executed and assembled between 1847 and 1850, and the two-light clerestory window of 1852 were destroyed by Second World War bombing.[20] The inital arrangement and subject matter of the ten canopied scenes in two rows of five in the E window is given in *HLRO 304, Pugin to Hardman*, letter no. 1017 (see below), which is changed in letter no. 379 by the transfer of the Transfiguration to the upper row and the introduction of a Jesse to the lower. This later arrangement is confirmed by the description in Webb and Docker, which also shows that in the upper row, the Transfiguration replaced the Agony in the Garden, and the Ascension was included as the fourth and not the fifth scene across. The fifth scene is described as the Descent of the Holy Ghost and is not mentioned in the Hardman letters or in the First Glass Day Book. The subjects mentioned in the Day Book, and not included in Webb and Docker (apart from the Agony in the Garden) are: Carrying the Cross, Resurrection, and Presentation in the Temple. With regard to the tracery Webb and Docker mention four rows of figures, which, reading from the top down, are named as: 'St. Peter. St. Paul. Angel with Shield. Angel with Shield. St. Michael. St. Gabriel/ S. Matthew. St. Mark, S. Luke, S. John'.

Office records. *Order Book*, undated, f. 25, (1st light I), the Rev. I.H. Fallow named as client. Cartoons £10. Order Book, f. 9: Subject 3rd light – 'Nativity' and 4th light – 'Annunciation'. Subjects of lights 5 to 10 as in Day Book, f. 90, viz. '1. Agony in the Garden. 2. Carrying the Cross. 3. The Resurrection. 4. The Ascension. 5. The Adoration of Wise Men. 6. The Presentation in the Temple.'; undated, f. 9 (rest of lights, I); 1852, f. 162, Jan. 12 (clerestory). *First Glass Day Book*, 1847, f. 19, Nov. (E, 1st light £30); 1848 f. 46, Nov. 11 (E, 2nd light, 7'10½" x 1'10", £30 & tracery, £35); 1849, f. 72, Nov. 5 (E 3rd light, £30 & 4th light, both 7'11" x 1'9½" £30); 1850 f. 90, May 18 (E 6 lights 7'11" x 1'9½" & new fig. for 2nd light, £180); 1852, f. 153, Jul. 17. 'To A Window of Stained Glass/of 2 lights for Clerestory/£32/2 Lights 7'4" x 2'0".../& 3 Tracery pieces'. *Cartoon costs per ledger summary*: 2nd light, Powell £1.0.0, Hendren 10s.0d, Oliphant £5.0.0; tracery, Powell 6s. 8d, Hendren 3s. 4d; 3rd & 4th lights, Powell £3.0.0, Hendren £1.6.8, Oliphant £5.10.0; 6 lights, Powell £7.10.0, Oliphant £32.7.0. Oliphant's account records that the payments were in respect of:

			£ s.d.
'1848	Sept 25	Compartment of Transfiguration	5.0.0.
1849	May 10	2 Compartments, Nativity & Annunciation @ 55/- sketched at Ramsgate	5.10.0.
	Aug. 8	2 Compartments, The Flight into Egypt & Adoration of the Magi @ 75/-	7.10.0.
1850	Jan. 7	4 Cartoons, Light of Tree Jesse, Entry into Jerusalem, Ascension, Descent of the Spirit	14.17.0.
	Jan. 24	Expenses to & from Ramsgate & time	3.0.0.
		9½ days Expenses at Ramsgate @ 7/-	3.6.6.
		8 days work do. @ 20/-	8.0.0.
		1 days do. Extra do. @ 20/-	1.0.0.
		[Difference with ledger summary]	(5 6 6.)
			32.7.0.'

Letters. *HLRO 304: Pugin to Hardman*, letter no. 41: 'I shall send you a great many windows this winter [1846] & I have a new one for Wells Street just ordered.' No. 837: '4. The Wells Street lights are just[?] finished pray get on with them as they have been so long in hand. they are a fine job.' No. 145: '2. The light for Wells Street goes off tonight it is a fine job [probably the 2nd light] remember to stain the lines[?] of our new yellow.' No. 1015: '2. Tracery Wells Street £35 light of transfiguration 30'. No. 1011: ' I am very anxious to see the transfiguration it ought to be very good.' No. 1019: 'I fear for your mens account that the transfiguration is not in keeping with the crucifixion at Wells Street but I will see it when I go up.' No. 811: 'what have you done about the payment for the Wells Street light?' No. 1022: ' let me have the cartoons of the lights for Wells Street to mark[?] the others by'. No. 1017: 'I return you the letter for S. Andrews church. The nativity & annunciation will come very well in my arrangement[?]. I shall want the cartoon of transfiguration back. I am very glad they are so well pleased.

agony in the Garden/riding the ass/crucifixion/resurrection/ascention [sic]
6 7 11 10 10
annunciation/nativity/transfiguration/adoration of wise men/flight into Egypt/
1 2 5 3 4'

No. 958: 'I shall want the Wells Street cartoons back to have Oliphant down & get done with the subjects'. No. 834: '1. I expect to have Oliphant down soon to get out the cartoons for St. Andrews Wells Street as soon as you let me have the old cartoons for sizes.' No. 140: '[Oliphant] is ready for Wells Street.' No. 686: 'I expect our Wells Street job will be a beast [written in 1850 in the context of the difficulties in painting glass in the Late style]. No. 936: 'I could finish the Wells Street window off in 3 days if this were done [a reference to cleaning up the mess in the study caused by modelling work – see *HLRO 304*, letter no. 939]. No. 939: 'I have just got the inclosed [sic] letter from Mr. Murray I see you have been throwing the blame on me for not getting the cartoons done when you know I have been waiting for your colours is it not so but really we are finishing the cartoons & you must get them done this horrid modelling takes up all the time. we don't move in the study & there is no sign of an end to it – it is very bad we are standing still in the glass way'. No. 855: 'I hope you dont neglect the Wells Street window I should like that up I think it will do good in London anything in London is seen 10 to one & the season[?] is coming on when that church is considered with the right sort of people. I think you should make an effort there'. No. 853: 'you must stick to this [St Mary, Beverley, Gaz 83] & Wells Street they are getting furious at last[?] I wrote last week a Long letter to keep things right but they are large figures & will cut easily, & paint easily & lead up easily so get on.' No. 820: 'I am obliged to alter the disposition[?] of the Wells

Street window which I will explain to you.' No. 379: 'There must be 3 new canopies for the lower lights at Wells Street for the transfiguration must be moved up into the upper lights. The 5 lower subjects are Jesse, annunciation, nativity, adoration of kings, flight into Egypt, being all connected with the Early life of Our Lord – so the Jesse, Nativity & flight will take new canopies.' No. 944: 'I dont see anything objectionable in the alternating of new & old canopies for Wells Street. it was often the case in the old windows that the canopies were alternated.' No. 224: 'I forgot to tell you that a whole lot of cartoons were sent off – all for Wells Street the new upper part of the transfiguration is a great improvement. *JHA: Oliphant to Hardman*, 1848, Aug. 28: 'I have on hand for you a compartment for the window in Wells Street it goes alongside the crucifixion subject. The Transfiguration, it is a fine arrangement and will come I think remarkably well and will take some doing. I have no precise orders as to the time it is to be done. I wish we could learn to do 2 things at once and then we should have no difficulties – But all that we can do to hasten your work you may depend on our doing'. Sep. 15: 'We are now proceeding with the compartment for Wells Street Church, it will be sent down early in the next week.' Sep. 23: 'The compartment of the Transfiguration for Wells Street will be finished this evening and shall be sent to Ramsgate first thing on Monday Morning.' 1849, May 12: 'Last Thursday we sent off to Ramsgate the 2 groups for Wells St. Church, London (the Nativity & the Annunciation)'. *Murray to Hardman*, 1847, Nov. 4: 'Mr. Myers has informed me that you have executed a figure of the Crucifixion for the East Window of St. Andrews Church Marylebone.' Nov. 10: 'the glass shd. be sent direct to the Church.' Nov. 29: 'I & many of my friends are much pleased with it. There were some who, while they admire the drawing think the colours are weak.' 1848, May 17: 'An offer has recently been made to me of money for another light for the East Window of St. Andrews Church ... I think I ought to write to Mr. Pugin on the subject so what is his address.' Monday 20: 'On receipt of your letter I wrote to Mr. Pugin who favoured me with a letter last week. We have decided upon the transfiguration for the compartment of the window beneath the crucifixion. This is in the centre. I begged Mr. Pugin to put the subject in hand with all possible expedition.' 1849, Aug. 17: queries when to expect the two lights of the E window. Nov. 16: 'I was very sorry I did not see you that day you called with Mr. Pugin at St. Andrews. I am however very glad you saw the glass in its place. I hear persons who are connoisseurs in stained glass criticizing the colour of the glass in the annunciation[?] where the angels are: It is said to look patchy & c – I mention this without giving an opinion myself. I like the Nativity exceedingly & it strikes me that the transfiguration is quite thrust[?] into the shade by it, that is by the colours. I trust you will do all you can to let us have the remainder by Xmas & I have only to say that there is no church in London where a good window wd be more appreciated than in St. Andrews, the church is visited by persons from all parts of the Kingdom principally on account of the Choral Music which is very good.' 1850: Jan. 28: presses for completion of E window, mentions that the W will probably be needed as well and threatens to go to another glass maker. May 22: Confirms that the E window is in and that it: 'exceeds my expectations ... The transfiguration is greatly improved, the figure of Our Lord a most majestic one. Perhaps I may not quite understand the subject, but the only part of the window to which[?] I cannot entirely admire is the [?] angels in the Annunciation although it has been so much improved by the moving of the bar from its former position ... I wish I knew whether Mr. Pugin has returned from Cologne.' *L.M. Mackenzie to Hardman*, 1848, Nov. 16: requests: 'to supply another light for the left hand lower division. It is wished it should be the Annunciation and I have no doubt that the Execution & Design of it will under your & Mr. Pugin's [?] as much satisfaction as those already put up ... I should beg of you to ask Mr. Pugin to prepare at the same time a Cartoon for a second light, the subject to be the Nativity also for the lower half of the window & next the Transfiguration.' Dec. 27 (in 1849 box): notes that the subscription list is getting on for the completion of the window: 'I can authorise you to proceed with the glass of the Nativity. The cartoons for the Offering of the Wise Men and Presentation in the Temple (instead of the Flight into Egypt) may also be put in hand. The Transfiguration light is much admired some however think there is rather too great a monotony of colour, of a yellow & orange, which a greater variety in the future lights will relieve. It is however much liked as is the tracery ... I believe an upper one is likely soon to be ordered. The Bearing the Cross – it will be necessary to remember that the Crucifixion was made too long – and the motto was obliged to be left out so that the figures rest upon the row of quatrefoils [?] the monogram. Should therefore any difference be made by Mr. Pugin in the rest of the upper glass it will be necessary to remember this in order to preserve the uniformity of the series – or perhaps some variation will be made in the Crucifixion itself to assimilate it to the rest.' *Butterfield to Hardman*, 1852, Oct. 25: 'You had better charge a usual price for Alfington [Gaz.26] & St. Andrews Wells Street windows. I believe no price was named.' Oct. 26: 'I went with Mr. Hope today to see the new window in St. Andrews Wells St. I was much disappointed with it so far as regards the canopies as I am sure you will be if you go and see it. The Canopies are heavy & tame to a degree I have seldom seen. Pray make a point of seeing it & letting me know whether you can in any degree improve it.'

Literature. *The Ecclesiologist*, 11, 1850, p. 68: paragraph on internal decorations including the following on the E window: 'It has great merit', although an example of: 'crowding groups full of figures and action into small spaces and surmounting

them with architectural canopies' – both features of which the *The Ecclesiologist* had, in the previous year, disapproved: 'the drawing is graceful and free from grotesqueness and the colours good, but there is not sufficient unity of colouration in the different panels'. Webb & Docker, 1897: a description of the fabric and a short account of the musical services.[21] *Journal of the Royal Institute of British Architects*, 3rd ser., 41, 1934, pp. 1051-9: description of the relocation, including a photograph of the reredos, above which the lower five lights of the E window are, indistinctly, reproduced.[22]

62 Roehampton, Convent of the Sacred Heart (RC)
1853. Window designed by J.H. Powell.

Office records. *Order Book*, undated, ff. 51, 58. *First Glass Day Book*, 1853, f. 177, Apr. 2: 'To A Stained Glass Window [circular]/of Tracery for East Window/of Convent Church' Subject, reference *The Tablet*, Jul. 9, 1853, p. 437: 'Sacred heart in centre surrounded by angels, with scrolls & c, containing verses from the Vespers of the Sacred Heart'.

63 Southwark, St George's Cathedral (RC)
c.1845-8. The stained glass windows were destroyed by bombing in the Second World War, but information as to size, subject matter, quality and authorship is available from contemporary journals, and the Hardman First Glass Day Book. It seems likely that those windows made prior to 1845 by Wailes, were designed by Pugin.

Chancel E window. *The Builder*, 1844, giving details of the progress of the church, reported: 'The Chancel window measures 30 feet by 18 feet, and is to be filled with stained glass of various colours containing a representation of the root of Jesse or the genealogy of Christ, the gift of the Earl of Shrewsbury and will cost £500 [cf. with £350 in Pugin's Diary – Wedgwood (see below)].' *The Tablet*, 1845, correcting the *Morning Chronicle*, noted that; 'this window consisting of nine lights is filled with fifty one figures ... from Adam and Eve represented in the centre light, through the Prophets and Patriarchs down to his Blessed Mother, who with a picture of the Crucifixion fills up the centre light.'; and a paragraph in *The Tablet*, 1845, quoting the *Art Union* described the window as being divided into compartments, each of which contains a full length figure, the subjects being the Kings of Judah and the Prophets.

When the church opened in 1848, *The Ecclesiologist* reported: 'The painted glass representing the Radix Jesse, by Mr. Wailes, is remarkable for the dingy yellow colouring of which his works of some years back affords specimens;' while *The Builder* considered the glass 'is not so harmonious as might have been desired.'

Chancel side windows. *The Ecclesiologist*, 1848, noted regarding the two three-light windows on the south side and the one on the north: 'These are filled with painted glass by Mr. Hardman. The drawing which is due of course to Mr. Pugin, is good, but the windows have Mr. Hardman's usual fault, the want of sufficient brilliancy. In avoiding the common and contrary fault of over gaudiness, this gentleman has run into the opposite extreme.' *Rambler*, 1848, commented: 'and the windows (chancel) filled with stained glass, of which the best are two windows on the right-hand side of the altar, executed by Hardman of Birmingham'. *The Tablet*, 1848, reported: 'The three side windows contain images of St. George, S. Stephen, and S. Lawrence, under canopies, with angels bearing crowns and laurels.'

Lady Chapel windows.

The Ecclesiologist, 1848: 'The windows, one of three lights at the east end, and two of two lights at the side, are by Mr. Wailes and not successful.' *The Tablet*, 1848: 'The stained windows contain an image of Our Lady, and the annunciation and salutation'.

Chapel of the Blessed Sacrament windows. *The Ecclesiologist*, 1848: 'The east window ... is from symbolic reasons very red in colouring, and represents the seraphim round our Blessed Lord, The effect is not happy.' *The Tablet*, 1848: 'The windows are filled with stained glass; the large one contains an image of Our Lord surrounded by Cherubims, and the two others are comprised of a quatrefoil pattern, filled with angels bearing scrolls.'

Nave aisle windows. *The Tablet*, 1848, quoting the *Brighton Herald*: 'There are six large windows of plain glass on each side of the church'. *The Ecclesiologist*, 1848: 'The aisle windows are of five lights, placed rather high. The western windows of the aisles are respectively identical in the number of their lights and their general position with the side ones, though of rather smaller size and placed a little higher.' *The Tablet*, 1848: 'The nave is being gradually filled with stained windows, three of which are commenced, and it is intended to erect chantries outside the church, in the spaces between the confessionals; one founded for the repose of the soul of the late Edward Petre Esq., is now constructing.'

Nave W window. *The Ecclesiologist*, 1848: 'the great west window (of six lights, with late geometrical tracery) ... is filled with painted glass ... This glass representing saints under canopies, with a great deal of mosaic work, by Mr. Wailes, is a great improvement upon that at the east end; still it is too much broken up into bits in the mosaic portion to produce any considerable effect. The design of the painted glass we need hardly say is from the pen of Mr. Pugin.' *The Builder*,

1848: 'Immediately over the entrance is a great window of six lights, with rich tracery in the head – each light filled with painted glass representing St. George, St. Michael, and other saints, under canopies; [this description is word for word the same as in *The Tablet*, 1848, except that there the canopies are referred to as 'lofty'. In a later paragraph it is stated that the window was given by M. Forristall Esq.]'.

Office records. *First Glass Day Book*, 1846, f. 2, Mar. 13: 'Repairing 4 Trefoil Tracery//pieces, putting in 36 new/leaves & c [no charge]', f. 9, Nov. 23: 'Tracery, for Confraternity/Window/ £5'; 1847, f. 14, Jul. 13: '1 Light... with Figure & c & c/£25/12ft 2½ In x 1 ft 3½ In... Cartoons £J[5]'; f. 23, Dec. 24: 'To Extra for Tracery for Confraternity Window.../ £10'; 1848, f. 29, Apr. 7: '15 pieces of Tracery to/2 Chancel windows sides) [no charge]'; f. 32, Jun. 3: '3 pieces of Tracery for/ Confessional..../ £2.5.0'; f. 34, Jun. 8: '2 Side Chancel Windows/of 3 Lights ea. With Figures & c/@£30 ea/£60/9'0½ In x 1'6½ In/.../Large Tracery pieces sent/"April 7 1848. fo. 29"/19 pieces of Tracery to 2 Windows/4 Small Tracery pieces/.../Cartoons £EH[14].../1 Side Chancel Window/of 3 Lights with Figures & c/ 7'8 In x 1'6½ In/.../Large Tracery sent April 7 1848. fo. 29/7 Small Tracery pieces [no charge]' Client – Rev. Dr. Doyle; f. 39, Aug, 3: 'a centre light in Side Window 12ft 2 In by 1ft 3½ In/.../£25/of St. Patrick./.../ 10 pieces of Tracery.../ £15/Client – Revd. J. Cotter, Fo. 41, Sep. 22 '10 pieces of Tracery/ for Window of St. Dominic [sic],/of Side Window.../ £15.[Client – Stuart Knill Esq., Walworth House, London]; 1849, f. 52, Feb. 20: '3 Small Windows for Chantry/.../£50/ of 2 Lights ea of Figures & c & c/ 4ft 1 In & 1ft 7½ In/ & 3 Small Tracery pieces to do', Client – Mrs Petre, 26 Witton Crescent, London.

Cartoon costs per ledger summary: Petre Chantry, Powell £2.13.4, Hendren 3s.8d; St Patrick window, centre light, Powell 13s.4d, Hendren 6s.8d; tracery Powell 6s.8d.

Letters. *HLRO 304: Pugin to Hardman*, letter no. 168: 'I went to St. Georges yesterday. nothing can be better than the St. Patricks light it is capital the only improvement would be the <u>deadening</u>[?] of the face which you must do in these situations but the glass is beautiful & I am out of all patience about it. Mr Cotter abhored[?] it & said how beautiful that Beastley window of the Lady Chapel is in comparison. it is no use attempting to please people who know <u>nothing</u> but you might write & blow Mr. B[?] up for giving way & saying everybody was crying out about it ... he ought to know better for it is a capital light.' No. 1022: '& then you will have Mrs Petres Chantry windows.' No. 1026: '2 of the figures for the Petre Chantry go off tonight – all the 6 canopies are alike. I think they are the best figures Powell has done – S. George is from Cologne.' No. 1032: 'Powell improves [?] he has drawn a fine figure of S. Edward for the Petre Chantry it will go tomorrow.' No. 980: 'I have had a <u>long letter</u> from Mrs Petre in which she says all the arms are wrong so you must write to Myers to take off the shields & send them back to you – she says she cannot <u>bear the glass</u>!!!' *HLRO 339: Pugin to Lord Shrewsbury*, letter no. 65, postmark 'CHEADLE NO 9 1842': 'St. Georges church looks most gloriously – it is surprisingly advanced the carving is exquisitely done I received the £42 quite safe the amount is quite in accordance with the general estimate I made for the windows & was contracted for by Wailes. I merely made the observation that the price was very moderate'. *JHA: M. Forristall to Pugin*, 1847, Dec. 7: 'I have received your Letter complaining of the 2 horrible windows in the Chancel of our New Church I can assure you that I am much displeased that they should have been placed in any part of the Church much more the Chancel – I had nothing whatever to do with them – I know not who did them – I understand someone from Norfolk – I have never paid for neither do I know what they are to cost – I have certainly understood that they have been done very cheap – but I am decidedly off [sic] opinion that they are dear at any price – and I am determined to have them out – I should like you to design two windows and give orders for them to be executed forthwith and I will pay for them – and when they are ready we will quickly take out the Rubbish and put in yours – these rascally looking windows were done without my knowledge or consent and the first time I knew anything about them was on seeing the first already fixed when I observed that the Figure which is supposed to represent St. James was more like one of the Forty Thieves and what a wretched Canopy in fact the whole thing is barbarous – and must not remain in – but still I think you will agree with me that their removal had better take place in the manner I have above described. Talking of stained Glass windows – I must tell you that there is an intention of having a window dedicated to St. Dominique which it would be desirable to have next the Rosary Windows he being the Founder of the Rosary – which windows have been taken by St. Georges Conference[?] of the Society of St. Vincent de Paul the tracery & Figure of St. Vincent you have done – we have not yet fixed the Figure in the second window because we thought it better to give up the second window for St. Dominique – and we fix St. Vincent in the 3rd window – I understand that you have expressed an opinion that the tracery already fixed in the 2nd window will do for St. Dominique's window – I have agreed with Mr. Robinson who has undertaken to collect for St. Dominques window that he shall have the tracery of St. Vincents window for 15 the amount we paid for it – which can be given to you for the Tracery of the third window – Mr. Robinson will pay me in a few days the 15 and as he proposes to adopt the same Plan as the Society of St. Vincent does namely – pay for as much work as may be done he will afterwards pay for the figure of St. Dominique you will therefore be pleased to take the order immediately for the Tracery of the 3rd

10.1 (*left*). St Peter, Great Marlow, Buckinghamshire, N aisle E window nII (Gaz.7), Pugin/Hardman, 1846. Annunciation.

10.2 (*below*). Jesus College Chapel, Cambridge, S wall windows sII–sV (Gaz.9), Powell/Hardman, 1853. Scenes from the Life of Christ.

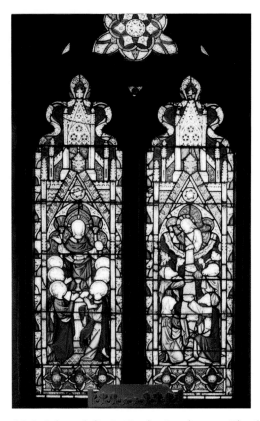
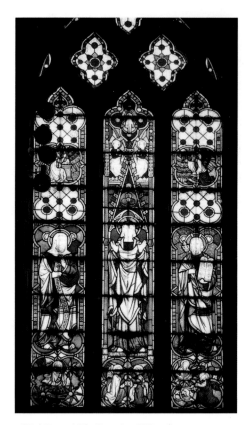

10.3 (*above left*). St Bede, Appleton, Cheshire, S aisle E window sII (Gaz.13), Pugin/Hardman, 1851. Last Supper, receiving manna. *Stanley Shepherd*.

10.4 (*above right*). St Oswald, Winwick, Cheshire, chancel S window sII (Gaz.18), Pugin/Hardman, 1848. Transfiguration. *Stanley Shepherd*.

10.5 (*left*). St James & St Anne, Alfington, Devon, E window I (Gaz.26), Pugin/Hardman, 1852. Crucifixion.

10.6 (*left*). St Mary, Ottery St Mary, Devon, S aisle E window sIV (Gaz.29), Pugin/Hardman, 1850. St Stephen (after restoration).

10.7a (*right*). St Mary Magdalene, Stoke Canon, Devon, S aisle window sII (Gaz.30), Pugin/Hardman, 1850. Ralph Barnes' family.

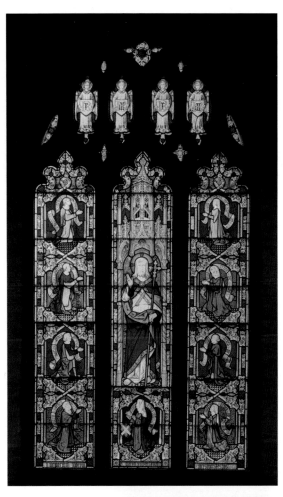

10.7b (*left*). Detail of 10.7a. Augusta Charlotte, Ralph Barnes's wife.

10.8 (*right*). St Cuthbert's College, Ushaw, Durham, library staircase window LS wI (Gaz.40), Pugin/Hardman 1851. St Thomas Aquinas. *Stanley Shepherd*.

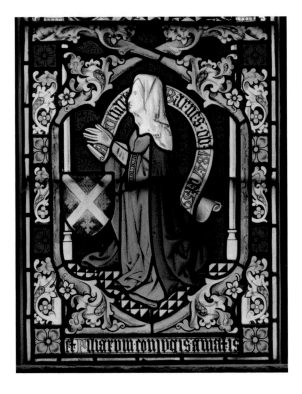

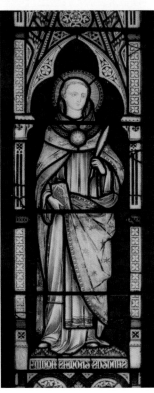

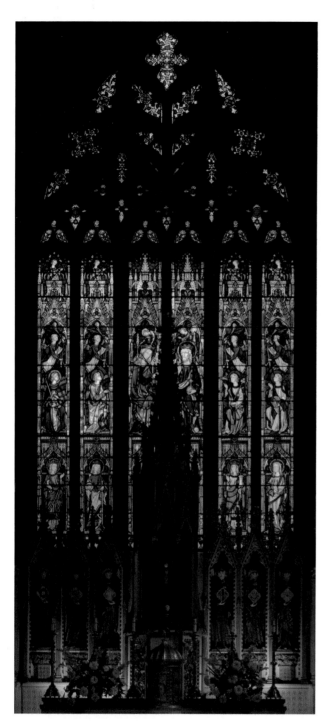

10.9a (*above*). Our Lady of Victories, Clapham,
Greater London, E window I (Gaz.52), Pugin/
Hardman, 1851. Coronation of the Virgin.
10.9b (*above right*). Detail of 10.9a.
10.10a (*right*). St John the Evangelist, Broughton,
Greater Manchester, chancel E window I (Gaz.66),
Pugin/Hardman, 1847. Christ, St John the Baptist,
the Twelve Apostles. *Jonathan and Ruth Cooke.*

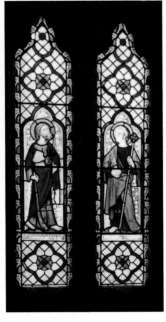

10.10b (*above*). St John the Evangelist, Broughton, chancel E window I (Gaz.66), sketch by Pugin for 10.10a, 30.3cm x 28.4cm. *Birmingham Museums and Art Gallery, BM & AG a.no. 2007-2728.2.*

10.11 *(far left)*. All Saints, Clehonger, Herefordshire, chancel E window I (Gaz.74), Pugin/Hardman 1850. Christ in Majesty. *Stanley Shepherd.*

10.12 (*left*). St Peter, Pudleston, Herefordshire, N aisle W window nV (Gaz.78), Pugin/Hardman, 1850. St James the Less, St Philip. *Stanley Shepherd.*

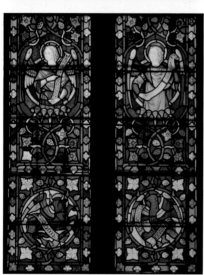

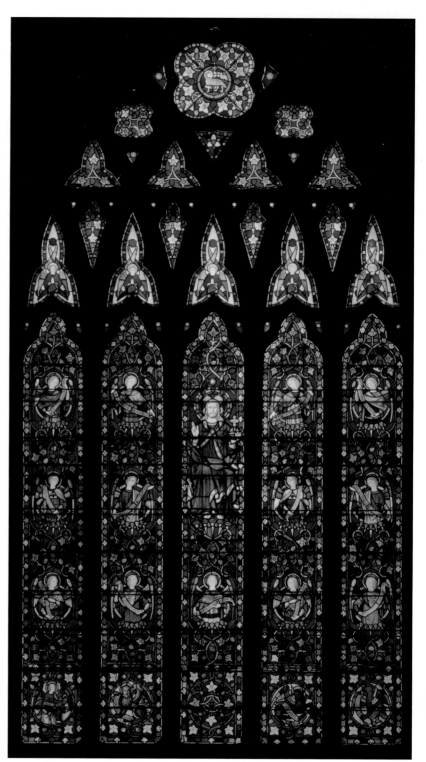

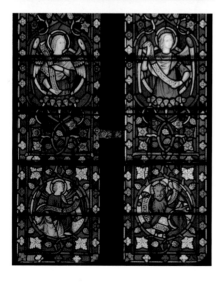

10.13 (*top left*). St Mary, Beverley, Humberside, W window wI (Gaz.83), Pugin/Hardman, 1850. Christ in Glory, Virgin Mary, the Twelve Apostles. *Gordon Plumb.*

10.14a (*right*). St Augustine, Ramsgate, Kent, E window I (Gaz.88), Pugin/Hardman, 1848-9. Christ with angels.

10.14b–c (*mid and lower left*). Details of 10.14a.

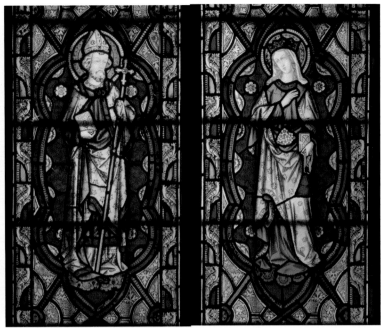

10.15a (*top left*). St Augustine, Ramsgate, chancel N window nII (Gaz.88), Pugin/Hardman, 1849. St John of Beverley, St Elizabeth of Hungary.

10.15b (*top right*). Detail of 10.15a.

10.16a (*bottom right*). St Augustine, Ramsgate, 2-light E cloister window (Gaz.88), Pugin/Hardman, 1846.

10.16b (*above*). Detail of 10.16a.

10.16c (*right*). St Augustine, Ramsgate, 3-light E cloister window (Gaz.88), Pugin/Hardman, 1846.

10.17 (*below*). St Augustine, Ramsgate, N window of school OCH nII tracery (Gaz.88), Pugin/Hardman, 1846. Annunciation.

window – and I think you may also take the order for the Figure of St. Dominique as I have no doubt the money will be collected long before the Figure is finished – '.

Literature. *The Builder,* 2, 1844, p.13; 9, 1848, pp. 439-40. *The Ecclesiologist,* 9, 1848, pp. 152-61. *Rambler* 1848 (Part 2, May to Aug.) pp. 227-8. *The Tablet,* 6, 1845 p. 103, correcting of the *Morning Chronicle*; 6, 1845 p. 759: quote from the *Art Union*; Jul. 8, 1848, pp. 435-6: opening of church; 1848, p. 452: report from the *Brighton Herald.* Wedgwood (Pugin's Diary), 1840, Feb. 14: 'Finished stained glass and estimates for St. Georges'; 1844, May 2: 'Sent Wailes £50 for St. Georges'; 1844 '[End papers at back of diary] [b] [Financial calculations] Wailes for St. Georges 350.0.0 [c] L.S. for B. St G 300.0.0. [note 80, p. 92, points out that this refers to £300 from Lord Shrewsbury for the E window, i.e. the balance of £350]'.

64 Westminster, New Palace of

1846-52. Client: Charles Barry. Apart from the windows for the Chamber of the House of Lords, which were made by Ballantine and Allan (to Pugin's designs and Oliphant's cartoons), all the glass in the New Palace was made by Hardman's. Up to the end of 1852 the work included glass for the windows of: Victoria Hall (now called the Prince's Chamber), the Peers' Lobby, the Chamber of the House of Commons, the Commons' Lobby, the Division Lobbies and a variety of waiting halls, cloisters, corridors and rooms. The designs were heraldic, except for that of the Lord's Chamber, which comprised twelve eight-light, transomed windows with tracery, each light containing a canopied figure of a king or queen of England or Scotland, and, although in this case Hardman didn't make them, he supplied a specimen window (1847, First Glass Day Book, f. 12), to be used as a guide in obtaining the desired effect in the Chamber. It is apparent from Barry's correspondence with Hardman, that as early as mid-1852, the designs of the paired two-light Commons' Chamber windows (reduced from large transomed windows in 1850), which had evolved through a series of specimen lights, and included the arms of cities and boroughs, had proved unsatisfactory, and the windows were either replaced or substantially altered (probably by 1854), with the original glass, seemingly, being re-used in the windows of the Central Lobby and the Commons' Lobby and ultimately, after 1856, in St Stephen's Hall. Part of the problem was the darkening effect of the stained glass which by October 1852, as shown in a letter from Barry to Hardman, was becoming a major concern. He wrote, that he had for the moment removed the glass that he admired from a corridor, because of the possible outcry, and asked Hardman to consider: 'the best mode of reducing the amounts of colour and showing more clear glass, both in the lights we have as well as in those which you have in hand'. After Pugin's death considerable quantities of glass, chiefly on the principal floor of the House of Lords, continued to be made by Hardman's.

Damage resulting from a bomb explosion under Westminster Hall in 1885 was successfully restored by Hardman's, but a great deal of the glass, including that of the Chambers of both the Lords and the Commons, the Members' Lobby, the Victoria Hall/Prince's Chamber, the central lobby, and the S window of Westminster Hall was destroyed by the bombing in the Second World War and was not restored to the original designs. However, much of the Pugin/Hardman glass does survive, though extensively restored, in a number of internal lights in the corridors and windows over archways on the river front, the Peers' Lobby, and St Stephen's Hall. (I am grateful to Alexandra Wedgwood for this information on the surviving glass. She also points to a stained glass light portraying William I which was discovered in the basement of the House of Lords in the early 1980s, now placed in the Lords' dining room, and which is indicative of the scheme of kings and queens for the windows in the Lords' Chamber [Atterbury & Wainwright, 1994, p. 230]).

Contemporary accounts are as follows:

Peers' Lobby (including reference to the Lords' Chamber): The Builder, 1847: 'some of the windows are filled with stained glass, containing the illustrations of the arms of the peers called to the first Parliament. The remainder will be completed shortly. These windows were executed like the one window in the House of Lords by Mr. Hardman, [a footnote explains: 'we were wrong it seems, in saying that the remainder of the windows in the House of Lords would be intrusted to the same artist. The contract for the whole of these windows is undertaken by Messrs Ballantyne and Allen, of Edinburgh, under the sanction of the Fine Arts' [sic] Commissioners. The window in question was executed under the direction of Mr. Barry for the latter to work by, as to colours and general treatment.]'

Commons' Chamber: The Builder, 1851: 'The House of Commons has been remodelled ... The ceiling has been brought down 5 or 6 feet in the centre and instead of being flat over the whole expanse, as before, it is sloped down on all sides. The upper half of the windows, which formerly had a central transom, is thereby put out of sight, and as this lessened the light considerably, the cills have been cut down about a foot ... The windows are filled with the arms of cities and boroughs in stained glass, by Hardman, good in colour and effect but unsatisfactory in design and drawing.'

The Builder, 1852: 'The stained glass windows, in the House of Commons, by Messrs Hardman, are not good; they are very far inferior to other works by the same firm. They are badly painted, the supporters especially (Mr. Humes "Red Lions", and sea horses), and contrast unfavourably even with windows of the same design in the central hall. A heraldic

lion or sea horse is conventional, but need not be a caricature.' *Art Journal,* 1859: 'The honourable members of the lower chamber found their house too dark with the painted glass windows, which have been removed, a lighter glass having been substituted ... The series of statues is complete in St. Stephen's Hall, and the windows have been filled with the stained glass which was removed from the windows of the House of Commons, each pane containing the arms of one of the cities or boroughs of Great Britain and Ireland.' *The Builder,* 1885: 'The large south window of Westminster Hall which was executed by Messrs John Hardman & Co between the years 1847 and 1851 ... is now placed in the hands of the same firm ... for restoration, since the destructive effects of the 24th ult. The window represents the arms of all the kings and queens and founders of reigning houses of England from some time before the Conquest downwards ... [the commission was 'to restore all that is destroyed or damaged, comprising a number of windows in the House of Commons, Division Lobbies and St. Stephen's Hall.'].'

Office records. First Glass Day Book, 1846, f. 7, Sep. 29: 'A Light.../.../of Matilda de Boulongue[sic] [no charge]'.
1847, f. 12, Mar. 1: '6 Windows for Victoria Hall/£225/consisting of 18 lights/@£37.10.0/ with/Centres & Borders & 36 Tracery pieces for do/7 Windows for Lobby of/House of Lords@ £60 ea/£420/consisting of/42 Lights & 42 Tracery pieces/including/1 Extra Window of Magna/Barons & Extra Work in Tracery/1 Window in House of Lords/£170/ consisting of/4 Lights with Figures, Kings/4 do.do. Queens/10 Tracery pieces/11 Small do. do./Reworking, Alterations & c to same/£130/14 Windows for Corridors @ £19.10.0/£273/consisting of 42 Lights of Figures, Quarries/ & Inscriptions/84 Tracery pieces for do'.
1848: nothing charged during this year.
1849, f. 51, Feb. 7: 'A Window of Stained Glass/for Corridor near Committee Rooms/ of 3 Lights, of Quarries, Centres/ & Borders 6'9" x 1'7½"/11 pieces of Tracery to do./.../£23.14.6', f. 55, Apr. 4: 'A Window for Screens in/Lobby, House of Lords/of 6 Top Lights 3'10" x 1½"/of Quarries, Borders & c & c/2 Lower Lights of do.do./3'11½" x 1' 1½"/4 Tracery pieces for do/2'0" x 0'5"/.../£24.17.3/1st Window Screens in Lobby [The same details are then recorded for the 2nd and 3rd Window Screen in Lobby except that the 3rd Window Screen has no lower Lights or Tracery and costs £16.18.0]', f. 56, Apr. 25: '2 Small Lights to go over/Door in Peer's Libraries/of Quarries, Borders & c/2'5" x 0'9½"/ £2.12.0', f. 60, May 26: '1 Light of Stained Glass/of Quarries, Inscriptions & c & c/6'10"x 1'9".../for Specimen Light House of/Commons/1st Specimen [no charge]', f. 62, Jun. 12: 'To Alterations in Stained /Glass Light for House of Commons/Sent May 26 1849/being 1st Alteration of Specimen Light/A Light of Stained Glass/for Division in Lobby/4'11" x 1'6".../for Specimen Light 1st Spec/A Light of Stained Glass/for Division in Lobby/3'2¼" x 1'6".../ for Specimen Light 1st Spec', f. 64, Jul. 25: 'To 6 Lights for Window for/Screen in Lobby House of/Lords/£16.18.0/of 6 Top Lights of Quarries, Borders & c & c/3'10" x 1' 1½"/.../being 4th Window in Screens in Lobby/To Alterations in Specimen/Stained Glass Light for/House of Commons sent/June 12 1849/being 2nd Alteration of Specimen/To Alteration in Large Specimen/Light for Division Lobby/sent June 12 1849/being 1st Alteration of Specimen [similarly for Small Specimen Light]', f. 66, Aug. 29: 'To Alterations in Specimen/Stained Glass Light for House of/Commons/ Sent July 25 1849/being 3rd Alteration of Specimen [similarly for Large and Small specimen lights of Division Lobby being 2nd Alterations]', f. 73, Nov. 5: 'To a Stained Glass Light/for House of Commons/of Arms & Supporters & c/6'10" x 1'9".../being 4th Specimen of House of Commons'.
1850, f. 84, Mar. 12: 'To Altering 4th Specimen/Light for House of Commons/with New glass for Shield, Crest & c/6lb of New Glass, Lead & c [no charge]'.
1851, f. 113, Feb. 20: 'For House of Commons/48 Lights of Stained Glass/of Shields of Arms Suppor/ters Mantling & c/7'7½" x 1'9¼"/making 24 Windows of/2 lights each/.../£644', f. 115, Apr. 16: 'For House of Commons/Alterations in Windows as below/6 prs Ruby Lions recut/3 prs yellow do.do. in place of ruby/1 pr of Owls/1 Dragon recut 2 prs Angels/part recut, Portcullis recut/1 pr Stags part recut pieces/of B4 round, Shields quar/tering of shields from B12 to B2/12 prs yellow Lions Stained darker/38 Ruby Tassels recut/.../£51.4.0' f. 126, Oct. 3: 'for Lobby of House of Commons/48 Lights of Stained Glass of/Shields of Arms Supporters/Mantling & c/Making 24 Windows of 2 Lights ea/84 pieces of Tracery for do./.../£722', f. 131-5, Dec. 31: 'For New House of Parliament/Lower Division Lobbies/ Upper Transom Lights of Quarries/Shields Borders & Inscriptions/Lower Transom Lights of Quarries/ Borders & Inscriptions/1 Large Oriel in centre/of 4 Lights 3'2" x 1'2".../4.do. 4'11" x 1'2".../7 do 3'2" x 1'5½".../7 do 4' 11" x 1'5½".../2 Side Oriels North & South/of 7 Lights each/of 14 Lights 3'2" x 1'5½".../14 do 4'11" x 1'5½".../4 Windows of 3 Lights ea/of 12 Lights 3½" x 1'5½".../12 do. 4' 11" x 1'5½"...74 pieces of Tracery/£294.9.0/Corresponding Lobby at other/Side/£294.9.0/Upper Division Lobbies/of Quarries Borders Inscriptions/1 Large Oriel in Centre of 4 Lights 4'11" x 1'2".../7 do 4'11" x 1' 5½".../4 Windows of 3 Lights each/of 12 Lights 4'11" x 1' 5½".../£58/Corresponding Lobby on other side/£58/Writing Room/of Quarries Borders & Centres/6 Windows of 4 Lights each/of 24 Lights 4'10"

x 1'7" .../48 Pieces of Tracery.../24 Small Pieces do.../£157.19.0/Lower Waiting Hall/of Quarries Borders & Badges/6 Windows of 2 Lights each/of 12 lights 5'9" x 1'6½" .../1 Window of 3 lights/of 3 lights 5'9" x 1'6½".../45 Pieces of Tracery.../£105.19.0/Upper Waiting Hall/of Quarries Borders & Badges/6 Windows of 2 Lights each/of 12 Lights 6'7" x 1'9"/£82.19.0/Corridor from Public Hall to/Centre Hall/of Quarries & Badges/5 Windows of 2 Lights each/of 10 Lights 4'1" x 1'2"/£38.10.0/Window North Side of Members/Entrance from Westminster Hall/of Quarries Borders Shields/Mantling/1 Window of 3 Lights/of 3 Lights 5'4" x 1'7"/5 Pieces of Tracery/£30.5.8/Screen West End of Top Cloister/of Quarries only/1 Window of 2/Lights/of 2 Lights 3'9" x 1'1".../34 Pieces of Tracery.../Screen Members Entrance/of Quarries only/1 Window of 2 Lights/of 2 Lights 4'2" x 1'4".../4 Pieces Tracery...£13.2.1½ /Screen Members Entrance by/Washing Room/of Quarries & Inscriptions/2 Windows of 3 lights each/of 6 Lights 6'2½" x 1'5½".../12 Pieces Tracery.../£29.0.1½ /Screen Committee Room Corridor/facing Commons Lobby/of Quarries & Badges/1 Window of 8 Lights/of 8 Lights 3'10½" x 1' 1½".../4 pieces Tracery.../£19.17.6/Staircase Members Entrance/of Quarries Borders Shields/Mantling & Supporters/3 Windows of 3 Lights each/of 9 lights 6'11" x 1'8½".../30 Pieces Tracery.../This Window as per Estimate/£128.0.0/Dressing Room for Members/of alternate Quarries only/2 Windows of 3 lights each/of 6 lights 6'11" x 1'8½"/20 Pieces Tracery.../£20.15.0/Washing Room for Members/of alternate Quarries Only/1 Window of 3 Lights/of 3 Lights 7'6" x 1'6"/This Window as per Estimate/£7.10.0/Upper Cloister/of Quarries & Inscriptions/Oriel Window of 4 lights/of 4 lights 6'4½" x 1'4".../6 Pieces Tracery.../This Window as per Estimate/£35.0.0/4 Windows of 4 lights each/of Quarries Borders & Inscriptions/of 16 Lights 6'4½" x 1'7".../60 Pieces Tracery.../£119.5.6/Lower Cloister/of Quarries & Inscriptions/Oriel Window of 4 Lights/of 4 Lights 7'1" x 1'4".../6 Pieces Tracery.../This Window as per Estimate/£30.0.0./6 Windows of 4 lights each/of Quarries Borders & Inscriptions/of 24 lights 7'3½" x 1'7".../Tracery complete for 6 windows .../£189.12.0/Sky Light Entrance House of Commons/of Ornamental Plates/4 pieces 2'7" x 1'10".../4 do. 2'5" x 2'0"/£34.8.6/Sky light Members Entrance/8 pieces 1 Circle 3'0" x 3'0"/£8.2.0/Skylight in Bishops Corridor/of Ornamental Plates/Copper Frame/Glass for do. 8 pieces 1 Circle 3'4" x 3'4"/£9.18.0/Altering Tracery Commons Lobby/of Foliage 48 pieces/£27.0.0/.../Plain Glass/Upper Oratory/5 Windows of 2 Lights each/10 Lights 5'3" x 1'0".../Members Entrance/4 windows of 3 Lights ea/12 Lights 5'8½" x 1'6".../24 Pieces Tracery.../Upper Cloister/10 Windows of 4 Lights ea/40 lights 4'11" x 1'7".../80 Pieces Tracery 2'0" x 0'7".../40 Small do.../Screen Members Entrance/from Westminster Hall/2 Windows of 4 Lights ea/8 lights 7'5" x 1'6".../10 Tracery Pieces 1'6" x 1'4"/£60.4.0'.

1852, ff.167-8, Feb. 1-Dec 1: 'St Stephen's Hall/2 Screens of 4 lights each/8 Lights 6'7" x 1'6".../Quarries Borders & Centres/28 Pieces of Tracery.../£56.17.6/Lobby of St Stephens/Hall/1 Window of 2 Lights/2 Lights 5'3½" x 1' 3½".../Quarries Borders & Centres 7 Pieces of Tracery/£11.00/Screens in Speakers/Corridor/1 Window of 8 Lights/8 Lights 3'11" x 1'1¼".../Quarries & Centres/4 Pieces of Tracery.../£19.0.0/Screens in Commons Lobby/Corridor/3 Windows of 8 Lights each/24 Lights 3'11" x 1'1¼".../Quarries & Centres/12 Pieces of Tracery.../£57.10.0/Lower Cloister/12 Windows of 4 Lights ea/48 Lights 7'4" x 1'7".../Quarries Borders & Centres/£334.10.0/Lower Cloister/2 Windows in Doors of do. of/2 Lights each/4 Lights 7'4" x 1'7".../Supporters Banners & c/4 Large pieces of Tracery.../3'11" x 1'7"/£60..0.0/This Window as per Estimate/Screen in Conference Room/2 Windows of 8 Lights each/16 Lights 3'11" x 1'1¼".../Quarries Borders & Centres/8 pieces of Tracery.../£38.5.0/Screens end of Peers Lobby/Corridor/3 Windows of 8 Lights each/24 Lights 3'11" x 1' 1¼"/Quarries Borders & Centres/12 pieces of Tracery.../£59.10.0/2 Extra Lights for sides of Doors/2 Lights 3'11" x 1'1¼".../4 Pieces of Tracery/Peers Corridor leading from Central Hall/8 Windows of 3 lights each/24 Lights 4'8" x 1'3½".../Shields with Mantling & Supporters/16 Pieces of Tracery & small/Tracery pieces.../This Window as per Estimate/£144.0.0/Screen Members Entrance/from Westminster Hall/1 Window of 4 Lights/4 Lights 4'7" x 1'6".../Borders Quarries & Centres/4 pieces of Tracery.../4 do.do. .../8 do.do. .../£20.5.0/Entrance from Westminster/Hall/2 Windows of 2 Lights ea/4 Lights 4'0" x 1'0½" .../Quarries Borders & Centres/2 small pieces Tracery.../£7.13.0/for Dining Room,/Clerk of Parliaments House/A Stained Glass Window/of 3 Lights of Quarries with/Shields of Arms in each light/3 Lights 5'8½" x 1' 9½" .../& including alterations in do./£30.0.0./For Dining Room/Librarians House,/A Stained Glass Window/of 3 Lights of Quarries with/Shields of Arms in each/Light/3 Lights 5'8½" x 1'9½" .../ & including alterations in do./£30.0.0'.

Order Book 2, undated but probably 1853, ff. 53-4, headed 'Alterations House of Commons'; there follows a list of names of forty six cities, towns and boroughs, with names of colours opposite them all, and capital letters A, B or C opposite some.' *Cartoon costs per ledger summary*: 1849, Feb. 1, re corridor, Powell 13s.4d.

Letters. HLRO 304: *Pugin to Hardman,* letter no. 229: 'I have had a most important interview[?] with Mr. Barry this morning & he has finally arranged for great quantity of work [sic] which I have no idea how you will get through But a complete list shall be sent to you tomorrow there are grates[?] & all sorts of things the great hall window is <u>now ordered</u> & mind he says it is indespensible [sic] <u>for the whole of the cartoons</u> to be drawn with all <u>possible expedition</u>

& then he can tell the commission that the whole of the windows are ready for execution & that a great <u>part of the expense</u> is already incurred. you will see what we have to do. it is impossible for Early to leave Ramsgate. when we shal[sic] recruit[?] more help for common work. this is too important a work to neglect in any way for the cartoons once done we are safe & I have arranged with Mr. B. about there being paid in full under any circumstances'. No. 283: 'I am sending off tonight the tracery for the Victoria Hall & c. the whole of the cartoons for the West window will go off this week I hope.' No. 776: 'I must up to London today & get a final order from Mr. Barry to proceed with <u>all the</u> windows of the Commons Lobby & for the Lords[?] Lobby a specimen window'. No. 2 'The lights for the Peers Lobby go off this evening try & make a good job of them by different shade of Ruby in the mouldings[?] some light some rich some deep we have yet 6 shields to send you for it.' No. 784: 'a great lot of the lobby glass will leave this week & all the tracery & c.' No. 297: 'I have not had a moment to reply to your letter till now – & first about the House of Lords. 3. There are 2 more windows to do. He is delighted with the one you have sent up indeed it looks very well.' No. 1042: 'The window for the House of Lords next.' No. 992: 'we have had the last but one window for the House of Lords to finish & that is done'. No. 1032: '3. there has been ½ a window to do for the House of Lords & this is the only work that brings in any money so I am driven to do it to get on at all'. No. 1043: '2. The House of Lords window goes off tonight I have left the white margin so wide that in case the templates are just taken in the clear[?] you can manage.' No. 427: 'I send off by post tonight a <u>pattern</u> light for the house of commons which should be in London next week when I am up & then we might get it settled.' No. 763: 'the new [?] lights for the House of Commons come out beastly & has to be done again alterations are certainly necessary indispensable[?] & this makes great delay.' No. 966: 'I saw Mr. Barry yesterday. The whole design of the house of commons window is to be changed & we are to have arms instead of Badges. You must send me back the old cartoons for size I will send you a new cartoon – the corridor windows Mr. B. likes very much but I see they can be very much improved by using another <u>Blue</u> & sundry other things which I will explain to you.' No. 175: 'I send you the bottom of the commons windows which you will understand making the best of a bad job.' No. 228: 'The house of commons cartoons go off tonight. they have had to drawn [sic] again there is no end of trouble with them something extra should be put down for these cartons this is the 3rd time they have been drawn.' No. 462: 'now about the glass of the Commons. I spent about 2 hours with Mr. Barry examining everything & what he says is perfectly true that a great deal of it leaves <u>nothing to be desired</u> & is as perfect as the old work & the finest of it. but there are several things that really require change. 1. what I always feared the ruby lions must be as light again & <u>no shadow on them</u> 2. the lions which are yellow & white dont answer[?] & they must be all yellow like the others which strange to say look incredibly[?] well. then there are other things the angels have too much colour & must have more white & <u>girdles</u> cutting[?] up the robes – the Windsor supporters must have branches turning up to break the uniformity the Leeds supporters must be altered. there are 22 lights to alter I then told Mr. Barry that what he suggested means great improvements & would certainly make it a very perfect work but that of course you could only undertake them as <u>additions</u> & <u>alterations</u> to the original work which had been duly created & everything must be <u>paid for as such</u> to which he instantly agreed he said there was no room whatever for complaint in anything that had been done but he aimed at perfection & that. could only be obtained in this way so the lights will be sent down to you <u>numbered</u> & I have reference to these numbers & must come down I expect on Monday week to you I must go over each light with you to explain the alterations in the meantime send me up the cartoons for Windsor Leeds & Oxford for the angels I shall certainly have to come to you on Monday week – & [?] in the meantime about the lobby I dont think you can use ruby much darker than 3 or 4 for the lions – but take great care of all the present lions as they will be useful on a future occasion.' No. 263: 'There was a horrid debate in the Lords against the decorations last night for goodness sake finish all the glass you can or it will be stopped.' No. 790: 'Mr. Barry has given me at least 50 windows more only waiting for you to come to me & estimate, if any window is as[?] important you better give up the job.' No. 345: 'I send you off the cartoons for the division lobby lights.' No. 517 '4. The cartoons for the 29 windows all go off tonight the cartoons are simple but effective how about the bars – are they <u>only cross</u> 7. Please to send me by <u>return</u> the <u>size of one</u> of the lights for the windows of the corridors between Commons lobby & waiting hall.' *JHA: Pugin to Hardman*, undated, marked '1847 box': '2. Mr. Barry orders the whole of the Peers lobby windows at £55 each the Victoria hall – at I think £35 each & he wants the whole of the corridor done as well I wish you had sent the pattern window up. I should have got it settled. I forgot what we agreed for the Price of them let me know by return of post. & send up the 3 lights. 3. the crowns in the victoria hall windows are to be simplified which will be easier to do. let me have an accurate tracing of them as they are drawn & as well a tracing of the <u>tracery</u> both for them & Peers lobby & I will alter them now I have promised all these for the opening of the house.' Undated, marked '1847 box': '1. I send you the altered crowns for the victoria hall they are simpler that is all you need <u>not alter</u> the <u>3 that are done</u>. but only the new ones you quite alarm me about the price not being enough for these windows mere quarries and now only a rose in the centre of them. Mind if these windows

do not pay well something must be wrong in the system. it is as [?] as Willement would have had & he always got 200 per cent. if they don't pay something is wrong for they ought to <u>pay well</u> I am a good judge 2. I send you the heads for victoria hall & peers lobby. I am obliged to send them in pencil – Powell is in the dumps & we cannot get on at present he gets miserable just like me. for the peers lobby they will be the same Roses but 2 with leaves between .' Undated, marked '1847 box': 'I got fully settled with Mr. Barry this morning 1. about the glass – the canopy is to have stronger lines no panels on pinnacles & a strong line down the middle [Pugin includes a small sketch to demonstrate what he means] no black panels on pinnacles that go down sides of niches. The robe to be of a <u>white</u> glass not yellow no. 1 – & the yellow powdering [?] on it to be closer. The face & hands to be also of white glass – the ground to be yellow no. 1 instead of white. The blue under canopy to be lighter but still purple in colour. you must try & get a tint. the light is 2' too short so you can add the 2' border to the pedestal which was omitted to reduce the height [again demonstrates with a sketch]. the face wants marking more strongly with dark lines it does not tell. The whole light is wanted to be lighter in effect by the introduction of the clear glass. of course you will only redo the parts to be altered & send it back as soon as possible.' *Barry to Pugin*, 1850, Oct. 10: 'I return your sketch for the light of the House of Commons which I admire exceedingly – The Beasts and such are glorious and the effect of the whole which if perfectly coloured will be "<u>The Thing</u>"'. 1851, Mar. 3: 'The condemned[?] lights are packed up and will be returned to Hardman tonight and as I am very anxious to have them up again in the amended form I hope you will soon be able to give Hardman the requisite directions applicable to each and having done this to beg of him to get the alterations made with the utmost despatch The house does not look like the same place without them – Pray do all you can to reduce the shadows on the supporters by acid or otherwise and let the flat tint proposed to be given to the sickly complexioned lions be a tawny yellow or warm brown rather than the gamboge colour of those which now remain in situ which is not satisfactory.' *Barry to Hardman*, 1847, Feb. 15: 'I have ordered the altered light of stained glass to be returned to you this day – The clear glass canopy here outlined is a great improvement as far as it goes, but the colour of the glass is rather too cold & raw which I have endeavoured to rectify by means of very rich colour laid over it which however is not quite deep enough – The ground of the niche detailing above it is given by contrast with the clear glass canopy [?] of a most disagreeable sooty blackness which is much increased by injudicious stippling – The colour of this background [?] that would I think upon the white look the best is a bottle green of the depth & tone given by placing two pieces of a broken bottle which I have included in the case with the light over one another – The pattern however & details of the [?] must be drawn upon the clear glass in a darker tone of the same colour, but without any stippling to interfere with its brilliancy – I am convinced this system of stippling in production offers the worst consequences whenever it is used particularly where the details are small and elaborate as in the top of the sceptre and other portions of the figure where it produces smugginess and confusion and destroys the brilliant & gem like character of the glass especially where it is removed[?] far from the eye as in the case of the House of Lords'. 1851, Jan. 29: 'I had hoped <u>long ere</u> this I should have received from you some of the painted glass for the House of Commons.' 1852, Aug. 9: ' I enclose the Design which you sent to me some time since for an alteration of the Commons windows glass. Have the goodness to get a cartoon made of it immediately and let me have a trial light as soon as possible in order that if it should prove successful we may get as many as possible of the windows altered before the next meeting of Parliament.' Aug. 23: 'I should be glad to see you and Powell respecting the glass patterns on Monday or Tuesday next … The labels & perhaps below the shields in the Commons lights are too solid … The appearance of a stem up the centre of the light to support the shield is desirable … The quarries require more force and character and the green glass in the labels has a disagreeable effect.' Oct. 1: 'I have desired Quarm to return to you the cartoon for the Commons lights … The former requires a more decided mounting of the central and other stems which I propose to be orange and the bottom of the light requires a greater base of colour which may come by putting green in the lower quarries and in the two bosses[?] now white – all these changes and the marking of the bosses black instead of [?] [?] white I have indicated on the Cartoon – '. 1853, Oct. 19: 'In order that not a moment should be lost, I have come up here from Brighton expressly to inspect the pattern light of the House of Commons. In respect of design and arrangement of quarries I am satisfied but the light will only take two badges instead of three, which may be placed as shown in the inclosed tracing. The border and wreath of the badges and the roses in the tracery are ruined by your abominable practice of stippling and putting too much outline and dandified drawing in the leaves which is all very well near the eye, but has a smudgy and indefinite effect at a distance … The sort of foliage which I prefer is of the smooth simple and conventional kind similar to that forming the ground of the Badges and I enclose two rough sketches of the leaves of the Borders and the wreath to explain what I mean which can be done with half the labor [sic], expense and consumption of time and which is all that is necessary for effect – The leaves of the border which I wish to be all white need not come home to the leading as you will find I have arranged in the sketch, and all veins of leaves, and they should be few in number, should be represented by one single line – The grounding tint

to show their outline should not be black but brown so that it may not appear as black as the leading which should appear clearly & well defined throughout – Pray prepare a pattern light express this principle and send it up as soon as possible ...You may go on with cutting the glass according to the proposed new arrangement of badges so as not to lose time – I wish you would not waste so much time in finnicky detail in your Glass, and avoid stippling altogether and you would produce twice the effect you usually do, at half the cost'. Nov. 8: 'I have seen the new lights and like the general effect of it very much – it will do however equally well without the [?] that cross the Badges and therefore <u>they</u> may be omitted – The bottom inscription however may be retained – The arrangement of the Badges is satisfactory and the treatment of the upper and lower ones is very good owing to the white ground which separates the Badge from the wreath – The Central Badge requires this kind of relief and the 4 leaves which surround it instead of being yellow towards the centre and white at the tips might be wholly of a Light and rich green so as to make out the form of the Lozenge more decidedly than is at present the case –with the modifications you may proceed with the whole of the works without any further submission of specimens.' *P.A. Feeney, 1956-7, pp. 143-4: Barry to Hardman*, 1856, Aug.: 'I should be glad if you would forward to me immediately all the diagrams and other data forwarded to you some years since for the heraldic glass originally put in the House of Commons windows and of which a portion has been re-used in the windows of Central Hall. I should be glad also to have the cartoon which I arranged with Powell for the further employment of them in St. Stephen's Hall and an account of all the glass you have in store describing the Arms of which it in part consists.' *JHA: Oliphant to Hardman*, 1848, Aug. 28: 'these last 4 [cartoon figures for Milton Abbey, Gaz.35] I had intended to stand over till I had completed half a window for the H. of Lords that is, till the end of next week, and you should have them the week following but you are aware I act under orders tho' in the absence of distinct instructions I am obliged to arrange as I believe to be best.' *J.H. Powell to Hardman*, undated, in 1847 bundle: 'Hendren goes on very well but I cannot succeed in getting cheaper lodgings at all comfortable...he has been hard at the Parliament windows this week will you keep account against the Governor [Pugin] for this work or shall I he has done a good 20 shillings worth at the cartoons this week.' *Thomas Earley to Hardman*, 1847, Feb. 26: 'I have just sent off the glass by the 5 O'Clock train Mr. Barry has marked on the Canopy of King Stephen what he wants done with Black paint, the little Roses that are painted yellow on the Canopy are to be Stained having a white margin and dots – the Inscriptions are to be on quite clear glass – I have sent in the case a piece that he had [?] such as he wants the diaper at back of figures.. I told him I thought you would find it difficult to get pot metal like that – he said if you Stipled [sic] some plain glass with black and burnt it in that would do – he will write to you all the particulars about it tonight. I have been with him all the day – the Canopys [sic] are to be of White Glass such as he will describe in his letter – do not mind any of the painting on the glass except that of King Stephen the rest are all wrong this is all he told me – my travelling expenses up and down with 5 journeys in Cabs is £1.17.6 I have been 2 days 7½ hours at the House beside the night Coming to London you give me what you please'. Undated, in Mar. 1847 bundle: 'I shall have fixed all the windows on side of the Victoria Hall before I leave work tonight – we have the glass for the 2 others on the opposite side & I shall fix one of them and the Glazier will put in the other after I leave tomorrow – the Glass looks very cheerful Mr. Barry is pleased very much with the tracery the lower part windows he considers too light he intends to have the plate Glass at the Back of the light Stipled [sic] with Varnish colour of a Brown Cast. I will tell you all about it tomorrow night.' May 19: 'I am going on well with the Glazing as you term it, I shall have the whole of the East Corridors' Windows in early on Friday morning.' May 22: 'I have finished the East Corridor and fix'd the two windows in the West Corridor I have no more glass on the corridors so I shall have a turn at the Lobby tomorrow morning ... Mr. Quarm has written to you to know the arrangment of the windows in Peers Lobby. I saw Mr. Barry late this evening. he said it did not matter where I fixed them as there was no particular date attached to any of them & I was to fix them as I chose. I shall prepare them ready for fixing but will not fix them till I hear from you.' *I. Bishop to Hardman*, undated, 1847 bundle: 'they have taken one of the figures out in the House of Lords and sent it off somewhere. it is the Figure Matilda of Scotland.' 1852, Sep. 29: 'Sir Chas. Barry has been here & wishes to see the Cartoon you will please send it by return of <u>Post</u> of the Alterations for Commons Light.'
T. Quarm to Hardman, 1850, Oct. 5 (in 1851 letters): 'I have to inform you that the lower lights only of the House of Commons will have stained glass and that the dimensions will be 12 inches exactly from the springing to the cill more than the Templets [sic] are marked Mr. Barry will give any further instructions that may be required in the design himself.' *E.M. Barry to Hardman*, 1853, Nov. 1: 'I understand that in the lights last settled for the House of Commons there are scrolls close to the badges as at A.A. [Barry includes a small sketch showing a circle marked badge, at the centre of a diagonal cross, with the letter A marked in two places alongside one diagonal, on opposite sides of the badge] My Father wishes me to say that he has doubts as to the effect of these scrolls and wishes you to have a light finished as soon as possible and sent up for his inspection ... In the meantime he wishes you to stay your proceedings <u>as far as regards the scrolls</u> but to push on the rest of the work without regard to them.' Nov. 3: 'I am really quite concerned at

the predicament in which you find yourself as to the glass for the H. Com – and fear it is only too probable that seeing a specimen light may induce still further alterations. I have forwarded your note to my Father …You may depend on it that unless you make him understand at the time how much expense and delay the alterations cause you, hereafter when the accounts are settled you will have difficulty'. Nov. 10: 'I enclose your sketch with my Father's approval. The shape of the badges will therefore now be all the same in the House of Commons and all the same in the House Lobby. Be sure to attend to the note I have written upon your sketch by my Father's direction.'

JHA Letter Book: Hardman to C. Barry, 1851, Jan. 30 (p. 49): 'I shall have all the 48 lights [for House of Commons, First Glass Day Book, f. 113] painted and leaded up next week & my man shall commence on the 10th of February & not leave until the work is in. There are 31 lights now up but they have not the inscriptions at the bottom these are being now done.' Feb. 27 (p. 55): 'I am delighted that the glass in the House of Commons give you such satisfaction.' 1853, Aug. 25 (p. 186): 'I now enclose you the drawing for the House of Commons Light as you proposed it & trust it will meet your approval.' Oct. (p. 198): I now send the Estimate for the Glass for the House of Commons for the Lobby for the Central Hall & St. Stephens entrance according to the design you settled upon with Mr. Powell in which there is much more work and a great deal more coloured Glass than that first calculated … I have done the best I can and am working hard at the House of Commons and the Cartoons are very far advanced for the Lobby, I will get a Light of the Commons off on Saturday night.' Oct. 20 (p. 202): 'I must confess I was a little disappointed in the receipt of your letter this morning as I thought I had carried out your instructions to Mr. Powell. I should not have minded if I had not got so much of the work done some of which will now be useless. However I have had every man in this place at work since morning at sample lights for the House according to your instructions & for the Lobby & Central Hall according to the Cartoons settled in London when Mr. Powell was up. All these shall be sent off on Saturday night without fail so that you may see them on Tuesday. I do not think it will be safe to paint anything more except quarries (which are nearly done for the House) until you have seen sample lights.' Nov. 9: 'I am duly in receipt of your letter respecting the glass for the House of Commons & beg to suggest that the best plan to get over the difficulty you mention in the centre badge will be to restore the one with the wreath like the upper and lower ones to its place in the centre from the lobby to which it was transferred so that the whole of the Badge with wreaths would come in the House of Commons & all those with the Lozenge form, in the Lobby as you originally proposed. I have had a small sketch of one of the Lozenge shape badges coloured in with 4 leaves which surround it in green & I am afraid you will find the effect will be heavy coming against the background of the badges. This background cannot be white in consequence of all the animals being white. These lozenge shaped Badges were always intended for the Lobby where the glass is very much nearer the eye than in the House. I enclose two rough sketches of the lights shewing the arrangement of Badges in the H. Commons & in the Lobby, as I should propose them & as you fixed them with Mr. Powell when you had all the Cartoons before you. I am sure you will be satisfied with them in this way. If possible please let me have your answer by return of post, so that I may get to work leading up.' 1856, Aug. 16 (p. 467): 'sending cartoons for using up glass from House of Commons Lobby in St. Stephen's Hall and authorities for arms of Cities, Boroughs, Towns & c for glass in Central Hall and House of Commons Lobby [an Order Book has an entry for Jul. 1857 in respect of St Stephen's Hall that reads: 2 lights for the adaption of the glass taken from House of Commons Lobby with the addition of new glass for the upper row of lights].'

Literature. *Art Journal*, N.S. 5, 1859, pp. 79-80. *The Builder*, 1, 1843, p. 241: details of Royal Commission's competition for stained glass; 5, 1847, p. 183: illustration of Lords' Chamber; 5, 1847, pp. 189, 303: illustration of the Victoria Lobby/ Prince's Chamber; 8, 1850, p. 6: illustration of Commons' Chamber before alteration; 9, 1851, pp. 461, 611: illustration of Commons Chamber after alteration; 10, 1852, p.129; 48, 1885, p. 265. M.H. Port, (J. Christian, 'Stained Glass'), 1976, pp. 245-57. P. Feeney, 'The Heraldic Glass in the Houses of Parliament', *Journal of the British Society of Master Glass Painters*, 12:2 (1956-7), pp. 142-7, includes an illustration of lights from windows in St Stephen's Hall. Wedgwood (Pugin's Diary): Pugin visits New Palace, 1847, Jun. 18; 1848, Jan. 10; 1849, May 9: 'finished all the cartoons for the House of Lords'; 1851, Aug. 28, Nov. 21: in note 36, p. 90, Wedgwood points out that Pugin rarely mentions in his diaries meetings with Barry in London or visits to the site at Westminster.

65 Woolwich, St Peter (RC)

1850. Client: George Myers, Ordnance Wharf, Belvedere Road, Lambeth, London.

N aisle E window nII 1.7m x 2.8 3-light £50

Description. nII. 3-light window and tracery. The Virgin and Child under a canopy are depicted in the centre light. The Virgin is in a green-lined, blue, hooded-mantle over a purple robe, standing in front of a red diaper screen trampling a red serpent underfoot. She cradles in her left arm the Child, who is in a green mantle over a yellow robe, holding an

orb in his left hand. The canopy has a trefoil head surmounted by a yellow-crocketed and finialed gable. From behind the gable rises a superstructure in the form of a red Gothic window, over which is a yellow-crocketed and finialed gable. The side lights each contain two, three quarter-length, censer-swinging angels enclosed in blue diaper quatrefoils. The remaining areas are filled with a diaper made up of white leaves outlined in black attached to curving yellow silver stain stems against a black-hatched ground (much of the hatching has worn away), overlain by a vertical series of red-outlined quatrefoils which are over-and-underlapped by blue diagonals – the quatrefoils containing the angels form part of the design. The borders are patterned with white leaves on yellow stems against red and blue grounds. The tracery-pieces consist mainly of three quatrefoils filled with geometrical leaf patterns on white grisaille grounds.

Office records. Order Book, 1850, f. 55, Jul. 19, re client, Rev. Cornelius Coles: 'charge to Mr. George Myers.' *First Glass Day Book*, 1850, f. 96, Aug. 23 (nII). *Cartoon costs per ledger summary*: Powell £3.5.0, Hendren £1.0.0.

Letters. JHA: C. Coles to J. Hardman, 1850, Jun. 10: complains of delay in receiving window for the Lady Chapel: 'Mr. Pugin, some weeks ago told me that the window would be ready by the time the Chapel would be ready for it. The Chapel is now finished & the window filled with plain glass, until the other glass is ready.' Jun. 13: 'I am exceedingly sorry to find by your letter, that my window is not yet commenced. I understood from Mr. Pugin on the 18th of April that the window would be ready by the time the Chapel was ready.'

Literature. London & Dublin Orthodox Journal, 16, 1843, pp. 34-6, includes a description of the church; pp. 328-30, describes opening ceremony and the church interior. Neither report mentions stained glass. Wedgwood (Pugin's Diary): Pugin visits Woolwich, 1842, Apr. 25, May 5, Aug. 12, Sep. 22-9, Dec. 26; 1844, Jan. 29.

GREATER MANCHESTER

66 Broughton, St John the Evangelist (CoE)

1847-9. Client: Rev. T.V. Bayne.

Chancel E window (**10.10a**)	I	3.3m x 5.0m	5-light	£210	1847
Chancel N & S windows	nIV, sIV	1.2m x 2.8m	2-light	£80 each	1848
Chancel S window	sIII	1.2m x 2.1m	2-light	£35	1848
Chancel N & S windows (**8.1**)	nII, sII	1.2m x 2.1m	2-light	£70 each	1848
Chancel N window	nIII	1.2m x 2.1m	2-light	£35	1849

Descriptions. **I.** 5-light window and tracery depicting, in blue foliage diaper medallions, Christ, St John the Baptist and the twelve Apostles. In the centre light, Christ in a green-lined, white mantle over a brown robe stands against a purple diaper screen holding a crossed-staff in his left hand. In the other four lights, arranged in three rows across the window, are the half-length figures of St John the Baptist – in front of a red diaper screen with a looping text above his head – and the Apostles – each in front of a white diaper screen with a crown above his head. From left to right they are: top row – St Andrew in a yellow-lined, red mantle over a blue robe, holding a small green-patterned diagonal cross in his left hand; St Peter in a green-lined, brown mantle over a blue-lined, red robe, holding the keys – top one blue, bottom yellow – in his right hand and a book in his left; St John the Baptist in a green-lined, white mantle over a brown robe holding a yellow quatrefoil plaque on which is depicted the Lamb of God in front of a crossed-banner, in his left hand; St Paul – in a blue-lined, red mantle, holding an upright sword in his right hand and a book in his left; St James the Great – in a white-lined, green mantle over a red robe, holding a staff with a flask attached, in his left hand and a book in his right. Middle row – St Matthew in a red-lined, white mantle patterned with yellow silver stain over a green robe, holding a quill in his right hand and a book in his left; St John the Evangelist in a blue-lined, green mantle over a red robe, holding a yellow chalice from which a green demon is emerging, in his right hand, and a book on which is perched an eagle, in his left; St Philip in a green-lined, purple mantle over a blue robe, holding a crossed-staff in his left hand; St Bartholomew in a green-lined, white mantle patterned with yellow silver stain over a red robe holding a flaying knife in his right hand. Bottom Row – St Simon in a green-lined, red mantle over a blue robe, holding a saw in his left hand; St Thomas in a green-lined, white mantle, patterned with yellow silver stain, over a blue robe, holding a lance in his right hand; St James the Less in a green-lined, white overmantle over a blue robe, holding an upright club in his left hand; St Jude in a red mantle over a yellow-lined, blue robe, holding a halberd upright in his left hand. The tracery-pieces are filled mainly with leaves and grapes on stems against blue grounds. The quatrefoil at the top contains a blue roundel enclosing the image of the Agnus Dei surrounded by four red roundels.

nIV. 2-light window and tracery depicting *Noli Me Tangere*. St Mary Magdalene in a blue-lined, red mantle over an orange-coloured gown, holding an ointment jar in her right hand, kneels under a canopy in the left-hand light. Christ in

a red-lined, white mantle patterned with yellow silver stain over a red robe holding a crossed-staff in his left hand, stands under a canopy in the right. The canopies have cinquefoil heads surmounted by yellow-crocketed and finialed gables behind and above which rise superstructures in the form of crocketed, finialed and gabled towers. The three tracery-pieces are filled with red rosettes and geometrical patterns on white diaper grounds.

sIV. 2-light window and tracery. Similar to nIV but the stained glass is no longer in place. The scene depicted was the Raising of Jairus's Daughter.

sIII. 2-light window and tracery. Each light contains three red foliage diaper medallions in each of which, set against a blue diaper roundel, is a half-length angel holding a text. The remaining areas of the lights are made up of quarries patterned with white leaves outlined in black on yellow silver stain stems,, against black cross-hatched grounds – except for the four quarries placed centrally between the medallions, which contain roundels with monograms in red-on-black which appear to read TSM. The borders are patterned with red and green leaves and orange flowers. The tracery-pieces are filled with red rosettes and geometrical leaf patterns on white diaper grounds.

nII, sII. 2-light windows and tracery. Each window contains a scene (nII, Annunciation; sII, Adoration of the Magi) depicted against a white diaper screen patterned with yellow silver stain flowers and under a canopy. The canopies have cinquefoil heads surmounted by yellow-crocketed and finialed gables. Each gable is flanked by a pair of half-length angels. In the Annunciation, the Archangel Gabriel in a green-lined red mantle over a yellow silver stain-patterned white robe, holding a sceptre in his left hand stands in profile in the left-hand light, and the Virgin Mary in a green-lined, blue mantle over a red robe, holding a book in her left hand, sits in the right. In the Adoration the three kings are in the left-hand light and the Virgin and Child in the right. One king kneels in profile in the foreground, with his right arm outstretched as he offers a gift to the Child, the other two stand in the background, looking at the Holy Figures, while holding white, yellow-conical-topped jars. The kneeling king is in a yellow silver stain-patterned white mantle over an orange robe and the others in a yellow mantle over a red robe and a green mantle over a purple robe, respectively. The Virgin is crowned and wears a green-lined, blue mantle edged in white over a reddish-brown robe while the yellow-robed Child stands in profile on the Virgin's lap with his left hand raised in blessing and his right extended towards the kneeling king. The main tracery-pieces are filled with red and white leaf patterns on blue grounds.

nIII. 2-light window and tracery. St Michael and St Gabriel, each standing under a canopy, were originally depicted in the left and right-hand lights respectively. All that remains of the stained glass is the head and part of the torso of St Michael, the patterned bottom panel of each light and the tracery. St Michael is in a red-lined blue mantle over a white robe holding a yellow-crossed lance in his right hand which he is plunging into a dragon, part of whose green tail is still in situ at the bottom of the left-hand side light. The head of the canopy is a yellow-crocketed and finialed ogee arch. The borders are patterned with white leaves on red grounds. The four tracery-pieces are filled with geometrical leaf patterns on white diaper grounds.

Office records. Order Book, undated, f. 5 (I, nIV, sIV, sIII), (re I) 'Cartoons £30, Our Lord & the 12 Apostles. To be dark & rich'; (re nIII, nIV) 'Cartoons £30 in total of £120 for windows'; diagram of the layout of the side windows is entered, identifying the windows by subject matter; sII is shown as Salutation crossed out and replaced by Adoration, the rest confirm the arrangement now in place; f. 4 (nII, sII, nIII). *First Glass Day Book*, 1846, f. 7, Sep. 29: (tracery I) 'A Small 3 Light Window £6.10.0/consisting of./ 3 Lights &/4 Small Tracery pieces', see letter Bayne to Hardman, 1846, Aug. 13; 1847, f. 12, Jan. 6: '24 Tracery pieces for/Side Windows £3.11.0', f. 13, Mar. 19: '2 New Centres to Tracery/pieces in place of Shields returned', f. 20, Nov. 22 (I); f. 24, Dec. 24 (fixing I); 1848, f. 30, Apr. 22, (nIV, sIV, sIII), f. 39, Aug. 8 (nII, sII); 1849, f. 64, Jul. 25 (nIII). *Pugin sketch*, BM & AG a. no.2007-2728.2, of a detail of I (**10.10b**). *Cartoon costs per ledger summary*: nIII, Powell £1.10.0, Hendren £1.0.0.

Letters. HLRO 304: Pugin to Hardman, letter no. 867: 'I have sent off by this post – a lot of work 1st [re St Cuthbert's College, Ushaw Gaz.40] 2nd the tracery for the sedelia [sic] window Broughton Manchester the remaining part of this window you will have this week.' No. 17: 'as regards the Warrington window [should be Broughton – see Bayne's letter below concerning the mix-up between the two churches] I think it on the whole a very fine job but I have made an infernal mistake & I cant think how you <u>let me do it</u> or let it go without remark in the canopies using[?] our blue 6 on a <u>blue ground</u> had they been[?] yellow 1 the whole thing would have been changed & nothing would have been said about the beards but it is all blue together.' No. 881: ' I am trying hard to get you off the sedelia window for Broughton.' No. 871: 'I send you the angels for the sedelia window Broughton Manchester.' *JHA: Bayne to Hardman*, 1846, Jun. 18: 'The Templets [sic] which you have sent me are for the Warrington [Gaz.17] East window – <u>My</u> East window is for Broughton.' Aug. 13: 'Now for the windows of my Chancel – you have the East W in hand. I wrote to Mr Pugin the other day requesting him to supply you with the Cartoons for a side window, it is to be a memorial – the subject Our blessed Lord raising the Daughter of Jairus by today's post I am giving instructions for two others, the subjects to be the

<u>Annunciation</u> & <u>Salutation</u> – for the three remaining windows I have not yet the money but have requested Mr. Pugin to give you the cartoons for the <u>tracery</u> the remainder will I hope be provided for by the time my present order is out of your hands. I should be glad of my little 3 light window with figured quarries as soon as you can let me have it – when will that be?' 1847, Nov. 26: 'The glass arrived and has been unpacked & I am glad to say has sustained no injury – Not a single light is yet fixed, so that I cannot speak of the effect. The glazier commenced with the centre and found the glass 1½ inch too long, they tell me they have been cutting away the stonework at the bottom but since it will look awkward for the border not to be even. I don't know what must be done … [worries about the donors withdrawing if the six side windows are not completed in accordance with a programme he set out for Feb. and April 1848] It is very mortifying to think I might have had seven windows, if I had not interfered with the donors who were perfectly willing to have given their own orders to Willement O'Connor & c but out of courtesy left it all to me because I wished the chancel to be an entire specimen of your work'. Undated: Complains of the incompatibility of the tracery with the figures: 'the former at a little distance looks just as if it were covered with black crepe, it wants brilliancy, the blue looks like ink compared with that below. The tracery in the sedilia would have just suited. The tone is the same whereas that in the East window appears in contrast.' 1848, Apr. 8: suggests legends in English for: Raising of Jairus's daughter: 'in the (Give place) the maid is not dead but sleepeth – (omit that in brackets if not room); for Our Lord [?] I ascend into my Father and your Father (and to my God and your God)'; For the Angels – S. Michael S. Gabriel, but if the space requires more: 'Michael & His Angels fought with the Dragon I am Gabriel that stand in the presence of God'. *Bayne to Pugin*, Apr. 19, and a similar letter dated Wed 7 to Hardman: 'Mr. Hardman has sent three of my windows and they are just put in viz. Raising D of Jairus [sIV] – Our Ld & S. Mary M [nIV] – & the Angels [sIII] – I am charmed with their exquisite beauty, they surpass anything that I have seen and call forth universal admiration and now with regard to the unfortunate E. window I know you believe that there is witchcraft employed against it. I am tired to death by people of taste and no taste alike, about the <u>blue beards</u>, and especially by one of the chief contributors – can these be altered? I quote your great name, and declare that it is in accordance with the best old examples, but all wont do & the more approved style of the three last windows has caused more to be said in disparagement of the Apostles. Mr. Hardman will next take in hand <u>The Annunciation</u> & what you have substituted for the <u>Salutation</u>, of which I had heard nothing till the other day [substituted by the Adoration of Magi: see Order Book above]. Let me have as much ruby as is consistent in these'. May 30: 'Go on with the Annunciation' [requests an inscription, if possible in the glass]'. Aug. 12: 'I am much pleased with the Annunciation I think it very rich and beautiful. I saw the cartoon of the Magi, there appeared to me a little awkwardness in the drawing of the figure making the offering & ask[?] that would not appear in the glass; but I name it that your attention may be called to the subject.' Aug. 26: 'The glass has safely arrived, one window is in, the other almost fixed – nothing can be more beautiful; they are quite the gem of the Chancel and elicit the strongest expression of admiration.' *Powell to Hardman*, postmark 'SP8 1847': 'I am at work at Broughton hard it is a very fine job for me and I improve very fast. I do believe in a little time I should be able to turn out very good figures but you will see these soon. They will be all complete and ready for the colours next Tuesday. I have finished St. John Bap' he was drawn first as you were likely to want it.' Postmark 'OC 1': '… more Broughton figures on Wednesday.' *I. Bishop to Hardman*, undated, 1847 box: 'he [Bayne] is much pleased with the window and says it will get many orders but says the Blue in Tracers [sic] is to [sic] dark it is 5 [sic] blue. Mr. Pugin has sent a letter to say they can be altered. I told Mr. Bayne not without taking out he thought that would be to [sic] much Troble [sic].'

Literature. The Ecclesiologist, 9, 1848, p. 136: a brief description of the church, in which the E window is erroneously described as a Jesse. Wedgwood (Pugin's Diary): Pugin visits Manchester, see Gaz. 67 below.

67 Hulme, St Wilfrid (RC)

The church, designed by Pugin, was opened in 1842. In 1845, after being closed for some time for re-decoration, the chancel was reopened, and a paragraph in *The Builder*, taken from a local paper, gave a detailed description of what it described as, for its extent, 'the richest specimen of polychromatic painting in England'. It attributed the design to 'Mr. Welby Pugin'. It also said: 'The eastern end is adorned with four windows of stained glass and the south side with one, all executed by Mr. Wailes of Newcastle-upon-Tyne'. Possibly these windows were also designed by Pugin (see diary for 1845 below). There is no record in the First Glass Day Book of any window for St Wilfrid's having been executed by Hardman, but the letter from L. Toole below, suggests that some designs were produced.

Letter. JHA: L. Toole (St Wilfrid's, Manchester) to Hardman, 1850, May 16: 'I return the sketch of the window – seeing the handwriting at the foot, it is presumptuous to find any fault – yet I should like some <u>subject</u> in the medallion of the Centre or elsewhere if it be not decidedly wrong. I might also mention to you that as these windows will be all on the

south side of the Church on which side we have a quantity of Land they will not be liable to be broken and we may consequently dispense with wire guards.'

Literature. *True Tablet*, nos 28 & 121, Sep. 3, 1842, pp. 453, 581; description of the opening of the church, but no mention of its design or decoration. *The Tablet*, 6, 1845, p. 422: re-opening of the chancel. *The Builder*, 3, 1845, p. 356: re-opening of the chancel and description of it. Wedgwood (Pugin's Diary): Pugin visits Manchester, 1837, Mar. 29-30, Apr. 4, Aug. 25-6; 1838, Apr. 22, Sep. 20-22, Nov. 12-14, 16; 1839, Apr. 2-3; 1840, Nov. 1; 1841, May 6, 7, 22, Jul. 2, Oct. 9; 1842, Mar. 9, May 12; 1843 no diary; 1845, Mar. 31; p. 61 '[endpapers at back of diary] [b], [e], and [f]', refer to lists of commissions, prices, small orders and work done by Wailes: reference to the original diary showed the lists included; 'for Wailes, Manchester 68 and 6.00'; and 'Manchester 2nd [no amount included]'; 1846 no diary; 1847, Sep. 13-14; 1848, May 4-5; 1849, Nov. 28.

68 Lever Bridge, St Stephen & All Martyrs (CoE)

1850. Client: John P. Fletcher, The Hollins, Bolton-le-Moors.

| Nave N wall window | nVII | 0.9m x 2.3m | 2-light | £18 |

The tracery work, seemingly, is by Thomas Willement (see letter, Fletcher to Hardman 1849, Nov 6, below).

Description. nVII. 2-light window and tracery. Each light contains a scene under a canopy; that depicted in the left-hand light being the election of St Matthias and in the right, the martyrdom of St Matthias. The canopies have trefoil-heads surmounted by yellow-crocketed and finialed gables. Rising behind and above each gable is a red diaper superstructure in the form of a section through a nave and aisles church. The nave resembles a multi-light Gothic window surmounted by a yellow-crocketed and finialed gable; the sloping roofs of the aisles are lined with yellow crockets. Below the scenes is a yellow-on-black inscription which reads: 'IN MEMORY OF FRANCES MARY WIFE/OF JAMES P. FLETCHER 1849'.

Office records. *Order Book*, 1849, f. 64, Nov. 12, adds to inscription 'Blessed are those servants, whom the Lord when he cometh shall find watching'. 'Lettering in inscription to be plain as pattern sent. Window not to be dark & heavy'. *First Glass Day Book*, 1850, f. 85, Mar. 26, f. 87, Apr. 25: '2 Glass Inscriptions for /Window sent March 26/50'. *Cartoon costs per ledger summary*: Powell 10s.0d, Oliphant £2.7.0. Oliphant's account records that the payment was in respect of '2 Groups S. Mathias [sic] @ 23/6'.

Letters. HLRO 304: *Pugin to Hardman*, letter no. 226: 'I have not got the groups from Oliphant for Lever Bridge but I will write to him.' *JHA: Fletcher to Hardman*, 1849, Nov. 6: Requests a memorial window for not more than £20: 'the tracery being already filled with Stained Glass by Willement in a simple manner viz blue ground a yellow palm Branch & a scroll bearing the legend of St. Matthias beheaded in bold blak [sic] letters about 1½ ins deep'. 1850, Apr. 15: 'we [John Fletcher and his brother] are much pleased with it, the subjects are well managed & the colouring is rich with however this defect, the too frequent one I think in modern glass – that in the upper part it is in too large masses; had the ruby & blue glass been in smaller pieces & relieved by white or light coloured glass, a more sparkling & agreeable effect wd. have been produced ... [points out that the brass is inharmonious with the objects around it and regrets the inscription was not on the window: this was rectified later]. Is there any other mode of protecting glass than by wirework? In this case it is so apparent through the figures as to produce rather a damaging effect.' Oct. 30: 'I have waited from day to day with some impatience for the completion of the fresh inscription which my brother desired you to execute in legible letters on Glass to be inserted in the window in place of the Brass Plate which you first sent contrary to distinct order, and afterwards of the the [sic] illegible glass which my brother objected to. It has not appeared to be deemed necessary on your part either to reply to my brothers request by refusing to do it – or by promising to execute it, and the object of my present note is to be you to acquaint me with your intentions.'

69 Salford, St Stephen (CoE)

1849. Client: Rev. J.G. Booth.

The E window was destroyed by Second World War bombing and the church was demolished in 1959. The file on St Stephen's in the Manchester diocesan records contains a faculty dated Nov. 16, 1947 for the E window which refers to the previous one having been destroyed by enemy action. There is also a letter, Jul. 6, 1959, from Dunlop Heywood & Co., chartered surveyors, 90 Deansgate, Manchester 3 to L.H. Orford of Orford, Cunliffe, Grey & Co, solicitors, 56 Brown St, Manchester, stating: 'As you are aware we are proceeding with the demolition of this Church under the provision of an Order in Council'. A rough sketch in the JHA 1848 letters, shows the window was round-headed and in the centre of an apse containing two others about half the size.

Office records. Order Book, undated, f. 43. *First Glass Day Book*, 1849, f. 54, Mar. 20: 'A Large window set in/non painted geometrical/ frame/ of 3 Lights with Figures & c/£100/& Tracery of Quarries & c & c./12ft. 2 In x 5 feet wide/ Window £90/Frame£10'; 1850, f. 88, Apr. 25: '2 Ruby Quarries/2 pieces of Blue Glass dotted/for East Window sent/ Mar 20 1849 fo:54/having been broken in window'. *Cartoon costs per ledger summary*: Powell £2.10.0, Hendren £1.0.4. *Letters. HLRO 304: Pugin to Hardman*, letter no. 1016: 'What do you mean about the templates of the window at Salford. What window is that.' No. 1027: 'The Salford window shall be got in hand directly.' No. 1025: 'The Salford window is in hand you will have the cartoons before Xmas so you can fix the time.' No. 988: 'I think you better use white glass for the heads at Salford.' No. 1030: 'I have made a fine job of the Salford window ... There must be an iron frame for the Salford window – like the one at Cambridge [Jesus College chapel, Gaz.9].' No. 1027: '4 you are the best judge about the iron frame for Salford. I should think it would come in for the window is not a very large job.' *JHA: copy letter, Hardman to Booth,* 1848, Sep. 30: 'I at length enclose a rough sketch of Mr. Pugins as he proposes to execute your centre window. I saw him on tuesday previous to his return home[?] from his long journey & gave him your letter with the memorandum of the window as you thought it ought to be done. Mr. Pugin seemed to think it would destroy the unity of the design to introduce so many subjects and none of them would be well carried out he has therefore drawn the enclosed & has taken the arrangement from a fine window in Troyes Cathedral. If it meets your approval please let me have templates or exact measurements of the window so that we may proceed with the Cartoons. If you will say when you want the window to be finished I will try to get it done so as to meet your wishes.' *Booth to Hardman,* 1849, Apr. 9: 'we have got the window up and for the first time it was exposed to view yesterday ... it gives the highest satisfaction ... the general effect produced by it to the whole church is greater than I had expected. I believe it not unlikely that I shall soon have to transmit you directions for one at least of the smaller windows ... If you should chance to see Mr. Pugin I should be glad if you would ask him whether he thinks such subject as the raising of Jairus's daughter would suit one of the small side windows, it being put in in memory of a young female Teacher connected with our Schools.' *Literature.* Wedgwood (Pugin' Diary): Pugin visits Manchester, see Gaz.67.

70 Whalley Range, St Margaret (CoE)

1848, 1850. Client: William Cunliffe Brooks, Barlow Hall, Manchester.
The stained glass currently in the three-light chancel window is of modern design depicting the Crucifixion, while the two-light tower window is filled with plain glass.

Office records. Order Book, 1848, f. 34, Aug. 28, re tower window: 'Texts to be put below 1. whoever drinketh of the water that I shall give him shall never thirst. 2. This is indeed the Christ the Saviour of the World. The Tracery to be filled with Lilies, Mr Brook to see cartoons before windows are commenced.'. *First Glass Day Book*, 1848, f. 49, Dec. 19: 'A window of Stained Glass/for Tower Window of/St. Margaret.../ (1) £45/ of 2 Lights of Figure &c &c/6'9" x 1'10"/ 3 pieces of Travery with Figures/.../.../... above subject, our Lord &/the woman of Samaria. An East Window of Stained/ glass for St. Margarets.../... of/1 Light of Figures &c/ 8'2" x 2'1"/2 Lights of do.do/7'9" x 2'1"/24 pieces of tracery for do/.../.../... above subject Crucifixion/£105'. *Cartoon costs per ledger summary*: tower, Powell £1.0.0, Hendren 16s.8d, Oliphant £4.5.0; chancel, Powell £2.0.0, Hendren £1.0.0, Oliphant £7.10.0. Oliphant's account records that the payments were in respect of: 'October 16 2 Cartoons, Our Lord & Woman of Samaria @ 42/6 £4.5.0. November 4: 7 cartoons of Crucifixion @ 21/6 7.10.0.[sic].' *Pugin sketch*, BM & AG a.no. not allocated, detail of I. *Letters. HLRO 304: Pugin to Hardman*, letter no. 288 re tower window: 'I cannot tell you how disturbed I am about that window of Mr. Brooks the subject is so bad for a decorated window it would do for later glass but the window is [?] decorated cannot you get him to change it for 2 saints? I sent you his letter about it.' No. 169: 'The following cartoons will go off tonight ... The canopy work of Mr. Brook's window Our Lord & the woman at the Well.' *JHA: Brooks to Hardman,* 1848, Aug. 3: 'The design is not what I could do with. These three admirable openings in the tracery deserve something better than kaleidoscope. I should like to see a pot of Lillies [sic] in the higher and a rose rayonne in each of the lower openings or Lillies in all three ... Let the subject be Our Lord talking with the woman of Samaria. I shall see no objection to the interference of the mullion – so Mr. Pugin may, as he pleases, arrange either Our Lord in one light and the woman of Samaria & the well in the other, or Our Lord and the woman in one light and the approaching disciples in the other.' Aug. 25: 'Enclosed is Mr. Pugin's sketch of tower window – I think it will do. Can I have an opportunity of expressing my opinion when cartoons are made before your work begins? Do not place angels in the tracery I should also like to see those cartoons ... I cant like the style of work at foot of the lights – Could these texts be there respectively placed. 1. "Whosoever drinketh of the water I shall give him shall never thirst" 2. "This is indeed the Christ, the Saviour of the world."' Aug. 25: 'Enclosed is tracing of the East Window [the tracing is still with the letter in

the archive]. I decide that the subject shall be the Crucifixion (I should like to see the sketch).' Undated: sends templates of the chancel E window and requests to see cartoons for the tower window. Undated: 'Please to note that in Chancel three light window of Saint Margarets Church the light marked six feet ought to be seven feet.' Undated: 'I should like to see this & the other window to be now completed as rapidly as good work will allow.' Oct. 27: 'I return the cartoons – but I must have an alteration in the attitude of Our Lord. There is no direction in the face – it should be either <u>profile</u> towards the woman or full towards the spectator. On the whole I prefer that it should be <u>full</u> thus by a pardonable licence making the spectator feel the words (I hope you are Leaving room for them in both lights) which was addressed to the woman. I like the detail greatly but am anxious to see the cartoons of the 3 openings in the head.' *I. Bishop to Hardman,* 1848, Dec. 23: 'have got most of the East window in its Place it looks verry [sic] well Mr. Brooks Esqr likes it very much I expect we shall finish on Friday night, if the Blue Ground had been rather darker it would of [sic] looked much better I think; They speak very highly of the Crucifistion [sic]'

71 Wigan, St John (CoE)
1852. Window designed by J.H. Powell.

Office records. Order Book, 1852, undated, f. 176. *First Glass Day Book,* 1852, f. 161, Nov. 9: 'To A Stained Glass Window/ for East Window of 3 lights/being A Mortuary window/3 lights 6'8" x 1'6½"/Subject suggested in letter from client: S. Raphael (centre light); St. Peter & St. Margaret (side lights) with kneeling male & female figure under the respective saints and the arms of the family under S. Raphael, f. 165, Dec. 20: 'For Ladye chapel/To A Window of Stained/Glass of 3 lights/3 lights/6'8" x 1'6½.../Subject In Centre light The B.Virgin/In side lights..Aaron with/budding rod & the stone cut from the mountain without hands in the Vision of Daniel'.

72 Worsley, St Mark (CoE)
1851. Client: the Rt. Hon. Lady Ellesmere, Worsley Hall, near Manchester.

Office records. Order Book, 1850, f. 123, Nov. 28. *First Glass Day Book,* 1851, f. 119, Jul. 12: 'An East Window of Stained/ Glass of 19 pieces of/Tracery//£35/A smaller East Window of Stained Glass of 11 pieces/of Tracery .../£10.'
Letters. JHA: John Tait to C. Barry, 1850 (in 1851 box): Nov. 20: 'I beg to forward you templets [sic] for the head of the communion window of St. Marks Church Worsley which I hope will convey all the information you require.' *Barry to Hardman,* 1851, Jul. 7: 'You may send your man to fix the Glass at Worsley Church as soon as possible.' *Lady Ellesmere to Hardman,* 1851 box, undated: 'The Window in Worsley church is completed & I am sorry to say unsuccessful. The execution is pretty <u>in itself</u> but wholly unsuited & the rest unendearing[?]. It has the effect of a gown[?] of which the skirt is crimson & the body pink. Now the question is can anything be done to improve it who is the executor of it? Did he ever see the window? I should be inclined to have him down to look at it; but before determining upon this I should like to know his name and address.'
Literature. Wedgwood (Pugin's Diary): Pugin visits Manchester, see Gaz.67.

HALTON, Appleton, St Bede, see CHESHIRE
HAMPSHIRE, East Woodhay, St Martin, see BERKSHIRE

HEREFORDSHIRE
73 Belmont Chapel[23]
1853. Window designed by J.H. Powell.

Office records. Order Book 3, 1852, f. 22, Dec. 28. *First Glass Day Book,* 1853, f.172, Jan. 29: 'For Private Chapel/To 5 lights of Glass/plain centres & stained Borders/5 Lights 6'2" x 1'8½"'; f. 187, Jul. 15: 'For East Window of Chapel/To A Stained Glass/Window of, 2 lights & Tracery./2 lights 6'5" x 1'6½" Figures of St. Peter & St. Paul'.

74 Clehonger, All Saints (CoE)
1850. Client: F.R. Wegg Prosser, M.P., Belmont, Hereford. Supervising architect: William Butterfield.

Chancel E window (**10.11**)	I	1.9m x 3.4m	3-light	£75

Description. **I.** 3-light window and tracery. Christ in Majesty under a canopy is depicted in the centre light and two

standing figures, one above the other in medallions, in each of the side lights. Christ, in a green-lined mantle over an orange robe sits, enclosed in a red mandorla edged with blue stylised clouds, holding a book in his left hand, the pages at which it is opened are inscribed with the letters Alpha and Omega. Two angels stand above and at either side of his head and another two beneath his feet. From left to right, the top two standing figures in the side lights are; the Virgin Mary in a green-lined, blue mantle over a purple robe, holding some lilies in her right hand and a book in her left; and St Catherine in a royal blue-lined, blue mantle over a green-sleeved, red robe, holding a small yellow wheel in her left-hand; and the bottom two: St Thomas of Hereford(?) in a yellow mitre, green-lined red mantle over a blue robe, holding a crozier in his left hand and St Francis of Assisi in a purple-lined, yellow mantle over a green-lined, blue-grey habit, with yellow rays of light issuing from the stigmata in his hands, feet and the right side of his chest. The trefoil head of the canopy in the centre light is surmounted by a yellow-crocketed and finialed gable, behind and above which rises a superstructure comprised of a line of three yellow-crocketed finialed, white-gabled Gothic windows – the centre window is green and the flanking smaller two, purple. Two angels holding a crown between them, hover in downward flight over the finial of the centre gable of the superstructure. The edges of the medallions containing the saints are patterned with white leaves on vertical stems against red grounds. The backgrounds to the female saints are made up of alternating, horizontal, broad black-patterned red bands and narrow, black-patterned green bands, while for the male saints the colours of the bands are royal blue and purple, respectively. The borders are formed by the edges of the medallions. The tracery comprises two small triangular pieces that flank the centre light. A plaque on the chancel S wall is inscribed: 'The East window of this church was restored in 1964 in memory of Alice Maud Davies of Gosmere Farm, Clehonger who for 48 years gave faithful service as organist of this Church.'

Office records. *Order Book*, 1850, f. 93, Jul. 13. *First Glass Day Book*, 1850, f. 99, Oct. 12. *Cartoon costs per ledger summary*: Powell £4.15.0, Hendren £1.10.0.

Letters. *HLRO 304: Pugin to Hardman*, letter no. 737: 'I have just got a letter from Butterfield in which he says you tell him that you have never had the cartoons for Cleonger [sic] now you had <u>them weeks ago</u> they are with the majesty & 4 Saints'. No. 778: '1. Mr. Wegg Prossers window for Cleonger [sic] was among the Last Lot of cartoons sent to you 4 saints in side lights & the majesty in centre so you can write to say you are working at it'. *JHA: Butterfield to Hardman*, 1850, Oct. 2: 'Mr Wegg Prosser is very anxious about his East window & has been asking about it today. Will you write to him'. *Prosser to Hardman*, 1850: Aug. 6: 'Will you have the kindness to inform me when you will be enabled to send me the glass for a window in Clehonger Church, the designs for which I believe you received about a month ago'. Oct. 11: 'I am glad to hear the window is done ' 1852, May 10: 'I send you a cheque for £75.11.6 ... I take this opportunity of saying that, although there is nothing in the window deserving any particular complaint, yet it does not as a whole (especially as regards the face & figure of Our Lord) come up to what one might have expected: there are of course some very good points about it.'

75 Hereford Cathedral (CoE)

1850. Client: N.J. Cottingham, 43 Waterloo Bridge Road, London, who was also the supervising architect.

Only the stained glass for the centre lancet of a triple lancet window placed high up at the E end of the chancel, made by Hardman's to Pugin's designs in 1850, was in place prior to Pugin being too ill in February 1852 to carry on working for the firm (**3.9a & b**). It would appear that cartoons had been prepared by Pugin for the side lancets (see Letters below) but there is no record in the First Glass Day Book up to the end of 1853 of the glass ever being made. The window was replaced in 1871 by that currently in situ which was also made by Hardman's.

Canon Paul Iles in, Aylmer and Tiller, 1999, quotes Bell's guide to the cathedral (1898) as to the subject matter of the 1850 lancet, which, contained in circular medallions three feet in diameter was: the Ascension, the Resurrection; and the Crucifixion; and in semicircular medallions: the Descent from the Cross; the Harrowing of Hell; *Noli Me Tangere*; and the Incredulity of St Thomas. He points out that stained glass with these features has been located in the clerestory windows in the E wall of the S transept of the cathedral (not distinguishable from the nave) and also refers to an 1872 minute in the Chapter acts which granted permission for some of the glass to be used by Canon Musgrave in his Residence House. The Hardman archive contains two letters in respect of the 1850 glass; on 6 Jan. 1871, Underwood & Knight acting for the Dean and Chapter ask Hardman & Co., 'what about the present Windows – is any & what allowances to be made for them?' In reply Hardman's wrote: 'It was proposed when the first idea of the present window was mooted that the old glass should be altered to suit some of the other windows in the Cathedral we have therefore omitted it entirely from our calculations.'

The style of the work (compare with the window at Jesus College Chapel, Cambridge (Gaz.9), and that at Chichester Cathedral (Gaz.184)), apart from the subject matter, confirms that the glass is almost certainly that made by Pugin/

Hardman for the chancel E window. It has been rearranged in two lancets. One contains two of the circular medallions (those featuring the Ascension and the Resurrection) and is virtually the same width as the medallions (that is to say three feet). It has wide borders patterned with blue and white leaves and white *fleur-de-lis* on curving stems against red grounds over which the medallions extend, and there are two censer-swinging angels, who face away from each other, as they hover, almost horizontally, at the top of the lancet. A leaf-patterned red roundel comes between the medallions, and the remaining areas are filled with a red diamond trelliswork infilled with white flowers on blue grounds. The third circular medallion (the Crucifixion), is contained at the centre of the second somewhat wider lancet, which has the four semicircular medallions arranged along its sides – two above (the Harrowing of Hell on the left; and *Noli Me Tangere* on the right) and two below (the Descent from the Cross; and the Incredulity of St Thomas) the central circular medallion – and two outward-facing, censer-swinging angels kneeling in profile in its shoulders. A small roundel similar to that described for the first lancet is set between and below the angels, and a half-roundel is at the top and bottom of the central circular medallion which is set on a rectangular ground similar to that which fills the small roundels. A further half-roundel is at the bottom of the lancet and two white-outlined diamonds filled with leaf-and-stem patterns on red grounds come between each pair of semicircular medallions. The same diamond trelliswork as is contained in the first lancet fills the remaining areas. The scenes within the medallions are set against blue grounds.

The lancet that Pugin and Hardman worked with at the E end of the chancel was 7' 1" wide allowing plenty of room for the circular medallions to be contained within its borders (this is the arrangement that Pugin designed in his sketch for the window at Chichester Cathedral, although there, as the lancet was only 3' 9" wide, the circumferences of the medallions were drawn to touch tangentially the inner lines of the borders). The four semicircular medallions might well have been arranged above and below the central circular medallion – as in the clerestory window – but this would presumably have contained the Resurrection, as implied by Bell's guide which suggests the Ascension at the top, the Resurrection in the middle and the Crucifixion at the bottom. There would have been room for the roundels and the diamonds, between, above and below the circular medallions, and the censer-swinging angels could have been accommodated at the top of the lancet. Whether or not the trelliswork was part of the original window is open to question. It is true that Pugin filled the backgrounds of the windows at St Edward, Clifford (Gaz.188) with similar trelliswork but that was his first attempt in the style back in 1848. When he came to Jesus College, Cambridge (1850), and Chichester Cathedral (1852), he made the backgrounds entirely of leaf-and-stem-pattern-work, although in both cases, particularly at Cambridge where the lancets were only two feet two inches wide, the windows were narrower and not as tall. Possibly the glass used in Canon Musgrave's window/s was comprised of some of the borders and of the leaf-and-stem pattern infill which may have originally filled the background of the Hereford Cathedral chancel E window.[24]

Office records. *Order Book,* undated, f. 73: 'A window of stained glass of 3 Lights 1 large & 2 small. Est. large £170 & small £110. Centre light gone.'. *First Glass Day Book,* 1850, f. 107, Dec. 26: 'To a Stained Glass/Window for East end/ of Chancel of 1 Light/being Centre Light/£145/.../19'2" x 7'1"/.../A Wrought Iron Painted Frame for above/£25' 1851, f. 114, Mar. 14: fixing window. *Cartoon costs per ledger summary*: Powell £7.10.0, Oliphant £2.10.0.

Letters. *HLRO 304: Pugin to Hardman,* letter no. 926: ' I am very glad indeed to hear about Cottinghams windows they are the best chance we ever had we can do something to set ourselves up for ever – It is a good chance.' No. 820: 'I have made a first rate design for Cottinghams window It will look magnificent if it is carried out.' No. 898: 'I have put Powell hard at work at Cottinghams window it will be a splendid job as soon as he has outlined it I take it in hand for the colour & expect very soon to finish it.' No. 895: 'When I returned home to my great vexation I found that Powell had completely[?] forgot all about Mr Cottinghams window I had set out for him & told him particularly to get out the lines & subjects to an inch scale for me against my return & they have not even stained the paper. It is really too bad. It is carelessness & forgetfullness that goes beyond [?] is execrable[?]. I told him the importance of this window [?] [?] [?] & this is the result'. No. 690: 'I think we can send off the Hereford window tomorrow night.' No. 693: 'I was obliged to do the side lights for Hereford before I sent the centre or we should not have kept the proportions.' No. 827: 'I am finishing Cottingham's windows they will make a fine job.' No. 897: 'I suppose I better send the windows straight off to Mr. Cottingham to save time as I cannot possibly finish them before Friday.' No. 900: 'Cottinghams drawings went today by passenger train direct to him they are <u>splendid</u> you better write to him about them.' No. 904: 'I understand the meeting for Cottinghams window was on the 10th & if so it would be in time I could not do more I have done my best – the work is tremendous the drawings I have taken with a letter of what a set of cartoons would take if the window was not done you must charge for them.' No. 903: 'I have got a letter from Mr. Cottingham he seems very pleased with the drawing he talks of putting the windows into your hands in a few days.' No. 329: 'What a foolish letter that is of Cottinghams [probably that of Jan. 31, 1850] it is all travels[?] I should just tell him that you had seen[?] the way some <u>colours</u> [?] [?] that were used for the early glass that you have matched them most carefully that the composition &

arrangement of the colours are taken from first rate examples at Chartres & churches & more cannot be done – what a vile drawing he has kept the original that I sent it is a beastley imitation most unlovingly done I sent a very harmonious drawing – it will be dreadful if they put the centre light in first it will go for nothing with a white light on each side it would be better to give them a better credit[?] & get all 3 in at once it will be well to verify the dimensions we have of three windows to prevent the possibility of an error which would be dreadful. I hope you did not think that drawing that Cottingham sent us done by me. it is a vile copy.' No. 777:' I have been marking in the Hereford window today.' No. 686: 'we sent [?] back the cartoons of Jesus College to work the Hereford groups by.' *JHA: Cottingham to Hardman*, 1850, Jan. 21: 'I am at length able to give you directions to proceed with the windows for Hereford.' Jan. 31: 'I sent yesterday by your nephew the designs for triplet for E. end of Choir of Hereford Cathedral. I am directed by the Dean to request you will place in hand forthwith the <u>centre light</u> leaving the two side ones till that is fixed by which time, if not before, the subscription for them all will in all probability enable him to authorise their being also commenced. I sincerely trust you will do your utmost to make a <u>really</u> fine work of this … occupying also the most prominent position in the Cathedral I am naturally most anxious about its success. <u>Recollect</u> it can <u>never</u> be closely inspected, and must therefore be dependent wholly on what modern glass generally fails in – Effect at a distance. Blemishes of glass is always more apparent at a distance than near the eyes. I should wish you to keep as <u>blue</u> & <u>silvery white</u> a tone as possible in the general effect, avoiding the coarse <u>purple</u> ensemble so often occurring in the diaper grounds of modern glass of this style – as for example that in the Temple Church, (good as it was for the time it was done). But little yellow and rarely any of that salmon tint which Wailes and others are so fond of ever occurs in Early glass, but a vast deal of a fine <u>silvery opaque white</u> and a <u>scarlet</u> flashed ruby. The windows, particularly the last one placed in Ely Cathedral by my friend the late Mr. Gerente were the nearest approach to the true feeling of the old <u>work of this period</u> that I have yet seen & I should much like you to give them a careful examination before commencing these for Hereford … The contrast with those by Wailes in the same building is immense the one all feeling the other the most packaged forms of 'popular Early English Glass' which is in other terms 'all wrong'. Mar. 11: 'It is not improbable that the Revd. H. Huntingford one of the Canons of the Cathedral who takes an interest in these windows & is indeed the principal subscriber may pay you a visit to see [?] – should he do so pray do not lose the opportunity of urging how essential it is to have the side lights proceeded with. He is almost the only one likely to give them.' Jul. 4: 'I am very anxious to know when the centre light for Hereford is to be fixed.' 1851, Feb. 17: 'I am sorry I am unable to give permission for the window you are doing for Hereford Cathedral to be exhibited at the Building in Hyde Park as the Committee are desirous that owing to the time it has been in hand it may be placed in the Cathedral without delay.' Feb. 26: 'I have this day written to my Clerk of Works, Mr. Smith at Hereford to have scaffold ready by Saturday 8th of next month & your man will receive every assistance so as I hope to enable him in four or five days to fix the whole, as the meeting I mentioned to you is definitely fixed for the 15th when I hope to have it completed to show them. Will you oblige me by a line per return, stating what the cost of the remaining two will be, inclusive of ironwork fixing & c.'. Mar. 1: 'I will do what I can to … give you order to proceed with the other two [side lights] as soon as possible. Mar. 12: 'I write a line to say I cannot for a few days give you a definite order to proceed with the two side lights as I am awaiting a decision of a gentleman now in Switzerland abt [sic] them.' Dec. 27: 'The gentleman who has borne the cost of this Hereford window is desirous of having a small finished drawing of it for his study, framed, to be made from the cartoons – will you therefore be good enough to forward these to me for a week or ten days and I will have a clerk do it for him – The original design for the three windows was handed over to late Dean & cannot be found or it would have served the purpose – I understood you to say you had the cartoons prepared for the other two windows – if so please send them & I shall then have a complete drawing made for him & so I hope induce him to complete his good work, by having them executed.'

Literature. *The Ecclesiologist*, 9, 1848, pp. 35, 205, refer to the restoration work intended for the chancel. *The Builder*, 9, 1851, pp. 152, 189: some of the background to the funding of the window. Morgan, 1979 pp. 21-3: history of the window. Aylmer & Tiller, (Paul Iles, 'The Stained Glass'), 1999, pp. 318, 319.

76 Kilpeck, St Mary & St David (CoE)

1849. Client: Rev. Archer Clive, Whitfield, Hereford.

Apse windows, E, N, S (**6.8a-c**)	I, nII, sII	0.3m x 0.8m	1-light each	£13.10.0

Descriptions. 3 1-light, round-headed windows, each containing a figure on a blue central vesica placed between two blue-centred, leaf-patterned red roundels. The figures are: I – King David, crowned and in a white lined, purple mantle over a blue-green robe, seated holding a yellow harp in his left hand while plucking it with his right. nII – A white Agnus Dei standing in left profile with its head turned back to the right, in front of a yellow-crossed white staff to which

a white banner is attached. sII – King David crowned and robed as in I standing in a frontal pose, holding the head of Goliath in his left hand and an upraised sword in his right.

Office records. First Glass Day Book, 1849, f. 76, Dec. 26 (I, sII, nII). *Cartoon costs per ledger summary*: I, sII, nII, Powell £1.0.0, Hendren 6s.8d. *Pugin sketch*, BM & AG a.no. 2007–2728, 3, for I (**6.8d**).

Letters. HLRO 304: Pugin to Hardman, letter no. 194: 'I send you a rough sketch for the window at Kilpeck Church you can tell Mr Clive that I will take care the figures & details are taken facsimile from the Early windows coeval with the Church – so as to look exactly like the old work. I return you his letter but keep the Dimensions he should settle about the other figures they should all be <u>seated</u> like the sketch explain this to him.' No. 172: 'I don't understand what is required for the 3rd light at Kilpeck David playing on his harp would have been much better It was an older kind of subject I could have made a good job ... on reading the letter again I see that we are to have David playing on the harp, bearing the head of Goliath, & the lamb, so that will be alright.' No. 960: 'Kilpeck tomorrow.' *JHA: Clive to Hardman*, 1849, Mar. 19: requests windows for Kilpeck Church and gives their sizes: 'something emblematical of St David with a Harp...the church for which they are intended is a very rude early Norman structure so the windows should be of the earliest sort of glass but made to transmit as much light as possible for no other direct light comes into the circular Chancel except these 3 apertures.' Aug. 3: requests information regarding progress of windows. *Hardman to Clive*, 1849, Mar. 23: 'as I have Mr Pugin's assistance in all the[?] works, you may depend upon the figures & details being facsimiles of the early works'.

Literature. The Ecclesiologist, 7, 1847, pp. 156-7: short paragraph on raising funds for the restoration.

77 Madresfield, Church.[25] Now in Worcestershire

1853. Windows no longer *in situ* (both probably designed by J.H. Powell but see the reference below to sketch regarding the E window).

Office records. Order Books 2 & 3, 1852, f. 3, Sep. 14 (E window); 'West window, with inscription: "Orate pro bonum Estate de Catherine Beauchamp". Arms of Lady Beauchamp to be introduced. Design the Baptism of Our Lord.' *Per Order Book 2*, f. 57: Subject matter of windows: 'East Top – Agony, Crucifixion, Resurrection./Bottom – Adoration, Nativity, Annunciation./West Top – Teaching in Temple, Baptism, Presentation./Bottom – Lazarus, Blessing Little Children, Nicodemus'. *Order Book 2*, 1852, f. 57 (W window). *First Glass Day Book*, 1853, f. 189, Oct. 4: 'To An East Window/of Stained Glass, of 3/Lights & Tracery, with/Groups of Figures in/Subjects introduced/& Shields of Arms in/Tracery/Centre light 12'0" x 2'1"…/2 side do 8'9" x 1'10"', f. 200, Dec. 20: 'To A Stained Glass Tracery/Light for New Head of/East Window in Ch/size of Head 3'7" x 3'1"'. *Pugin sketch*, BM & AG a.no. not allocated, of the E window, appears to be by Pugin and contains the above subject matter, although the order of the bottom row is reversed. Whether Powell utilised this design for his cartoons or created something new is unknown.

Letter. JHA: Catherine Beauchamp to Hardman, 1852, Nov. 1: 'I am most concerned that the <u>West</u> window... should be commenced directly ... that this & the East window may both be ready at the <u>opening of the church next March</u> ... Perhaps you will be so good as to show this letter to Mr Powell who made the sketch for the West window'. The letter includes the W window inscription as in the Order Book above, and gives the subject matter for the window as 'The Baptism of Our Lord & c & c'.

78 Pudleston, St Peter (CoE)

1850. Clients: Rev. J. Whitfield; Elias Chadwick, Pudleston Court, Leominster (sVIII). Supervising architect: H. Woodyer.

N & S aisle windows	nII, nIV, sVI, sVII	0.8m x 0.9m	2-light	£39. 0.0
N aisle window	nIII	0.3m x 0.9m	1-light	£1.10.0
N aisle W window (**10.12**)	nV	0.8m x 1.5m	2-light	£15.10.0
S aisle E window	sV	0.8m x 1.9m	2-light	£18. 0.0
S aisle W window	sVIII	0.8m x 1.5m	2-light	£15.10.0

Descriptions. **nII, nIV, sVI, sVII.** 2-light windows. Each light contains a depiction of an Apostle standing against white quarries patterned with black-outlined flowers touched with yellow silver stain. From left to right the Apostles are: nII – St Jude in a green-lined, blue mantle over a red robe, holding a book in his right hand and an axe in his left; St Simon in a blue-lined, red mantle over a green robe, holding a book in his left hand and a downward-pointing saw in his right. nIV – St Bartholomew in a blue-lined, wine-red mantle over an orange robe, holding a book in his right hand and a flaying knife in his left; St Matthew in a brown-lined, yellowish-brown mantle over a green robe holding a

book in his left hand and a yellow pouch in his right. sVI – St James the Great in a blue-lined, green mantle over a red robe holding a staff (to which is fastened a flask) in his right hand; St Andrew in an orange-lined, brown mantle over a blue robe holding a diagonal-cross between his hands. sVII – St Thomas in a blue mantle over a brown robe, holding a lance in his right hand; St John the Evangelist in a light-blue-lined, red mantle over a green robe, holding a green palm in his left hand and a yellow chalice, from which a green devil emerges, in his right. The borders of these windows are patterned with alternate white and orange florets on red and green grounds.

nIII. 1-light window containing two leaf-patterned blue roundels against quarries patterned as in the Apostles windows. The borders too are as in the Apostles windows.

nV. 2-light window. Each light contains a standing Apostle, head turned inwards, depicted within a trefoil-headed, canopy-like medallion. St James the Less in a white-lined, red mantle over an orange robe, holding a book in his left hand and a club in his right, is in the left-hand light; and St Philip in a reddish-brown-lined, blue mantle over a red robe, holding a book in his right hand and a yellow-crossed staff in his left, is in the right. The ground in the medallions is made up of a white, flower-on-stem grisaille. The remaining areas of the lights are comprised of quarries patterned with black-outlined flowers on stems, within black-outlined frames. The quarries are overlain by red-outlined quatrefoils patterned in similar fashion to those in nIII.

The borders are patterned with white leaves on undulating yellow stems against red, blue and green grounds.

sV. 2-light window with a single quatrefoil tracery-piece. The design is as for nV but St Peter in a blue-lined, red mantle over an orange robe, holding a book in his right hand and the keys in his left, is depicted in the left-hand light; and St Paul in a blue-lined, purple mantle over a dark green robe, holding a book in his right hand and an upraised sword in his left, in the right. The quatrefoil tracery-piece is patterned with a red rosette in each of its foils and has a red roundel at its centre all on a white grisaille ground.

sVIII. 2-light window. Each light contains a centrally-placed, red outlined, elongated, quatrefoil medallion enclosing an angel holding a text. The angel's head is turned inwards, and he stands holding a text against a white, leaf-on-stem diaper ground. The remaining areas of the lights are filled with a grisaille of white flowers on yellow silver stain stems overlain by a vertical series of red-outlined diamonds linked in with the medallions. A shield is at the top of each light. The one on the left portrays the 'five wounds', against a red-patterned ground, and the one on the right, a cross outlined in yellow, against a white grisaille ground. The letters 'P(?)', and 'A' appear in small yellow circles at the top of the right-hand shield and the words 'non est' are in its borders. Two small decorated roundels, each inscribed with an A C monogram, are in the bottom section of the lights, over the intersections of the diamonds. An inscription across the bottom margins of the lights reads: 'Alice [?] of Elias Chadwick of [text worn away] esquire deceased at Leominster April 22 Anno Domini 1848 aged 72 years'.

Office records. Order Book, 1850, f. 100, Aug. 2 (sVIII), f. 116, Sep. 25. *First Glass Day Book*, 1850, f. 107, Dec. 26 (two entries covering all the windows). 1851, f. 112, Jan. 10: 'fixing Windows'. *Cartoon costs per ledger summary*: sVIII, Powell £1.5.0; others, Powell £6.5.0.

Letters. HLRO 304: Pugin to Hardman, letter no. 733: 'I have an order for Pudleston [also 731]'. No. 747: 'The windows for Pudleston are badly wanted the cartoons will go off this week.' *JHA: Woodyer to Hardman*, 1850 box: 'Mr. Woodyer writes to inform Mr. Hardman that he has this night sent tracings for all the Pudleston windows off to Mr. Pugin including Mr. Chadwicks – they will be wanted by November.' *Whitfield to Hardman*, 1850, Sep. 28: 'Mr. Whitfield would be obliged to Mr. Hardman if he would inform him whether he had received the cartoons from Mr. Pugin for 8 small windows for Pudleston Church.' 1851, Jan. 27: requests costs for: 'East window & two South windows in one sum the Squires memorial window by itself & also the windows in the North aisle by themselves in one sum as they are offerings from distinct parties.'

79 Ross Church[26]
1853. Window designed by J.H. Powell.

Office records. Order Book 2, 1853, f. 94, 'as sketches by Mr Buckle'. *Order Book 3*, f. 68, Aug. 23. *First Glass Day Book*, 1853, f. 199, Dec. 20: 'To 2 Lancet Lights of/Stained glass for/South side of Tower/of Church.../2 lights 5'7" x 1'7" x 1'1"'.

80 Stretton Grandison Church[27]
1852. Window designed by J.H. Powell.

Office records. Order Book, 1852, f. 172, Mar. 12. *First Glass Day Book*, 1852, f. 152, Jul. 9: 'To A Stained Glass Window/of one light for/sedelia [sic] window/1 light 5'9" x 1' 8½" .../subject The Good Shepherd'.

HERTFORDSHIRE

81 Great Berkhampstead Church.[28]

1853. Window designed by J.H. Powell.

Office records. Order Book 2, 1852, ff. 13, 36, Oct. 27; 'Small Lancet Light, subject the Holy Trinity with the Dove above the hand of the Eternal Father in benediction.' *Order Book 3*, f. 15, Oct. 27. *First Glass Day Book*, 1853, f. 172, Feb. 9: 'To A Stained Glass Window/of 1 Light/1 Light 4 ft 1 In x 10½ ins.../Subject Figure of our/Lord'.

82 Old Hall Green, St Edmund's College (RC)

1847-8, 1850-1. Client: Very Rev. Dr E. Cox.

Chapel E window (**6.3a–c**)	I	6.1m x 8.7m	7-light	£350	1847-8
Chantry chapel E window	nVII	1.4m x 4.0m	2-light	£90	1850-1 (glass destroyed)

Descriptions. **I.** 7-light window and tracery. Each light contains depictions of two saints, one above the other, standing under canopies, against white screens, forming two rows of figures under canopies across the window. The bottom panels of the lights are filled with geometrical leaf patterns on white grisaille grounds. From left to right the saints are: top row – St Peter in a white-lined, red mantle over an orange robe, holding one yellow and one white key in his left hand and a book in his right; St John the Baptist in a green-lined, mauve mantle over a wine-red robe, holding in his hands a blue plaque, displaying a white Agnus Dei; the Blessed Virgin, crowned and in a green-lined, blue mantle patterned with white *fleur-de-lis*, over a mauve robe, holding white lilies in her right hand; Christ in a green-lined, yellow mantle over a red robe, holding a crossed staff in his left hand; St John the Evanglist in a blue-lined, red mantle patterned with white leaves, over a green robe, holding a chalice, from which is emerging a green devil, in his right hand and a book in his left; St Andrew in a blue-lined, mauve mantle over a green robe, holding in his hands a green diagonal-cross; St Paul in a white-patterned, green-lined, red mantle over a blue robe, holding a book in his right hand and an upraised sword in his left. Bottom row – St Augustine in a white mitre and a purple rosette-patterned, red-lined, yellow(?) mantle over a blue-lined, green dalmatic and a white alb, holding a crossed-staff in his right hand and a book in his left; St Bede in a green-lined, blue mantle patterned with white crosses on yellow ground, over a mauve robe, holding a crozier in his right hand and a book in his left; St Gregory in a yellow and white papal-tiara and a green-lined, red chasuble over a purple-lined, green dalmatic and a white alb, holding a triple-crossed staff in his left hand and an open book in his right; St Edmund in a white mitre, and the pallium over a green-lined, red chasuble, a purple dalmatic and a white alb holding a crossed-staff in his left hand; St Thomas of Canterbury in a white mitre, and the pallium over a red-lined, yellow chasuble, a green dalmatic and a white alb, holding a crossed-staff in his left hand; St John Chrysostom in a red-lined, green mantle dotted with orange patterned rectangles, holding a crozier in his left hand; St Charles Borromeo in a flat red hat and a white-lined, red mantle over a white robe, holding a book in his right hand and a crossed staff in his left. Both sets of canopies have trefoil-heads contained within pointed arches (yellow-crocketed in the case of the lower set). The arches of the upper set are surmounted by yellow-crocketed and finialed gables, behind and above which rise superstructures made up of three-light Gothic windows surmounted by yellow, crocketed gables and flanked by pinnacled-buttresses. The borders are patterned with yellow and red rosettes, and green and blue florets. The tracery is filled with patterns of white leaves on yellow stems against red grounds.

nVII. Destroyed by bombing during the Second World War, the window had two lights containing depictions of St Thomas Apostle and St Thomas of Canterbury, the patron saints of Bishop Griffiths the founder of the chapel, whose altar tomb stands beneath the window (Ward, p. 271).

Office records. Order Book, undated, f. 12 (I), f. 45A (nVII). *First Glass Day Book*, 1847, f. 17, Oct. 16 (tracery for I), f. 20, Dec. 2 (tracery for I); 1848, f. 26, Jan. 26 (centre light, I), f. 28, Mar. 25 (six lights I); 1850, f. 91, May 18 (tracery nVII); 1851, f. 129, Nov 19 (lights & tracery, nVII); 1852, f. 154, Aug. 6: 'To Alterations in 5 pieces/of Tracery sent for East/Window of Chantry [nVII]/May 18th 1850'. *Pugin's sketch,* BM & AG 2007-2728.4 (**6.3d**), of I, reveals him, with a few rapid pencil strokes, capturing and highlighting the elegant stances of the figures, the natural fall of their draperies and the angular nature of the folds, all aspects of the Decorated style.

Letters. HLRO 304: Pugin to Hardman, letter no. 23, postmark 'NO 8 1847': 'I send you by train 2 last images for S. Edmunds ... I entreat you to do your best for S. Edmunds I am getting into great disgrace with Dr. Cox & I cannot afford

to <u>offend</u> him so pray help me out with something ... as regards the St. Edmunds window you must make a ground up to the spring of [?] white diaper & then the heads[?] Ruby & Blue 7.' No. 626: 'I examined the E. window S. Edmunds & I see clearly a few alterations of colours would make it quite another thing the y4 or 9 crockets are the worst of all they must be made the same as that window in London and some of the borders are of the dreadful blue.' No. 465: 'a 2 light window for the Chantry Chapel of the Late Right Rev. Dr. Griffiths at the Collegiate Chapel of S. Edmunds College the images represent S. Thomas the apostle & S. Thomas of Canterbury.' No. 181: 'The cartoons for S. Edmunds [nVII] ... go tomorrow.' No. 633: 'They would like the Bishops Chantry window in as soon as it can be sent in.' *JHA: Powell to Hardman*, 1847, Oct. 26: '5 more figures S. Edmunds are ready.' 1847 box: 'I enclose the rest of the canopies for St. Edmunds ... In the canopy for S. Edmund you will find that the Governor [Pugin] has altered the colouring of the roses up border by changing the yell 3 into Brown Pink please see that this is corrected in the upper canopy.' *E. Cox to Hardman*, 1848, May 2: 'Our East window is now entirely put in, and I must write to inform you that it is a magnificent thing. We shall have half the Country coming to see it'. *H. Telford to Hardman*, 1852, Jul. 30: 'The stained glass has arrived safe.'

Literature. London & Dublin Weekly Orthodox Journal, 15, 1842, p. 363, reproduces the letter of appreciation from the college students to Pugin, following the latter's stay on Nov. 29, 1842: the letter also appears in the *True Tablet*, nos 41 & 134, 1842, pp. 664, 792). *The Tablet*, 6, 1845, p. 613, refers to the design and progress of Pugin's new chapel; 1853, May 28, p. 341, covers the consecration and opening of the chapel which it describes, calling the E window: 'One of the best which has been produced by Messrs. Hardman, whether the correctness of the drawing, or the effective translucency of the glass or rich colouring be regarded'. St David is included erroneously amongst the saints depicted. B. Ward, 1893. Wedgwood (Pugin's Diary): Pugin visits Ware, 1842, Nov. 29-30; 1845, Sep. 15, Oct. 28; 1849, Apr. 26; 1850, Apr. 11.

HUMBERSIDE

83 Beverley, St Mary (CoE). Now in East Yorkshire
1850-3. Client: Rev. W.T. Sandys.

W window (**10.13**)	wI	5.1m x 6.3m	14-light	£300	1850
N aisle W window (**6.18a, e, f &g**)	nXVI	2.1m x 3.5m	3-light	£100	1852
S aisle W window (**6.19c**) ★	sXXI	2.1m x 3.5m	3-light		after 1853

 ★probably designed by J.H. Powell

Descriptions. wI. 14-light window and tracery. Christ in Glory under a canopy is depicted in the centre of the seven upper lights and the Virgin Mary in the centre of the seven lower. Depictions of the twelve Apostles standing in front of screens, (red or blue in the upper lights and green or orange in the lower) under canopies, are depicted in the other lights. The canopies are in perspective and have ogee-curved heads (of which three sides are visible) surmounted by crocketed and finialed gables. Behind and above the gables rise, in perspective, multi-pinnacled towers. There are pedestal bases to the canopies, also in perspective on which the Apostles stand. From left to right they are: upper lights – St Bartholomew in a green-lined, blue mantle over a yellow robe, holding an upright knife in his left hand; St James the Great in a green-lined, red mantle patterned with white scallop shells, over an orange robe, holding a book in his right hand and a staff (to which a flask is fastened) in his left; St Peter, clothed as for St James, except that floral patterns replace the scallop shells, holding a book in his left hand and bluish-white keys in his right; Christ in Glory, seated within a mandorla in a green-lined red mantle over a white robe, holding an orb in his left hand. The symbols of the evangelists are at his shoulders (eagle and angel) and feet (ox and lion); St Paul in an orange-lined, red mantle over a green robe, holding a book in his left hand and a downward-pointing sword in his right; St Andrew in a purple-lined, green mantle over a blue robe, is behind a large diagonal-cross; St Philip in a green-lined, blue mantle over a red robe, holding a book in his right hand and a crossed-staff in his left. Lower lights – St Matthias in a white-lined, blue mantle over a red robe, holding a book in his left hand and an upraised axe in his right; St Thomas in a purple-lined, brown mantle over a green robe, holding a lance upright in his left hand; St James the Less in a green-lined, wine-red mantle over a blue robe, holding a club in his right hand; Virgin Mary in an orange-lined, blue mantle over a wine-red robe standing in a Glory of yellow tongues of flame with the Holy Dove hovering to the right of her face; St John the Evangelist in a blue-lined, orange-patterned, red mantle over a green robe, holding a chalice in his hands; St Matthew in a green-lined, orange mantle over a red robe, holding a book in his right hand and a set square in his left; St Simon in a red-lined, blue mantle over a white-patterned, yellow robe, holding a book in his left hand and a saw in his right. The central mullions of the window intersect in the tracery to form two lancets, each containing ten small lights in ascending rows of four, four and two. Sixteen of these lights contain depictions of prophets holding scrolls, standing against red grounds. They are Amos, Zechariah, Jonas,

Mica, Zephania, Haggai, Obadiah, Malachi, Isaiah, Joel, Habbakuk, Jeremiah, Ezekiel, Nahum, Hosea and Daniel. The remaining four lights contain angels against blue grounds, as do four of the six lights in the top section of the tracery (two appear against red grounds). The remaining two lights at the very top of the window seem to contain a representation of the Annunciation. The rest of the tracery pieces are mainly patterned in red and blue.

nXVI. 3-light window and tracery. St John the Baptist preaching in the wilderness is depicted in the centre light; the Baptism of Christ in the left-hand light; and the Beheading of St John in the right. All three scenes are shown under canopies similar to those that appear in wI but without the pedestal bases. Each of the six lights in the tracery contains a standing angel depicted holding a text, under a canopy, against a red diaper ground. The canopies have cinquefoil heads surmounted by yellow-crocketed, finialed and pinnacled gables. The letters IHS are inscribed in a roundel, at the centre of a blue-patterned quatrefoil, at the top of the tracery. The remaining small pieces are filled with red rosettes on blue-patterned grounds.

sXXI. 3-light window and tracery. As with nXVI the lights contain scenes beneath canopies, although the canopies are much reduced in size and complexity. This is probably because, unlike nXVI, the side lights are only about two thirds the size of the centre light, with the remaining third taken up by tracery pieces that are separate from those in the main tracery section. This meant that for the scenes to be of comparable size to those in nXVI, the canopies had to be reduced. The scenes portrayed are the Adoration, Transfiguration and Presentation. It appears from the letters to Hardman from Sandys and Thomas Shepherd (see below) that Pugin produced a design for the window that included at least the latter two scenes, but that by late 1852, (after Pugin's death) this design had been lost. The window does not appear in the First Glass Day Book as having been executed by the end of 1853. It may have been made in 1856 (cost sheet No. 42 for that year refers to a side window for St Mary, Beverley of 3 lights and tracery £100.0.0, with no mention of the subject matter). At some time Pugin sketched the design for nXVI in the framework of sXXI which he wrongly believed to be that of the NW window (sketch in Birmingham Museum & Art Gallery). Design sketches for both nXVI and sXXI dated 1850 appeared in an exhibition in the Moss Galleries, London, in Jan. 1994 (**6.19a & c**) The subject matter of the sketches in nXVI was as for the completed window, but in sXXI the scenes illustrated were the Annunciation, Nativity and Adoration of the Magi of which only the latter scene appears in the window as executed, and to a different design. It would seem, therefore, that either Pugin produced two designs for sXXI or J.H. Powell designed, for Hardman to execute, a window with scenes containing subject matter that had been wrongly recollected.

Office records. *Order Book*, undated, f. 52 (I); 1852, f. 166, Feb. 20 (nXVI). *First Glass Day Book*, 1849, f. 67, Aug 29 (Tracy wI), f. 76, Dec. 22 (Tracy wI); 1850, f. 94, Jun. 25 (Lights wI); 1852, f. 156, Jul. 1: '1 piece of yellow glass for Repairing/ Figure in West Window of Church' 1852 f. 161, Nov. 15 (nXVI). *Cartoon costs per ledger summary*: I, Powell £10.10.0, Oliphant £33.12.0. Oliphant's account records that the payment was in respect of:

			£ s. d.
'1850	Mar 28	10 Large cartoons Apostles & BV.	17 15 0
	Apr 25	Expenses to & from Ramsgate & time	3 0 0
		9 days Work do @ 20/–	9 0 0
		11 days Inn expenses @ 7/–	3 17 0'
			————
			33 12 0

Private collection, Pugin sketches of nXVI (**6.18b**) and sXXI (**6.18d**). *Pugin sketch*, BM & AG a. no. not allocated, of nXVI. ***Letters.* wI.** *HLRO 304: Pugin to Hardman*, letter no. 911: 'I shall be very glad to have the glass fixed in the tracery at Beverley – I dare not write them till something goes to them. I have every expectation that window will make a great stir & bring trade.' No. 969: 'I also send the Beverley tracery now this is a job – which will be a trial for the men in the way of Late Painting if well done on the old principle it will be very brilliant – The figures are capital we impress[?] here necessarily[?]. I think if the tracery was in it would quiet them a bit – & make them more patient for the rest of the window.' No. 280: 'the tracery for the Beverley window will be [?] very soon indeed Powell is doing it I mean the small pieces to hold in [end of page, the next page of the letter is missing]'. No. 341: 'The tracery (the small bits) for the beverley window go off this evening. they will have to be built in with the stone work so you must put a <u>wide Band</u> of lead all round outside to Lay [?] hold of the stone & send them off as soon as you possibly can not to stop the masons ... now my dear Hardman try to get the old white glass with rather a greenish tint for this glass, <u>pale</u> yellow stain and good Brown shading. that will give it the true perpendicular characteristics. Above all the tint of white greenish is important – not positive green but <u>greenish</u> I think you have an old bit of white to work by'. No. 959: 'I am very anxious to get the tracery into Beverley as soon as possible the stupid man has fixed all the glass inside out it will be necessary in marking the pieces for the future to say that the numbers refer to the <u>inside</u> – I am very anxious about the Beverley window

I believe they are waiting to see what sort of a job we shall make to decide on a W. window for the Minster It is very large I told them £700 would be the price. It will be very necessary to give a [?] look to the W. Window Beverley for the sun is so powerful in the afternoon.' No. 960: 'I am very glad to hear the Beverley tracery comes out so well Powell has done two splendid lights for it & I have improved the canopy very much. No. 834: '4. I have at length succeeded in establishing proper hours in the study. Powell had a bad system of doing whole length figures at home & having them <u>finished</u>. the consequence is 2 thirds of the Beverley window has to be done over again the figures have no connection whatever with each other – each quite a separate idea. for the future I have positively ordered that all is to be sketched out here & the whole Lot of figures traced [?] [?] to see how they come together as a whole. this will throw us all back again.' No. 686: 'Oliphant is a liar he has had all the Beverley figures & <u>not sent me one</u>.' No. 853: 'In a few days a lot of the Beverley window goes.' No. 957 (not in Pugin's hand): 'Figures for Beverley do they work twice over. I seem to have exactly half the window.' No. 762: 'Your Birthday is on the 21 will the Beverley window be done by that time???' No. 773: 'Pray let me know when you think the Beverley window will be done as Mr. Sandys is very anxious to have it for some church meeting on the 9th July & I want to give them an answer.' *HLRO 339: Sandys to Pugin*, letter no. 300, Beverley, Dec. 10, 1848[?]: 'We wish you to restore the Painted Glass in the West window at a cost of £300. The sum you mentioned to us when last in Beverley ... I am afraid we shall not be able to raise by subscription the whole of the £300 for the west – window – perhaps not more than about £200 – could you then arrange as to spare only £400 on the fabric & so keep the Ch. Wardens out of debt.'

nXVI. *HLRO 304: Pugin to Hardman*, letter no. 917: 'The glass has arrived to my great joy I think the N. window <u>very good</u> with the exception of the heads which are painted on a horrid glass and quite spoil the job. They look quite modern and beastly this is a very important thing indeed for if you do all the windows in the same way they will be Ruined pray see to this for I have been in agony since I saw them – why should they not be the same white glass as the rest of the window It is a most curious thing but in every job there seems something, just something to prevent it being a real grand job. I don't feel quite happy about the foliage or the quarry[?] work it does not come quite right yet & you must careful [sic] of the stain spreading as it gives a <u>yellow</u> look that is quite destructive to effect [sic] nothing is worse than yellow too much yellow is the ruin of almost all modern windows'. *JHA: John James per pro George Myers to Hardman*, 1849, Aug. 24: requests stained glass for W window of St. Mary's Church: 'Mr. Pugin will have the glass put in as we set the stone work.' 1852, Nov. 26 (re nXVI): 'I am Happy to say that we have the Stain [sic] Glass window in and all Wright [sic] to the Great Satesfaction [sic] of all the Gentleman and Ladies in the town ... The Revd. Mr. Sands [sic] do say that he shall wright [sic] to you in a day or two about another Stain Glass window.' *Sandys to Hardman*, 1850, Sep. 16: acknowledges: 'the receipt of the most <u>satisfactory</u> window [wI] you have placed in my Church St. Marys I have made [?] right now & I hope [?] [?] soon make another call on you in the form of a window if not windows. Mr. Pugin is to be here on the 19th'. 1852, Sep. 3: 'will you do me the favour of informing what delays the sending of the Painted window [nXVI] for my church [chases again on Nov. 12].' Sep. 8 (re repairs wI): requests 'Your portion of the glass for the window of my church.' Nov. 26: 'The window [nXVI] is put in & is <u>most</u> satisfactory some parts are slightly cracked but the cracks are scarcely visible If you have the plan for the second window [sXXI] drawn by the late Mr. Pugin would you be so good as to send it to Beverley – we could now that the iron is hot raise the money for it at once – delay may be dangerous ... If you have not the plan for the other small window perhaps young Mr. Pugin may have it – I have written to him to make sure.' *T. Shepherd to Hardman*, 1852, Dec. 3: pays £100 for 'the Stained Glass window just put in St. Mary's Church [nXVI] I will trouble you to send a description of the West Window you have put up with figures mottoes & c. I am sorry that the sketch of the 2nd window [sXXI] has been lost & I can only remember two of the lights – one being the Transfiguration & the other the Adoration. Is it to be found amongst the late Mr. Pugin's papers?' *J. Testing (sexton) to Hardman*, 1852, Dec. 2: 'I am sure you will pardon me for again troubling you for a coppy [sic] of the inscriptions on the figures of the beautiful window [nXVI] you have sent us.' *Letter Book: Hardman to Testing*, 1852, Dec. 20, p. 139: Description of the Stained Glass window latterly sent [nXVI]. 'In the centre light "The Preaching of St. John in the Wilderness" and in the tracery above two Angels holding scrolls with the words "Vox clamantis in dessote[?] Parats Viam Domino" translated ("I am the voice of one crying in the Wilderness prepare ye the way of the Lord"). In the right hand light St John baptising Our Lord with Angels holding the words "Hic est filius meus dilsaties in que nihi complacini" translated ("This is my beloved son in whom I am well pleased"). In the left hand light, The beheading of S. John with an Angel holding the words "Misit que et decilla vis Joannem in carcere" translated ("And they took and beheaded John in Prison").'

Literature. *The Builder*, 7, 1849, p. 105: short piece on the costs of restoring wI with stained glass; the subject matter; and the decayed state of the church; 8, 1850, p. 406, reports the completion of the window, including a more detailed explanation of the subject matter. Wedgwood (Pugin's Diary): Pugin visits Beverley, 1841, May 27; 1842, Oct. 11-12;

no diary 1843; 1844, Sep. 26; 1845, Apr. 11, Jul. 1, Sep. 20; no diary 1846; 1848, Aug. 31; 1849, Apr. 24, Jul. 18, Oct. 16; 1850, Sep. 19; 1851, Jun. 25-6.

84 Brigg. Now in North Lincolnshire

Literature. Wedgwood (Pugin's Diary), p. 57, 1844 '[double blank leaves between pp. 24 and 25] [long list of financial transactions]' – includes: 'Window at Brig[?] 16.0.0;' on p. 58, '[end papers at back of diary] [b] [financial calculations] Wailes for Brigg [no amount is included]'.

ISLE OF WIGHT

85 Ryde, Holy Trinity (CoE)

1853. Window designed by J.H. Powell.

Office records. Order Book 2, 1853, f. 73; *Order Book 3,* 1853, f. 47, Jun. 6. *First Glass Day Book,* 1853, f. 197, Nov. 26: 'To Stained Glass/Window for South Transept of Church/of 2 lights & Tracery/.../2 Lights/10'4" x 2'0½"/.../Subjects "Figures of the/ Four Evangelists"/ being Memorial Window /of the Late Vice Admiral Montague'.

KENT

86 Brasted, St Martin (CoE)

1849. Client: Rev. Benjamin Webb.

Office records. First Glass Day Book, 1849, f. 75, Dec. 1 (entered as 'Brastead'): 'a Small Stained Glass Light 2'9" x 0'7". [No charge]'.

Letters. HLRO 304: Pugin to Hardman, letter no. 824: '1. I made today a template of a small narrow window for Rev. Webb for his own church. I want to astonish him will you knock it off & send it to him Brastead [sic] Rectory Sevenoaks Kent – if you do not object I thought of giving him this little window he is a capital man & the editor of the Ecclesiologist. I know he is not rich & I think he would be pleased now my dear Hardman use the true blue & streak the ruby with white & make a true little thing. I rely on you.' No. 903: 'I had a very kind letter from Mr. Webb. he is delighted with his window – & very much gratified at its being presented to him.' *JHA: Webb to Pugin,* 1849, Nov. 19: 'I had been rather hoping to have heard from you again in reply to my last letter I now write to ask if you will kindly order for me, of Mr. Hardman, stained glass to fill a small Romanesque window (which I take to be before the Conquest) lately opened by me in the north wall of the nave of this church. The church is dedicated in honour of S. Martin, and we have no stained glass left The dimensions are as follows: but I send you, Enclosed, [sketches alongside, a round-headed window, marked with the dimensions] as good a templet [sic] as my poor skill will make, which may make my meaning more clear I should exceedingly like to know what you recommend for filling so small a light; and if you would send Mr. Hardman a cartoon & request him to let me have the glass as soon as possible – (for the window is now unglazed) I should be exceedingly obliged to you. I suppose mosaic glass alone would be suitable. I shall be glad to hear of your success in the experiments you said you were going to make in colours [possibly with James Hartley, see chapter 2 [congratulates Pugin on the birth of his child – Margaret Mary, born Oct. 17, 1849, Pugin's first child by his third wife Jane]. Mr Warrington has been writing to the Ecclesiologist in the consequence of the paper on his book in the last number [*The Ecclesiologist,* Oct. 1849]. His letter was full of very absurd charges against you: but of course we declined any controversy of that kind.'

87 Ramsgate, The Grange

*c.*1844, 1848. Client: A.W.N. Pugin.

Chapel E window (**5.10a–c**)	I		
Chapel S window (**5.11a–c**)	sII		
Dining room S windows (**5.12, 5.13**)	DIR sII, DIR sIII	0.5m x 0.6m	2-light
Library S window (**5.6a & b**)	L sII	0.5m x 0.91m	4-light
Library W window (**5.7a & b**)	L wI	0.5m x 0.6m	3-light
Drawing room S window (**5.8**)	DRR sII	0.5m x 0.6m	1-light
Drawing room W window (**5.9**)	DRR wI	0.5m x 0.6m	3-light

The only reference to work at the Grange by Hardman's appears in the First Glass Day Book in 1848, and concerns

alterations to the lights in the windows in the dining room where, 'fresh Arms & c & c' were put in, and those in the 'blue room' (not identified) which involved, 'putting in fresh shields of Arms & c & c, doing twice', all at a cost of £9. The dining room alterations would presumably have been the introduction of the Knill arms, required after Pugin's marriage to Jane in August that year. The other glass in the house (built during 1843-4)[29] referred to below, is likely to have been executed by William Wailes (see *Letters*, John Wailes to Hardman, below).

Descriptions. **I, sII.** 2-light windows and tracery. Each light contains a depiction of the standing figure of a saint under a canopy. The canopies have trefoil-heads surmounted by yellow-crocketed and finialed gables containing shields of arms (St George in I and red-patterned roundels in sII). The bottom panels of the lights are each filled with a red-outlined quatrefoil. Three of the quatrefoils contain a single praying figure kneeling in profile, and the fourth a group of figures. The names of the worshippers are marked on bands running behind them, across the middle of each quatrefoil. Red shields emblazoned with the Pugin coat of arms – a black martlet on a gold diagonal band – are in the bottom left-hand foils of the quatrefoils, in front of the single kneeling figures. From left to right the saints and worshippers are: I – St Augustine in a yellow ornamented mitre, a green-lined, red chasuble over a purple dalmatic and a yellowish-white alb, holding a crossed-staff in his right hand. Below, Pugin in a white habit. Both figures are portrayed against blue diaper grounds. St Gregory against a red diaper ground, in a gold papal tiara and a yellow-lined, blue cape over a purple dalmatic and a yellowish-white alb, holding a triple-crossed, dove-headed staff in his left hand. Below Pugin's second wife, Louisa, in a yellowish-white head-dress and a red dress pattered with diagonal yellow stripes containing black martlets, accompanied by her step-daughter, Anne, and daughters Agnes and Katherine, all against a blue diaper ground: this arrangement presumes that the composition of the window had been decided upon prior to the birth of Louisa's third daughter, Mary, on September 25, 1843. sII – St Edward the Confessor, in a white-lined, purple mantle over a blue robe, holding a ring in his right hand and a sceptre in his left. Below, Edward Pugin in a yellowish-white shirt and trousers and a blue topcoat. Both figures are portrayed against green foliage diaper grounds. St Cuthbert, against a red diaper ground, in a white mitre, and a purple-lined chasuble over a green dalmatic and yellowish-white alb, holding the crowned head of King Oswald in his right hand and a crozier in his left. Below, against a green diaper ground, Cuthbert Pugin dressed similarly to Edward Pugin but in a red topcoat instead of blue. The borders of I are patterned with shields emblazoned with the Cross of St George against red flower-patterned grounds. Those of sII with yellow rosettes on red grounds. The topmost of the three main tracery pieces in I shows St George in a blue-surcoat adorned with his coat of arms, over greyish-white armour, standing astride a red dragon, holding a staff with a banner attached, in his right hand and clasping the hilt of his sheathed-sword with his left. The other two pieces each contain a depiction of an angel playing a musical instrument. The grounds in all three pieces are blue. The main tracery piece in sII contains a leaf-patterned roundel on a blue diaper ground.

DIR sII, DIR sIII. 2-light rectangular windows of plain glass, with the upper panels of each light made up of white quarries patterned with yellow silver stain rampant lions. Each panel contains a roundel decorated with a shield of arms. Around the rims of the roundels are texts inscribed in yellow-on-white. From left to right the arms represented are those of the families: Towers and Knill (DIR sII) and Pugin and Welby (DIR sIII). The vertical borders are patterned alternately with blue flowers and Pugin's coat of arms. The horizontal borders are similar but the arms have been replaced with Pugin's part motto, 'avant', inscribed in yellow-on-white.

L sII. 4-light oriel window of plain glass with the pointed upper sections made up of white quarries patterned with Pugin's monogram in yellow silver stain. In the middle of each section is a roundel, of blue foliage diaper in the outer lights, and red the inner. Each roundel contains a depiction of a saint in a white robe touched with yellow silver stain, standing in front of a horizontal band on which his Latin name is inscribed in yellow-on-white. From left to right the saints are: St Augustine, St Anselm, St Thomas of Canterbury and St Dunstan. The borders are patterned with red leaves alternating with yellow silver stain leaves on stems. In the bottom borders the leaves on stems are replaced by the part-motto 'avant'.

L wI. 3-light rectangular window of plain glass with flat-headed upper sections stained as in LisII but having red-rimmed roundels of Netherlandish origin of *c*.1500[30] containing biblical scenes.

DRR sII. Single rectangle of stained glass made up of white quarries patterned with black martlets perched on yellow silver stain foliated stems. A red diaper roundel containing a blue diaper shield emblazoned with three white towers and a white chevron bisected along its length by a pair of blue dividers, is in the centre of the rectangle and is encircled by a Latin inscription to St Barbara. The borders are similar to those of L sII, but the leaves on stems are replaced by a yellow silver stain bird perched on a yellow silver stain stem with leaves.

DRR wI. 3-light rectangular window of plain glass with the upper sections stained as in DRR sII. The roundels,

however, are in white glass with yellow silver stain designs which, from left to right, portray: St Peter with the keys; twelve ancient churches illustrated on a plan of the Isle of Thanet; and the Virgin and Child. Each is encircled by an appropriate Latin inscription, the one around the churches being in black script on blue glass as opposed to the yellow-on-white of the other two. The inscription around the Virgin and Child is punctuated by six small roundels; three are red with yellow centres and they alternate with the others which are blue and contain yellow *fleur-de-lis*.

Office records. *First Glass Day Book,* 1848, f. 50, Dec. 24: 'To Altering Lights in/Dining Room [DisII]/putting/in fresh Arms & c & c/To Altering Lights in Blue/Room, St. Augustines [not identified] putting in fresh shields of Arms & c & c doing twice/£9.0.0'.

Letter. *Birmingham Archdiocesan Archives: Hardman correspondence file No. 163, John Wailes to Hardman,* 1844, Aug. 26: 'I had Mr. Myers here last week he left me some designs for your house windows & explained your objections to having them treated in the manner proposed by Mr. Pugin. Should you have seen Mr. Pugin's windows at Ramsgate I can of course offer no plea in favor [sic] of it on the score of lightness as they were of as light a character as we could well do them – in that case we could insert them (the bosses [perhaps, roundels]) in sheets of plate glass in which holes could be cut as you propose – this could be done very neatly. If however you have not seen those done for Mr. Pugins I can assure you they are very bright and by no means sombre or dark and looked exceedingly well. Of this however you would be be [sic] best able to judge should you have an opportunity of seeing them'.[31]

Literature. Atterbury & Wainwright, 1994, p. 259, illustrates details of I and sII.

88 Ramsgate, St Augustine (RC)

1846-53. Clients: A.W.N. Pugin; John Knill, Fresh Wharf, London Bridge, London (nII); John Hardman (sII– sIV); J.R. Herbert, R.A., 22 Church Road, Hampstead Row, London (sVII).

Church

E window (**10.14a-c**)	I	3.6m x 6.0m	5-light	£100	1848 (tracery), 1849 (lights)	
Lady Chapel E window	sII	2.1m x 4.0m	3-light		1848 (tracery), 1853 (lights	
& new tracery). A new window, presumably the present one, was made in 1861. Designed by J.H. Powell						
Lady chapel S windows (**3.10**)	sIII, sIV	1.2m x 2.9m	2-light	£50	1848 (tracery), 1851 (lights)	
Chantry chapel E window	sV	1.2m x 2.5m	2-light		1849 (figured quarries £20:	
subsequently replaced. Replacement not in First Glass Day Book)						
Chantry chapel S window (**10.18**)	sVI	2.3m x 4.6m	4-light		1849 (tracery), 1861 (lights)	
designed by J.H. Powell						
S aisle window	sVII	2.0m x 3.7m	3-light		No record (tracery), 1861	
(lights) designed by J.H. Powell						
S aisle W window	sVIII	1.3m x 3.4m	2-light	£30	1849 (tracery), 1851 (lights)	
W window	wI	2.7m x 5.1m	4-light		1849 (tracery), 1875 (lights)	
designed by J.H. Powell						
Chancel N window (**10.15a & b**)	nII	1.4m x 3.4m	2-light	£45	1850	
Nave N window (tower window?)	nIII	1.2m x 3.3m	2-light	£30	1849 (if tower window)	
Nave N window	nIV	2.0m x 3.4m	3-light		1849 (tracery), 1868 (lights)	
designed by J.H. Powell						

Designated Old Chapter House and Sacristy (Old School Room) in church guide

Old Chapter House N window (**10.17**)	OCH nII	2.0m x 2.5m	5-light		1846
Old Chapter House S window	OCH sII	1.5m x 2.5m	3-light		1846
Above two windows cost £55					
Old School Room window	OSR sIII	2.0m x 1.0m	3-light		1849

Cloisters

E Cloister windows & one in N Cloister (**10.16a-c**)					
	1.0m x 1.7m	2-light	(6 windows)	£30	1846
			(4 windows)	£11.5s	1848
	1.5m x 2.1m	3-light	(2 windows)	£20	1846
Confessional (**2.5**)	0.3m x 0.7m	2 single lights		£8	1849

In 1849, the windows, not yet stained, were filled with plain quarries as a temporary measure. By the time of Pugin's last illness, stained glass designed by him filled the E window of the church (I), the N window of the chancel (nII), and

perhaps the nave (nIII), the S windows of the Lady Chapel (sIII, sIV), and the W window behind the font (sVIII). Of the rest, excluding, perhaps, that for sV, Pugin's glass was limited to the tracery. The lights of these windows were filled with stained glass designed by J.H. Powell and executed by Hardman's between 1861 and 1875 as shown above.

Descriptions. **I.** 5-light window and tracery. The centre light contains a depiction of Christ in a green-lined, yellowish-brown mantle over a red robe holding an orb in his left hand. He is seated, enclosed in a red foliage diaper medallion. Beneath, in a smaller, similarly-patterned, medallion, a frontally-posed angel, is depicted holding a text. At the bottom of the light is a red quatrefoil enclosed in a circle, both outlined in yellow-beaded-glass, patterned with green and white vine leaves and green grapes on yellow stems. The other four lights each contain three medallions with angels, as in the centre light, and at the bottom of each light is a yellow-beaded circle containing one of the four symbols of the Evangelists, from left to right: angel, lion, ox and eagle, with texts. The background in all five lights is blue. Linking the medallions and the medallions and circles are ovals patterned with green and yellow grapes on red grounds; alongside the ovals are patterns of vine leaves and grapes on climbing stems. The borders are patterned with alternating yellow and green leaves on green and mauve grounds. The large red quatrefoil at the top of the tracery has at its centre a blue roundel containing a white Agnus Dei, surrounded by white vine leaves and green and purple grapes on stems. The five trefoils immediately above the lights contain depictions of angels against white grounds. The rest of the tracery pieces are filled with white and green vine leaves and purple grapes on stems, against blue grounds.

sII. The main tracery-pieces are three large blue trefoils, each containing a depiction of an angel holding a text. From his letters (see below) it is clear that Pugin designed angels for the tracery, but the First Glass Day Book suggests that the 1848 versions were replaced in 1853. It is not clear whether new tracery glass was made with the new lights in 1861.

sIII, sIV. 2-light windows and tracery. Each light contains two episodes from the life of the Virgin depicted in blue foliage diaper quatrefoil medallions. The remaining area of the lights are filled with a grisaille of white leaves and yellow silver stain berries on yellow silver stain stems against black cross-hatched grounds, all overlain by a vertical series of red-outlined diamonds that link with the medallions. The scenes illustrated in the top and bottom of the left-hand light of sIII are: Nativity and Annunciation and in the right-hand light: Adoration of the Magi, and Visitation. The equivalent scenes in sIV are: Death of the Virgin, Presentation in the Temple; and Coronation of the Virgin, and Flight into Egypt. The scenes are dominated by the figures, with only a minimum of narrative detail, such as: the background rail with pieces of curtaining in the Nativity; the vase of lilies between the two figures, and the Holy Dove in a ray of light, in the Annunciation; the star in the Adoration; the altar between the figure and the basket with two doves held by a third figure, in the Presentation; and the column with a falling idol in the Flight into Egypt. The borders are patterned with white leaves on vertical stems against green, blue and purple grounds. The main tracery-piece is a large trefoil containing a central, blue, leaf-patterned roundel surrounded by white leaves and green rosettes on red grounds.

sV. 2-light window with tracery. The lights at present contain representations of St Laurence and St Stephen, which are probably post-Pugin, since the only First Glass Day Book entry for the lights, in 1849, records them as: 'figured-quarries with stained borders'.

sVI. St Louis, in white, is depicted seated in a large quatrefoil at the top of the tracery against a red quatrefoil ground, holding a sceptre in his right hand. Blue trelliswork infilled with yellow *fleur-de-lis* fill the foils of the main quatrefoil. Two blue quatrefoils below each contains a censer-swinging angel.

sVII. The tracery pieces are comprised mainly of a quatrefoil at the top, two more below and a row of three trefoils immediately above the lights: they are patterned with intertwining white and green vine leaves on yellow stems, with grapes, against red grounds.

sVIII. 2-light window and tracery. St Ethelbert in a purple-lined white mantle patterned with yellow silver stain, over a yellow robe, holding a sceptre in his right hand and a book in his left, is depicted standing under a canopy in the left-hand light. St Bertha, clad likewise, with the addition of a white head-dress, is similarly posed in the right-hand light. The canopies have trefoil-heads surmounted by yellow-crocketed and short-finialed gables, behind and above which rise superstructures made up of three green-patterned, Gothic windows with yellow-crocketed and finialed gables, flanked by yellow-pinnacled buttresses and topped by white-tiled, yellow-parapeted, pitched roofs. The top and bottom panels of each light are filled with a grisaille of white leaves outlined in black, on yellow silver stain stems, against black cross-hatched grounds, overlain by a red-outlined, concave octagon crossed by two yellow-beaded diagonals. The borders are patterned with white flowers on yellow undulating stems against red and green grounds. The three main tracery-pieces are patterned with green vine leaves and yellow grapes on yellow stems against white grounds The topmost piece contains, in addition, a red shield emblazoned with the profile of a white rearing horse.

Above the window is a roundel containing four large quatrefoils patterned with leaves and grapes on stems against red and blue grounds.

wI. The main tracery-pieces comprise four large trefoils with red roundels at their centres patterned with leaves and grapes on stems. At the top of the tracery is a similarly-patterned large quatrefoil that has at its centre a red quatrefoil medallion decorated with a blue diaper shield emblazoned with a white Y-shaped cross.

nII. 2-light window and tracery. Each light contains a saint depicted standing in an elongated red diaper quatrefoil medallion. The remaining areas of the lights are filled with a grisaille of white leaves and yellow silver stain berries on yellow silver stain stems, overlain by a vertical series of red-outlined quatrefoils which overlap blue-beaded-outlined diamonds. The saints are from left to right: St John of Beverley in a white mitre and a green-lined, white mantle over a yellow dalmatic and white alb, holding a book in his right hand and a crossed-staff in his left; St Elizabeth of Hungary, crowned and in a blue-lined, white mantle over a yellow robe. There are white roses in the apron of her mantle and she holds a book in her left hand. The borders are patterned with white peacocks, and yellow silver stain leaves on white undulating stems, against red and green grounds. The main tracery-pieces are three trefoils filled with white grisaille on which are shields against coloured trefoils – blue in the top piece and blue and red respectively in the lower two – within roundels. The shield at the top impales the arms of the two below, which are: on the left a yellow lion rampant on red ground, and on the right a horizontal band of blue and white rectangles on a yellow ground.

nIII. 2-light window and tracery. Similar in design to nII but with a grisaille of yellow silver stain flowers on yellow silver stain stems, overlain by red-outlined diamonds only; and borders where the peacocks and yellow leaves are replaced by white flowers on yellow stems. St Catherine is depicted seated in the left hand light. She is crowned and in a yellow-lined, white mantle over a blue robe, holding a green palm in her right hand and a small yellow, spoked-wheel in her left. St Margaret of Antioch is depicted seated in the right-hand light. She is crowned and in a yellow-lined, white mantle over a blue-green robe, holding a foliated-crossed-staff and trampling a purple-winged, grey-green dragon beneath her feet. (The staff could be read as a spear transfixing the dragon). The three main tracery-pieces are patterned with white vine leaves and purple grapes on yellow stems against red grounds and additionally in the top piece, a geometrical leaf-patterned yellow quatrefoil, and in the bottom two, geometrically-leaf-patterned blue roundels.

nIV. The smaller tracery-pieces – a row of three trefoils immediately over the lights, and a triangular piece at the top of the window – are patterned with white and green leaves on yellow silver stain stems, against red grounds. Two large red dagger-shaped pieces positioned symmetrically above the trefoils, contain facing angels in white mantles over red robes, holding texts, set against blue roundels. One of the tracery pieces (according to the Hardman records) was made in 1868 and, on the grounds of style, is, perhaps, the middle trefoil of the three, which contains a blue-patterned shield emblazoned with the Chi-Rho monogram.

OCH nII. 5-light window with tracery. The lights are of plain quarries, and have borders patterned with yellow florets on red grounds. The inner three lights are shorter than the outer two and unlike them are closed at the bottom by a red border (perhaps indicative of structural changes since Pugin's day). The three main tracery-pieces illustrate the Annunciation: with the Archangel Gabriel and the Virgin Mary depicted in the two outer pieces and a vase of lilies in the piece between, all against blue grounds. The figures, vase, lilies and throne-like chair on which the Virgin sits are all in white touched with yellow silver stain. A foliated letter M surrounded by four crowns and contained in a roundel, is at the centre of each of four blue quatrefoils situated in the tracery immediately above and between the lights of the window.

OCH sII. 3-light window and tracery. The lights consist of yellow silver stain, leaf and flower-patterned quarries. The borders in the outer lights are patterned with yellow *fleur-de-lis* on red and green grounds, and in the middle light on blue and red grounds. The principal tracery-pieces are made up of three quatrefoils. There is a leaf-patterned blue roundel in the top piece and red and blue roundels, respectively, containing shields, in the bottom two. The blue diaper shield on the left is emblazoned with a yellow Y-shaped cross, and the white diaper one on the right with a red cross.

OSR sII. 3-light square-headed window in which the middle light is made up of two sections, the upper being just over a third the size of the lower. Each light is formed of yellow silver stain floral-patterned quarries, and each has borders patterned alternately with white leaves on yellow stems and four-petal yellow-centred florets.

Cloister windows. These comprise: ten, two-light, and two three-light, and tracery. The two-light windows are made up of yellow silver stain-patterned quarries; the patterns comprising leaves, flowers, *fleur-de-lis*, and in one case diagonal rows of monograms of the Pugin family initials, alternating with rows of floret-centred stars. Each light contains a differently patterned roundel. The borders are patterned with four-petal yellow florets on red grounds. The main tracery-piece is aligned above and between the lights and contains a central geometrically-leaf-patterned quatrefoil. The grounds in the tracery pieces and the quatrefoils alternate between red and blue diaper. The three-light windows are made up of yellow silver stain flower and leaf-patterned quarries. They contain no roundels and have large white vine leaves in place of the yellow florets in the borders. The tracery in each is comprised of six large pieces – three trefoils over the

lights, two quatrefoils above the trefoils and a diamond at the top. All are filled with patterned-roundels and red rosettes on white diaper grounds.

Confessional windows. Two single-light windows made up of yellow silver stain flower-patterned quarries. Each light contains two leaf and flower geometrically-patterned blue roundels. The borders are patterned alternately with four-part orange, and white leaves on red grounds.

Office records. Order Book, undated, f. 44, (nII, sII–sVIII). *First Glass Day Book,* 1846, f. 8, Oct. 22: 6, 2-light cloister windows, OCH nII; ff. 8-9, Nov. 7 OCH sII tower; 1848, f. 29, Apr. 7, 4: 2-light cloister windows, '4 Old Lights Repaired &/New Shields put in &/part New Borders to do/£1'; f. 38, Aug. 3: 2, 3-light cloister windows '2 Lights with New Shields/'; f. 43, Oct. 12: tracery for I, sII, sIII, sIV, sV; 1849, f. 54, Mar. 20: tracery for nIV & sII; f. 61, Jun. 2: sacristy, tracery for wI, sVI, sV, sVIII, tower; f. 63, Jul. 6: 'To Altering 11 pieces of tracery/for East Window putting/New Centres to each'; f. 66, Aug. 18: To Altering Tracery for/West Aisle Windows [sVIII]/To Altering Tracery for/Tower Windows/3 feet of New Glass in alteration'; f. 70, Oct. 12: tracery for sVIII & sVI; temporary plain quarries for sIII, sIV, sVI, sII, nII, tower, sacristy, nIV, wI, sVIII; stained lights for sacristy & confessional; f. 71-2, Oct. 19: I, sV; f. 75, Dec. 15: tower, perhaps nIII, organ chamber; f. 76, Dec. 20: tracery for nIV; 1850, f. 89, May 9: (nII), f. 90, May 18: 'To Altering North Chancel/Window [nII].../2 Lights & 3 Tracery pieces/part New Border to 2 Lights/309 pieces of glass for Border/.../1 Small Tracery piece...'; f. 105 Nov. 9: plain glass window; 1851, f. 129, Nov. 19: sIII, sIV, sVIII; 1852, f. 139 Mar. 10: fixing windows; 1853, f. 202; Dec. 31: (sII), f. 203, Dec. 31: 'To 3 pieces of Quarry Glass/ptd. with pattern to/repair window in St Augusti,'s Church Ramsgate'. *Cartoon costs per ledger summary*: I, Powell £5.0.0, Hendren £1.13.4; sV, Powell £1.0.0, Hendren 10s.0d; tower, Powell £2.0.0, Hendren 6s.8d; nII, Powell £4.15.0. *Pugin sketch,* BM & AG a. no. not allocated, for nII.

Letters. **Tracery.** *HLRO 304: Pugin to Hardman,* letter no. 437, postmark 'JY 25 1849': 'I go in & out of the church in despair It is the brown Pink leaves on the blue that do all the mischief if you could substitute white I think it would do – is it not daunting this window making I thought would look so well turns out so beastly & yet in the eye the glass looks Rich & beautiful. It makes me miserable & the glass is built in the stonework what do you think about the possibility of substituting <u>white leaves</u> now it is up. I think the lead might be turned up & the white leaves inserted. it is distressing to see It makes me miserable it looks <u>modern</u> positively modern. It is miserable to see I have been so feverish all day but I could do nothing but look at it.'

I. *HLRO 304: Pugin to Hardman,* letter no. 1002: 'I send you by tonights post the East Window for Ramsgate is one you get shot of. borders & pattern work. I use[?] up the figure of Our Lord that is done you must remember that 10 feet off this window the ugliest building may be created it will not do to have any transparent glass.' No. 840: 'I fear the East Window is too heavy & wants white glass but we shall see.' No. 901: 'My East window is really a <u>good job</u> Lady Pembroke was looking at it for a ½ of hour yesterday.'

nII. *HLRO 304: Pugin to Hardman,* letter no. 911: 'I am going to send you the North Window for my church Mr. Knill pays for it & therefore it is as good as any other job & I dont like to leave it too long.' No. 901: 'The last image goes off tonight for my N. window.' No. 842: '2. It will be a great comfort to have the 2 lights for the organ loft & the tracery for N. Window.' No. 965: 'I have made a great mistake in using blue grounds to my tracery it looks beastly the N. chancel window against the flint wall is positively <u>black</u> – I must have pink [?] tracery by & large it is intolerable.' No. 957: '4. It is a dreadful thing if our blues are too light – it will <u>affect all</u> the blues are the stumbling block & if they are not right we cannot get the old effect my traceries are all <u>ruined by blues</u> so much so that if I can get any money I shall apply it to take them out the N. Chancel is absolutely beastly. black I fret everytime I go in more & more'. No. 849: 'I am quite convinced that I have made a mistake in using a Late style of colour for the 2 Saints in my North Window they dont go with the rest of the work.' No. 709: 'You need not send back the cartoons of the Knill window as you can alter it without a fresh drawing.' No. 772: 'The Chantry looks really magnificant & Early has done his job expertly the improvement in the glass is wonderful the Knill window is now completed[?] – you must reclaim[?] the cost & a good profit with any alterations & send at once the account to Walworth[?] as Mr.Knill <u>was anxious to pay</u> when he was here.'

nIII. *HLRO 304: Pugin to Hardman,* letter no. 920: 'I shall never bear the sight of the North tower window we have ruined it that is not <u>you</u> but <u>me</u>. In yellowing the Roses in the ground. The stem is coarse & beastly. vily done like <u>everything Hendren is trusted to do</u> – you can hardly believe the ruin this has caused. you remember I told you how beautiful the confessional windows looked. now this same glass owing to the yellow has lost all the silvery effect it is wretched it looks like yellow! – what experience it requires – but you must profit by this – in all you have in hand keep back the yellow & paint the <u>stems</u> thin & light like nature the only thing I did not see about this window was this wretched stem work & as soon as summer comes – we here shall have to do them again for they are unbearable it will be necessary to go next Spring & get full sized tracings of stem work for it very [sic] difficult ... [continues with the

St Louis ... see sVI below] The North towers lights are now in were it not for the infernal yellow in the Quarry work. they would be magnificent they have a most brilliant appearance but the silver look of the white part is destroyed by the yellow. This is my fault in a great measure only the yellow stain has run about a great deal which makes it worse – but I find the stems must be very fine no yellow about the flowers. yellow is a most dangerous colour a little goes a great way – I believe they would be the 2 best lights yet done but for the heavy yellow stains so much that I think in summer we must change them [continues with the design ... see sVI below] I have had to alter all the patterns we have done for Ottery [Ottery St Mary, Gaz.29] since I have seen the bad effect of using yellow – oh the difficulties of painted glass – I expect you will see me in a straight jacket yet. if I get my own windows right they will be of immense service in tying the combinations of colours – nothing is so beautiful as these geometric windows with subjects or images in quatrefoils they are the true thing when well done – but the work on the Quarry part requires the greatest skill [?] [?] the old work is lovely especially at York – we must get the true thing for our present attempts at this foliage quarry work is Execrable I would hardly have believed we could have designed anything so bad'.

sII. *HLRO 304: Pugin to Hardman*, letter no. 894: 'I am deeply depressed with the effect of the Lady Chapel tracery it looks heavy & almost dark I don't know what to do about them. it is the dark blue that does the harm.' No. 815: 'the moment I can afford it I will pull out the tracery angels in my Lady Chapel which look beastly so beastly that they will for ever destroy my devotion if they remain they just [sic] beastly & the colours are horrid. [see sIII and sIV below for the continuation]'.

sIII, sIV. *HLRO 304: Pugin to Hardman*, letter no. 465: '2. South window for the Lady Chapel S. Augustines Church Ramsgate containing 8 mysteries connected with the life of the Blessed Virgin interspersed with Grisaille.' No. 620: 'The side windows in my church [?] in very dull weather have a fine effect but the East [sII] looks horrid at present' No. 640: 'These side windows look to me most brilliant I was saying my offices in the chancel this morning & the effect is quite changed and I am sorry to say my people don't feel it but I am sure they are far better than all images under canopies they increase the size of the window & are a splendid contribution to the church ... of course there is some degree of new look which cannot be avoided – but it is the true way of treating these side windows in small churches we get plenty & Great sparkling colours [?] the groups fill the quatrefoils perfectly they are to me admirable compositions of filling up – the top trefoils are such an improvement I am well satisfied with this job we want more glass every light we put in is a great improvement the tone of the Lady Chapel is 3 times as good.'

sVI. *HLRO 304: Pugin to Hardman*, letter no. 815 (follows on from extract re sII above): 'while on the other hand the angels in the Chantry windows which come within a circle look beautiful.' No. 920: 'The S. Louis is in & when I say it is Execrable I say too little it is the most beastly thing we have ever produced without Exception. how could you bear to let it go – I assure if [sic] it was not so important to keep out the weather I would not let it stop an hour in the window I am so ashamed of it – & what is worst the angels – kill all to to [sic] pairs these are finely painted faces with Reddish tint and yellow hair – S. Louis is all white hair nimbus face everything. is is so dreadful. I cant bear to look at it & the painting is so bad so faint you cannot see it – the white figure from below looks like a mass of dirty white ... the first return of spring out it must come so you better send me the cartoon to prepare a fresh one. Oh I sink when I look at the beastly things & it is vilely done in the Cartoon, one of Powells Mooney productions while I was away, execrable ... but this beastly production, beastly in design, beastly in drawing, beastly in execution beastly in effect surpasses all failings I ever had to do with. The painting of the angels below it are 3 times as good This window has completely alarmed me we are going down – the painting as painting is so abominable are you coming here we will have [?] & you will see there is no line not a sharp bit about it it looks like a panel of flannel ... altogether it has come like a sheet of ice ... I don't know which is worst the design or the execution but both are infernal I shall paste some paper on it when you have seen it to save my [?] [continues with the N towers, see nIII above] – the design the principal of the design of the S. Louis is poor to [sic] much blue here [sketches the quatrefoil and indicates the trelliswork in the top right foil]. it reduces the centre figure to nothing I believe to produce a really good thing it is necessary to do a bad one first to see where the faults lie I think I shall begin to colour the cartoons It is very costly but it is the only way of ascertaining the effect & I think it would be cheaper in the End.'

sVIII. *HLRO 304: Pugin to Hardman*, letter no. 447: 'You must do that west window of Herbert's for S. Augustines. It will just fill up what difficulty can there be? there are 2 months & a ½ now. 2 lights without tracery nothing can be easier you will ruin the whole job to have such a vacuum. [this letter is in respect of the display at the Great Exhibition]'. No. 452: 'Remember my Font window at Ramsgate is quite a different class from the others it is a paying window charge on completion Herbert wrote about it the other day I am sure you will be able to finish it it is so small.'

wI. *HLRO 304: Pugin to Hardman*, letter no. 894: 'We want the tracery of my west window very badly. We are up to it & are obliged to stop setting so you are answerable for the "salary of the building".' No. 401: 'All the tracery for my

west window must be <u>deadened</u> as it comes right against the roof of the house in perspective[?] & if the glass is very transparent the blue slates will show.' No. 43: 'the tracery of my west window which I thought would come out so well looks miserable – all deficient <u>in the design</u> & arrangement of colour.'

Cloisters. *HLRO 304: Pugin to Hardman,* letter no. 362: 'I send you the tracery & c for my 2 cloister windows.'

Confessional. *HLRO 304: Pugin to Hardman,* letter no. 840: 'The little windows in the confessional are <u>perfectly beautiful</u> that glass used in the quarries has the silvery look so my friend be sure you make all the leafwork of geometrical windows of this glass it is quite lovely.'

Literature. *The Tablet,* 7, 1846, p. 5: letter from Pugin refuting an article in the previous week's issue which he regarded as a very highly coloured account relating to his intended building at Ramsgate.

89 Ramsgate, St George (CoE)
1852. Window designed by J.H. Powell.

Office records. *Order Book,* 1852, f. 194, Aug. 31. *First Glass Day Book,* 1852, f. 164, Dec. 9: 'To A window of Stained/ Glass of 2 lights and Tracery.../2 lights 6'4 x 1'10½ ".../4 Tracery pieces '.

90 Rusthall, St Paul (CoE)
1850. Client: Rev. A.R. Ashwell, Caius College, Cambridge.

Office records. *First Glass Day Book,* 1850, f. 106, Nov. 23: 'a Stained glass Window/of 1 Light for South Window/of Chancel.../£14/8'4" x 1'3". *Cartoon costs per ledger summary:* Powell £1.0.0.

Letters. *JHA: Ashwell to Hardman,* 1850, Jun. 13: 'The Revd A.R. Ashwell will be much obliged if Mr. Hardman will let him know at about what cost he can prepare him a window of the enclosed dimensions [includes sketch], and of some such design as the following. Ground colour – a deep azure. The figure of the Dove in the head as drawn – below – two ornamental oval lozenges with either one or two angels in attitude of praise – Colouring of these & the detail Mr. Ashwell will be glad to leave to Mr. Hardman. At the foot "O ye Angels of the Lord Praise Him & Magnify Him forever" or something to that purport'. Jun. 25: gives Hardman the order to proceed and asks him to consider 'that the sketch which he [Ashwell] enclosed on the thirteenth was meant to convey the <u>general idea</u> ... and not at all to limit Mr H's treatment of it Mr Ashwell wd be glad to have a drawing of the window wh. Mr. Hardman wd. Suggest – before it is actually commenced.' Jul. 10: asks that the legend at the foot of the window be' "Holy Holy Holy Lord God Almighty"'. Sep. 10: inquires about progress of the window. 1851, Jan. 6: 'Mr. Ashwell has seen and very much approves the light for Rusthall Church.'

91 Tunbridge Wells, Dornden
1851. Client: Banks & Barry, 8 Duke Street, London, for Jas(?) Field, Dornden, Tunbridge Wells.

Office records. *Order Book,* 1851, f. 134, Jun. 22, both the Library and the staircase windows are noted as being: 'North Aspect'. Re the staircase window: 'Coat of Arms in Centre Light' and 'Crest of Mr. Field is a hand in armour grasping a globe'. *First Glass Day Book,* 1851, f. 122, Aug. 27: 'A Stained Glass Window/for Library of 4 lights of quarries with Badges & Initials/£8. 10. 10/Transom Window/Above Transom 4'1" x 1'5"/ Below..2'1" x 1'5"/.../A Stained Glass Window for/Stair Case of 3 lights of Quarries with Inscriptions/Badges & Initials/£14/Transom Window/Above Transom 3'7½" x 1'4 ? "/ below do. 1'6" x 1'4 ?"'. 1852, f. 140, Apr. 1: '8 Dozen of Quarries Stained/with patterns as Window/for Library sent 27 Aug/51/£2.8..

Letters. *JHA: Charles Barry junior to Hardman,* 1851, Jul. 23: 'The motto which was promised to be sent for the stained windows to the Library at Tunbridge which you are doing in the L.C. panel is to be Celer et Fidelis.' Aug. 16: request for Mr Field's window for Dornden.

LANCASHIRE
Appleton, St Bede, see CHESHIRE
Broughton, St John the Evangelist, and Hulme, St Wilfrid, see GREATER MANCHESTER

92 Kirkham, The Willows, St John the Evangelist (RC)
*c.*1844, 1848. Client: Rev. Thomas Sherburne.

E window	I		3-light		
N aisle E window	nIII	1.8m x 2.0m	3-light	£35	*c.*1844
S aisle E window (**10.14**)	sIII	1.8m x 2.0	3-light	£35	
Above windows executed by William Wailes					
N aisle W window	nVIII	0.9m x 1.6m	2-light	£16	1848
S aisle W window	sIX	0.9m x 1.6m	2-light	£16	1848

The Tablet of 1844, in describing the Pugin-designed church, refers to the chancel and the two side chapels (the Lady Chapel and the Chapel of the Holy Cross) and mentions that the former: 'will be lighted by six windows all of which will be decorated with stained glass.' There are currently three stained glass windows: I, nIII and sIII – the side windows of the chancel (nII, sII) and of the Lady Chapel (sIV except for the tracery) are now filled with plain glass. The church was opened in 1845 and F.J. Singleton suggests the glass in I is the original. If so, it would have been executed by Wailes to Pugin's design and is, presumably, the altar window referred to by Wailes in his letter to Pugin dated Oct. 15, 1844 (see *Letters* below). Wailes in the letter submits his account for the windows in the side chapels and it seems reasonable to conclude that he executed the glass at present in nIII and sIII.

Descriptions. I. 3-light window and tracery. St John the Evangelist is depicted standing in the centre light in a green-lined, blue mantle over a red robe, in front of a white diaper screen, under a canopy, holding in his left hand a chalice from which a demon is emerging. The canopy has a cinquefoil-head within a pointed arch surmounted by a finialed gable. Strips patterned with four-petal yellow florets on red grounds make up the inner borders of the light, the arch, the gable and its finial. Alternating yellow and white leaves follow the lines of the gable and finial with three yellow leaves forming the apex. The side lights of leaf and berry-patterned white quarries and inner borders of strips of red glass, each contain three blue-foliage, quatrefoil medallions which act as the grounds for scenes from the saint's life (the bottom quatrefoils are concealed by the reredos). The scenes in the left-hand light from the top down are: St John arriving on the island of Patmos, his boat in the background and Christ(?) standing before him; and Agony in the Garden; and in the right-hand light: Crucifixion; and St John immersed in a cauldron of boiling oil, surrounded by standing and seated figures. Between each medallion is a roundel containing a yellow chalice from which a demon is emerging. The borders are patterned with white pelicans on blue and red grounds. Each of the three trefoils which comprise the main tracery-pieces contains a depiction of a seated yellow-winged angel in white holding a horizontal text, on a ground patterned with green vine leaves and yellow grapes on white stems.

nIII. 3-light window and tracery. St Helen is depicted standing in the centre light; she is crowned, has a yellow-lined, white head-dress and is in a red mantle over a blue robe, holding a large upright green cross in her hands. The pavement of yellow squares patterned with black diagonal crosses on which she stands, recedes in perspective, and the remaining areas of the light are filled with rows of quatrefoils – each quatrefoil contains a yellow crown on a yellow foliated-cross against a black ground – alternating with rows of purple-leaf-patterned, ogee-sided, black diamonds. The side lights each contain two blue-foliage diaper quatrefoil medallions on each of which is portrayed a red seraphim holding a yellow plaque inscribed with a symbol of the Passion. From left to right and the top down the symbols are: the crown of thorns encircling the letters IHS; the robe, lance, sponge, bowl and dice; Cross, ladder, loincloth; and the hammer, pincers and nails. Ovals patterned with yellow crosses on black grounds link with the quatrefoil medallions and four black, yellow-patterned roundels flank each oval; there are two similar half-roundels at the bottoms of the lights. White leaves on black grounds fill the remaining areas. The borders are patterned with white-on-black crosses on red and green grounds. The middle two tracery-pieces each contain a red seraphim holding a plaque inscribed in yellow with the initials IHS. The remaining pieces contain roundels patterned with red foliated-crosses within black quatrefoils, surrounded by patterns of green leaves on stems against black grounds.

sIII. 3-light window and tracery. The Virgin and Child are depicted in the centre light; she is crowned, in a blue hooded-mantle over a red robe, standing, cradling the child in her left arm; He is crowned and in a yellow robe holding an orb in his left hand. The remaining areas of the light are filled with a green-patterned diamond trelliswork infilled with quatrefoils inscribed with blue foliated MR monograms on black grounds. The spaces left between the quatrefoils and the points of the diamonds are filled with yellow *fleur-de-lis*. The borders are patterned alternately with blue leaves on stems and yellow *fleur-de-lis* on black grounds. The side lights contain depictions of what appear to be the donors kneeling in profile, in prayer, in front of their patron saints. All the figures are turned towards the centre and their names are inscribed in yellow-on-black bands that run behind them, at shoulder-height in the cases of the saints, and in the bottom margins of the lights, for the donors. St William (Archbishop of York) in a yellow-ornamented white mitre, the pallium, a purple-lined, green chasuble over a blue dalmatic and yellow-lined, yellowish-white alb, holding a crossed-staff

in his left hand; and William Irving in a red mantle over a yellow robe with the maniple(?) hanging over his wrists are in the left-hand light. St William (Archbishop of Bourges) in a yellow-ornamented, white mitre, the pallium, a green-lined, red chasuble over a purple dalmatic and a yellow-lined, yellowish-white alb, holding a crossed-staff in his left hand; and William Heatley in a blue mantle over a yellow robe with a cross on a chain hanging over his wrists, are in the right-hand light. The remaining areas of the lights are filled with rows of touching, yellow leaf-on-stem-patterned quatrefoils with black red-patterned roundels surrounded by white leaves filling the intervening spaces. The borders are patterned alternately with yellow *fleur-de-lis*, and red rosettes on blue and green grounds. The five blue, trefoil tracery-pieces are patterned with yellow *fleur-de-lis*, and each contains a central black roundel inscribed with, in yellow, the monogram MR.

nVIII. 2-light window and a single tracery-piece. St Peter in a green-lined, red mantle over an orange robe, holding a blue key in his right hand and a book in his left is depicted standing under a canopy in front of a blue foliage diaper screen, in the left-hand light. St Paul in a white-lined, red mantle over a green robe, holding an upraised blue, yellow-handled sword in his right hand and a book in his left is posed as for St Peter, in the right-hand light. The canopies have cinquefoil-heads contained within pointed arches which are surmounted by yellow-crocketed and finialed gables. The borders are patterned alternately with red and yellow florets. The tracery-piece is patterned with white leaves around a central blue roundel. The roundel contains a bust of St William of York in white touched with yellow silver stain; the saint's Latin name is inscribed along the bottom section of the rim of the roundel.

sIX. 2-light window and a single tracery-piece. The Ascension is depicted in the left-hand light and the Resurrection in the right. In both scenes the Christ figure is standing enclosed within a green diaper mandorla contained by a red foliage diaper medallion and two hovering, facing angels flank the apex of the mandorla. Immediately below each scene is a figured-blue foliage diaper quatrefoil medallion. In the Ascension, Christ is in a white-lined, red chasuble over a brown dalmatic and a white alb while the disciples are contained in the quatrefoil medallion below. In the Resurrection the only changes are that Christ is in a red-lined, white mantle over an orange robe holding in his left hand an upright staff, fastened to which is a red-crossed, white banner, and the sleeping soldiers are in the quatrefoil medallion below. The tracery-piece is as for nVIII but the bust is of St John the Baptist with the Agnus Dei.

Office records. *Order Book,* undated, f. 43. *First Glass Day Book,* 1848, f. 49, Dec. 16 (nVIII, sIX). *Cartoon costs per ledger summary*: nVIII, sIX, Powell £1.6.8, Hendren 13s.4d.

Letters. JHA: *W. Wailes to Pugin*, 1844, Oct. 15 (included in the 1849 letters; the date can be read as 1849 although it seems inconceivable that Wailes would be employed by Pugin at that time, the more likely explanation is that Pugin passed on the letter and account to Hardman to consider, when costing for nVIII & sIX): 'To Stained Glass forwarded 8th Inst. to new Catholic Church Kirkham Lancashire. To East Window of Lady Chapel [sIII] as per estimate £35/ Two windows for Porch Do. £3/ Side Window for Lady Chapel [sIV] Do. £12/ North Window of Chancel [nII] Do. £16/ East Window to Chapel of Holy Cross [nIII] Do. £35/ South Window to Chancel [sII] £24/ £125. I really feel extreme regret at being compelled to send you the account for the Kirkham glass but having only returned home after nearly 3 months absence copying old glass on the continent. so little money has been paid during that time. That I am pressed to meet some payment due next week. I am very sorry my Brother had not as I fully expected finished the windows earlier. owing to his anxiety to make them as perfect as possible by keeping them in the hands of my best workmen only. and am sure when you see them [?] most fully satisfied. I can only say that I could not do others equally rich for the same price. but having once given you the cost I sent perfectly satisfied [sic]. As the Altar window was paid for when you sent the order. I have not included it.' *Sherburne to Hardman*, 1848, Nov. 10: 'On the whole I like very much your sketches of the windows which you have sent me If it is not too late to attempt a little change. I should prefer somewhat more of animation in the figure of the Ascension by the Arms being more raised; & in that of the Resurrection instead of your two Pastoral figures wh. I don't well understand would not the half opened door of your Monument & your Guards confounded, not sleepg be more intelligible? These are suggestions & do as you see best, only have the goodnesss to finish the work as soon as convenient.' Dec. 21: 'The windows are in their places, & I think look well … This morning I sent off the returned packages with the sketches enclosed.'

Literature: F.J. Singleton, 1983, pp. 32-6, identifies the two saints William. *The Tablet*, 203, 1844, p. 199; 1845, p. 278: description of opening ceremony. Wedgwood (Pugin's Diary): Pugin visits Kirkham, 1841, Jul. 25; 1844, Feb. 28, Oct. 1; p. 58: 'End papers at back of diary [b] [financial calculations] 'Wailes for E. window Kirkham 12.0.0.'; 1845, Apr. 1.

Knowsley, St Mary, see MERSEYSIDE
Lever Bridge, St Stephen & All Martyrs, see GREATER MANCHESTER
Liverpool: Orphan House; Bishop Eton, Our Lady of the Annunciation; Copperas Hill, St Nicholas;

Edmund Street, St Mary; Old Swan, St Oswald; Oswaldcroft; Salisbury Street, St Francis Xavier; see MERSEYSIDE
Salford, St Stephen, see GREATER MANCHESTER

93 Stonyhurst College, Church (RC)

1850, 1851. Client: Rev. Charles Cooke. N.B. the church is orientated N-S geographically. The windows are identified by their liturgical positions.

Silence Gallery W window(**10.19**)	SG wI	2.1m x 1.9m	3-light	£30	1850
N aisle window	nIV	1.8m x 4.0m	6-light	£80	1851

Descriptions. SG wI. 3-light window and tracery depicting the Crucifixion under canopies. Christ on the cross, together with two small donor(?) figures who kneel in profile facing each other at Christ's feet, are in the centre light; St Mary the Virgin in a white head-dress, a patterned-blue-lined, white mantle over a purple robe, in the left-hand light; and St John the Evangelist in a green-lined, white mantle over a red robe, in the right. A red leaf-and-thistle-patterned screen is behind Christ, while those behind St Mary and St John are white and the patterns yellow. The screens are three-sided creating shallow spaces behind the figures. The canopy in the centre light has twin round-arch heads surmounted by ribbed vaults contained within crocketed and finialed ogee arches. A finialed, conical-topped tower rises between the arches and appears to front a corner of a four-sided balustraded structure with arcaded sides. The vaults, tower and arcades are shown in perspective. There are similar canopies in the side lights but their heads are at a lower level than that in the centre light so that more is seen of the arcaded superstructures. The borders are patterned with yellow frond-like leaves on vertical stems against green and red grounds. The tracery-pieces are filled with red diaper: the two larger pieces over the centre light contain small yellow roundels patterned with white florets.

nIV. 6-light window and tracery. Each light contains a scene from the Life of the Virgin Mary. From left to right the scenes depicted are: upper three lights: Annunciation, Assumption, and Visitation; lower three: Angel appearing to Joachim, Marriage of the Virgin, and Presentation of the Virgin. The two central and largest pieces of tracery each contain a depiction of a standing figure: perhaps on the left, Joseph in a white mantle over a green robe, leaning on a stick held in his right hand; and on the right Mary in a white mantle over a blue robe, holding a book in her left hand. The other four pieces each contain a depiction of a standing angel holding a text.

Office records. *Order Book*, 1849, f. 69, Nov. 20 (SG wI), re SG wI: 'Our B Lady & St. John standing by Cross.'; 1850, f. 121, Nov. 4 (nIV). *First Glass Day Book*, 1850, f. 95, Jul 19 (SG wI); 1851, f. 125, Oct. 3 (nIV). *Cartoon costs per ledger summary*: SG wI, Hendren £1.0.0, Oliphant £4.0.0. Oliphant's account records that the payment was in respect of: '3 Cartoons, Crucifixion Window'.

Letters. SG wI. *HLRO 304: Pugin to Hardman*, letter no. 824: 'I send you the sketch for Stonyhurst but I expect this is another of their [?] windows below the skyline & if so it must tinted[?] opaque.' No. 773. 'The Stonyhurst window is finished but it is a great failure the subject does not at all suit the window & it is impossible to make a job – I dont think it can be better but it is very poor it is a window for 3 subjects.' *JHA: Cooke to Hardman*, 1850, Feb. 11: 'I hope I shall not appear too urgent by asking you for some information regarding the progress of the window. As it is put up in honour of the Blessed Virgin & represents the subject of the feast of her Dolours, I should very much like to see it up on that Festival, which is this year celebrated on March 22nd. Fr. Rector, the Revd. Francis Clough has twice asked me about it as he is anxious to have some designs he has in view executed, but first wants to see your window.'

nIV. *HLRO 304: Pugin to Hardman*, letter no.758, postmark 'OC13 1850': 'I send you a rough sketch of the Stonyhurst window but it is sufficient to show what is intended it would make a fine job & just the sort of work for hill [Frederick Hill] you can tell the Stonyhurst people that they shall have a brilliant window if they [?] to you.' No. 792: 'I have no templates for this window for Stonyhurst'. No. 651: 'The inscriptions for the angel in that Stonyhurst window should refer to his meaning the B.Virgin when the angel says Fear not & c you can find it out in any commentary[?].' *JHA: Cooke to Hardman*, 1850, Oct. 4: 'I enclose a cheque for the sum mentioned in your letter of the 20th ult. As I mentioned before the window has given satisfaction; & one result is that Fr Rector, the Revd. Francis Clough wishes to communicate with you regarding your designs and estimate for a large window in our church. Its situation is third in our West Aisle – next to a window representing the Saints of the Society, by Willement. It is to surmount an altar dedicated in honour of our Blessed Lady;[32] & therefore the design is to represent the chief mysteries of her life [he goes on to describe the structure of the window and its measurements, which tally with those recorded in the First Glass Day Book]. The window stands almost 9ft from the ground – our church unfortunately looks almost due North & South.' Nov. 2: 'we hope then that on the first day of May we shall have another fine specimen of your works decorating our Lady Altar, which will be of beautiful Italian marbles. The designs I leave to your good taste – the price is settled at £80.' 1851, Jul. 12: 'there is no

news of the window. Can you mention any day by which I should be sure to have it, if not it were much better for me to break off the bargain we made last November'. *W. Clifford to Hardman*, 1851, Nov. 3: 'It has been quite an accident that you have not had earlier notice of the safe arrival of the window. You have certainly been able to give a real richness of colouring to the glass and many prefer it to any of the other stained windows in the Church. I am not such an ardent admirer of the Gothic, I candidly avow I do not quite agree with them, though I admire the window very much.' *Literature.* Wedgwood (Pugin's Diary): Pugin visits Stonyhurst, 1837, Apr. 1-3.

Warrington, St Elphin, see CHESHIRE

94 Whalley, St Mary & All Saints (CoE)
1848. Client: William Cunliffe Brooks, Manchester.

 S aisle E window sVIII 1.4m x 2.6m 3-light £57.10.0

Description. **sVIII.** 3-light window and tracery. The Virgin and Child are depicted under a canopy in the centre light. Mary crowned and in a green-lined, red mantle over a blue robe, stands in front of a white diaper screen, cradling the Child – who is in a white robe patterned with yellow silver stain florets – in her right arm. St John the Evangelist in an orange-lined, red mantle over a green robe, holding a chalice – from which a blue devil is emerging – in his left hand, is depicted standing in front of a blue foliage diaper screen, under a canopy, in the left-hand light; St Anne in a blue-lined, red mantle over a brown robe, holding a book in her left hand is depicted, similarly posed to St John, in the right. The trefoil-heads of the canopies are each surmounted by four pinnacled-columns, the two inner being taller than the two outer. The columns flank three, two-light Gothic windows each of which is surmounted by a finialed gable. The central windows are larger than the outer ones. The borders are patterned with green and purple leaves on white grounds. The two main tracery-pieces immediately above the centre light each contain, on a blue diaper ground, an inward facing, half-kneeling angel who swings a censer above his head. The other tracery-pieces are filled with blue diaper patterned with white florets.

Office records. *Order Book*, undated, f. 25. *First Glass Day Book*, 1848, f. 36, Jun. 30: the reference to the window as being at the end of the N aisle must be a clerical error, although see letter from J.W. King below. *The Builder* refers to its erection as being at the end of the south aisle in St Mary's Chapel. *Cartoon costs per ledger summary*: Powell £1.6.8, Hendren 3s.4d.
Letters. HLRO 304: *Pugin to Hardman*, letter no. 807: '10 – have you got the templates for the Whalley Window I shall be ready to take that in hand at once.' No. 806: '6. I am very anxious to do the Whalley window if I had <u>the templates</u>'. No. 375: 'the Walley [sic] templates are here you shall have the cartoons so you can write to say so.' *JHA: J.W. King to Hardman*, 1848[?], 'Saty Mar 18 – I have received yours of yesterday ... I am sorry to find that the figure is St. Nicholas and not the Blessed Virgin. The chapel is without doubt dedicated to the latter but the mistake has probably arisen from the ambiguity of Dr Whitaker's account in the History of Whalley. The North Chapel is that of St. Nicholas or as it is now called "St. Nicholas' Cage" and we have it in contemplation to insert a corresponding window there introducing the patron Saint so that it is doubly unfortunate. Perhaps your figure might do for this window only I object to putting <u>another</u> perpendicular window in a building of so much earlier date'. *Brooks to Hardman*, 1848, Mar. 27: suggests subject for a three-light window of a Lady Chapel: 'Perhaps B.V. Mary in centre & monograms in side lights.' Apr. 5: 'Let 3 figures be the Blessed Virgin in the centre & on either side S. Anne and St. John.' Apr. 13: 'Herewith the Blessed Virgin (I must confide to you the important decision of attitude & c) and attendent on her Saint Anne & Saint John – to the former was confided her early & to the latter her declining years.'
Literature. *The Builder*, 6, 1848, p. 405: brief description of the window including the comment: 'The artists are said to have here "exerted all their skill and lavished all the resources of their art' in the attempt to disprove the assertion that the art of glass-painting is lost.'

Wigan, St John, see GREATER MANCHESTER
Winwick, St Oswald, see CHESHIRE
Worsley, St Mark, see GREATER MANCHESTER

95 Yealand Church.[33]
1853. Window designed by J.H. Powell.

Office records. *Order Book 3*, 1852, f. 8, Sep. 18. *First Glass Day Book*, 1853, f. 173, Feb. 24: 'To A Stained Glass East

Window/of 3 Lancet Lights for East Window/2 Lights 10'3" x 1'2"/1 Light 12'8" x 1'2"'.

LEICESTERSHIRE

96 Grace Dieu Manor, Chapel (RC) Now part of Grace Dieu School

1853. Client: Ambrose Lisle Phillipps (entered as Phillips in First Glass Day Book), Garendon Park, near Ashby de la Zouch, who commissioned nIII for Mrs Petre.

N aisle window	nIII, nIV	1.8m x 3.0m	3-light	£60 each

Although the dates in the inscriptions on the windows are 1848 and 1849, the First Glass Day Book suggests that they were not executed until 1853. nIII was ordered in May 1850 so that Pugin may have produced a design, which in general terms was then followed in nIV. Purcell and Edwin de Lisle's *Life & Letters of Ambrose Phillips* say 'the figures were drawn and most correctly modelled by German artists', a statement that seems to have been elaborated by Pevsner, 1960: 'Two N windows designed by German artists under Pugin's general direction and made by Hardman' (not repeated in the revised edition, 1984). There is still sometimes popular mention of German involvement here so it is worth stating that, apart from Enrico Casolani, no artist with German connections was employed in the cartoon room and Pugin would not work to other people's designs. In the present case it is just possible that he had been asked to look at some German painting of the subjects or even at German prints (cf. Erdington (Gaz.177), *Letters*, wI, HLRO 304 letter no. 325).

Descriptions. **nIII.** 3-light window and tracery. The Last Supper is depicted in the centre light, and preparations prior to the Exodus from Egypt, and Melchizedek bringing bread and wine to Abraham, in the left- and right-hand lights respectively. The borders are patterned with white leaves on blue grounds.

The four main tracery-pieces each contain an angel holding a text, while a quatrefoil piece at the top contains at its centre, the letters IHS in red-on-black.

nIV. 3-light window and tracery which in general design is as for nIII. The scenes are concerned with the life of Elizabeth of Hungary (see Order Book 4, f. 77 below).

Office Records. Order Book 4, f. 76, re inscriptions; 'B.S. window [nIII]': 'Of your Charity pray for Laura Widow of the Honourable Edward Petre who gave this window to the capel [sic: corrected in the window] of the Holy Sacrament in the Year of our Lord MDCCCXLIX [appears in the window as of the S. Sacrament A.D...]'. (nIV) 'Of your Charity pray for Maria Countess of Shrewsbury widow of John XVII Earl of Shrewsbury, who gave this window in honour of the glorious Saint Elizabeth of Hungary [MDCCCXLVIII appears in the window]', f. 77: 'Ambrose Lisle Phillips [sic]', is entered at the head of the page, below which are set out details of the subject matter of the windows as follows: nIV – '1st Light St. Elizabeth taking her ducal crown off her head in sight of a crucifix as she entered a church when a child. The Duchess Sophia, her mother in law, and her sister in law, standing by finding fault with her for so doing.' '2nd – The miracle of the Roses as belonging to her married life.' '3rd – As a Nun with distaff & spindle or else one of her cures she performed often taking the habit of St. Francis 3rd order. This is for her widowhood life.' *First Glass Day Book*, 1853, f. 173, Feb. 24 (nIII), f. 185, Aug. 13 (nIV), f. 191, Oct. 24: 'For South side.../To 4 Stained Glass/Windows of 2 lights ea. and Tracery.../Subjects 'Figures of Saints/8 Lights 8'0" x 1'6½"'.../16 Pieces Tracery.../2 Pieces of Stained glass/Tracery for East & West/end of Aisle in Church/.../2 wrt Iron Casements/& Frames'.

Letter. JHA: *Letter Book, Hardman to Phillipps*, 1853, May 18: apologises for window not being done.

Literature. London & Dublin Weekly Orthodox Journal, 5, 1837, pp. 283-6: articles taken from the *Staffordshire Examiner* on the consecration of the chapel. N. Pevsner, *The Buildings of England: Leicestershire and Rutland*, Harmondsworth, 1960, p. 111. Wedgwood (Pugin's Diary): Pugin visits Grace Dieu, 1837, Nov. 24-7; 1839, Sep. 21-3; 1840, Jan. 15, 19, Apr. 27-8, Aug. 8-10, Oct. 9-12; 1841, Apr. 3-5, Aug. 28-30; 1842, Feb. 26-8, Apr. 4, May 18, Sep. 6, Oct. 3-4; 1843 no diary; 1844, Mar. 19-20, Jun. 11-12; 1845, Sep. 21-2; 1846 no diary; 1848, May 2-3 (note 10 refers to Pugin's major extension of a new Blessed Sacrament aisle, with the chapel being re-opened on May 20, 1849); 1850, Apr. 6-8.

97 Little Dalby, St James (CoE)

1851, 1852 and 1853. Clients: E.H. Hartopp, Dalby Hall, Melton Mowbray (nVI, nIV, nV, I); Mr Bunney, Little Dalby, Melton Mowbray (sVIII); Rev. Robert P. Hartopp, Davenport, Bridgnorth (sVI?, sIV, sV); Benjamin Broadbent, builder, Leicester (nVII).

N transept N window	nVI	1.7m x 2.8m	3-light	£65	1851
N transept E windows	nIV, nV	0.4m x 1.9m	1-light	£11	1851
E window	I	2.0m x 3.6m	3-light	£80	1852

S aisle window	sVIII	1.2m x 1.8m	3-light	£17	1853
S transept S window	sVI		3-light	£80	1853
N aisle window	nVII	1.4m x 1.8m	3-light	£17	1853
S transept E windows	sIV, sV	0.4m x 1.9m	1 light	£11	1853

From the dates in the Order Book and the First Glass Day Book, it is clear that Pugin would have been responsible for the designs and cartoons of nVI, nIV and nV. He might have produced a design for I, sIV and sV (in any event the latter two follow nIV and nV), and possibly sVI, but those for nVII and sVIII would have been by J.H. Powell, working close to Pugin's style, if for no other reason than to harmonize with the windows already completed.

Descriptions. **nVI.** 3-light window and tracery. Each light contains a figured scene under a canopy. Christ in a yellow-lined, red mantle over a green-lined, green(?)-patterned robe is depicted enthroned in the centre light. He gestures to standing figures in the left-hand light, and St Mary Magdalene, half-kneeling, in a blue(?)-lined, brown mantle over a red(?) robe, holding an ointment jar in her hands; St Peter in a blue-lined, red mantle over an orange robe, holding the keys in his right hand; and an unidentified saint in a red-lined, green mantle over a blue robe are in the right-hand light. An inscription (much of it worn away) runs along the margins beneath the scenes. The canopies have cinquefoil heads within pointed arches surmounted by yellow-crocketed and finialed gables. Rising behind and above the gables are superstructures (much of the paintwork has gone) which appear to stand on purple pitched roofs between pinnacled buttresses supported by yellow-crocketed flying buttresses. Surmounting the superstructures are yellow-crocketed and finialed gables. The borders are patterned with white leaves on undulating yellow stems against green and red grounds. The tracery includes a large geometrically patterned top piece in the shape of an upturned triangle superimposed on a trefoil, and two smaller geometrically patterned trefoils.

nIV, nV. Single lights filled with a grisaille of white leaves outlined in black on yellow silver stain stems, against black cross-hatched grounds (a good deal of the patterning has disappeared), overlain by a vertical series of bulbous shapes formed by two touching undulating lines of yellow glass – the 'bulbs' are crossed by red diagonals. The borders are as for nVI.

I. 3-light window and tracery. Each light depicts a scene under a canopy representing: Resurrection in the centre light; Agony in the Garden, and Christ Carrying the Cross, in the left- and right-hand lights respectively. An inscription (much of it worn away) is in yellow-on-black, in the margins beneath the scenes. The centre light canopy has a cinquefoil head contained within a pointed arch surmounted by a yellow-crocketed gable; rising behind and above the gable is a superstructure similar to that in nVI, flanked by two green-winged, white- robed angels on pedestals. The canopies in the side lights are lower than in the centre light, their heads are contained in yellow-crocketed and finialed pointed arches and two, two-light Gothic windows surmounted by gables replace the angels. The borders are as for nVI but the grounds are red and blue instead of green and red. The tracery-pieces are filled with geometrically patterned, red-rimmed roundels on white grisaille grounds. The paintwork throughout the window is in poor condition.

sVI. A 3-light window and tracery. Each light contains a scene in a medallion against a grisaille ground. The scenes illustrate the parable of the Prodigal Son (see *JHA Letters, E.H. Hartopp to Hardman*, 1852: Jun. 23) but are obscured by the organ.

sIV, sV. Similar to nIV and nV but the undulating lines are red rather than yellow, the diagonals yellow-beaded instead of red and the grounds in the borders green and blue as opposed to green and red.

Office records. *Order Book,* 1850, f. 109, Sep. 17 (nIV–nVI), re nVI: 'subject our Lord. Inscription in Legible Characters – wherefore I say unto thee, Her sins which are many are forgiven for she loved much. Luke 7 v.47 [requested by E.H. Hartopp in a letter to Hardman dated Nov. 4, 1850]'; re nIV & nV : 'of geometrical grisaille and bands of colour introduced'; 1851, f. 142, Sep. 1 (I, sIV & sV), re I: 'East window'; re sVI: '(subject) In Medallions'; 1852, f. 184, Jul. 27, re-entered Order Book 2, 1853, f. 33, undated (sVI?, sVIII); *Order Book 2,* 1853, f. 98, Sep. 23: re nVII: 'Inscription. In memory of Reuben Broadbent son of the Master Mason of this church. Born died aged [this is as it appears in the window except that born and died are substituted with AD 1851]'. re I 'White Roses for Tracery of East window in place of blue'. *Order Book 3,* 1853, f. 74, Sep. 23 (nVII). *First Glass Day Book,* 1851, f. 123 Aug. 27 (nVI, nIV & nV – Day Book refers to E side of chancel instead of transept; 1852), f. 158, Oct. 18 (I); 1853, f. 173, Feb. 14 (sVIII), f. 176, Apr. 2 (sVI), f. 196, Nov. 26 (nVII), f. 197, Nov. 26 (sIV, sV). *Pugin sketch,* BM & AG a. no. not allocated, for nVI,

Letters. *HLRO 304: Pugin to Hardman,* letter no. 498 (re nVI): 'what is the meaning of the little Dalby window the tracery was first done with foliage. I very[?] much[?] disliked[?] figures, then we <u>were to have</u> the holy trinity. now it is done away & we have[?] to do foliage again!!!' *JHA: Letter Book, Hardman to Hartopp,* 1850, Aug. 30, re nVI: 'I sent the tracery to Mr. Pugin with the remarks you made to me & he has sent me the enclosed sketch – He says the subject will come

in very well in the three lights Our Lord in the centre with the Apostles or guest, on one side & the woman kneeling with figures behind her as other guests in the third light. This will tell the history very well & the text referring to it can come below the subjects, the only thing I did not mention to Mr. Pugin was the low canopies but the ones he has put in are not very high ones they can however be altered.' Sep. 5: 'I beg to acknowledge the receipt of your letter returning the sketch, & fortunately Mr. Pugin was with me when it arrived – He says the alterations you point out can be made without difficulty and he will attend to them when the Cartoons are made … The Figures are quite as high as the width of the light will allow.' 1852, Mar. 17, re I 'I have been from home almost ever since the receipt of your letter of the 4th or I should have answered it before. The drawing was not made to scale so that it does not show the exact proportion of the lights. I quite agree with you that the borders & columns occupy too large a space & will take care that in the Cartoons the groups shall be as large in proportion as those in the North Transept & occupy as much space as the lights will allow. The figure of Our Lord in the Resurrection shall not look as though it were in a sitting posture. It is difficult in a small sketch like this to convey the exact idea of what is intended. In the third group the female figure is not intended to represent the Blessed Virgin but one of the women to whom Our Lord said "Daughters of Jerusalem weep not for me & c." But if you prefer a soldier as one of the rabble there can be no objection. I have the templates & the Cartoons shall be proceeded with as soon as possible.' *JHA: Letters, Hartopp to Hardman,* 1850, Sep. 9, re nVI: 'I should much wish the beautiful amber colour and green which you showed me on the Angels for Tofts Church [West Tofts, Gaz.120] to be prominently introduced.' Oct. 25: templates forwarded together with sketch for proposed window: 'the window has a <u>Northern aspect</u>. Please to avoid all slaty blues and dull reds … I should like to know your ideas for the Light No. 1 – should prefer some single Emblem unless the opening is considered too large to be filled by it'. 1851, Mar. 25: 'I will leave the Design for the Tracery and Foliage to you – only reminding you that I dislike dull red and slaty blues … You will remember to omit the Nimbus around the head of the Penitent'. Mar. 30 'I return the Cartoons with which I am especially pleased with the exception of the Design for the wheel at the top. Any representation of God the Father in a Human Form is repugnant to Protestant feeling and could not be admitted into one of our churches. Some other Design must therefore be substituted and I really know not what to suggest [see *HLRO 304, Pugin to Hardman*, letter no. 498].' Aug. 6: 'I am anxious to know how soon I can have the windows. The Transept is ready and I am extremely desirous to have them as soon as possible. I understand that Mr Keal's window is to be put up in Melton Church [Gaz.98] early next week. [Suggests that it would be a good idea to have his & Keal's put up at the same time]'. Sep. 1: 'I made a mistake in my letter to you of yesterday. I said Ascension instead of Resurrection. It is the Baptism, Resurrection and Agony that I propose for the new window.' Sep. 13: 'I feel anxious as I stated to you in my former letter that you should if possible give me a day here & see the window which has been put up [nVI], and to discuss some matters connected with the one in contemplation [I]. I am not on further reflection altogether satisfied with the subject I have proposed and think that the "Crowning with Thorns" or "Bearing the Cross" would harmonize together with the other subjects than the Baptism'. Dec. 21: 'The Church is now approaching completion and I am very anxious that no time should be lost in ordering the new window [I].' 1852, Apr. 14: 'I sent you the other day from Dalby two sets of Templates one for the S. Transept window, the other a S. Aisle window which one of the [?] in the Village seems anxious to have filled with stained glass in memory of his wife should the expense not be too great for him … what would be the cost of the window with an inscription filled with three nice Tracery and a handsome border in the same style as the two small side windows in the N. Transept … I trust you will oblige by making the sight[?] lines of the windows you are about to execute as <u>narrow as possible</u>. I see they vary very much in your windows and I cannot say how infinitely superior I think is the effect produced by the narrow ones. Those in Mr Keal's window at Mowbray are just what I like … You might perhaps bring the Cartoon for the East window [I] with you.' Jun. 23: not received Cartoons for the E. window yet. Aug. 4: 'I have had the opportunity of seeing again the cartoons in which Mr. Powell has made some alterations I suggested to him on Monday. I like them very much now with the exception of the Head Dress of the Roman Soldier in the Bearing of the Cross which I observed to Mr. Powell on Monday does not give the idea of a Soldier at all … I trust you will be able to get forward with the Cartoons of the "Prodigal Son [sVI]"'. Oct. 26: re I 'I find it on the whole extremely satisfactory … The Groups are charming and leave nothing to be desired – The only fault I find with it is the same I found with the N. Transept window viz that the Tracery in the head of it is <u>too dark</u> for the lower part thereby arresting the eye as it ascends and presenting a whole not entirely harmonious It strikes me you have not sufficiently considered the darkening effect of the heavy mass of Stone Tracery in the head of the window – The chief defect consists in the context of the pale straw coloured pinnacles and the comparatively dark blue rosettes with which the glass above is studded. Had the Pinnacles been of the gold yellow hue of those in the N. Transept window the blue would not have been nearly so objectionable – As it is the contrast is too great and indeed the glass in the Trefoils immediately above the Pinnacles is rendered nearly opaque by the large blue spots. I think if these were replaced by others of a silvery white

where the ground is yellow, or pale yellow where it is white, a very great improvement would be effected. The exchange of the green Trefoils in N. Transept window [nVI], for others of white and yellow has made the most <u>surprising improvement</u> in that window. I should like you to see the E. window and I hope that when the S. Transept window, [sVI], is put up you will favour me with a Visit & see the two. I am anxious to know if you can ascertain it whether the Glass in the background of the E. window is <u>the same</u> as that in the similar position in N. Transept – it appears to me <u>colder</u> but I am not sure whether it is the difference of aspect it certainly does not please my eye so much ... Can you inform me ... whether Glass has been ordered for the two Lancets in S. Transept [sIV, sV], corresponding with those in N. T ... and if so whether they were ordered by my brother or myself. In any case we must have it.' *R.P. Hartopp to Hardman,* 1852, Oct. 13: 'I trust it has not escaped your memory that there is a window to be executed for the South Transept [sVI], for six months have now elapsed since we agreed upon the details, and, to speak candidly I feel grievously disappointed that the Cartoons have not yet even been forwarded, from which it would seem that no progress whatever has been made during those six months ... now that the church is so <u>nearly complete</u>, this deficiency is the more glaring ... My brother will be writing to you no doubt on the subject of the Chancel window [I: see E.H. Hartopp's letter dated Oct. 26, 1852]. I shall therefore confine myself to a general expression of admiration.'

98 Melton Mowbray, St Mary[34] (CoE)
1851. Client: John Keal.

S transept E window	sV	2.4m x 3.6m	4-light	£85

Description. **sV.** 4-light window and tracery. Each light contains a depiction of a saint standing barefoot under a canopy in front of a foliage diaper screen (the colour sequence of the screens is, red blue, red, blue), in a frontal pose, with his head turned towards the centre. An inscription (see Order Book, f. 101 below) in yellow-on-black runs across the bottom margins of the window. From left to right the saints are: St Luke in a green-lined red mantle over a white robe, holding a book – on the top edge of which lies a small brown ox – in his right hand and a quill in his left; St Paul in a green-lined, red mantle over a yellow robe, holding a downturned sword in his right hand and a book in his left; St James the Great in a green-lined, purple mantle over a greenish-white robe, holding a club in his right hand and a book in his left (although the attribute is that of St James the Less the inscription reads 'SANCTUS JACOBUS MA'); St John the Evangelist in a blue-lined, green mantle over a purple robe, holding a quill in his right hand and a book (on the top edge of which perches the figure of an eagle) in his left. The canopies have trefoil heads contained within pointed arches surmounted by yellow-crocketed and finialed gables. Rising behind and above the apices of the gables are superstructures in the form of sections through a nave and aisles church where the naves appear as two-light blue Gothic windows with yellow-patterned and gabled rose windows above, surmounted by yellow-crocketed and finialed gables – all flanked by yellow-pinnacled buttresses; and the aisles are long round-headed, red single-light Gothic windows beneath yellow-crocketed, pitched roofs. The borders are patterned with white leaves on yellow undulating stems against purple and green grounds. The tracery-pieces are made up of three large circles in a triangular formation over the lights. Each circle contains four white-patterned roundels, in which are red quatrefoils patterned with red and white leaves around green-floreted centres, linked by a central diamond-shaped grid of white-beaded glass. In the circle at the apex of the triangle the grid is replaced by a red diaper roundel containing a yellow lion rampant, in the topmost circle.

Office records. *Order Book,* 1850, f. 101, Aug. 7 (sV): 'Inscription: Mary Christian Keal the wife of John Keal, She [who] died November [Nov] 7 1849. Aged 54 years [54]. Dead in Christ, [the square-bracketed insertions quote the substitutions made in the completed window]'. *First Glass Day Book,* 1851, f. 121, Aug. 13 (sV).

Letters. HLRO 304: Pugin to Hardman, letter no. 271: '3. I suppose I may proceed with the Melton Mowbray window a one of saints under canopies.' No. 722: 'I shall attend to the Melton window but I don't think I can get it done here.' No. 721: 'I send you 2 sketches for the window at Melton – you can explain to him that in the geometrical work – was included shields & c but that not knowing anything of the person to be commemorated I did not indicate this – also they must select some saints if they have images & canopies with references to them clearly on the [?].' No. 746: 'what has become of the Melton Mowbray Window? let me know about this.' *JHA: J. Day to Hardman,* 1850, Jul. 19: includes a mention of a red lion two-thirds triumphant. Keal to Hardman 1850, Aug. 31: 'Mr Day has given me the two sketches for the windows which you have been kind enough to forward to him. I have made choice of the one with figures. I should like it to be executed and put in before the latter end of the year. The figures I wish to be introduced are St. Luke, St. John, St. Paul and St. James and the demi lions & a sconce[?] in the shield at the top.' Sep. 30 (in 1851 box): 'I wish you would send me your design of the whole window with what you would have introduced into the three wheels in the

upper part, and the sort of drapery you intend using for the figures. Such a simple and inexpensive design which you [?] the other day will be sufficient'. 1851, Jul. 14: 'The inscription for the <u>window</u> only which I sent you was the following I think. Mary Christian Keal the Wife of John Keal who died November 7th 1849 aged 54. "Dead in Christ"'. Jul. 30: 'The time you have fixed upon (Monday 11th) will do very well for putting in the window'. Aug. 11: 'I like the window now it is in its place very much, I think it is a very suitable memorial of a dear and departed relative.'
Literature. Wedgwood (Pugin's Diary): Pugin visits Melton Mowbray, 1848, Aug. 26.

99 Melton Mowbray, Thorpe End, St John the Baptist (RC)
1841.

| E window | I | 1.7 m x 3.3m | 3-light | £70.15.0 |

Pevsner, 1960, quoting Stanton, refers to the design as St John and two kneeling donors, and attributes it to Pugin: the window is not mentioned at all in the revised edition, 1984. It was made by Willement (see *Literature* below) who does not refer to Pugin, but, then, he did not mention Pugin's designs when recording details of the windows at the Hospital of St John, Alton (Gaz.148).

Description. **I.** 3-light window and tracery. St John the Baptist in a blue mantle over a red robe, holding a book – on which stands the image of a lamb – in his right hand is depicted , in the top half of the centre light, under a red pointed arch-headed canopy surmounted by a yellow-crocketed and finialed gable. A kneeling, praying figure with an inscribed scroll undulating in an S-curve from his hands to above his head, is depicted in the panel next to bottom of each side light. The one on the left, has, perhaps, tonsured hair, is in a green-lined, red mantle over a white robe and the maniple(?) hangs over his wrists. The one on the right, has long flowing hair and is in an orange-lined, blue mantle over a red robe. The remaining areas of each light is filled with a grisaille of yellow oak leaves and acorns on stems overlain by a vertical series of touching, white-outlined, quatrefoils containing concentric bulbous shapes similarly outlined; the quatrefoils are crossed vertically, horizontally and diagonally by leads, the intersecting points of which are masked by yellow and blue leaf-patterned red roundels. The borders are patterned with alternate small yellow and blue roundels on which are a black bird, and a vertical yellow band, respectively, in the side lights; and a yellow letter E, and a white I(?) in the centre light. Three large quatrefoils comprise the main tracery-pieces. The topmost contains a representation of Christ on the Cross against a blue ground; the other two each contain a red shield emblazoned with symbols of the passion (that on the left, a hammer and the crown of thorns bounded by three nails; and on the right, the column crossed by the lance and the sponge on a staff, flanked by two other objects, the scourge(?) and the chalice(?); all against a grisaille similar to that in the lights.
Literature. N. Pevsner, *The Buildings of England: Leicestershire & Rutland*, Harmondsworth, 1960, p. 191. *True Tablet*, 10 & 103, 1842, pp. 159, 207, reports on the opening but no reference to the glass. 'Ledger of Thomas Willement', p. 70, (microfilm at Borthwick Institute of Historical Research, York): 'The Revd. Thos. Tempest, Melton Mowbray. 1841 July 5th. To an altar window for St. John the Baptist/Chapel Melton Mowbray with figure of St. John/in centre window canopy & 2 kneeling figures/in side openings with ornamental borders & c/70.15.0 Packing Case, packing & Booking 1. 2. 0 [total] 71.17.0'.

100 Mount St Bernard Abbey (RC)
*c.*1841. Pugin's diary and Lord Shrewsbury's letter to Ambrose Phillipps de Lisle (see below) suggest the chapter house windows were made in early 1841, perhaps by William Warrington to Pugin's designs. The largest window, over the entrance, is hexagonal in shape, approximately 1.2m x 1.2m. It consists of seven individual leaf-patterned, blue roundels, two along each of the vertical sides of the hexagon, one in each of the top and bottom angles, and one in the middle. High up on the same wall is a quatrefoil-shaped window patterned in the middle with a red-centred white quatrefoil over a blue roundel and red, blue, yellow and white leaves. There is a similar one on the wall opposite. In addition to these there is some plain brown glass in the foils of the tracery trefoils of two, two-light windows in the entrance wall.
Letters. *E.S. Purcell and E. de Lisle quoting Lord Shrewsbury to Ambrose Phillipps de Lisle,* Aug. 14, 1841: 'Pugin tells me the stained glass in the chapter house is excellent; let me know your opinion.'
Literature. *London & Dublin Weekly Orthodox Journal,* 5, 1837, pp. 284-5: description of the setting and the opening of the monastery, taken from the *Staffordshire Examiner.* Purcell & de Lisle, 1990, p. 80. Wedgwood (Pugin's Diary): Pugin and Mount St Bernard Abbey: 1840, Jan. 1: 'Began St Bernds Mon'. 1841, Jan. 4, p. 50: '[d] stained glass for St. Bernard's 25.0.0'; 1844, Jun. 12, visits monastery.

101 Over Whitacre, Church [35] (included here in error, should be under WARWICKSHIRE).
1853. Window designed by J.H. Powell.

Office records. *Order Book 2*, 1853, f. 75, Jul., re subject – 'with words Sursum Corda'. *Order Book 3*, 1853, f. 50, Jul. *First Glass Day Book*, 1853, f. 199, Dec. 21: 'To A Stained Glass/Window, being centre/Light of East Window/…/1 Light 9'6" x 4'3"…/ Subject the Ascension of Our Lord'.

102 Shepshed, St Winefride (RC)

Now a private house. This church with a school in the basement was built to Pugin's design in 1842 (illustration in Atterbury & Wainwright, 1994, p. 67) but no information about stained glass is known.

103 Syston, Ratcliffe College (RC)

The first buildings of this RC college, founded as a novitiate for the Rosminian Fathers and designed by Pugin, were opened in Nov. 1844. The college became a school in 1847 by which time the buildings had been doubled in size and a much larger chapel opened (Wedgwood). The original chapel is at the end of the N front and contains original stained glass (Pevsner). If this is so and it was installed in 1844 it seems likely to have been designed by Pugin and made by Wailes.

Literature. N. Pevsner, *The Buildings of England: Leicestershire and Rutland*, Harmondsworth, 1960, p. 216. Wedgwood, 1985, p. 89, note 8

104 Wymeswold, St Mary (CoE)

*c.*1845, 1848. Client: Rev. Henry Alford.

Chancel E window	I	3.2m x 4.9m	10-light		(Wailes *c.*1845)
W window	wI	2.3m x 2.8m	3-light		(Wailes *c.*1845)
S aisle W window	sIX	1.2m x 2.4m	2-light		(Wailes *c.*1845)
N aisle window	nVIII	1.0m x 2.1m	2-light		(Wailes *c.*1845)
S aisle window	sVIII	1.4m x 1.6m	3-light	£15	1845
N aisle W window	nIX	0.6m x 1.8m each light (3 lights)		£20	1845
N and S aisle windows	nV–nVII, sV, sVII tracery heads only			£15 (four)	1845
N aisle E window (**10.20**)	nIV	2.1m x 2.0m	3-light★	£20	1848

★1 light and tracery of stained glass

Descriptions. **I.** 10-light window in two rows of five and tracery. A barefooted saint under a canopy is depicted in each of the lights except for the middle lights in each row, where St Mary the Virgin (top) and Christ (bottom) are portrayed. All the figures stand upon receding black and white triangular mosaic pavements, in front of white screens made up of quarries, patterned so that each group of four forms a cross. From left to right the figures are: upper – St Andrew in a green-lined, red mantle over a blue robe, holding a book in his right hand and a diagonal cross in his left; St John the Evangelist in a blue-lined, red mantle over a green robe, holding a chalice in his left hand; St Mary the Virgin in a white head-dress, white-lined, blue mantle over a red robe, holding a book in her right hand; St Thomas in a patterned, blue-lined, purple mantle over a red robe, holding an upright lance in his right hand; St Barnabas in a blue-lined, red mantle over a blue robe holding a pile of stones on his right hand. Lower – St James the Great in a blue-lined, green diaper mantle over a wine-red robe, holding a book in his right hand and a staff with a flask fastened to the top, in his left; St Peter in a green-lined, yellow diaper mantle over a red robe, holding two keys, one white, one yellow, in his left hand; Christ as Salvator Mundi, in a yellow-lined, red robe, raising his right hand in blessing. St Paul, in a yellow-lined, blue diaper mantle over a red robe, holding a downward pointing sword in his right hand and a book in his left; St Matthew in a white lined, yellow diaper mantle over a red robe, holding an upright lance in his right hand, and what appears to be a set square in his left. The canopies have trefoil-heads, those in the bottom lights being surmounted by a row of three crocketed and finialed gables and those in the top by a short-finialed gable flanked by two rounded forms. The heads are filled with blue rinceaux grounds except for that above Christ which contains four kneeling angels. The tracery-pieces are filled mainly with white and yellow silver stain rosettes on red and blue grounds, but in the topmost piece there is a flame encircled, yellow Chi Rho monogram(?) and in the pieces immediately below, the letters IHS in yellow silver stain. **wI.** 3-light window and tracery. The lights are made up of white quarries with patterns outlined in black, much of which have been worn away. In the middle of the centre light, is a red vesica containing a representation in white of the Agnus Dei. Above and below are red roundels inscribed in yellow with the letters IHS. Blue roundels containing

the symbols of the evangelists are at the tops and bottoms of the side lights. Those in the left-hand light are: top, angel; bottom, green-winged white ox; the equivalent in the right-hand light are: green-winged, yellow lion; and yellow-winged pink eagle. The borders are made up of alternate rectangles of blue, red and patterned-yellow glass. The tracery-pieces contain yellow and green leaf patterns around red and blue rosettes. The middle piece has the letters IHS inscribed in yellow at its centre.

sIX. 2-light window and tracery. St Clement and St John the Baptist are depicted, standing against blue rinceaux grounds, under canopies, in the left- and right-hand lights, respectively. St Clement is in a yellow-ornamented white mitre, a yellow-lined, red chasuble over a green dalmatic and a white alb, holding a crozier in his right hand and a book in his left. An inscription below reads 'Sanctus Clemens/Memento Henricum Alford/Sibi Vindicavit Christ'. St John the Baptist is in a white-lined, purple mantle over a yellow robe, holding a circular black plaque with a yellow-beaded rim, containing the emblem of the Agnus Dei, is in the right-hand light. An inscription below reads 'Sanctus Johannes Baptist. Baptizatum Intemeratum. Anno Salutis MDCCCXLIV'. The canopies have trefoil-heads contained within pointed arches surmounted by yellow-crocketed and finialed gables. The borders are patterned with yellow leaves on white stems against light and dark blue grounds. The main tracery-piece is a large red trefoil patterned with blue vine leaves and purple bunches of grapes on yellow stems. The stems intertwine to form a circle around the centre in which is depicted the Agnus Dei against a blue diaper ground.

nVIII. 2-light window and tracery. St Stephen and St Philip are depicted, under canopies, in the left- and right-hand lights, respectively. St Stephen is in a red diaper dalmatic over a white alb, holding a blue palm in his right hand and a pile of stones in his left; St Philip is in a yellow diaper dalmatic over a white alb holding a book in his hands. The canopies have trefoil heads contained within orange-crocketed and finialed ogee arches. The tracery-pieces comprising a quatrefoil and two trefoils are filled with orange and blue diaper grounds respectively. The former is patterned with white-centred red rosettes and green leaves, around a red-rosette-centred green roundel overlain by four white leaf-patterned blue rosettes arranged symmetrically around its centre; and the latter each contain a yellow crown surrounded by three red rosettes.

sVIII. 3-light window and tracery. The lights are made up of white quarries patterned with a three-part leaf outlined in black, against black-hatched grounds. Each light contains three, symmetrically placed, geometrically patterned, white diaper roundels, except for the middle roundel of the centre light which is larger than the other eight and contains a red-rimmed blue roundel on which is a depiction of a purple Agnus Dei, in front of a red banner fastened to a yellow crossed staff. The borders are made up of pieces of red, green, blue and yellow patterned glass. The two main tracery-pieces are trefoils filled with white rinceaux ground patterned with three red rosettes around a red roundel that contains a small white crowned head.

nIX. 3-light window and tracery. The lights are made up of white quarries patterned with yellow silver stained-centred flower heads outlined in black. Each light contains two geometrically patterned roundels, one near the top and the other near the bottom. The borders are patterned with alternate red rosettes and yellow *fleur-de-lis* on blue and green grounds. The tracery-pieces are filled with red, yellow, and blue geometrical patterns on white grounds.

nV–nVII, sV, sVII. 3-light windows and tracery. The lights are of plain white quarries except for nine black and yellow silver stain patterned quarries which form a diamond in the middle of each light. The tracery pieces are filled with geometrically patterned stained glass.

nIV. 3-light window and tracery. The Nativity is depicted under a canopy in the centre light, with the inscription 'GLORIA IN EXCELSIS DEO' in black-on-white in the margin below. The canopy has a cinquefoil head contained within a yellow crocketed and finialed ogee arch. The side lights are filled mainly with plain white quarries, but some, towards the middle of the lights, are marked either with black and yellow silver stain patterns, or black-outlined scrolls containing the letters IHS. The borders are patterned with alternate yellow *fleur-de-lis* and blue, four-petal florets. The main tracery-pieces are three large red quatrefoils which contain depictions of half-length angels holding texts. The remaining pieces are patterned with white vine leaves and bunches of green grapes on yellow stems, against red grounds.

Office records. Order Book, undated, f. 2, re entry Dec. 15, 'Altering 2 of the above windows with Ornamental Quarries [these would be sVIII & nIX, see undated letter from H. Alford to Pugin below]'. *First Glass Day Book*, 1845, f. 1, Dec. 15 (sVIII & nIX and tracery for four of nV, nVI, nVII, sV & sVII); 1846, f. 2, Mar. 13: 'Altering Plain Quarries &/Borders in 6 Windows sent/before to figured Quarries &/Altering 15 Centres do…£5.10.0'; 1848, f. 30 Apr. 22 (nIV). *Pugin sketch*, BM & AG a. no. not allocated, of a detail of nIV.

Letters. **nIV.** *HLRO 304: Pugin to Hardman*, letter no. 375: 'We cannot find the nativity for the S. Transept Ushaw [Gaz. 40] have you got it I want it for Wymeswold.' No. 806: '10 I shall send you the N. Window of Wymeswold … this week.' No. 994: '2. I have just had a letter from Wymeswold Mr. Allford [sic] is very anxious for his window the pupil [?] who

gives it is just leaving pray write to him by post & tell him when he can have it.' *JHA Pugin to Hardman*, undated, marked '1845 box': 'I send you 2 windows for Wymeswold. the South one 3 lights without tracery £15.0.0. the N W one 3 lights & tracery 20.0.0 [written alongside in the margin 'full price altered by Mr. Alford']. I have drawn a pattern on the Quarries but I think you <u>better omit it</u> & make the rough thick <u>glass plain</u>. I think you will understand them of course you will get the lead work carefully set out. I have not the time nor patience for it but I have marked everything & the colours. – you will of course use our new colours. you better if you find any difficulty set out the Lead work on <u>thin</u> paper & send them to me to see by post.' Undated, marked '1845 box': 'the Quarries for Wymeswold though plain will be <u>square</u> as they must not come in to the pattern'. Undated, marked '1845 box': 'The 2 side pieces of tracery for Wymeswold are the same as the top which I have drawn. All the tracery for the trefoils will be the same but I am not quite satisfied about the templets [sic] they have sent. I think you better write to Myers & tell him to get you an accurate set he has men at work there.' *Alford to Pugin(?), 1846*, undated: 'My dear Sir I wrote some time since respecting the E window of the North aisle [nIV], which a friend of mine has offered to give – and as he seems willing to give <u>more</u> if required we should have <u>figures</u>, by all means. I send a suggestion for the same. The East Window [I] is now in, and we like it very much indeed. The colours are paler and more brilliant than any modern window I have seen – and the figures beautifully designed. This is by far the best thing we have. The tracery heads [nV, nVI etc] which Hardman has done we very much like; but <u>not so</u> the two whole windows [nIX, sVIII]. They are altogether a very inferior job and I must confess I do not like to see them in the Church at all: so much so that I have determined to appropriate the donation which furnished one of them to another purpose, and bear the expense myself, for I am sure the donor will be disappointed. He has made the lights of plain transparent glass instead of flowered or figured quarries as the tower window [wI] is done – and this gives them a mean & hall staircase sort of look. Can we by sending them back have the plain glass altered? ...Will we see you again before our opening?' *Alford to Hardman, 1848*, Apr. 20: 'The window [nIV] has arrived safe ... I like it very much all but the face of the child which is not pleasing.'

Literature. Belcher, 1987, p. 157, quoting from Anon. [H. Alford], *A History and Description of the Restored Parish Church of Saint Mary, Wymeswold, Leicestershire*, 1846: 'The whole of the figures in the stained glass windows, were executed by Mr. Wailes, of Newcastle, from drawings by Mr Pugin; the emblematic work in the north aisle, and south-west window of south aisle by Mr. Hardman, of Birmingham', a quotation which is also used in the hand guide to the interior, available in the church. *The Ecclesiologist*, 4, 1845, p. 194: a paragraph reporting the work in progress; pp. 286-7 (a more detailed update, including the information: 'the great east window [I], a new one entirely, is being stained. The north and south windows [nII, nIII], are being done in Powell's quarries, to prevent transparency, but with the hope of one day exchanging them for something more costly. The other two windows [nIII, sIII] ... have plain glass with stained heads, bearing emblems of the Passion.... In the nave every window head, and three entire windows [the designs for sIX, nVIII and wI are described] will be stained glass'. Wedgwood (Pugin's Diary): Pugin visits Wymeswold, 1844, Apr. 2, Jul. 18, Dec. 3; 1845, Apr. 5, Jan. 30, Sep. 17, Oct. 20 'Sent Wailes Wymeswold window, £12.0.0; p. 61' [End papers at back of diary] [b], [e]) and [f]', refer to lists of expenses, small orders and stained glass work for 1845 in respect of Wailes and others. The diary itself reveals one of the items on the lists is 'Wymeswold tower W 18' 1845; 1846 no diary.

LINCOLNSHIRE

105 Algarkirk, St Peter & St Paul (CoE)

1851-2. Client: Rev. Basil Beridge. Supervising architect: R.C. Carpenter.

Chancel E window	I	4.0m x 6.6m	5-light	£190	1851
Chancel N windows	nII–nIV	1.2m x 3.5m	2-light		1852
Chancel S windows	sII–sIV	1.2m x 3.5m	2-light		1852
Chancel S window	sV	0.5m x 2.4m	1-light	£9.10	1852

Total cost of nII–nIV and sII–sIV £168

Descriptions. **1.** 5-light window and tracery. The Crucifixion is depicted under a canopy in the middle of the centre light, and a scene from the life of St Peter or St Paul, also under a canopy, in each of the other four lights. The panels at the tops and bottoms of the lights are filled with grisaille. The paint has largely disappeared from the features of the figures in the scenes, which are enacted in front of alternately red and blue grounds, and are from left to right: St Peter walking on the sea; St Peter receiving his Charge; Crucifixion; Conversion of St Paul; Martyrdom of St Paul. The cinquefoil heads of the canopies are contained within pointed arches surmounted by yellow-crocketed, short-finialed gables. Rising above and behind the gables are superstructures which give the impression of being the facades of three-bay, towered buildings, the centre and wider rectangular bays being filled with red diaper and the round-headed archways of the side bays containing two-light Gothic windows with green rose windows above. The grisaille is of white leaves

outlined in black on black cross-hatched ground (much of it has been worn away) overlain by a red-outlined convex decagon with a blue geometrically patterned quatrefoil at its centre. Alternate yellow and red-beaded triangles (elements of a series of incomplete diamonds) have their bases on the sides of the panels and their apices at the points of the quatrefoil. The borders are patterned with white leaves on yellow undulating stems against red and blue grounds. The topmost tracery-piece is a quatrefoil containing a depiction of a standing angel holding a white plaque inscribed in yellow silver stain with the crossed keys (or perhaps a key crossing a sword). Immediately below are two butterfly-shaped pieces containing angels hovering horizontally and holding texts. At the edges of and halfway up the tracery are two quatrefoils each containing a standing, red-haloed figure (St Peter and St Paul, perhaps, or more angels) about whom an inscribed scroll unfurls. The remaining pieces are filled mainly with white diaper patterned with large red and smaller blue and green rosettes, linked, for the most part, by yellow stems.

nII–nIV, sII–sIV. 2-light windows and tracery. Each light is made up of yellow silver stain patterned quarries and contains four roundels evenly spaced along its length. The roundels are filled with geometrical patterns except as follows. In nII, those at the top and bottom are marked with: on the left, the crossed keys of St Peter; and on the right the crossed swords of St Paul; the two next to the top contain portrait busts of, presumably, the two saints (the paint is badly worn) and the remaining two portray angels holding texts. In nIV the top two contain the letter IHS on the left; and an unidentified object on the right; the two below, perhaps the dice (the yellow silver stain is badly worn), and the crown of thorns; the next two, instruments of the Passion, and Christ's robe, and the bottom two, angels similar to those in nII. In sII, the two next to the top each contain a depiction of a demon's head as does the roundel at the bottom on the left. The borders are patterned with alternating white leaves on stems and red florets. The single quatrefoil tracery-piece in each window is filled with geometrical patterns on white diaper.

sV. Single-light window made up of yellow silver stain, black-outlined, flower-patterned quarries, containing three evenly spaced roundels; those at the top and bottom are inscribed in red-on-black with the letters IHS and that in the middle portrays a yellow-handled, white-bladed sword crossing a yellow key. The borders are patterned similarly to nII–sIV above.

Office records. *Order Book*, 1850, f. 89, May 23. *First Glass Day Book*, 1851, f. 129, Nov. 19 (I); 1852, f. 142 Apr. 9 (nII–iv, sII–v). *Pugin sketch*, BM & AG a. no not allocated, of I.

Letters. *HLRO 304: Pugin to Hardman,* letter no. 764: 'I have not got any templates for Algarkirk.' No. 922: 'I send you back the window altered but who could imagine the Holy <u>Rood</u> meant the crucifixion a Rood is a cross & your directions[?] were most <u>loosely</u> expressed you said the window was to illustrate the <u>life of S. Peter</u> his walking on the water his call the holy rood the conversion of S. Paul his martyrdom'. No. 166: 'I am also marking out Algarkirk side windows.' No. 570: 'he [Powell] has also the side windows for algarkirk.' No. 742: 'they have made a great mistake in the algarkirk tracery putting an ornament on the <u>Ruby bands</u> this you must omit as it is of the highest importance to have streaky ruby for the bands – & without painting pray mind this, I have written on the cartoons they are to be altered.' *JHA Letter Book, Hardman to Carpenter*, 1850, Jan. 4: 'I send you herewith a sketch for the East Window of Algarkirk which I think will meet your means. I have put the cost of the different windows on the other side & all of them to be carried out like the old sample which I found to be very thick glass & carefully pencilled & since you were here I have succeeded in getting the thick varied ruby made like the old glass which gave much brilliancy to the windows.' *Hardman to Beridge*, p. 85, 1851, Oct. 1: mentions that the E window was finished long ago but requests that the side windows be delayed, despite the cartoons being done, to await better quality glass, explaining, 'The modern white glass is ruined from the excessive clearness of the glass in consequence of which the pattern painted upon it does not show & the whole has a thin appearance however thick the glass may be used. The old glass had a kind of silver running thro' it & this I believe I shall succeed in obtaining in a short time.' *JHA letters: Powell to Hardman*, 1851 box, undated: 'The cartoons will start tomorrow of Algarkirk.' *Copy letter Hardman to Carpenter*, 1850, Feb. 14: 'They [the windows] will be of thick strong glass & lead & as carefully pencilled as the old ones in fact in every respect as good windows – I have succeeded in procuring the thick irregular ruby like that formerly used & which gave such beauty to windows of this date. I should be glad to know at your early convenience if they are likely to be ordered [at the end of the letter he gives the cost of the E window as £190, the two light window, £28, the one light window £9. 10. 0 and he includes a sketch of the E window (not including the scenes) of five lights, with the subject matter, reading from left to right] St. Peter walking on the sea, St. Peter receiving his charge, the Holy Rood, St. Paul's conversion, St. Paul's martyrdom [and he adds a note] as the old glass to be introduced on part of B i.e. the single light.' *Carpenter to Hardman*, 1850, Feb. 15: acknowledges receipt of sketch and estimate. 1851, Jul. 21: 'Respecting the windows for the sides of Algarkirk glass, we really <u>must not wait</u> for Mr. Pugin's return as Mr. Beridge is most <u>peremptory</u> in his requirements that the Chancel be finished out of hand you must here please to proceed to produce the old example which I am sure without reference to time will please him

better than making any changes in it; as he considers <u>his</u> old glass to be perfection'. Aug. 11: 'I enclose you a template for the one light window of the south side of Algarkirk Chancel no corresponding window will be required for the north side.' *Beridge to Hardman*, 1851, Oct. 4: 'On my return home yesterday I found your communication concerning the side windows in my Chancel that I am desirous should be of the <u>best</u> description of glass. I have therefore no alternative but to wait a while longer [?] for their completion. With respect to the East window which you mention is finished I think no further time should be lost in having it put in ... From your statement of your inability <u>now</u> to pronounce the glass of the best quality I conclude the East window cannot be so satisfactory as could be wished.' Oct. 24: confirms the arrival of the glass for the E window. *I. Bishop to Hardman*, 1851, Nov. 15: 'I have seen Mr. Beridge & commenced scaffolding this morning. I arrived here last night he wants the side windows bad.'

106 Boulton Hall, Boultham, near Lincoln
1849. Client: Major R. Ellison.

Office records. *Order Book*, undated, f. 54. *First Glass Day Book*, 1849, f. 60, May 26: 'a Small window of 2 lights/with Shields, Mantling & c & c./ £12/3'11" x 1'1" .../3 Small Tracery pieces'. *Cartoon costs per ledger summary*: Powell 10s.0d, Hendren 6s.8d.

Letters. *JHA: Ellison to Hardman*, 1848, Nov. 17: 'I am getting the measurements of the window accurately taken, & preparing the armorial bearings for you, which shall be sent soon'. 1850, Sep. 14: 'you will recollect executing a small two light window in stained glass for me in 1849 for Boultham Church. I intend to fill a fellow – window on the same side, with painted glass, & should prefer that it were done in the same style & tone of colouring – so far as difference of subjects will allow ... you will find that the window executed for me was done especially to order, containing six shields of arms, with much work in impaling & quartering the cost ... £12. The border was enriched with Initials done to order.'

Brigg, see HUMBERSIDE

107 Leadenham, St Swithin (CoE)
1848. Client: Rev. B. Smith for the Rev. William Dodson, Claxby, near Alford.

Chancel S window	sII	1.7m x 2.5m	3-light	£50

Description. **sII**. 3-light window. The Raising of Jairus's Daughter is depicted under a canopy in the centre light with the inscription 'HE SAID UNTO THE MAID ARISE' in the margin beneath the scene. The bottom panel of the light portrays a female figure kneeling in prayer in front of an altar of which the side parallel to the window plane is decorated with a shield of arms. A scroll inscribed 'JESUS SON OF GOD HAVE MERCY ON ME' unfurls in a semicircle over her head. In the margin at the bottom of the light is the inscription 'IN MEMORY OF MARY ANNE BROWN, WHO DIED FEBRUARY XIX MDCCCXLVIII AGED XII YEARS X MONT'. Three half-length angels holding texts are depicted in red diaper quatrefoil medallions in each of the side lights, the remaining areas of which are made up of quarries patterned with black-outlined flowers on yellow silver stain stems against black cross-hatched grounds. The canopy head is divided into three parts by two pinnacled columns with pendant bases. The wider central section contains the tops of a two-light Gothic window with a rose window surmounted by a concave, crocketed-and-finialed gable, which is in turn surmounted by two single red diaper lancets separated by a pinnacled column. The side sections are defined by white, cusped areas, above which are red-patterned, two-light Gothic windows surmounted by roses and gables, as in the central section. Behind each gable in all three sections is a white, parapeted, openwork screen. The borders are patterned alternately with the letters M and B in yellow-on-black on red grounds.

Office records. *Order Book*, undated, f. 18: 'Through Revd. Bernard Smith Oscott.' *Cartoon costs per ledger summary*: Powell £1.6.8, Hendren 13s.4d. *First Glass Day Book*, 1848, f. 46, Nov. 24 (sII).

Letters. *HLRO 304: Pugin to Hardman*, letter no. 997: 'The Leadenham group goes tonight'. No. 996: 'The group for Leadenham will go tomorrow.' No. 1002: 'the groups for Leadenham & c'. No. 995: '3. There is not any tracery for Leadenham it is – square headed – or nearly so.' *JHA: Smith to Hardman*, 1847, Dec. 17: 'Pugin has probably communicated with you before this about the window for the church at Leadenham.' *Leadenham Rectory to Hardman*, 1848, Dec. 1: 'the window has arrived [?] begs to thank both Mr. Hardman & Mr. Pugin for the splendid specimen of their joint design.'

London, see GREATER LONDON

MERSEYSIDE
108 Knowsley, St Mary (CoE)
1847. Client: Rev. F.G. Hopwood.

Office Records. *Order Book*, undated, f. 8: 'Cartoons £12.'. *First Glass Day Book*, 1847, f. 13, Mar. 1: 'A Window.../ consisting of/1 Light with Figures, Vine Leaves & c/2 do. do. do/.../£60 [this may have been the window replaced in 1892-3 as mentioned in Carr, 1981, pp. 14, 59]'.[36]
Letter. JHA: *Powell to Hardman*, 1847 box: 'Enclosed you will find the subjects for Knowsley window the vine stems run through the quatrefoils behind the figures as marked in large cartoons.'

109 Liverpool, St Catherine's Orphanage, Faulkner Street (RC) [37]
1846. Client: James Gibson. This, the former east window of the chapel (**3.2a & b**), is on loan in the Metalwork & Glass Decorative Art Department, Liverpool Museum, and has been on display in the Craft & Design Gallery of the museum since October 2004.[38]

Chancel E window	I	size unknown	2-light	£28

Description. 2-light window and tracery, illustrating the Annunciation. St Gabriel, in a green-lined, brown mantle ornamented with a white diamond trellis infilled with large white *fleur-de-lis*, over a brown robe, holding a curving scroll inscribed in white-on-black 'AVE MARIA [GRATI] A PLE[NA]', is depicted standing under a canopy, in the left-hand light. St Mary in a green-lined, royal blue mantle over a red robe, holding a book in her left hand, stands under a similar canopy in the right. The trefoil heads of the canopies are contained in yellow-crocketed and finialed ogee arches. The grounds behind the figures are made up of beaded glass diamond trellises (blue for Gabriel and white for Mary) with blue floral-patterned infill (Gabriel) and blue *fleur-de-lis* (Mary). The blue foliage diaper quatrefoil tracery-piece has a foliated MB monogram at its centre.
Office Records. JHA: *Order Book,* undated, f. 9. *First Glass Day Book*, 1846, f. 2, Apr 4 (I): '2 pieces of Copper Lattice for Lights/1 piece of do.do. for the Tracery/piece/£1.6.6.'
Letters. HLRO 304: *Pugin to Hardman*, letter no. 874: 'That angel Gabriel will not do you must send me the cartoon & I will get Oliphant to do another I am sure it will damn us with the Liverpool people. I will pay for the other myself.' No. 885: 'I have seen Early & given directions about the orphan house the windows look exceedingly [?] well. the angel Gabriel <u>perfect</u>'.

110 Liverpool, Bishop Eton, Our Lady of the Annunciation (RC)
1846, 1848. Client: Rt Rev. Dr Brown.

E window	I	Pugin glass of 1846 no longer in place		£70	
S aisle window (**10.21a & b**)	sV	1.7m x 2.2m	3-light	£30	1846
N aisle window (**10.21c**)	nVIII	1.4m x 2.6m	2-light	£25	1848
N aisle window (**10.21c**)	nV	1.9m x 2.5m	3-light	£25	1848

Descriptions. sV. 3-light window and tracery. St Oswald, crowned, and in a red robe, holding an upraised sword in his right hand, stands under a canopy, against a background of a white diamond trellis infilled with a blue floret-patterned ground, in the centre light. The canopy head is contained within a yellow, crocketed and finialed ogee arch. In each of the side lights are two green-patterned roundels each containing a yellow crown. The roundels are enclosed in blue-patterned, white-beaded-outlined diamonds which link with smaller diamonds that fill the remaining areas of the lights. The borders are patterned with alternate yellow-on-black foliated crosses, and blue leaves on curving stems, with five grotesque lion heads replacing the crosses in the head of the centre light and three in the side lights. The main tracery-pieces are three trefoils containing at their centres blue-patterned roundels with green-patterned centres, around which are arranged three crowns.
nVIII. 2-light window and tracery. Each light contains three patterned quatrefoils separated by two roundels; the grounds in the upper and lower quatrefoils are blue foliage diaper and in the central, which contains two yellow-patterned crossed keys, red diaper. The roundels are inscribed with blue, foliated letters 'M'. The remaining areas of the lights are made up of quarries patterned with white oak leaves outlined in black on black-hatched grounds. The borders are patterned with yellow leaves on red and green grounds. The tracery-pieces are patterned with leaves and rosettes on blue foliage diaper grounds.

nV. 3-light window and tracery. St Edward the Confessor in a white-lined, green mantle over a brown robe, holding a ring in his left hand and a sceptre in his right, is depicted standing in front of a mauve foliage diaper screen, under a canopy, in the centre light. The canopy has a trefoil head contained within a pointed arch surmounted by a yellow-crocketed and finialed gable. A blue shield emblazoned with the arms of a foliated-cross on which four birds are perched, with a fifth beneath, is contained in a red roundel at the centre of the bottom panel of the light. Each of the side lights contain two red quatrefoil medallions enclosing shields of arms, which alternate with two smaller leaf-and-floret-patterned red roundels each of which have foliated letters 'E' at their centres. The remaining areas of the lights are made up of yellow silver stain crown-patterned quarries. The shields at the tops of each of the lights have the same arms as in the roundel in the centre light, while those between the roundels, have crossed keys – one white, one yellow – on the left, and three crowns on the right. The borders are patterned with alternate yellow and green leaves on red grounds. The three main tracery-pieces are filled with red diaper and have a yellow crown on a blue diaper roundel at their centres.

Office records. Order Book, undated, f. 3: 'Cartoons: £15 [I], £5 [sV]; £6 [nV]; £6 [wI]' reference is made to a W window for Edward Bretherton and a side window for Mary and Peter Bretherton.. *Order Book 2*, f. 25, 1853, undated, refers to the Roskells' window (see HLRO 304 Pugin to Hardman letter no. 842 below). *First Glass Day Book*, 1846, f. 10 Dec. 16 (I, sV); 1848, f. 42, Sep. 25 (nVIII, nV). I is described as: 'An East Window, consisting of/ 3 Large Lights with Figures/3 Large Tracery pieces with do/7 small do. do.' *Pugin sketches*, BM &AG a. no. 2007-2728.5 (**10.22**), for sV; a.nos. not allocated, for nV, and for a two-light window (see below).

Some confusion has arisen in respect of the 1848 windows. The information in Pugin's letter HLRO 304, no. 842, below and confirmed, except for the price, in the Order Book, appears to be correct. The entries on f. 42 in the First Glass Day Book were altered by Hardman's clerk (the locations of the windows were transposed) to establish that the two-light window was on the N side and the three-light was on the W; but to fully correct the entries he should have also changed round the names of the donors and the prices of the windows. Pugin seems to have thought, initially, that the Mary and Peter Bretherton window was of two lights and was in the W, and he produced a sketch (annotated 'west window' in his hand) showing the donors' patron saints under canopies in the lights (sketch reference no. not allocated, see above). His letter HLRO 304, no. 322 acknowledges the mistake in the design, although he still refers to it as the W window. The letter's reference to quatrefoils and keys would appear to identify nVIII as being the window in question. Perhaps letters HLRO 304, nos 283 and 509 mean that Hardman made up a two-light window to the wrong design. From the description in the First Glass Day Book, the use of Edward Bretherton's patron saint, and Pugin's sketch for sV, it seems reasonable to assume that nV was the original W window, moved to its present position during the later reconstruction.

Letters. HLRO 304: Pugin to Hardman, letter no. 866, postmark 'JA22 1846': perhaps re I: 'The Liverpool window can be managed by altering 2 of the canopies and adding a band to the 3 centre pedestals & taking 1 band away from the 2 outer ones I have sent off today a roll of all the drawings with the new canopy set out – & a drawing showing the alteration of pedestals.' No. 236: '3. I find the estimate for the Bishop Eton window is £70'. No. 867 (*c*.1848): '1. As regards the B. eton window you never sent me the Query before. but the Large spaces better be filled with the same pattern enlarged ... 3. I send you back the tracery for the side windows at Bishop Eton I shall soon have the centre light ready for you again.' No. 322: '1. It is all a mistake about the W. window Bishop Eton it ought to be quarries with quatrefoils & keys. I have been in such a disturbed state I make all sorts of mistakes'. No. 283 (*c*.1848-9): '& as regards the window for Bishop Eton it is all my fault & I ought & will suffer you can leave out the diaper or anything [?] do not quite spoil the window but I will willingly share the loss.' No. 509 (*c*.1848-9): 'I send you £25 for Liverpool window I am a pattern of honourable dealing.' No. 842: '1. The only mention of the Bishop Eton windows I can find is as follows.

a side window	Mary Bretherton	£25
	Peter Bretherton	
a west window	Edward Bretherton	£30

This may be some guide. There is nothing at all about the Roskells.' No. 907, postmark 'DE14 1849': '2. I send you the sketch of the B. Eton window. I think there are templates of 2 spandrels wanting.' No. 780 (*c*.1850): 'we cannot find either the arms or inscriptions for Mr. Roskells window for Bishop Eton the cartoons are just drawn & I want these to finish them.' No. 456 (*c*.1850): 'I have not been able to finish B. Eton yet but it ought to be rather good.' No. 159 (*c*.1850-1): 'I feel the Bishop Eton window is not very good but I will look at the cartoons.' *JHA: Powell to Hardman*, undated but *c*.Sep. 1846: 'I enclose you the East window Bishop Eton. it is complete except the marking of the colours. you will find a small pencil sketch of the whole this is for the Governor [Pugin] to try the colours on. also enclosed are 3 shields the size you want. the Governor wrote to me to tell me that you would send me names and arms of 7 more to make up 10. he mentioned 3 viz Brockholes, Cayly, Gillow. Brockholes is enclosed. Cayly I have not got and Gillow which I send is quite a guess. perhaps you can tell whether it is right. Mr. Gibson's is not here perhaps the Governor may have

it but I have not seen it will you please try to get me the rest as soon as you can.' *Henry Brewer to Hardman*, 1847, Sep. 28: 'The East window placed in the Bishop's Chapel Bishop Eton is to be paid for, and presented to the Bishop by the Benedictine Clergy of Lancashire.'

Literature. Wedgwood (Pugin's Diary), 1845, p. 93, note 33, re the incorporation of the chapel of 1840-50 into a larger church of 1857-8. Pugin visits Liverpool, see Gaz.113.

111 Liverpool, St Nicholas, Copperas Hill (RC)

1841, 1849. Client: Rev. John Walmersley. Church demolished 1972, stained glass presumed destroyed.

An article in the *London & Dublin Weekly Orthodox Journal*, 1841 (taken from the *Liverpool Journal*), refers to a new stained glass window over the altar erected from designs and under the superintendence of Welby Pugin; the glass prepared at Newcastle upon Tyne (this must have been in Wailes's workshop) was described as follows: 'The style of the window is ... of the thirteenth and fourteenth century. It is embellished with a great number of scripture or religious figures the principal of which are St. George, St. Nicholas, the Blessed Virgin, St. Cuthbert and St. Patrick. Beneath the feet of these figures are several smaller ones taken from the Revelations. The upper part of the window consists of beautiful Gothic Canopies, also embellished with figures, and above these the remainder of the window is chiefly filled with richly stained diamond-shaped glass.'

In a letter to Lord Shrewsbury (Belcher, 2001: dated by her Nov. 28, 1841) Pugin writes: 'I have just set up a very Large Stained Glass Window at St. Nicholas Liverpool – which has produced a great effect. the figures all in beautiful drawings & very rich very far superior to Willement and the whole window including stone tracery carriage fixing wire work Commission & every expense – was only £325 & it is a very Large window indeed.'

Office records. *Order Book*, undated, f. 36: 'Inscription at bottom of windows – Orate per [sic] anima Thomas Youens STD qui obit. Do. for Mr Gillow'. *First Glass Day Book*, 1849, f. 69, Oct. 10: Client: Rev. John Walmersley, '2 Side Windows.../of 3 lights ea with Figures/groups and c. 11'3" x 1'5½"/£120/26 pieces of Tracery for/do/13 pieces to each Window/.../ Memorial Window of Revd. B. Youens & Revd. R. Gillow'. *Cartoon costs per ledger summary*: '2 side windows', Powell £6.0.0, Hendren £2.6.8, Oliphant £6.15.0. Oliphant's account records that the payment (entered May 4, 1849) was in respect of '4 Groups of Figures, Confession, Baptism, Holy Eucharist & Extreme Unction @ 33/9 ea'.

Letters. HLRO 304: *Pugin to Hardman*, letter no. 425: 'The Liverpool windows leave Tonight – I have left spaces under Dr Youens & Mr Gillow for inscriptions. I should think they should be Orate per [sic] anima Thomas Youens STC qui obit get the date Do. for Mr. Gillow. Don't forget the casement in the sedilia light.' No. 401: 'the Liverpool windows will leave tomorrow'.

Literature. *London & Dublin Weekly Orthodox Journal*, 13, 1841, pp. 301-2. Belcher, 2001, p. 293. Wedgwood (Pugin's Diary): Pugin visits Liverpool, see Gaz.113.

112 Liverpool, St Mary, Edmund Street (RC)

1846. 1847. Clients: James Gibson and the Rev. James Wilkinson.

Designed by Pugin and constructed during 1843-4, the church was destroyed in the Second World War (Wedgwood, 1985, p. 84, note 34). A description of the church by Pugin was published as part of an article that appeared in *The Tablet*, Aug. 1845 (taken from the *Liverpool Mercury* of Aug. 1). He referred to the windows as follows: 'at the eastern extremity of the south aisle is a window of five lights filled with stained glass, executed at the cost of Mr James Gibson of Liverpool. The centre light contains an image of Our Lord under a high canopy, on either side St. Peter and St. Paul and St. John and St. James the patrons of the donor of the outer lights ... The great east window is filled up with stained glass, representing the whole life of the Blessed Virgin in fourteen compartments, surmounted by canopies; the tracery is filled with lilies, stars and other devices of the Blessed Virgin interspersed with angels bearing scrolls. The Ladye Chapel is at the east end of the north aisle ... immediately above the reredos is a tracery window of five lights, filled with stained glass representing the life of St. Anne, the gift of Miss Lynch. ... The lateral windows [of the nave] might also be filled with stained glass, without too great a reduction of light'. The article went on to record that the stained glass was furnished by Wailes of Newcastle – presumably Pugin's account looked forward to the S aisle window that was to be made by Hardman's in the following year.

Office records. *Order Book*, undated, f. 8: cartoon costs, re S aisle '£15, [re side] £10.'. *First Glass Day Book*, 1846, f. 3, Apr. 7, client: James Gibson: 'South Aisle window consisting of /5 Figure lights/5 Large Tracery pieces/10 Smaller do.

do./£65'; 1847, f. 18, Oct. 19, client, the Rev. James Wilkinson: 'A Side Window.../£40/of 2 lights with figures & c, 7'3" x 1'9½"/4 Tracery pieces do. do'.
Literature. The Tablet, 5, 1844, p. 280: laying foundation stone; 6, 1845, p. 502. Wedgwood (Pugin's Diary): Pugin visits Liverpool, see (Gaz.113), 1844, p. 57, 'end papers at front of diary [opposite p.15] Paid Wailes 100.0.0 for Liverpool 40 for schools see cheque book [between pp. 24 and 25] window for Liverpool 100. 0. 0, window for Liverpool 9.10.0'; p. 58 'End papers at back of diary [c] Liverpool window 105.0.0'; 1845 May 5 – '£50 to Wailes for Liverpool'; May 31 – '£50 to Wailes for Liverpool'.

113 Liverpool, St Oswald, Old Swan (RC)

1846, 1847. Clients: Pattison Ellames, Edward Latham, and Henry Sharples.
A Pugin-designed church dedicated in 1842, it was rebuilt in 1951-2 (Pevsner). References to the original windows (presumably destroyed) appeared in the *True Tablet*, 1842: 'The Chancel in which the original altar is situated is lighted by a handsome stained-glass lancet window worked into stone mullions. A beautiful stained-glass figure of St. Oswald occupies the centre pane; the rest of the window is formed of almost innumerable pieces of stained glass, exhibiting more brilliant hues than those of the rainbow ... The body of the church which is lit by six windows is calculated to accommodate comfortably from six to eight hundred persons'.

Office records. Order Book, undated, f. 7, re mortuary window 'for Mrs Ellams [sic], Cartoons £8.'. *First Glass Day Book*, 1846, f. 4, Jun. 12, client, Pattison Ellames: 'A Mortuary Window/.../£40/consisting of/1 Large Light with 4 Figures/2 do. do. with 4 shields/5 Small Tracery pieces' 1848, f. 47, Nov. 25, client, Henry Sharples, Oswaldcroft, Wavertree, Liverpool: 'To a Window of 3 Lights/.../£40/ of Centre Light of Figures & c/7'0" x 1'2½" /2 Side Lights of do/5'6½" x 1' 2½" /5 Tracery pieces to do'; 1850, Jun. 1, f. 91, client, Henry Sharples, 43 Sefton Street, Liverpool: 'To a Stained Glass Window/.../given by Edward Latham Esq/£40/of 3 Lights Centre 7'1" x 1'2½" /2 Side Lights ea 5'7" x 1'2½"/5 pieces of Tracery to do', f. 93, Jun. 22: 'To 8 pieces of Copper/Wire Latticing for '/Latham Window'/.£2.' *Cartoon costs per ledger summary*: Powell £4.5.0.
Letters. HLRO 304: Pugin to Hardman, letter no. 970: 'You must send me the templates of the window we put up for Mr. Sharples at St. Oswalds in order that I may prepare the other one for his friend which is the same size.'
Literature. London & Dublin Weekly Orthodox Journal, 15, 1842, pp. 90-1. *True Tablet*, 24 & 117, Aug. 6, 1842, pp. 390, 518. The 1842 periodicals each carried the same article describing the church; attributed in the case of the *Orthodox Journal* to the *Liverpool Journal* and the *True Tablet* to a correspondent. Wedgwood (Pugin's Diary): Pugin visits Liverpool, 1841, Mar. 29, May 5-6, 22-3, Jul. 2-4, Oct. 6-9; 1842, Mar. 7-9, May 12-14, Jun. 12-13, Jul. 22-5, Sep. 16-17; 1843 no diary; 1844, Feb. 15-17 & 27, Mar. 1, Apr. 19-20, Jun. 6-8, Jul. 23-4, Aug. 7, Oct. 2, Dec. 7-8, 9-10; 1845, Mar. 31, Apr. 1-2, May 20-1, Jun. 3-4, Jul. 18, Sep. 12; 1846 no diary; 1847, Jul. 6, 9; 1848, Jun. 23-4, Jul. 6, 8-9, 28, Sep. 11-12; 1849, Apr. 16-17, May 31-Jun. 1, Nov. 27-8; 1850, Sep. 13-14, 19-20; 1851, Jan. 15-17, May 7-8, Jun. 26-7, Aug. 20-1.

114 Liverpool, Oswaldcroft. Now St Joseph's Home, Nazareth House, Wavertree

1847, 1848. Client: Henry Sharples, Wavertree, Liverpool.
The porch window *c*.1844 is taken as the notional E one for the purpose of numbering the windows.

Porch window	P I	0.2m x 0.6m	1-light
Entrance hall window	EH nII	2.4m x 3.1m	8-light
Lounge window	LO sII end sections	0.5m x 0.7m	5-light
	mid sections	1.8m x 0.7m	3-light
Dining room windows	DIR sII, DIR sIII	2.4m x 0.7m	4-light

The 1848 oratory window, recorded in the First Glass Day Book, has, presumably, been lost, perhaps during later building works. The stained glass at present in the porch, entrance hall, dining room and lounge is not recorded in the Day Book (apart from a reference to shields and inscriptions for Henry Sharples – for the lounge window, perhaps) and is probably the work of Wailes *c*.1844 in the first two cases and perhaps Wailes *c*.1844 and Hardman post-1853 in the latter two.

Descriptions. EH nII. 8-light transom window of white quarries forming diagonal rows inscribed alternately with the black-outlined, foliated initials H and S. Each of the four trefoil-headed lights above the transom contains a red rose-patterned quatrefoil, outlined by successive bands of blue and white diaper, on which is a blue shield of arms. From left to right the arms are: three crowns; three stars; a foliated cross together with five birds; and a Y-shaped cross marked with three black crosses. The borders, which are overlapped at the sides by the quatrefoils, comprise a line of white-

beaded glass sandwiched between two lines of red and punctuated by black-hatched, yellow diagonal crosses on yellow rectangular grounds.

P I. A small single-light pointed arch window made up of white quarries inscribed with foliated yellow letters S. A leaf-on-stem-patterned blue roundel overlies the centre of the light and extends into the relatively wide borders which are patterned with undulating acanthus-like white leaves on stems.

LO sII. 5-light bay window with stained glass pointed top sections made up of white quarries patterned alternately with black-outlined, yellow silver stain initials H and S. A red-rimmed, blue foliage diaper roundel containing a shield of arms is at the centre of each section. The borders are patterned with alternate red foliated crosses on oval black-hatched grounds, and yellow on white mitres – the borders at the bottom have Latin texts between the initials H and S, all in yellow silver stain on white grounds.

DIR sII, DIR sIII. 4-light windows as for LO sII (but not in a bay) except that: the initials in the quarries and bottom borders are H and N; the roundels are red diaper with yellow rims and contain, (in the outer lights) lions(?) heads turned inward in profile, and (in the inner) the initials H and N. The borders, apart from those at the bottom, are patterned alternately with blue rosettes, and yellow and green leaves.

Office records. Order Book, undated, f. 3 (oratory window). *First Glass Day Book*, 1847, f. 19, Nov. 4: '8 Shields/18 Inscriptions/£3.5.0'; 1848, f. 48, Nov. 25: 'To a Window for Oratory/of 2 Lights /£18/ with Figures & c 5'3" x 1'6½" /& 1 Tracery piece'. *Cartoon costs per ledger summary*: 'Oratory window', Powell 13s.4d, Hendren 10s.0d, Oliphant £3.15.0. Oliphant's account dated Oct. 31, 1848 records that the payment was made in respect of '2 do [cartoons], St. Frances [sic] and St. Henry @37/6'.

Letters. HLRO 304: Pugin to Hardman, letter no. 1004: 'as for Mr. Sharples window I don't know what to do ... The cartoons for the canopies & c for Mr. Sharples window were done while I was away & they will not do. I want something very good.' No. 1001: 'I have at length pleased myself with a design for Mr. Sharples little Chapel window I have sent off sketches tonight to Oliphant of the 2 figures & Powell will prepare the Canopies & c at once.' No. 996: 'The canopy & tracery for Mr. Sharples goes tonight you will have to give a reddish shadow to the faces of the window like the old ... remember this is a Late window & must look very rich.' No. 1002: 'I hope Mr. Sharples will be a beautiful window.' No. 820: '2. Why did you send me the templates for Mr. Sharples window at Oswald Croft?' *JHA: Sharples to Hardman,* 1850, Jun. 4: 'I also send the size of the stained glass for the motto "Sola virtus lavicta" that was omitted & which now makes a blot in my dining room window [current lounge, perhaps]'.

Literature. Wedgwood (Pugin's Diary), 1844, p. 89, note 7: 'Pugin began Mr Sharple's house, Oswald Croft ... this year'. Pugin visits Liverpool, see Gaz.113.

115 Liverpool, St Francis Xavier, Salisbury Street (RC)

1851. Client: Rev. Joseph Johnson. The E windows, including those of the Lady Chapel, were destroyed by bomb blast during the Second World War.

Office records. First Glass Day Book, 1851, f. 114, Mar. 24: 'For East window of Ladye/ Chapel/A Stained Glass Window of/2 lights 7ft 11 in by 2ft 3½ in/' &1 large Tracery piece'/£45.

Letters. JHA: Johnson to Hardman, 1850, Nov. 5: 'I send the enclosed measurement of a window immediately over our Altar of the Bd. Virgin. We are anxious to have the Virgin and Child in one Light and St. Joseph in the other and a suitable design in the cinquefoil. We require a rich window and as the sanctuary windows are on a blue ground, we fancy that the colouring ought to be in a style that would harmonise with the centre. I should also wish to know what will be your charges if you were engaged to insert two diaper windows in the side windows of the Lady Chapel. The size is almost the same as the one of which I send a partial drawing. The Lights are, I think three inches less wide, and therefore not so high.' Nov. 16: 'We were very anxious to see the windows of the Altar of the Bd Virgin finished by the Feast of the Purification, but we are waiting to allow you till the annunciation for its completion if you will engage to have it ready by that day – As your window will be exposed to a comparison with the windows executed by Mr. Wailes (with which Mr. Scholes, Mr. Hansom, & other Judges have declared themselves much pleased) I think for your sake and our own, that it will be worthy of the Church and of Her to whom it is offered ... we have not as yet come to any determination with regard to the side windows. As you will not require the print which I sent, you will oblige me by returning it, as it was borrowed from a friend'. Nov. 27: 'It seems to us that the figures in your window are too small. Although the present windows have larger figures than yours we hear complaints of the small size of the figures. 2. We expected a design for the cinquefoil. ... 3. We had thought that you would have deemed it desirable to have seen our present windows before you proposed to begin the windows for the Lady Altar. I state this because there is so great a preponderance of blue in

our present windows that we think that great care will have to be observed in the colouring of yours, as I have often heard much said against the quality of yellow which is to be seen in your windows'. 1851, Apr. 3: asks whether discount for ready money is allowed on windows.

116 Southport, St Marie (RC)

c.1840. Warrington's records show he made: '1 East window for Southport Romanist Church'. It seems likely that this window was moved to the N aisle E when rebuilding took place in 1875.[39] The window, with its depiction of the Virgin and Child in the centre light, and geometrically-patterned roundels in the side lights – two inscribed with the letter M – is virtually identical with that of the N aisle E window at Dudley (nII, Gaz.181). Also the borders in both of the windows are made up of alternate white and yellow leaves attached to green stems against red grounds. The plain white quarry backgrounds may be the result of changes, made at a later date, to introduce more light into the church.

Literature. Warrington, 'c.1855(?)'

NORFOLK

117 Great Yarmouth, St Mary (RC)

1852. Window designed by J.H. Powell.

Office records. Order Book, 1852, f. 182, Jun. 8. *First Glass Day Book*, 1852, f. 162, Nov. 15: 'To A Stained Glass Window/ of 2 lights & Tracery/for East Window of Side Chapel of aisle/£30/2 lights 5'9" x 1'8½" .../7 Tracery pieces.../To a Stained Glass Window/of 2 lights & Tracery for Side Window of side Chapel of Aisle/£30/2 lights 5'11" x 1'8½" /5 tracery pieces'.

118 Lynford, Sutton Chantry Chapel

Demolished, glass presumed lost.

Literature. Wedgwood (Pugin's Diary): Pugin visits 'Lyndford [sic]', 1844, Oct. 4, p. 91, note 40, states the chapel was demolished after Sir Richard Sutton's death in 1855. Diary entry (p. 57): '[opp. p. 23] Wailes £30 for Sir R. Sutton'.

119 [King's] Lynn, St Mary (RC)

c.1855. Demolished, glass presumed lost.

Literature: *London & Dublin Orthodox Journal*, 17, 1843, p.109: engraving of exterior of church; p. 110: article by John Dalton, giving some details and background for the proposed church designed by Pugin, but nothing about the windows; p. 269: engraving of interior. *The Tablet*, 5, 1844, p. 310: paragraph on the laying of the foundation stone with some details of the proposed design of the church; 6, 1845, p. 311: paragraph on the dedication of the church on May 8, with a short description including: 'the east window is filled with painted glass by Mr. Wailes'. Wedgwood 1985 (Pugin's Diary), p. 61 '[End papers at back of diary] [b], [e], [f]' refer to lists of expenses, small orders, and work done by Wailes in 1845. The Diary itself reveals one of the items on the lists is: 'Oct. 10 Lynn full 50'.

120 West Tofts, St Mary the Virgin (CoE)

1849, 1850. Clients: John Sutton, Jesus College, Cambridge, for the Rev. A. Sutton (N aisle windows); Rev. A. Sutton (nave windows).

N aisle E window	nVIII	3-light	9'8" x 2'0½" (lights) and 7 tracery-pieces
N aisle windows	nIX–nXII	2-light	6'7" x 2'0½" (lights) and 5 tracery-pieces each
N aisle W window	nXIII	2-light	9'0½" 2'0½" (lights) and 5 tracery-pieces
Nave S windows	sVI–sVIII	2-light	6'7" x 1'8½" (lights) and 1 tracery-piece each

Windows nVIII–nXIII cost £220; sVI–sVIII cost £75

The church is closed and stands within grounds set aside for military training. Permission to visit needs to be obtained from the Norwich Diocesan Office and the military authorities. Much of the glass has been removed but, according to Tricker, that mentioned in the First Glass Day Book remains.[40] As described in the report of the Council for the Care of Churches, PM1356, 1983; and Tricker; and Haward; the subject matter is as follows: sVI: 2 lights with tracery; St John the Baptist and St John the Evangelist under canopies on grisaille-patterned grounds in the lights, and patterns

in the tracery. sVII: 2 lights with tracery; St Andrew and St James the Great in settings as for sVI. sVIII: 2 lights with tracery; St Lawrence and St Stephen in settings as for sVI. nVIII: 3 lights with tracery; elegant grisaille patterns, and strongly coloured medallions in the centres of the lights; the medallions contain scenes of Christ carrying the Cross, the Flagellation and Gethsemane; the tracery contains the Crucifixion, the Virgin Mary, and St John. nIX–nXIII: two-light windows filled with grisaille patterns.

Office Records. *Order Book*, undated, f. 45 (N aisle windows), re nVIII: 'end of aisle'; 1850, Jul. 1, f. 90: 'nave windows'. *First Glass Day Book*, 1849, f. 75, Dec. 15 (nVIII–nXIII); 1850, f. 98, Sep. 26 (sVI–sVIII). *Pugin sketch*, BM & AG a. no. not allocated, of nave window. *Cartoon costs per ledger summary*: nVIII–nXIII, Powell £12.0.0, Hendren £4.0.0; sVI–sVIII, Powell £3.15.0, Hendren £1.15.0.

Letters. *HLRO 304: Pugin to Hardman*, letter no. 1025: '4. I will send you Mr. Suttons windows as soon as I can as although they will not be wanted till next year there is a lot of plain pattern work that will help you.' No. 1008: 'This job in Norfolk Tofts Church is settled to go on there are several windows.' No. 978: 'In the course of this week I send you a Lot of tracery & one window for Rev. A Sutton of Tofts now if you could knock this off it would keep all right there & there is not a great deal of work in the window pray try & do this.' No. 841, postmark 'NO 13 1849': 'I am very anxious about the glass for Tofts. I have just got a letter from Mr. Sutton – I think if you sent the tracery it would be good pray send that glass off before everything or endanger [?]. I want to keep Mr. Sutton all right.' No. 736: ''Let me know when the tofts windows will be done they are badly wanted. ' No. 963: 'The <u>Tofts badly wanted</u>'. No. 824: 'Now <u>I must get you</u> to write a line to the Rev. A. Sutton West Tofts near Brandon & tell him what is the real state of glass. I get a letter every week & I cant[?] write any more do pray send him a few lines & tell <u>him the truth</u> & what he may rely on. that has been a most unfortunate job all through and I see the bad weather & the cold has completely upset him I dare not write but pray send him a few lines.' No. 969: 'I am in the greatest distress about Mr. Suttons glass. he will not let the walls between the arches be pulled down till the glass is in & I think he is <u>right</u> but it stops all the men. Myers declares it is all my fault & that he cannot leave so much labour & if he takes the men away they will have to be sent back very shortly at a great expense. under these circumstances I exhort of you to do your best all the cartoons <u>leave today</u> there are 5 windows all of a <u>sort</u> & Large pieces of glass. pray knock them off as soon as you can everything depends on the <u>white</u> you are making[?] should have [sic] a real old look pray be careful about this the rest is sure to come well. I recommend them most urgently to you. if you have not the new colours match them as well as you can with the old (give this glass a little of the old <u>tinge</u> especially in the borders).' No. 967: 'they have made the end aisle window the same height as the sides so we have a gable with about 15 feet of blank wall though it is distinctly marked on the drawings to the contrary. I thought something was wrong when they sent templates for 5 windows of a size. now you must let me know by return & direct to Ramsgate how much longer the length would be to [?] of another length of figure in the pattern[?] which I think is in large [?] square. I would think about 2.6 but let me or send me a tracing of the cartoons that I may arrange it. It is evident that I cant trust him [Myers] to look after anything that I must watch every job like a cat.' No. 957: '2. you must lengthen 2 of the of the [sic] lights for Tofts by one length 2.5½ [includes a sketch]: This will be for the West window. it is a sad job we have to cut the wall away & rebuild the tracery & it was all written on the drawing that the <u>men</u> had to work from.' No. 964: 'I hope you will draw in the [?] about the Tofts window as they are wanting to know the height to alter it. it is a sad job.' No. 971: 'send off the <u>tracery</u> of tofts as soon as it is ready & they will fix it before I get there.' No. 730: 'I cannot imagine how the mistake about the Tofts window has occurred they are this [includes a sketch highlighting a triangular tracery piece at the top of a nave window between the two lights] & perfectly remember marking the tracery colours. It is another infernal mistake of Powells – I must get another template & have them done at once or the window will look beastly that white patch will ruin all.' No. 686: 'I have just been to Tofts. The tracery of the East window is as nearly the old thing as possible – and I believe it is owing to the ruby ground the tracery of the side windows are also excellent but our patterns on the Quarrys are not bold enough in some of the lines – I see a deal yet wanting[?] in the painting of the Quarried figures. we are too much afraid of Black the Quarry glass looks light I think we must use green 10 Mr. Sutton has sent you £100 on account & he says he will send the rest as soon as he can he is a capital man.' No. 688: 'I assure you the groups at Tofts look miserably modern they are somehow not drawn on the old principle I get quite disheartened for I see nothing at all satisfactory our glass is bad from the foundations It is not the <u>white </u>the old men painted on Mr. Sutton has been glass painting & with using the fine [?] to burn in he took me in with his work I could have sworn they were old quarries – but I found he got a sort of old quarries out <u>of a cottage & painted on them</u>. I believe all the old Quarry glass is taken out of Eton College windows it would be a capital thing to buy it – all the plain glass with the leaves at Tofts looks miserable.' No. 693: 'I am very sorry to hear so bad an account of the Chester lights [Chester Cathedral, Gaz.14]. I have no doubt you are right the grisaille is miserable it is so

at Tofts – we don't do it half strong enough.' No. 936: 'Mr. Sutton has ordered 3 more windows for Tofts.' *JHA: A. Sutton to Hardman*, undated, Aug. 1849 bundle: notes the arrival of the glass and points out that Mr. Myers has not sent anyone to fix it. *A. Sutton to Pugin*, undated, 1850 box: asks for a plan and estimate for a new porch and 'the cost of filling the three south windows with proper glass.'

Literature. Birkin Haward, 1989, re. West Tofts and plate 23. Tricker, 1987, p. 13. Wedgwood (Pugin's Diary): Pugin visits West Tofts, 1849, Apr. 25, Jul. 20, Oct. 18; 1850, Apr. 5-6, Jul. 26-7, Sep. 24.

NORTHAMPTONSHIRE
Culworth Church, see OXFORDSHIRE

121 Northampton Convent[41]
1852. Windows designed by J.H. Powell.

Letters. *Order Book*, 1852, f. 193, Aug. 31. *First Glass Day Book*, 1852, f. 157, Sep. 28: 'To A Window of Stained/ Glass of 2 lights each/ & Tracery/ 2 lights 7'4" x 1'5½"…/ 1 Tracery piece'.

122 Northampton, St Felix (RC)
1845. Pevsner records that the three complete figures of *c*.1845 in St John the Baptist church, Bridge Street (now a restaurant), came from the church of St Felix. They were presumably made by Wailes. The small collegiate chapel of St Felix was built by Pugin in 1844, and enlarged to three times its size by E.W. Pugin in 1863 to become the cathedral of St Mary and St Thomas. *The Tablet*, 1844, in a paragraph reporting the opening of St Felix, mentioned that it was designed by Pugin in the Early English style and that: 'the stained glass in the east window is particularly fine.' Perhaps the three aforementioned figures formed part of that window.

Details of the windows *in situ* in the former St John the Baptist church:

S aisle windows (**10.23**)	sIV–sVI	0.6m x 1.1m	1-light

Descriptions. sIV–sVI. Single rectangular panels each containing a depiction of a figure standing between two columns. The fact that arches spring from the capitals of the columns, and columns continue upwards, suggest that canopies were originally present, and that the panels were at one time part of a larger scheme. The details portrayed in the panels are as follows:

sIV. St Felix in a white, gold-patterned, white mitre, the pallium, a red chasuble over a blue dalmatic and a yellowish-white alb. The maniple hangs from his left forearm and he holds a yellow, crossed staff in his left hand. A piece of glass is missing from alongside his right leg.

The borders are patterned with yellow oak leaves and small white flowers on undulating stems against blue grounds.

sV. The Virgin and Child. The Virgin is crowned and wears a blue mantle over a red robe. She cradles the Child who is crowned and in a yellowish-white robe, in her right arm while holding a lily in her left hand.

The borders are patterned as in sIV except the stems are vertical and the leaves yellow and white.

sVI. St Thomas of Canterbury wears a gold-patterned, white mitre, the pallium, a red lined, yellow chasuble over a green-lined, purple dalmatic and a yellowish-white alb. The maniple hangs from his left forearm and he holds a yellow-crossed staff in his left hand. A sword is thrust diagonally through (although it appears to be behind) his head. The borders are as in sIV with the leaves more recognisably of oak.

Literature. N. Pevsner, *The Buildings of England: Northamptonshire*, Harmondsworth, 1961, p. 312. *The Tablet*, 5, 1844, p. 405. Wedgwood (Pugin's Diary): Pugin visits Northampton, 1844 Mar. 5 (note 10, p. 89, gives the date of the opening of the church as Jun. 29), Apr. 22; p. 58: '[end papers at back of diary] [b] [financial calculations] Wailes for Northampton 30.0.0.'; 1848 Feb. 22; 1850, Aug. 10; 1851 Jan. 14, Feb. 26 (note 33, p. 100, refers to the design of the church of St Thomas the Martyr).

123 West Haddon, All Saints (CoE)
1850. Client: Rev. H.M. Spence.

S aisle E window (**10.24a & b**)	sIV	1.6m x 3.0m	3-light	£45

Description. sIV. 3-light window and tracery. The central panel of each light contains a red-outlined, blue foliage diaper quatrefoil medallion illustrating a New Testament scene. From left to right the scenes are: the Raising of Lazarus; the

Marys at the Tomb (?); and the Raising of Jairus's Daughter. The remaining panels are filled with a grisaille of units of black-outlined, white leaves on yellow silver stain stems enclosed within black lines that follow the shapes formed by the leads. The stems are attached to further stems which trail across the enclosing lines and seemingly, behind the leads. Randomly placed, in groups of three, are yellow silver stain berries. Overlying the leaf and berry patterns are red-outlined diamonds over-and-underlapped by two tangentially – touching blue-outlined, half-quatrefoils. The borders are patterned with white leaves on yellow silver stain undulating stems against blue and red grounds. The five main pieces of tracery over the centre light each contain a representation of an angel holding a text. The remaining pieces are patterned with white leaves and red rosettes.

Office records. *Order Book*, undated, f. 15, inscription: In memory of Margaret Millicent wife of H.M. Spence, Vicar of this Parish, who died August 11th 1849 aged 42'. This inscription appears in the bottom borders of the lights, except that the date is inscribed 'Aug XI MDCCCXLIX'. *First Glass Day Book*, 1850, f. 81, Feb. 26 (sIV). *Cartoon costs per ledger summary*: Powell £4.15.0.

Letters. *JHA: H. Minton to Hardman*, 1849, Nov. 20: 'I hope you have received from our friend Pugin the drawing for the West Haddon window and that you are getting on with it.' 1850, Feb. 18: enquires as to the readiness of the window. *Spence to Hardman*, 1850, Mar. 14: 'The window at West Haddon being now in Mr. Spence begs to state to Mr. Hardman his perfect satisfaction with the execution thereof which has been already much admired the grouping, arrangement and blending of the colours is really beautiful – but there appears to be some uncertainty & division of opinion amongst persons who have seen the window as to what are the subjects represented by the figures in the Centre of the Lights. Mr. S. will therefore be much obliged if Mr. Hardman will favour him with a line definitely stating the subject in each light'.

NORTH LINCOLNSHIRE, see HUMBERSIDE

NORTHUMBERLAND
124 Bamburgh, Church[42]
1852. Client: Rev. William Darnell.

Office Records. *Order Book*, 1851, f. 148, Nov. 12, inscription: 'In memorium mortuorum AD 1851'. *First Glass Day Book*, 1852, f. 155, Aug. 27: 'To A Window of Stained Glass of 2 lights and/Tracery.../2 lights 7'4" x 1' 5½"...1 Tracery piece.../ Subject: Figure of St. Aidan/ & St. Cuthbert/£27/. To Extra Charge for Figure/ in Tracery not included/ in Estimate/15/-'.

Letter. *JHA: Darnell to Hardman*, 1851, Oct. 24: 'I have to thank you for your prompt attention to my letter, & to express my readiness to accede to your terms for the window, containing figures of St. Cuthbert & St. Aidan ... Perhaps you will be kind enough to send me sketch of what you propose for the window. At the bottom may be inserted these words – In Memoriam Mortuorum M F[?] AD 1851.'

Newcastle upon Tyne, St Mary's Cathedral, and Stella, St Mary & St Thomas Aquinas, see TYNE AND WEAR

NORTH YORKSHIRE
125 Bilsdale (near Stokesley) Church[43]
1852. Client: Rev. John Fletcher for Lord Feversham. Supervising architects: Banks & Barry.

Office records. *Order Book*, 1851, f. 155, Oct. 27. *First Glass Day Book*, 1852, f. 136, Feb. 21: 'To A Stained Glass/ East Window of 3 Lancet lights.../£35/Centre Light 11'0" x 1'11"/2 side lights 8'10" x 1'7½"'/f..143, Apr. 20: 'To 5 Windows of Stained/Glass of single lights for/side windows of Church/£17.10.0/Each light 6'0" x 0'9½ "...'/Lancet lights'.

Letters. *Charles Barry junior to Hardman*, 1851, Sep. 19: 'I shall be in Birmingham on Saturday morning the 27th inst & shall call at your Manufactory when I hope you will be able to let me see the Bilsdale Church window finished & set up.' Oct. 27: requests windows, since 'church to be opened...on 13th Nov.' 1852, Feb. 23 requests an account for the windows: 'I suppose you have a copy of Mr. Pugin's estimate for them contained in his letter to us in last August ... he estimated the East Triplet at £35 and each of the single light, side windows at £3. 10. 0.' Apr. 30: 'I am rejoiced to hear that all the stained glass has arrived at Bisdale.'

126 Bolton Abbey, Priory Church of St Mary & St Cuthbert (CoE)
1853.

| S wall windows (**6.7**) | sII–sVII | 1.4m x 3.8m | 4-light transom |

The bottom margins of sII are inscribed in yellow-on-black: 'These windows were placed by order of William Spencer Duke of Devonshire. John G Crace Fecit 1853'. The cartoons were made by Pugin for Crace during 1850-2 as described in Wedgwood, 1977.

Descriptions. 4-light windows. Each of the two lights above the transom in all the windows contain two blue, figured medallions, illustrating New Testament scenes, while in each of the two below there is only one. The remaining areas of the lights are filled with a diaper, and there are patterned geometrical figures above, below and between (where relevant) the medallions. From left to right and top to bottom by medallion, the scenes are:

sII. Annunciation, Annunciation to the Shepherds, Adoration of the Kings, Nativity; Presentation in the Temple, Flight into Egypt.

sIII. The Dispute in the Temple, St John the Baptist preaching in the wilderness; Baptism, Temptation; Sermon on the Mount, Wedding at Cana.

sIV. Christ and the Woman of Samaria, a sick woman touches Christ's garments; the Beheading of St John the Baptist, Miraculous Draught of Fishes; Feeding the Multitude with loaves and fishes, Healing of the Blind Man.

sV. Transfiguration, Blessing the Children; Raising of Lazarus, Christ's feet anointed by St Mary Magdalene; Entry into Jerusalem, Last Supper.

sVI. Agony in the Garden, Betrayal; Mocking of Christ, Carrying the Cross; Crucifixion, Deposition.

sVII. Entombment, Resurrection; *Noli Me Tangere*, Supper at Emmaus; Ascension, Pentecost.

Border designs: three types of are introduced:

sII, sV. Non-touching, white-outlined semicircles patterned with green and red flowers (blue in the case of sV), on a red ground decorated with blue and green leaves on yellow stems, which spreads across the white-beaded glass that marks the inner line of the border.

sIII, sVI. Linked white-outlined ovals patterned with leaves and grapes on alternately red and blue grounds.

sIV, sVII. Similar to sIII and sVI but the white outlined ovals become yellow stems and enclose only those leaf patterns that are on red grounds.

Each of the windows has a single quatrefoil tracery piece containing a patterned roundel on a diaper ground.

Literature. Author unknown 1990, includes brief descriptions and some illustrations of the windows. *The Ecclesiologist*, 9, 1849, p. 268: windows to be filled with painted glass at the cost of the Duke of Devonshire: 'The artist employed is Mr. J.A. Gibbs.'[44] Wedgwood, 1977, under catalogue no. 37, lists the cartoons held in the collection, and comments on some of them.

127 Gargrave, St Andrew (CoE)
1852. Client: Rev. C.A. Marsden.

| S aisle window | sV | 1.1m x 2.4m | 2-light | £30 | 1852 |

The First Glass Day Book records the manufacture of two windows: one is sV and the other a three-light E window. No window with the subject matter given for the latter (see First Glass Day Book below) is now in place. Perhaps it was originally sIV, which now contains glass signed 'Capronnier, Brussels, 1865'. It appears not to have been the E window of the chancel (the current window has five lights) which seems to have been given to Nixon & Ward (see letters below). sV is in a poor condition, virtually all the painted details having disappeared.

Description. **sV.** 2-light window and tracery. The Annunciation under a canopy is depicted in the left-hand light and the Nativity, also under a canopy, in the right. The canopies are three-dimensional: three sides are displayed each with a trefoil head contained in a pointed arch, behind which are yellow silver stain fan vaults. The superstructures rising behind and above the gables of the side facades are low-roofed structures, while those of the main facing façade are tall niched towers with yellow-parapeted, crocketed, finialed tops flanked by yellow-pinnacled buttresses, which form pendants in the roofs of the canopies. The borders are patterned with white and yellow silver stain leaves and red and blue florets. An angel holding a text is depicted in each of the two main tracery-pieces.

Office records. *Order Book*, 1852, f. 168, Mar. 4. *First Glass Day Book*, 1852, f. 151, Aug. 6 records both sV and: 'To a Window of Stained/Glass of 3 lights & Tracery/for the East Window of /Church/£50/3 lights 6'11" x 1' 6½".../6 Tracery pieces.../.../ Subject/In the Centre Light "Our Lord"/In Side lights, "St. Andrew/ & St. James Major".../.../Brass

Inscription plate to/Memory of Mrs. Mary Marsden.' The inscription plate for sV reads: 'To Memory of Mrs. Sarah Preston'.

Letters. *JHA: T.A.L. Marsden to Pugin*, 1851, Jul. 7: 'there will be no difficulty about the substitution of single figures for subjects in the three lights. At the same time, the window is intended as a memorial of a woman my brother seems to wish that figures on either side of Our Lord should be those of women also. In which case should it not be too much of a <u>subject</u> we should like to have a Virgin & Child on one side, and Mary the Sister of Lazarus sitting at the feet of Our Lord on the other. If you should still prefer the single figures even to these. The Blessed Virgin one one side and Mary the mother of S. James who was present at the Crucifixion of Our Lord − on the other [the letter includes an inscription identifying the lady commemorated as the wife of the Reverend Anthony Marsden Vicar of Gargrave, and the donors as her three children].' Nov. 8 (re sV): 'Thank you for your kind letter and endeavours to satisfy our minds on the subject of the Annunciation. We thought it best under the circumstances to forward your letter and the design, along with some authorities I had rummaged out to headquarters, and have this morning received the reply, which is that the light with the nativity <u>cannot</u> be spared and that the original design must be adhered to, only the kneeling position of the Blessed Virgin must be a <u>little more distinctly</u> shewn, so as to leave no doubt whatever about it. I assure you no one imagined it to be the case from the original design, but that I doubt not you can do without materially injuring the effect ... the inscription for the brass will be ... in Memory of Sarah − the wife of the Reverend John Preston of Hasby Hall in this Parish. This window is set up by her affectionate daughter Olivia − In the year of Our Lord 1852.' *T.A.L. Marsden to Hardman*, 1852, Mar. 28: 'I have just been informed of the severe affliction with which Mr. Pugin has been visited and the intelligence has given me great distress − Mr. Pugin was kind enough to undertake the designing of two windows of stained glass for Gargrave Church at my request and I was in communication with him on the subject great [sic] part of the last year. I am now at some loss to know how the windows are proceeding. They were to be finished & put up in Gargrave church by Ascension day in this year, or before if possible...I had written to Mr. Pugin respecting some alterations in the design of the two light window which he agreed to make...I am anxious to have the windows as well done as possible for Mr. Winston has the East Window in hand by Messrs Nixon & Ward, & there is likely to be a good deal of stained glass in the church eventually [A number of the aisle windows were later executed by Hardman's] ... I was induced to apply to Mr. Pugin for them in consequence of my admiration of the window you put up under his directions in the church of my friend Mr. Murray of Wells Street, Oxford St. [Gaz. 61].' Mar. 31: 'I presume the one for which the cartoons are prepared is the one with three lights − and that can be proceeded with immediately − the other one I understand has proceeded no further than the <u>design</u> [again points out that he had agreed an alteration in the design with Pugin and asks that he may see it, to confirm that it had been done, after which the cartoons could be prepared and the window proceeded with]. I am glad to hear from you a better account of Mr. Pugin as his loss will be a most serious one, indeed it can never be entirely replaced ... The windows are under my direction, but it is my <u>brother</u> who is the vicar of the parish.' May 5: 'Thank you for the sketch of the two light window − I see from it that Mr. Pugin did not make the alteration agreed upon ... I wrote to him last December in consequence of a judgement delivered by the Bishop of Exeter and which affected the design for the Annunciation ... The point was as to the position of the Angel S. Gabriel − and the last words in the letter [Pugin's] was I remember well "Pray don't trouble yourself any further about the matter for a standing angel Gabriel you shall have"'. Aug. 7: 'The windows ... arrived here last Wednesday and your glazier came on the following morning & has now set them up in their places and it is with great pleasure I write to tell you that we have every reason to be pleased & satisfied with them − they are most beautiful.' *C.A. Marsden to Hardman*, 1852, May 10: 'My brother Mr. T. A. Lister Marsden forwarded your letters respecting the 2 light memorial window to me yesterday ... we are glad to find you can make the Angel Gabriel <u>standing</u>. This was the posture Mr. Pugin assured my Brother in which he would draw the Angel and each is the wish of the Lady who sets up this Memorial window. In the Nativity I think the five candlesticks with candles burning spoils the effect of the drapery of St. Joseph and give an air of stillness to that part of the painting. I would suggest that they may be left out'.

128 Skipton, St Stephen (RC)
1851. Clients: Rev. Andrew Barrow. Sir Charles Tempest, Bart, Broughton Hall, near Skipton, re alterations in 1853.

E window	I	2.8m x 4.5m	3-light	£80

Description. **I.** Triple lancet window, the centre lancet being wider and taller than the other two. Christ on the Cross with two angels hovering at his sides and St Mary Magdalene kneeling at his feet, is depicted in a blue foliage diaper medallion in the middle of the centre lancet. The Virgin Mary in a green-lined, red, hooded-mantle over a white

robe, and St John the Evangelist in a white-lined, brown mantle over a green robe holding a book in his left hand, are portrayed in similar but smaller medallions in the left- and right-hand lancets, respectively. At the tops and bottoms of all three lancets are roundels (top blue; bottom red except in the centre lancet which is blue) in each of which is depicted an angel holding a text. The remaining areas of the lancets are filled with a grisaille of white acanthus leaves and berries, on white stems, against black cross-hatched ground, overlain in the central lancet by a vertical series of red-outlined, touching quatrefoils crossed by red-outlined diamonds; and in the side lancets by a similar pattern but with the quatrefoils replaced by vesicas. The vesicas, quatrefoils and diamonds extend the full width of the lancets between the borders. The borders in the centre lancet are patterned with alternate white and green leaves on red and blue grounds. Those in the side lancets are similarly patterned but the alternating leaves are green and blue and the ground red.

Office Records. *Order Book*, 1851, [sic] f. 133, Jul. 8. *First Glass Day Book*, 1851, f. 115, Apr. 12; 1853, f. 175 Mar. 17: 'Alterations .../as per arrangement', see *Letters* below for the problems the window created.

Letters. *HLRO 304: Pugin to Hardman*, letter no. 271: '1. you have never answered my question about the windows the 3 lancets for Skipton – I saw them done some time ago & you said you altered the ground of the angels I have got 2 letters from the Priest there & I dont know what to say.' No. 501: 'you often accuse me & without justice of not replying to letters but I can get nothing from you on the question which torments me. what has become of the 3 Lancet window done for the Priest at Skipton?? Letters arrive to me & I don't know what to say I have put this question 6 different times & nothing without counting[?] a sigh but pray pray pray direct a letter to this point for when I receive three letters from three people & I cannot reply it makes me wild he is a jesuit & I have done my best to get him his window. he will give me a <u>bad name again</u> when I do my best And all for want of 2 lines of information.' No. 578: '7. I enclose a very annoying letter about that accursed window for Broughton [Broughton Hall, see *Barrow to Pugin*, May 26 below] – what can be done about it – these ruby windows are detestable – when not rich in design – it is a disgrace I know & I ought to be flogged for ever attempting it. it is a nasty detestable style without rich treatment if I was not so wretchedly poor I would pay for it myself & take it out. do look into a bit [sic] & see what it has really cost I thought it was cheap too cheap I curse the hour I ever heard or saw the beastly window or endeavoured to make anything out of it & to make it because that detestable white glass has ruined it. I saw it was a failure altogether – I know these things will be brought up against me I am a wretched man I have worked my heart out in trying to do good things and what with beggarly prices & all sorts of things they are detestable failures if you will ever let me work out I will pay for this window my dear Hardman I am poor as you know but I will willingly work it out & then you can send[?] & fetch it out & there will be an end of it. & break it up & throw it into the dust heap & I shall hear no more about it.' *JHA: Barrow to Pugin*, 1851, Mar. 19: 'We have been longing some time for tidings of our stained window for the little church at Skipton. May we hope to see it finished & in its place by Easter?' May 10: 'I should at once have written to acknowledge the safe arrival of the Glass'. May 26: 'Our new window has been fixed only during the last fortnight [has delayed writing until the benefactress had seen it] I regret to say that her disappointment was very great I had almost anticipated it myself for the white glass in the window bears a very large proportion to the stained glass, nearly two thirds to one. There is indeed a diaper pattern on the white glass but it is very faint To use her own expression the window looks poverty stricken in the extreme. You are of course aware that the third row of Medallions, shown in your first design has been entirely omitted I suppose nothing can be done now to satisfy her wishes: she spoke of having the diapering taken out & replaced by something similar on coloured instead of white glass I myself have endeavoured to dissuade her from it as being impracticable, though of course I should be glad that anything could be done to shake the mortification & disappointment which she has felt. We all indeed partook of the disappointment & regret it the more as we are sure it will cause you pain to find that the work has not given satisfaction ... I must not omit to say that the border of the window is admired & the Crucifixion too would have pleased were it not for the great vacant field above & below it [Pugin has written three paragraphs at the bottom of the letter in which – much as in HLRO 304 letter no. 578 above – he castigates himself for undertaking the window and concludes: 'this is the consequence of trying to make cheap windows. It is very far[?] better to decline doing them at all unless there is a respectable price']. Jun. 9: 'I have nothing but complaints from our friends about our window. In justification of my unfortunate suggestion about the price, I must say, that an eminent artist had offered to complete the work for £70; the unpictured portion of the window to be filled up in the style of the window called the five sisters in York Minster – Your own justly great reputation & the lady's partiality for your work gave you the preference though your estimate was higher. Your subsequent letters justified our expectations of something more than has been sent for you promise in your letter of Oct 6th that we shall have a good thing if we only give you time & in its predecessor you say "It is quite possible to produce a devotional & effective looking window for £80 but a simpler style from what I designed still keeping the general idea & subject I do not think it is possible if thick glass like the old be used to produce a respectable window at a less cost than this." My poor friends mortification is such that she asked

whether the window could not be taken out & employed in some other Church whether you could have seen it before it left Birmingham? Whether you could come over to see it & at the same time plan some decoration for the Altar & c. I scarce know what reply to make to such enquiries if you were to see the window I think you would agree with us that it does not fulfil our reasonable expectations. Perhaps you might be able to suggest some alteration which might add to it without having to remove it. You must not however make the reduction of the estimate bear the entire blame of the failure for surely even at the reduced cost what ruby glass was employed should have been free from fault which it is not. Do not however think that I am questioning the intention with which you have acted in the matter whilst I am lamenting the result. It was not cheap magnificence that I was aiming at but a devotional & effective window at a modest cost. For I do not think that the sum offered by our kind Benefactress was an illiberal & niggard [sic] price for such a window of such dimensions.' *M.C. Tempest to Hardman*, 1852, Apr. 14: 'As the window in St. Stephen's Church Skipton must be removed in order to take down the wall I will thank you to send the packing cases without delay that I may forward the glass to Birmingham. Mr. Pugin informed me some time ago that the new glass to be introduced was quite ready & he wished me to write for the cases as soon as the window could be spared.'
Literature. Wedgwood (Pugin's Diary): Pugin visits Skipton, 1851, Jun. 26.

129 York, St George (York UA) (RC)
1852. Client: J.T. Dolman.

| E window | I | 3.2m x 4.3m | 4-light | £100 |

(There is a clerical error in the First Glass Day Book which gives the width of the lights as 1'3½" instead of 2'3½")

Description. I. 4-light window and tracery. Each light contains a scene depicted under a canopy. From left to right the scenes are: St George and the Dragon; Raising of Lazarus; Raising of the Widow's Son; and St Helen discovering the True Cross. The Latin names of the saints are inscribed in yellow on black in the margins beneath the feet of the figures in the outer lights, and the inscription 'Adolescens Tibi dico surge' under the scene in the inner right light; the plain yellow glass under the scene in the inner left light has presumably replaced what was an inscription. The canopies in the outer lights have trefoil heads contained within pointed arches surmounted by yellow-crocketed and finialed gables. Rising behind and above the gables, and flanked by pinnacled buttresses, are superstructures in the form of two, two-light, light green foliage-patterned Gothic windows with wheel tracery, surmounted by two yellow-crocketed and finialed gables, one above the other. White screens pierced by Gothic windows form the bases of the superstructures and run behind the gables of the canopies. The canopies in the inner lights are similar but have cinquefoil heads and the superstructures are in the form of two-storey, rectangular, parapeted towers flanked by pinnacled buttresses. The lower storey is of blue foliage diaper and the upper is filled with two, two-light blue foliage diaper Gothic windows separated by a central niched and pinnacled buttress. A grisaille made up of units of three white oak leaves outlined in black on black-hatched grounds overlain by a red-outlined polygon which is in turn overlapped by a red-outlined diamond (part of a vertical series masked by the canopies) fills the heads of the lights. An inscription in yellow on black at the bottom of the two centre lights is badly worn and the decipherable parts read: '... of Boxwood ... who died ... 18 1851 and his wife ... who died ... 1828 [see *Letters* below]'. The borders are patterned with white leaves on yellow undulating stems against red, blue and green grounds. The tracery consists mainly of four large trefoils immediately over the lights with a quatrefoil above and between each pair of trefoils, and a large hexagon at the top of the window. The hexagon contains what appears to be a representation of the Resurrection against a white grisaille ground decorated with geometrical patterns. The four trefoils contain red-rimmed, blue, geometrically patterned roundels that are inscribed at their centres with the monogram 'SC'. The two quatrefoils each contain a shield emblazoned with three blue bars on yellow grounds and with a lion's head in the top left-hand corner.
Office records. *Order Book*, 1851, f. 135, Jul. 2. *First Glass Day Book*, 1852, f. 145, May 19 (I), f. 150, Jul. 9: 'To 4 pieces of Stained Glass with/Shields of Arms for bases of lights/of ea.window sent 19th March 1852/2 Centres altered in Tracery of do.'; 1853, f. 185, Aug. 1: 'To A Coloured Drawing/of Stained Glass Window/made for A.Dolman/Esq, being East Window/of St. Georges Catholic/Church York/£2.0.0'.
Letters. *HLRO 304: Pugin to Hardman*, letter no. 578: '2. the sketch for the York window I think you might manage it for the money but I should certainly refuse the putting in of the glass or travelling expenses to be included. these 4 light windows are detestable both the subjects he mentions are central subjects, you cannot put the crucifixion as a pendant to anything. I have therefore introduced 2 subjects relative to the restoration of the dead by Our Lord when on earth & the 2 subjects he wanted. it is the best thing I can propose.' *JHA: Dolman to Hardman*, 1851, Jun. 5: 'I have some intention of presenting a stained glass window to St. Georges Church in the City a plan of which I enclose, it is the East window

& is to be a memorial to a deceased Relation. I have not decided on any particular design therefore shall feel obliged if you will send me one which you think will be suitable... I wish the accompanying Arms to be introduced.' Jun. 12: 'with respect to the figures I rather prefer groups what wd. you think of the Crucifixion and Ascension for the two middle lights & St. Helen and St. George in the two outer ones the other lights in the top of the window might be in some rich and elegant pattern <u>without</u> figures this would reduce the expense without I think taking anything from the beauty of the window. I thought Arms wd. look well in the position I have marked, but I do not understand what you mean by panels. the deceased Samuel Cox, died 18 April 1851.' Jun. 28: 'the sketch of the window is approved of by my family and also by the Rev. Mr Rendel of this place I have only to add that I hope you will make it as light and briliant [sic] and <u>elegant</u> as you can & then I have no doubt you will get other orders from York for as yet we have only one stained window in the church and I think soon we shall have another and principal church built in this Town. I am not very fond of canopies over figures for they are generally stiff and heavy but this I must leave to your better judgement. I should like to know when you think the window will be finished for Mr. Rendel intends to lower the Reredos Which at present covers a foot of the bottom of the window and this had better be done first. P.S. I may as well mention that Mr. Hansom objects to lower [sic] Reredos but I hope in your next letter you will insist on it being done for if left at its present height it will spoil the proportion of the window. The inscription I shall leave to you.' Dec. 9 (in 1852 bundles): 'On consideration we think that the Arms in the compartments No. 1 & No. 2 had better be left out, you can fill up their places with anything you may think suitable. As Mr. Cox was a widower I should like to introduce the name of his wife in conjunction with his own if there is space you may mention my name as the person who has put up the window to their memory. Mrs. Cox's name was Elizabeth, she died 18 October 1828 aged 27.' 1852, Jun. 1: 'I find during my absence the window has been put in, it looked very well but on the whole it is too light, wanting depth of color [sic]. I am sorry to say that the bottom part containing the Arms & inscription is exactly five inches too deep, neither can be altered for there is not space enough to contain both, therefore the only way will be to fall back on the original plan, which will render it necessary for the three top lights to be removed.' Sep. 27: 'I shall be much obliged if you will have a coloured drawing made of the window in St. Georges church on a small scale but still large enough to admit of all the figures being distinctly seen. I was in York last month and was much pleased with the window I think it looks remarkably well.' *JHA Letter Book: Hardman to Dolman*, 1851, Jun. 17: 'I have taken the liberty of changing the subjects as it is not right to put the Crucifixion in a side light, it always ought to be a Central Object & I have therefore put two miracles of our Lord raising the dead Lazarus & the Widows Son.' 1852, Jun. 2: 'with respect to the colour I think you will find on looking at it a little more that it is quite right. I have no doubt you will have been accustomed to see windows with very little white in them which is one of the great curses of modern times & I also beg to quote your letter of the 28th June in which you say 'I hope you will make it as light & brilliant as you can.'
Literature. Wedgwood (Pugin's diary): Pugin visited York on a number of occasions, as his diary shows, the last time being Aug. 9, 1849.

NOTTINGHAMSHIRE
130 Nottingham, Convent of Mercy (RC). Now residential appartments. Chapel intact.
1847-9 Clients: Rev. Mother (I); Francis Brockhole (nII or sII); William Vavasour (nV).

Chapel E window (**7.2a & b**)	I	3.3m x 5.0m	5-light	£150	1847
Chapel N & S windows (**10.25, 10.26**)	nIII, nIV	1.2m x 2.6m	2-light	£70	1847
Chapel N & S windows (**10.27**)	nII, sII, nV	1.2m x 2.6m	2-light	★	1848
Cloister window		0.5m x 1.1m each light	2-light	£17	1848
Community room window (**10.28**)	CR I	0.4m x 1.3m each light	2-light	£20	1848
Cloister window		0.6m x 1.9m each light	3-light	£35	1849

★ nII and sII cost £30, nV £35

Descriptions. **1.** 5-light window and tracery illustrating the Mysteries of the Rosary. Each light contains three scenes bounded by yellow-outlined quatrefoils, arranged in three rows across the window. The quatrefoils are linked by sinuous bands of white vine leaves on red grounds which form green diaper lozenges around them and smaller purple diaper leaf-patterned ovals between. The remaining areas are filled with white vine leaves and geometrically patterned roundels on a whitish-blue diaper ground. From left to right the scenes depicted are: top row: Resurrection; Ascension (?); Pentecost; Assumption of the Virgin; Coronation of the Virgin: middle row: Agony in the Garden; Flagellation; Mocking of Christ; Carrying the Cross; Crucifixion: bottom row: Annunciation; Visitation; Nativity; Presentation in the Temple; Dispute in the Temple(?). The borders are patterned with white vine leaves on red grounds and merge with the bands which form around the quatrefoils containing the scenes. The tracery pieces contain white leaf patterns and green-patterned

roundels on red diaper grounds. The top-most piece – a quatrefoil with a long vertical axis – has a representation of the Madonna della Misericordia in its middle section; each of the two butterfly-shaped pieces immediately below contain a depiction of an angel holding a text; each of the two quatrefoils below these, at the outside edges of the tracery, contain a pair of figures in profile facing inwards – those on the outside stand behind and appear to bless those kneeling on the inside; the two pieces between the quatrefoils each contain a roundel inscribed with the letter M.

nII–nV, sII. nII, sII: these, according to the First Glass Day Book contained , 'quarries with centres & c & c,' are now filled with later stained glass, while the canopies and base panels in nIII, nIV and nV have been replaced with plain white quarries. These latter three are two-light windows each with a single large quatrefoil tracery piece. Every light in them contains a depiction of a saint standing in front of a foliage diaper screen – blue in nIII, green in nIV and white in nV. From left to right the saints are: nIII: St Thomas of Canterbury, in a yellow-silver stain-patterned mitre, a red-lined, white, yellow silver stain-patterned chasuble over a green dalmatic and a yellowish-white alb, holding a crossed staff in his right hand. A sword appears to pass behind his halo rather than through his head; St William of York(?), as for St Thomas, except that there is no sword, his chasuble is green-lined, dalmatic pink-lined and blue, and alb white, and he is holding the crossed staff in his left hand. nIV: St Lucy, in a red-lined, white, yellow silver stain rosette-patterned mantle over a brown-patterned robe, balancing a platter, containing her eyes, on the palm of her left hand, and holding a palm in her right; St Helen, crowned, and in a brown-patterned, lined, white, yellow silver stain-patterned mantle over a red robe, holding a green-patterned cross against her body with her left hand. nV: St Edward, crowned and in a green-lined, orange-brown-patterned mantle over a red robe, holding a ring in his right hand and a sceptre in his left. St Gregory, in a white and yellow-banded papal tiara and a green-lined, red chasuble over an orange dalmatic and a yellowish alb, holding a book in his left hand. The yellow, white-patterned columns of the canopies remain in nIII and nV as parts of the borders, the remainder of which are patterned with white leaves on red grounds. It would appear that the columns in nIV have been replaced by a continuation of the borders, which are as in nIII and nV except that the grounds are blue. Each tracery-piece contains a portrayal of an angel, sitting with his feet on a band of blue, stylised cloud, against a blue diaper ground. Those in nIV and nV hold crowns above their laps, while the one in nIII holds a shield emblazoned with a coat of arms of three castles and an inverted white chevron on a green ground.

CR I. Described in the First Glass Day Book as a two-light window, only one light (that containing under a canopy a representation of St Joseph carrying the Christ Child) remains. Two seemingly separate lights are mentioned in *The Tablet* (see *Literature*); perhaps they were always separated, for if the St Joseph light is in its original position, there is no room for a second light alongside, unless in the interim period structural changes have been made. St Joseph is in a red mantle over a yellow robe and stands in front of a green clover leaves-on-stems diaper screen, cradling the Christ Child (who is in a brown robe) in his left arm. Beneath the feet of the saint is his Latin name inscribed in yellow on black, and below that the words: 'Ora Pro Nobis'. The canopy has a trefoil head contained within a pointed arch surmounted by a yellow-crocketed and finialed gable. The borders are patterned with alternately white-on-black rosettes and red and green clover leaves on stems.

Cloister windows. The stained glass in the two-light windows of the upper cloister is not by Pugin (although one in the lower cloister containing a depiction of the Virgin and Child, and St John the Evangelist may be).[45] That in the three-light end window of the upper cloister, with, from left to right, representations of St Lucy with two children, the Virgin and Child with a kneeling donor(?) figure and St Teresa, in the lights, suggests the Pugin/Hardman style, but is, perhaps, either later, or an altered original. The subject matter concurs with Oliphant's description of two triple figures and a single one, and with one of the saints (St Teresa) mentioned in Mr Maxwell's letter to Hardman (see below).

Office records. Order Book, undated, f. 10 (I, nIII, nIV, CR I, cloister), I, 'Cartoons £30'; nII, sII, 'Cartoon £16'; CR I, 'Cartoons £6'; Cloisters, 2-light, 'Cartoons £5'; Cloister 3-light, 'Cartoons £5 cost £17'; undated, f. 28 (nII, nV, sII). *First Glass Day Book*, 1847, f. 13, Apr. 22 (I), f. 14, Jun. 12 (nIII, nIV), f. 17, Sep. 28: '2 Tracery pieces with/Figures altered for East Window [I]'; 1848, f. 28, Apr. 7 (CR I), f. 33, Jun. 8 (cloister, 2-light), f. 42, Sep. 25 (nII, nV, sII), f. 44, Oct. 18 (tracery pieces for nII, sIV, nV); 1849, f. 68, Oct. 1 (cloister, 3-light), f. 69, Oct. 10 (wireguard). *Cartoon costs per ledger summary:* nII, nIV, nV, Powell £1.6.8, Hendren 6s. 8d; cloister, Powell £1.10.0, Hendren 13s.4d, Oliphant £5.10.0. Oliphant's account records that the payment (entered Jul. 4, 1849) was in respect of '3 Cartoons, 2 Triple Figures 40/- & 1 Single @ 30/-'. *Pugin sketches*, BM & AG a no. not allocated, of nV detail; a. no. 2007-2728.6 (**10.29**), of CRI.

Letters. HLRO 304: Pugin to Hardman, letter no. 49: 'I am getting the Nottingham window and the side Brighton [St Paul, Gaz. 41] next.' No. 41: 'The tracery & all the panel & border work for the East window of the Nottingham Convent will go to you in a day or 2.' No. 394: 'You will receive the whole of the Nottingham window in a few days.' No. 806: '9. I have promised to let the Rev. Mother at Nottingham have the glass for the Community Room & cloister by lent, what have you done in respect of the 2 windows the cloister window I have here & shall finish it at once & send it to you.'

No. 292:'I have got another window for Nottingham to do.' No. 58:'1. I have been to Nottingham [presumably Oct. 12, 1848, per diary] & I expect we shall be able to send Early [sic] there as soon as he leaves St. Georges [Southwark, Gaz.63] 2. I was horrified at the side window with s. lucy & s. helen they are both on green 4 grounds & the effect is beastly how I made this mistake I know not but it is dreadful, the 2 bishops are on the contrary beautiful & I like the East window very much.' *Pugin letter not numbered, in J.H. Powell section of letters,* postmark 'JY 22 1849':'Oliphant has finished Brighton side windows & Nottingham. No. 852 'let me know by Return if Mr. Maxwell paid for the Nottingham window & if so how much? I believe I have been outstandingly insulted in that [?] & if my suspicions are correct I shall take it up at once [written, possibly by Hardman, on the letter, is '£35 for Glass/1-8 Iron/12/- Carr']'. *HLRO 339: Pugin to Jane, his wife,* letter no. 274:'I went to Nottingham to see the window [presumably the Chancel E window (I)] It is a capital window you never heard such nonsense they persuaded the Rev. Mother that the glass was only painted not stained & that it would rub off!!! It is quite wonderful what fools there are.' *JHA: Powell to Hardman,* 1847 bundles, undated:'the large cartoon sent is for Nottingham there are five lights all the same.' Undated:'enclosed you will find cartoons for side windows Convent Nottinghamshire complete excepting `one figure' which please ask the Governor [Pugin] about when you see him. I think it is St.William of York to be the same as one of the Bishops in End Cloister Window, Ushaw [Gaz.40].' *Caroline Borini to Hardman,* 1847, Jul. 7:'I enclose a cheque for £150 being the amount for the East Window of our Chapel.' 1848, Apr. 1:'Rev. Matthews wishes me to inform you of the safe arrival of the glass ... but we were disappointed the glass for the other windows was not sent as we understood from Mr. Pugin that it was finished some time ago.' *Constable Maxwell to Pugin,* 1849, Nov. 15: Complains about his window in Nottingham Convent of Mercy (which included depictions of St Stanislaus and St Teresa), with regard to its transparency, poor drawing and lack of rich colour, and for which he was charged an extra cost.

Literature. *The Tablet,* 12, 1851, p. 339: letter from J.J. Mulligan, Nottingham, dated May 26, 1851, headed 'Mr. Pugin and the Devotion of St. Joseph', mentions two windows for the Community Room of the Convent, designed by Pugin which 'were fitted up in the south end of the room. From the relative position in which they were placed they were evidently designed to form an harmonious contrast, the one to the other. Our Blessed Lady is standing alone, with a book in one hand ... St. Joseph is represented holding Our Lord in his arms'. Wedgwood (Pugin's Diary), see Gaz.131 for Pugin's visits to Nottingham.

131 Nottingham, St Barnabas' Cathedral (RC)

*c.*1844. Client: Lord Shrewsbury who donated the glass at a contracted price of £600, which was executed by William Wailes. Client for alterations Rev. F. Cheadle, *c.*1844.

E chapels E windows	nII, sII	0.9m x 1.8m	2-light
SE chapel S windows	sIII, sIV	0.4m x 2.5m	single lancet
NE chapel N windows	nIII, nIV	0.5m x 1.5m	single lancet
N choir aisle window	nV	0.4m x 3.4m	single lancet
Chapel of the Blessed Sacrament:			
(S choir aisle) windows	sV–sVII	0.4m x 3.0m	single lancet
N transept W window	nXI	0.4m x 2.7m	single lancet
S transept W windows	sIX	0.4m x 4.9m	single lancet
N & S aisle windows	nXII–nXV, sX–sXIII	0.4m x 1.9m	single lancet
S aisle W window	sXIV	0.4m x 3.0m	single lancet

The windows have been much altered, in some cases to introduce more light into the church (see *Letters* below), and in others replaced by later glass (these include the transept windows nX and sVIII and the E window of the Lady Chapel, I. In the case of the latter, the centre and one of the side lancets as described in the *Illustrated London News*, appear to have been moved to sIII and sIV respectively). In a letter to Lord Shrewsbury, 1841, Dec. 1 (Belcher, 2001), Pugin referred to the glass as follows:'This will be of 4 descriptions. for the aisle windows, figured quarried with Rich borders and emblems and shields introduced at 12s 6d per foot. for the west end of the nave [sXIV is currently filled with white grisaille and red and blue geometrical patterns], – end of transepts, side windows of transepts, rich foliated patterns Like the chapter house, york at 15s 6 per foot. for the window in the chapel of B Sacrament. Windows of Ladye chapel and east chapels [nII, sII]. Circular window over high altar exceedingly rich glass, ruby & blue Mosaic with subjects introduced as at Sens, Chartres & c 25s per foot. for the Clerestory ornamented quarries with ornamental work introduced 6s per foot. The whole of the Glass to be stained on thick glass. Leaded up. Packed and delivered, contract for glazing the whole church £600.' The *Illustrated London News* of 1844 described the windows in an article commemorating the consecration of the church:'The windows of this church, 76 in number, are all glazed with stained glass. The circular window over the

eastern end of the Choir represents the adoration of the lamb. In the windows of the nave are the following armorial bearings: Talbot, Neville, Furnival, Lovetot, Verdon, Lacie, Right Rev. Dr Walsh, Right Rev. Dr Wiseman, Right Rev. Dr Willson, Bishop of Hobart Town, The Town of Nottingham, St, Jermyn's Cross, Croxton Abbey, and Worksop Priory. The lights of the Chapel of the Blessed Sacrament [sV to sVII] have been designed with especial reference to that great mystery: they consist of a succession of cherubim in ruby colour, signifying the intensity of Divine love and are placed on a field of azure, bordered by alternate crosses and ciboriums, Or. The eastern window of the Ladye Chapel contains the mysteries of the Annunciation, Visitation, Birth of Our Lord, Adoration of the wise men and the Coronation of our Blessed Lady: these are placed in circular compartments on a field of lilies intersected by blue bands [now in sIII?]: in each of the side lights are angels, each bearing a verse of the Magnificat, or Canticle of the Blessed Virgin. (Luke 1.46) [now in sIV?] ... the chief benefactor is commemorated by the following inscription running along the bottom of the aisle windows: Good Christian people [nXV]/of your Charity pray [nXIV]/for the good estate of [nXIII]/John Earl of Shrewsbury [nXII]/the chief benefactor [sX]/to the building [sXI]/of this church [sXII]/to Saint Barnabas [sXIII], [the article gives the last part of the inscription as "dedicated in honour of Saint Barnabas"].' Of the windows in place and not mentioned above, nIII & nIV each contain three blue roundels, with red rims (two decorated with single yellow grotesque lions heads), and plain white quarries, and stained borders; nV & sIX are both made up of white quarries with stained borders but the former contains four, alternating, geometrically patterned roundels and quatrefoils, and the latter, five roundels with alternately blue and red rims, containing angels playing harps, against alternately red and blue grounds. The angels are in a frontal pose, have yellow haloes, and alternately blue and green wings and wear alternately green and blue robes. nXI consists of white quarries and a blue border. It contains three red-rimmed roundels: the centre one contains a yellow cross on a green ground; and each of the upper and lower ones, a white Agnus Dei on blue ground. The clerestory windows are made up of plain white quarries, with stained borders. They contain single, blue, red-rimmed roundels, some containing the emblems of the evangelists.

Office records. *First Glass Day Book*, 1848, f. 44, Oct. 18: 'To Altering Lights for Church/.../£9.10.0/for 1 Light as below/Diapered ground for 7 Centres/68 Border pieces & New White/Round Border, & Cleaning light/with Acid/. Taking out old glass for above/ & putting in New Glass/for Lights/4 New white grounds to/29 Centres/35 Circles painted as Stars/236 Border pieces & New White Borders round Lights/New grounds for 3 Tracery/pieces/Taking out old glass for above/& putting in & Leading New Glass/£9.10.0'. 1849, f. 57, Apr. 26: 'To Repairing and Altering/.../3 windows.../£4.15.0/ putting in 180 White Roses for/10 New Inscription pieces/18 Border pieces Fleur de Lys/16 Centres. White grounds/& New Narrow White Outside/Borders/& Releaded & c & c'. 1852, ff. 147-8: 'To Altering & Repairing/9 windows of 2 lights/each & releading in/parts with New White Glass/.../£13.10.0 & cleaning Lights with Acid/Each light 4'8" x 1'2"/To 1 Window altered and/repaired of 2 Lights releaded 2 Lights @ 21/-ea/with New Ruby Border/& cleaning Lights with Acid/ 1 Window altered and/repaired of 2 Lights releaded with New Border and Background to Centres/2 Lights @ 21/ea/£2.2.0/& cleaning Lights with Acid'

Letters. *Stanton, 1950 (Appendix VII): Pugin to Lord Shrewsbury, 1843* 'The stained glass is fixing in the interior and in a few weeks it will be well worthy going to see'. *JHA: Cheadle to Hardman*, 1849, Mar. 16: asks for windows in Lady Chapel to be lightened as had been done in the Chapel of the Blessed Sacrament: 'the blue in the wings of the cherubim might be exchanged for white, as before.' 1852, Apr. 30: 'We are anxious to throw a little more light into our Church which all will admit is desirable. As a first experiment, I should like to have the borders of the two lights at the end of the North & South aisles altered in a manner similar to what was done to those in the Lady Chapel, and also the yellow dingy glass of the clerestory windows in the nave, changed for plain glass or what would be equivalent to plain glass in admitting light...I could send the two lights above named and also one of the clerestory, that you may tell what you think of the matter, and what would be about the expense of alteration of the twenty lights in the clerestory'. May 3: 'The alterations in these two windows should be confined to the borders. The blue should be changed for white, the red for whatever colour you judge best, the object being to admit as much light as possible without affecting the appearance of the windows. The present borders when seen from a little distance down the church have a dark appearance, but no colour is visible. 'I have sent the two windows from the west end of the north & south aisles. The Alterations in the windows of the Lady Chapel, were confined to the borders. The rectangular pieces of dark blue were taken out and white glass put in. Every alternative rectangular piece was yellow I have sent also one clerestory window. I have no objection to plain quarries slightly tinted with green, as you suggest, provided they will admit an equal quantity of light, and will be about the same expense and if you consider the slight tint of green preferable to plain white; otherwise I should prefer white glass. White glass at that height, would not look amiss with the monograms, and border The border, I suppose, would remain as it is, unless found more convenient & less expensive to alter it. There are twenty windows in the clerestory and I should like to know the expense of their alteration that I may be able to pay twenty shillings in the pound – P.S. I

have sent <u>two</u> clerestory windows as the borders in each are different. I have been looking at the windows for the nave of the church and my own feeling, as well as that of others, is that plain <u>white</u> quarries would be preferable.' May 9: 'The windows reached in due time to have them in for Sunday. The two lights at the end of the North & South Aisle are very much improved in appearence but the difference in the light is not so great as I had expected still there is an improvement in this respect. The two altered windows in the clerestory make a most striking difference in the light, and I quite approve of the slight tint. I will have half the remaining windows (nine) sent off tomorrow evening … I should like to have had the borders altered at the same time, but we cannot afford the expense. P.S. I have also sent one of the eight aisle windows, that I may have your opinion whether anything can be done with them considerably to increase the light without much expense, and without spoiling the appearance of the windows. As the windows are within four feet of the ground it would be objectionable to have plain transparent glass. But it appears to me that if plain glass slightly tinted were black lined similarly to the present ones, the black lines would be a significant obstruction to the view.' May 20: 'I should like to have as soon as convenient a sample of the alterations that you propose in the aisle windows [the aisle windows now contain plain quarries as background to the armorial bearings].'

Literature. *The Ecclesiologist*, 5, 1846 p. 14, 'The Artistic Merit of Mr. Pugin', in which article the St Barnabas windows were described as 'of a very inferior quality … (far better would it have been to have good glass in the principal windows only, and to have left the rest for other days)'. *London & Dublin Weekly Orthodox Journal*, 14, 1842, p. 366: brief description of the building with an account by Pugin taken from the *Dublin Review*, Feb. 1842, including: 'The windows of this church are all intended to be glazed with stained glass, of various devices and subjects, in the rich early style'. *True Tablet*, 13 & 106 May 21 1842, pp. 209, 337: notice of laying of foundation stone. *The Tablet*, 5, 1844, p. 550: report of the consecration, taken from *The Times*; p. 564: consecration and opening of the church; p. 579: report of the consecration taken from the *Morning Post*. Wedgwood (Pugin's Diary): Pugin visits Nottingham, 1837, Sep. 5; 1838, Apr. 25-6; 1840, Mar. 2, Apr. 28-9; 1841, Aug. 30, note 33, 'Building began discreetly on Sep. 29 1841', Oct. 11-12; 1842, Feb. 25-6, Mar. 31, Apr. 1, May 9-10, note 14: 'foundation stone… laid', 17, Jan. 23, Aug. 10-11, Sep. 3-4, 5-6, Oct. 4, 31; no diary 1843; 1844, Feb. 20-1, Apr. 2-3, Jan. 11, 13, Jul. 18-19, Aug. 5, Sep. 24-5, Dec. 3, p. 58 '[End papers at back of diary] [b] [financial calculations] Wailes for Nottingham 100.0.0 [d] [lists of costs under heading] Nottingham… Stained Glass 604.0.0' 1843; 1845, Apr. 5-7, Sep. 3, 17; 1848, Jan. 14, Aug. 28, Oct. 12; 1849, Apr. 23; 1850, Feb. 21. Belcher, 2001, p. 292.

OXFORDSHIRE
131A Banbury, St John, South Bar Street (RC)
*c.*1841-2.

Chancel apse E window (**1.6a-c**)	I	1.8m x 4.1m	3-light
Chancel apse N & S windows	nII, sII	1.2m x 4.1m	2-light

In a letter to the Rev. Dr Rock, dated Aug. 25 1841 (Belcher, 2001) Pugin wrote 'I shall arrange to get down to you at Farringdon when I go to Banbury where I am making several additions to the Church – in the shape of stained windows & c'. The windows at present in the apse of St John's might be those to which Pugin was referring. Although the faces of the figures exhibit more modelling than might be expected in a Pugin window (possibly they have been subject to some 'restoration', or perhaps Pugin had even less control than usual for this time) they contain details that are to be found in the roughly contemporary E window made by Wailes at Pugin's instigation for St Augustine, Kenilworth (Gaz.168), see Chapter 1 pp. 29-30.

Descriptions. **I.** 3-light window and tracery. The Virgin and Child under a canopy is depicted in the centre light and St John the Baptist and St John the Evangelist, also under canopies, in the left- and right-hand lights, respectively. The Virgin stands in front of a black-patterned, green screen, on a yellow floret-patterned, white tiled pavement, which recedes in a none too convincing perspective. She is crowned and in a purple-lined, deep blue mantle over a wine-red, black-patterned robe, cradling the Child in her right arm and holding a sceptre in her left hand. The Child is crowned, and in a yellow silver stain-patterned, white robe holding an orb in his left hand. In the bottom panel of the light, immediately beneath the inscribed Latin name of the Virgin, the figure of a man (perhaps the donor) kneels in profile on a pavement similar to that on which the Virgin stands, and in front of two three-light Gothic windows partly obscured by the pendant of a vaulted roof. He is in a brown habit, and a white scroll inscribed in black with the Latin text, 'Exultabo in deo [?] meo', curving over his head. St John the Baptist in a royal blue mantle over a yellow camel hair robe holding a closed book – on which lies a yellow-haloed, white Agnus Dei – in his left hand, stands barefoot on a similar pavement to the Virgin, in front of a black-patterned, red screen. In the bottom panel immediately beneath the

inscribed Latin name of St John, in a blue leaf-patterned quatrefoil, edged cartouche-like with white fronds, and with sprays of three white leaves, at each of the foils, all against a red-leaf-patterned ground, is a depiction of a yellow-haloed Agnus Dei standing in profile with its head turned back to the right, in front of a crossed staff to which is attached a white banner. St John the Evangelist in a purple-lined, white mantle over a royal blue robe stands on a similar pavement and in front of a similar screen to St John the Baptist, holding a yellow quill and an inscribed scroll in his left hand, and a closed book – on which perches a yellow eagle – in his right. In the bottom panel immediately beneath the inscribed Latin name of St John is a white-haloed, yellow eagle, alighting in profile facing left and holding in its beak a scroll inscribed 'Sanctus Johan[nus]'. The eagle is displayed in the same manner as the Agnus Dei beneath St John the Baptist. The canopies have cinquefoil heads (the foils can be read as strap-patterned or as vaulted roofs in perspective) contained in pointed arches surmounted by yellow-crocketed and finialed gables. The gables contain the yellow letter M in a red quatrefoil, in the case of the centre light, and the Agnus Dei, and a yellow chalice containing a sphere patterned with a cross and surrounded by *fleur-de-lis* outlined in black, respectively, in the side lights. Behind the gables are linenfold-like screens and flanking the finials stand angels holding inscribed scrolls which read, on the left, 'St. Johannes Bapt' and on the right 'Pro Ora Nobis'. The yellow letters M appear in white roundels in the foils of the heads of the lights. The four tracery-pieces above the centre light each contain a depiction of a standing, angel in white. In the top two pieces they hold blue shields and in the bottom two, red. The shields are emblazoned with, from left to right and top down: the letters IHC, the letter M, the Agnus Dei, and a yellow star. The remaining large pieces are patterned with white leaves on blue and red grounds and the two small pieces immediately above each of the side lights, red leaves around yellow rosettes.

nII. 2-light window and tracery. Each light contains three symbols or monograms on backgrounds of quatrefoils within roundels framed by cartouche-like quatrefoils (these are similar to those described for the bottom panels of window I, except that they are turned through ninety degrees so that the sprays of leaves are at the tops, bottoms and sides of the frames). From the top down those in the left-hand light are: the letters IHC in yellow with a yellow crown above, all against a red-patterned ground; a yellow foliated cross against a blue-patterned ground; and a white Agnus Dei behind a crossed staff with a banner, all against a red-patterned ground. Their equivalents in the right-hand light against similar backgrounds are: a yellow letter M; a yellow star; and the letters IHC in yellow. The rest of the lights are made up of yellow silver stain patterned quarries forming alternate rows of: *fleur-de-lis* alternating with chalices (similar to those described for the gables of the side lights of I); and the letters M. There are five white roundels at the top of each light. Each group of five contains in yellow: the letters IHC at the top, two letters M immediately below, and two letters I at the bottom. The borders are patterned with the chalice and sphere motif, as in the quarries, which alternate with blue, and red foliated crosses. The main dagger-shaped tracery-piece at the top of the window contains a central roundel ornamented with a white Agnus Dei in front of the banner and staff. Beneath the roundel, in the 'blade of the dagger', are two smaller roundels inscribed with the letters IHC and the letter M, respectively. The two smaller upturned dagger-shaped pieces immediately over the tops of the lights are patterned with white leaves on blue and red grounds and the four small pieces to the sides of the lights, red leaves around yellow rosettes.

sII. Is the same as nII, except to achieve symmetry across the apse, the symbols and monograms in the lights have been reversed. Hence those in the left-hand light of sII are the same as in the right-hand light of nII, and similarly for the right-hand light of sII and the left-hand light of nII.

Literature. Belcher, 2001, p. 267. Wedgwood (Pugin's Diary): Pugin visits Banbury, Sep. 28 1838; Aug. 21-2 1840; Apr. 12, Oct. 13 1841.

132 Cuddesdon, All Saints (CoE)[46]
1853. Window designed by J.H. Powell.

Office records. Order Book, 1852, f. 189, undated; Order Book 2, f. 31, 1852, undated. *First Glass Day Book,* 1853, f. 181, Jun. 4: 'To A Window of Stained/Glass of 3 Lights & Tracery/ 3 Lights 7'10" x 1'5½"'.

133 Culworth, near Banbury, St Mary the Virgin (CoE)[47]
1851. Client: Rev. I. Spence.

Office records. Order Book, 1850, f. 82, Apr. 4. *First Glass Day Book,* 1851, f. 128, Oct. 10: 'A Stained Glass Window/of 2 lights 7'3" x 1'10½"/£50/and 3 pieces of Tracery/.../Memorial Window/ Subject Transfiguration & Our Blessed/Lord

talking with the Woman of Samaria. [There is no window with this subject matter now in the church].'[48]

Letters. JHA: *Spence to Hardman*, 1851, Sep. 4: 'I think you had instructions from Mr Pugin to prepare a memorial window for our Church ... If finished please send it.' Oct. 28: 'We have just unpacked the window ... you will oblige by stating the subjects represented on it.'

134 Deddington Clifton, St James (CoE)[49]

1852. Tracery design by J.H. Powell.

Office records. First Glass Day Book, 1852, f. 157, Sep. 28: 'To A Trefoil piece of/Tracery for Gable of Stained/Glass/.../ of East end over Triplet'.

135 Henley-on-Thames, Sacred Heart (RC)

The five-light E window came from the now destroyed chapel at Danesfield, Bucks (Gaz.6); Sherwood and Pevsner suggests the glass is Pugin/Hardman *c*.1850 and Goodhart-Rendel also attributes it to Pugin. As shown below, however, it was ordered and made eight years after Pugin's death and the glass must be regarded as designed by J.H. Powell and made by J. Hardman and Co. The window is recorded in a Hardman Order Book as being commissioned by the Hon. Mrs Scott Murray on Aug. 17, 1860. The subject matter is given as Eve, Sara, Rachel, Rebecca, Immaculate Conception, Anna, Ruth, Judith and Ester. All contained in lights of 9'0¾" x 1'11" which is consistent with the present window. A letter from J. Hardman & Co. in glass Letter Book no. 3, Aug. 9, 1860, begins 'we now beg to send you the estimate for filling the East and side windows of your chapel in the very best way according to the designs. The East window will be £320'.

Literature. J. Sherwood & N. Pevsner, *The Buildings of England: Oxfordshire*, Harmondsworth, 1974, p. 638. H. S. Goodhart-Rendel, 1942, pp. 27-32.

136 Milton, Church[50]

1853. Window designed by J.H. Powell.

Office Records. Order Book, 1852, f. 185, Jul. 27; *Order Book 2*, 1853, f. 50, undated. *First Glass Day Book,* 1853, f. 174, Mar. 16: 'To A Stained Glass Window/for West Window/of Aisle of Church/of 4 Lights and Tracery/4 Lights/6'0" x 1'6½"/14 pieces of Tracery.../Subject All Saints '.

137 Oxford, St George's Chapel, George Street (CoE)

1850. Client: Rev. Jacob Ley, Christ Church, Oxford.

Built by G. Wyatt of Oxford to the designs of J.P. Harrison, the chapel was consecrated in Dec. 1850, and was intended as a chapel of ease to the church of St Mary Magdalene. It contained windows by Wailes, Warrington and Hardman (*The Builder*, 1850) and was demolished in 1935. The glass is presumed lost.

Office Records. First Glass Day Book, 1850, f. 109, Dec. 26 for Nov. 22: 'A Stained Glass Window/for extreme West Window/on North side of Chapel of/St. George the Martyr/£38/ of 2 Lights with Figures/7'4" x 1'5½"/ & 7 Tracery pieces to do/.../Figures of St. George & St. Margaret'. *Cartoon costs per ledger summary:* Powell £3.15.0, Hendren £1.0.0.

Letters. JHA: *Ley to Hardman*, 1850, Sep. 19: 'I am pleased with the sketch which you have sent me ... perhaps less canopy would accord better with the general architecture and arrangement of the building. Might not the lower canopy remain, and the upper position be replaced by grisaille glass? this I fancy would accord with a period of decoration rather earlier than the sketch and would harmonise with my other windows in which I have requested to have a considerable portion of white glass that I may not lose too much light ... Mr. Harrison, the architect has been taken seriously ill; and this may probably cause delay; but I still hope to bring the Chapel into use before winter.' Dec. 26: 'Your window is in place, and pleases me very much.'

Literature. The Builder, 8, 1850, p. 608. *Victoria County History of Oxfordshire*, 4, 1979, p. 390: a short history of the chapel.

138 Oxford, St Mary Magdalen, Choir School Magdalen College (CoE)

1851, 1852. Client: Rev. Dr Bloxham, Magdalen College, Oxford. Supervising architects: J. and C.A. Buckler.

The glass is no longer *in situ* in Magdalen College. What was the new schoolroom of 1851 is now the College Library (*c*.1930) and Magdalen College School has moved to a new site in Cowley Place.[51]

Office Records. *Order Book*, 1850, f. 102, Aug. 27: : 'West Window Tracery, shields to be placed in parallelograms in upper compartment of window'. *First Glass Day Book*, 1851, f. 112: '1 Light of Stained Glass with/Shield Arms of Bishop Waynflete @ 88/-/£4.8.0/2ft 6in x 1ft 4 in/ 1 do. do. Arms of Cardinal/Wolsley 2ft 6in by 1ft 4in/ @ 88/-/£4.8.0'; f.131: '8 Lights of Stained Glass with/Shields & c 2'6" x 1'4½"/£33.10.0/.../1. Arms of Bishop Stokesley/2. do. Bishop Parkhurst/3. do Bishop Bickley/4. do See of Raphoe & Derry/impaledwith Hopkins/5. Arms of Bishop Hartley/ impaling See of Hereford/ 6. Arms of Bishop Nicholson/impaling See of Gloucester/7. Arms of See of Winton/8. do of John Holt'. £33.10.0; f. 147: 'To A west window of/Stained Glass of Ten/lights with Shields/of Arms & c./.../£67.10.0'; f. 150: 'To 11 pieces of Tracery for/West Window sent 25th /May/£7.10.0/24 Quarries for Repair/of West Window.'
Letters. *JHA: C.A. Buckler to Hardman*, 1850, Dec. 12: 'The Contractor is at work in glazing the windows of the Chorister's School – we are therefore anxious to have your specimen of arms ... There are sundry arms to be done.' 1851, Mar. 18: We are very anxious that the glass already ordered, as well as that for which I now send the authorities, should be executed without loss of time ... will you kindly oblige us with the estimate for all these including the eight coats of arms for the East Window ... There is one shield for the East Window – that of Raphoe & Derry, which is to receive the impalement of Hopkins: be pleased to make this addition to the same – & compress[?] the arms of the see as I have indicated in a little rough sketch. The shape for the shield & mitre will of course be retained & the introduction of the strange[?] sinister half is the only alteration I have to suggest. It is desired that the tracery of the said East Window should be filled in – for this I send the idea, & the mottos [sic] shall follow. Now we will proceed to speak of the West Window of which it is determined to fill the five upper compartments: The diapered ground to consist of quarries – each light containing abt: 2 dozen monograms – the intermediate quarries displaying the lily – of which I sent you a sketch long since: In the centre of each light a shield of arms; the whole within a narrow border. I will draw the monograms to the full size, to spare you time & trouble. Be very strict in yr: injunctions that no departure from the design is to be made by the Cartoon draughtsmen. I love ancient heraldry & abhor the modern – I have shown the erased[?] Leads as in old times – & the lilies & ermine spots are equally authentic: so much for the detail. The forms of the shields are to be studiously retained, for commendable as were the former specimens, the Founders arms were deteriorated in my estimation by the loss of the severer form I had represented & which is the only one throughout the college coeval with the Founder himself, the rest being comparatively modern. I have also to request that the sketches be returned to me when their intention has been fulfilled. I am in possession of the initials for the monograms but these I will send a little later they will appear three in a row – the halves being made up with semi lilies, which will serve for all interstices.' Sep. 5: 'I am sorry that I was not earlier made acquainted with the real cause of the delay of the painted glass for the school although I have several times urged its completion [see *Hardman to C.A. Buckler*, 1851, Sep. 5]. The order was given months ago – & the sketches were made to so intelligible a scale that it should not have taken much time or rare genius to have enlarged them ... I am not surprised to find that the Master has written in terms of anxiety – as it will be very inconvenient to incur further delay – '. *J.E. Millard to Hardman,* 1851, Sep. 1: 'We have hoped to hear of the painted glass for the Chorister's School – which we are anxious to have fixed before the Boys return. Pray send as much as is prepared & expedite the completion of the whole.' Nov. 28: 'The box containing eight shields has arrived safely, we are very anxious for the remainder in order that the whole may be put up at one time and be ready before our distribution of prizes next month.' Dec. 8: 'The ten shields which we have now received are placed in the East window of the School and greatly add to its beauty though we think that those that last [sic] display less depth of colour than the first samples. Especially the sable & azure ... I trust the remaining glass will be sent at least in time to be in its place before the opening of the school five weeks after Christmas.' 1852, Jun. 10: 'Be kind enough notwithstanding to let me have your bill for what is already done – also the drawings (by Mr. Buckler) for the shield of Dr. Buckler and Mr. Edwards – we are anxious that Mr. Buckler's designs should be as closely followed as possible – and that the sable, if any, should be more intense.' Jul. 15: 'The glass for the head of the window has arrived and seems to be excellent in Execution and colour I am surprised at the want of some care in reviewing[?] the glass after it is leaded. The lights for the West window had several monograms inserted upside down – some the wrong side outwards – some omitted altogether, and some containing the wrong initials. That which has just arrived contains two inscriptions written thus, by transposition Ne su sapiens sicut teipsum/Justus germinabit apud lilium while another is twice repeated as follows omitting the words in brackets, which were necessary to make sense. Sapientia aedificavit (sibi domum) The absurd effect which is given by all these blunders sadly diminishes the value of the windows which are otherwise beautiful. I do not wonder that your journeymen are not prompt at comprehending a Latin sentence or a medieval monogram, but it seems strange that their work should not be subjected to inspection before it leaves the premises.' *JHA Letter Book, Hardman to C.A. Buckler*, 1851, Sep. 5: 'I am in great trouble about the glass for the Choristers' School. Mr. Pugin writes me that the cartoons have been drawn once that he was not satisfied with them & is having them done over again. Both of us have been abroad studying glass & my nephew who draws the cartoons, so that all our work is behind.'

139 Oxford, St Mary the Virgin (CoE)

*c.*1843, 1848. Client: George Bartley, 11 Woburn Square, London.

S aisle E window (**6.15a & b**)	sVII	3.0m x 4.4m	4-light		*c.*1843 (by Wailes)
S aisle window (**6.16a & b**)	sIX	3.0m x 4.4m	4-light	£150	1848

Descriptions. **sVII.** 4-light window and tracery. Each light contains a scene from the life of St Thomas Apostle depicted under a canopy. From left to right the scenes are: the saint before Christ, the saint touches Christ's wound, the saint preaching, and the martyrdom of the saint. The canopies have cinquefoil heads contained within pointed arches surmounted by yellow-crocketed and finialed ogee gables. Within the heads are three-dimensional ribbed vaults and pendants. Above and behind the gables are superstructures made up of single trefoil-headed niches surmounted by yellow-crocketed and finialed ogee gables. The niches each contain a representation of an angel standing behind a decorated screen, holding a crown. The two outer bottom panels of the lights portray: on the left, Thomas Bartley (who is commemorated by the window) in a gown over a contemporary brown suit, kneeling in right profile, in prayer, in front of an altar on the top of which is his mortar board, behind him is a shield inscribed in yellow-on-red with the monogram TB; on the right is his father George (who donated the window) in a contemporary bluish-green coat kneeling in left profile, holding in front of himself an image of the window – the head and hands of a second figure kneeling in prayer alongside him are visible, and behind the two figures is a shield inscribed in yellow-on-red with the monogram GB. The two inner bottom panels contain a depiction of the Annunciation. In the bottom margins of the lights is a yellow-on-black inscription that reads 'In memoriam Thomae Williams Bartley/Collegii Exoniensis commensalis parentes/non sine spe maerentes Obdormivit in/Christo mensis Maii XVIII: MDCCCXLII'. Every tracery-piece contains an angel in white on a blue ground. Those in the four large pieces over the lights are standing, as alternately purple and green texts form figures of eight, open at the bottom, around them.

sIX. 4-light window and tracery. Each light contains a scene from the life of St Mary Magdalene under a canopy. From left to right the scenes are: the saint as a sinner(?), the saint preparing to wash Christ's feet(?), the Maries and St John at Christ's tomb(?), and *Noli Me Tangere.* The canopies have crocketed and finialed Tudor arch heads. The spaces above the canopy heads are separated into three sections (the middle section is wider than the other two) by two pinnacled-columns emanating from pendants in the canopy heads. The sections are filled with blue and red diaper and capped by concave, crocketed and finialed gables, the one in the centre section being at a higher level than the other two. Three of the four bottom panels of the lights each contain a white shield emblazoned in yellow with the monogram SB. The panel on the far right contains against a red diaper ground, a portrayal of Sophia Bartley in a blue gown with a yellow sash, kneeling in left profile looking to the front while resting her hands and forearms on a green-covered altar. The side of the altar – parallel to the plane of the window – has attached to it a smaller version of the shields that appear in the other three panels. An inscription in Latin in memory of Sophia Bartley is inscribed in yellow-on-white in the margins at the bottom of the window – the portion under the figure of Sophia reading, 'Anno Domini MDCCCXLVI'. The four large tracery-pieces, arranged in pairs over the lights, each contain an angel in white holding a shield inscribed in yellow-on-white with the letters IHC. The smaller pieces that flank each of the pairs are patterned with yellow-on-black *fleur-de-lis.* The two central pieces at the top of the window contain roundels inscribed in yellow-on-black, with the letters IHC.

Office records. *Order Book,* undated, f. 28. *First Glass Day Book,* 1848, f. 29, Apr. 15 (sIX), f. 45, Nov. 2: 'To Altering glass, taking/out & refitting Lights in/Stained/Glass Window ... see f. 29/Altering 4 Lights with New/Panels & Centres in Canopies/& New Pieces in Figures – /£9.18.0'.

Letters. re sIX: *HLRO 304: Pugin to Hardman,* letter no. 811: 'The Oxford window goes tonight mind it must be a <u>first rate job</u>, remember the circumstances & where it is going'. No. 393: '6. The Lovely figure of Miss Bartley for the Oxford window.' No. 994: 'I should like to have one more look at the Oxford window before it goes they will have *wire* work & would you believe it the Parish have made Mr Bartley find £200 the interest to be employed[?] in <u>cleaning the glass</u>!!!!!!!!!!! Beasts.' No. 187: '3. I have been to Oxford & the window looks worse than I expected, the situation is much against it [see Convent of Mercy, Nottingham [Gaz.130], HLRO 304 letter no. 825 re windows below the skyline] but it is evident that it cannot go we must give the white the milky look of old by an opaque tint It must be done for that situation I will go any [sic] expense to make it right for it is a serious injury to us you will get one light away & let us make that right. I am sure this clear glass will not do for churches especially in the later style we better have the 4th light sent there right away. you better write to Mr. Eden – it must be done now <u>everybody is away from Oxford</u> & it might be done without any Row this is really important. I went from St. Marys to look at some later glass at Merton – it is the dead white that produces the effect & the pale streaky Ruby doesn't do in the later glass it is an important job but we must alter it so do not lose any time in writing to Mr. Eden & telling him I have been there & that the solution [?] the

glass to be opaqued'. No. 996: 'I have had a very kind & gratifying letter from Mr. Bartley about his window at Oxford – I am very glad it was done.' No. 1022: 'you must have the cartoons for Oxford window I want to make a drawing for Mr Bartley of the window & you must let me have this as soon as you can.' No. 1032: '1. the cartoons of the Oxford window have never arrived so you are preventing me from Earning the few pounds I should get by the only job I have to do.' *JHA: Bartley to Hardman*, 1848, Apr. 6: 'I do not know what address to furnish you with for the packing cases containing the stained glass window to be erected in St. Mary's Church Oxford – You probably [sic] aware this is the second window that has been executed for me for that church: and to whom Mr. Wailes of Newcastle (who executed the first) consigned his packages I know not.' *JHA Letter Book: Hardman replying to an enquiry from J. Vincent* of 90 High Street, Oxford, 1851, Jun. 6: 'In reply to say the window in the South Aisle of St. Mary's Church was executed by me. It is a window of four lights with groups. But having painted [it] some years since it is not by any means so good as I could wish. Since that time I have succeeded in reproducing the exact colours of the ancient glass & have also had much more experience in using them.'

Literature. Wedgwood (Pugin's Diary), Pugin visits Oxford, 1839, Jan. 29-30; 1840, Aug. 20-1, Oct. 29-30; 1841 Feb. 19-22, May 11-12, Jun. 14, Oct. 13, 15; 1842, Jun. 1; 1843 no diary; 1844, Feb. 12-13, Apr. 15-16, Jul. 11, Sep. 19, Oct. 15-16, Dec. 11; 1848, Aug. 23.

139A Radford, Holy Trinity Chapel (RC)

*c.*1841. Decommissioned in the early 1970s and now privately owned.

E window	I	0.38m x 2.0m (centre lancet), 0.29m x 1.8m (side lancets)

Description. **I.** Triple-lancet window filled with a grisaille of white, curving acanthus-like leaves on stems, outlined in black against black cross-hatched grounds. Overlying the grisaille in the centre lancet are three red-outlined vesicas alternating with two yellow-outlined diamonds. The vesicas and diamonds extend in width and length to the boundaries of their containing panels the former being approximately half as tall again as the latter. In the corners of the panels containing the diamonds are small yellow-outlined roundels which touch, tangentally, the sides of the diamonds, and the vesicas close to their pointed tops and bottoms. The centres of the vesicas are patterned with blue and yellow leaves arranged around red floret centres, while at the centres of the diamonds are white foliated crosses on red grounds. At the top of the lancet is a blue, red-rimmed roundel containing a yellow shield emblazoned with the black letters IHS. The grisaille in the seven equal panels of each of the side lights is overlain by a blue-outlined diamond that has a yellow semicircle on each of its sides. The centres of the diamonds are marked by red florets. The tops of the lancets are decorated in a similar fashion to that of the centre lancet but the shields are emblazoned with a black letter M (the glass at the top of the right-hand lancet and in the panel immediately below is missing). A line of blue glass runs around the borders of all three lancets inside a line of white fillet glass.

Literature. Belcher, 2001, p.183, note 5 gives a description of the Pugin-designed building taken from *'The Tablet*, 37 (23 Jan. 1841)', p. 55, which includes: 'There are three stained glass windows over the altar'. Whether or not Pugin provided a design for the glass is unclear but, as finished, it seems to lack his usual subtlety. Were he involved, then presumably either Warrington or Willement would have been asked to make the window.

SHROPSHIRE

140 Oswestry School

1850. Client : R. Kyrke Penson.

Office records. Order Book, 1850, f. 106, Aug. 27. *First Glass Day Book*, 1850, f. 98, Oct. 4: 'To A Window of Quarries & c/2 lights 4'10" x 1'4½".../and 1 Tracery piece to do/£5'.

SOMERSET

141 Butleigh, St Leonard (CoE)

1851. Clients: Rev. and Mrs F. Neville. Supervising architects: J.C. & C.A. Buckler.

S side 'pulpit' window (**10.30**)	sVI	1.9m x 3.0m	3-light	£45

Description. **sVI.** 3-light window and tracery. Each light contains a depiction of a saint under a canopy.
From left to right the saints are: St John the Baptist in a green-lined mantle over a purple hair robe, holding an image of the Agnus Dei in his left hand; St Peter in a blue-lined, red mantle over a yellow robe, holding a long-handled key upright in his right hand and a book in his left; and St Paul in a white-lined, purple mantle over a blue robe, holding

an upraised sword in his right hand and book in his left – there is a small hole in the window just below the sword handle. The canopy in the centre light has a cinquefoil head within a pointed arch surmounted by a yellow-crocketed, short-finialed gable. Rising behind and above the gable is a superstructure in the form of two green-patterned Gothic windows and white tracery flanked by two pinnacled buttresses and surmounted by a crocketed and finialed gable. The canopies in the side lights are similar but crocketed and finialed ogee arches replace the gables. Three quatrefoils arranged in a triangular pattern comprise the main tracery-pieces. They have roundels at their centres, containing: the Agnus Dei in white on a red ground, in the top piece; two crossed keys (one yellow and one white) in the left-hand piece; and two crossed swords (white blades, yellow handles) in the right. A brass plate beneath the window is inscribed 'Charlotte B. Blackwood gave this window A.D. 1851'.

Office Records. Order Book, 1851, f. 124, Jan. 10. *First Glass Day Book*, 1851, f. 122, Aug. 27.

Letters. *HLRO 304: Pugin to Hardman*, letter no. 160: '1. the S. Leonards window is half done already'. No. 127, dated 'Mores Catholici 1851': 'Bucklers 3 Light window is done I have sent it today.' *JHA: C.A. Buckler to Hardman*, 1850: Dec. 10: 'I have enclosed a slight sketch for glass to be inserted in a new window on the south side of Butleigh Church Somerset.' – requests an estimate. 1851: Jan. 10: 'I have much pleasure in returning the sketch design for the Pulpit window of Butleigh Church with the request that you will have it put in hand at your earliest convenience (Clerk of Works – Mr. Nettle, Butleigh Court, Glastonbury) Mr. Neville does not approve of the Apostolic emblems on <u>shields</u> therefore these shall be settled. I will subsequently communicate them to you. Your experience has given you such a knowledge of the details & characteristics of fine glass especially in this style, that I feel that I have given you sufficient <u>hints</u>, for both figures & Canopies [refers to the Magdalen College School project, Gaz.138] I hope I gave all my information correctly tho I have seen so much of your heraldry at Ushaw [Gaz.40] that you wd rectify my inaccuracies if otherwise.' Jan. 13: 'When I made a sketch of the East window of Butleigh Church[52] several objections were raised against the kind of foliage you have suggested & to which I am always partial: but at the same time we do not want for fine precedent for shields – as in Bristol Abbey, the almost unrivalled tracery of Merton College & c the age and style being those to which you refer. Jan. 16: 'I send you an idea of the emblems for the south window of Butleigh Church which I am sure you will suceed in adorning with the characteristic beauty & expression of the early style.' Jan. 16 (in 1852 bundles): 'You shall have the Butleigh templates which I hoped you had received long ago'. Jun. 7: 'Pray favour me with a line that I may tell Mr. Neville when he may expect the glass for the S. window of <u>Butleigh Church</u>.' Jul. 4: 'The chancel of this church is to be re-opened on the 5th of August, and it would be very acceptable if the window you have in hand for the church could be in its place by that time.'

142 Taunton Convent (RC)[53]
1850. Client: the Rev. Mother. Supervising architect: Charles Hansom.

Office Records. *First Glass Day Book*, 1850, f. 92, Jun. 8: 'A Light Single of Stained/Glass, Rolled Glass Quarries/& c 6'1" x 1'6½" /1 Tracery piece to do/£5.15.0'. *Cartoon costs per ledger summary*: shows that no costs were charged.

143 Yeovil Church.[54]
1853. Tracery designed by J.H. Powell.

Office Records. Order Book 2, 1852, f. 10, Oct. 27: 'The lights of this window to be filled with Powell's Stained Quarries. Subject of Tracery to be Prophets & Angels bearing scrolls.' Order Book 3, 1852, f. 14, Oct. 27. *First Glass Day Book*, 1853, f. 185, Jul. 9: 'To 33 pieces of Stained glass/Tracery being the upper/portion of the East window'.

SOUTH YORKSHIRE
144 Rotherham, St Bede (RC)
Literature. Wedgwood (Pugin's Diary), p. 57, re 1844, is headed: '[Double blank leaves between pages 24 and 25] [Long list of financial transactions]'. The list includes the item, 'St. Bede 100.0.0', which comes immediately after two items for windows and is referenced to note 71 on p. 92 which states: 'Possibly this is a reference to the Roman Catholic Church of St. Bede, Masborough Street, Rotherham, which was designed by M.E. Hadfield in 1843 and praised by Pugin. Perhaps Pugin designed stained glass for it.'

145 Sheffield, St Marie (RC)
1850. Client and supervising architect: M.E. Hadfield.

W window (**7.8a & b**) wI 2.7m x 5.2m 4-light £180

Description. wI. 4-light window and tracery. Each of the lights contains three medallioned scenes from either the Old or the New Testaments, which form three rows of four across the window. The scenes in each row consist of two pairs of types (old testament) and antitypes (new testament). From left to right and starting with the top row, they follow chronologically, events in the life of Christ as follows: top row: The crossing of the red sea, baptism; David with the ark entering Jerusalem, entry of Christ into Jerusalem; middle row: Abraham and Melchizedek, last supper; Abraham and Isaac, Christ carrying the Cross; bottom row: Moses striking the Rock, Crucifixion; Jonah and the Whale, Resurrection. The blue diaper lozenge-shaped medallions have long straight sides and curved tops and bottoms formed by bands patterned with white and orange leaves on stems against red grounds – their sides make up the borders of the lights. Between the medallions the bands form blue diaper bulbous shapes, each of which contains a portrayal of the head of a patriarch or prophet. Each 'bulb' is bounded by four geometrically patterned bluish white, roundels and two larger geometrically patterned half-roundels. There is inscribed in yellow on black in the bottom margins of the respective lights: 'PRAY FOR THE GOOD ESTATE OF THE NOBLE LADY/AUGUSTA MARY CATHERINE MINNA COUNTESS/OF ARUNDEL & SURREY WHO CAUSED THIS WINDOW/TO BE MADE IN THE YEAR 1850'. The quatrefoil at the top of the tracery contains a depiction of the Virgin and Child – she is crowned and in a red robe and the Child in a yellow robe – against a red ground patterned with orange rosettes and white and blue leaves. The four pieces below each contain a depiction of a hovering angel holding a text, against a red ground. The two bottom quatrefoils each contain a depiction of a figure standing in front of a blue, white-rimmed roundel, with the rest of the ground similar to that in the top piece. The left-hand figure represents the Church (see *HLRO 304* letter no. 862 below) and is in a green mantle over a white robe, holding a goblet and a loaf of bread in its left hand and a sceptre in its right. The right-hand figure represents the Synagogue, is blindfolded, and is in a white mantle over a purple gown holding some thongs in its right hand and the tablets of stone in its left.

Office Records. *Order Book*, 1850, f. 75, Mar. 1. *First Glass Day Book*, 1850, f. 97, Aug. 23 (wI). *Cartoon costs per ledger summary*: Hendren £6.10.0, Oliphant £20.10.0.

Letters. *HLRO 304: Pugin to Hardman*, letter no. 863: 'I send you a sketch for Mr. Hadfield's window but it is utterly out of the question to attempt these types at that price. there would be 16 subjects carrying[?] with the expenses & Oliphants time at least £4 each making £64 before the glass is tinted[?] or anything done you know what a group window is – the price puts it quite out of the question at the figure. on the opposite side I have filled a light which could be done I think for the money. images of saints under canopies & a field of geometric work this would look very well I quite [sic] sure if they would not look better than the groups.' No. 862: 'I send a few types not arranged in order but in the class of subjects for the Sheffield window – I have taken them from old examples in the illuminated books of hours & I dare say a great many more may be found at the top the Church & the Synagogue.' No. 860: 'I will attend to Sheffield when I get the templates.' No. 851 postmark 'PM MR 14 1850': '1. I had no observation to make on the Sheffield window. It is in hand & partly set out I am quite satisfied now the number of subjects are reduced.' No. 852: 'It is a great nuisance[?] about this inscription all the Sheffield window was set out & we have to cut the work in 3 places to reduce[?] it & get in the band.' No. 844: '3. You have not sent me the cartoons I most wanted the small bits of tracery Mr. Haighs West Window [St Thomas & St Edmund of Canterbury, Erdington, wI Gaz 177] the confections[?] of colour is beautiful & I want it for Sheffield.' No. 771: 'Sheffield is nearly done.' No. 687: 'some of the bars of the Sheffield window will come across the groups it cannot be helped.' No. 763: 'I assure you half the groups Oliphant sent down for Sheffield have been altered [see *Letters*, New Palace of Westminster (Gaz 64) for remainder of sentence] No. 769: 'half the Sheffield groups have had to be altered – they were beastly in parts & would not do ... By infinite exertion I have got the Sheffield window done. they have finished it & it goes tomorrow so I hope you will get it on Monday.' No. 734: 'that Sheffield window will be an eternal disgrace to us or rather to me misere mei on a false principle it is false & beastly I know it I saw it was coming I told you what I thought but I did not see my way but now we have it.'

JHA: Hadfield to Hardman, 1850: Mar. 12: re the inscription 'Pray for the good state of the Nobel Lady: Augusta Mary Minna Countess of Arundel & Surrey who caused this window to be made in the year of peace 1850'. Easter Eve: 'the Lady Arundel has a fourth name "Catherine" which must be added.' Aug. 28: 'The window is in and is exceedingly beautiful and full of exquisite detail. "Comparisons are odious" but we shall see what the wise men say at the opening.'

Literature. *The Builder*, 5, 1847, p. 41: notice of the impending building of the church, including a description (but nothing as to the stained glass in the W window) with details taken from the *Sheffield Times*. *The Tablet*, 11, 1850, pp. 594-5: report on the dedication of the church with a detailed description of the building taken from the *Sheffield Times*. A passage on the W window, described as 'sparkling in unrivalled brilliancy', and details of the subject matter in the lights and tracery.

146 Sheffield, The Farm[55]
1849. Client: Michael Ellison.

Office Records. Order Book, undated, f. 54. *First Glass Day Book*, 1849, f . 57, Apr. 26: '3 Lights of Stained Glass/of Quarries, Centres & c & c/3' 5½ " x 1'2½' £6.10.0'. *Cartoon costs per ledger summary*: Powell 10s.0d, Hendren 3s.4d.

STAFFORDSHIRE
147 Alton Towers
Thomas Willement's papers show he made stained glass windows for Lord Shrewsbury for Alton Towers in 1833-4 before Pugin's involvement with the house. William Warrington also made windows for it, presumably to Pugin's designs, as his records indicate. Letters from Pugin to Lord Shrewsbury reveal that Willement was working there under his (Pugin's) direction during 1840-1 as was, seemingly, William Wailes in *c.*1844-5, after which Pugin's designs for Alton Towers were executed by John Hardman. None of the glass remains except for the: windows in the entrance hall (now gift shop), which may be the ones referred to by Warrington as 'lobby windows'; the tracery and an arrangement in the three centre lights of some of the heraldic glass that originally made up the two inner lights and one of the two identical outer lights of the Pugin/Hardman, S side 5-light Talbot window; and glass in the 27-light N bay window made by Hardman in 1856, possibly to designs by Pugin. The centre light of the Talbot window, as evidenced by a 1951 photograph (English Heritage, NMR AA52/7052 [**3.11**], drawn to my attention by Michael Fisher), portrayed the crowned, armoured and frontally-posed standing figure of the Great Talbot, the first Earl of Shrewsbury, holding an upraised sword in his left hand and a sceptre in his right. Vested as a Knight of the Garter his long cloak is draped around his shoulders and arms and trails vertically down along his back and behind his legs before partly covering a lion which stretches in profile beneath his feet. According to Fisher, *Alton Towers: A Gothic Wonderland*, the Talbot window glass was removed in 1952. It is not clear if the remnants, as mentioned above, were put in place at the same time.
The *London & Dublin Weekly Orthodox Journal*, 1840 describes the house, and draws attention to the following now lost windows:
Octagon Hall: 'In four of the spaces are lancet windows of coloured glass on which are stained the archbishops and bishops of the Talbot family [Willement's work – see Pugin to Lord Shrewsbury letter 24 below]'.
Talbot Gallery: 'The gallery ends with an angular tower lighted by two windows, with the arms of the Earls of Shrewsbury who have been Knights of the Garter, in coloured glass ...A small groined passage leading from the drawing room to the ordinary dining room the spandrels of the groining being filled with richly stained glass.'
Chapel: 'At the eastern end, in an arch opening to the altar, is a stained glass window.'

Office Records. First Glass Day Book, 1848, f. 35, Jun. 29: 'A Stained Glass Window/for Library,.../£50/of 2 Lights with Figures, Bases/& Canopies &c/9'10" x 1'10½'"; f.. 47, Nov. 25: 'To a Small Window for/Library of 2 Lights/£10/ of Inscriptions, Quarries & c & c/2'10" x 1'3"/1 tracery piece for do/1'10" x 1'3"/'; 1849, f. 55, Mar 24: 'A 2 Light Window of/Arms, Mantling for Small/Room by State Rooms/£29/of 2 Lights of Arms & c & c/7'2" x 1'6½'/& 3 Tracery pieces to do'; f. 56, Apr 12: '12 pieces for Bordering/of Stained Glass, for/Picture gallery and Passage'; 1851, f. 126, Oct 3: '1 Cast Iron Frame...'; f.. 127, Oct 10: 'A Stained Glass Window for/Great Dining Hall, Talbot Window/£150/7'11" x 2'0"/of 5 Lights with Figures/Tracery of above sent'. *Cost sheet No. 6*, 1856, dated Feb. 6, refers to the cost of stained glass (shields of arms and mantling etc.) for 18 transom lights and 9 tracery pieces of the bay window in the dining hall. The total cost of £311 19s. 6d. was credited with £32 10s. 0d. in respect of the amount charged to the executors of the Earl of Shrewsbury as the proportion of work finished at the date of his death on 9 November 1852. Taken together with Pugin's letter to Lord Shrewsbury in Jul. 1847 (see below), this allows for the possibility of Pugin producing the design sketches for the window, with J.H. Powell using them to make the cartoons: the glass is still *in situ*. *Cartoon costs per ledger summary*: library window, Powell £1.0.0, Hendren 10s.0d, Oliphant £8.0.0. Oliphant's account records that the payment (entered Apr. 29, 1848) was in respect of: '2 Cartoons, Knight & Lady 4ft 9 In @ 4 £ea [for] Library'; small window library, Powell 6s.8d, Hendren 3s.4d; small room, Powell 13s.4d; Hendren 3s.4d.
Letters. Wedgwood, 1985, Pugin to Shrewsbury, letter 24: '[1842, Feb. 13]': 'As for agreements they are of no use with Willement. Did not your Lordship agree with him for the bishops window in the octagon & now he argues as a reason for what he now charges being dearer in comparison that the octagon window is not rich & this latter glass [Hospital of St John Gaz.148(?)] is rich. But the octagon window was intended to be rich & with all I could do he could not make it so.' Letter 36 [1844?, Jan. 30?], 'The glass is gone & will be at Alton I hope immediately after your Lordship arrives.' Letter 82 [1850, Apr. 30]: 'I leave for Alton tomorrow with Lord Shrewsbury. He seems[?] very kind & is astonished with

the progress of the painted glass.' *HLRO 304: Pugin to Hardman,* letter no. 1011: '2 small windows have come in from Lord Shrewsbury one of which I have promised <u>next week</u> & the cartoons go off tomorrow night as you say there will be a great deal of glass to do – the great hall at alton will have to be done next year.' No. 465: a List of Painted Glass which included 'A 5 light window for the new Banqueting hall at Alton Towers – containing an effigy of the Great Talbot in the centre & animal bearings connected with him in the side lights'. No. 362: '1. I hope you are working hard at the <u>alton window</u> remember I must not disappoint Lord Shrewsbury on any account pray get on with it'. No. 496: 'I am dreadfully distressed & disgusted to find that in the alton window they have actually copied one set of Labels for the other light with 6 different shields so that the same Labels or names are under totally different charges it has been dreadfully[?] laughed at already & I cannot conceive how you could possibly let such a monstrous & inexcusable mistake pass. it is degrading & it shows a complete ignorance of Heraldry & these are arms which are well known the glass on the whole looks very well and quite successfully[?] planned'. No. 507: 'I think this mistake in the Talbot window a very serious matter & one which I am going to investigate here very seriously. I can hardly conceive it possible. that after I supplied Powell with all the names of the shields <u>but one</u>, that he should not have forwarded them – & how in any case such a mistake as that of doubling one set to serve for 2 sets of sheilds [sic] , could take place. I cannot conceive. It is very sad. we are always in these messes which cost a deal of money & loss of time, & disgrace & I shall speak most strongly to Powell if I can trace any neglect. I am astonished that when the error & difficulty[?] was discovered at Birmingham that no application was made for the names & that such an act as repeated[?] the names like a stencil to all sorts of arms could be perpetrated – the ridicule to which it has exposed me is abominable Willement was there making fun & others they must be altered as quick <u>as possible at any cost or trouble</u>'. No. 508: 'your letter came in tonight – you do not say anything about the errors in the Talbot – I think you could hardly have received my letter about it but it is <u>very important</u>'. No. 956: 'you say I write dismally how can I do otherwise everything turns out a failure everything comes very different from what one intends – a series of mistakes. I see now that the variety of tint which looks so well in a distant window is very bad when seen near – ecce ecce the Lines in the small library window alton all this is my fault even what I design right is spoilt by others. my great window of dining hall [sic] which would have been a grand thing is now totally ruined by recent alterations.' *HLRO 339: Pugin to Shrewsbury,* letter no. 49: 'I am going to proceed with the working drawings of the Dining Hall we must have some white stone for the fireplaces. of course your Lordship will allow me to put new glass in the great window for that which is there at present is miserable. I suppose it is to be all completed for the summer of 48.' *Stanton, Appendix VIII: Pugin to Shrewsbury,* 1845: 'I have sent off to Wailes by this post. The windows will be quickly forthcoming and will be a good job …You may rely on my keeping the large window in the dining room without alteration'. 1847: Jul.: 'The dining hall at Alton is a large job and will necessarily take some time in preparation but when finished I think it will be worth the time and labour. I am preparing a scheme of all the armorial bearings for the windows which I will submit to your Lordship when I come down next time.'

Literature. *London & Dublin Weekly Orthodox Journal,* 11, 1840 , pp. 110-12; 17, 1843, pp. 130-3 (includes a description of the gardens). William Warrington, '*c.*1855', p. 27, Staffordshire: 'Alton Towers, Chapel 2 Quatrefoils; 7 lobby windows.' Thomas Willements' papers, per index by M. Archer, C. Wainwright and S. Mole, (held in V & A Museum, London), indicate glass was made for Alton Towers in 1833, 1834, 1840 and 1841. Ledger of Thomas Willement (microfilm in Borthwick Institute of Historical Research), p. 76: 're The Rt. Honble the Earl of Shrewsbury. 1841 May 1st. Two large circular lights in Stained Glass for Alton Towers each containing arms, mitres, Initials and ornamental borders. £19. 10 .' Wedgwood (Pugin's Diary): Pugin visits Alton, 1837, Aug. 31-Sep. 5 (note 55 points out that Pugin persuaded the Earl to put all future work in his hands), Oct. 23 (note 62; 'From this date Lord Shrewsbury's patronage of Pugin began' – particular project not indentified). Nov. 8-13, Dec. 19; 1838, Apr. 28, Sep. 14-17; 1839, May 7-8, Jun. 29-Jul. 10, Aug. 6-7, 9-12, 17-18, 20, Sep. 3-14, 18-21, 23-7, Oct. 3-5, 20-31; 1840, Jan. 11-14, Feb. 25-5, Apr. 22-7, May 1-2, 6-8, 23-6, 29-30, Jun. 4-10, Jul. 3-6, 25, Aug. 5, 24-6, Sep. 5-10, 23-6, Oct. 15-22; 1841, Mar. 31-Apr. 3, May 19-21, Jun. 30-Jul. 1, Aug. 26-8, Sep. 27-9, Dec. 15-17; 1842, Feb. 23-5, Apr. 1-3, May 16-17, Jun. 13-20, Jul. 7-22, Aug. 17-Sep. 3, Sep. 7-15, Oct. 5-8, 25-7; no diary for 1843; 1844, Mar. 1-4, 20, Apr. 2, Apr. 5-6, 16-19, Jun. 14-15, Jul. 19-Aug. 1, Aug. 7-10, 16, 19-20, Sep. 29-Oct. 1, Dec. 4-7; 1845, Apr. 14-15, May 18-20, Jun. 27-31, Sep. 4-5, 22-Oct. 3; no diary for 1846; 1847, Jul. 1-6, Sep. 14-17; 1848, May 5-10, Jun. 24-9, Oct. 12-17; 1849, Apr. 18-23, Jul. 11-18, Oct. 6-15, Nov. 28-30; 1850, Feb. 21-3, Apr. 9, May 1-2, Jul. 31-Aug. 9, Sep. 10-18; 1851, Jan. 15, May 7, Jun. 7, Aug. 23-5, Sep. 19, Nov. 27-9. Fisher, 2nd edn, 2002, p. 128.

148 Alton, Hospital of St John (RC)

1841. Client: Earl of Shrewsbury.

The hospital was designed to accommodate 'a warden and confrater both in priest's orders, six chaplains or decayed

priests, a sacrist, twelve poor brethren, a schoolmaster and an unlimited number of poor scholars' (Noonan). The whole project was described in the *Dublin Review* thus: 'the buildings, forming three sides of a quadrangle, now comprise the parish church, village school, the Convent of Mercy, and the Presbytery'.

The present church of St John the Baptist was originally divided into two by large hinged doors within a stone arch, making what is now the nave of the church into a school and leaving the E end as a chapel. The windows of this building were made by Thomas Willement in 1841 to Pugin's designs and all but the W window (which is of later glass) remain.

E window (**1.3a & b**)	I	2.1m x 3.0m	3-light	£128
N & S wall windows	nIII (**5.3**), nIV, sII (**5.4**)	1.3m x 1.4m	2-lights	£74
N & S wall windows	nV–nVII, sIII–sV	2.1 m x 3.0m	3-lights	£294
Chapel N wall window (**5.5**) nII		3 small single lights		

Descriptions I. 3-light window and tracery. The Virgin and Child under a canopy is depicted in the centre light and St John the Baptist, and St Nicholas, also under canopies, in the left- and right-hand lights, respectively. The Virgin in a white-lined, blue mantle over a red robe stands in front of a yellow diaper screen cradling the Child (in a purple robe and holding an orb in His hands) in her right arm and holds an orange in her left hand. An inscription in black-on-white with a large yellow, illuminated letter A in the bottom panel reads: 'Ave Maria gratia plena/Dominus tecum benedicta tu/ in mulieribus et benedictus/fructus ventris tui Jesus'. St John in a blue-lined, yellowish-white mantle over an orange-brown camel hair robe, stands in front of a red diaper screen, holding an image of the Agnus Dei with staff and banner, in his left hand. An inscription in black-on-white with a large yellow illuminated initial letter I in the bottom panel of the light reads: 'Inter natos mulierum/non surrexit major/Johanna Baptista'. St Nicholas in a white, yellow, patterned mitre and a white-lined red chasuble over a blue dalmatic and a white alb stands in front of a green diaper screen with the maniple hanging from his left wrist and holding a white pennanted, yellow crozier in his right hand. Three naked children sit in a grey barrel at his feet in the left corner of the canopy. An inscription in black-on-white with a large yellow, illuminated letter E in the bottom panel reads: 'Ecce sacerdos magnus qui/in diebus suis placuit dei/et inventus est justus'. The canopies have vaulted, cinquefoil heads contained within ogee arches surmounted by yellow-crocketed and finialed concave gables. They are drawn in perspective with three sides visible. Superstructures in the form of niches, each containing a depiction of an angel in white, flanked by buttresses and surmounted by concave-sided gables, each capped by a cross, rise above and behind the arches. The four main tracery-pieces each contain a depiction of an angel. The two outer angels hold texts and the two inner, shields of arms – the left-hand shield is emblazoned with a yellow Talbot lion rampant on a red ground and the right-hand one with a red diamond trellis on a white ground.

nIII, nIV, sII. 2-light windows and tracery. The lights consist of yellow silver stain-patterned quarries and each light contains a shield, a roundel or a quatrefoil. The details for the windows are as follows:

nIII. Quarries: two differing patterns arranged in alternating horizontal rows. One pattern is a yellow cross formed by four Ts outlined in black, which are joined around a small circular centre and there is a small yellow cross in each of the resulting four interstices. The other is a multi-pointed star overlain, horizontally, by a scroll inscribed in black 'honor deo'. Shields: there is one in each of the upper portion of the lights. That on the left is blue and is patterned with a white band that follows the line of the shield, and ends in small white cartouches at its upper and lower extremities: these are joined by diagonal white bands to a larger cartouche at the centre of the shield. Latin words are inscribed in black on all four cartouches and also along the bands. Those in the cartouches read: 'pat[?]; fils; Deus; and ms fanet'; respectively, while the bands are inscribed, 'non eft'. The right-hand shield contains symbols of the passion, in white and yellow, on a red ground. The symbols consist of: in the centre, the cross ringed with the crown of thorns and diagonally crossed by the staff which holds the sponge, and the lance; on the left of the cross the column and nails; and on the right, the robe. The borders are patterned with, in sequence, and in yellow-on-black: the letters IHS, a crown and the letter M on red and blue grounds. At the top of each light are five small roundels containing yellow letters, which reading from the bottom left are: 'I, E, S, U, S'.

nIV. Quarries: similar to nIII but the patterns in the alternating horizontal rows are of lilies and *fleur-de-lis*, respectively. The *fleur-de-lis* are crossed horizontally by scrolls inscribed in black with 'Ave maria'. Roundels: one in each of the upper portions of the lights, both being blue with yellow-banded rims. The one on the left contains a yellow-patterned letter M at its centre. The M is patterned with white lilies on a brown ground arranged around two small roundels which contain a representation of the Annunciation, the Virgin being in the left-hand roundel and Gabriel in the right. The yellow-banded rim is inscribed in black with 'Ora pro nobis faucia[?] dei genetrix ut digni[?] efficiamus piomissioninbus Christi'. The roundel in the right-hand light contains a representation of a vase of lilies with white flowers and green

leaves. Interwoven with the flowers is a white scroll inscribed in black with: 'Salve[?] meus ora picna', and the inscription around the banded rim reads: 'Sancta maria mater de ora pro nobis peccatoribus nuncet in hora mortuis nostri Amen'. The borders are as in nIII, but are patterned alternately with a diagonal floriated cross and a floriated *fleur-de-lis*, and the letters at the top read 'M, A, R, I, A.' sII. Quarries: similar to nIII but the patterns in the alternating horizontal rows are of leaves and flowers, respectively. Quatrefoils: four in all, one at the top and one at the bottom of each light. All have yellow-beaded, black rims and each contains a representation of one of the symbols of the evangelists together with a scroll inscribed with its saint's Latin name. From left to right and top to bottom the symbols are: angel, lion, ox, eagle. The borders are as in nIII but the pieces are patterned alternately with geometrical patterns and the yellow letter E. At the top the letters appear to be 'M, M, E, L, I.'

nV--nVIII, sIII–sV. 3-light windows. Each light contains a centrally placed shield emblazoned with arms, and four equally-spaced diagonal bands of yellow silver stain mottoes, which appear to read: 'Prest D'accomplir'.

The rest of the lights are made up of diagonal rows of quarries, each alternate row being patterned with yellow silver stain I T monograms and the letters S, respectively. From left to right the details emblazoned on the shields are as follows: nV. A white Agnus Dei with an inscribed scroll on a red ground, the yellow letters S and B flanking a large white letter I, on a blue ground; a white and yellow eagle in profile looking left, with an inscribed scroll against a dark ground.

nVI. Quartered arms consisting of (1) the Talbot lion rampant on a red ground (2) a white diagonal cross on a blue ground (3) a red diagonal band on a white ground, with three red birds in profile in triangular formation above the band, on the right, and three in a diagonal line below the band, on the left (4) a red-outlined diamond on a yellow ground, overlain by a red diagonal cross; a white Agnus Dei on a blue ground with two shields above, that on the left repeating (4) from the previous shield's quarterings and on the right (1); the shield is divided vertically, in two, repeating (1) to (4) above in the left half, and filling the right half with the Talbot lion rampant on a red ground.

nVII. All three shields are divided vertically in two, each has the Talbot lion rampant on a red ground in the left half, with, from left to right, in the right half: a white diagonal band with black serrated edges that runs from the top left to the bottom right, contained by two yellow lines, on a blue ground; chequered red and white diamonds; quartered arms consisting of a white lion rampant on a red ground in (1) and (4) and a red chevron patterned with yellow dots, bounded at the top and bottom by a horizontal blue(?) band, all against a white ground, in (2) and (3).

nVIII. Obscured from view.

sIII. A red cross on a white diapered ground, a yellow foliated cross on a blue ground with four yellow birds in profile looking left, perched in the spaces around the cross, and a fifth at the bottom on the shield immediately below the cross, and a red diagonal cross on a white grounds.

sIV. The shield is divided vertically into two, with a half-yellow, half-white cross (as described for the quarry patterns in nIII) and four small crosses (two white and two yellow) in its interstices all on a red ground, in the left half, and a horizontal blue band on a white ground, with two red birds in profile looking left, above the band, and another below the band, in the right half; the shield is emblazoned as for the left half of the previous shield; the shield is divided vertically into two with the Virgin Mary, crowned and in a yellow hooded robe, standing in a frontal pose against a blue ground in the left half, and a central, white, ermine-patterned chevron, with two small white crowns above and a larger one below, all on a blue ground, in the right.

sV. Obscured from view. The borders in the side lights are inscribed alternately with the letters T and I on red grounds. Those in the centre lights are patterned alternately with the yellow Talbot lion rampant on a red ground, and yellow leaves on stems(?) on black grounds, the two motifs being separated by a blue ground. The roundels at the tops of the lights are set out as in nIII and contain yellow letters which reading from the bottom left are 'T, A, B, O, T.'

Inscribed in black-on-white along the bottoms of the windows are the following:

sII. 'Of your/charity/pray for [sIV] the good/estate of/John the [sV] XVII Earl of Shrewsbury who founded [nVIII] Thif hospital and chapel of Saint John [nVII] the Baptift in the year/of our Lord [nVI] one thoufand/VIII hundred/and forty [nV] Saint John/the Baptift/pray for us'.

nII. 3 small single lights. Each light contains a depiction of an angel in a white robe with touches of yellow standing in a frontal pose holding, from left to right for the first two angels, respectively: a white cross with a yellow crown of thorns looped around the top; and a white shield inscribed in black outlines with the letters IHC. The third angel holds a white column in the crook of his right arm and a yellow multi-thonged scourge, in his left hand. Beneath the feet of the first and third angels Latin texts are inscribed in black, on white grounds, (that under the middle angel has, presumably, been lost and replaced with plain green glass), which read: 'Per crucem … [?]iv[?]ra nos domine'. The three texts when complete, translated as: 'By thy cross and passion, O Lord deliver us.'

Letters. *Belcher, 2001, p. 197, Pugin to Lord Shrewsbury,* 'late January 1841?' 'I can assure your Lordship the windows in

the school will not in the least resemble a factory. The stained glass will be a great addition.' p. 269, Aug. 28: 'the Glass painters will shorten my days. they are the greatest plagues I have. the reason I did not give warrington the windows at the hospital is – he had become Lately so conceited that he has got nearly as expensive as Willement – the Newcastle man [William Wailes] had not turned up when they were commenced ... Warrington is a wretched herald I shew your Lordship that it was fully setled to have sheilds in the school windows [this seems to suggest that originally Warrington was to have made the windows for the school]'; p.306, Dec. 24: 'The hospital is rappidly advancing towards compleation ... the stained windows are all in & the effect is Glorious. I think your Lordship will not complain of want of richness this time. the figures too are very devotional & well drawn. I made full sized drawings of every detail so there is great variety.' *Stanton, 1950, Appendix VIII Pugin to Lord Shrewsbury*, Aug. 18: 'The glass for the school at Alton is all finished and looks exceedingly well.' *Wedgwood, 1985, Pugin to Lord Shrewsbury*, letter 23, [1841] Sep. 29: 'The Hospital looks quite glorious, the school will soon be finished, the chapel will be ready for dedication by the time your Lordship returns. I am taking the greatest pains with every detail ... I feel assured when your Lordship sees the glorious effect of the glass in the schoolroom you will not blame me. It is not for the urchins but the elite who will flock to see the building which should be in all respects a perfect specimen of the style. This and Cheadle [Gaz.151] are all my hope.'

Literature. *Dublin Review*, 12, 1842, pp. 117-20: detailed description of the school and chapel including the subject matter of the windows. Girouard, 1960, pp. 1226-9. Noonan, pp. 25-7. Wedgwood (Pugin's Diary): Pugin visits Alton (see Gaz.147), p. 50, shows payments were made or costs incurred in 1841 of £160 and £210 for stained glass for the chancel and school respectively. 'Ledger of Thomas Willement'[56] (microfilm at Borthwick Institute of Historical Research), p. 76:

'1841 May 1st The Rt. Honble. the Earl of Shrewsbury.

	£ s d
Three large circles in rich Stained Glass with emblems inscriptions & c highly finished, for window of Cloister Alton Hospital. £ 3.10.	10.10.0
Three windows of two lights each for side of Chapel, Alton Hospital, the ground full figured quarries rich ornamental borders to the lights each containing a sacred emblem with inscriptions highly finished @ £12.7.10	74.7.0
One large window for Altar end of Chapel, containing in 3 lights, whole length figures of the Virgin, St. John & St. Nicholas, carefully finished each under elaborate canopies & on rich figured backgrounds. In the tracery four figures of Angels bearing shields and inscriptions in the richest colours.	128.10.1
Two large circles of Stained Glass containing the emblems of the Holy Lamb & the Pelican with Inscriptions highly finished in the richest colours for the Porch. £ 3.10	7.0.0
Six side windows & one end window for School of 3 lights each, the ground of full figured quarries with mottoes in diagonal lines rich borders with initial heads, continued inscriptions through the lower part of the windows, each opening containing one Coat of Arms in richest colours.	294.0.0
Three figures of Angels carefully finished, holding emblems of the Passion with Inscriptions on a ruby ground for the Sepulchre	21.0.0'

149 Blithfield, St Leonard (CoE)

1846-53. Client: Hon. & Rev. Henry C. Bagot.

| S aisle window | sVII | 1.1m x 1.8m | 2-light | £18 | 1846 |

S clerestory window	SV		3-light	£45	1848
Side window			2-light	£27	1848
S clerestory window	SII		3-light	£45	1849
Side window			2-light	£27	1849
N aisle windows	nVII, nVIII	1.1m x 1.8m	2-lights	£54 total	1852
S aisle W window	sIX (original glass not in place)				1853

A sketch by Pugin suggests an arrangement of four, two-light windows having as subject matter respectively St Philip and St Stephen; St Luke and St Mark; St Michael and St Gabriel; and St John and St James. St John the Baptist and St James(?) appear in nIX (although stylistically the window does not seem to be of Pugin's period) and St Philip and St Stephen (Pugin made a small sketch of these) could have appeared in nVI (which now contains later glass). The four windows of Pugin's arrangement were then, perhaps, nVI and nIX together with the two-light windows recorded in the First Glass Day Book as side windows. These may be nVII (where only St Mark remains) and nVIII where perhaps St Matthew and St John the Evangelist were substituted for St Michael and St Gabriel.

Descriptions. **sVII.** 2-light window and tracery; possibly the one recorded on f. 9 of the First Glass Day Book and described as '2 Lights with Vine Leaves & Shields'. Each of the lights consists of plain white quarries overlain by a vertical series of alternately small and large white-outlined diamonds linked in each of the bottom panels to a quatrefoil outlined in white-beaded glass. The left-hand quatrefoil contains a shield emblazoned with quartered arms. Two blue chevrons on white grounds make up the top left and bottom right quarters, and a pattern somewhat like the teeth of two horizontal saws – one black one white – meshing, in the other two quarters. The shield in the right-hand quatrefoil is divided vertically into two, with both halves emblazoned with quartered arms. The two sets in the left half are the same as those in the shield in the left-hand quatrefoil, and those in the right half are: white lions rampant on blue grounds in the top left and bottom right quarters; a white cross on red ground dotted with white in the top right quarter and a red lion rampant on yellow ground in the left. The borders are patterned with yellow four-petal florets on blue and green grounds sandwiched between two lines of white fillet glass. The main tracery-piece above and between the lights is patterned with yellow vine leaves and green grapes, on white stems, against a red ground. The patterning is arranged around a shield that is divided into two, with blue chevrons on a white ground emblazoned on the left side, and quartered arms on the right. The other two smaller tracery pieces are patterned with red roundels on white grounds.
SV, SII. 3-light clerestory windows and tracery. Each light contains a depiction of a barefooted saint standing in a frontal pose against a foliage diaper screen – blue in the centre lights and red in the side – under a canopy. From left to right the saints are:
SV. St Simon in a pink-lined, olive green mantle over a brown-patterned robe, holding a downward-pointing saw in his right hand. St Bartholomew in a red-lined, blue mantle over a green robe holding an upward-pointing flaying knife in his right hand. St Matthias in a yellow-lined, blue mantle over a white robe, holding an axe in his right hand.
SII. St John the Evangelist in a red-lined, green mantle over a white robe patterned with yellow silver stain, holding a chalice – from which a purple demon is emerging – in his left hand. St Peter in an orange-lined, red mantle over a green robe, holding the keys upright, in his right hand and a book in his left. St James the Great in a blue hat with the pilgrim's badge attached to the front, a green-lined, slate blue mantle over a similar robe to St John, holding an open book in his right hand, and a staff with a gourd fastened to the top, in his left.
The Latin names of the saints are beneath their feet, but the inscriptions below are indecipherable.
The canopies are similar to those at the Hospital of St John, Alton (Gaz.148), but in the centre lights they are flattened out and do not have angels in the niches. In the side lights the central niches become simply flat red areas between pinnacled buttresses, acting as backgrounds to the long finials of the gables.
nVII. 2-light window and tracery. Originally both lights would, presumably, have contained figures beneath the canopies, but the right-hand light is now filled with plain glass. The window is dedicated to the memory of Giorgiana Augusta Mackenzie Fraser (the First Glass Day Book, f. 141, calls for one of the two windows of the aisle to be charged to Colonel Fraser, being a memorial window of Mrs Fraser). Although the paintwork is badly worn, the figure standing in front of a blue screen under a canopy in the left-hand light can, from his attribute of a lion, be identified as St Mark. He is in a purple(?)mantle over a green robe holding a scroll, which curves down from his hands to the lion sitting in profile at his feet. The canopy has a cinquefoil head contained within a pointed arch surmounted by a yellow-crocketed and finialed gable. The superstructure (the detail has been worn away) that rises above and behind the gable is flanked by

two pinnacled buttresses which rest on the top of the brown pitched roof of a rectangular structure, just visible behind the gable. The top and bottom panels of the light are filled with grisaille the make up of which has been worn away. Overlying the grisaille in the top panel is a red-outlined concave-sided octagon crossed by two yellow diagonals. The panel at the bottom is divided into two squares crossed by red diagonals.

The borders are patterned with white leaves (the leaf patterns have gone) on undulating yellow stems against red, blue and green grounds. The tracery-pieces are patterned with white and green leaves on yellow stems, against red grounds.

nVIII. 2-light window and tracery, dedicated to the memory of Emiline Marie Conways died Dec. 1813[?]. As with nVII stained glass appears only in the left-hand light, the right-hand one being filled with plain glass. The design is similar to nVII with St Matthew and the angel adopting the positions of St Mark and the lion but the screen behind the figures is green. St Matthew is in a red-lined, blue mantle over a yellow robe. The canopy is similar to that in nVII but the pitched roof is whitish yellow. There are no geometrical shapes overlying the grisaille in the top or bottom panels of the light where the quarries have given way to quatrefoils formed by the leads. The main tracery-piece above and between the lights contains a shield, divided vertically into two halves, emblazoned with arms. The arms in the left half comprise a plain white top third, and white dots on a grey ground for the remaining two thirds; in the right half there are two blue chevrons on a white ground. The rest of the piece is patterned with white leaves on yellow stems (the stems encircle the shield) against red grounds. Similar patterns fill the two smaller side pieces of tracery.

sIX. Neither this window, nor any other in the church, contains a representation of the Salutation of St Elizabeth, as mentioned in *Letters, Bagot to Hardman*, 1852, Nov. 21, and recorded in the First Glass Day Book, 1853, Oct. 8.

Office records. *Order Book*, undated, f. 9 (sVII); undated, f. 33 (SV & side); undated, f. 32 (SII & side); 1851, f. 154, Oct. 27 (nVII, nVIII[?]); *Order Book 2*, 1852, f. 15, Nov. 25 and *Order Book 3*, 1852, Nov. 25, f. 17 (sIX). *First Glass Day Book*, 1846, f. 9, Nov. 12 (sVII), f. 9, Dec. 5: '2 pieces of Copper Lattice/for Lights of Window, side of Nave' 1848, f 47, Nov. 25 (SV & side window); 1849, f. 62, Jun. 19 (SII & side window); 1852, f. 141, Apr. 1 (nVII, nVIII(?)), f. 166, Dec. 27: 'To Alterations and/Repairing 6[?] Windows/of Stained Glass for/Chancel.../consisting/of 2 Lights and 1/Tracery piece each' 1853, f. 190, Oct 8 (sIX). *Cartoon costs per ledger summary*: SV, Powell £2.0.0, Hendren £1.0.0, side, Powell £1.0.0, Hendren £1.0.0; SII, Powell £4.0.0, Hendren £1.6.8, side, Powell £2.0.0, Hendren 13s.4d. *Pugin sketch*, BM & AG a no. not allocated: arrangement of windows.

Letters. *HLRO 304: Pugin to Hardman*, letter no. 1023: 'Powell has made a famous S. Paul [could this have been turned into St Simon?] for Blithfield.' No. 1024: 'you will have Mr Bagots window next I do my best but these cartoons take a deal of time for I make Powell take the greatest Pains It impresses him so much he has done 2 famous figures for Blithfield I assure you in a short time he will surpass Oliphant'. No. 351: 'the stained window Blithfield you will receive the templates of the head[?] from Rev. Mr. Bagot.' No. 97: '4. I am now going to begin my oil[?] painting for there is <u>nothing to do</u> of any description – a bright look out for 1849. 5. The Blithfield [?] windows are very good as you say if Powell sticks by me I can make him a first rate man. he will do these things so beautifully.' No. 1037: '1. You must send back the cartoons for the 3 light clerestory window that went to Blithfield as Mr. Bagot has ordered <u>another</u> to be done immediately'. Not numbered – in J. H. Powell section, postmark 'MR16 1849': 'we are going on well with Frieth [Gaz.5] & Blythfield [sic] a few days will finish both.' No. 1000: '3. you must send me the cartoons of <u>Blithfield window</u> I mean the 2 light one & I will send you the cartoons for the new window. 4. have you sent the clerestory for Blithfield I am anxious to know [makes a sketch of the outlines of a Blithfield 2-light window].' No. 637: 'I have been so anxious to make a nice[?] window for Blithfield Mr. Bagot they have been down here & the last is worse than the first no scale, no nothing you talk about my worrying[?] myself but if I did not what should we come to. I think our Heraldry is perfect but we fail dreadfully in the older saints when once we leave the quaintness of the old men it is a failure & I think there is a disposition rather to ridicule[?] this wonderful [?] of the human figure to fill cartoons spaces & c.' No. 1014: '3. I dont think any price was fixed for the small windows at Blithfield.' No. 145: '7. I find that the rest of the window for Blithfield can go off tonight the canopies are a good job.' No. 123: 'Colonel Bagots window next. I have included the saints he wished & it will be a very good job in the same style as Lord Bagots.' *Stanton, 1950 , catalogue, Pugin to Hardman*, 1849: 'I am sorry to hear so bad an account of the glass at Blithfield we are most unfortunate I ought really to see everything before it goes It is a very bad job indeed. I am very sorry about it. It will bring great discredit upon us'. *JHA: Powell to Hardman*, undated, in 1847 bundles: 'I enclose a window for Blithfield complete excepting that we have not got the templets [sic]. I have guessed the shapes when you get them you will see whether they will do'. *Bagot to Hardman*, 1846 (in 1847 bundles), Aug. 5: 'I send you the templates of the Tracery of the window of the Church ...The two lights & the 2 corners are exactly the same size'. Nov. 29: 'The window is just fixed in this Church, and I am glad to say it is very much admired.' 1848, Aug. 2: 'I should be much obliged to you to tell me if I can see what you have done of the window for the Church of Blithfield or see Mr Pugin's Cartoon for it.' Dec. 27: 'Have you heard from Mr. Pugin about

Col. Bagot's window. I have ordered also another clerestory window & should like to know if you have heard from Mr. Pugin about that.' Dec. 30: 'I should be glad if you could make out the accounts of the two windows which are in the church'. 1849, Dec. 15: 'the windows are just put up in this Church, and are much admired I wish now to make another clerestory window, with the three apostles St. Andrew, St. Philip and St. Thomas in it ... I should like different canopies from the others and the inscription at the bottom will be 'This window was made to the memory of Louisa Frances, daughter of William Lord Bagot, who departed out of the miseries of this sinful world on the XVII day of February MDCCCXXIX – Mercy Jesu' [the saints are represented in SIII, the canopies are three dimensional, and the inscription is as quoted, presumably the window was executed after Dec. 31 1853]'. 1852, Mar. 19: 'It was arranged by Mr. Pugin and myself that there should be <u>no</u> arms in the tracery of the windows. The arms with an inscription are to be placed on the cill below the window; probably on a brass plate ... you may finish the tracery and I hope the patterns in the tracery will be good, for that part of the first window is not quite satisfactory.' Apr. 7: 'I have just got the windows in & am very much pleased with them.' Nov. 21: 'I am commissioned to order another window for the Church. It is the window in the south aisle which looks to the east ... The subject is to be the Salutation of Elizabeth ... The window must correspond with the former ones which you have put in. I should be glad to hear something of my Chancel windows. It is hard to imagine the discomfort & inconvenience of having service in a Chancel which has not a single sound window in it.' Dec. 4: 'I have put in the windows which you have sent, and am very pleased with them. You have however made one mistake. The window which you marked No. 3 should have been No. 2. Consequently you have put the wrong arms into it. No. 3 is the window with the border of Castles & fleur de lys. [none of the windows described above have this border]'. Dec. 17: 'I find that you have not sent me the head of window No. 5 (that is the parts in which the arms are). That window also is 3 inches too short, but there is no border at the bottom: if therefore you would make me a border for the bottom of each light I could have it put on here, and it would just make the window the right length. All the rest do very well.' *Bagot to Pugin*, 1851, Aug. 20: 'I have to order another window for the North Aisle of my Church. The figures, according to our arrangement will be S. Mark & S. Luke: it is to be a memorial window ... an inscription might be placed ... on the stone above the cill ... The arms are also to be placed in the trefoil at the top of the window ... The window is to commemorate Mrs. Fraser a cousin.' Sep. 18: 'I inclose [sic] you a description of Col. Frasers arms which I hope will be sufficient for the window – you know the Bagot coat well enough. I am afraid the Fraser coat will cut the glass, in the small space of the window, rather too much to look well, but that cannot be helped. If they <u>will</u> have their arms they must only remember the Bagot must be on the right as we look at it.'
Literature. Wedgwood (Pugin's Diary): Pugin visits Blithfield, 1851, Jan. 17, Jun. 6-7.

150 Brewood, St Mary (RC)
*c.*1844.

| N aisle E window | nIII | 0.8m x 1.3m | 2-light |

The right-hand light was originally part of William Wailes's three-light E window given to the church by Pugin. The Hardman & Co. records show that this glass was fitted into its new position in Jul. 1923. The absence of a border and the elimination of the S and part of the A of 'SANCTA' and the final A of 'MARIA' in the Virgin's name at the bottom of the light indicate that it needed to be cut down to size. The rest of the window, that is the left-hand light and the tracery, was made by Hardman & Co. and put in place in 1924.

Description. **nIII.** The Virgin is in the right-hand light, crowned and in a yellowish-white head-dress, and a blue mantle over a red robe. She is seated, under a canopy, against a screen patterned with a yellow diamond trellis infilled with yellow lilies on black grounds, holding a pomegranate(?) in her left hand. The Child in a yellow-patterned robe stands on her lap resting against her right arm. The canopy has a trefoil head contained within a pointed arch surmounted by a yellow-crocketed and finialed gable inscribed with the red letter M.

Office records. Glass Day Book, 1923, f. 91, Mar. 14: 'East window 3 lights and tracery. Old glass to be carefully taken out, packed and delivered to the convent [the Dominican Convent at Brewood has since closed and the Chapel is used by a school. The side lights (an old photograph illustrated in M.J. Fisher, *Pugin-Land,* indicates that each was filled with plain or patterned quarries, contained three symmetrically placed geometrically-patterned bosses and had stained glass borders) are not in the chapel, while the tracery glass is stored in the cellar of St Mary's church (information Rev. David Standen)]'. 1923, f. 124, Jul. 17: 'The figure of Our Lady recently removed from the East window to make way for new glass to fit the dexter light of a two light window in Lady Chapel.' *Glass Day Book,* 1924, f. 251, Jun. 2: 'Calvary Chapel Dex[ter] St. Anthony Lady Chapel Dex St. Dominic Sin[ister] – this was fitted in Jul. 1923 with the Madonna taken from East window but we now have to fill the tracery opening [Hardman & Co. have, seemingly, become confused in their use

of dexter and sinister. The light is the right-hand light as one looks at the window].' 'Insc[ription] – Lady Chapel – Pray for the artists [this is entered in the margin below the figure of St. Dominic]'

Letters. Hardman & Co. Letter Book, *Mar. 10, 1922 to Sep. 6, 1922,* f. 560, *Hardman's to the Rev. P. O'Toole* Jun. 20, 1922: 'Mr Oswald Pippet has been to examine the east window. It is I believe by Warrington [the date of the window, the meticulous drawing, the deep colours and the entries in Pugin's diary (see Wedgwood, below) all point to it being made by Wailes]. It is of very thin glass and thin lead. It seems a pity to have to replace a work that has some history value, but if it is not done now it will have to be done in a few years as the materials used are not good enough to stand the passage of much more time; indeed they are in a bad state now.' *Sep. 7, 1922 to Feb. 22, 1923,* ff. 871-2 *Hardman's to O'Toole,* Feb. 2, 1923: this is a covering letter to an enclosed description of the new east window designed by Oswald Tippet. The description is preceded by: 'In place of the east window at present existing in St. Mary's Church, Brewood which we understand is to be removed and reerected in the Convent a new window is in the course of preparation.'

Literature. The Tablet, 5, 1844 p. 390, paragraph noting the consecration of the church and giving a description of it which includes: 'there are three windows of stained glass, the gift of Mr. Pugin.' Wedgwood (Pugin's Diary): Pugin visits Brewood, 1844, Mar. 1, p. 57: '[Long list of financial transactions] Stained glass Brewood 30.0.0'; p. 58: '[End papers at back of diary] [b] [Financial Calculations] Wailes for Brewood 25.0.0'. Fisher, 2002, p. 141, illustration 107.

151 Cheadle, St Giles (RC)
*c.*1845.

Chancel E window (**1.9**)	I	3.0m x 4.1m	5-light
Chancel S & N windows	sII, nII	0.8m x 1.4m	2-light
Blessed Sacrament Chapel E window (**1.10a & b**)	sIII	each light 0.5m wide	3-light
Blessed Sacrament Chapel S windows	sIV, sV	0.3m x 1.2m	1-light
S aisle windows (**1.13**)	sVI–sIX	1.7m x 2.7m	3-light
S & N aisles W windows	sX, nVII	1.1m x 2.7m	2-light
N aisle window	nIII	1.7m x 2.7m	3-light
N aisle windows (**1.11a & b, 1.12a & b**)	nIV–nVI1	.1m x 2.7m	2-light
W window	wI	3-light (plain glass, see Pugin to Lord Shrewsbury, *HLRO 339,* letter no. 71 below)	

As is evident from Pugin's letter to Hardman written in Jun. 1846 (see below), some alterations were made to the windows at the time, seemingly to admit more light. More radical changes were made a hundred years later when plain glass replaced the coloured backgrounds of the windows in the aisles[57] (remnants of the original schemes remain and these have been noted in the descriptions below). Pugin's article in *The Tablet* described some of the backgrounds thus: sVIII: side windows: 'a rich diaper'; sIX: 'the side lights are divided into eight floriated quatrefoils'; nIII: side lights 'the Annunciation of a rich diaper of flower-de-luces'; nVI: 'a diaper of foliage'

Descriptions. **1.** 5-light Jesse window and tracery. Each of the lights contain half-length depictions of five of the ancestors of Christ, except for the centre light where three are depicted together with, at the bottom of the light, a portrayal of the seated Jesse, equivalent in size to two of the ancestors. Two undulating red bands patterned with yellow vine leaves on white stems run the length of each light forming en-route medallions of closed bulbous shapes in which the ancestors are contained against dark blue, foliage diaper quatrefoils. In the case of Jesse the bands run up along his legs, kink in at the waist, and come together above his head. Red trefoils on white grounds, with a green vine leaf in each of their foils and overlain by red, pointed propeller-like forms, fill the spaces created by the undulating bands above and below the medallions. Above and below each of the trefoils, along the outer margins of the lights, are three, blue, pointed leaves arranged propeller-like around red-rosetted centres. The ancestors of royal lineage are crowned and hold sceptres in one hand (some in the right, others in the left) and orbs in the other – King David, who is in the middle light immediately above Jesse, holds a harp rather than an orb in his left hand. The names of the kings are inscribed in white on black on bands that run behind them, midway across the medallions in which they are contained. The names of the other ancestors are inscribed on scrolls which they hold in various positions across their bodies. Four more ancestors appear in the tracery pieces, the topmost of which is a quatrefoil containing a half-length representation of the Virgin and Child.

sII, nII. 2-light windows and tracery. Each of the lights contains two roundels. The top ones contain yellow representations of the symbols of the Evangelists (the angel and the winged lion in nII and the ox and the eagle in sII) on black grounds and the bottom ones, yellow foliated crosses on black grounds patterned with small crosses and *fleur-de-lis.* A small blue rosette at the centre of every four quarries, suggest that the background patterning in the lights may

have been at one time similar to that in nVI (see below). The borders are patterned with alternate yellow and red rosettes on blue grounds. A roundel similar to those in the lights and patterned with leaves is contained in each of the single quatrefoil tracery-pieces of the two windows.

sIII. 3-light window and tracery. The centre light contains a depiction of Christ, under a canopy, and the side lights, seraphim holding inscribed scrolls. Christ is crowned, and in a yellow-patterned, lined, red mantle held together at the neck by a diamond-shaped white and yellow ornamented brooch. He stands barefoot against a ground of purple foliage diaper, holding a crossed-and-pennanted staff in his left hand. Beneath his feet, inscribed in yellow-on-black, are three lines of text with an illuminated initial letter A, equal in height to that of all three lines. The text reads 'AMEN AMEN DICO VOBIS/EGO SUM PANIS VIVUS QUI/DE COELO DESCENDIT'. The canopy has a trefoil head contained within a pointed arch surmounted by a yellow-crocketed gable. A yellow-patterned cross with quatrefoils attached to its extremities rises from the apex of the gable. The quatrefoils contain the symbols of the Evangelists (the angel at the top, the lion on the left, the ox on the right and the eagle at the bottom) in yellow, against black grounds. Covering the crossing is a similar quatrefoil which contains an image of the Agnus Dei in red, on a black ground. Two facing angels in red mantles over white robes hover on either side of the cross. Three yellow and white-winged, red seraphim holding inscribed scrolls relevant to the mystery of the Eucharist are depicted in blue foliage quatrefoils in each of the side lights. At the top of each light and touching, tangentially, the topmost quatrefoil is a red roundel that contains a white Agnus Dei on a blue ground. Filling the spaces around the quatrefoils and the roundels are white vine leaves and bunches of grapes, on yellow stems, against blue grounds. The borders are patterned alternately with a bulbous yellow jar surmounted by a cross, and a foliated red cross on a dark ground. The two tracery-pieces over the side lights each contain a red foliage diaper shield on a green foliage diaper ground, within a roundel. The left-hand shield is inscribed with the white letter alpha and the right, omega.

sIV, sV. Single light windows of plain white quarries. The windows each contain two red rimmed quatrefoils which enclose representations of the Agnus Dei, in yellow, against a blue foliage diaper ground.

sVI. 3-light window and tracery. The centre light contains a depiction of Christ standing barefoot on blue, stylised clouds, in a yellow-rayed glory edged by a band of white six-petal, yellow-centred rosettes alternating with green leaves. The side lights each contain in two rows of eight, sixteen roundels inscribed in red with the letters IHS. Christ in a white-lined, red mantle over a yellow robe, holds his right hand across his chest pointing to the motif of a red heart, encircled by a yellow chain and surmounted by a yellow cross rising from two leaves, that adorns his robe over his heart. Four angels in frontal poses are grouped above and around his head: the top two in white robes strum yellow, lute-like instruments; the bottom two in green mantles over white robes, beat yellow drums, with crossed drumsticks. Another angel stands in a frontal pose in the head of the light. He is in purple and holds a musical instrument(?) across his chest. Two further angels in red mantles over white robes, who are playing harps, sit facing each other on either side of Christ's feet. Beneath them and running across the light is the inscription in yellow-on-black: 'VULNERASTI COR MEUM'. The bottom panel of the light contains a quatrefoil at the centre of which is a small roundel inscribed with the letters IHS in yellow-on-black. The rest of the panel is patterned with white leaves and yellow bunches of grapes on yellow stems. The roundels inscribed with the letters IHS in the side lights are encircled by bands of plain glass and then yellow bands inscribed with petitions of the Litany of Jesus. In the central spaces between every four roundels are small roundels containing green-on-black foliated crosses within green-outlined quatrefoils – the remaining spaces are filled with plain glass. A red cross, its vertical post extending down to between the first pair of roundels and its crossing encircled by a yellow crown of thorns, is in the head of each light, which are otherwise filled with plain glass. The plain glass is part of the later alterations. The borders of the side lights are patterned with yellow leaves and white berries on continuous white undulating stems against blue and red grounds. The three main tracery-pieces are butterfly-shaped and filled with patterns of bluish-white(?) leaves and yellow bunches of grapes on yellow stems; the stems encircle small blue foliated crosses at the two central points of each piece.

sVII. 3-light window and tracery. From left to right, the lights contain depictions under canopies of St John the Evangelist, St Giles and St Chad. St John is in a white-lined, red mantle over a green robe, holding a yellow chalice from which a white, yellow-winged demon emerges, in his left hand. St Giles is in a pink mantle over a white robe, holding a crozier in his left-hand. St Chad is in a yellow-ornamented, white mitre, the pallium and a green-lined, yellow chasuble over a yellow-lined, red dalmatic and a white alb, holding a crozier in his left hand. The canopies have trefoil heads contained with pointed arches surmounted by yellow-crocketed and finialed gables. Flanking the finials are white-robed angels seated in frontal poses and playing musical instruments. No traces remain of the original backgrounds within the canopies and the heads of the lights. The borders of the left-hand light are patterned with alternate yellow chalices from which emerge devils, and green leaves on stems, against dark grounds; the centre light, yellow leaves and white

berries on continuous undulating stems against green and blue, patterned grounds; the right-hand light, alternate yellow crosses – made up of four Tau crosses joined around a circular centre and with small crosses in the interstices – and red foliated letters C. The tracery-pieces each contain a central crown, with the remaining areas filled with patterns of blue and white leaves on yellow stems.

sVIII. 3-light window and tracery. The centre light contains a depiction of the Virgin Mary, and each of the side lights two emblems from the Litany of Loreto alternating with two images of red seraphim. The Virgin in a white-lined, blue mantle over a red robe stands barefoot on a large white crescent moon. She is bareheaded with long golden hair that reaches to the small on her back and protrudes at her sides. Behind her is a dark screen patterned with yellow stars, and in the margin beneath her feet 'PULCHRA UT LUNA' is inscribed in yellow-on-black. The panel under the inscription contains a roundel in which is a representation of a white lily and green leaves on a white stem, in a yellow jar. The emblems and images in the side lights are contained in blue diaper, round-cornered hexagons. The emblem at the top of the left-hand light is a yellow-centred, white rose above a spray of green leaves and purple roots. A label inscribed in yellow-on black is placed just above the roots. The emblem in the panel next to the bottom of the light is a white star. The equivalent emblems in the right-hand light, are the Tower of David and the House of Gold (a gabled gateway flanked by two towers), each in white, ornamented with yellow and with inscribed labels running behind them, midway up the hexagons. A trelliswork pattern in the leading occurs in all three lights and indicates the nature of the original ground. In each of the side lights, eleven quarries patterned with yellow *fleur-de-lis* on blue grounds arranged in flanking pairs above and below each hexagon, and a single quarry in the head of the light, are, presumably, the remains of the original diaper ground. The borders are patterned with alternating yellow *fleur-de-lis*, and red leaf-on-stem patterns in the centre light, and blue leaf-on-stem patterns in the side lights. Two large quatrefoils in the tracery contain patterned diamond shapes that have 'AVE' inscribed in yellow along the sides and the red letter M in roundels in the centres. A diamond-shaped tracery piece at the top is decorated with three white lilies and green leaves.

sIX. 3-light window and tracery. The centre light contains a depiction of St John the Baptist standing in a frontal pose beneath a canopy, and each of the side lights, four portrayals of virtues and vices. St John is in a white-lined, blue mantle over a yellow hair robe holding an image of the Agnus Dei in his left hand. The canopy has a trefoil head contained within a pointed arch surmounted by a yellow-crocketed and finialed gable. Above the canopy is a blue roundel surrounded by seven white stars, on a blue ground, which contains a representation of the Holy Dove, flattened out and in downward flight. The virtues presented in female forms, standing on the vices (in animal forms) are contained in blue diaper roundels. Red horizontal bands inscribed with the names of the virtues run midway behind the figures. The church guide (*Pugin's Gem*) lists them, reading from the top down as: left-hand light, largitas and a dog; humilitas and a lion; veritas and a panther; and misericordia and a hound: right-hand light: modestia and a donkey; temperantia and a pig; patientia and a bear; and pudicitia and a goat. Remnants of the original backgrounds are apparent in the leading which forms a series of four quatrefoils containing the roundels in each of the side lights, and part of a similar series in the area above the canopy in the central light. The borders are patterned with yellow leaves on blue-patterned grounds. The tracery-pieces are filled with white leaf on stem patterns around red rosettes.

sX, nVII. 2-light windows each having single large quatrefoil tracery piece. The lights are made up of plain white quarries and each contains three leaf-patterned quatrefoils. The borders are patterned with yellow leaves on red grounds. The tracery-pieces each contain a shield emblazoned with the yellow Talbot lion on a red ground.

nIII. 3-light window and tracery. The centre light contains a depiction of the Virgin and Child under a canopy, and each of the side lights two roundels both inscribed with the letter M surmounted by a small yellow crown; between the roundels is a figured quatrefoil. The two quatrefoils together depict the Annunciation. The Virgin, crowned and in a white head-dress, and a blue mantle over a red robe, sits in a frontal pose in front of a green diaper screen, holding the Child against her right arm. He is in a yellow silver stain-patterned, white robe. The canopy has a cinquefoil head contained within a pointed arch surmounted by a yellow-crocketed and finialed gable. At the bottom of the light is a two line inscription in yellow-on-black, reading 'SANCTA MARIA/ORA PRO NOBIS'. The background glass in all the lights was similar to that in sVIII, but as with that window much has been replaced by tinted glass. In each of the side lights twelve of the original *fleur-de-lis* patterned quarries are arranged symmetrically in rows of three above and below the roundels. The borders are patterned alternately with yellow *fleur-de-lis*, and blue foliage.

The tracery-pieces contain arrangements of small red and yellow stars in circular leads on white grounds – the original grounds have probably been removed (suggested by two small pieces at the top of the window with a blue ground).

nIV. 2-light window and tracery. The seven corporal acts of mercy and the Holy Dove are illustrated in eight blue diaper roundels (four to each light) the scenes being contained within red-outlined quatrefoils. From top to bottom, the scenes represented are, in the left-hand light: clothing the naked, ministering to prisoners, giving drink to the thirsty,

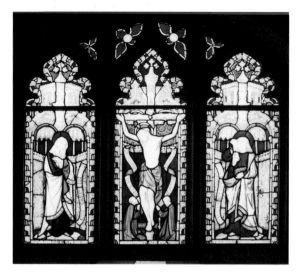

10.18 (*left*). St Augustine, Ramsgate, chantry chapel S window sVI (tracery) (Gaz.88), Pugin/Hardman, 1849. St Louis with angels.

10.19 (*right*). Stonyhurst College Church, Lancashire, Silence Gallery W window SG wI (Gaz.93), Pugin/ Hardman, 1850. Crucifixion. *Stanley Shepherd*.

10.20 (*left*). St Mary, Wymeswold, Leicestershire, N aisle E window nIV detail (Gaz.104), Pugin/Hardman, 1848.Nativity. *Stanley Shepherd*.

10.21a (*right*). Our Lady of the Annunciation, Bishop Eton, Liverpool, S aisle window sV (Gaz.110), Pugin/ Hardman, 1846. St Oswald.

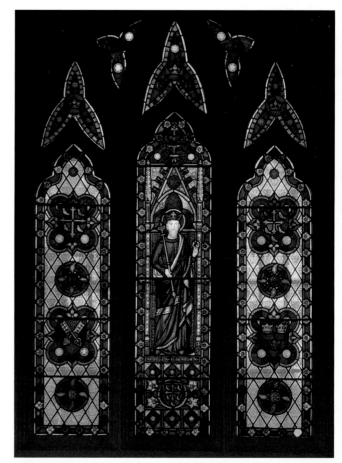

10.21b (*above*). Detail of 10.21a.

10.21c (*right*). Our Lady of the Annunciation, Bishop Eton, Liverpool, N aisle window nV (Gaz.110), Pugin/Hardman, 1848. St Edward the Confessor.

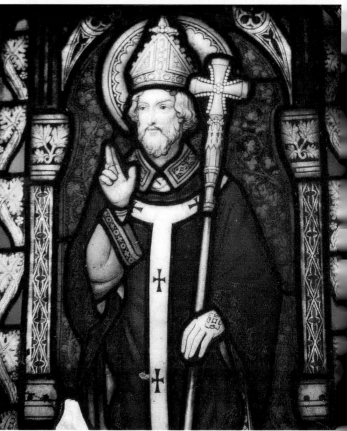

10.22 (*above*). Our Lady of the Annunciation, Bishop Eton, Liverpool, S aisle window sV (Gaz.110), sketch by Pugin for 10.21a, 32.5cm x 53.3cm. *Birmingham Museums & Art Gallery, BM & AG a.no.2007-2728.4.*

10.23 (*right*). St Felix, Northampton, S aisle window sIV detail (Gaz.122), Pugin/Wailes, *c.*1845. St Felix. *Stanley Shepherd.*

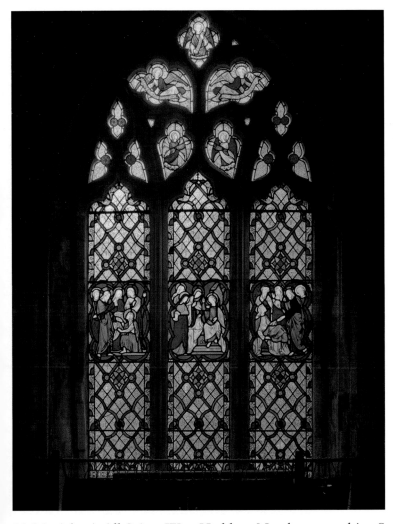

10.24a (*above*). All Saints, West Haddon, Northamptonshire, S aisle E window sIV (Gaz.123), Pugin/Hardman, 1850. Raising of Lazarus, the Marys at the Tomb (?), Raising of Jairus's Daughter.

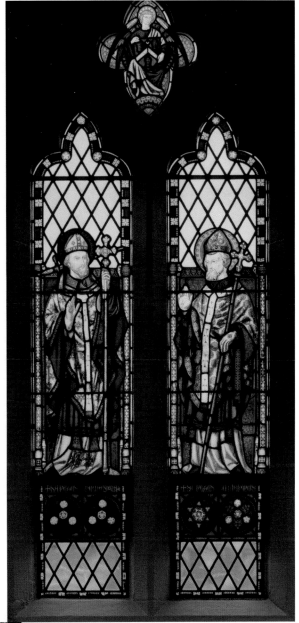

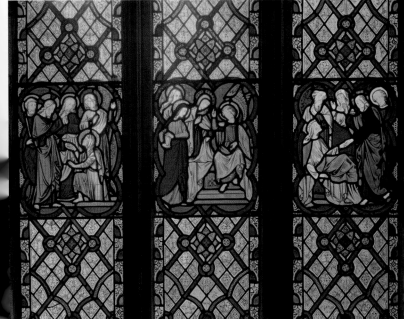

10.24b (*left*). Detail of 10.24a.

10.25 (*above*). Convent of Mercy, Nottingham, chapel N window nIII (Gaz.130), Pugin/Hardman, 1847. St Thomas of Canterbury, St William of York (?).

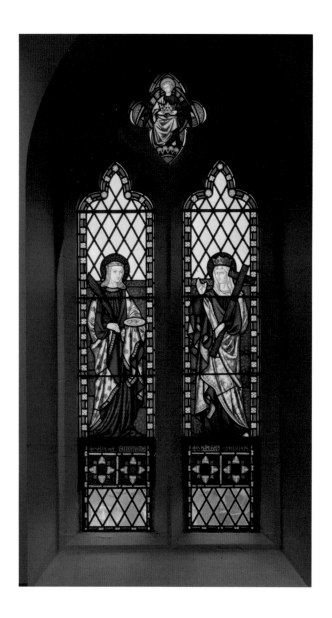

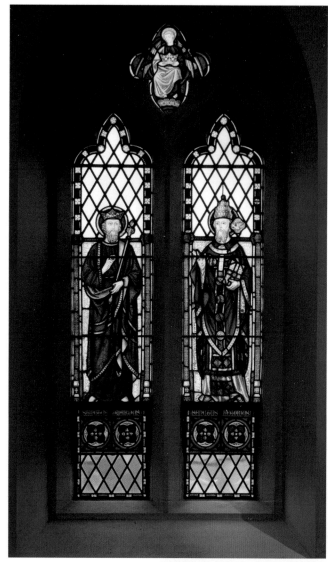

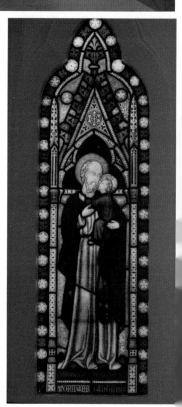

10.26 (*above left*). Convent of Mercy, Nottingham, chapel N window nIV (Gaz.130), Pugin/Hardman, 1847. St Lucy, St Helen.

10.27 (*above right*). Convent of Mercy, Nottingham, chapel N window nV (Gaz.130), Pugin/Hardman, 1848. St Edward, St Gregory.

10.28 (*right*). Convent of Mercy, Nottingham, community room window CR I (Gaz.130), Pugin/Hardman, 1848. St Joseph carrying the Christ Child. Window no longer in place. *Stanley Shepherd*.

10.29 (*right*). Convent of Mercy, Nottingham, community room window(s) CR I, (Gaz.130) as originally intended (see p. 315), sketch by Pugin: Joseph carrying the Christ Child, the Virgin Mary, and border details, 32.2cm x 28.8cm. *Birmingham Museums & Art Gallery, BM & AG 2007-2728.6.*

10.30 (*below right*). St Leonard, Butleigh, Somerset, S side 'pulpit' window sVI (Gaz.141), Pugin/Hardman, 1851. St John the Baptist, St Peter, St Paul. *Stanley Shepherd.*

10.31 (*below left*). St Mary, Cresswell, Staffordshire, sanctuary N window nII (Gaz.153), Pugin/Hardman, 1848. Annunciation. *Stanley Shepherd.*

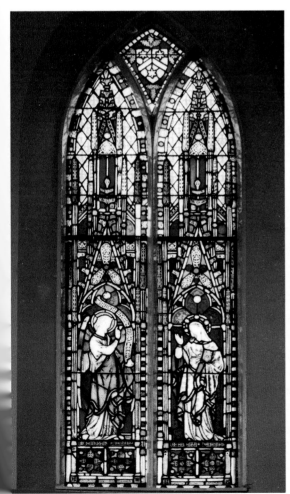

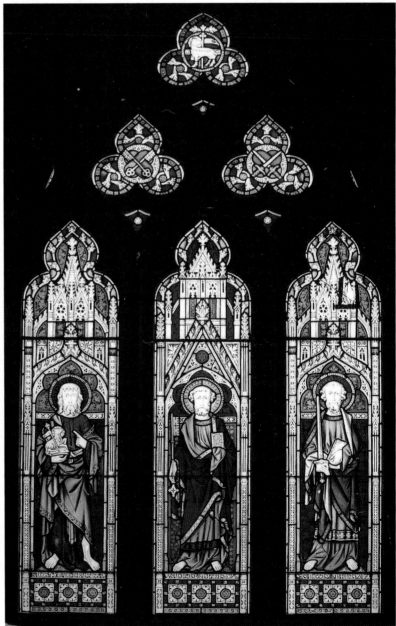

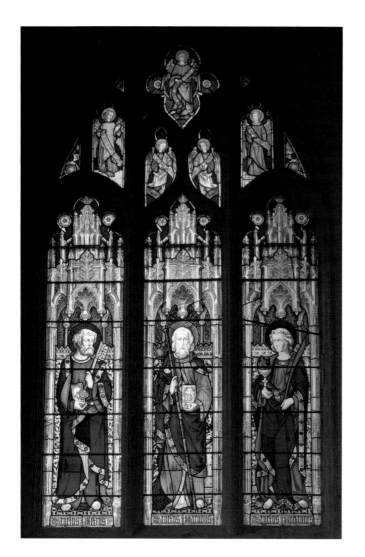

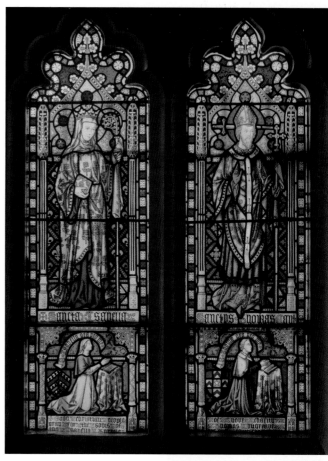

10.32 (*above left*). St Andrew, Farnham, Surrey, chancel S wall window sII (Gaz.162), Pugin/Hardman, 1851. St Peter, St James the Great, St John the Evangelist.

10.33 (*above right*). St Augustine, Kenilworth, Warwickshire, N aisle window nIII (Gaz.168), Pugin/Hardman, 1848. St Isabella, St Thomas of Canterbury.

10.34 (*right*). St John the Baptist, Wasperton, Warwickshire, S wall window sVII (Gaz.172), Pugin/Hardman, 1847. St John the Baptist.

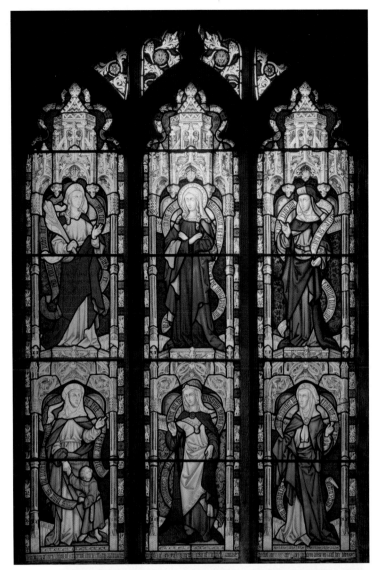

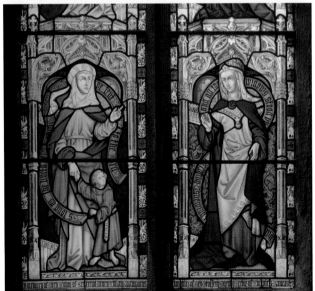

10.35 (*above left*). St Chad's Cathedral, Birmingham, N aisle window nIX (Gaz.176), Pugin/Hardman, 1852. St Francis of Assisi, St Thomas Apostle.

10.36a (*above right*). St Mary the Virgin, Badsworth, West Yorkshire, chancel S window sIII (Gaz.187), Pugin/Hardman, 1852. Ruth, the Virgin Mary, Sarah, Hannah, Dorcas, Anne.

10.36b (*below right*). Detail of 10.36a. Hannah with the young Samuel, Dorcas.

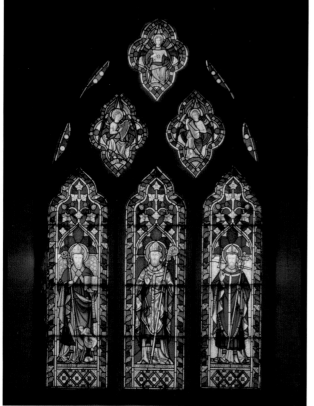

10.36c (*above left*). St Mary the Virgin, Badsworth, chancel S window sIII (Gaz.187), sketch by Pugin for 10.36a, 18.8cm x 28.4cm. *Birmingham Museums & Art Gallery, BM & AG a.no. 2007-2728.9.*

10.37 (*above right*). St Martin, Bremhill, Wiltshire, chancel S wall window sIII (Gaz.194), Pugin/Hardman, 1851. Angels. *Stanley Shepherd.*

10.38 (*left*). St Osmund, Salisbury, Wiltshire, chancel E window I (Gaz.198), Pugin/Hardman, 1848. St Martin, St Osmund, St Thomas of Canterbury.

harbouring strangers; and in the right-hand light: the Dove, feeding the hungry, visiting the sick, the burial of the dead. Above the top roundels and between each of the others are two adjacent sets of four quarries patterned with white leaves on black grounds arranged around central blue rosettes. These presumably belonged to the original background scheme, plain tinted quarries having replaced the rest. The borders are patterned alternately with yellow quatrefoils on black diamonds outlined in yellow, and red rosettes, the grounds have been replaced with tinted glass. The three tracery-pieces are patterned with white and green leaves, on stems which curve around blue rosettes.

nV. 2-light window with a single large quatrefoil tracery-piece. The lights contain depictions beneath canopies of, on the left St Peter, and the right, St Paul. Both saints stand frontally-posed against screens patterned with blue diaper quatrefoils. St Peter in a yellow-lined, red mantle over a purple robe stands in a frontal pose holding two upright keys (one yellow, one white) in his right hand, and a book in his left. St Paul in a blue-lined, red mantle over a green robe, stands in a frontal pose, holding an upraised sword in his right hand and a book in his left. The canopies have cinquefoil heads within pointed arches, surmounted by yellow-crocketed and finialed gables. The gables contain yellow-rimmed roundels in which red quatrefoils enclose the saints' attributes (that on the left, crossed yellow keys, and on the right, crossed white-bladed, yellow-handled swords). The attributes also appear in three white-outlined, red quatrefoils at the top of each of the lights. The bottom panels of each light contains a blue roundel. The one on the left encloses a white-outlined, red quatrefoil within which is a representation of St Peter in a blue robe, upside down on a cross. The one on the right has a white-banded rim which is inscribed 'SANCTE PAULE APOSTOLE PRAEDICATOR VERITATIS ET DOCTOR GENTIUM INTERCEDE PR NOBIS AD DEUM [ref: *Pugin's Gem*]' and encloses a white-outlined, red quatrefoil within which is a depicted a book open at the beginning of the letter to the Romans (ref: *Pugin's Gem*) and which lies on downward-pointing crossed swords. The backgrounds to the panels are filled with a diamond trelliswork formed in double lines of leading, and those in the areas at the top of the lights by a similarly defined square trelliswork; both are now filled with tinted glass where originally there would have been diaper, but no suggestion of the pattern remains. The borders in the left-hand light and in the tracery are patterned alternately with yellow keys on black grounds and red rectangles – the keys are substituted by crossed swords in the right-hand light.

The quatrefoil tracery-piece contains the saints' attributes in combined form (two crossed keys bisected by a vertical sword) in four red quatrefoils that occupy its foils. A quatrefoil containing a yellow papal tiara overlying crossed keys is at its centre.

nVI. 2-light window and tracery. Each light contains three blue roundels in each of which is a small yellow-rimmed roundel containing a depiction of a named crowned head of a Saxon saint, on a black ground. The saints in the left-hand light are kings and in the right, queens, and are Edmund, Edward the Martyr, Edward the Confessor, Etheldreda, Ethelburga and Mildred respectively [ref: *Pugin's Gem*]. Quarries make up the remainder of the lights. Originally these were in blocks of four, patterned with three-part white leaves outlined in black, arranged around central blue rosettes. Remnants of these blocks (two at the tops of the lights, two at the bottoms and four above and four below the middle roundels) remain, as do the balance of the rosettes, but the rest of the quarries are now tinted glass. The inner borders of the lights are patterned with white clover-like leaves on undulating stems against black grounds. The outer borders are patterned with red versions of the inner border design, which alternate with yellow four-petal flowers. Two further crowned heads (one a king, the other a queen) are contained in the trefoil tracery-pieces immediately above the lights. They are enclosed in pink roundels with yellow beaded rims. The quatrefoil at the top of the window contains an angel in white standing in a frontal pose, holding a yellow crown on a tray covered with a white cloth.

Office records. *First Glass Day Book*, 1846, f. 3, May 21: 'Alteration in Windows/New Glass in 2 lights/do.do.do./do.do. do/do.do.do./ in 4 lights/10 New Rosettes, 4 pieces of Ruby/4 pieces of Dotting/Repairing Centres and Borders/of 10 Lights/£7'.

Letters. *Wedgwood, 1985, Pugin to Lord Shrewsbury*, no. 23, 'Sep. 29 [1841]': I will have a pattern of Glass ready by the time you arrive, one of each sort of window.' No. 31' [summer 1843]': I hope to find several glorious details for the Cheadle windows among the early works at Antwerp, Louvain & c.' No. 41: '[? Jul. 1844]': The glass is proceeding as fast as possible. It is indispensable to get it all in by the end of this year & before the bad weather of the latter part of autumn comes on.' *Pugins's Gem, p. 7, Pugin to Lord Shrewsbury*, May 1842: 'Wailes has written to me to pay him for the Cheadle window £42 which I think is moderate for such rich glass'. *HLRO 339: Pugin to Lord Shrewsbury*, letter no. 71, postmark 'UTTOXETER AU 28 1841': 'respecting the estimate for Cheadle glass. I never contemplated any painted Glass at all. the north side is diapered but every window different and painting requires a great repetition of the same patterns on the side of the porch there is no window to the south so that there is fact [sic] very little difference between the two aisles in respect of the quantity or Quality of the glass. I never anticipated for a moment your Lordship would object to stained glass in the W aisle windows [nVII & sX, these are filled with stained glass – see description] all we

agreed was for the windows under the tower [wI(?)] this is the first word about the aisles. if they are plain the whole thing is ruined. the most beautiful effect of stained glass is from the setting sun is it not so in the state apartments at Alton [Alton Towers, Gaz.147]. the reflection thrown from the West windows up the church is glorious. In making the south windows Larger than the north I have been guided by the best authorities. I am quite disturbed at your Lordship proposing to change all this details [sic] & windows over which I have spent so much time before I commenced the working drawings – I expended above £30 of my own money in travelling by gig to see & sketch the best parish churches of [Norfolk is crossed out] a similar date. I can show your Lordship authority for everything. I took the very cream of the norfolk churches ... I implore & entreat your Lordship let me carry it out. as I have arranged.' No. 78: 'I have this day seen the Cheadle windows in progress they will be glorious excellent drawing the acts of mercy [nIV] are really admirable I am certain that your Lordship will be pleased with them, they combine the richness of the old men with true drawing'. No. 25: 'I have every reason to believe that all the aisle windows for Cheadle will be there by the Early part of next month they are all I have ascertained very forward. I think £100 would finish them very quick & if your Lordship can send him [Wailes] that amount it would do a deal of good. I am very anxious to get the glazing done before Xmas all but the East window which we cannot get till Spring [see Wedgwood (Pugin's Diary), 1844, Dec. 5: 'sent Wailes £100 for Cheadle.')]'. *HLRO 304: Pugin to Hardman*, letter no. 986: 'the glass in Cheadle Church looks horrid I long I burn to see one rich good window'. *JHA: Pugin to Hardman*, postmark 'JU20 1846': 'I am in utter despair about the Cheadle windows. I have sent them back again at once how could you dirty all the Quarries over when the express object of having them done was to get light clear glass of the greenish tint with a little amount just to give character without obstructing light. 1.they were just like this before all dirt. 2. Lord Shrewsbury had them taken out & quite clear glass put in to get light which looked Beastly. 3. I to meet the difficulties designed a simple pattern on our greenish white glass quite clean[?] You have smudged them all over & upset all my good intentions if Lord S. saw them he would have his white glass back again for heavens sake alter them. I will try anything rather than he should resort again to his plain clear quarries of White Crown[?] glass which ruins[?] everything [at the top of the letter Pugin writes: 'pray see about the white flint glass of greenish tint like the piece I gave I know it can be done & it is most important.'].'

Literature. The Tablet, 7, 1846, pp. 568-9: commentary on the opening including a description of the church by Pugin, with particular reference to the subject matter of the windows. Short, 1981, pp. 74, 75. Wedgwood (Pugin's Diary): Pugin visits Cheadle, 1839, Oct. 30; 1841, Mar. 31, Apr. 2 (p. 50 '[f] [Estimates]', note 47 comments that this list of estimates must be for S. Giles: it includes: 'S.Glass 670, Carriage & fixing glass 100'); 1842, May 16; 1844, 'DECEMBER 5 At Alton: sent Wailes £100 for Cheadle'; 1845, Sep. 4.

152 Cotton, St Wilfrid (RC)

1848-50. Client: Rev. F. Faber.

According to Higham and Carson the only window of the five ordered by Faber to survive is the three-light one (now the fourth from the E, on the S side of the nave but see note 58 for Hardman's placement) which, they point out, was originally over the altar in the Lady Chapel. They also note that the W window contains glass formerly in the old E window (transferred when the new chancel was added in the late 1930s).[58]

Descriptions. **W window.** 4-light window of plain white quarries and tracery. Each light contains a depiction of a frontally posed standing saint, who, from left to right, are St Etheldreda, St Wilfrid, St Chad and St Hilda. St Etheldreda is crowned and in a white head-dress and a green-lined, yellow mantle over a purple robe, holding a crozier in her right hand and a book in her left. St Wilfrid wears a white mitre and is in a green-lined chasuble over a yellow dalmatic and a white alb, holding a crossed staff in his right hand and a book in his left. St Chad wears a white mitre, and is in a blue-lined, red mantle over a yellow dalmatic and a white alb, holding a crozier in his right hand a book in his left. St Hilda is crowned and in a green-lined, white-edged, yellow mantle over a red robe, holding a crozier in her left hand and a book in her right. The borders are patterned with yellow rosettes on red and green grounds. The tracery-pieces are, like the lights, of plain white quarries and have similar borders. The three main quatrefoil pieces are arranged in a triangular fashion and have at their centres roundels containing depictions of crowned heads.

Nave window. 3-light window and tracery. The centre light contains a depiction of the Virgin and Child under a canopy, and the left- and right-hand side lights, St Andrew and St Peter (also under canopies) with the small figures of St Wilfrid and the Rev. Faber kneeling, respectively, in front of the saints. The Virgin is crowned and in a white head-dress and a light blue-lined royal blue mantle over a red robe. She stands against a white screen cradling the Child, (who is in a yellow silver stain-patterned white robe, sitting up holding an orb(?) in his left hand), in her left arm. St Andrew is in a purple(?)-lined, green mantle over a brown robe, standing in front of a white screen and holding a small, white diagonal

cross in his left hand. St Wilfrid wears a white mitre and is in a red-lined, yellow silver stain-patterned mantle over a blue robe,. He is in right profile kneeling in prayer. A crossed staff rests between his arms and against his chest. St Peter in a green-lined, red mantle over a blue robe, stands in front of a white screen holding an upright white key in his right hand and a book in his left. The Rev. Faber in a light blue biretta and a similarly coloured cassock, is in left profile kneeling in prayer. The canopies have cinquefoil heads contained within pointed arches (ogee arches in the side lights) outlined in yellow and surmounted by white-crocketed gables. White vine leaves on vertical yellow stems against red grounds give the impression of finials attached to the heads of the canopies. The sides of the canopies, which lack columns, are completed by yellow lines (white in the side lights) merging with the outlines of the pointed arches. The borders are patterned with small white roundels and yellow leaves on red, blue and green grounds, The main tracery-pieces are geometrically patterned and consist of three red quatrefoils (one at the top of the window and two immediately below) and three red trefoils positioned immediately above the lights. The left-hand quatrefoil contains within its patterning a white diagonal cross and the right-hand one, white crossed keys.

Office records. Order Book, undated, f. 23: 'East, Lady Chapel and sedilia windows'; undated, f. 30: '2 side windows'. *First Glass Day Book*, 1848, f. 27, Mar. 18: '29 pieces of Tracery for/East Window.../; 16 pieces of Tracery for/Lady Chapel Window/12 pieces of Tracery for/Sedilia Window'; f. 29, Apr 7: '14 Small bits of glass/Tracery/for East Window'; f. 36, Jul. 8: 'An East Window for Chancel/of 3 Lights of Figures & c & c/£200/10ft by 1ft 10½ In/2 Lights do. 11ft 1 In by 1ft 10½ In/.../Tracery for above sent March 18/do.do.do. April 7'; f. 38, Jul. 15: 'To Man's time & travelling/expenses.../to fix glass £5.2.0'; f. 41, Sep. 16: 'A Window for Lady Chapel.../£100/of 3 Lights with Figures & c & c/9'8" x 1'9½"/ Tracery for above sent March 18/1848 A Window of 3 Lights for/Sedilia.../£60/of 3 Lights with Figures & c/6'10" x 1'9½" /Tracery of above sent March 18/1848'; f. 45, Nov. 8: 'To A light of Stained Glass/of Quatrefoil Shape,/1'6" x 1'6"/. An Iron Casement Frame to Swing [?] painted & c for West Window/£1.5.0'; 1849, f. 54, Mar. 24: '2 Side Windows.../£120/ of 3 Lights of Figures & c to each/6'10½" x 1'9½"/.../Tracery for above sent/June 22'; 1850, f. 93, Jun. 22: 'To 24 pieces of Tracery/of Stained Glass/.../ in 2 Side Windows.../, sent Mar 24, 1849, fo. 54'. *Cartoon costs per ledger summary*: sedilia, Powell £1.6.8, Hendren 13s.4d, Oliphant £4.15.0; two side windows, Powell £1.6.8, Hendren 13s.4d, Oliphant £9.10.0. Oliphant's account records that the payment was in respect of: 'June 28 1848 3 cartoons, St. Buonaventure [sic], St. Anthony of Padua & St. Bernadine 3ft 6 In high Sedilia. January 6. 6 Cartoons, St. Joseph, St. Joachim, St. Anne, St. Catherine of Sienna, St. Clare & St. Thresa [sic], @ 32/6 3ft 6In 2 Side Windows'.

Letters. HLRO 304: *Pugin to Hardman*, letter no. 354: 'the East window S. Wilfrids leaves tonight a very fine set of cartoons indeed.' No. 422: 'I hope to send you the greater part of the East window S. Wilfrids you say nothing about the cartoons'. No. 321: 'The East window S. Wilfrids will be done this week ... I cannot understand you not receiving the East window cartoons they left early on Monday.' No. 323: 'I send you the tracery for the 2 East windows S. Wilfrids'. No. 997: 'you can assume that the canopies & c for the 3 windows of Chancel at S. Wilfrids are all the same so they can be finished the figures are now doing[?] in London & will soon be sent.' No. 191: 'mea culpa on looking at the figuring[?] of the Cotton windows again I find it is my fault so of course I am quite ready to pay all the expense I send you the design of the cartoons for the bottom of figures[?] Lady Chapel which I think you will understand'. No. 1002: 'The following are the prices you want ... 2. The side windows of Church St. Wilfrid £60 each I have 2 more nearly ready for you ... you will soon have the 2 other side windows for S. Wilfrids.' No. 1037: '5 of the images for S. Wilfrids side windows go off tonight the 6 which is S. Anne is doing[?] & will be ready for Monday night'. No. 963: 'The heads for the Cotton tracery go off tonight.' *JHA: Faber to Hardman*, 1848, Apr. 3: 'The stained glass is up in both windows and looks wonderful'. W.S. Hutchison to Hardman, undated, in an envelope marked 'oddments 1845': 'I am very glad that we are to soon have our East Window'. *N.A. Hutchison to Hardman*, 1848 bundles, undated: in consideration of the available finances, he writes: 'reckoning in the two East windows ... If the three other stained glass windows are not yet in hand I should like to have them put off for a little time.'

Literature. The Tablet, 7, 1846, p. 600-1, mentions the settlement of, and gives background information regarding, a new religious Community of Brothers of the Will of God at Colton (sic) Hall near Cheadle, and noting their intention of erecting a Pugin-designed church to be known as St Wilfrid's. Higham & Carson (1997), pp. 61-2. Wedgwood (Pugin's Diary): Pugin visits Cotton: 1848, Jun. 25.

153 Cresswell, St Mary (RC)

1848. Client: Rev. C.K. Dunne.

Sanctuary N window (10.31)	nII	1.3m x 3.1m	2-light	£60

Description. nII. 2-light window and a single tracery-piece. The lights together contain a depiction under canopies of the Annunciation, with the Archangel Gabriel on the left and the Virgin Mary, the right. The Archangel is in a green-

lined, brown mantle over a yellow robe. He stands barefoot and in profile against a red diaper screen (much of the diaper has worn away), holding in his left hand an undulating scroll inscribed in white-on-black with 'AVE MARIA GRAZIA PLENA'. The Virgin wears a white head-dress, and is in a green-lined (the lower left side is purple-lined) yellow silver stain-patterned white mantle over a blue robe. She stands in a frontal pose against a red diaper screen holding a book in her left hand. The canopies have trefoil heads, outlined in white-beaded glass. They are contained within similarly defined pointed arches surmounted by yellow-crocketed and finialed gables, which are also outlined in white beaded glass. Rising above and behind the finials of the gables are superstructures made up of , two-light red Gothic windows with white wheel tracery surmounted by yellow crocketed and finialed gables and flanked by two pairs of yellow-pinnacled buttresses (the inner pair being taller than the outer). The borders commence above the columns of the canopies and are patterned with white leaves and green rosettes on red and blue grounds. The red diamond-shaped tracery-piece contains a shield emblazoned with a white chevron and three white, six-pointed stars on a white ground. A metal plaque next to the window reads 'The Good Dowager Lady Mary Stourton deceased/the twelfth date of April AD MDCCCXLI/In memory of whom the congregation of Cresswell/in her Manor of Draycot gave this window to the/Church. May she rest in peace.'

Office Records. *Order Book*, undated, f.11, re-entered f. 57: 'Cartoons £16 of Coronation of B.V.M.': this entry is, perhaps, a clerical error, or it relates to subject matter subsequently rejected in favour of the Annunciation. *First Glass Day Book*, 1848, f. 28, Mar. 21 (nII).

Letters. *HLRO 304: Pugin to Hardman*, letter no. 811: '7. Tomorrow we send Mr. Dunns window for Cresswell'. No. 810: '1. The cartoons for Barntown [Gaz.205] & Cresswell go off by this post [the Barntown window contains an Annunciation, and it is clear that the same cartoons or designs have been used for it and Cresswell] I have not the dowager Lady Stourtons arms [perhaps for the shield in the tracery of nII – see description above]. You can get them & send them to me as I have kept the size.' No. 376: '1. It is an infernal lie of Mr. Baird about the Cresswell window & I will write & tell him so & let him know my mind does he think I work at tinkers prices 15s a foot for rich glass!! I never even mentioned to him anything of the sort. I said £70 for the window. It is lie [sic] it was Mr. Dunn I spoke to ... Mr. Baird is a liar 15s a foot!!! – what is his address? I will write to him myself'. No. 1000: '7. Did you not say that another window was to be done for Cresswell.' *JHA: Powell to Hardman*, undated in 1847 bundles: 'Cresswell is also nearly ready.' *B. Baird to Hardman*, 1848, Feb. 24: 'On the receipt of your letter I wrote to Mr Laryduke[?] for the late Dowager Lady Stourtons Arms, and I have this morning received the enclosed from him. The Revd. Mr Dunn will have written to you respecting the Brass Plate, Mr. Pugin is wrong about £70 being allowed for the window I heard him tell Mr. Dunn at Cheadle that the cost would be 15/- per foot you are aware I think that the window is put in at the Expense of the Tenantry and in lieu of a Brass Plate I should prefer subscribing for a Companion window to the memory of the good [?] E.V. [?] Bt.' *John D. Hunter to Hardman*, 1848: 'Thurs. 3rd of Lent' – 'I am glad that our window is at last finished & is on its way to Cresswell ... I am delighted to hear it is a good one as I hope thereby to induce the executors of poor Sir Edward to erect one on the ops. position as a memorial to him [sIII is opposite and contains modern glass]'. Apr. 14: 'The window is come ... 1½" too short'. May 30: 'I have not yet fixed on the figures but I think that St. George & Edward would not be inappropriate.[since there is no record of it in the First Glass Day Book, if this second window was ever made, it must have been after 1853].'

Dudley, Our Blessed Lady & St Thomas of Canterbury, see WEST MIDLANDS

153A Leigh, All Saints (CoE)
Chancel E window I

Description. I. 5-light window and tracery. Each light contains three quatrefoil, figured medallions. The medallions, the backgrounds of which are of red diaper or blue – save for the two at the tops of the second and fourth lights which are green – are separated from each other by rectangular blocks of white grisaille, each block being overlain by two diamonds outlined in green, beaded glass. In the trefoil heads of the lights are representations of red and white-winged, white-robed seraphim, while along the bottom margins runs a latin inscription reading: 'O quam gloriosum/ est regnum/in quo cum Christo/gaudiant/omnes sancti'.[59] In line with the dedication of the church, the figures in the medallions represent single, pairs, or groups of saints. The enthroned Christ is portrayed in the topmost medallion of the centre light, and St Peter and St Paul in the medallion beneath, in the middle of the design. The 14 main tracery pieces are dagger-shaped and contain representations of standing angels – apart from the four immediately above the outer lights where the angels recline. Six of the pieces form a wheel at the top of the window; two – the largest – are

positioned halfway up the tracery head, aligned one on each side over the medallions separating each pair of outer lights; four have been mentioned above and the remaining two are situated above two smaller curved and patterned, triangular pieces that are over the head of the centre light. There are eight of these pieces, the other six being on the circumference of the above-mentioned wheel. Finally two each of four small non-curved patterned, triangular pieces flank the two largest dagged-shaped pieces.

Letter. *Belcher, 2003, p. 206, Pugin to an unidentified correspondent*, 1844, Jun. 11: 'I hereby certify that Mr Wailes has duly performed so much of the glass of the Eastern Window of All saints Church Leigh as to entitle him to a payment of one hundred pounds on account.'

154 Longton (Stoke-on-Trent UA), St Gregory (RC)[60]

1850. Client: Rev. Edward Daniel. Church demolished in the 1970s.[61] Glass presumed lost.

Office Records. *Order Book*, 1850, f. 92, Jun. 17. *First Glass Day Book*, 1850, f. 95, Aug. 10: 'A stained glass window for the Lady Chapel/£20/of 3 Lights /= 6'0½" x 1'3¾"; 2 side do. 5'1" x 1'3¾" 2 pieces of Tracery for do'. *Cartoon costs per ledger summary*: Hendren £1.0.0.

155 Rugeley, St Joseph & St Etheldreda (RC)

1850. Client: Francis Whitgreave.

Office Records. *Order Book*, undated, f. 42. *First Glass Day Book*, 1850, f. 90, May 9: '1 Small Light of Centre & Quarries & c 2'7" x 0'11½" /.../£2/ for Presbytery'. *Cartoon costs per ledger summary*: shows no costs were charged.
Literature. *The Tablet*, 10, 1849, p. 180: 'Blessing and Laying the First Stone of a New Church'.

156 Stafford, St Mary (CoE)

 N aisle W window (**9.1**) nXIII 0.7m x 3.8m 1-light

The letters below show that the window was made in 1871 to a Pugin design probably created in 1851. The book referred to in J. W. Hardman's letter of Nov. 23 1870 must have been that published in 1852 at the behest of Mrs Masfen, which contained views of the church after the restoration in 1842-4 by George Gilbert Scott. The views were drawn by her son John in whose memory the window was made. Pugin designed the frontispiece (reproduced in Fisher, *Pugin-Land*) including in it a coloured drawing of his window; to be used by Powell as the design for the window made by Hardman's nearly twenty years later.

Letters. *JHA: H. Minton to Hardman*, 1851, Mar. 21: 'I met accidently [sic] Mrs. Masfen, who informed me that she was going to put up a small window in St. Mary's Stafford, and I found that she had recd an Estimate from Warrington I believe. I told her that she ought to have applied to you, if she wanted it first rate and I offer'd to ask you for an Estimate, if she wd give me the particulars. I now send you her Letter & will thank you to send me an Estimate, if you can do so without making a Design [Mrs Masfen's letter included as well as the dimensions of the window the following passage: 'it is at the West end I should like rich colours for the western sun to illumine, & to warm up & brighten the cold dreary looking aisle of wh. it is at the end – that is the north aisle of the nave – It has been suggested by the friends of my dear departed Boy that a single figure of St. John the Evangelist would be suitable and as to words the quantity must depend on the space they would choose to allot to them – Our very good friend the Revd Mr. Crabtree whose name I daresay you know says the following would be suitable. `This window is placed here by the desire & in memory of John, Son of John and Anna Marie Masfen of this town – He died Novbr 10 1846 aged 19'"Blessed are the dead which die in the Lord for they rest from their labours & their works do follow them" "Requiescit in pace". If this is too much of course it can be diminished']'. *Letter Book, Hardman to Minton*, 1851, Mar. 22 : 'I am much obliged to you for looking out for orders for me – To carry out the window in the best way for Stafford Ch. would be worth about £38. The figure of St. John the Evangelist in a panel with an Angel in a panel above & below bearing texts – the ground filled up with our ruby diapered would produce a very good effect.' *Letter Book 1870/1: J.W.B.(?) Hardman to Dr Masfen*, 1870, f. 602, Nov. 3: 'The Rev. Mr. Finch has sent us the size of your window – I find it to contain about 30ft of glass – and we cannot find Mr. Pugin's design – I therefore think it will be the best thing for Mr. John Powell to call on you sometime when he is passing thro' Stford & assess the matter in situ'. f. 609, Nov. 5: 'It will facilitate matters in any case for us to have another copy of Mr. Pugin's design – will you therefore kindly send me one'. Nov. 23: 'John Powell returned home today & I showed him the design for the window in the book you sent – He says if you wish the design carried out

we will do so for the sum of £30 – to include all expenses – except the scaffolding that we shall require at the church to fix. He thinks there will now no [sic] necessity for him to visit Stafford'. 1871, f. 814, Jan. 26: 'We can readily insert the Memorial inscriptions at the base of the lights but we shall have more difficulty to introduce the texts which are of considerable length – but this point we can settle better when we make the full sized drawings.' *Letter Book 1871-2: J.W.B.(?) Hardman to W.E. Masfen*, 1871, f. 239, Jun. 20: 'I am glad to hear the window gives satisfaction. I will send you the Book & Invoice shortly – I send a short description on the other side – The West window of the North Aisle of St. Mary's Church has recently been filled with stained glass at the expense of Dr. Masfen to the Memory of the late John Masfen Junr. The window consists of a single light & contains a figure of St. John the Evangelist who carries a Book & Pen [writing indecipherable] writer of one of the Gospels at his feet is the Eagle his well known symbol [St John stands beneath a canopy. Two angels holding texts are in the bottom panel of the light while the top panels contain the canopy superstructure which consists of two angels beneath canopies flanking a taller and wider canopied four-light Gothic window]'.

Literature: Fisher, 2002, col. plate 9 and pp. 159-60.

157 Stoke-on-Trent (Stoke-on-Trent UA). Church unidentified
1849. Client: Herbert Minton.

Office Records. Order Book, undated, f. 44A. *First Glass Day Book*, 1849, f. 68, Oct. 1: '2 Stained Glass Windows/of 2 Lights ea. with Figures & Inscriptions with Family Names & c/£80/8'9" x 1'7"/2 Large Tracery pieces'. No information is given as to the church in which these windows were installed. *Pugin(?) sketch*, BM & AG a. no not allocated. *Cartoon costs per ledger summary*: two windows, Powell £4.0.0, Hendren £1.6.8.

158 Stone, St Dominic's Convent (RC)
1853. Tracery designed by J.H. Powell.

Office Records. *First Glass Day Book*, 1853, f. 184, Jul. 8: 'For Convent Church.../To 4 windows of 2 lights ea./8 Lights 4'0" x 1' 4½"/1 Window of 2 Lights/2 Lights 4'10" x 1'7"/(Tracery for above windows)/5 pieces 2'2" x 2'0"/1 do. 1' 7" x 1'7"/10 do. 1' 0" x 0'7"/Tracery heads for above/4 windows, Sep. 12th/8 pieces 1'9" x 1'0"/4 do. 2'0" x 2'0"'; f. 184, Jul. 13: 'For Cloister in Convent/To A Set of Tracery heads/in Stained Glass'; f. 191, Oct. 21: '(For St Philopmena's Chapel in/Covent Church)/To 2 windows of Stained/Glass of 2 Lights each/& Tracery subjects from the life of/St Philomena in/Meallions, 4 Lights/6 pieces Tracery'.

Tofts Church, see WARWICKSHIRE

159 Uttoxeter, St Mary (RC)
*c.*1840. Pugin described the windows of the church in his article in the *Orthodox Journal* as follows: 'Over the entrance doorway is a circular window, divided into twelve compartments, with a sexfoil in the centre, filled with richly stained glass ... At the east end are three high lancet windows, filled with mosaic stained glass, of intricate patterns, given with other ornaments, to this church by the Earl of Shrewsbury.'

The glass was made, presumably, by Warrington, although there is no reference to it in his manuscript . That in the three E lancet windows has been replaced by some of late-nineteenth-century Munich manufacture but in the W circular window it may still be the original. The design in each of the twelve compartments of this latter window is made up of a boss formed of stylised leaf patterns, alternately red and blue, from compartment to compartment against backgrounds of white leaf patterns on yellow stems. In the sexfoil is a green-rimmed, orange roundel (the rim being studded with six red rosettes) inscribed with a red letter M – the foils contain white leaves on stems against black cross-hatched grounds.

Literature. London & Dublin Orthodox Journal, 9, 1839, pp. 33-6: article by Pugin, including an illustration of the chancel, describing the interior. Pugin, 1841, p. 332: 'The three lancet windows over the altar are filled with stained glass, of an early character, and at the western end is a rose window, very richly glazed.' Wedgwood (Pugin's Diary): Pugin visits Uttoxeter, 1838, Nov. 28; 1839, Feb. 9, Apr. 6, Jul. 1, Aug. 21-2; 'St Maries Uttoxeter dedicated', p. 47 'Diary 1840 [opposite p. 31:] Uttoxeter [?] fixing [?] 26.0.0.' appears immediately below a payment to Warrington of 100.0.0. p. 47 '[End papers at back of diary] [a] Uttoxeter window 30.0.0.' p. 48 '[e] Window of Uttoxeter 24.0.0.' appears immediately below 'Warrington 70.0.0.'

Stockton-on-Tees, see CLEVELAND
Stoke-on-Trent, see STAFFORDSHIRE

SUFFOLK
160 Wrentham Church[62]
1853. Window designed by J.H. Powell.

Office Records. Order Book 3, 1853, f. 45, May 16. *First Glass Day Book,* 1853, f. 190, Oct. 19: 'To A Stained Glass/ Window of 3 Lights & /Tracery being East/Window of North Aisle/.../Centre light 9'7" x 2'0"...//2 sides do. 8'3" x 2'0"...//12 pieces of Tracery.../Subject 'The Ascension''.

SURREY
161 Albury, St Peter & St Paul, Drummond Chapel
*c.*1844. Windows made by W. Wailes (**3.8**).

Literature. Stanton, 1971, pp. 173-5. Wedgwood (Pugin's Diary): p. 57, 'Diary 1844 [double blank leaves between pp. 24 and 25:] Mr. Drummonds windows 35.16.0.'.

162 Farnham, St Andrew (CoE)
1851. Client: J.M. Paine.

Chancel E window (**2.4a & b**)	I	3.8m x 5.7m	5-light	£300
Chancel N window (**3.7**)★	nII	lights 8'4" x 2'0"	3-light	
Chancel S window (**10.32**)★	sII	lights 8'4" x 2'0"	3-light	
★combined cost of nII and sII £200				

Description. **1.** 5-light window and tracery. Each light contains two scenes, one above the other, of events in the life of Christ. Those in the inner and outer side lights are under canopies, while in the taller central light, only the top scene (Crucifixion) has a canopy, the one below (Transfiguration) being shown beneath a four-centred arch. To balance the design, similar four-centred arches appear above the canopy superstructures of the four lower scenes in the side lights. Beneath each of the scenes a text is inscribed in black-on-white with yellow initial letters. From left to right, the two rows of scenes depicted and the inscribed texts are as follows: top row: Christ with four of his disciples, 'THOU ARE THE CHRIST THE SON OF THE LIV" GOD'; Noli Me Tangere, 'I ASCEND UNTO HIM FATHER'; Crucifixion, 'TRULY THIS MA'S THE SON OF GOD'; Death of the Virgin, 'SHALL SO COME IN LIKE MANNER'; Incredulity of St Thomas, 'MY LORD AND MY GOD'; bottom row: Adoration of the Magi, 'THEY FELL DOWN AND WORSHIPPED HIM'; Baptism, 'THIS IS MY BELOVED SON'; Transfiguration, 'THIS IS MY BELOVED SON HEAR HIM'; Christ and St John the Baptist, 'BEHOLD THE LAMB OF GOD'; Presentation in the Temple, 'MINE EYES HAVE SEEN THY SALVATION'. The canopies are in perspective, vaulted, and with central pendants. Three sides of each canopy are visible; each having a cinquefoil-head contained in a pointed arch surmounted by a concave, yellow-crocketed, finialed and shaded gable. The gables are flanked by yellow pinnacled buttresses, the lower portions of which end in pendants framing the vaulting. The spaces between the buttresses are filled by walls, each containing two round-headed niches which run behind the gables and are topped by leaf-patterned parapets, above which are three bands of yellow mouldings. Rising up behind the walls are canopies, buttressed, crocketed, finialed and gabled like those below, but with central yellow cylindrical, conical-capped towers. The eight larger pieces of tracery each contain a standing figure against a red ground (see HLRO 304 letter no. 864 below) holding an inscribed scroll. The smaller pieces and the quatrefoil at the top, each contain a frontally posed angel. The two angels in the side pieces hold their hands together in prayer and the one in the quatrefoil holds out an inscribed scroll.

nII. 3-light window and tracery. The centre light contains St Andrew standing in front of an orange leaf-on-stem patterned screen, under a canopy, and the side lights, canopied scenes from the New Testament in front of blue foliage diaper screens. St Andrew is in a green-lined, wine-coloured mantle over a blue robe, holding a large diagonal cross. The scene in the left-hand light is, perhaps, the prelude to the miracle of the loaves and fishes; and in the right-hand light, possibly, Christ walking upon the water. There are faded texts beneath both lights. The canopies have fan vaults with pendants and are shown in perspective in white glass with yellow touches and black shading. That in the centre

light is positioned with the middle of its three visible faces to the front. It has a four-centred arch head surmounted by a gable with serpentine yellow crockets and finial. Rising above and behind the gable is a superstructure made up of a two-light Gothic window in a rectangular frame, above which is a patterned moulding, topped by a yellow parapet (the parapet is surmounted by a yellow-crocketed, gabled niche). The other two faces are similar but the four-centred arches are now ogees and the gables, simple mouldings. The Gothic windows in the superstructures are surmounted by wide red diaper-filled semicircular arches flanked by pinnacled buttresses, instead of gabled niches. The canopies in the side lights have two of their faces visible, shown receding in perspective from a central buttress. The buttress has a trefoil-headed, yellow-crocketed and finialed gabled niche at its base. Each canopy face has an ogee arch head surmounted by a tall yellow-crocketed and finialed gable behind which runs a rectangular frame complete with patterned moulding and yellow parapet as in the centre light. Rising above and behind the mouldings are two-light Gothic windows surmounted by yellow-crocketed and finialed gables. The tracery pieces each contain a frontally-posed angel on a red diaper ground holding an inscribed scroll.

sII. 3-light window and tracery. St James the Great is depicted under a canopy in the centre light and St Peter and St John the Evangelist, under canopies, in the side lights. The saints all stand barefoot in front of foliage-patterned screens. St James the Great is in a green-lined, purple mantle over a blue robe, with a white shell badge attached to the right shoulder of his mantle. He holds a staff to which a gourd is fastened, in his right hand, and a book in his left. St Peter is in a green-lined, red mantle over an orange-brown robe, holding a yellow key in his left hand and a book in his right. St John the Evangelist is in a blue-lined, red mantle over a green robe, holding a green palm in his left hand and a yellow chalice (from which a green demon is emerging) in his right. The canopies are all alike and are similar to the central one in nII, but the four-centred gabled arch in the centre face is now an ogee, and the gabled niche in the superstructure is replaced by a circular series of vaulted open arches crowned by a yellow-crocketed steeple. The tracery-pieces contain angels as in nII.

Office Records. *Order Book*, 1850, f. 80, Jul. 13. *First Glass Day Book*, 185, f. 130, Dec. 20 (I, nII, sII). *Pugin sketch*, BM & AG a. no. 2007-2728.7, for I (**2.4c**).

Letters. *HLRO 304: Pugin to Hardman*, letter no. 465: includes in a list of windows 'a 3 light window for the chancel of Farnham Church representing S. Andrew & 2 subjects from his life. a centre light for the East Window of the same church representing the transfiguration & Crucifixion of Our Lord.' No. 864: 'I send you a rough sketch of the Farnham window. I think the tracery ought to be filled with images from the old testament of the Types of Our Lord, Adam, Noah, Moses, Melchizedek & Prophets bearing scrolls with inscriptions prophetic of the divine incarnation. subjects 5, 7 or 6 are not well selected for glass as the story can only be told by fine expressive[?] contours[?] which will be discernible at a short distance – we want subjects with striking outlines – but if they are indispensable as part of the series we must manage them, if this window is ordered it will be indispensable to prepare a finished drawing same scale as the tracing – showing all the subjects in a detailed manner to prevent any misapprehension of the way in which they will be treated, it will be a work of great[?] time & Labour they are like a series of historical pictures & will require great care.' No. 453: '4. I am sorry to say things are going very bad in the study every drawing is Execrable Powell is so much away & all that is done to be [?] out. Everything is Execrable that has been done this 2 days some of the Farnham things Ludicrous. I have torn them up'. No. 690: '1. as regards the Farnham window I will prepare coloured drawings instantly & send them to you.' No. 692: 'I am now going to make coloured diagrams of the Farnham Window Oliphant is going to do the subjects.' No. 700: 'I send you the Farnham Windows. I think I have made a fine job of it but I hope everybody will not want this sort of design for they have taken me nearly[?] 3 days very hard work. you will of course explain to them that the colours will look very much richer in the window than the drawing – as soon as they have decided Oliphant shall commence the groups.' No. 763: 'if Oliphant is to do the Farnham Window – when am I to have the templates. I would rather Powell did them but I am afraid we shall not pull through in time.' No. 764: 'have you got the templates for Farnham?' No. 718: 'as soon as Hill comes we all begin the Farnham Windows we must do all here. I will give Oliphant 2 or 3 figures to drop[?] off[?] away[?] but we must do all here amongst ourselves it will pay better & we shall get the true thing.' No. 729: 'I wish we had the S. M. Magdalene [Magdalen College Chapel, Cambridge, Gaz.10] ones [cartoons] for Hill to make the Farnham ones from.' No. 743: 'we cant send off the Farnham Windows yet the side windows will come first but the East window is a heavy job.' No. 742: 'When I came to examine the cartoons for Farnham I mean those for the East window attentively[?] & by the side of the old work from which they were taken I found it was impossible to let them pass if we had done so we should have been disappointed for ever there are portions of them quite execrable I am willing to grant[?] at a general view thay appear to pass muster[?] but there is not one passage in them that is understood. in these matters you must rely certainly on me for I act on mature judgement & it will never do to disgrace [?] by [?] deformity – why then is the relative positions of figures in lights which are close

together figures 1/3rd less [Pugin demonstrates with two sketches]. at least you would hardly expect that Hill during my absence from Here & his first attempt succeed perfectly – it I was to send you the cartoons as they are you would have either to the [sic] glass over again or return the money'. No. 785: 'hill does not impress when I am away the Cartoons are beastly. The Farnham windows will be a disgrace I cant get out of my mind the horrid heads & c I saw painted up. they are only to be matched in the grisailles of Peckett [sic] of York AD 1790.' No. 756: 'as regards the cartoons for Farnham I assure you I was not in any stern mind. but as soon as I began to take them in hand for details & colours & found such tremendous discrepancy in their execution & even size of the figures that it was impossible to to [sic] let them go & you would say so yourself if you was to see them. – the side windows you shall have very soon for 2 of these [?] groups will do, they are very superior to the other & the transfiguration will do for the East Window. You better write the truth to Mr. Pain [sic] & tell him that I am not satisfied with the [?] of the Cartoons & am making new ones these windows are just like pictures.' No. 789: 'Hill has recently improved the cartoons – for Farnham – if you were to see both groups together you would be impressed.' No. 163: 'I [sic] the trees in the background of Farnham I have had them coloured & you must match the tints as near as you can I believe[?] in these places spirit[?] on fired[?] glass will often come in most[?] invaluable it would modify & harmonise the tints you must look to this yourself'. No. 466: '11. The Farnham light is diabolical disgraceful I have heard the comments of the man who painted it. It is not the least like the cartoon they have put powerful shadows where there are half tints & half tints where there are strong shadows It is a most infamous careless caricature of the cartoons & all painted with black instead of brown shadows which I have begged & prayed for, but nobody in the place has the remotest idea of Late Work & this is damnable it will be a discredit & a shame. My dear Hardman if you don't turn over a new leaf about Late work the jobs may be given up at once. how I have exhorted for brown shadows in Late Canopies – & they have altered altered [sic] the lines thinness[?] they have made lines the same thickness[?] which we double and tripled on the cartoons It is a most careless & [?] production I took the greatest pains with the drawings of the canopies & now the glass is not the least like it.' No. 784: 'Edward has now so greatly improved he is really one of our best hands you will see a St. Peter that he has put in for Farnham [see chapter 3 p. 77 for remainder of the quote]'. *JHA: Paine to Hardman*, 1850, Oct. 28: 'It is so long since I have heard anything from you that I am continuously tempted to believe our church window is forgotten – You will of course bear in mind the suggestions which I offered in my last letter upon some matters of detail – which incident in the life of St. Andrew have you chosen as a substitute for his martyrdom – John VI 8,9 [Miracle of the Fish & Loaves] or John XII 22 [?] I presume the cartoons are not finished or you would have informed me, as you recollect we agreed to submit them to the Bishop of Winchester for his inspection before the work in glass was completed.' 1851, Dec. 18: 'You will be pleased to hear that the glass for the windows arrived safely with one exception viz a crack in the glass of the canopy over the head of St. John – The glass was set in this afternoon; but it was nearly dark before I was enabled to go down to the church & therefore I cannot say that I have really seen the whole of the East Window in full light.' *Caroline Paine to Hardman*, 1851, Nov. 28: 'Mr. Paine being much engaged tonight, he has begged me to copy for you the list of texts; 1. Matt 2.11. "They fell down & worshipped Him" 2. Luke 2.30 '"Mine eyes have seen Thy salvation" 3. Matt 3.17. "This is my beloved Son" 4. John 1.29 "Behold the Lamb of God" 5. Mark 9.7. "This is my beloved Son: hear him" 6. Matt 16.16. "Thou art the Christ, the Son of the Living God." 7. Matt 27.54 "Truly this was the Son of God" 8. John 20.17 "I ascend unto my Father" 9. John 20.28. "My Lord & my God" 10. Act 1.11 "Shall so come in like manner as ye have seen him go into heaven." we are very glad to hear that we may expect the windows so shortly Mr Paine would be obliged by your letting him know a week or ten days beforehand, when we may expect your workmen, because advantage will be taken of the putting up of the scaffolding to repaint the roof of the Chancel. We were pleased to see our opinion as to the superiority of your glass over that of any English Artist confirmed by the opinion of the Jurors at the Exhibition; and have no doubt that we shall be gratified with the remaining light, as with those which we have seen. I never saw any glass to compare with your figure of St. Andrew.' Dec. 26: 'You will remember our saying that the Bishop of Winchester was extremely fastidious about stained glass and that we were anxious not to lay ourselves open to his censure. I think therefore you will be pleased to hear that he has expressed himself both privately and publicly as entirely satisfied and that he took an opportunity the other day of stating openly that he had seen no windows in England and very few on the Continent which he thought superior ... Would it be giving Mr. Pugin much trouble to make some day sketches of the windows as they now are; which is somewhat different from the first designs he sent us; of which indeed I now only have the two small ones. If it would not take up too much time I should like to have sketches of them to keep entirely; but if it would perhaps he will be good enough to return to me the old design for the East Window.'

163 Witley, Church[63]
1853. Window designed by J.H. Powell.

Office Records. *Order Book 3*, 1852, undated, f. 9. *First Glass Day Book*, 1853, f. 176, Mar. 31: 'To A Stained Glass / Window of 3 lights [no dimensions given] / & Tracery / Subject Our Lord / in centre light and the / Evangelists symbols / in the side lights /. Inscription at foot'.

SUSSEX, see EAST SUSSEX and WEST SUSSEX

TYNE AND WEAR
164 Newcastle upon Tyne Cathedral, St Mary (RC) *c*.1844.

E window (**1.7a & b**)	I	5.8m x 7.2m	7-light
Blessed Sacrament Chapel E window (**1.8a & b**)	nII	2.2m x 4.0m	3-light
Lady Chapel E window (**1.8c**)	sII	2.2m x 4.0m	3-light

A guide book of 1848, written by the then parish priest, mentions that all the stained glass windows in the church at that time were made by William Wailes from designs by A. Welby Pugin. All but the three at the E end were destroyed as a result of Second World War bombing.[64]

Descriptions. **I.** 7-light Jesse window and tracery. Each light contains depictions of two of the ancestors of Christ who combine to form two rows of figures across the window. With some exceptions, the crowned figures are seated in frontal poses, holding swords in their right hands and sceptres in their left. Those who do not conform are: Jesse, at the bottom of the centre light and the figure above him, who are not crowned (the figure holds an inscribed scroll; Jesse is obscured by the reredos); David, on Jesse's right, who is seated on a throne with lions heads at its sides, holding a harp; and the figure at the top of the left-hand outside light, who holds the sword in his left hand and the sceptre in his right. Excepting those in the centre light, the names of the ancestors are inscribed on bands running behind their shoulders. All the ancestors are enclosed in blue diaper ovals formed by thick green stems which emanate from Jesse and spread across the bottoms of the lights and then upwards, finishing as spikes in the trefoil tops of the lights. Attached to the stems, mainly at the tops and bottoms of the ovals, are white, yellow and blue vine leaves and purple bunches of grapes, all on red grounds. Above each ancestor, and superimposed over the stems which branch out to form heart shapes, are yellow-crocketed, short-finialed gables supported by yellow-pinnacled columns. In the bottom left-hand corner of the first light is a small red shield inscribed in yellow with the monogram 'WW' (William Wailes) and in the bottom margins of the lights, running across the window, in yellow-on-black, the inscription 'PRAY FOR THE GOOD ESTATE / OF GEORGE THOMAS DUNN ALSO / OF MARGARET DUNN & ELIZABETH / DUNN WHO ARRANGED [centre light inscription is obscured] / FOR THE GLORY OF GOD AND / IN HONOUR OF THE BLESSED / VIRGIN MARY MDCCCXXXXIIII'. The borders are patterned with continuous vertical white stems, with yellow and white leaves and purple grapes attached, against blue grounds. The Virgin Mary, crowned and in a blue mantle over a red robe, holding the standing Christ Child against her right arm is depicted seated and in a frontal pose in the red trefoil tracery-piece at the top of the window. Two angels in white sit at her shoulders. The two trefoils immediately below each contain two half-length figures holding texts. Two butterfly-shaped pieces, below and outside the two trefoils, contain similar figures and between them is a small piece containing a shield emblazoned with a rampant yellow lion on a red and blue ground (the Talbot arms). Beneath is a propeller-shaped piece containing a shield emblazoned with the Talbot arms empaled with arms that include a central chevron. The rest of the pieces are filled with patterns of vine leaves and bunches of grapes on stems, against red grounds.

nII. 3-light window and tracery. Christ under a canopy, standing against a screen of yellow and green patterned quatrefoils is portrayed in the centre light and seraphim under canopies in the side lights. Christ is in a blue-lined, red mantle over a pleated white robe and holds a crossed staff (that has a yellow-backed white pennant fastened to it just below the cross) in his left hand. In the margin below his feet two lines of text are inscribed in yellow-on-black: 'EGO SUM PANIS VIVUS / QUI DE COELO DESCENDIT'. The canopy has a trefoil head contained within a pointed arch surmounted by a yellow-crocketed and finialed gable (the finial takes the form of a long Latin cross) containing a roundel inscribed with the red-on-black letters IHS. Two angels in blue mantles over yellow robes, sit in frontal poses, on either side of the base of the finial, holding inscribed scrolls. In the panel beneath the inscription, figures are grouped, facing each other on either side of an altar. The end face of the altar is covered by a shield which is divided in two by a horizontal blue band above which are what appear to be two blue sheaves of corn on a white ground, and below a further sheaf. On top of the altar is a yellow effigy of a lion. Above the figures are three blue shields emblazoned with the yellow letter R (a reference perhaps, to the Riddell family who are, presumably, represented here). There are two depictions of yellow-

haloed red seraphim against blue foliage diaper backgrounds beneath canopies, in each of the side lights. The canopies are similar to that in the centre light, the principal differences begin: instead of columns, white-beaded glass runs along the inner borders of the lights and into the heads of the canopies; the finials are much shorter and are not crossed; and the roundels in the gables contain red foliated crosses within quatrefoils, in place of the letters IHS. Between the seraphim, and contained in blue roundels, are depictions of the Agnus Dei. White vine leaves on curving yellow stems fill the remaining areas of the lights. The borders are patterned with continuous undulating yellow stems, with white leaves attached, against blue and green grounds. Four quatrefoils arranged in the form of a diamond are at the head of the tracery. Each contains a blue roundel in which is a symbol of one of the Evangelists, together with a text. The symbol in the top quatrefoil is an angel in pink, and in the bottom an ox standing in profile with its head turned back looking to the right; in the quatrefoil on the left is a yellow lion in a similar pose to the ox, and on the right a pink eagle standing in profile with its head turned back looking to the left. Two propeller-like pieces above the side lights each contain a shield with the same blue sheaf arms as appeared on the end face of the altar in the bottom panel of the centre light.

sII. 3-light window and tracery. The Virgin and Child are depicted under a canopy in the centre light and St John the Evangelist and St George, under canopies, in the left- and right-hand lights, respectively. The Virgin is crowned, and in a white-lined blue mantle over a red robe standing in a frontal pose against a green foliage diaper ground, cradling the Child on her left side. He is crowned and in a yellowish white robe. St John the Evangelist in a blue-lined, green mantle over a red robe, stands in a frontal pose against a red foliage diaper ground, holding in his left hand a yellow chalice from which a yellow demon is emerging,. St George is helmeted and in white, yellow-ornamented armour on the breastplate of which is emblazoned a large red cross. He is in a frontal pose standing against blue foliage diaper ground holding a lance(?) in his hands which he thrusts diagonally down the throat of a red dragon on which he is standing. The canopies are similar to that in the central light of nII but have cinquefoil heads, and the gables end in short finials which are flanked by long lines of green(?)-beaded glass capped by yellow pinnacles and decorated with evenly-spaced red rosettes. Above the apices of the gables, and alongside the flanking lines, are angels in white who stand beneath yellow-crocketed and finialed gables. The panel at the bottom of each light contains a twelve-sided geometrical figure which acts as a frame for the scene or symbol contained within. The middle panel contains a cross which has a yellow foliated letter M surrounded by four yellow crowns at its centre. The ground within the frame and outside the cross is blue-patterned overlain by yellow *fleur-de-lis*. The left-hand panel contains a figure (the Rev. John Eyre) in a white skull cap and a white robe, kneeling before a square altar placed diagonally to the window plane. The altar is covered by a white cloth decorated on each of its hanging sides with a single red chevron patterned with yellow *fleur-de-lis*. The right-hand panel contains a line of four contemporarily dressed figures (two men and two women) kneeling in profile with their hands pressed together in prayer (the glass in front of the first figure is holed). A text curves over their heads and there are shields above and below the holed area, and also in the corresponding positions on the opposite side. Shields on yellow ground also hang from the text, above the heads of the first three figures. Two lines of text in the bottom margins of the window read: 'OF YOUR CHARITY PRAY FOR THE GOOD ESTATE/OF GEORGE JOSEPH CALEY OF WHOSE GOODS THIS/WINDOW WAS MADE ANNO DOMINI MDCCCXLIV/ALSO FOR THE SOUL OF THE REV JOHN LEWIS/EYRE WHOSE REMAINS REST AT THE FOOT OF THIS ALTAR BONIS ET MORS ET VITA DULCIS'. The borders in the left-hand light are patterned with blue-winged, white eagles, looking alternately to the right and to the left, on red grounds, alternating with yellow chalices from which emerge yellow demons, and occasionally with yellow leaves on stems (these may represent repair work). In the centre light red rosettes alternate with yellow *fleur-de-lis* on blue grounds; and in the right-hand light, red crosses on white grounds alternate with green dragons which are in profile looking inwards. The monogram 'W W' (William Wailes) appears on a red shield in the bottom corner of the border of the centre light. The main tracery-piece at the top of the window is patterned with a multi-flowered white lily with green leaves in a yellow two-handled vase, on a blue ground. The rest of the pieces contain, within roundels, either or both of: white three-petal lily-heads and green leaves; and red roses with yellow letters M at their centres, on blue ground.

Literature. The Tablet, 5, 1844, pp. 549-50: article on the opening of the church which includes: 'Since St. Mary's was last noticed in *The Tablet* the splendid painted window presented by Mr. Wailes of Newcastle has been put up, making six painted windows, the largest and most splendid of which, over the altar, was the gift of Alderman Dunn: Thomas Dunn Esq; Mrs Margaret and Miss Elizabeth Dunn; the Rt. Rev. Dr. Riddell; George Caley Esq; and Miss Helen Caley contributed the others, except the testamonial window in memory of the Rev. James Worswick which was the contribution of the congregation.' *London & Dublin Weekly Orthodox Journal*, 19, 1844. pp. 116-17, includes descriptions of the three windows above and also one of those since destroyed. That of the Jesse window I is: 'The large east window in St. Mary's new church, Newcastle-Upon-Tyne, was completed a few days ago. The stained glass is the work of Mr.

Wailes, from the designs of Pugin. It is a Jesse window. At the lowest part of the centre division Jesse is represented as seated, and from him springs a vine, whose branches and leaves spread all over the eight lights of the window. From the branches proceed the descendants of Jesse – David, Solomon, Roboam, Abia, Asa, Josaphat, Joram, Ozias, Joatham, Achaz, Ezechias, Manasses, Amon, Josias, Jechonias, Salathiel, Zorababel, Abiud, Eliacim, Azor, Sadoc, Achim, Eluid, Eleazar, Mathan, Jacob, Joseph. At the top is the fruit from the root of Jesse, in the Virgin and Child. The magnificence of this window, both as regards design, colouring, or workmanship, is unrivalled by any modern, and surpassed by but few ancient, specimens of coloured glass.'; 20, 1845 p. 306 (includes descriptions of two further windows, since destroyed). Wedgwood (Pugin's Diary): Pugin visits Newcastle, 1840, Aug. 29; 1841, May 3-4, Oct. 4-5; 1842, Mar. 2-4, Jul. 27-9, Aug. 8, Oct. 15-17, 21 -2; 1843 no diary; 1844, Feb. 22-3, Jun. 10: 'Paid W 40 N'; Sep. 26-7; 1845, Apr. 11-12: 'Paid Wailes 49 big balance'; 1846 no diary; 1847, Jul. 10, Nov. 27.

165 Stella, St Mary & St Thomas Aquinas (RC)

1849. Client: Rev. R. Platt.

Chancel E window	I	centre lancet 0.5m x 4.6m, side lancets 0.3m x 3.4m	£70
Chancel S windows	sII–sIV	single lancets 0.2m x 0.2m	£21
Chancel N window	nII	single lancet 0.2m x 0.2m – not in First Glass Day Book	

Descriptions. **1.** 3-lancet window. The centre lancet features an elongated red-outlined, blue medallion containing a depiction of the Virgin Mary above a red-outlined, blue quatrefoil medallion that contains one of Good Count Flanders. Similar elongated medallions (except that the central parts of their sides are convex) in the left- and right-hand side lancets contain depictions of St George and St Thomas Aquinas, respectively. There is an angel in a red-outlined, blue quatrefoil medallion at the top of each lancet and a shield with arms in a similar medallion at the bottom. The remaining areas are filled with grisaille. In the centre light the grisaille is white and is comprised of leaves and berries on yellow silver stain stems, overlain by red-outlined quatrefoils crossed by red diagonals. Blue-patterned bosses cover the centres of the quatrefoils and a roundel replaces the quatrefoil at the top of the lancet. The grisaille in the side lancets is the same as that in the centre other than that red-outlined diamonds with a half-roundel outlined in yellow, on every side, replace the quatrefoils. The Virgin in a white head-dress, and a red-lined, brown mantle over a green-lined, light blue robe, stands in a frontal pose with an angel in white at each of her shoulders and flanking her feet. Good Count Flanders in a red mantle over a yellow robe and with a white cape around his shoulders, kneels in profile praying while looking to the left. He is flanked by two shields, the one in front of him being emblazoned with a white lion rampant on a yellow ground and one behind, a white star on a yellow ground. At the bottom of the lancet the shield is emblazoned with the Townley arms. St George in a green-lined, brown cloak over a white surcoat emblazoned with a red cross, and grey armour stands frontally-posed on a red dragon, while thrusting a sword into the creature's mouth with his right hand and holding a lance with his left. The shield at the bottom of the light is emblazoned with the Silvertop arms. St Thomas Aquinas in a brown-lined, olive green mantle over a white robe, stands in three-quarter view looking to the left, holding a chalice in his right hand and a book in his left. The shield at the bottom of the light is emblazoned with the Witham arms.

sII–sIV. Single-lancet windows each containing a central figured medallion and two red-geometrically-patterned roundels, one at the top and one at the bottom, with the remaining areas made up of quarries patterned with three leaves on stems, outlined in black, against black cross-hatched grounds. Each of the centre leaves is in yellow silver stain, the others being white. The figures in the central medallions are bust-size and in three-quarter view looking to the right. They are: sII – St Emma, crowned and in a red mantle over a blue robe, holding three white flowers on long green stems in her right hand. sIII – St Joseph in a mauve garment holding a flower, similar to those held by St Emma, in his left hand. sIV – St Henry in a white-lined, purple mantle over a blue robe, who seems to be kneeling in prayer before an altar. Each of the lancets has an inscription in the bottom border reading, as appropriate, 'Holy Emma [or St Joseph or St Henry] pray for us'

nII. A single lancet window (not recorded in the First Glass Day Book) with quarry and roundel patterns identical to those in sII–sIV. A third roundel instead of a medallion occupies the middle of the window. It is, perhaps, a Hardman window made after 1853.

Office records. *First Glass Day Book*, 1849, f. 58, May 2 (I, sII–sIV). *Pugin sketches*, BM & AG a. nos. not allocated, of I. *Cartoon costs per ledger summary*: I, Powell £5.0.0, Hendren £2.0.0; sII–sIV, Powell £2.0.0, Hendren £1.0.0.

Letters. HLRO 304: *Pugin to Hardman*, letter no. 1015: 'I send you sketch for the church at Stella. I would think the side windows would be another £10 each. there must be a good deal of white glass in them as this church will be pitch dark. East triplet. side lights £20 each centre light £30'. Nos. 134, 135, 292, 352, 399, 950 all contain references to the

windows being despatched in the near future. No. 140: 'you have not sent me the Townley arms for the centre light Stella.' No. 142 : 'I cannot understand about Stella you told me Wailes was to do one of the 3 Lancets & you give me instructions for 3 how is this? [see *Platt to Hardman*, 1849, Jan. 31]'. *Pugin to Hardman, included with unnumbered letters from Powell to Hardman:* 'It was time I staid [sic] at home one afternoon untill [sic] ½ past 3 on purpose to sketch those 3 small Stella Figures which we wanted to get off that day and which as usual are to be outlined[?] before the diaper was put on. It is a great advantage to do so.' *JHA: Platt to Hardman*, 1849, Jan. 4: 'I feel convinced from the Ushaw ones [Gaz.40] that your windows will be much superior to Wailes.' Jan. 31: '1. I have to inform you that Wailes declines executing the other light of the Triplet & that Mr Silvertop has given me leave to transfer the order to you. It has to contain a figure of St. George (on horseback Mr Silvertop would wish but I think there will be hardly room). Mr Silvertop's arms herewith sent are also to be introduced. I have also got the armorial bearings of the other benefactors except Mr Townley's, which I expect in a day or two: viz – Mr. Dunn's – St. Matthias; Mrs. Dunn – St. Emma; Mr. Englefield – St. Henry; Rev. Thos. Witham – St. Thos. Aquinas. You will see from the rough sketch on the opposite Page the order of them.' Re window gauze: 'You must throw that into the bargain Wailes does. There are two or three windows spoken for in the body of the Church which he is going to do: & he says `I have seen the Ushaw Windows & I am sure I can beat Mr. Hardman!'

Warrington, see CHESHIRE

WARWICKSHIRE

166 Bilton Grange. Now Bilton Grange School
1847-8. Client: George Myers, London (all but billiard room and bedrooms); Captain Hibbert (billiard rooms and bedrooms). The entrance is taken as the notional E for the purpose of numbering the windows: all windows date from 1847 except those for the classroom which are of 1848.

Gallery open side windows (**5.1**)	G nIV, G nV	3.0m x 1.8m	5-light
Gallery end wall adjacent to entrance hall	G nII, G sII	0.5m x 1.9m	1-light
Gallery open side window	G nIII	1.1m x 1.8m	2-light
Gallery end wall adjacent to drawing room	G wI		6-light (now plain)
Dining room windows opposite balcony (**5.2a & b**)	DIR nII, DIR sII	2.4m x 3.3m	12-light (4 now plain)
Dining room balcony window	DIR wI	2.4m x 1.8m	4-light
Dining room side wall window	DIR nIII	1.1m x 1.8m	2-light
Entrance hall window opposite entrance	EH sIV	0.6m x 2.0m	1-light
Entrance hall window on entrance wall	EH nII	0.6m x1.1m	1-light
Entrance hall window on entrance wall	EH sII, EH sIII	0.6m x 1.1m	1-light
Entrance hall window on entrance wall	EH I		3-light (now plain)
Drawing room: two windows on garden side one on end wall	DRR sII, DRR sIII, DRR wI		5-light (now plain)
Library garden side windows	L sII, L sIII		5-light (now plain)
Classroom side windows	CR sII–CR sV	0.5m x 1.1m	8 lights in 4 sets of pairs
Bedrooms: stained glass no longer in place			

Costs: gallery windows £65; dining room windows £40; entrance hall windows £20; drawing room window £80; classroom windows £36.

Bilton Grange was the home of Captain John Hubert Washington Hibbert and his wife Julia Mary Magdalene (née Tichborne).

The 1847 bundles of letters in the Hardman Archive contain a sketch and a letter from J.H. Powell (see below), which show that what are now the games room and the library were originally the library and the drawing room, and that the windows, now plain, once contained crests or initials in circles in their upper sections. The initials in the two library windows were: in L sII – Hibbert and his wife together with those of his father; and in L sIII – Hibbert and his wife together with those of his mother. In the drawing room, apart from those of Hibbert and his wife, 3 talbots (his wife's family) are indicated for DRR sII, the initials WLM for DRR sIII, and BCP for DRR wI.

Descriptions. G nIV, G nV. 5-light four-centred arch windows made up of floral-patterned white quarries. Each light contains an inclined shield emblazoned with arms, flanked by garlands of leaves and with a helmet over the upper end of its slanting top edge. The shields in the centre and two outside lights have white grounds patterned with what appear

to be black arrow heads with three black dots in triangular formation over the tips of each of the arrows. A broad band outlined in black containing three white crescent moons on greyish-black grounds, all against a general ground of white leaf-and-stem patterns on a black ground, runs diagonally across each shield from the top left to bottom right. A hand clutching a crescent moon issues from the top of each helmet. The garlands are of large white leaves shaded in black – tassels are attached to the lower ends of the garlands. Beneath the shields are white, blue-backed scrolls inscribed with the name HIBBERT – the initial letter is yellow and like the end of the scroll is ornamented with yellow clover-like leaves on black curving stems. The quarries are patterned with single six-petal flowers that are outlined in black and have yellow silver stain-dotted centres, with similar dots between the petals. The top thirds of each of the other two shields are decorated with brown foliage patterns and the bottom two thirds with a chequered pattern consisting of alternate white-on-black seaweed-patterned white bells and white-on-blue seaweed-patterned, inverted, blue bells. The motif at the top of each helmet is the head and neck of a red winged horse(?), in profile, looking to the left. The leaves of the garlands are alternately blue and yellow and the name inscribed below is TICHBORNE.

G nII, G sII. Single-light four-centred arch windows, identical to the HIBBERT lights of G nIV and G nV. The top right-hand leaves of the garland in G sII have been damaged.

G nIII. 2-light four-centred arch window; the left-hand light as in the HIBBERT windows and the right-hand light as in the TICHBORNE lights of G nIV and G nV.

DIR nII, DIR sII. 12-light windows in three rows of four. The lights at the top finish in four-centred arches , while those in the middle and at the bottom rows are rectangular. The top two rows are made up of of patterned quarries and mottoes with each light containing a centrally placed roundel; the roundels in the top lights each contain a shield of arms and those in the middle an initialled shield – the arms and initials refer to Captain Hibbert and his wife. The bottom lights contain plain glass. The top light on the left-hand side is made up of: quarries patterned in yellow silver stain with the letter H; four diagonal bands (each band separated by two rows of quarries) containing the motto (or parts of it) in black-on-white with yellow initial letters, reading 'Sit prudentia'; and a red roundel containing the Hibbert shield (as in G nIV and G nV). The light immediately below has similar quarries and mottoes but the roundel is of blue foliage diaper and the shield red foliage diaper emblazoned with the initials WH. The quarries in the next pair of lights are patterned with the letter T; the motto is 'Pugna pro Patria'; the upper shield is that shown as TICHBORNE in G nIV and G nV and the lower one is emblazoned with the initials IH. The designs in these four lights are repeated in the next four.

DIR wI. 4-lancet window and tracery. Each lancet is made up of white quarries patterned with four-petal flowers outlined in black that have yellow silver stain-dotted centres, and small yellow silver stain dagger-heads in the interstices of the petals. In the top part of each light are the initials 'WH' outlined in yellow. The shields in the bottom parts of each light are alternately those of HIBBERT and TICHBORNE per GnIV and GnV. The borders are patterned with red-on-black four-petal flowers, alternating with two three-part yellow leaves on stems that emanate from a vertical stem which forms the outside edge of the border, all on a black-hatched ground. The main tracery-piece contains at its centre the hand clutching a crescent moon as seen in G nIV and G nV. The other two smaller tracery pieces are each filled with a red rosette on white flower-patterned grounds.

DIR nIII. 2-light four-centred arch window. The lights contain the designs described for the first two lights in the middle row of DIR nII and DIR sII.

EH sIV, EH nII–EH sIII. Single-light four-centred arch windows of plain white quarries, and borders patterned alternately with red and blue four-petal florets and white three-petal clover leaves on black grounds.

CR sII, CR sIII. 2-light four-centred arch windows, with only the top sections having stained glass (but see below regarding CR sIII). The borders are as in EsIV etc, but the quarries are patterned in yellow silver stain with, in CR sII , two leaves and a cone outlined in black on a vertical stem, and in CR sIII, three leaves on a vertical stem. Each light contains a roundel, which, in the left-hand light of CR sII contains a stag's head in white shaded with black, with a cross between its antlers, and in the right-hand light a crown over the yellow initials HS; in the left-hand light of CR sIII is a horn within a pattern of leaves while the right-hand light contains plain glass.

CR sIV, CR sV. Similar to CR sII and CR sIII. The motifs in the roundels are: CR sIV, left-hand light, a stag, outlined in black, recumbent on the ground with a cross between its antlers; right-hand light, a crown over the yellow letter H. The corresponding motifs in CR sV are the horn, as in CR sIII, and the stag as in CR sIV.

Office records. *First Glass Day Book*, 1847, f. 16, Aug. 17 (G nIV etc), Aug. 20 (DIR nII etc), f. 18, Oct. 19 (EH sIV etc), f. 20, Nov. 11 (DRR sII etc & L sII etc.), f. 23, Dec. 24: 'Mr George Myers/To Expenses incurred making/Extra Glass for gallery.../The Templates being erroneous/To do.do.in/Altering Hall/Windows/.../Templates being erroneous/£7.10.0' 1848, f. 25, Jan. 26: '1½ lb of bright ruby glass @ 3/-lb/[£]0.4.6', f. 27, Feb. 26 (CR sII etc(?)), f. 32, Jun. 8 '4 lights with Figures &/c for 4 Windows .../3'0" x 1' 6½"/£40/ for Bedrooms', f. 43, Oct. 10: '24 Quarry pieces for/Dining room .../6" x 4"/Stained T & H on them.'

Letters. HLRO 304: Pugin to Hardman, letter no. 994: 'I send you a small sketch to show you the way in which the arms will be arranged in the Dining Room windows – the glass will leave here on Monday night or Tuesday. Don't forget to alter the Bilius [sic] yellow in the border.' No. 318: '3. Captain Hibbert does not like the [?] in the [?] in truth it is rather <u>droll</u> I should like to do it over again – if you can send me the cartoon it is in the tracery.' No. 381: '1. I have one of the horrendous[?] letters from Captain Hibbert pray pray send the glass for the drawing rooms as quick as possible <u>write at once & say when it will go</u>,' No. 36: '4. You must credit me £20 on the Billiard Room Windows Bilton they are not in any of our lists. I need the 4 circles for the windows you will repeat each of them.' No. 393: '5. I send the cartoons for Captain Hibberts bedRoom[sic] windows <u>Very good</u>.' *JHA: Powell to Hardman,* 1847 bundles, undated: 'I am now at work at the Bilton windows, you may expect them on Saturday.' Undated: 'How many lights have you to do like the one you have done? The places these circles are for are the upper lights of – 5 windows in drawing room and library each window being comprised of 5 lights [includes a rough sketch] making 25 if every upper compartment contains one circle. The Governor [Pugin] has written on the sketch [(?) paper damaged] circles to be filled with Initials to be got from Captain Hibbert – if he cannot find enough names his own is to be repeated to make up the number...We may introduce those you have already done in the windows very easily ... please send with the names the size of Circles and Quarries.'

Literature. Wedgwood (Pugin's Diary): Pugin visits Bilton Grange, 1844, Feb. 13-14, 19, Mar. 18-19, Apr. 3; 1845, Mar. 27-8, Nov. 17-18; 1846, no diary; 1847, Mar. 10-11, Oct. 28-30; 1848, Mar. 3, May 3-4, Sep. 15; 1849, Apr. 17.

Birmingham, see WEST MIDLANDS

167 Dunchurch, St Peter (CoE)

1847. Client: Captain W. Hibbert, Bilton Grange (see Gaz. 166).
Pugin's stained glass in the E and side windows has been replaced with later work and is presumed destroyed.

Office records. First Glass Day Book, 1847, f. 20, Nov. 4: 'An East Window for/.../£100/ of 2 Lights with Figures, Vine leaves & c/9' 1½" x 1' 10½"/1 Light with Figures, Vine Leaves & c/10'1" x 1'11½" /3 Tracery pieces with Figures/ 2'5" x 1' 10½"/11 Tracery pieces without figures'; f. 22, Dec. 24: 'A Side Window for/.../ of 2 Lights with Centres & c./6'10" x 1'6"/2 Large Tracery pieces for do/4 Small do.do.do./ £30'. 1848, f. 39 Aug. 3: 'Alter Lights'.

Letters. HLRO 304: Pugin to Hardman, letter no. 381: 'I am very anxious to get the east[?] window at Rampisham [Gaz.36] done & also the side windows for Dunchurch.' *JHA: Powell to Hardman,* 1847 bundles, undated: 'I next turn to the Dunchurch window which is wanted very badly'. Postmark 'AP 30 1847': 'I am now at the East Window Dunchurch.' Undated: 'I send you the Dunchurch & small window tracery and 3 side windows Winnick [Gaz.18].' *T. Sandford to Hardman,* 1847, Nov. 8: 'I am glad to hear that the East window of my church is so near completion.'

168 Kenilworth, St Augustine (RC)

1848. Client: Francis Whitgreave, Moseley Court[?].

Chancel E window (**1.5a & b**)	I	1.7m x 2.6m	3-light		*c.*1842
N aisle window (**10.33**)	nIII	1.0m x 1.5m	2-light	£20	1848

Window I, which according to Pugin's letters to Francis Amherst (see below) was close to being completed by mid-Oct. 1841, merited the following entry on page 1 of Louisa Amherst's diary (Birmingham Archdiocesan Archives, P182/5/3): 'during our stay on the Continent, the East window was stained by Wailes at Newcastle on Tyne'.

Descriptions. **1.** 3-light window and tracery. The centre light contains a depiction of St 'Austen', and at the top and bottom of each of the side lights a symbol or monogram in a red quatrefoil, contained within a yellow roundel and framed by a yellow cartouche-like quatrefoil. The remaining areas of the lights consist of alternate white quarries patterned in yellow silver stain with: in one row the letters A, and in the other, stars. The saint wears a yellow, white patterned mitre, the pallium, a purple-lined, red chasuble over a blue dalmatic and a pinkish-white alb, with the maniple hanging from his left wrist. He stands in a frontal pose holding a crossed staff in his left hand. The letter M inscribed in yellow is in the top quatrefoil of the left-hand light and a pinkish-white Agnus Dei in the bottom quatrefoil. The letters IHC, in yellow, and a yellow, floriated cross are in the corresponding quatrefoils in the right-hand light. The borders are patterned with alternate yellow letters A and small blue florets. Three small roundels in the borders are at the top of each light; the ones at the very top are blue and contain a yellow letter A, the rest contain red, yellow-centred roses. The two main tracery-pieces, which are over the central light, comprise tall narrow lights, each containing a standing saint

under a canopy. On the left is St John the Evangelist in a pinkish-white mantle over a similarly coloured robe, holding a quill in his left hand and a book (on which perches a yellow eagle) in his right. On the right is St John the Baptist in a pinkish-white mantle over a yellow camel hair robe holding a book (on which lies the Agnus Dei) in his left-hand. The canopies have trefoil heads enclosed in pointed arches surmounted by yellow-crocketed and finialed gables behind which are white and yellow linenfold-like screens topped by white crosses. The two triangular pieces which flank the saints are filled with similar but smaller inscribed quatrefoils to that in the top of the right-hand light while each of the two pieces over the side light contains a yellow mitre ornamented in white, above a yellow letter A, on a red ground.

nIII. 2-light window. The left-hand light contains a depiction of St Isabella (Elizabeth) of Portugal and the right-hand light St Thomas of Canterbury (both saints are under canopies). Isabella Turvile and Thomas Whitegreave, in whose memory the window was erected, are portrayed in the bottom panels of the respective lights. St Isabella, crowned, wearing, a white wimple, and in a reddish-brown-lined, white mantle patterned with yellow silver stain four-petal flowers and leaves on stems, over a reddish-brown robe, stands against a background of a diamond trelliswork of blue-beaded glass, infilled with yellow *fleur-de-lis*. She holds a white pennanted crozier in her left hand and a book in her right. St Thomas wears a white, yellow-ornamented mitre, the pallium, and a white diaper chasuble patterned with yellow silver stain florets, over a green diaper dalmatic and a yellowish-white alb. He stands against a similar background to St Isabella except that the trelliswork is in a red-beaded glass and is infilled with yellow-foliated crosses. A sword runs horizontally through his head and he holds a white-pennanted, crossed staff in his left hand. The canopies have cinquefoil heads contained within crocketed and finialed gables. Isabella Turvile and Thomas Whitgreave kneel in prayer in profile looking to the right. Each is in front of an altar, placed diagonally to the window plane. The altars are covered by white, yellow silver stain flower-patterned cloths, an open book rests on each of them. Isabella is in a light green-lined, white head-dress and a yellow dress with a green top and Thomas in a green robe and a short, yellow-collared cape. Above each of their heads is a curved scroll inscribed in black-on-white and with a yellow initial letter: 'S. ISABELLA [or THOMAS as appropriate] ORA PRO ME', and behind them are shields (that behind Isabel is red, and Thomas, royal blue), respectively emblazoned with: three chevrons ornamented with black, pot-like shapes, on white grounds; and four squares each decorated with a red chevron on white ground, grouped around a central square containing a white star on a blue ground. Three lines of text in black-on-white , with yellow initials to the names, and yellow flowers between the words are beneath each figure, and, run across the two lights. They read 'GOOD CHRISTIAN PEOPLE/ OF YOUR CHARITY/PRAY FOR THE SOULS OF /THOMAS WHITGREAVE/AND ISABELLA TURVILE'. The borders are patterned with red and white florets and white leaves.

Office Records. *Order Book*, undated, f. 31: 'St Thomas of Canterbury & St. Isabell [sic] of Portugal. kneeling figures with shields. Shields of Turvile & Whitgreave with Inscription running underneath in English. Mortuary window to Thomas Whitgreave & Isabel Turvile [includes a sketch of the Whitgreave Shield of arms showing the four chevrons but no star].' *First Glass Day Book*, 1848, f. 40, Aug. 16 (nII). *Cartoon costs per ledger summary*: Powell 13s.4d, Hendren 6s.8d.

Letters. Re I: *Birmingham Archdiocesan Archives, Pugin to Francis Amherst.*[65] Full transcripts of these letters have been made by Belcher who has translated Pugin's dates from his references to various saints days and festivals, to those of days of the months. These latter dates have been used in parenthesis, below. letter no. R868 (Oct. 17, 1841): 'I should be much obliged to you if you would send me an order for £30 as I expect the stained window for your church will be finished daily and I have been obliged to send down. as usual. a portion of the money to help on the work & shall have to pay the rest almost immediately'. R869 (Nov. 14, 1841) 'I expect the stained glass window is in by this time I hope it is before they [Amherst's Mother and family, who had just returned from the Continent] see the chapel.' R873 (Jun. 29, 1842): 'I have not yet been able to get round & see the church at Kenilworth but mean to do so on the first opportunity I hope it looks well & I hope you will have the side window of chancel glazed as soon as possible with stained glass [there is no evidence that the side window of the chancel was ever filled with Pugin-designed stained glass, although six years later nIII was installed, positioned according to Hardman's First Glass Day Book, on 'North side next Chancel [presumably in the N wall of the church].' According to Elizabeth Meaton, the church was enlarged in 1852 when the window [nIII] must have been moved to its present position. Perhaps poor rehousing on that occasion is the reason for the bottom line of the inscription being obscured by the edge of the window frame, although Meaton also points out that in the original inscription the words 'of your charity' had been omitted, so that a clumsy alteration is an additional possibility].' *Literature.* Meaton, *c.*1992 , pp. 42, 48. Belcher, 2001, pp. 279, 285, 357. Wedgwood (Pugin's Diary): Pugin visits Kenilworth, 1841, May 31, Sep. 24, Dec. 21; 1842, Mar. 30, Nov. 2-3; 1844, Feb. 14; 1848, Sep. 15.

Over Whitacre Church, see LEICESTERSHIRE (where it has been placed in error)

168A Princethorpe College Chapel (RC)

*c.*1845. E window. Only the upper part and the tracery remain.[66]

Literature. *London & Dublin Orthodox Journal*, 20, 1845, pp. 304-5, reports: 'We have just been favoured with a light of the stained glass, executed by Mr. Wailes, of Newcastle, for the east window of the chapel of St Mary's priory, Princethorpe. It is a most superb work, both as regards design and execution. The design was furnished by A.W. Pugin Esq. It is the finest window that has yet been executed by Mr. Wailes, and may be considered the *ne plus ultra* of the present art of staining glass.

The window is of a considerable size, being about thirty-three feet high and seven wide; it is divided into three lights. In the lower part of the window the centre light represents the crucifixion: The Blessed Virgin and St John are standing by the cross, over it are the Father and Holy Ghost, and the letters I.N.R.I on a label – and angels in the air are receiving the blood from the wounds in the hands and side in chalices. On the right of the centre light is represented St Augustine, vested in his archiepiscopal robes, with the crosier and pallium. Below the saint is the kneeling figure of the donor's father, Alderman Dunn, in his civic robes, bearing the window in his arms. On the left of the centre light is St Agnes, with the lamb and palm branch. Below her is the figure of the donor, represented kneeling in the habit of her order, and the arms of the convent beside her.

Above the transom in the centre light is represented the assumption of our B. Lady. At the lower part of this division an angel is represented looking into the tomb, which he finds empty: and from him proceeds a label with the words: " *+Assumpta est Maria in coelum.*" Above the tomb our Blessed Lady is depicted rising into the air, and borne up by the hands of angels – two angels are holding the crescent upon which her feet are resting. Above her head two angels are holding a most sumptuous crown, formed of lilies exquisitely interlaced.

In that portion of the right side light, corresponding with the assumption, are angels flying in a blue starry firmament, with scrolls and legends. On the scroll of the first angel, are the words "+ *Maria Virgo assumpta est;*" – second angel, "+*Ad aethereum thalamum:*" – third angel, "+*In quo res regum stellato sedet solis*" Below this is the sun, with the words "+*Electa ut sol.*"

On the left side light are three other angels, with scrolls in a similar manner: – first angel, "+*Exaltata est sancta Dei genetrix:*" – second angel, "+*Super choros angelorum,*" – third angel, "+*Ad coelestia regna, alleluia.*" Below this again is the moon, with the words "+*Pulchre ut luna.*"

Above the centre light is a large quatrefoil, in which the Blessed Virgin is represented as being crowned by God the Father. Above the side lights, in quatrefoils, are angels playing harps; and above again are three foiled cusps, with the lily and monograma of the Blessed Virgin Mary. Nothing can be more beautiful in design, better in effect, and richer in colour than this window, designed by the first, we were going to say the only master of design, and executed by the best stainer of glass in the kingdom.'

169 Rugby College Chapel

1853. Window designed by J.H. Powell.

Office records. *Order Book 2*, 1852, f. 21, Dec. 28; *Order Book 3*, 1852, f. 25, Dec. 28. *First Glass Day Book*, 1853, f. 174, Feb. 24: 'Transept Window/To a Window of Stained/Glass, Single light with/Figure of St. John/ 1 Light 8' 2½" x 2'5'".

170 Rugby, St Marie (RC)

1847. Client: Captain W. Hibbert, Bilton Grange (see Gaz.166).
None of the windows mentioned in the First Glass Day Book remain *in situ*. The figures of the Annunciation in the present N aisle and the emblems of the Evangelists incorporated into the tower windows may, perhaps, be elements of the original windows. The N aisle and the Lady Chapel were pulled down when the church was extended in 1864. The E window, as indicated in Pugin's sketch, contained representations of the Virgin and Child in the centre light and St Mary Magdalene and St Julia of Corsica in the side lights. Some details of the S aisle windows are given in the letters (see below) and those of the N aisle and W end of the aisle (the Evangelists) in the First Glass Day Book.

Office records. *Order Book*, undated, f. 22, re costs of cartoons: 'North Aisle, 3-Light £5, South Aisle, 2, 3-Light £15, Tower 2-Light £3, W. end of Aisle 2-Light £5, Side Chancel 2, 2-Light £10, East Window 3-Light £12, Lady Chapel 2-Light £5, one same as Tower 1-light £(?), one Under Tower 2-light £(?).' *First Glass Day Book*, 1847, f. 15, Jul. 13: 'A North Aisle Window/.../£25/of 3 Lights with Centres & c/4'2" x 1' 6½"/3 Small Tracery pieces/2 Tracery pieces with

figures/2 South Aisle Windows/£60/ of 6 Lights with Figures/5'8" x 1' 6½"/6 Small Tracery pieces/4 Large Tracery pieces with figures; 1 Window for Tower/£18/of 2 Lights with Quarries, Centres & c/6' 6½" x 1'4½" /3 tracery pieces for do; 1 Window West end of Aisle/£25/of 2 Lights Quarries & Evangelists & c/6' 6½" x 1'6½" /1 Tracery piece; 2 Windows Side Chancel/£40/of 4 Lights with Figures & c/5'2" x 1'7"/ 6 tracery pieces; East Window £55/3 Lights with Figures & c/7'2" x 1' 9½" /6 Tracery pieces; 1 Window for Lady Chapel/£20/of 2 Lights with Figures & c/4' 6½" x 1' 4½"/1 Tracery piece for do; 1 Window same as Tower/£6/of 1 light only 4'9½" x 1' 4½"; 1 Window for Under Tower/£3.10.0/of 2 lights 2'2" x 1' 0½"/1 Small tracery piece/1 Iron Casement & Frame/for Tower Window/ 1 Iron do for South Aisle Window/1 do.do. for North do.do./1 do. do. Small Window/Under Tower'. *Pugin sketch*, BM & AG a. no. not allocated, for E window.

Letters. JHA, Powell to Hardman, postmark 'JUL 13 1847': 'The south windows Rugby went with the others from here. they are the two Te Deum windows I sent the templets [sic] for one complete. the design is Angels holding scrolls with different portions of the Te Deum. the other window is to be the same only the inscriptions to continue from where the other ends. The rest of them had started today.' *Thomas Earley to Hardman*, 1847: Aug. '1 o'clock Thursday': 'I fixed the East Window Chancel. 2 South windows & Lady Chapel Window. Tracery in North Aisle and Window near the Font also first Window South aisle in which there is a mistake in the Inscriptions upon the Scrolls. the 3rd light is exactly like the first [includes a sketch of a window with three trefoil-headed lights marked 1, 2 & 3 respectively; two quatrefoil medallions are shown in light 1; the tracery consists of two large quatrefoils positioned symmetrically over the middle light, and three smaller pieces]. 1. Te deum Laudamus 2. Te dominum Confitemus 3 again Te Deum Laudamus – is that as it should be ? I have fixed the 3rd light Temporarily – so that it may be altered if necessary.'

Literature. The Builder, 5, 1847, pp. 448-9: notice of the consecration, including a mention that the stained glass windows were put up by John Hardman of Birmingham. Derek & Lucy Thackray, 1987. Wedgwood (Pugin's Diary): Pugin visits Rugby, 1842, Mar. 30-1; 1843 no diary; 1845, Nov. 17; 1846 no diary; 1847, Jan. 18-21, Jun. 28-30, Jul. 28, Aug. 1-2, 24-5, Sep. 4; 1848, Jan. 12-14, Mar. 2, Jul. 29; 1849, Apr. 17-18; 1850, Feb. 20-1, Aug. 9, Sep. 10; 1851, Mar. 27, Jun. 5-6 'Rugby School', Aug. 27, Sep. 18.

171 Tofts, Church[67]

1853. The First Glass Day Book refers to the church as being in Staffordshire but no such place has been traced. Windows designed by J.H. Powell.

Office records. Order Book 2, 1853 Jun. 30; Order Book 3, 1853, Jun. 30. *First Glass Day Book*, 1853, f. 195, Nov. 9: 'To A Stained Glass Window/of 2 Lights & Tracery/£25/2-Lights 5'7" x 1'3"/1 Tracery piece'.

172 Wasperton, St John the Baptist (CoE)

1847, 1852. Client: Rev. Leveson Lane (entered in First Glass Day Book as 'Revd Levison Lane').

S wall window (**10.34**)	sVII	0.4m x 1.9m	1-light £10	1847
Chancel E window (**6.17a & b**)	I	2.1m x 3.8	3-light £75	1852

Descriptions. sVII. 1-light window containing a depiction of St John the Baptist, standing frontally-posed, against a white diaper screen, under a canopy. He is in a green-lined, yellow mantle over a purple-patterned robe, holding a round pink plaque ornamented with the Agnus Dei, in his right hand. The canopy has a cinquefoil head contained within a yellow-crocketed and finialed, ogee arch. The pinnacled columns form part of the borders which at the top of the light are made up of patterns of yellow leaves on stems and white rosettes on red and green grounds. The main tracery piece is a trefoil containing a roundel inscribed in yellow-on-black with what appears to be the monogram IS (perhaps the letters IHS). Each of the foils contains a red or a white rosette similar to those in the light, and is filled with white diaper. I. 3-light window and tracery. The Baptism of Christ is depicted in the centre light and St John preaching in the wilderness, and the Beheading of St John, in the left- and right-hand lights, respectively. All three scenes are under canopies. The canopies have cinquefoil heads contained within pointed arches surmounted by yellow-crocketed and finialed gables. Flanking the gables in all three lights are depictions of two small purple Gothic windows and rising above and behind the gables are superstructures formed by white and blue (centre light), and white and purple (side lights) glass topped by representations of two, two-light Gothic windows beneath tall crocketed and finialed gables. The borders are patterned with continuous vertical stems with white leaves attached, on blue and red grounds. The main tracery pieces are trefoils filled with white, yellow and green, leaf-on-stem patterns, on red grounds.

Office records. Order Book, undated, f. 29 (sVII); 1851, f. 128, Mar. 7 (I). *First Glass Day Book*, 1847, f. 17, Oct. 11 (sVII);

1848, f. 31, May 19: '20 Quarries of green glass/£-3.4'; f. 32, Jun. 8: '6 Quarries of green glass/£-1.0'; f. 50, Dec. 22: '4 pieces of Stained Glass/ Tracery for heads of Lights/.../£3'; 1852, f. 149, Jun. 30 (I), f. 151, Jul 9: 'To Alterations in East/ Window sent June 30th/inc New Glass for ditto'. *Pugin sketch*, BM & AG a. no. not allocated, for sVII. *Cartoon costs per ledger summary*: tracery (see Dec. 22 above), Powell 3s.4d, Hendren 1s.8d.

Letters. HLRO 304: *Pugin to Hardman*, letter no. 39: '12. I send you a sketch of St. John B for small window for Rev. Mr. Lane. I must have it back again.' No. 1032: 'I hope to send back Mr. Leveson Lanes tracery by this post.' *JHA: Powell to Hardman*, 1847 file, undated: 'Wasperton is also enclosed complete.' *Lane to Hardman*, 1847, Aug. 6: ' I was sorry not to find you at home when I called yesterday, as I wished to talk to you about the small stained glass window for the Church here. As the cartoons for the sketch I saw are not made, I think I should like a window with one, two or three medallions therein of scriptural subjects rather than the full length of the St. John the Baptist, as he ought to be introduced in an east window if I am able to put one up [as is evident from sVII this idea was not carried through. See also letter, 1851, Feb. 18].' Sep. 15: 'I am glad to hear that the cartoon is arrived and shall be glad to have the window as soon as maybe.' Oct. 23: 'The window is in & looks very well but I did not know that any glass had been ordered for the Tracery which had stained glass before & is unfortunately of quite a different shape to the glass sent so that I cannot introduce it. I like the colours better than those that are in & if it could be altered to the tracery I should be inclined to do so if not I must beg you to take it back again.' 1851, Jan. 28: 'I am thinking of having some painted glass for the East Window in the Chancel & shall be obliged to your ascertaining the probable cost. Mr. Hegler will convey the drawing of the window to you tomorrow when you can take the dimensions.' Feb. 18: 'I have sent the details of the East Window for Chancel ... The Church is dedicated to St. John the Baptist & I should like a design worthy of its situation. His figure is introduced in the S. aisle.' Mar. 6: 'I like the design for the East Window much & I hope that you will do the best you can for me at the price named: if Mr. Pugin introduces some pale blue in his draperies I shall be better pleased but I do not like to interfere with men so well qualified for the task as yourselves & rely with great confidence on your better judgement: shall I return the design or may I keep it? [a note in Hardman's hand reads: 'get Mr. Pugin to trace drawing & return sketch mention about light blue']'. Mar. 8: 'I mentioned pale blue as being a favourite colour but I am very fond of rich ruby; the only fault I find with your windows in general is a weakness of colouring.' Sep. 27: 'when will my window be ready for the church?' 1852, Jun. 18: 'the general effect lacks colour & I think the subjects are not sufficiently thrown out & it is decidedly to my mind & taste too green'. Jun. 28: 'The lower lights of the window are inserted the wrong way for the respective inscriptions.'

WEST MIDLANDS

173 Birmingham, Charles Iliffe
1847.

Office records. First Glass Day Book, 1847, f. 13, May 29: '2 Small Lights for Hall/with Figured Quarries & c/2 feet by 12 in'.

174 Birmingham, Lander, Powell & Co., New Street
1849.

Office records. First Glass Day Book, 1849, f. 60, May 26: '3 Lights of Stained Glass/of Quarries, Borders & c & c//4'0" x 1' 5".../fixing in shop, New Street. /£8.1.6'. *Cartoon costs per ledger summary*: Powell 10s.0d, Hendren 3s.4d.

175 Birmingham, Bishop's House (RC)
Client: John Hardman, Handsworth; Rt Rev. Dr Ullathorne for chapel window. The house, built 1840-1 to Pugin's design, was demolished in 1960. Some stained glass, including a figure of St Chad and various shields of arms surmounted by bishops' mitres, was saved and is exhibited in a passageway linking St Chad's Cathedral with the administration offices: access is through a door in the S aisle of the nave.

Office records. First Glass Day Book, 1847, f. 25, Jan. 26: 'End Window in Dining Hall/of 4 Lights/.../of Figured Quarries/£10. 5. 0'; 1848, f. 31, Apr. 22: '6 Lights for Side Windows/in Dining Hall/35 feet @/10/-/foot £17.10.0./of Figured Quarries. Work in/Centre of light 5'0" x 1'2"/26 blue Rosetts [sic/in Borders @ 6d £[0] 13[s.0]/12 Ruby do. do./@6d/£[0] 6[s.0]/60 White pieces Stained &/lettered. 2 New Shields &/Mitre & c/£1.10.0'; 1850, f. 84, Mar. 15: '1Light in Side of Chapel/of Figures, Quarries, Centres & c/£7. 10. 0./6'0" x 2'0"/.../1

New Iron Casement &/Frame for/above Light/£1/To Altering East Window/of Chapel with New Glass & c.£14/ New Figure in Centre Light/3'10" x 1'2"/.../4 feet of Glass New Leaded/ in do/ In Side Lights /9½ feet Figured Quarries/19 Border pieces. White stained/Blue & Ruby to do. &/2 Side Lights. New Leaded/Tracery/6 pieces new White ground to do & part Leaded & Repaired/4½ lbs of White Glass diapered/Cleaning and fixing in/Bishops Chapel'; f. 89, Apr. 25: 'For Dining Hall.../2 Small Tracery pieces/Altered & Repaired, with/New White ground & c & c'.

Letters. HLRO *304: Pugin to Hardman*, letter no. 941: 'The cartoons for the window of the Bishops Chapel goes tonight'. No. 905: 'how can a professional man like you argue that it is possible to make cartoons of tracery from measurements they will do for a drawing but I dont believe we could get right [sic] by inches in the glass. again without [?] to prepare to put geometrical glass into the 4 centred window at the bishops house – I hope they mean to pay for this alteration if they dont they will never get the cartoons ... by the way you do not say the height of the image under the canopy in the centre light Chapel B. house you only give the light so I dont know how to find one to fit.

Literature. Pugin, 1842: the external NW view, plan, and interiors of the chapel and the Common Hall are illustrated in plate XI, which is inscribed with Pugin's monogram. A discussion of the principles governing the design of ecclesiastical residences appears on pp. 127-31, and a description of the building follows on pp. 132-3. The three-light window shown in the interior view of the Chapel is described by Pugin on p. 132 as: 'a stained glass window with an image of St. Chad vested as he used to say mass, standing under a canopy, together with shields charged with his cross, and in the upper part of the window, many angels [a standing figure beneath a canopy, in the middle light, with centrally placed shields emblazoned with crosses and surmounted by mitres in the quarried side lights, can be observed in the illustration].' The exhibited figure of St Chad has a green-patterned halo and wears a yellow mitre ornamented with white floral patterns, a white alb, an orange-patterned dalmatic that has a fringed hem, a white-patterned, green-lined overmantle with white and orange-patterned edges and red shoes (only the right shoe is visible). He is not wearing a chasuble as would be expected for mass, and the canopy is missing. He stands in a frontal pose, holding an upright crozier in his white-gloved right hand and a book in his left. The figure described in the article would presumably have been made by Warrington or Wailes but Hardman's First Glass Day Book records that a new figure was put in the centre light in 1850, and it is assumed that this is the one on show. The article also notes that, 'In the bay window [of the Hall] are the arms of the four new vicars-apostolic, and in the window at the upper end, the arms of the present Queen, the Earl of Shrewsbury and the late C.R. Blundell of Ince great benefactors to these buildings, and that, 'the side windows are also filled with ornamented quaries [sic] rich borders and arms, with scriptures, vigilandum, and omnia pro christo, running bendy'. Other windows mentioned include the three library windows which: 'contain six shields of arms: Bishop Walsh, Bishop Wiseman, the Earl of Shrewbury, Mr J. Hardman. St. Chad's and St. Mary's Oscott.' It also mentions the oriel windows in the audience chambers which have: 'emblems in stained glass, representing the holy name of our Lord illuminated, the emblems of the Passion and a device illustrative of the most Holy Trinity, with appropriate scriptures.'

176 Birmingham, St Chad's Cathedral (RC)

1841-53. Clients: Lord Shrewsbury (nII, I, sII); Mr John Hardman, St John's, Handsworth (sIII); Mrs Wareing (sVI); John Fitzherbert, Swynnerton Park, near Stone, Staffs (nIX).

Windows known to have been designed by Pugin:

Chancel apse E windows (**1.2**)	nII, I, sII 1.6m x 6.2m	2-lights			c.1841
Glass made by W. Warrington: white glass introduced 1850 by Hardman					
Chancel S window	sIII				1848
Glass replaced c.1928, original presumed destroyed					
S aisle window (**3.1c & d**)	sVI	1.6m x 7.2m	2-light	£85	1850
N aisle window (**10.35**)	nIX	1.6m x 6.7m	2-light	£88.10.0	1852
N aisle window (**3.1a & b**)	nX	1.6m x 6.7m	2-light	£27.15.5	1853

Other windows where Pugin's involvement is unknown:

Lady Chapel E window	nIII	3-light (glass made by Warrington)		
Baptistery windows	nVI–nVIII	2-light		c.1843
Lady Chapel N window	nIV	2-light		c.1844

Rev. Leith (one of the cathedral clergy from 1842 onwards) notes in his 'Chronicle' that the windows in the sanctuary (nII, I, sII) are the work of W. Warrington after designs of A.W. Pugin; he also mentions other windows, without

reference to maker or designer, as follows: nIII (claimed by Warrington, in Warrington, 1848 – a matter of some surprise to *The Ecclesiologist*), and nIV–nVIII, which he records, were added to the church in 1843 and presented in 1844: these latter windows, if designed by Pugin, would presumably have been executed by Wailes (see Pugin's diary below, 1844, payment of £40 for Birmingham).

Descriptions. nII, I, sII. 2-light apse windows and tracery. From left to right the lights contain depictions under canopies of: in I, Virgin & Child and St Chad; nII, St John the Evangelist above St Michael, and St Peter above St Edmund; sII, St Joseph above St Edward, and St Paul above St Edmund. The panels beneath the saints contain red shields emblazoned with arms. In I, the two beneath the Virgin and Child are emblazoned with the yellow Talbot lion, those beneath St Chad are obscured by the gable of the wooden canopy of the old high altar; nII, those beneath the upper figures with the yellow Talbot lion, and beneath the lower figures, the cross of St Chad, and Bishop Walsh's arms, respectively; sII, upper as for nII, lower, the arms of Oscott College, and John Hardman, respectively.

The Virgin wearing a yellow head-dress and a white-lined, blue mantle over a red robe, stands in front of a red diaper screen cradling the Child, who is in yellow, in her left arm. St Chad wearing a white, yellow-ornamented mitre and a red chasuble, stands in front of a purple diaper screen holding a crozier in his right hand. St John the Evangelist in a purple mantle over a green robe stands in front of a red diaper screen holding a chalice from which a red demon is emerging, in his right hand; St Michael (in spite of the name inscribed below the saint, Leith identifies this figure as St Ethelred) wearing a yellow and green turban and a white-lined, blue-green mantle over a red robe, stands in front of a purple diaper screen holding a sceptre in his right hand. St Peter in a white-lined, red mantle over a green robe stands in front of a purple diaper screen, holding the keys upright in his right hand; St Edmund, crowned and in a white-lined, purple mantle over a red robe, stands in front of a green diaper screen, holding a sceptre in his right hand. St Joseph in a white-lined, green mantle over a red robe stands in front of a reddish-brown diaper screen, holding, a sceptre in his left hand. St Paul in a white-lined, red mantle over a brown robe, stands in front of a green diaper screen, holding a book in his right hand and a downward-pointing sword in his left; St Edmund (Leith identifies this figure as St Edward K.M), crowned and in a white-lined red mantle over a green robe, stands in front of a purple diaper screen holding a sceptre in his right hand The upper canopies have trefoil heads contained within pointed arches surmounted by yellow-crocketed and finialed gables. Rising above and behind the gables are superstructures in the form of red niches surmounted by yellow-crocketed and finialed gables, each containing an angel holding a shield of arms. The lower canopies are similar except that they have no superstructures. The borders for all the lights are patterned with undulating stems with yellow leaves, on red and green grounds. The main tracery-piece for each window comprises a large hexagon made up of a smaller central hexagon surrounded by six quatrefoils. The quatrefoils are filled with white leaf forms. The central hexagon is filled with white leaves and contains a yellow-rimmed, blue roundel at its centre.

sIII. The glass currently in place was given in 1928 (ref: Hodgetts); the original entered in the First Glass Day Book in 1848 is described by Leith as: 'consisting of quatrefoils of St. Chad's cross and diapered diamond squares.'

sVI. 2-light window and tracery. St George and the Virgin and Child are depicted under canopies in the central portions of the left- and right-hand lights, respectively. The remainder of the lights consist of panels containing grisaille and white glass, apart from those next to the bottom, which contain scenes portraying the Death of George Wareing (the husband of Mary, the donor of the window, who collapsed while assisting at High Mass) in the left-hand light, and Wareing's praying children in the right. St George is in blue armour, a white surcoat and a green-lined, purple cape. A white diaper shield emblazoned with a red cross is attached to his left arm. He stands in a frontal pose before an orange diaper screen, thrusting a lance into the mouth of, a red, green-winged dragon that lies beneath his feet. The Virgin is crowned and in a green-lined, blue mantle over a wine-red robe, standing in front of a white diaper screen looking down at the Child, who is in a white mantle over a brown robe, cradled in her right arm. The canopies have cinquefoil heads contained within pointed arches surmounted by yellow-crocketed and finialed gables. The superstructures that rise above and behind the gables have red rectangular bases, on which stand two, two-light blue Gothic windows with green, wheel traceries. The windows are surmounted by overlapping, yellow-crocketed and finialed gables. On each side of the bases are two-light green Gothic windows, surmounted by yellow-crocketed and finialed white gables. The grisaille which is formed of white vine leaves and yellow grapes on white stems, against black grounds, is contained within a series of red-outlined quatrefoils, that run down the middle of each light. The quatrefoils are linked to each other by red-outlined circles that have yellow-rosetted centres, and to the lines of red glass that run around the insides of the borders of the lights, by red-outlined semicircles that have either yellow- or blue-rosetted centres. The circles and semicircles are also filled with grisaille. The glass not contained within the quatrefoils is plain white. The borders are similar to those in the apse windows (nII, I, sII) but the leaves are white on yellow stems and the backgrounds red and blue. The main tracery-

piece is also similar to those in the apse windows, but the six surrounding quatrefoils and the hexagon around which they are grouped have been replaced by roundels.

nIX. 2-light window and tracery. St Francis of Assisi and St Thomas Apostle are depicted under canopies in the left and right-hand lights, respectively, with grisaille filling the rest of the lights, that is the bottom panels and most of the top two. St Francis of Assisi in an orange-lined, mauve habit, stands in front of a red foliage diaper screen, holding a book in his right hand. Rays of light representing the stigmata pierce the tops of his feet, the back of his right hand, the palm of his left, and his right side. St Thomas Apostle in a white-lined, red mantle over a green robe stands in front of a light blue foliage diaper screen, holding a blue lance in his left hand. The canopy heads are similar to those in sVI, but the superstructures consist of two, two-light red Gothic windows surmounted by yellow-crocketed and finialed gables. Flanking the windows are blue rectangles containing round-headed niches, above which are two small green-patterned and yellow-patterned rectangles, one on top of another. Above these are two-light, red Gothic windows contained in long rectangles. Blue-tiled pitched roofs are visible behind the double gables over the red Gothic windows. The upper stages of the superstructures consist of niches between yellow-pinnacled, white buttress. The niches contain standing angels in white who hold inscribed scrolls. Over the niches are overlapping yellow crocketed and finialed gables. The grisaille consists of white leaf patterns on black-hatched ground, overlain by red-outlined quatrefoils and yellow-beaded-outlined diamonds. The vertical points of the diamonds meet at the centres of the quatrefoils, where, in the upper part of the lights, they are encircled by yellow-beaded glass, and in the bottom panels covered by shields. The borders are the same as those in sVI. The tracery sexfoil has at it centre a portrait bust of St Cecilia playing a harp. She wears a white wimple and a blue robe. (Leith records that the tracery piece was given by Benz, the organist of the church, in December 1850 but no record of this appears in Hardman's First Glass Day Book).

nX. 2-light window and tracery. St Luke and St Andrew of Crete are depicted under canopies in the left- and right-hand lights, respectively. The rest of the design is in line with that of nIX, the only significant differences being: blue-outlined diamonds rather than yellow-beaded in the geometrical patterning overlying the grisaille; and the inclusion of scenes (depicting Hardman's workers at work – they donated the window) in the bottom panels. As indicated in *HLRO 304*, Pugin to Hardman, letter no. 476 (see below), Pugin produced an initial design for this window. He suggested St Gregory for one of the saints, urged that it must harmonize(?) with Mrs. Wareing's window (sVI) opposite and indicated the presentation of the window, in scenes in quatrefoils, in the lower panels. As the window was not completed until December 1853, it seems likely that J.H. Powell created a new design and drew the cartoons unaided, after Pugin's last illness in early 1852. If this is so, he followed closely Pugin's arrangement of saints under canopies as in nIX, but rejected the idea of enclosing the scenes in quatrefoils and excluded the presentation of the window from the subject matter.

Other windows: nIII. 3-light window and tracery. A figure under a canopy is depicted in the top half of each light, with the Virgin & Child in the centre light and St Cuthbert and St Chad in the left- and right-hand lights, respectively. The canopies have trefoil heads contained within pointed arches surmounted by yellow-crocketed and finialed, yellow patterned gables containing red-patterned quatrefoils:'W. Warrington 1844' is scratched across the centre quatrefoil.[68] The large tracery-piece contains a representation of the crowning of the Virgin, with accompanying angels (the backgrounds to the figures and canopies were altered by Hardman's, see First Glass Day Book for details).

nVI–nVIII. 2-light windows and tracery. The left-hand lights of nVII and nVIII and the right-hand light of nVI contain depictions of St Patrick, St James the Less and St Thomas of Canterbury under canopies, respectively, together with two panels containing scenes of incidents in their lives. The scenes are illustrated within red-outlined, blue diaper quatrefoils. The left-hand light of nVI and the right-hand light of nVII have seven similar quatrefoils, which contain alternately, starting from the top, a scene, then an angel holding a text. The right-hand light of nVIII contains scenes in all seven of the quatrefoils. The names of the saints are inscribed in yellow-on-black beneath their feet and relevant inscriptions are similarly inscribed beneath the scenes. Leith refers to nVI, nVII & nVIII variously as: 'three large bays of stained glass in the North Transept' and, 'the large window in the North Transept consisting of six lights – three of which together with the tracery above are finished'. For this latter arrangement he records that there are two lights with three quatrefoils below and four above the canopied figures of St Patrick and Bishop Walsh, respectively, and five quatrefoils of the same dimensions one over the other each containing an angel with extended wings. The order in which he gives the scenes is different – and more logical – to those seen in the windows today, so, possibly, structural changes have occurred since the glass was put in, or the design as Leith understood it, was changed after he made his observations.

nIV. 2-light window and tracery, depicting the Annunciation with the Archangel Gabriel in the left-hand light and the Virgin Mary in the right-hand light, both under canopies. In the panel above each canopy is a patterned-roundel, and in the panels below the Archangel Gabriel, and the Virgin Mary are two more containing light blue-patterned shields emblazoned with yellow seraphim(?). Between the latter roundels are red-outlined quatrefoils containing blue grisaille

octagons which act as backgrounds to figures kneeling almost in profile, and facing each other across the lights and with their hands pressed together in prayer. The two in the left-hand light are boys, and in the right, girls (the window was presented by the boys and girls of St Chad's poor schools in 1844). The rest of the window is made up of plain white quarries. (Leith describes the quatrefoils as containing four (rather than two) children each.)

Office records. Order Book, 1850, f. 97, Jul. 10 (sVI): 'Inscription: Underneath in a chantry lieth the body of George Wareing who whilst devoutly assisting at High Mass in this Cathedral on Passion Sunday AD 184 [sic] was suddenly called out of life, in the year of his age. Also in the same chantry lieth the body of Mary, wife of the said George Wareing, who deceased the day of AD 18 [sic] whose souls have ye in remembrance, craving God for Mercy. [this inscription does not appear in the window].'; 1851, f. 153, Nov. 6 (nIX); *Order Book 2*, undated, f. 28. *Order Book 3*, undated, f. 23 (nX). *First Glass Day Book*, 1848, f. 31, Apr. 28 (sIII): 'A 4-light Chancel window .../£60/of 4 Quarry Lights with/Centres, Borders & c/13'6" x 1'9½ "/2 Large Tracery pieces/& 8 Small Tracery pieces'; f. 43, Oct. 2 for Apr. 28: 'To Stone Work, Mullions & c/for Chancel Window [sIII].../as per Myer's Bill/£33'; 1850, f. 92, Jun. 15: 'To Altering East Window/,,,/taking out Glass & New Glass added & releading & c & c./ 2 feet Stained Glass/3 feet of White Glass/.../ - £10.15.0'; Jun. 22: 'To Altering East Window/ & Side Window of Ladye Chapel/£3.6.0/taking out Cleaning, Altering/& repairing above Windows/. 3 New Inscriptions. New back/ground to 3 Figures & Canopies'; f. 95 Aug. 2: 'To Repairing Side Window/.../30 Quarries of Glass'; f. 106, Dec. 5 (sVI); f. 109, Dec. 26: (tracery sVI); 1851, f. 118, Jun. 28: '4.../Casements & Frames.../£5.2.0'; f. 121 Aug. 18: '3 Lights New Leaded.../3 Lights part Leaded & Repaired/.../40 New Quarries...'; 1852, f. 160 (second of folios so numbered), Nov. 4 (nIX); 1853, f. 200, Dec. 20 (nX). *Cartoon costs per ledger summary*: sVI, Powell £5.0.0, Oliphant £3.0.0; sVI tracery, Powell 5s.0d. Oliphant's account records that the payment entered Jun. 26, 1850 was in respect of: '2 do. [Cartoons] Figures of St. George & Female/Saints/. Groups of Donors below'.

Letters. Re nII, I and sII, *Belcher, 2001, p. 143, Pugin to John Rouse Bloxham*, 1840, Sep. 13: 'the details of Birmingham church dedicated to God in honor of S[t] Chad will please you exceedingly. I have taken infinite pains with their design and am at present superintending their execution with the greatest care … we shall start with a great deal of stained glass copied from Twekesbury [sic] abbey & Bristol and with the zeal that exists among the people I have every hope that we shall shortly fill every window with stained glass.' *Wedgwood, 1985, p. 102, letter 21, Pugin to Lord Shrewsbury*, 1840: 'Xmas eve … We are proceeding fast with the interior of Birmingham. A good deal of the stained glass is now in & Looks Glorious. Warrington will have completely finished by March, and when your Lordship sees the glass I feel sure you will be exceedingly pleased & you will not find any want of colour for it is as rich as possible.' *HLRO 304: Pugin to Hardman*, letter no. 796: '1. I send you the sketch of Mrs. Wareings window [sVI] in the 1st quatrefoil I should represent the death in the church in the other the family as it was during mass. I should represent a priest at an altar in the corner. It is a very fine window & nearly finished.' No. 844: 'Mrs Wareings window is nearly done − I am only waiting for Oliphant to do the Lower subjects & I want you to let me know how many in familly [sic] are to be represented. the sex & ages ? the lights & tracery are done.' No. 476: '3. I send you a sketch for the glass painters window [nX] of course in carrying it out it must merge[?] with Mrs. Wareings. in the lower quatrefoils are the painters making the window & offering it S. Gregory would make a capital 2nd saint as I believe the greater part of your painters are in the choir & now they are quitting the gallery thing are worthy of such a patron.'

Literature. London & Dublin Weekly Orthodox Journal, 9, 1839, pp. 308-20: account of ceremony of blessing and laying the foundation stone; 12, 1841, pp. 400-10: account of the consecration and dedication. *The Ecclesiologist*, 10, 1849, p. 89 (a critique of Warrington's *History of Stained Glass*, 1848, commenting, 'There are however two windows which we should except from the general condemnation ... One is the large window at S. Chad's [nIII] ... at Birmingham, which is good, because it is a mere canopy and figure window, with careful drawing, and no attempt at finery and allusion. Indeed did not its appearance in this place [Warrington's book] at once dispose of the supposition, we should have thought that the drawing was Mr. Pugin's, and the glass work alone Mr. Warrington's. In execution however, it unhappily turns out to be as spotty and smudgy as any that its burner ever performed.' *Warrington*, 1848, p. 40: 'Not unfrequently a large portion below the figures (where they were singly used) was portrayed in rich and minute mosaics as is to be seen in the principal window of the Lady Chapel of St. Chad's Birmingham [nIII].' In a note on the same page Warrington remarks: 'This window was drawn and also executed by the Author, from which his name has somehow been obliterated.' *The Birmingham Catholic Magazine*, 1914, published the manuscript about St Chad's by Thomas Leith who was one of the cathedral clergy from 1842 onwards (Hodgetts). His manuscript is in the Birmingham Archdiocesan Archives, Cathedral House, and a micro-film copy in the Birmingham Central Reference Library. The references to St Chad's windows are as follows: p. 663 (N transept, 3 bays, 1843); p. 667 (sIII, 1848); pp. 750-1 (descriptions of subject matter and dates for nII, I & sII, nIII (no date) nIV, nVI (part); pp. 788-9 (continues from p. 751, nVI (part), nVII, nVIII, sIII, sVI, nIX, nX). *The Builder*, 5, 1847, p. 508: description of the roof decoration in the nave and aisles; 1851, p. 593: notice of erection

of sVI, with description. Warrington, 'c.1855(?)', p27: '3 in Choir, 1 Lady Chapel.' Hodgetts, 1987. Wedgwood (Pugin's Diary): Pugin visits St Chad's, 1839, Apr. 8-9, Oct. 29: 'Corner stone of Cathedral laid;' p. 44 '[long list presumably of payments made to Pugin during 1839]' includes 'Birmingham Windows 30.0.0'; Jun. 21 'Consecration of St. Chad's' Jun. 23 'Opening of St. Chad's', 1841; Aug. 30, 1844 'My Dearest Louisa [Pugins second wife] buried at St. Chad's'; p. 58: '[b] [financial calculations] Wailes for Birmingham 40.0.0'; Mar. 10 1851 'Edw. [?] Walsh buried' R.I.P'

Pugin recorded other visits to Birmingham as follows: 1837, Aug. 29; 1838, Feb. 15, 21, 26, Apr. 4, 30, May 1-2, 16, Jun. 11-12, 23, 26, Sep. 13-14, 22-4, 29, Nov. 11-12, 17, 29-30; 1839, Feb. 1, 28, Mar. 15, 17, Apr. 6, 19-21, May 6-7, 17-19, 29, Jun. 5-7, 28, Jul. 10-13, Aug. 5-6, 14, 23, Sep. 2-3, Oct. 2, 28, Nov. 2, 4-5; 1840, Jan. 10-11, 20, Feb. 21, 23-4, 27-8, Apr. 11, May 2-6, 8, 22-3, 30, Jun. 1, 3-4, 10, 12, Jul. 2-3, 6-7, 24-5, Aug. 5-8, 22, 24, Sep. 10-12, 22, 26, 28-29, 30, Oct. 9, 22-24, 26-28, 31, Nov. 2, Dec. 8, 9; 1841, Feb. 22-3, Mar. 25-7, Apr. 5-7, 10, 27-29, May 8, 10-11, 18-19, 23-4, 28-9, 31, Jun. 16-25, 28-30, Jul. 7-9, Aug. 24-6, Sep. 21-25, 27, Oct. 9, 11, Dec. 14, 17, 20-3; 1842, Feb. 21, Mar. 9-11, 23, 28, Apr. 4-5, May 6-7, 14-16, Jun. 23-4, Sep. 17-19, Oct. 27-9, Nov. 1-2; 1843 no diary; 1844, Feb. 17-19, Mar. 4-5, Apr. 4-5, 20-1, Jun. 5-6, 17, Jul. 17-18, Aug. 1-2, 6, 14-16, 28-9, Oct. 2-3, 18-19, Nov. 30-Dec. 2, Dec. 10; 1845, Mar. 28-9, 31, Apr. 2, May 17-18, Jul. 18, Sep. 2-3, 20-21, Oct. 3-5, Nov. 17, 18; 1846 no diary; 1847, Jan. 16-18, Mar. 11, Sep. 4-5, Oct. 30; 1848, Jan. 13, Feb. 29-Mar. 1, Mar. 20, May 11-12, Jun. 21-23, Jul. 27-29, Sep. 14, 16-18; 1849, Apr. 14-15, Jun. 1, Aug. 6-7, 18-20, Oct. 4-6, Nov. 30-Dec. 1; 1850, Feb. 23-5, 26-7, Apr. 27, May 1, May 2-3, Jun. 20, 26-7, Jul. 27-9, 31, Sep. 4, 5, 20-3, Nov. 5-7, 20; 1851, Jan. 14-15, 17, Feb. 5-6, 26-7, Mar. 11, 26-7, May 6-7, 8-9, Jun. 7-9, 12-13, Aug. 18-20, 26-7, Sep. 18-19, Nov. 24-6, Nov. 29-Dec. 1.

177 Birmingham, Erdington, St Thomas & St Edmund of Canterbury (RC)

1849-53. Client: Rev. D.H. Haigh. Supervising architect: Charles Hansom. Windows sVIII–sXI designed by J.H. Powell.

Chancel E window (**7.12a & b**)	I	3.9m x 5.6m	5-light	£300	1849	
Chapel of Blessed Sacrament:						
E window	sVII	2.5m x 4.4m	3-light	£80	1850	
W window (**3.6**)	wI	4.6m x 7.0m	6-light	£300	1850	
St Thomas' Chapel:						
E tracery window (**7.13**)	SVII			£35	1850	
S wall window	sVIII	1.1m x 2.1m	2-light		1853	
S wall window	sIX	1.1m x 1.3m	2-light		1853	
S wall window	sX	1.1m x 2.1m	2-light		1853	
W wall window	sXI	1.3m x 2.9m	2-light		ordered 1853(?)	

Descriptions. **I.** 5-light window with tracery illustrating the Heavenly Jerusalem. The ranks of the elect are portrayed standing in frontal poses, against blue grounds and between bands of stylised blue-white clouds. They form three rows of figures, in groups, across the window – the third and bottom row of figures is obscured by the reredos. The groups in the top two rows are mainly made up of three figures shown full length in the foreground, with overlapping heads in the background to give the impression of large crowds. The exceptions are those in the three inner lights, the top rows of which contain full-length overlapping figures, five in the middle light and four in each of the other two. The figures in the top row of the three inner lights are the Apostles: left-hand inner light: St John the Evangelist and St James the Great in the foreground and St Andrew and St Thomas in the background. St John is in a blue-lined, white mantle over a white-lined, red robe, holding a chalice (from which a white(?) demon is emerging) in his right hand. St James wears a green hat that has a white pilgrim's badge attached to the centre of the brim, and is in a green-lined, purple mantle over a yellow robe, holding a staff (to the top of which a gourd is fastened) in his right hand. St Andrew is in a red-lined, green mantle over a blue robe, holding a diagonal cross in his right hand and a book in his left. St Thomas is in a mauve mantle over a violet robe, holding a lance in his left hand. Middle light: St Peter and St Paul flank the foreground with an unidentified figure between them. St Peter is in a blue-lined, red mantle over a green robe, holding the keys in his right hand, and a book in his left. St Paul is in a red-lined, blue mantle over a yellow robe, holding a downward-pointing sword in his left hand, and a book in his right. The unidentified figure is in a purple mantle over a green robe. The two background figures have green haloes, the one on the right points upwards with the forefinger of his right hand, and the one on the left, perhaps St Philip, holds a crossed staff in his left hand. Right-hand inner light: an unidentified saint and St Simon are in the foreground and the head and shoulders of an unidentified saint between them in the background. Just behind and to the right of St Simon is St James the Less. St Simon is in the middle of the composition, holding a

downward-pointing saw in his left hand. He is in a red-lined, white mantle over a green robe. St James is in a green-lined, purple mantle over a blue robe, holding a club in his right hand and a book in his left. The unidentified figure on St Simon's right is in a white-lined, red mantle over a yellow robe, holding an upraised sword in his right hand and a book in his left. The yellow-haloed figure in the background between the unidentified figure and St Simon may be St Matthias. He is in a red mantle over a yellow robe and holds an axe in his left hand. The figures in the foreground of the top row of the left-hand outside light, are perhaps: Abraham who is in a white-lined, red robe and holds an upraised knife in his right hand; Moses who is in a green-lined, blue mantle over a purple robe and holds what appear to be the tablets of stone with his left hand; and David who is in a red mantle over a yellow-patterned robe and plays a harp. Female saints are portrayed in the top row of the right-hand outside light: the one in the central foreground is in a green-lined, blue mantle over a purple robe and holds a text in her hands. The central, figure (St Edmund(?)) in the foreground of the second, or middle row of the left-hand outside light, is in a green-lined, red mantle over a purple robe and holds a book in his right hand and a crozier in his left. On his right is a figure in a brown habit, and on his left a figure in a purple-lined, blue mantle. The central figure of the equivalent group in the adjacent light is St Thomas of Canterbury. He wears the pallium and is in a red chasuble over a blue dalmatic and a white alb. A sword is thrust horizontally, through his head. On his right, standing on a red-winged dragon, is St George who is in a red-lined, yellow surcoat and holds a staff – to which a banner marked with a red cross on a white ground is fastened – in his left hand, and a downward-pointing sword in his right. On St Thomas's left is a figure – perhaps St Stephen – who is in a yellow dalmatic and a white alb and holds a book in his right hand and a censer in his left. The figures in the middle light are obscured by the reredos but the crowned heads that are visible suggest that they are 'queens'. 'Bishops' and 'kings' are depicted in the adjacent light to the right, where the central figure (unidentified) in the foreground is crowned and in a green-lined, red mantle over a yellow-patterned robe. On his right is a figure (St Lawrence [?]) in a yellow-patterned dalmatic over a white alb who carries a book in his left hand and what is possibly a gridiron, in his right. On the unidentified king's left, is a figure in a yellow-lined, blue mantle over a purple robe holding a staff, to which a yellow banner is fastened, in his right hand. The right-hand outside light, contains 'abbotts' and 'abbesses'. Angels playing harps, each flanked by two singing angels, are in the heads of the lights. The tracery is made up mainly of a large wheel which is at the top of the window and two smaller oculi that are positioned over each pair of outer lights. Christ and the Virgin Mary enthroned are depicted in an orange diaper roundel at the centre of the wheel – a white-winged angel hovers above and extends its wings over their heads. Christ is on the left in a green-lined, red mantle over an orange robe crossed by white straps. The Virgin is crowned and in a green-lined, blue, white-patterned mantle over a wine-red robe. An angel with blue and green wings and in a red mantle over a blue robe is depicted in each of nine trefoils distributed equally around the roundel, inside the circumference of the wheel. The oculi contain sexfoils filled with stained glass which have roundels at their centres containing half-length figures of angels surrounded by six smaller angels. Angels also appear: in a trefoil above each oculi; in two dagger-shaped pieces on either side of the head of the middle light; and in trefoils that crown the heads of the lights.

sVII. 3-light window and tracery. Christ is depicted in the centre light in a large blue-diaper medallion outlined in white, while scenes relevant to the Eucharist are in smaller blue diaper medallions outlined in white, in the side lights. The remaining areas of the lights consist of a red ground overlain with white vine leaves and green bunches of grapes on yellow stems. Christ is in a white-lined, red mantle over a yellow robe standing in a frontal pose with his arms held out in a welcoming gesture. Two frontally-posed, angels in white are at his shoulders and a further two angels kneel at his feet. The borders are patterned with white vine leaves separated by alternating green and red bunches of grapes – the green grapes are on red grounds and the red on blue. The tracery-pieces contain similar patterns of leaves and grapes on stems against red grounds.

wI. 6-light window and tracery illustrating, in blue quatrefoil medallions that have elongated convex sides, events in the Life of Christ. Four events are depicted in the each light, creating four rows of six scenes across the window. From left to right and starting with the top row they are: Journey into Egypt, Christ among the Doctors, Baptism, Temptation in the Wilderness, Marriage at Cana, Unidentified. Second row: Christ and the Woman of Samaria, Crossing the Sea of Galilee, Sermon on the Mount, Feeding the 5000(?), Navicella, Transfiguration. Third Row: Blessing the Children, St Mary Magdalene annointing Christ's feet, Raising of Lazarus, Entry into Jerusalem, Driving the traders from the temple, Last Supper(?). Bottom row: Agony in the Garden, Christ before Pilate(?), Mocking of Christ, Flagellation, Carrying the Cross, Crucifixion. The medallions are formed by fillets of white glass which become the stems for vine leaves and bunches of grapes, The stems intertwine to form a blue oval containing a purple rosette, above and below each medallion. The remaining areas of the lights are patterned with vine leaves and grapes on red grounds. The borders are patterned with small red and white rosettes on yellow, purple, green and blue grounds. The main pieces of the tracery

consists of three quatrefoils above and between each pair of lights and three trefoils, two arranged symmetrically above and between the quatrefoils and one at the top of the window. Each of these pieces contains a scene set against a blue ground as follows: in the trefoil at the top of the window is a depiction of Christ enthroned, with Christ in a red mantle over a white robe and angels in orange holding Instruments of the Passion – that on Christ's left is the Cross – hovering on either side of him; in the left-hand quatrefoil is the Nativity, in the centre, the Annunciation to the Shepherds and in the right, the Adoration of the Kings. The other tracery pieces, where large enough, are patterned with white vine leaves on yellow stems, against red grounds, the stems forming around blue rosettes. Those smaller contain a single yellow rosette on a red ground, and the smallest, are filled with red, yellow or white glass or combinations of these colours. The pieces are arranged roughly in circles around the trefoils and in rectangles between the quatrefoils.

SVII. The window above sVII is a 35-piece tracery window. The central sexfoil contains a seated, crowned figure in a blue mantle over a red robe, encircled by a band of stylised, blue-white cloud, and surrounded by the six angels who occupy the foils. It is not clear that the window is that recorded on f. 88 of the First Glass Day Book or that the figure is of St Thomas of Canterbury.

Office Records. *Order Book,* 1849, f. 58, May 22 (I, sVII, wI, SVII), re sVII: 'containing figure of Our Lord & Angel adoring'; re wI; 'with Life of Our Lord'; re SVII: 'An East Circular Window Chapel of St. Thos. of Canterbury with Martydom of St. Thos. in the centre space & angels holding crowns around it.' *Order Book 2,* 1853(?), f. 35, undated (sVIII–sX). *First Glass Day Book,* 1849, ff. 77-9, Dec. 26 (I, tracery wI): '2 Windows over Confessionals/of 30 pieces of Tracery/2 Lights for Window, Room over/Porch, of Quarries, Borders & c/ea. 3'8" x 1' 1".../A small Light for Staircase/to above/1'8" x 0'7".../6 Lights for Windows in Sacristies/3 ea. 4'1" x 1'6½" .../3 ea. 3'2" x 1'3½".../2 Lights for Room over Sacristy./2ea. 4'4" x 1'3½".../A Wrought Iron Casement 1'3" x 1'6"Square & Frame//Window in Organ Chamber /of 2 Lights 5' 6" x1' 8½". 1 Large Tracery piece & 3 Small do. do.../A Wrought Iron Casement/1' 7¼" x 1'6"/Square & Frame/A Small light for Top of/Sacristy Staircase 2'9½" x 0'9½". A Small Light for side of Sacristy Staircase 1'8" x 0' 7½"/To Dulling 6 Windows in Chancel.../[cost of above excluding (I) & Tracery (wI) £46.7.6] 6 Lights of Stained/ Quarries & c & c/for 2 Windows in Aisle/of Rolled glass/12 pieces of Tracery to do.../ £22.13.6 [the windows over the porch and sacristies seemingly are no longer in place]': 1850, f. 85 Mar. 22 (sVII), f. 87, Apr. 25 (wI), f. 88, Apr. 25 (SVII): 1853, f. 177, Apr. 18 (sVIII–sX). *Cartoon costs per ledger summary*: I, Powell £6.0.0, Hendren £2.16.8, Oliphant £66.5.0; sVII, Powell £3.15.0, Oliphant £7.10.0; wI, Powell £6.0.0, Oliphant £66.3.0; SVII, Powell, £4.5.0. Oliphant's account records that the payment were in respect of:

			£ s. d.
'1849	June 5.	Sketched at Ramsgate/5 Groups (Apostles & Saints) @60/-/East Window/	15.0.0
	June 21	Expenses to & from Ramsgate/with time/ East & West – [windows]	3.0.0
		Inn expenses at Ramsgate 15 days/@ 7/	5.5.0
		12 days works at do. @ 20/-	12.0.0
	Aug 15	5 Groups for East window @ 60/-	15.0.0
		5 Groups for do. do. @ 62/-	15.10.0
	Dec 19.	2 Cartoons, Groups of the Innocents, East Window @ 30/-	3.0.0
	20.	Groups for Tracery @ 30/-, East Window	3.0.0
		[Difference with ledger summary]	(5.10.0)
			66.5.0
1849	Oct 16.	6 Groups for West Window	11.6.0
		6 Groups for do. do.	10.17.0
	Oct 27.	5 Groups for Tracery, West do. @ 30/-	7.10.0
	Nov 19.	12 Groups for West Window	19.10.0
	Nov 26.	Expenses to & from Ramsgate/time included/	3.0.0
		5 days Expenses @ 7/-/East & West	1.15.0
		4½ days work @ 20/-, - "-	4.10.0
	Dec 20.	1 Group for West Window @ 45/-	2.5.0
1850	Feb. 14.	Trefoil for Tracery for West do.	1.15.0
		[Difference with ledger summary]	3.15.0

		66. 3.0
1849	Dec 14. 4 Cartoons, Figure of Our Lord & 3 Groups for	
	Sacrament Window @ 30/-	5.15.0
	[Difference with ledger summary]	1.15.0
		7.10.0'

Letters. General. *HLRO 304: Pugin to Hardman*, letter no. 424: '3. Mr. Haigh has sent me a lot of windows to design.' No. 360: 'I have sent Mr Haigh his drawing for the West Window & had it returned <u>approved</u> tonight I send his side chancel chapel of B. Sacrament Chapel of St. Thomas in all 16 windows besides the 2 great ones.' No. 54: 'Oliphant is making a first rate job both of the Brighton [St Paul, Gaz.41] & Erdington windows.'

I. *HLRO 304: Pugin to Hardman*, letter no. 335: 'I have sent you off the design for Mr Haighs window by the Early post so that it may reach you on Sunday. I have filled the sexfoils with groups of angels which will come better than what Mr. H proposed. I see he says in his letter that he shall judge by the estimate of this window how many windows he shall have done but this is <u>no criteria</u> at all for it is the most costly window that can be no canopy work no pattern or repetition whatever but a <u>mass of figures</u> – so you must explain this to him & the cartoons will take a long time & be costly I do not believe the window can be done under £300 & you might make an effective window of another sort for less than half.' No. 130: 'There is <u>no</u> Light figured from the syl to the spring in the Erdington E. Window – it appears to me they all alike [sic] – & have not the most important dimensions you should overhaul the templates & see that these things are right for I have Oliphant here & am stopped in all 3 windows Erdington.' No. 4: 'Oliphant is here & that stops Powell [John Hardman Powell] I shall be right glad when he is gone but this East Window Erdington is a huge job & in the way he works takes a long time to draw out.' No. 135: 'we are making a very fine work of Mr Haighs East Window. The figures are small but very fine' No. 976: 'all Mr. Haighs tracery for East & west windows excepting groups goes off tonight & I have got all his groups for East Window noted[?] in detail & colour'. No. 963: 'the groups for Mr. Haighs East window in a day or 2.' No. 957: '1. I hope to send off some of Mr. Haighs lights tomorrow but the work is interminable they will not pay at any price – there is no repetition whatever' No. 352: 'I am well satisfied with the groups of the erdington window they will be a fine job'. No. 937: '3. what is it that Mr. Haigh complains of it sometimes will happen that colours[?] are [?] but I declare I took the greatest pains with his groups in every way'. No. 688: 'the best job done is Mr Haighs East Window.' *JHA: Haigh to Hardman*, 1849, Apr. 3: 'I should not like the Holy Innocents to be omitted in the East Window, please to tell Pugin so and tell him that I think their best place would be at the feet of Our B. Lord & Our B. Lady in the large group[?] They would not diminish the size of these two figures because of course they could be represented in front with their palms & crowns adorning.' Jun. 5: 'I want to know something of the cartoons of the East Window, and if you write to Pugin tell him I shall be [sic] to hear from him about the East Window of the Blessed Sacrament Chapel.' *Oliphant to Hardman*, 1849, Jun. 8: 'I have brought down with me, the first 5 groups for Erdington East window.' Jun. 25: 'I regret that the groups for East Window Erdington came to so much but have kept them down as much as possible and shall endeavour to do so still further in those that remain – those for the west window which I have just sketched at Ramsgate will not be nearly as expensive.' Aug. 7: 'the 2 compartments for Wells St. [St Andrew, London, Gaz.61] shall be sent to Ramsgate tomorrow and 5 more Groups for East Window Erdington shall follow them about the end of the week or Monday of next.' Aug. 15: 'I have sent off today to Ramsgate the 5 Groups for Erdington mentioned in my last [sic]. [added to the bottom of the letter] we proceed with the next 5 Grps for Erdington E. Win. which will complete the body of the window.' Aug. 25: 'The cartoons for Erdington shall be got thro' as quickly as possible. My brother [mentioned as 'my assistant' in a letter to William Powell dated Aug. 23, 1849] has been in Scotland and the work has suffered in consequence but he returns today and nothing further will I trust interrupt their completion.'

sVII(?). *HLRO 304: Pugin to Hardman*, letter no. 905: '3. What about the side aisle chapel B. Sacrament & Lady Chapel as I want subjects for Oliphant & these would be just the thing.' No. 407: 'I will send Mr. Haigh the window of the B.S. Chapel but I have not got the german print he wants imitated – if he wants these kind of things he should send me the Print picture[?] – he would have had his design long ago if he had left to [sic] me but I have been waiting for the Print this creates the delays.' No. 228: 'I have found The Print of Our Lord and have <u>sent off the design</u> to Mr Haigh but when can we draw it out I dont know unless Oliphant will strike out & get the other 2 windows done.' No. 820: '1. we have not got the templates for Mr. Haigh B. Sacrament E. window & are stopped for it if we had them we could finish it off.' No. 977: '5. I send you Mr Haighs cartoon [?] for Chapel of B. Sacrament.'

Aisle windows (not in First Glass Day Book): *HLRO No. 304, Pugin to Hardman*, letter no. 142: '2. I will attend to Mr. Haigh's letter. The subjects he proposes for the side windows will do very well. No. 962: '4. his side windows & trefoil

windows will go off tomorrow night.' *JHA: D. Haigh to Hardman*, 1849, Mar. 31: 'I send you tracing of Aisle Windows. They are close to confessionals & therefore contain the history of two penitents. They are close to the eye and therefore though the figures be small will be well seen. The interlacing scroll which I have shown may be coloured as well as the border the rest to be of white glass with the subjects drawn in lines. In the tracery I have placed emblems of penance below & of beatitude above. There will be room at the foot of each window for an inscription. These are suggestions which you will please to communicate to Pugin and let me know how he likes them.'

wI. *HLRO 304: Pugin to Hardman*, letter no. 325: 'I am getting the groups for Mr. Haigh tracery done by Oliphant but Mr Haigh has sent me the german print of Our Lord descending to Earth with no saint which he intends for the top tracery. I wonder at going ahead just now – when everything is [sic] such a state [continues with matters concerning St Augustine, Ramsgate, Gaz.88] Mr. Haigh is very wrong to have subjects in his tracery. they come very bad in form'. No. 974: 'I hope tomorrow to send off Mr. Haighs tracery.' No. 686: 'we sent back the cartoons of Jesus College [Cambridge, Gaz 9] to work the Hereford [Cathedral, Gaz 75] groups by – also the small bits of tracery for Mr. Haighs west Window.' No. 835: 'I will send the 2 pieces of tracery for Mr. Haigh this week.' No. 927: 'I have put the Last piece of Mr. Haighs tracery in hand.' No. 905: 'Mr. Haighs west window is nearly ready.' No. 918: 'the whole of Mr. Haighs w. window will be done this week it has been a sort of interminable job one mass of work.' No. 920: 'Mr. Haighs west window is completed with the exception of 3 groups which must be redone. & the top subject of tracery for which Mr. Haigh promised a saint but which I have never got – this will be a very good window window [sic] if your people manage it well but they dont appear to me to be up to the scraping out work of the old men. there is a deal to be done in that way.' No. 960: 'you must make Mr. Haighs window Exactly[?] like 15 century glass.' No. 407: '. I should be sorry to offend Mr. Haigh but if he wishes me I will give up the job – no man on earth can do more than I do but as to drawing cartoons of scripture history & c it is impossible. Can you make Oliphant work. I cannot – I had him here for weeks about Mr. Haighs windows every group was sketched altered & realtered under my own eyes then he takes them up to put in sepia[?] & the devil himself cannot get him on function[?] – will you try & see what you can do. he says he is always ill & cant work – he drives me wild –mechanical work can be done to a time but all artist work is uncertain.' No. 908: 'we have been working incessantly[?] at Mr. Haighs windows if he is disappointed I cannot help it for no man can take greater pains or work harder than I do if a man was asked to paint the life of Our Lord on canvas it would be thought a great thing but on glass it is nothing. no one not even you know the labour of his windows we have had nothing like them before except E Ushaw [Gaz.40] & that is nothing like so good.' No. 49: 'we have got a first rate job of Mr. Haighs West Window groups. I have satisfied myself quite[?] in that[?] some of them are quite grand in composition.' *National Library of Scotland, MS 23204, f. 17, Pugin to Oliphant*, undated: 'I cant bring my mind to like the subject of Pilate washing his hands it does not go at all with the rest it is quite different in its treatment & there is a great deal too much perspective & late school about it. I send you a sketch which I think you can work out with much better effect I wish our Lord to be represented in front the kneeling figure in the middle & Pilate in the foreground [in the window the kneeling figure offering a dish of water to Pilate is in the centre of the composition between and in front of Christ and Pilate who are in the left and right foregrounds respectively] pray let me have this as quick as possible as all the rest of the window is done.' *JHA: Oliphant to Hardman*, 1849, Nov. 10: 'whole of remaining groups for Erdington W Window will be done this next week.'

Unidentified windows: *HLRO 304: Pugin to Hardman*, letter no. 130: 'Mr. Haigh's new window it will never do to have quarries in decorated work it must be a geometrical pattern like that I sent you for the nave Brighton [St Paul, Gaz.41] if I get a tracing of his window I will fill it in they will look wonderfully[?] well & not costly.' No. 269: 'as for Mr. Haigh it is past all suggestion the idea of placing 3 images[?] against 3 lights in windows. you better persuade him to have the 3 lights fitted with a decorated diapered work in patterns & then the windows will always look well & the pattern can be made rich nothing whatever could possibly be seen of the image if they are stuck in the window lights it is a delusion altogether & cannot be suffered – let us fill the windows with a grand pattern – but I dont think it is necessary to show him a drawing as he will certainly object – & he may consent to a decorated diaper. we can make a respectable window with a rich pattern but a ruby window is too ridiculous.'

Literature. Wedgwood (Pugin's Diary): Pugin visits Erdington, 1850, Apr. 29; for visits to Birmingham, see Gaz.176.

178 Birmingham, Handsworth, Convent of Our Lady of Mercy (RC)

The only clients recorded are James Gibson for the N aisle three-light window, and Hardman senior for the S aisle two-light window.

The red-brick buildings of the convent, erected in 1840-1, included a small chapel. A public church was added in 1846-9 for which Pugin/Hardman supplied the stained glass as recorded in the First Glass Day Book. The buildings were badly damaged by bombing in July 1942 (and ultimately demolished) when all the stained glass was destroyed. The chapel was

described by Pugin in the *Dublin Review*, 1842. His comments on the glass included: 'the east window of three lights is filled with stained glass, presented by the noble earl (Lord Shrewsbury): in the middle day [sic] is an image of our Blessed Lady, under a rich canopy; and on either side are effigies of the Earl of Shrewsbury and Mr. Hardman (Senr) as co-founders, in a kneeling attitude, attended by their patron saints, St. John the Baptist and St. John the Evangelist. The side windows of the choir are also filled with stained glass of varied design and rich effect ... A doorway on the north side of the lower end of the chapel leads into the cloisters ... At the end of the north alley is an oratory with a stained window.' Thomas Willement's, 'Chronological list', includes under 1840: 'The nunnery Birmingham R.C. – The Earl of Shrewsbury & Mr. Hardman A window with whole length figures under canopies and emblems for the Chapel.' This, presumably, would have been the E window mentioned above. Possibly Willement also executed the other glass referred to, without including the fact in his list.

Office records. *Order Book*, undated, f. 27 (includes all Pugin/Hardman windows up to 1850 except for the Kitchen window), re E Window: 'Mem. Mr. P. had £10 on cartoons for East Window viz for 1 Light & Tracery. Commission to be allowed on other Lights £80. Cartoons Tracery £5. 5-Lights £5 ea.', f. 60 (S aisle window); *Order Book 2*, 1853, f. 44, undated (side window). *First Glass Day Book*, 1847, f. 14, Jun. 5: 'A Window for Church/£15/consisting of 3 Lights of Quarries & c/3 Tracery pieces with Figures & c/7 small Tracery pieces' f. 23, Dec. 24 '1 Centre Light for East// Window of Church/8'7½" x 1' 9½"/£20/.../19 Large Tracery pieces for do/16 Small do. do. do/- £30; 1848, f. 50, Dec. 22: '4 Lights of Stained Glass /with Figures & c & c/£80/for East Window of Church/& Completing same with/Invoice of December 24 1847/8'7" x 1'6½"'; 1849, f. 53, Mar. 5: '2 Lights of Quarry Glass/for Kitchen 4'1" x 1'3"/A New Iron Casement &/Iron Bars/.../Glass taken from East Window/of Church'; f. 57, Apr. 26: 'A North Aisle Window/of 3 Lights with Figures/of St. Anne, St. James & St. John/£45/6'3" x 1'6½"/7 pieces of Tracery to do'; 1850, f. 108, Dec. 26: 'A Stained Glass Window/for Convent Church of 2 Lights /& Tracery piece 6'6" x 1'9" £30.../A Wrt Iron Casement & Frame/Subjects S. Matthew & S. Winefrid [sic]/for South Aisle Window'; 1853, f. 204, Dec. 31: 'To A Stained Glass Window/of 2 Lights & Tracery/for side window of/Church/.../2 Lights 6'6" x 1' 9½".../1 piece of Tracery/2'3" x 1'8"/Subject Figures of 'St Charless Borromeo' and 'St [sic]'/To A Wrought Iron Casement & Frame for above' [window designed by J.H. Powell]'. *Cartoon costs per ledger summary*: N aisle, Powell £1.10.0, Hendren 13s.4d; S aisle, Powell £2.15.0..

Letters. *Wedgwood, p. 102, letter 21: Pugin to Lord Shrewsbury*, 1840 'Xmas Eve': 'The stained window is also in the Convent Chapel.' *HLRO 339: Pugin to Lord Shrewsbury*, letter no. 71, postmark 'UTTOXETER AU 28' (quoted by Phoebe Stanton in Appendix VIII of her unpublished Ph.D thesis, 1950): 'I cannot tell your Lordship how annoyed I have been with Willement for the stupid mistake about the hand of the Blessed Virgin at the Convent I have called & written about it several times & he is at last preparing to replace it'. *HLRO 304: Pugin to Hardman*, letter no. 693: I cannot remember the saints intended for the convent window at Handsworth & Powell has lost the Papers I gave him about it pray let me know.' No. 996: 'How could you select St. Vincent of Paul for the East Window of Convent there is no colour about the costume & it will be invisible – pray see if you cannot take S. Vincent Deacon a fine Dalmatic & c do let us have some colour S. Vincent of Paul has nearly ruined our reputation in S. Georges [Southwark, Gaz.63].' No. 1013: 'We shall make a splendid job of the convent east window ... the east window will be done tomorrow night.' No. 1000: '1. The time is arrived that I can do the windows for the Convent Church let me have the templates of the end window of aisle.' *JHA: J.H. Powell to Hardman*, 1847 bundles: undated: 'My dear uncle directed May 1st. I have got a letter from the Governor [Pugin] today [Pugin was then in Italy]... I send enclosed an idea for the convent east window. it is very slight but you will understand it. please send word what you think about whether it will be attempting too much or whether single figures will be well introduced as the Governor designed changed thus /S. Chad/S. Anne/Our Blessed Lady/S. John/S. Vincent of Paul. and I will immediately get out the coloured drawing.' Undated: 're saints for Convent window – /St. Thomas/S. Peter/Our Blessed Lady/S. John/S. Chad.' Post mark '1847 NO 27': 'I have finished the cartoon for Convent and I think it comes very well although 1 foot is cut away which of course I have left plain glass.'

Literature. Pugin, 1842, pp. 133-5. Willement, 1812-1865. *The Builder*, 5, 1847, p. 508, records 'An additional stained window is to be placed in the Convent Church at Handsworth, from a design by the same architect (Pugin), to be executed by Mr. Hardman'. Wedgwood (Pugin's Diary): 1840, Apr. 21: 'Birmingham Convent began'; May 4 'At Birmingham Convent commenced [?]', p 70, 'Diary 1850 for 1849...[f]. Addition to Convent B 20.0.0.' For Pugin's visits to Birmingham see St Chad's Cathedral (Gaz.176). R. O'Donnell, 2002, pp. 70-3.

179 Birmingham, Handsworth, St John, Hunters Lane (RC)

1848. Client: John Hardman, St John's, Hunters's Lane.

Office records. First Glass Day Book, 1848, f. 43, Oct. 10: '7 Lights of Quarries with/Centres & Borders /£12.15.0/2'7" x 1'5"./.../for Drawing Room'.
Letters. See Gaz.87, *Letters.*

180 Birmingham, Northfield, St Laurence (CoE)

1850, 1853. Client: Rev. H. Clarke (entered in First Glass Day Book as Rev. H. Clark). Windows nII and sIII designed by J.H. Powell.

Chancel S window	sII	1.8m x 1.8m	3-light	£28	1850
Chancel N & S windows	nII, sIII	1.8m x 1.8m	3-light		1853

Description. **sII.** 3-lancet window. The centre lancet (taller and wider than the side ones) contains a depiction of St Michael enclosed in a central, blue, elongated, convex-sided quatrefoil medallion. Above and below are single (blue at the top and red at the bottom) quatrefoil medallions each containing a representation of a seraphim. The side lancets each contain three red quatrefoil medallions within each of which is a representation of an angel. The white-winged, St Michael, in a white mantle over a red robe stands in a frontal pose on a yellow-winged, green dragon, thrusting a lance, diagonally into its mouth. A shield emblazoned with a red cross on a white ground is attached to his left forearm. The top seraphim is pink with red wings, and the bottom one white, with blue wings. The angels in the side lancets are in white mantles and green robes except for the middle one in the left-hand lancet who is in white and blue. The glass in the remaining areas of the lancets is comprised of quarries patterned with oak leaves outlined in black, and yellow berries, all on yellow silver stain stems, against black, cross-hatched grounds. The central quarries above and below each medallion and linked to them, are outlined in yellow-beaded glass and are filled with blue, leaf patterning. An inscription in black-on-yellow runs across the bottom of the window and reads 'In Memy of William Sheppey Greene/who deceased MDCCCX[indecipherable] Jesu Merci'. The patterning throughout the window was badly worn as was the painted detail on the figures but the window has since been restored (post 1996) by John Hardman Studios, Birmingham.
Office Records. Order Book, undated, f. 61 (sII): 'inscription "In memory of William Sheppey Greene who deceased June 21 1849 aged 43 years Jesu Merci"'. *Order Book 2,* 1853, f. 82 (nII), f. 83 (sIII) Jun.; *Order Book 3,* 1853, f. 56 (nII), f. 57 (nIII), Jun. *First Glass Day Book,* 1850, f. 83, Mar 12 (sII); 1853, f. 186, Aug. 17: 'To A Stained Glass/Window of 3 lights /for North Side of/Chancel being/Memorial Window/ of Mr. Henry Elkington./Centre Light 7'0" x 1'6"...'/2 Sides do 6'1½" x 1' 1½".'To A Stained Glass Window/of 3 lights for South/side of Chancel/Centre Light 6'1½" x 1'5"/2 side Lights 5'2½" x 1'1".[both windows designed by J.H. Powell]'. *Pugin sketch,* BM & AG a. no. not allocated, for sII. *Cartoon costs per ledger summary*: sII, Powell £3.15.0.
Letter. JHA: Clarke to Hardman, 1850, Mar. 20: 'window [sII] is satisfactorily put up and is much admired.'

181 Dudley, Our Blessed Lady & St Thomas of Canterbury (RC)

*c.*1840.

N aisle E window	nII	1.7m x 2.5m

Pugin refers to the church in the *Dublin Review,* 1841, and comments on the glass thus: 'The eastern windows are filled with stained glass of a mosaic pattern, interspersed with emblems and subjects'.
The present E window containing the Crucifixion and the martyrdom of St Thomas was fitted in 1862 (Order Book, JHA) at which time it was stated 'the present glass of the east window put into west.' No trace of this glass is to be seen in the church.
William Warrington records making : '1 East Window and 2 others for Dudley Romanist Chapel'. It seems likely that one of these 'others' is nII (see St Marie, Southport, Gaz.116 where there is an identical window).

Literature. Pugin, 1841, footnote p. 329. N. Pevsner, *The Buildings of England: Staffordshire*, Harmondsworth, 1974, p. 121. Warrington, '*c.*1855(?)', p. 27. Wedgwood (Pugin's Diary): Pugin visits Dudley, 1838, Jun. 23, Nov. 18; 1840, Jan. 22, Jun. 11, Sep. 11, Oct. 26, Dec. 9; 1841, Mar. 27, Sep. 24, p. 50 '[d], Stained Glass Dudley 16.0.0'; 1842, Mar. 29: 'At Dudley church consecrated'.

182 Oscott, St Mary's College (RC)

1837, 1848-50. Clients: Henry Lamb (RC 2); Rev. F.K. Amherst (RC 3): RC numbering relates to the positioning – left to right – of the windows in the Rector's Corridor (see below).

Chapel central window of apse (**0.1b & c**)		I	3.4m x 3.9m (including the plain		
5-light glass panels at the bottom of the window which are hidden from view)				1837	
Chapel N window of apse (**0.1d**)		nII	1.6m x 3.9m	3-light	1837
Chancel S window of apse (**0.1e & f**)		sII	1.6m x 3.9m	3-light	1837

Rector's Corridor, formerly known as the Picture Gallery) on the first floor – the windows look out on to the quadrangle:

	RC 2	2'7" x 1'5½"	2-light	£7.0.0	1848
	RC 3	2'7" x 1'5½"	3-light	£10.10.0	1848
	RC 1	2'7" x 1'5½"	1-light	£3.10.0	1849
	RC 4	3'4½" x 1"5½"	4-light	£9.0.0	1850

Descriptions. **I.** 5-light window and tracery. The centre light contains a depiction of the Virgin and Child, the left and right inner lights those of St Catherine and St Cecilia respectively, and the corresponding outer lights, St Gregory, and St Thomas of Canterbury. The Virgin is crowned, and is in a red-lined, orange mantle over a blue robe, holding a sceptre in her right hand and cradling the Child in the crook of her left arm. He is crowned and in a purple robe. St Catherine, crowned and in a red-lined, yellow robe, stands in three-quarter view turned towards the right, holding a downward-pointing sword in her right hand and a book in her left. A yellow-spoked wheel rests against her right leg. St Cecilia in a red-lined mantle over a bluish-green-sleeved, purple robe, stands in three-quarter view turned towards the left, holding a yellow portable organ in her left hand and playing it with her right. St Gregory in a yellow mantle over a white robe, kneels in three-quarter view turned to the right looking up at the Virgin. A double-crossed yellow staff rests against his right shoulder, and his papal tiara, is on the ground at his feet. St Thomas in a yellow-lined, blue chasuble over a red dalmatic and white alb is in a corresponding pose to that of St Gregory. His yellow crossed staff is in the crook of his left arm and his red mitre with yellow cross-pieces is in front him, on the ground. A large yellow mandorla enclosed in a band of stylised, bluish-white clouds and overlain by pointed yellow rays of light and red tongues of flame (which appear to emanate from the Virgin) acts as a background to the Virgin and Child and gives the illusion of spreading behind the mullions into the inner lights and behind St Catherine and St Cecilia. Single angels float above the figures in the inner lights, while groups of them occupy the tops of the outer lights – the lowest one in each holds a text directly above the head of the relevant kneeling saint. The tracery is made up of ten lights (two above each of the main lights), that form a broad-based triangular section immediately over the main lights. Each tracery light contains a depiction of a frontally-posed angel with his separated wings held up above his head and down beneath his feet, against a blue ground.

nII, sII. 3-light windows and tracery. Each light contains depictions of two Apostles, standing one above the other, under canopies. St John the Evangelist and St Philip; St Bartholomew and St Matthew; and St Peter and St Thaddeus are represented in nII and St James the Great and St Thomas; St Paul and St James the Less; and St Simon and St Andrew in sII. The heads and bases of the canopies are shown in perspective but coloured patterned screens behind the Apostles limit the spaces in which they stand. The lower canopies have rounded heads containing ribbed vaulting with central pendants and are surmounted by small yellow-crocketed gables. A series of small diameter yellow columns behind the gables, together with two larger diameter yellow-ornamented, white columns at the sides, support yellow-ornamented, angled entablatures which act as the superstructures for the lower canopies, and bases for the upper. The heads of the upper canopies are similar to the lower, but they are surmounted by more substantial, white, yellow-crocketed gables, flanked by yellow-pinnacled columns, and have elaborate finials at their apices. The superstructures are similar to those of the lower canopies but are three-dimensional showing three sides, and are surmounted by crests of yellow leaves. The bases of the lower canopies appear to be made up of a series of open arches above which is an entablature ormanted with yellow leaves. Each of the Apostles has trailing from one of his arms, an unwinding scroll on which is inscribed a text, in black-on-white, that gives the saint's Latin name followed by 'Ora pro nobis'. St John the Evangelist is in a yellow mantle over a mauve robe, holding a chalice in his left hand. St Philip is in a red-lined, blue mantle over a white robe patterned with yellow silver stain, holding a brown wooden cross in his left hand. St Bartholomew is in a yellow-lined, red mantle over a green robe holding a book in his left hand, and an upraised flaying knife in his right. St Matthew is in a yellow-lined, purple mantle over a red robe holding a downturned sword in his left hand and has a book balanced on the palm of his right. In the panel beneath St Matthew is a small figure of a woman kneeling in profile looking to the right. She wears a white wimple and is in a blue mantle, ornamented with a coat of arms comprising two facing yellow lions rampant (see *Literature, The Oscotian,* below) over a white robe. St Peter is in a red-lined, yellow mantle over a blue robe, holding the keys in his left hand. St Thaddeus is in a yellow-lined, purple mantle over a green robe, holding a book in his

right hand while a club rests against his right forearm. St James the Great is in a blue-lined, grey mantle that has a white scallop shell fastened to its right shoulder, over a blue-green foliage-patterned robe, holding a pennanted staff in his left hand and a book in his right. St Thomas is in a yellow-lined, purple mantle over a blue robe, holding a lance in his right hand and a book in his left. St Paul is in a yellow-lined, blue mantle over a red robe, holding a large downward-pointing sword in his right hand and balancing an open book on his left. St James the Less is in a yellow-lined, blue mantle over a purple robe, holding a club in his right hand. In the panel beneath St James is the small figure of a man kneeling in profile looking to the left. He is in greyish-white armour with yellow ornamentation, and a green surcoat on which is emblazoned a coat of arms similar to that for the corresponding woman beneath St Matthew in nII (see *Literature*, *Oscotian*, below). St Simon is in a yellow-lined, purple mantle over a brown foliage-patterned robe, holding a book in his left hand, and pressing against his body with his left wrist and forearm a large saw that runs diagonally from his left shoulder to his right foot. St Andrew is is a yellow-lined, purple mantle over a green robe, balancing an open book on his right hand, pressing a large diagonal-cross against his left side with his left forearm and holding the top of his name scroll in his left hand. The main tracery pieces each contain a representation of an angel similar to those in the tracery of I.

Rector's Corridor (formerly known as the Picture Gallery):

RC 1–RC 3. The top sections of the lights of otherwise white quarry windows are ornamented with shields emblazoned with arms, helmets and mantling, as recorded in the First Glass Day Book. The shields are all inclined (with their flat tops to the left and pointed bases to the right), have scrolls inscribed with the appropriate names in black-on-white (the initial letters are yellow and are foliated) beneath, and are set against backgrounds of diagonal mottoes (inscribed in the same manner as the names) alternating with diagonal rows of quarries inscribed with appropriate yellow, foliated initials.

RC 4. 4-light window containing in the two inner lights shields emblazoned with the arms of Nicholas Wiseman and Thomas Walsh, respectively, each surmounted by a mitre and held up by a pair of blue-winged angels who kneel in profile, facing each other. The angels holding up the Wiseman shield wear green-lined, yellow mantles over red robes and those bearing the Walsh shield, yellow-lined, red mantles over green robes.

Office records. Order Book, undated, f. 32. *First Glass Day Book*, 1848, f. 26, Feb. 14: '2 Windows in Very Revd Dr. Logan's Room/of 18 squares of glass of various sizes £3.9.6'; ff. 34-5, Jun. 24 (RC 2; Arms of Lamb and Amherst); f. 48, Dec. 16 (RC 3: Arms of Logan; Bull & Sir John Acton Bart); 1849, f. 53, Feb. 24: '2 lights – Arms of Rt. Hon Lord Vaux of Harrowden & Rt. Hon Lord Camoys [window not traced] £9.0.0'; f. 79, Dec. 26 (RC 1: Arms of O'Reilly); 1850, f. 93, Jun. 22 (RC 4). *Cartoon costs per ledger summary*: RC 2, Powell £1.0.0, Hendren 5s.0d; RC 3, Powell £1.0.0, Hendren 5s.0; RC 1, Powell 13s.4d, Hendren 6s.8d; RC 4, Powell £1.5.0.

Letters, receipts, etc. St Mary's College, Oscott, archives, W. Warrington to the Rev. W. Weedall, 1837, no. 758, Jun. 29: 'Received £55 in adv. on act of Part Payment of Stained Glass for St. Mary's College Chapel being executed by me.' Aug. 11: 'Received an amount of £5.' No. 789, Aug. account includes '3 windows of Stained Glass for Chapel constituting about double the Original Estimate. Including charge for 5 Blank Bottom parts of Altar Windw 300-0-0 [the lower panels of window I, which are hidden from view, remain blank]'. No. 829, Nov. 6: 'Received the sum of thirty pounds on account'; 1838, no. 870, Jan. 10: 'Received the Sum of Three Hundred and Eighty Two Pounds Fifteen Shillings and Four Pence as per Account delivered for Stained Glass for three Altar Windows St. Mary's College Oscott. [I, nII, sII]'. No. 925, Apr.: 'Received on Account in Advance twenty pounds'. No. 949, Jun. 1: 'Received on Account in Advance thirty five pounds'. No. 974, Jul. 13: a letter from Warrington to the Rev. Dr Weedall in which the opening paragraph reads: 'Mr. Pugin has called on me this morning and we have finally arranged agreeable to your Plan respecting the window of Side Chapel at Oscott. And I have promised him to go to Rouen in Normandy to see the glass and other things there so you will have the advantage of what information I may gain there. Mr. Pugin has had an accident with his Foot but is better & goes to Germany very shortly – do not think by enclosing your account I mean it as a hint for settlement I merely send it being obliged much against my will to request the Favour (I am always asking Favours of you) to let me have £40 I have not nor do I intend charging for the spandrels of Fourth Window [sVI perhaps]. I shall go to Derby [Gaz.24] on Sunday wk and if you have any desire for me to call on my Lord[?] I will with pleasure do so [The account totals £132. 2s. 9d. being mainly for glass for spandrels of 3 windows [I, nII, sII (?)] £53.16.3; 3 Guest Room Windows £31.10.0 and 5 Prints from German Masters including frames and glazing £10.0.0.].' No. 981, Jul. 17: 'Received on Account in Advance Forty Pounds'. No. 1041, Sep. 26: 'Received on Account in Advance Twenty Pounds'. No. 1075, Nov. 23: 'Received One Hundred and Twenty Two Pounds Two and 9d as per Accounts delivered'. 1839, no. 1296, Dec. account which includes: '5 windows to Side Chapel £150.0s.0d [these appear to have been replaced at a later date but see Wedgwood, 2005, *Literature* below re sVI] 2 Coats of Arms & Wire Work Gt Rm £21.0.0d,' and a deduction of £30.0.0d for, '5th part of Sd Glass Side Chapel: My own Contribution' No. 1032: 'Received Two Hundred and Twelve Pounds Twelve Shillings as per Account [this is in respect of No. 1296 without the deduction of £30.0.0d].'

Literature. Greaney, 1880, p. 24, no. 319, names the figures in I; no. 320 records the twelve Apostles as the subject matter of nII & sII and draws attention to the kneeling figures as the donors; it continues: 'These windows were designed by A.W. Pugin, the drawings, of the figures of the twelve apostles being copied from the paintings of the Boisserée Collection, in the Old Pinacothek at Munich, [see also Wedgwood, 2005, below] and were executed by Warrington, of London.' A further paragraph on p. 25 commences: 'The windows numbered 319 [I], 320 [nII, sII], 324 were painted by Warrington of London about the year 1837 and 1838'. No. 324 is sVI. If Greaney's dating is correct, Pugin may have been involved in the design which includes standing figures of St Agnes, St George, St Michael and St Ursula beneath canopies, with panels below containing kneeling figures of alumni (whom the window commemorates) with their coats of arms. At the feet of St Agnes in the right-hand corner of the light is a small shield, with a white W inscribed on a red ground, which, presumably, signifies Warrington as the maker. (See also Wedgwood, 2005, below) Warrington produced other windows for the Chapel and College with Pugin being involved in the design of at least one of them. (see *Letters* etc. St Mary's College, Oscott archives, above in particular no. 974). *London & Dublin Weekly Orthodox Journal*, 6, 1838, pp. 90-1: description of windows (I, nII, sII) taken from the *Birmingham Journal,* 6, 1838, pp. 381-4 which gives a report of the consecration, including a brief description of the interior decorations. The *Oscotian*, 'Jubilee edition, 1838-88' (1888), pp. 69-70: brief description of the apse windows including for the arms of the male figure kneeling in sII: 'Argent a base vert, thereon a poplar tree supported by two lions rampant, proper, crowned or', being, 'the arms of Gandolfi of Lagneto, nobles of Genoa', and for the female figure in nII, 'the foregoing blazon impaling azure, on a bend embattled counter embattled, argent, a wolf passant between two escallops sable' being 'the arms of Hornyold of Blackmore Park, Worcestershire … The windows were erected in 1838 as a remembrance of having been educated as Oscott' by Mr. John Vincent Gandolfi of East Sheen, Co. Surrey, heir of the marquisates of Gandolfi, Melati and Montecresengio and to perpetuate the memory of his parents, John Vincent Gandolfi (d.1818) and Teresa his wife (d.1860 [sic]) daughter of Thomas Hornyold of Blackmore Park (d. 1813)'. Warrington, 'c.1855(?)', pp. 31-3: 'East Windows, 1 do. in Transept; 1 by the Font; 1 in Guest Room').

Wedgwood (Pugin's Diary): Pugin visits Oscott, 1837, Mar. 27-9, Apr. 4-6, May 24-31 Aug.17-19, 27-8, Nov. 13-20 (lecture on 17th) 27-9; 1838, Feb. 16-19, 23-5 (lecture on 23rd), Apr. 5, 19, May 29 'Solemn consecration of Oscott Church', June 4, 14, 24, Sep. 18-19 (lecture on stained glass on 19th); 1839, Feb. 1-3, 7, 10, Mar. 16, 23-5 (lecture on 23rd), Apr. 7, May 9, 30, Aug. 12-13, 15-17, Sep. 15, Nov. 1,3; 1840, Jan. 21, Feb. 22, Mar. 1, Apr. 12-13, 15-20, May 31, Jul. 7, Aug. 7, 23, Sep. 11, 27, Oct. 25, Nov. 1; 1841, Mar. 28, Apr. 7-9, 11, May 9, 29-30, Jun. 14, Sep. 26, Oct. 10, Dec. 17-19; 1842, Feb. 22-3, Mar. 24-7, May 8, Oct. 29-31; 1843 no diary; 1844, Apr. 6, Jun. 6, 16, Oct. 20; 1845, Mar. 30, Nov. 16; 1846 no diary; 1848, Mar. 1; 1849, Apr. 15, Aug. 10. Wedgwood, 2005, pp. 10-12, gives an account of the Boisserée Collection and Pugin's use of it in the design of the apse windows; p.16 suggests that the window referred to in the Oscott archives 1839, no. 1296 (see above) is sVI (see *Literature*, Greaney above) moved from the side chapel to the main chapel around 1862 after alterations were made to the former. As only four lights were needed for the window in the main chapel the conclusion is drawn that the fifth light of sVI became lost. If this version of events is correct then Pugin would have been involved in the design of sVI.

183 Solihull, St Augustine (RC)

Client: Rev. Archer Clive. Window not in place, possibly destroyed during the 1976 extension of the church.

Office records. *First Glass Day Book*, 1847, f. 17, Sep. 28: 'A Window of Three Lights/£23.15.0/.../of 3 Lights with Centres & Borders/7'7½" x 1'3½" /3 Tracery pieces for do'.

Literature. *Catholic Magazine*, 3, 1839, p. 287: short paragraph on the opening of the chapel, with a brief description of the interior but no mention of stained glass. *London & Dublin Weekly Orthodox Journal*, 8, 1839, pp. 105-6: description of opening ceremony and interior of chapel but no mention of stained glass. Wedgwood (Pugin's Diary): Pugin visits Solihull, 1838, Apr. 6, Sep. 27, Nov. 30; 1839 Feb. 5, Feb. 6, 'Solihull Chapel opened'.

WEST SUSSEX
184 Chichester Cathedral (CoE)

1852. Client: Rev. C. Pilkington, Stockton Rectory, Southam.

S window, St George's Chapel (**6.6a & b**)	sXII	2.6m x 5.4m	2 lancets	£135

Original design by Pugin likely to have been reworked by J.H. Powell prior to the window being made.

Description. **sXII.** 2-lancet window with a single large cinquefoil tracery-piece. Scenes from the Life of St Paul are

illustrated in four large blue circular medallions, two (one above the other) in each lancet. The scenes represent, top first: the Conversion of St Paul and St Paul before Festus in the left-hand lancet, and St Paul preaching at Athens and the Martyrdom of St Paul in the right. The medallions are held in place by iron frames which form part of the design pattern of the window. Between the medallions are blue diamonds (also part of the iron frame) which are flanked by blue semicircles. The diamonds are patterned with purple and green leaves, arranged in a cross formation, which emanate from the rectangular, yellow-patterned centres of the diamonds. The semicircles are patterned with green and yellow leaves, and bunches of purple grapes. There are also diamonds above the top medallions which are not part of the iron framework but are outlined in white(?)-beaded glass. The remaining areas of the lancets are filled with long narrow green and yellow leaves on sinuous white and yellow stems against red grounds, apart from the bottom panels – which are isolated from the rest by lines of yellow-beaded glass – where the ground is blue.

Similar type leaves to those in the general backgrounds of the lancets are attached to stems that undulate around the wide borders – the undulations are filled, alternately, with red and blue glass. Lines of white glass run around the outsides of the borders, and red and yellow-beaded, around the insides. The tracery-piece is patterned with geometrical shapes, white florets, and leaves like those in the lancets, on blue grounds.

Office records. Order Book, 1851, f. 139, Aug. 20 (sXII). *First Glass Day Book*, 1852, f. 153, Jul. 17 (sXII).

Pugin sketch, BM & AG a. no. 2007-2728.8, of sXII (**6.6c**): the sequence of scenes in the sketch are: left-hand lancet, top – martyrdom, bottom – conversion; right-hand lancet, top – before Festus, bottom – preaching at Athens.

Letters. HLRO 304: *Pugin to Hardman*, letter no. 572: 'That window for Chichester is admirable for width and appears to me well calculated for subjects, but it is certainly an early window & should I think be painted in the same style as those at Sens & Chartres with magnificent mosaic work between I hope it will be done in this manner we can send a design for him to see on this principle which I think is best adapted for that at Chichester we could make a fine job of this you better write to him to that effect.' No. 568: 'I hope to send you the drawings for Chichester & c on Monday'. No. 564: 'I send you the window for Chichester which I think is a good job & will come out very rich in glass I dont understand the space at bottom & have left it in Pencil pray get this inspected for I think there is something wrong about it. These sort of window designs are no joke.' *JHA: Pilkington to Hardman*, 1851, May 14: 'Enclosed I send a drawing of a Window in our Cathedral, in which I mentioned to you I was anxious to place Painted Glass. The design will be determined as soon as I have received from you information on one or two points. Do you consider the style & size of the window best adapted for a Scripture subject containing several figures or for single figures only? if the latter, how many; two or four? On hearing from you I will decide [?] on the design & then request you to send a sketch.' *I. Bishop to Hardman*, 1852, Aug. 1: 'I have got the window in at Chichester. Mr. Butler thinks they will look verry [sic] well but it was getting dark on Saturday night before they was all put in. I think the window looks very well there is one of Connors opposite.' *J. Butler to Hardman*, 1852, Aug. 2: 'Your window was put up late on Saturday'

Note: There is a letter in the archive from Butler to Hardman dated Jun. 19, 1849 which reads: 'Your glass arrived here yesterday afternoon. The Dean is not here at present and will be absent for 2 or 3 weeks – You may rely upon every care being taken of the glass until his return – and that your instructions shall be followed when the glass is exhibited. I now write to Mr. Carpenter to this effect and for myself beg your acceptance of my best thanks for your compliance with his request [clearly this glass can have nothing to do with the cathedral window but perhaps was intended for R.C. Carpenter's, St Peter, Chichester. There is no record in the First Glass Day Book of windows being made for this church].'

Literature. Wedgwood (Pugin's Diary): Pugin visits Chichester, 1850, Nov. 8.

185 Staplefield, near Crawley, St Mark (CoE)[69]

1852. Client: Rev. W. Wilson. Glass replaced perhaps c.1914, the year of the death of the person commemorated in the present window.

Office Records. Order Book, 1852, f. 174, Mar. 12: '? what price given by Mr. Pugin – price Letter Oct. 29 1851 £100 – do. Jan. 27 1852 £5 extra.' *First Glass Day Book*, 1852, f. 166, Dec. 27: 'To A Stained Glass East/Window of 3 Lancet/lights/£105/Centre light 14'6" x 1'10".../2 Side lights 11'8" x 1' 6½" .../.../Subject in Centre light/"The Crucifixion" & "The/ Scourging of Our Lord"/& in the side lights 'The/Four Evangelists. 2 in each light'; 1854, f. 205, Jan. 4 'see entry previously of Dec 27th/1852, folio 166/Lattice for window'.

Letters. *JHA: unknown to Hardman*, 1852: Jun. 5: 'I was glad to receive your letter of Mar. 12 informing me that the Cartoons of Windows to my ch: had been sent to you by Mr. Pugin and were beautiful in design'. *Letter Book, pp. 166-7: Hardman to the Rev. Robert Wilson*, 1853: May 27: 'I can only suppose that when Mr. Pugin wrote the letter which you

quote of January 11 he made a mistake & put £80 instead of £100. At that time he was very far from well in fact the fatal malady which carried him off was growing rapidly upon him.'

186 West Lavington, St Mary Magdalene (CoE)

1850, 1852. Clients: Rev. Charles John Laprimandaye, Graffham Rectory, Petworth (I); Rev. James Currie (the remainder). Supervising architect: William Butterfield.

Chancel E window	I (glass replaced)		3 lancets		1850
W window	wI	1.3m x 2.5m	3-light	£25	1850
Chancel N window	nII	1.1 x 2.1m	2-light		1852
Chancel S windows	sII, sIII	1.1m x 2.1m	2-light	£69 (for nII, sII, sIII)	1852
S aisle E window	sIV	1.1m x 2.0m	2-light	£15	1852
S aisle window	sV	(replaced c.1897)	2-light	£15	1852
S aisle window	sVI	(replaced c.1917)	2-light		1852
N & S aisles W windows	nVI, sVII	0.3m x 1.4m	1-light	£7.10.0	1852
N aisle E window	nIII	0.3m x 1.4m	1-light	£3.15.0	1852
N aisle windows	nIV, nV	1.2m x 2.3m 2 lancets		£30	1852

Much of the paintwork and grisaille in the windows has worn away.

Descriptions. **wI.** 3-lancet window and tracery. St Michael is depicted in a medallion in the centre lancet, and an angel in a medallion in each of the side lancets. The saint is in a red mantle over an orange robe and has a shield emblazoned with a yellow cross on a white ground strapped to his left forearm. He stands barefoot in a frontal pose on a green-winged, red dragon, thrusting a lance, held in his right hand, diagonally down its throat. The angel in the left-hand lancet is in a green-lined cape over a yellow mantle and a blue robe and holds a fish by its head, in his right hand The angel in the right-hand lancet is in an orange-lined, blue mantle over a red robe and holds a sceptre in his left hand. The medallions are contained in the lower sections of the lancets. They are outlined in red and the spaces left by the figures are filled with a white leaf-on-stem grisaille in which the leaves and stems are outlined in black, and spread across the black lines that form white borders with the lines of the leads. The remaining areas of the lancets are filled with a similar grisaille, overlain by a vertical series of touching red-outlined, leaf-patterned quatrefoils which link with the medallions. The borders are patterned with florets on red and green grounds. The three tracery pieces contain geometrical shapes patterned with leaves and flowers on white grisaille grounds.

nII, sII, sIII. 2-lancet windows, each with a large quatrefoil tracery-piece. The top and bottom panels of each lancet are filled with geometrically patterned grisaille and between them is a saint depicted standing in front of a coloured foliage diaper screen, under a canopy. St Anne and St Mary Magdalene feature in the left- and right-hand lancets, respectively, of nII; St John the Evangelist and St Luke, sII; and St Mark and St Matthew, sIII. St Anne is in a green-lined, blue, hooded mantle over a brown robe, holding a book in her right hand. St Mary Magdalene wears a white head-dress and is in a green-lined, orange mantle over a red robe, holding a white ointment jar, touched with yellow silver stain, in her left hand. St John the Evangelist is in a white-lined, red mantle over a green robe, holding a quill in his right hand and with a scroll inscribed in yellow-on-black with the text, 'in principe er[...]' curling over his left forearm and falling diagonally across his body to the head of a brown eagle (which stands in profile, with its head turned back looking to the left) at his feet. St Luke is in a green-lined, brown mantle over a blue robe, holding one end of an inscribed scroll in his right hand and a quill in his left. A green-winged, green ox sits in profile at his feet, with the other end of the scroll resting against its chest, St Mark is in a brown-lined, yellowish-green mantle over a yellowish-green robe, holding a quill in his right hand and pressing a curving, inscribed scroll against his body, with his left. A yellow lion sits in profile at his feet with its head turned towards the onlooker and its right front paw reaching up to the saint. The bottom end of the scroll rests against the left side of its face. St Matthew is in a blue-lined, red mantle over a yellow robe, holding a quill in his right hand, and with an inscribed scroll looped over his right forearm. An angel in a green-lined, white mantle over a white robe, half kneels in profile at his feet. The canopies have cinquefoil heads surmounted by white-patterned, yellow-crocketed and finialed gables. Bands of yellow-on-black patterning that have the appearance of parapets, run the width of the lancets behind the apices of the gables. The grisaille is similar to that in wI with the overlying geometrical patterning in each panel consisting of a red-outlined quatrefoil crossed by diagonals of yellow-beaded glass. At the centres of the quatrefoils

are bosses containing geometrical patterns made up of stylised, red, green, white and orange leaves. The borders are patterned with continuous undulating (vertical in nII) yellow stems with white leaves attached, on red and blue grounds. In the right-hand lancets of sII and sIIIi the leaves are replaced by six-petal white flowers. The quatrefoil tracery-pieces have geometrically-patterned centres on white grisaille grounds.

sIV. 2-light window with a large cinquefoil tracery-piece. The lights each contain a scene in a medallion, that in the left-hand light being St Mary Magdalene annointing the feet of Christ, and in the right-hand light St Mary Magdalene at the feet of Christ (John, Chap II v. 32 (?) – see Butterfield's letters below). The medallions are red-outlined, blue foliage diaper quatrefoils with elongated convex sides. They are linked at the tops and bottoms with red-outlined, leaf-patterned diamonds that overlay the white grisaille that fills the remaining areas of the lights. The grisaille is made up of leaves and stems outlined in black plus an occsssional, similarly defined, four-petal floret. The borders are similar to those in nII but the stems undulate, the leaves are larger and the red and blue grounds correspondingly smaller. The tracery-piece contains a rosette-and-leaf-patterned red roundel surrounded by patterns of white and yellow leaves on blue foliage diaper ground.

nVI, sVII. Single lights filled with a grisaille made up of white leaves on white stems, all outlined in black, overlain by a vertical series of red-outlined quatrefoils with floral-patterned centres, each crossed by yellow-beaded diagonals. The leading patterns comprise: diamonds which run down the centres of the lights enclosing alternately, the patterned centres of the quatrefoils and the flower-patterned ovals formed by the outlines of the quatrefoils as they link together; and non-touching semicircles along the borders. The borders are patterned with continuous undulating yellow stems with white leaves, on blue and red grounds. There are two small white leaf-patterned tracery-pieces that define the top corners of the rectangles formed by each of the lights.

nIII. A single-light window filled with a white leaf-on-stem grisaille overlain by red-outlined diamonds containing leaf-patterned roundels. The leading patterns comprise a vertical series of diamonds crossed by vertical and horizontal leads. The borders are patterned with red and blue florets on white-patterned grounds.

nIV, nV. 2-light windows (nV are lancets) and single tracery-pieces. The lights are filled with quarries patterned with white leaf-and-stem grisaille, overlain by geometrical patterns. The patterns in each light of nIV are similar to those in nVI and sVII except that the quatrefoils are not linked together but are separated by diamonds patterned with red *fleur-de-lis* around blue rosette centres. The borders are similar to those in nVI and sVII. In the tracery-piece, is a yellow-foliated cross enclosed in a circle of leading, and flanked on the outside by two yellow leaves. The rest of the piece is filled with white leaves on a green-patterned ground. The patterns in each light of nV comprise blue-outlined quatrefoils with patterned centres, over-and-underlapped by red-outlined bulbous shapes. The leading patterns consist of: concentric bulbous shapes within the bulbs; circles at the centres of the quatrefoils, touched tangentially by segments of larger, flanking circles that have their bases on the insides of the borders; diagonal lines that pass through the centres of the quatrefoils and the bulbs; and parallel diagonal lines that meet on horizontal axes through the centres of the bulbs. The borders are patterned with white leaves on continuous vertical yellow stems against red and green grounds. The dagger-shaped tracery-piece has a leaf and floret-patterned centre and is filled with a white grisalle.

Office records. *Order Book*, 1850, f. 95, Jul. 25. *First Glass Day Book*, 1850, f. 103, Oct. 28: 'An East Window of/Stained Glass of 3 Lights/£95/1 Centre Light/8'10½" x 2'3"/2 Side do 8'7" x 1'9½" /& 7 pieces of Tracery;' (wI); 1852, f. 138/9, Mar. 10 (nII, sII–sIV), '2 Side Windows of Stained/Glass of 2 Lights each &/Tracery for South Aisle/Each Window 2 Lights/6'5" x 1'7½"/1 Tracery piece/1'6" x 1'6"/1 do.do./Geometrical Grisaille glass/£30 [sV, sVI]'; (sVII, nIII–nVI). *Cartoon accounts per ledger summary*: I, Powell £7.10.0; wI, Powell £2.5.0. *Pugin sketch*, BM & AG a. no. not allocated, for I.

Letters. HLRO 304: *Pugin to Hardman*, letter no. 594: 'leave the Hatching out of the Lavington Window if they <u>are so inclined</u>. it will save money & give us more. by all <u>leave it out</u> [sic].' No. 584: 'the side windows of Lavington are not begun I have already told all sorts of lies but the truth is that we have not been able.for the study is a joke it is now completely broken up for <u>3 weeks</u>. Early has been coming[?] for 3 weeks before this began. it was broken up at Easter – it is a joke I know it cannot be helped but we we [sic] cannot make any cartoons as things go. I will do the Lavington windows as soon as possible but Cumbrae [College, Gaz.214] error[?] is not treated[?] we use Butterfield very bad we do nothing for him & I have 7 windows ordered by him.' No. 179: 'I have been working exceedingly hard today & have marked S. Mary Magdalene [Munster Square, London Gaz 59] greenwich east window [Our Lady Star of the Sea, Greenwich, Gaz 53] Chancel & aisles Lavington'. No. 732: '2. Powell has done an admirable group for Lavington [sIV(?)] the first true thing in the way of a group that has been accomplished I assure you when you see it you will understand my extreme disgust at the Sheffield [St Marie, Gaz.145] window. this is what I have always been trying for & could not get that heathen Oliphant never could do it. no man who has worshipped Baal & the Beast[?] can ever sort out the

true thing. I knew we were wrong, I know we can never completely [?] but with Oliphant it was impossible he is only fit for Late debased style.' No. 734: '2. When you see the groups for Lavington you will say that all previous <u>cartoons ought to be burnt</u> indeed I don't think I would give 1s for the lot.' *JHA: Currie to Hardman*, 1851, Oct. 3: 'As the glass for West Lavington Church has been so long delayed I am desirous of making an alteration in the subjects of the Chancel windows and have written to Mr. Butterfield on the subject. I have to request therefore that as I have left the decision with him you will take no further steps in the matter till you hear from him. I am quite willing to wait for the new glass for the Nave windows. My letter of the 1st was not to be taken as a sign of impatience & have the windows done, but as a means of ascertaining that there was <u>a purpose of doing them</u>.' Oct. 20: includes dimensions of various windows and continues: 'I would be obliged by your stating also the additional cost if any which will be occasioned by the substitution of the figures of the four evangelists for those originally designed.' Oct. 30: 'Not being able to hear anything about the glass ordered for West Lavington Church and concluding from this that no progress has been made in it, I write to say that I will give you no further trouble in the matter but will withdraw the order and get it executed elsewhere.' Nov. 10: 'N & S aisle windows are all two light windows, E & W windows of N aisle & W windows of S aisle are single lights. All these windows with the exception of the East Window of South aisle which will have figures are to have geometrical grisaille glass, the glass to be of the new kind you were having made for this purpose.' Nov. 17: 'I should be obliged by your putting the windows in hand immediately. You will hear shortly no doubt about the Aisle Windows, all the others are I think decided on and may I suppose be proceeded with.' Nov. 24: 'Mr. Butterfield wished me to decide about the East aisle window – I have to say therefore that I adhere to my own suggestion – that the two acts of Mercy mentioned in Mr. Butterfield's letter to you should be represented in it.' 1852, Apr. 2: 'I shall be glad to have your bill for the glass. We are on the whole well satisfied with it. You have probably seen Mr. Butterfield and heard from him his opinion of it. He also undertook to speak to you about the East Window – I do not think it has given entire satisfaction to anyone – & it will certainly require considerable alteration & make it harmonize tolerably with the later glass I need not go into details on the subject as Mr. Butterfield undertook to see or communicate with you on the subject. generally we think the side lights overcharged with yellow colour which gives a disagreeable hue to the whole window, especially the canopies and their shafts – the quatrefoils above & below appear to me too strong – and generally the whole ground of the window wants lightening – The central figure was objected to by Mr Woodyer a short time back as not being a religious figure – and Mr. Scott who has also seen it agreed I think in this opinion – I do not know whether it can be altered in any way – there are other details which Mr. Butterfield undertook to point out to such as the Arcading above the figures – and the Tombs which are not pleasing and the upper compartment of the tracery I think very poor ... the window does not tell its own story with sufficient <u>distinctiveness</u> as <u>very</u> few persons understand it at first sight'. Apr. 22: settles account for windows. *Letter Book: Hardman to Currie*, 1851, Oct. 1: 'I am exceedingly sorry the windows should have been delayed so long but preparing for the Exhibition in the commencement of the year & men visiting London since to see it have completely thrown my work behind. Trusting under the circumstances you will recall your letter of the 1st Inst. ... I am trying to get a new Cathedral glass made of the grisaille ground which shall not be quite so clear as the modern glass & I am promised some very soon but I'm afraid you have been kept waiting so long that you will not like any additional delay. Otherwise it would be an immense improvement to the windows.' *I. Bishop to Hardman*, 1852, Mar. 18: 'I shall finish here on Friday night & go on to Ramsgate on Saturday. the glass looks very well and Mr. Currie is much pleased with them he wishes to have some alterations in the East Altar Window he thinks there is to [sic] much Colour in it he thinks it looks too yellow the side lights in particular he has explained to me what he wants I am to tell you & then you are to write to him & let him know if it will do – to alter it'. Mar. 23: 'I have told Mr. Powell what he [Mr Currie] wants & he states it can be done up here [Ramsgate].' *Butterfield to Hardman*, 1851, Apr. 3: 'I had supposed the Cumbrae [College, Gaz 214] window was ready ... I lay great stress on the grisaille of this window. There were 2 shades in the Lavington East Window which was very unpleasant.' May 13: 'Can you tell me what is doing about the side windows for Lavington Chancel. They are very urgent for them. You will remember that you furnished an East Window.' Jul. 10: 'I have sent a check [sic] to the banker today for £98.19.0 the amount of the Lavington East Window'. Sep. 18: 'How does the Lavington glass go on. I want a memorial inscription to be inserted at the foot of the East Window – which is now there – It will be very short thus. + In memory of John Hubbard by his children John, Anne, and Ellen.' Sep. 30: 'It is thought best that the inscription for the foot of the East window at Lavington should only be thus. + In memory of John Hubbard who died 6th January 1850'. Nov. 15: 'Will you write to Mr. Currie for templates. He is anxious for the glass. He proposes 2 of the acts of St. Mary Magdalene for the East Window of South Aisle. The church is dedicated in memory of her. I am not fond of subjects but perhaps to please Mr. Currie this might be managed. Is it possible?' Nov. 21: 'The two subjects Mr. Currie wishes are in the 11th & 12th Chapters of St. John's Gospel. He seems to wish it very much as the Church is dedicated in memory of <u>St. Mary Magdalene</u>.'

Literature. The Ecclesiologist, 10, 1849, pp. 67-9: description of the church but no mention of the stained glass.

WEST YORKSHIRE
187 Badsworth, St Mary the Virgin (CoE)
1852. Client: Rev. H. S. Champneys.

Chancel S window (**10.36a & b**)	sIII	1.6m x 2.5m	3-light	£60

Description. **sIII.** 3-light window and tracery. The centre light contains portrayals under canopies, one above the other, of the Virgin Mary and Dorcas, and the left- and right-hand lights, respectively, Ruth and Hannah; and Sarah and Anne. Inscribed scrolls undulate around the figures who stand in frontal poses, before patterned-drapes hung from rods inclined downwards on each side, to give the impression of space behind the figures. The drapes are red, except for those behind Sarah and Dorcas, which are orange and green, respectively. The Virgin Mary wears a white head-dress and is in a green-lined, blue mantle over a purple robe. Dorcas wears a green turban and is in a blue-lined, red mantle over a silver-grey short-sleeved tunic and a brown robe. Ruth wears a beige turban and is in a green-lined, red mantle over a beige robe belted at the waist. She holds a sheaf of wheat in her right hand. Hannah wears a creamy-white turban and is in a blue-lined, yellow mantle over a purple-lined, creamy-white, yellow-belted robe, holding the right hand of the bare-footed child Samuel in her right. Samuel is in a green robe held in by a belt patterned with white, diagonal crosses on a black ground. Sarah wears a red turban over a loose white wimple-like headdress, and is in a green-lined, reddish-purple mantle over a light violet robe. Anne wears a white turban, over a loose wimple-like headdress and is in a green-lined, blue mantle over a beige robe. The canopies over the top figures are vaulted, with pendants, and three of their sides are shown in perspective – the central sides are parallel to the window plane. Each side has a trefoil head contained within a yellow-outlined, four-centred arch surmounted by pairs of large yellow single-leaf crockets and tall yellow, foliated pinnacles, and are flanked by niched, gabled and pinnacled buttresses. Behind the arches are niched rectangular walls with moulded parapets, above which rise the superstructures comprising hexagonal towers (three sides are visible) with niched sides, zigzag and trefoil-patterned parapets and conical crocketed and finialed tops. The lower canopies are without towers; the heads of the central sides alone are visible and these are in the form of Tudor arches decorated with large yellow leaves on undulating stems. The superstructures over the arches, which act as bases for the upper canopies, comprise niched rectangular walls with upper bands of floriated ornament under yellow and white mouldings. The interiors of the heads of all the canopies are lined with red stonework, below which the tops of the two round-headed, cusped, open arches can be seen (the standing figures obscure the spaces between the arches which may or may not contain a third open arch) trees silhouetted against the sky can be seen through the arches of the left-hand upper canopy and trees and buildings through those of the middle and right-hand lower ones. The inscription at the bottom of the window is the same as that recorded in the Order Book, except that the date of Lucy Champney's death is inscribed 1840 instead of 1849, and the Rev. Hornby is referred to as Rector of Winwick in Lancaster instead of Lancashire. The two central tracery-pieces are filled with white leaves on stems that encircle small yellow grotesque lion-heads on red grounds. The other two pieces are filled in similar fashion but the lion-heads are replaced by green rosettes.

Office records. Order Book, 1851, f. 127, Feb. 5: : 'In memory of Lucy, Widow of Revd. William Henry Champneys (and daughter of the Revd. Geoffrey Hornby, Rector of Winwick in Lancashire) she died Nov 25 1849 aged 74 Her Children arise up and call her blessed'. *First Glass Day Book*, 1852, f. 136, Mar. 2 (sIII); f. 140 Mar. 22: 'To 15 Coloured Etchings/of stained glass window /[sIII]/£15'; f. 143, Apr. 21: 'To One Coloured Etching/.../£1/sent March 2nd 1853 [sic]'. *Pugin sketch*, BM & AG a. no. 2007-2728.9, of sIII (**10.36c**).

Letters. HLRO 304: Pugin to Hardman, letter no. 795: 'This is a horrid window for Mr. Hornbys nephew how is it possible to explain his ideas about all these holy people in a window where balance of colour is everything – the lights are only 1.7 & they require regular subjects to explain what he wants however I will do my best'. No. 568 'I hope to despatch the window for Mr Hornbys nephew which I think be a fine job [sic].' No. 570: 'Powell has a great many cartoons ready & a capital set for Mr Hornbys nephew so you better let him know that the cartoons are ready.' *JHA*: included in the archive is the following list from Champneys to Hardman, giving reasons for including the respective figures, and recording the texts which were eventually inscribed on the scrolls around them:
'1. The Virgin Mary as an example of Humility & Faith – underneath the figure the words "Behold the Handmaiden of the Lord. Be it unto me according to thy word"
2. Ruth as an example of Filial Love & Duty "Ruth love[?] unto her."
3. Sarah as an example of Conjugal Duty "Even as Sarah obeyed Abraham, calling him Lord."
4. Hannah presenting Samuel in the Temple as an example of Maternal Love & Piety. "As long as he liveth he shall be lent unto the Lord."

5. Dorcas – as an example of alms – deeds & good works – "And all the Widows stood by weeping & shewing the coats & garments which Dorcas made, while she was with them."

6. Anne in the Temple as an example of Devout Widowhood "Which departed not from the Temple but served God with fastings & prayer day & night".'

Champneys to Hardman, 1851, Feb. 3: 'I beg to return you the sketch of proposed window. The only alteration I should wish is Samuel removed from Hannah's arms [he is cradled in Hannah's left arm in the Birmingham Museum and Art Gallery sketch] & placed on the ground taking the Mother's hand. This I think more correct from the recorded age of Samuel & it may prevent the confusion of a familiar idea with the intended one'. May 24: 'when may I expect the Cartoons for my poor Mother's Window ?' Aug. 1: 'Can you [?] give me any idea as to the probable time I may expect the Cartoons from Mr. Pugin for my window?' Oct. 27: 'My Friends patience is quite [?] and almost exhausted. Can you kindly inform me when the Cartoons of my Window will be ready for my inspection? It is now nearly a year since you undertook the Window & I am anxious for its completion' Nov. 21: I dispatched the cartoons from Lichfield yesterday & hope you have received them safely. I am much pleased with them, and doubtless[?] the Window when finished will be much admired. I have shown them to many members of my Family, the Rector of Winwick amongst others. He tells me Mr. Pugin courts inquiry & is ever ready to take a hint – If so I should much like Samuel, the only figure found fault with, altered. He looks more like a stunted man, than a Child – face too old – hair hardly flowing enough, hands & feet much too large. I think too he would look much better in white, but this may not harmonise with the other colours. Then Sarah is too old for the place she occupies, coming before Hannah, could not her face be made rather younger? I simply offer these as hints. I am afraid you will not get the whole of the inscription in at the bottom. If anything is omitted it must be "daughter of Revd. G. Hornby Rector of Winwick" "Her Children arise up, and call her blessed" must be inserted [The whole inscription was included in the window]. How soon are you likely to finish it? and may I when completed have the Cartoons?' *J.H. Powell to Hardman*, 1851 letters dated 'Sunday': 'The cartoons will start tomorrow of Algarkirk [Gaz.105], M. Minsell[?] M. Champaneys [sic] which are all you want immediately.'

188 Clifford, St Edward (RC)

1848. Client: Rev. Edward L. Clifford, Clifford, Tadcaster.

N aisle windows (**6.4a–c**)	nIII, nV	0.7m x 2.3m	1-light	£70	

The two windows recorded in the First Glass Day Book can be satisfactorily identified as nIII and nV from the details given in Clifford's letter dated Sep. 9, 1848 (see *Letters* below) of the subject matter and the diamond trellis diaper background. Both Clifford (letter Sep. 24, 1848) and Pugin (HLRO 304, letter no. 102) refer to four windows, but it would seem that the additional two were never ordered. Clifford's letters also refer to four smaller windows for the Blessed Sacrament Chapel and Pugin appears to have worked on designs for them. The sketches that are in the Victoria and Albert Museum (see Wedgwood, below) were probably for the two additional large windows (or possibly they are the two sketches for the larger E window in the Blessed Sacrament Chapel referred to by Clifford in his letter dated May 7 1850, or even those referred to in the letter written from St Matthew's) and there is a sketch for a small window in the Birmingham Museum and Art Gallery. It seems probable that because of lack of funds the four smaller windows were never ordered; there is no reference to them in the First Glass Day Book and the E and three S windows currently in place in the Blessed Sacrament Chapel are marked 'A. Lusson et E. Bourdont Paris 1854' and 'A. Lusson Paris 1854', respectively: the E window carries the inscription 'Orate Pro Animate, George et Marine'.[70]

Descriptions. **nIII, nV**. Single-light, rounded-headed windows each of which contain three blue foliage diaper roundel-medallions outlined in white-beaded glass. Similarly outlined within each medallion is a quatrefoil (the outline of the foils of which merge into the circumference of the medallion) containing a figured scene. The scenes in nIII are from the life of St Anne (Meeting at the Golden Gate; Birth of the Virgin Mary; Teaching the Virgin to read) and those in nV, from the life of St William of York(?) (Consecration of St William; Audience with the Pope; Return to York as Archbishop (?)). The remaining areas of the lights are filled with a diamond trelliswork in yellow-beaded glass (with red four-leaf florets over the points at which the lines of the trellises meet) infilled with a blue diaper patterning of foliated-crosses. Lines of white-beaded glass run around the insides of the borders of the lights and are complemented by fillets of white glass around the outsides. The borders are patterned with white lilies, each flanked by two green leaves, and yellow four-petal flowers, on red and blue grounds.

Office records. *Order Book*, undated, f. 27 (nIII, nV). *First Glass Day Book*, 1848, f. 40, Aug. 29 (nIII, nV). *Cartoon costs per ledger summary*: nIII, nV, Powell £2.0.0, Hendren £1.16.8. *Pugin sketch*, BM & AG a. no. not allocated, probably in respect

of a window, never made, for the Blessed Sacrament Chapel.

Letters. *HLRO 304: Pugin to Hardman*, letter no. 815: 'I am working away at Mr. Cliffords window'. No. 102: 'There are 4 windows for Mr. Clifford 2 arrived first which are the 2 Powell will bring down'. No. 1002: '1. The following are the prices you want 1. Revd. Mr. Cliffords windows £35 each'. No. 955: '3. I send you the sketches for Mr. Cliffords window – the prices I have put down is about what I think the glass is worth independent of iron work but I hardly think I have put down enough so you better add for them as this small glass is troublesome & [paper torn] in Leading up.' *JHA: Clifford to Hardman*, 1848, Sep. 9: 'The windows arrived here last night but I am sorry to say are 3 inches too short – you have made them <u>7 feet 4 inches long</u> whereas in the Dimensions I sent to Mr. Pugin I put <u>7 feet 7 inches</u>, & if he has the note I sent he will find it as I say. I am indeed sorry for the mistake as the windows are beautifully executed & compared with the three that are already in, are "Hyperion to a Satyr!" My suggestion for both would be to take off the bottom margin, & either add three inches of the ground work diamond diaper, or make a fresh bottom altogether. But you will know best what to do & the sooner the better. The rest of the window fits beautifully exact. There is one crack, but it is of little consequence & will not be noticed. I would also wish to know the parts of history wh: are represented. I suppose one is St. William & the other St. Ann – '. Sep. 16: 'I have just returned home & find yours of the 12th & will do as you say in regard to the bottom pieces of each window – viz. return them but I think it will not be exactly right for me to undergo the expenses of carriage & c, as the fault is very plainly on any side but mine'. Sep. 19: 'I have sent the case with the bottoms of the windows today ... I hope they will soon return, as the Church is open to all weathers until they return'. Sep. 24: 'Though I only recollect ordering two windows yet there are four to be made, but before you commence them I should like Mr. Pugin to know that though I like the two that have been sent yet I would prefer the <u>darker style</u> of Norman windows viz in <u>small compartments, & many</u>, with a course of the life or subject whatever it may be that is shewn. I shall feel obliged therefore if you would not commence them until I have had some conversation on the subject with Mr. Pugin wh: I hope to have shortly at the dedication of St. Cuthbert's [Ushaw, Gaz. 40, chapel consecrated Sep. 27, 1848, and opened on Oct. 11] where I propose to attend. 1849, May 15: 'sending money off for windows – cheque £20 and a half £10 note & other half on hearing of their safe arrival – money received from <u>donors of windows</u> by £5 a time.' Aug. 22: 'I have had a promise of the four windows in my chapel of Bd. Sacrament wh: I am anxious the donors should obtain from you – but I think designs would make them more anxious & I should prefer the whole of the windows to agree with one another & tell their tale together [includes outline sketches of and gives dimensions for round-headed windows viz; one 8'3" x 2'3" looking E and over the altar', two 4'7½" x 1'8½"; and one 4'7½" x 1'4½" these latter three look S, with the third running up against the wall so making it narrower than the other two]. I do not wish you to begin the windows, but if a good subject was given & a design for each it would perhaps make the donors choose yours, rather than one whose glass I <u>abominate</u>. Let me know if any expenses will be incurred from these arrangements, as I could not incurr [sic] any such, except what the donors will give towards the windows wh: you would favour me greatly by naming price of each. You must think me a bad customer by this time but I assure you it is not my fault your bill has not long ago been settled.' 1850, May 7: 'I have had a present made of one of the <u>small</u> windows in the Chapel Bd. Sacrament if it is only £12; but no more. Now could you not change your figures & make the three at £12 each, as money is hard to get & even two pounds more frightens those who are inclined to give. I return you the sketches of the windows with the order of them to be these [sketches the outline of the three small windows each of which contains two large roundels separated by a small diamond; the scenes named in the roundels: top one first: 1st window, Sacrifice of Abraham; Offering of Melchizedek; 2nd window, Passover; Manna in the Desert; 3rd window (truncated by the wall) nothing suggested], as the large window will be completely changed, according to one of the two designs sent since, & wh: I retain to show any good soul that will offer to give it, as Mrs. Maxwell has entirely given up all intention to do so.' Undated (written from St Matthew, Clifford, Tadcaster) – 'I am anxious to have as soon as possible a stained glass window of the following dimensions [sketches a round-headed window 4'6" x 2'3"] according to the centre part enclosed design No. 2 of Pugin. It is destined to be in the most prominent place in the Church'. 1851, Jan. 13: apologises for inability to pay for the windows already sent. 'I hope the window I last ordered is near its completion as the Revd. Philip Vavasour who is the donor is most anxious to see it in its place. I have also had an offer of the 3 other windows of the Chapel of the Bd. Sacrament, the drawings of which I returned to you but are given on condition they shall not cost so much – £7 a piece is offered to me, but I will if you choose make up £25 for the three'. Feb. 27: 'I was surprised not to hear from you when I last wrote about the windows of the Chapel of the Bd. Sacrament. I have had great trouble in getting the order from Revd. Philip Vavasour & Mr. Marmaduke Maxwell & am therefore anxious they should be worthy of their situation in my church & still more anxious to have them fixed.' *Letter Book: Hardman to Clifford*, 1850, Jun. 28: 'Price of 3 windows if ordered all together £12 each'.

Literature. Wedgwood, 1985: catalogue no. 279: 'Two preliminary designs for round-headed single light stained glass

windows, c.1848 Insc. 1, 2; – 1 seems to be connected with Leviticus, and 2 book of Revelations'.

189 Keighley, St Anne (RC)

Willement 1812 to 1865 includes under 1840: 'Keighley Chapel (R.C.) Yorkshire, The same [this refers to the previous entry which names Augustus W. Pugin as the client] Heraldry & c.' This description may have been alluding to decoration in the chapel rather than the manufacture of windows, if, however, heraldic windows were made by Willement, it is not known to the author if they are still extant – Pevsner, *The Buildings of England: Yorkshire: The West Riding*, Harmondsworth, 1967, p. 281, says 'the original very modest building was much altered and enlarged in 1907.'

190 Leeds, St Saviour (CoE)

W window	wI	3.7m x 7.7m	5-light	c.1845	
S transept S window	sVI	3.7m x 7.7m	5-light	c.1846	.
N transept N window	nVI	3.7m x 7.7m	5-light	c.1846	

Pugin designed the windows in 1844 (see Wedgwood (Pugin's Diary), below) which were made by Michael O'Connor.

Descriptions. **wI**. 5-light window and tracery, the centre light being taller and wider than the other four. The upper halves of the three middle lights contain a representation of the Crucifixion, with Christ on the cross within a red and blue triangular-chequered diaper mandorla, all under a canopy, in the centre light and St Mary the Virgin and St John the Evangelist under canopies, in the inner side lights. Yellow bands of glass separate St Mary and St John from those of the two Marys under canopies beneath them and a similar band cuts across the centre light, running behind the cross, to isolate St Mary Magdalene, who is depicted kneeling at the foot of the cross. Beneath St Mary Magdalene and separated by yet another yellow band, is a large rectangular panel containing three standing angels depicted beneath canopies, holding texts. Two male figures under canopies (the Centurion and St Joseph of Arimathea) stand on a line with the two Marys, in the outer lights. Three angels in quatrefoils, one above the other, are depicted above the canopies in each of the outer lights and another angel is above the gable of each canopy in the inner lights – these form a line with the topmost angels in the outer lights. The bottom panels of the inner and outer side lights containg kneeling angels holding texts. The canopy above the cross has a trefoil head contained within a pointed arch surmounted by a yellow-crocketed and finialed gable. The superstructure that frames and rises up behind the finial of the gable, takes the form of a light blue niche with a trefoil head outlined in white and contained within a similar pointed arch to that of the canopy head. St Mary Magdalene in a long red robe holds a yellow ointment jar in her left hand, a skull rests on the ground beside her, in the left-hand corner of the panel. St Mary the Virgin in a green-lined, blue, hooded mantle over a red robe, stands with her hands pressed together in front of her looking down at the ground. Behind her is a diapered screen of alternate rows of blue and yellow foliated-cross-patterned diamonds topped by a patterned yellow band. St John the Evangelist in a purple-lined, red mantle over a green robe, stands in a corresponding pose to that the Virgin Mary, although he is looking up towards Christ. He holds a yellow-covered book in his right hand. Behind him is a screen diapered with alternate rows of yellow and blue, eagle and chalice-patterned roundels, topped by a patterned yellow band. The Centurion stands in profile looking to the right and up towards Christ. He is in a red surcoat over light blue armour that has yellow kneecaps, shoulders, elbows and spurs. A sheathed dagger hangs from his right side and his sword is on the left. A green lozenge-shaped shield is attached to his left arm. The Mary next to the Centurion adopts a similar pose to him but her hands are pressed together in front of her chest. She is in a yellow-lined, blue, hooded-mantle over a red robe. The screen behind her is diapered with rectangles containing yellow *fleur-de-lis* that alternate with small red squares. The other Mary stands in three-quarter view looking towards the left. She wears a white wimple, and is in a white-lined, blue mantle over a red robe. Her hands are pressed together in front of her chest. Behind her the screen is comprised of yellow diaper octagons interspersed with small red rosettes. St Joseph of Arimathea wears a red cap and is in a blue-lined, red mantle over a blue robe, standing in profile looking to the left. The screen behind him is patterned with a diaper of touching yellow bell-like shapes on a blue ground. The trefoil heads of the canopies within which these figures stand are contained within pointed arches surmounted by yellow-crocketed and finialed light blue gables. The borders, that enclose all but the bottom panels of the lights, are patterned with continuous undulating white and yellow stems with white and yellow leaves attached, against red and blue grounds. The three main pieces in the oculus of the tracery contain blue-rimmed, red roundels patterned with symbols of the passion, set against royal blue grounds decorated with leaves and grapes on white stems, and red rosettes.

sVI. 5-light window and tracery, with the centre light wider than the other four. The upper two-thirds of the centre light contains a depiction, under a canopy, of Christ carrying the cross (the symbols of the evangelists, with inscribed

scrolls, flank the apex of the crocketed and finialed gable surmounting the canopy, and the top of the finial) and the lower third, two crowned saints under a double canopy – the one on the left is, perhaps, King Edward Martyr, and on the right, King Edmund. The other four lights are each split by bands of yellow-patterned glass into three equal parts; each part contains a saint standing under a canopy. From the top down and starting with the left-hand light the saints are: unidentified, St Stephen, St Catherine; unidentified, St Peter, St Agnes; St George, St Paul, unidentified'; unidentified, St Lawrence, St Cecilia. King Edward Martyr(?) and King Edmund(?) are both crowned and in green-lined, white mantles over red robes, standing in frontal poses in front of light blue screens. Edward holds a sceptre in his right hand and an upraised sword in his left Edmund a sceptre in his right hand and an arrow in his left. The double canopy beneath which they stand takes the form of a Gothic window that has two trefoil-headed lights (represented by the canopies) and a royal blue-patterned quatrefoil tracery-piece, all within a yellow crocketed and finialed pointed arch. The first unidentified saint is a male figure wearing a yellow papal tiara, the pallium, and a green-lined, red chasuble over a blue dalmatic and white alb. He holds a crossed staff in his right hand and a yellow-covered book in his left. Behind him is a screen decorated with alternate rows of yellow and blue-patterned roundels on a red ground. St Stephen in a yellow dalmatic over a white alb, carries three stones in his right hand. Behind him is a screen decorated with alternate rows of red and blue-patterned roundels on a blue ground. St Catherine, crowned and in a light blue-lined, red mantle over a light blue robe holds a downward-pointing sword in her right hand and an open book balanced on the palm of her left; a spoked wheel, half of which is visible stands upright against her left leg. Behind her is a screen decorated with rows of alternate yellow and green-patterned roundles on a light blue(?) ground. The second unidentified saint is a crowned male figure in a white-lined, blue mantle over a red robe. He appears to be holding something in his left hand and a downward-pointing sword in his right. Behind him is a screen decorated with rows of alternate red and green-patterned roundels on a yellow ground. St Peter in a green-lined, red mantle over a brown robe, holds the keys upright in his left hand, and a red-covered book in his right. Behind him is a screen decorated with blue-patterned roundels on a red ground. St Agnes in a green lined, white robe, holds a red-covered book in her right hand and an upright green palm in her left. A yellow lamb with white highlights sits, facing the front, on the ground next to her right foot. Behind her the screen is decorated in the same manner as for St Stephen. St George in a blue-lined, red cape over bluish-white armour and pink chain mail, stands on a pink-winged, green dragon, thrusting a lance down its throat with his right hand and steadying an upright shield emblazoned with a red cross on a white background, with his left. The screen behind him is obscured except for a purple-patterned roundel in the upper right corner. St Paul in a blue-lined red mantle over a white robe holds an upright sword in his right hand and a book in his left. Behind him the screen is decorated with yellow and white-patterned roundels on a purple ground. The third unidentified saint is a female figure in a red-lined, white, hooded mantle holding a palm in her left hand. Behind her the screen is decorated with yellow and blue-patterned roundels on a red ground. The fourth unidentified saint is a male figure wearing a papal tiara(?) and a green-lined, blue mantle over a red dalmatic and a white alb. He holds a crozier in his right hand and an open book on the palm of his left. Behind him the screen is decorated with alternate rows of yellow and blue patterned roundels on a red ground. St Lawrence in a yellow-patterned dalmatic over a white alb holds a blue-grey gridiron in his right hand and an open, red-covered book on the palm of his left. Behind him the screen is decorated with alternate rows of red and green-patterned roundels on a yellow ground. St Cecilia has a garland of red rosettes around her head and is in a light blue-lined, white mantle over a purple robe holding a harp in her left hand and playing it with her right. Behind her the screen is decorated with rows of alternate red and green-patterned roundels on a yellow ground. Two different types of canopies are used in the inner and outer side lights. Those at the tops of the lights have yellow-crocketed, trefoil heads with the centre foils formed of ogival curves – crowns are placed just above the apices from which finials reach into the heads of the lights. The rest have trefoil-heads contained within pointed arches surmounted by crocketed and finialed gables, with crowns placed just above the apices of the gables. Apart from the lower panel in the centre light, where the borders are strips of white glass evenly dotted with red florets, the borders are made up of combinations of patterned pieces of green, red and yellow glass on blue grounds. The tracery-pieces comprise in the main nine large trefoils in ascending rows of two, four, one and two; each trefoil contains a frontally-posed, half-length, red-winged, green-robed angel against a royal blue ground, who holds, in front of his chest, a large crown on a purple drape. The remaining pieces are largely concave-sided triangles each of which contain a blue-patterned roundel, overlain with red and yellow geometrical patterns.

nVI. 5-light window and tracery, illustrating scenes from the Passion of Christ. Each of the lights contains two scenes. From the top down, those in the centre light are: Agony in the Garden, and Crucifixion; and in the outer lights beginning at the left-hand side: Betrayal, and Flagellation; Christ before Caiaphas, and Mocking of Christ; Binding of Christ, and Pilate washing his hands; Christ before Pilate, and Carrying the Cross. The scenes are under canopies similar to those at the tops of the side lights in sVI. Between the scenes, and above those at the top, are flower-on-leaf-and-stem

patterns against white diaper grounds. Apart from the centre light where the Crucifixion scene extends down to the bottom of the window, the panels beneath the bottom scenes contain blue roundels in which red-winged, white-robed angels kneel in three-quarter views, looking towards the centre and holding yellow quatrefoil plaques inscribed with the IHS monogram. The window can only be viewed from close to in the confined space behind the organ, so that the content of the tracery cannot ascertained.

Letters. *Wedgwood, 1985, Pugin to Lord Shrewsbury*, letter no. 36 '[?30 Jan. 1844]': 'I am very full of Business just now & amongst other things a large window for Dr. Pusey.' *HLRO 339: Pugin to Lord Shrewsbury*, letter no. 33: 'The Bishop of Ripon has quite spoilt the windows I designed for Dr. Pusey. he has asked the [sic] angels receiving Our Lords Blood to be removed & plain blue glass substituted also the Veronica the coat & dice & several other emblems. very disgusting [none of these items appear in the completed windows].' *HLRO 304: Pugin to Hardman*, letter no. 296: 'I went to St. Saviours Leeds yesterday. I never saw glass before that was calculated to inspire suicide but certainly this is. compared with that our glass is so good[?] for brilliancy & beauty it is perfectly <u>execrable</u>. it is past bearing to look at. It is the sort of glass the devil would have barring the subjects. [The letter appears to have been written prior to the winter of 1848, although there is no specific mention in Pugin's diary of visiting St Saviour's or, indeed, Leeds during that year. He was, however, in the Whitby, York, Ripon area from Sep. 1 to 4].'

Literature. *The Builder*, 3, 1845, p. 564. This account of the church, dated Nov. 4 and taken from the *Leeds Intelligencer*, includes, for the stained glass: ' It is intended that all the windows shall be filled with stained glass of the richest description. At present the whole is not executed [then follows a paragraph concerning the E window]. Of a different conception, is the western window [wI]. The subject of this is the Crucifixion. At the foot of the cross, clasping it in her hands, is the figure of the Magdalen. On either side are seen the three Marys, St Joseph of Arimathea, and the Centurion; and on either side of Our Lord are the figures of Angels, hiding the face [sic] at the sight. The south transept window [sVI] is at present incomplete: it contains in the centre the figure of Our Lord, as the King of Martyrs bearing his Cross, and surrounded by the figures of those saints who have borne testimony to the doctrine of the Cross by sealing it with their blood. The north transept [nVI] window is also incomplete; it is intended to represent the various scenes in the history of the Passion. The painted glass was executed by Mr. O'Connor late of Bristol, now of London'. *The Ecclesiologist*, 8, 1848, pp. 130-1. Part of an article on 'Three Churches in Leeds' which compares O'Connor's E window in St Saviour's with those designed by Pugin, remarking: 'The west window and the end ones of the transepts, designed by Mr. Pugin, are far superior but still liable to criticism . They want relief; and the red which is very predominant in them, is of a scarlet hue in place of the old mellow ruby tint: they are however quite free from antiquation. The west window contains the Crucifixion symbolically treated; the north transept window the scenes of the Passion ending in its awful consummation; the south transept window, Our Blessed Lord, the King of Martyrs, and about Him various holy men and women who followed the example of their Divine Master in yielding their lives for the faith'. *The Tablet*, 6, 1845, p. 724. Paragraph taken from the English Churchman: 'when giving an account of the stained glass in St. Saviour's Church, we were not aware, that the two large windows of the transepts and the west window, were designed by Pugin. We are informed by one who has seen the cartoons for the north transept window, of which one compartment only is completed, that they are the most devotional he ever saw. It is a series containing the history of the Passion, and very remarkable for representing indignities so awful in a manner so very reverent; the absence of this reverence makes most representations of these mysteries so very painful.' G.G. Pace, `Pusey and Leeds', *Architectural Review*, 98, 1945, pp. 178-80. This article establishes Dr. Pusey as the anonymous donor of the church. In respect of the windows Pace comments: 'Through Webb, Pugin offered a design for the great west window; the window with the representation of the "Holy Face" of Our Lord, which was later to be removed at the order of the Bishop.' A footnote adds: 'Pusey writing to Webb says about Pugin's design". "I like his design. The only thing about which one can have doubts is the introduction of the "Holy Face" there are two remaining in Cirencester Church."

Wedgwood (Pugin's Diary): 1844, Jan. 26: 'Dr. Pusey came [Pugin was in London at this time]'; Jun. 10 'At Newcastle. Paid W 40 N [presumably, paid Wailes £40 re St Mary, Newcastle upon Tyne (Gaz.164)], and £15 Dr. Pusey. [This seems to imply that Wailes was involved in the preparation of the cartoons for St Saviour's]'; Sep. 3: 'Dr. Pusey [again in London]'; Nov. 14: 'Finished designs for Dr. Pusey's windows.'

Belcher, 1987, p. 45, re Dr Pusey, quotes the above diary entries, the article by Pace, and also, p. 293, the transcript by C.J. Webb of the journal of Rev. Benjamin Webb which for Jan. 26, 1844, reads: 'Dr. Pusey called on me: examined cartoons of his windows: with him to Pugin's.' Since, on the face of it, Pugin didn't receive the commission from Pusey until the meeting on Jan. 26, 1844 (see letter to Lord Shrewsbury above), the reference to cartoons is puzzling. Perhaps the cartoons Webb examined were in respect of windows for St Saviour's other than those designed by Pugin e.g. the E window by O'Connor; or perhaps Pusey had negotiated with Pugin during 1843 (there is no surviving Pugin diary for

that year), on the basis of which, cartoons had been prepared (see the problem of the 'Holy Face' mentioned by Pace) and were to be discussed at the meeting on Jan. 26 1844. Possibly the cartoons, may just have been sketches by Pugin or perhaps ideas of Pusey's to be put to him.

191 Ackworth Grange, near Pontefract, Jesus Chapel (RC)

*c.*1842. Building demolished: for glass remnants, see Durham Cathedral (Gaz.39).

Literature. Pugin, 1842, pp. 126-7, plate facing p. 144: 'This edifice has been erected by Mrs. Tempest, who resides at the Grange, near Pomfret to serve as a private chapel to the mansion with which it communicates by means of a cloister on the north side. It consists of a nave, chancel, chantry chapel containing a family vault, and a sacristy. All the windows are filled with stained glass; those of the nave contain figured quarries, rich borders, and quatrefoils filled with sacred emblems; in the east window of the chantry, the centre light is filled with an image of our Lady & with Our Lord, under a canopy, and a serpent crushed beneath her feet; the two other lights contain the emblems of the four Evangelists, and the holy name in bordered quatrefoils. The upper part of the window is filled with angels, holding labels and scriptures. 'The east window of the chancel contains the crucifixion of our Lord, the adoration of the wise men, and the resurrection with appropriate scriptures. The side window of the chantry chapel is filled with armorial bearings of the Tempest family.'

WILTSHIRE

192 Alderbury, St Marie's Grange

*c.*1835. Client: Pugin for himself. (**1.1**). The interior of the house, built in 1835, has been altered and whilst the stained glass in the hallway and the bedroom (formerly the chapel) is original, it is probably not in its original position. All the lights measure 0.4m x 1.2m.

Descriptions. **Hallway.** 2-light window. At the top of each light is a roundel (blue in the left-hand light and red in the right) containing a shield of arms, and surmounted by a crown (the crown in the left-hand light has been damaged and the broken pieces replaced with plain glass). The shield in the left-hand light is red and is crossed by a yellow diagonal band running from the top right-hand corner to the bottom left (there is no indication of the black martlet on the band, which would have completed Pugin's arms and which appeared on the shields in the chapel windows of the Grange, Ramsgate (Gaz.87). The shield in the right-hand light is blue and is inscribed with the foliated AWP monogram, in yellow. The remaining areas of the lights are made up of white quarries patterned with either the AWP monogram in yellow silver stain, or the word `avant', inscribed in black on a white scroll encircled by a yellow silver stain budded stem. Two diagonal bands inscribed in yellow with the Pugin motto 'En Avant' separated by a row of quarries, cross each of the lights, below the roundels (the 'En' in the top band of the left-hand light is no longer extant). The borders are patterned with a yellow silver stain leaf-and-stem design in the form of a letter S, on red grounds, although a small part of the ground in the borders of the left-hand light is blue.

Bedroom. 3-light window with only the centre light containing stained glass. This glass is similar in design to that in the lights in the hallway window, except that: the blue diaper roundel is geometrically patterned and does not contain a shield; some of the quarries have been replaced with plain glass; and the ground in the borders is blue.

Literature. Piper, 1945, pp. 91-3: in a footnote Piper suggests Collins, who did some work in St Peter, Brighton, as being the possible maker of the glass. Wedgwood (Pugin's Diary) entries for 1835: Jan. 27: 'went with Mr. Beare [note 13, p. 74, suggests Mr Beare could be John Beare, painter and glazier]', Jan. 28 'first painted glass [may refer to the windows at St Marie's Grange].' Alexandra Wedgwood has confirmed to me her belief, on the evidence of these entries, that John Beare of Salisbury executed the windows.

193 Bishopstone, St John the Baptist (CoE)

*c.*1845. The S window of the S transept (acknowledged by Pevsner as being by Wailes/Pugin and described by him as, 'certainly nothing at all special') was removed probably in the late 1960s or early 1970s,[71] and is presumed to have been destroyed.

Literature. N. Pevsner & B. Cherry, *The Buildings of England: Wiltshire*, Harmondsworth, 1975, p. 117. Owen B. Carter 'Architect', 'Some Account of Bishopstone Church in the County of Wilts.', *Weale's Quarterly Papers on Architecture*, 4, 1845, p. 3-4: 'Under the opposite window – the south window of the transept – has been lately erected another monument. It is in commemoration of the late rector, the Rev. George Augustus Montgomery, M.A., ...The window above this tomb

has been carefully taken out and restored and is now filled with stained glass representing the Resurrection. It is said that a portion of the glass is imitated from a church in the city of York, which has been lately lost or destroyed. The window is well executed by Wailes, of Newcastle. The design forms a portion of the memorial to the late lamented Rector and is (together with the tomb) from the pencil of the celebrated Pugin. The effect is altogether rich and good, and much enhances this portion of the church.'

194 Bremhill, St Martin (CoE)

1851. Client: Rev. Henry Dormy.

Chancel S window (**10.37**)	sIII	0.3m x 1.6m	single lancet	£4

Description. **sIII**. Single-lancet window containing two yellow-beaded-rimmed, red foliage diaper roundels, each of which encloses a depiction of a half-length angel, in a white mantle, over a green robe (upper) and a yellow robe (lower), holding an inscribed scroll. There is a geometrically patterned boss, contained within a quatrefoil formed by the leads above, below and between the roundels. The remaining areas of the lancet are filled with a grisaille made up of white leaves (oak?) on white stems, all outlined in black, on a black-hatched ground. The stems give the appearance of trailing under the leads of the quatrefoils and into the surrounding areas, but they do not cross the leads within the quatrefoils themselves. A vertical series of red-outlined diamonds is superimposed over the grisaille, but they are to a greater part is obscured by the roundels so that the general effect is of crossing diagonals, between, above and below the roundels, the crossing points of which are covered by the bosses. The borders are patterned at regular intervals with alternate green and yellow four-petal flowers which overlay, an outer line of white fillet glass and an inner band of red glass. In the bottom margin of the lancet is an inscription in white-on-black reading 'in memory of Will. E. & Mary. A. Pinniger'.

Office records. Order Book, 1851, f. 126, Jan. 21 (sIII), f. 134: 'Inscription – William Edwin Pinniger born Sep 9: 1817 died Oct 21 1817 Mary Alice Pinniger born Oct 1: 1818 died Dec 5 1828 Son and Daughter of Broome Elizabeth Pinniger, Tytherton.' *First Glass Day Book*, 1851, f. 121, Aug. 18 (sIII).

Letters. JHA: Dormy to Hardman, 1850, Oct. 10: 'A parishioner of mine desires to fill two small Lancet windows in my chancel with painted glass memorialising two children – one for a boy the other for a girl. I have seen some of your glass lately at Ottery [Gaz.29] and am much pleased with it … The party is not in very good circumstances and would therefore wish for something simple and reasonable. The name should be en-scrolled in each window of the child commemorated … P.S. The names of the children are William Pinniger, Mary Alice Pinniger'. Undated: 'At all events the parties have determined only to to have one window done instead of two'. 1851, Apr. 15: 'I hope that you will now be able to complete the little job I have put in to your hands for Bremhill Church – The parties for whom it was to be done are almost tired of waiting, and I should be very sorry that they should seek to put it into any other hands than yours'. Jul. 2: 'I very much like the pattern you have sent me for an East Window but I regret to say that the delay with respect to the little lancet you have in hand has determined the promoters[?] to have the larger window painted elsewhere – I am sorry for this result, as I like your glass better than almost any I have seen in this country – but I could not deny the justice of the decision [the present E window is not one of Hardman's]'. Aug. 11: 'You will really much oblige me if you can confirm a time for the arrival of the Bremhill Chancel Window'. Undated: 'I am extremely pleased with the window. It is in place and cannot but be universally admired.'

195 Longbridge Deverill, St Peter & St Paul (CoE)

1852. The windows were designed by J.H. Powell.

Office Records. Order Book, 1852, f. 180, May 26. *First Glass Day Book*, 1852, f. 158, Oct. 21: 'To A Window of Stained/ Glass of 2 Lights & Tracery/being South Chancel Window/2 Lights 6'0" x 1'5½ "…/9 Tracery pieces…/…/Subject Figures of/St. Peter and St. Paul' f. 163, Nov. 23: 'To An East Window of/Stained Glass of 3 Lights/& Tracery/3 Lights 9'0" x 2'7"…/ 25 Tracery pieces…/…/Subject in Centre Light Our/Lord seated in Majesty the/Emblems of the 4 Evangelists/ In the Side Lights The Two/Archangels St. Michael/ & St. Gabriel with Angels/ holding Scrolls & Musical/ Instruments [this window was removed *c*.1931].'

196 Monkton Deverill, King Alfred (CoE)

1849. Client: Hon. and Rev. Lord Charles Thynne. The church was declared redundant in 1971 and converted into a private dwelling at which time the windows in question were destroyed.[72]

Office Records. *Order Book*, undated, f. 63, re inscriptions: '1 "By thy cross & Passion, Good Lord deliver us". 2. "Jesu Merci". 'Brass plates for each on one, 'M.S. Jonathan Phillips obt May 7 1849.'. *First Glass Day Book*, 1849, f. 76, Dec. 26: '2 Small Windows of/Angels & c & c//5'6" x 1'0'/ £16/.../.../Brass Inscription plate sent/ with above. J Phillips & c'. *Pugin sketch*, BM & AG a. no. not allocated , for window. *Cartoon costs per ledger summary*: two windows, Powell £1.0.0, Hendren 6s.8d.

197 Newbury, Marlston, Church (CoE)[73] (included here in error, should be under BERKSHIRE)
1853. Window designed by J.H. Powell.

Office Records. *Order Book 3*, 1853, f. 32, undated. *First Glass Day Book,* 1853, f. 190, Oct. 8: 'To 2 Stained glass/Windows being East/Lancet Lights.../.../2 Lights ea. 7'2" x 1'3½'''.

198 Salisbury, St Osmund (RC)
1848, 1853. Client: John Lambert.

Chancel E window (**10.38**)	I	2.0m x 3.0m	3-light	£55	1848
Chancel N window (**4.1**)	nII	1.0m x 1.8m	2-light	£28★	1848
★ cost for two windows: only one remains					
S aisle (Lady Chapel) window	sII	1.1m x 2.1m	2-light	£18	1848
S aisle window	sIV	1.1m x 2.1m	2-light	£10	1853
S aisle window (unidentified)		1.1m x 2.1m	2-light	£10	1853

Descriptions. **I.** 3-light window and tracery. The centre light contains a depiction, under a canopy, of St Osmund, and the left- and right -hand lights, also under canopies, St Martin, and St Thomas of Canterbury, respectively. St Osmund wears a white, yellow-ornamented mitre and the pallium, and is in a white chasuble ornamented with yellow silver stain patterns , over a green dalmatic and a white alb. He stands in a frontal pose, holding a crozier in his left hand. St Martin wears a similar mitre to St Osmund and is in a patterned green-lined, red mantle over a red-patterned dalmatic and a white alb. He stands in a frontal pose holding a crozier in his right hand and an open book, facing outwards in his left. A bearded, bare-chested beggar wearing a white head-band, and in a white-lined, red robe, kneels in profile next to the saint's left foot. His bound legs are tucked beneath his body and he supports himself on crutches while holding up a begging bowl in his right hand. A small yellow flask is attached to his left side. St Thomas of Canterbury wears a mitre similar to those of the other two saints and the pallium, and is in a white-lined, red chasuble over a green dalmatic and white alb. He stands in a frontal pose, holding a crossed staff in his left hand. A sword pierces his neck, almost horizontally, from left to right. The canopies have cinquefoil heads contained within ogee arches. White vine stems follow the lines of the arches, and merge at the apices to form finials. White vine leaves attached to the stems along each side of the arches act as crockets. The foliage diaper screens behind the saints are red in the centre light and white in the side lights. Fillets of white glass run along the outer perimeters of the borders, and lines of white-beaded glass, the inner. The borders are patterned with green and yellow leaves, on yellow-beaded stems, which run alongside the white-beaded glass. The main tracery-pieces consist of three quatrefoils, two symmetrically placed over the centre light, and the third at the top of the window. Each contains a depiction of a seated angel resting his feet on a convex band of blue, stylised cloud, while playing a musical instrument

nII. 2-light window and tracery. St Peter and St Paul are depicted in the left- and right-hand lights, respectively standing in elongated quatrefoil red foliage diaper medallions. St Peter is in a green-lined, orange mantle over a yellowish-white robe, holding white keys in his right hand and a blue-covered book in his left. St Paul is in a red-lined, yellowish-white mantle over a green robe holding an upraised sword in his left hand and a white-covered book in his right. Above and below the medallions are single geometrically-patterned roundels. The remaining areas of the lights are made up of white quarries each of which is patterned with three leaves outlined in black, on a yellow silver stain stem, against a black-hatched ground. The patterns are contained within black-outlined diamonds that leave white margins with the quarry leads. The borders are patterned with white leaves on yellow-beaded stems, against red grounds. The top tracery-piece is a quatrefoil patterned with leaves and rosettes on white diaper ground. The two other tracery pieces are white diaper-filled trefoils, each containing a shield ornamented with a red rosette on a green foliage diaper ground.

sII. 2-light window and tracery, illustrating the Annunciation. The Archangel Gabriel is depicted in the left-hand light, standing barefoot, in three-quarter view, in front of a blue foliage diaper screen. He is in a green-lined, orange mantle

patterned with *fleur-de-lis* diaper, over a yellow robe, holding in his left hand an undulating scroll inscribed in yellow-on-black 'AVE MARIA GRATIA PLENA DOMINUS TECUM'. Mary wears a light blue head-dress and in a green-lined, yellowish-white mantle (patterned with yellow silver stain flowers) over a wine-coloured robe, stands in a frontal pose, in front of a blue foliage diaper screen. She holds a book with yellow-ornamented covers in her left hand. The borders are similar to those in nII but the leaves are alternately green and white. The three tracery-pieces are patterned with white rosettes and yellow *fleur-de-lis* on red grounds.

sIV. 2-light window with a single quatrefoil tracery-piece. St Osmund and St Joan are depicted standing frontally-posed under canopies, in the left- and right-hand lights, respectively. St Osmund wears a white, yellow-ornamented mitre, the pallium, and a white lined, blue chasuble over a green-lined, orange dalmatic and a yellowish-white alb. He holds a yellow quill in his left hand and a book and crozier in his right. St Joan is crowned and wears a white wimple and a white-lined yellow mantle over an orange-brown robe. She holds a book in her right hand and a crozier in her left. The canopies have trefoil-heads contained within pointed arches surmounted by yellow-crocketed gables. Behind each gable appears to be a line of white Gothic windows topped by a band of patterning – above which is a yellow ballustrade and a purple-tiled, pitched roof. In the margin at the bottom of the panels is an inscription in white-on-black which reads 'EX VOTO AUGUS' WELBY PUGIN/SEPTEMBRIS AD MDCCCL'. The borders are patterned with continuous undulating stems with white roses attached, on red and blue grounds. The quatrefoil tracery-piece contains a depiction of a standing angel in white holding an inscribed scroll. The window was perhaps designed by Pugin who probably did not supervise the making of the cartoons.

Office Records. *Order Book*, undated, f. 23 (I, nII, sII); 1851, f. 59, Jun.; *Order Book 3*, 1853, f. 59, Feb. (sIV). *First Glass Day Book*, 1848, f. 37, Jul. 15 (I, nII, another for side chancel, sII); 1853, f. 193, Oct. 28 (sIV and an unidentified window for the S aisle: sIV for Pugin, the other for John Lambert). *Pugin slight sketches*, BM & AG a. nos not allocated, perhaps, the chancel side windows.

Letters. Re I, *HLRO 304: Pugin to Hardman*, letter No 838: '3. You have now sent me the templates for that window at S. Osmunds I want to get done'. No. 1004: 'The one for S. Osmunds will go off tomorrow evening' No. 1001: 'The window for S. Osmunds ... go tonight ... I will send you the instructions for the Lady Chapel S. Osmund in a day or 2.'

Literature. *The Builder*, 6, 1848, p. 329: notice of the approaching completion of the church; 6, 1848, p. 490: notice of the opening of the church on the 6 Sep. together with a brief description, including: 'The windows in chancel and Lady Chapel are all filled with stained glass, by Hardman, of Birmingham.' *Salisbury & Winchester Journal*, Sep. 6, 1848: notice of the opening of the church including a description, and, in respect of the stained glass: 'The whole of the windows in the chancel are of stained glass, of which it is unsurpassed by any modern glass we have seen [then follows a note of the subject matter of the windows in the Chancel and of the Annunciation in the Lady Chapel]'. From this report and the entries in the First Glass Day Book, it would appear that there was a second two-light window in the chancel, containing emblems of the Evangelists, which is no longer extant. *The Tablet*, 9, 1848, p. 628: description of the church, including remarks on the windows similar to those in the *Salisbury & Winchester Journal* except that St Edmund instead of St Martin is named in the E window. Wedgwood (Pugin's Diary): Pugin visits Salisbury, 1847, Oct. 14.

WOKINGHAM, see BERKSHIRE
WORCESTERSHIRE, Madresfield Church, see HEREFORDSHIRE
Kemerton, St Nicholas, see GLOUCESTERSHIRE
YORKSHIRE:
Beverley, St Mary, see HUMBERSIDE
Bilsdale, Church; Bolton Abbey; Gargrave, St Andrew; Skipton, St Stephen; York, St George, see NORTH YORKSHIRE
Rotherham, St Bede; Sheffield, The Farm; Sheffield, St Marie, see SOUTH YORKSHIRE.
Ackworth Grange, near Pontefract, Jesus Chapel; Badsworth, St Mary the Virgin; Clifford, St Edward; Leeds, St Saviour, see WEST YORKSHIRE

EIRE

CORK
199 Lismore Castle
1850. Client: Crace & Son, 14 Wigmore Street, London, for the Duke of Devonshire.

Office records. Order Book, 1850 [sic], f. 104, Aug. 14. *First Glass Day Book,* 1850, f. 96, Aug. 10: 'To 9 Lights of Stained Glass/ of Shields of Arms, Mantling & c/£28.7.0/1st. 1st Earl of Devonshire, Keighly, 2nd. 2nd do. do. Bruce/3rd do. do. Cecil/4 1st Duke of do. Bath KG/5. 2nd do. do. Russell/KG. 6. 3rd do. do. Hoskins KG/ 7. 4th do. do. Boyle KG/ 8 5th do. do. Spencer KG/ 9. 6th do. do[no name included]/4 Lights above 1'11" x 1'8½"/2 do.do.1'11" x 1'6"/3 do. do. 1'11" x 1' 5"'. *Cartoon costs per ledger summary:* '9 Shields', Powell £2.5.0, Hendren £1.0.0.

DONEGAL
200 Ballyshannon Church.[74]
1852. Client: Rev. I. McMenemin. Supervising architect: J.J. McCarthy.

Office records. Order Book, 1851, f. 132, Jul. 8. *First Glass Day Book*, 1852, f. 148, Jun. 12: 'To 3 Windows of Stained/Glass of 1 light each/£42/3 lights 13'2" x 1'4"/Subject, Figure of St. Patrick/in Centre light and bands/of Colour & c in 2 side lights'.
Letters. JHA: McCarthy to Hardman, 1851, Oct 28: 'The Ballyshannon windows are not expected till after Xmas the Rev. W. McNamara was anxious to know how soon after he might expect them'. *J.W. McNamara to Hardman*, 1852: Jun. 25: 'The Stained Glass Windows reached me safely...I happy [sic] also be [sic] able to add that I expect they will give general satisfaction. These are the first that have been got to this part of the country in latter times'.

DUBLIN
201 Dublin, J.J. McCarthy, 7 Leinster Road, Rathmines
1853. J.J. McCarthy (1817-82), architect, sometimes called the 'Irish Pugin': see also 200, 202, and 204.

Office records. First Glass Day Book, 1853 f. 183, Jul. 8: 'To Specimens of Stained/Glass, leaded up, showing/ styles of Quarry Glass/each specimen 12ins x 12ins.'

KILKENNY
202 Newbridge, St Corluth (RC)
1852. Client: Rev. P. Carey. Supervising architect: J.J. McCarthy.

Office records. Order Book, 1851, f. 3, Jul. 8; undated, f. 132, re inscription: 'This window is the gift of John Michael O'Donohoe Esq., Borahard House, Pray for his deceased friends.' *First Glass Day Book*, 1852, f. 154, Aug. 6, 'To A Stained Glass Window/of 3 lights & Tracery/£60/3 lights 8'10" x 1'10½" .../3 Tracery pieces.../.../Subject in centre light/ Figures of B.Virgin,/St Corluth 1st Bishop of/Kildaire, & St. Bridget'.
Letters. JHA: McCarthy to Hardman, 1852, Feb. 16: 'I ordered a stained glass window for the Church of Newbridge Co. Kildare.' *Carey to Hardman*, 1852, Apr. 21: wishes to know of progress in 'the window ordered by Mr. McCarthy for our New Church'. Apr 29: 'The figures I wish to be done in each of the three compartments are in the centre The Blessed Virgin full figure. On each side St. Bridget & St. Corluth Bishop. The Inscription I would wish in some obscure part of the window is [gives the wording recorded in the Order Book above]'.

LIMERICK
203 Tervoe, William Mansell Oratory (RC)[75]
1851-2. Client: William Mansell M.P., Tervoe, Limerick. Supervising architect: P.C. Hardwick.

Office records. Order Book, 1851, f. 141, Aug. 27. *First Glass Day Book*, 1851, f. 130, Dec. 20: 'For Oratory/2 Stained Glass Windows/of 3 Lights each 4'0" x 1'2".../£20/.../.../of diapered Quarry Glass/with Ornamental Border/& Subject in Centre Light/2 Centres in each of Side Lights/but not subjects'; 1852, f. 155, Aug 27: 'To Alterations in One/light of Stained Glass/Window for Oratory/sent 20th Dec 1851'.

WATERFORD
204 Waterford Cathedral (RC)
1851. Client: Rt Rev. Dr Nicholas Foran, Bishop of Waterford. Supervising architect: J.J. McCarthy.

Office records. Order Book, 1850, f. 107, Aug. 12; 1851, f. 138, Jun. 27: '[entered on both ff.] Mr. McCarthy wishes introduced a Legend in Centre Window representing the prayers of the faithful for Nicholas Foran, Lord Bishop of Waterford & Lismore & another in the Window containing the Figure of St. Patrick for the Revd. Dominic O'Brien DD they being the gifts of these Ecclesiastics.' *First Glass Book* 1851 f. 126, Oct. 3: '3 Large Windows of Stained Glass/for East End of Cathedral/Centre Light of Crucifixion/2 Side Lights of St. Patrick/& St. Bridget/£100'.

Letters. *HLRO 304: Pugin to Hardman*, letter no. 718: 'I have not got the size of the Waterford Windows nor the saints let me have them for these windows Oliphant should do'. *JHA: McCarthy to Hardman*, 1851, Feb 5: 'It is two months since you wrote to me to say that you would see Mr. Pugin and tell me when we might expect the windows for Waterford Cathedral'. Sep 30: 'I have just had a letter from the Rev. W. Fitzgerald of Waterford complaining angrily of the great delay in getting the windows for his church. He says he has written to yourself about them, and that he got no answer except a very unsatisfactory one signed J. Hardman & Co.' Oct. 11: 'the glass has arrived safely in Waterford'. *Richard Fitzgerald to Hardman*, 1851, Oct. 12: 'Last evening the glass arrived per the Victory[?] It could not be removed to the church in consequence[?] in the interests of the hour ... He [the Bishop] also wants to know whether you could manufacture two other windows for the church by the 12th or 15th of April 1852. The windows to be exactly the same size as those you made for the Apse, one to be placed over the Altar of the Blessed Virgin and the other over the Altar of St. Joseph. The design which you would recommend he would like to know'. Oct. 31: 'I am happy to inform you that the Bishop & Clergy admire The Windows.' *Letter Book, Hardman to McCarthy*, 1850, Jun. 28: 'I duly received your letter of the 22 inst. but waited to see Mr. Pugin before answering it. He can carry out the side Windows in a commendable[?] way for £50 each keeping the Figures of St. Patrick & St. Bridget & filling the rest with geometrical work which will look very well.'

WEXFORD
205 Barntown, St Alphonsus (RC)[76]
1847. Client: J.H. Talbot.

Office records. Order Book, undated, f. 29. *First Glass Day Book*, 1847, f. 27, Feb. 26: 'A Window of .../.../5 lights with 3 Figures & Quarries/Stained Borders & c & c/13' 4" x 1'6½"/.../15 pieces of Tracery for do. [The subject matter in the side lights, the Annunciation, is of the same design as that in the window at St Mary, Cresswell, Staffordshire (Gaz.153). A vase of lilies with a bust of Christ above – the two being separated by a band of stylised cloud – is depicted in the centre light]'.

Letters. *HLRO 304: Pugin to Hardman*, letter no. 320: 'I enclose a letter from Mr. Talbot which is our order for the window you better keep it.' No. 811: 'Tomorrow we send Mr. Dunns window for Cresswell [Gaz.153], & Barntown' No. 810: '1. The cartoons for Barntown & Cresswell go off by this post.' No. 1022: '& a lot of tracery for Mr. Talbot.' *JHA: Talbot to Pugin*, 1847, Oct. 23: 'I have just received your kind letter, your window will be beautiful, recollect you are to engraft some way the Family that will be the Donor – & perhaps it may give good example & get us a good prayer.'

206 Enniscorthy, St Aidan's Cathedral (RC)[77]
1849. Client : J.H. Talbot, Ballytreat.

Office records. Order Book, undated, f. 42. *First Glass Day Book*, 1849, f. 53, Mar 14: 'A Window for North/Choir Aisle of Centre Light/& Figure & 2 Side Lights, Quarries/£25/6'3½" x 1'6½"/& 7 Tracery pieces to do./.../.../A Window for South Choir Aisle of Centre Light & Figure/8'2"/2 Lights of Quarries/6'3½" x 1'6½"/£25/ & 5 Tracery pieces for do/. To Tracery for East Window/.../of 33 pieces of Tracery, Quarries & c'. *Cartoon costs per ledger summary*: '2 windows', Powell £1.6.8, Hendren £1.0.0; tracery, Powell £2.0.0, Hendren 10s.0d.

Letters. *HLRO 304: Pugin to Hardman*, letter no. 1017: 'Inclose you a letter from Mr. Talbot about some windows at Enniscorthy the figure is very low but so is the county & we must do our best to ensure the taste for good things are there. I will send you the windows they will be very simple & Easily done but will have a good effect'. No. 1038: 'we are all working including my wife as hard as possible to send you off the tracery for the E. window Enniscorthy tonight – which will give you a lot of glass a plain Right effective job. the side windows in a few days. [in the margin at the top of the letter] To save labour in the Enniscorthy window I have made plain Bands but they must be stippled so as to look [?] & rich.' No. 1011: 'A letter has just come from Dr. Keating for a lot of glass for Enniscorthy – it seems to rain glass.' *JHA: Talbot to Hardman*, 1849, May 1: 'I saw our friend Pugin on Friday he says they are glorious windows'.

Literature. Wedgwood (Pugin's Diary): Pugin visits Enniscorthy, 1845, May 23.

207 Convent of Mercy & St Michael (RC)
Client: Mrs Kelly.

Office records. Order Book, 1850, f. 96, Dec. 9: 'St. Michael & the Dragon in Tracery Light.' *First Glass Day Book* 1852 f. 153, Jul. 17 'To A Stained Glass East/Window of 3 Lights & Tracery/£50/3 lights 9'4" x 1'9".../6 Tracery pieces.../.Subject in Centre Light/"Figure of the B. Virgin"/ In side lights Figures of / "St. John Evangelist"& "St.Joseph"/. In Tracery "St.Michael" & The Dragon'.

Letters. JHA: Sequative(?) to Hardman, 1851, Nov. 21: 'my communication was to know when we might expect the window'. *Mrs Kelly to Hardman*, 1850 [corrected to 1851 by Hardman's clerk] see *Order* Book, Dec. 9 above: 'Mrs Kelly was sorry to hear from Mr. Pierce that there was such little chance of getting the stained glass window done – As soon as she expected – however she could not think of giving it into the hands of any other person save Mr. Pugin he has been so generous and making such a reduction in the price, besides that she feel assuredly it will be elegantly executed under his inspection.' *Richard Pierce to J. Hardman*, 1852, Apr. 16: 'In reference to the stained window for the Covent of Mercy of this town, the Revd. Mother wishes me to say to you that she is anxious to have in each of the side lights a figure of an equal length with the Blessed Virgin in the middle – the names of which figures she will have given you I presume herself by letter. I enclose you a tracing of the original design as supplied by Mr. Pugin, by which you will see the alteration required. Mr. Pugin himself, some time previous, consented to make this change at the request of the Revd. Mother, and as his present deplorable situation prevents for the moment any reference to him on the subject, she assumed that my writing to you will be sufficient to incline you to the modification so anxiously desired by her, and agreed to by Mr. Pugin. She is much pleased to learn that it is at last about to be completed.' *Sister M. Ignatius to Hardman*, 1852, Jul. 22: 'Rev. Mother commissions me [?] to you the safe arrival of the window ... P.S. Rev. Mother wishes me to ask whether it is to you she is to pay the amount of the window, as the agreement was made with Mr Pugin.'

NORTHERN IRELAND

DOWN
208 Castlewellan Church[78]
Client: Earl of Annesley. Supervising architect: Charles Lanyon.

Office records: Order book, 1851, f. 147, Nov. 12: 'The Dragons to be omitted and ornament introduced instead.' *First Glass Day Book,* 1852, f. 149, Jun. 30: 'To 3 Windows of Stained/Glass, being large/Lancet lights/£120/Centre light 19'8" x 3'1½"/2 Side lights 12'10½" x 2' 7½" /.../Grisaille Glass with/Bands of Colour Introduced.'

Letters. JHA: Hardman to unknown (extract from Glass Letter Book filed in 1851 client's letters): ' I enclose you a design for the Chancel Window of Castle Wellan Church, which I trust will meet your & Annesleys approbation. The line of the lancets is so fine and well calculated for stained glass that I have returned to introduce the Crucifixion & figures with S. Peter & S. Paul in the side lights. It would really be a pity to fill them with merely ornamental glass. The cost of the 3 Lights carried out from this design would be £150 and it will make a very fine window.' *Lanyon to Hardman*, 1851, Oct. 13: 'In answer to yours of the 9th inst I beg to say that you may proceed with the Glass in the windows of C. Wellan Church according to your design and Estimate.' Nov. 5: 'Did you receive a letter from me dated the 21st Oct relating to the window of C. Wellan Church for which Lady Annesley wished to have another design instead of the one you lately forwarded to me – if so will you be good enough to let me have a reply as we are desirous of having the window finished as soon as possible. My letter was to the effect that Lady Annesley wished to dispense with either figures or Emblems in the window and I therefore required that you would be good enough to let me have a design & Estimate for a plain window'. 1852, Apr. 12: asks when the E window will be ready.

209 Clough, Fitzpatrick Chantry[79]
Office Records. First Glass Day Book, 1852, f. 163, Nov. 23: 'To An East Window of Stained Glass of/3 lights & Tracery/£30/Centre light 8'0" x 1' 10"/ 2 Side lights 7'7" x 1' 10½"/.../To 2 Side Windows of Stained Glass of 2 lights ea, and Tracery/Each Window/2 lights 5'0" x 1'6".../5 Tracery pieces...'

SCOTLAND

ABERDEEN (CITY), see GRAMPIAN

GRAMPIAN

210 Old Deer (Aberdeen (City) UA), St Drostan (Episcopalian)
1853. Window designed by J.H.Powell.

Office records. Order Book, 1852, f. 181, Jun. 4. *First Glass Day Book,* 1853, f. 188, Sep. 12: 'To An East Window of Stained Glass of 3/ Lights / Lancet window/Centre light 13'9" x 2' 3½"/.../2 sides do. 9'2" x 1'9½" .../ Subjects in centre light/"Our Lord appearing to St/ Mary Magdalene/ in side Lights, "The Passage/of the Red Sea" & "the/Raising of Jairus's Daughter"', f. 193, Nov. 21: 'To Alterations made in/Stained Glass Window/executed for the Honble/Arthur H Gordon/(consisting of alterations in size of Lights and/repairing & c New centre /for Tracery pieces).'

EDINBURGH, see LOTHIAN

HIGHLAND

211 Arisaig, near Fort William, St Mary (RC)[80]
1849. Client: Rev. William McIntosh.

Office records. Order Book, undated, f. 57. *First Glass Day Book,* 1849, f. 65, Jul. 25: '11 pieces of Stained Glass/ Tracery/£7.10.0'. *Cartoon costs per ledger summary*: Powell 10s.0d, Hendren 3s.4d.
Letters. HLRO 304: Pugin to Hardman, letter no. 973: '1. Did you send all that tracery to Fort William in the highlands.' *JHA: McIntosh to [presumably] Pugin*, 1849, Apr, 16: 'You will perhaps be surprised at my presuming to address you without previous acquaintance. But though I am a stranger to you, you are known at least by fame to me. I even made an attempt to be introduced when I was in London, but in that I failed. I might on the present have applied to you through a third party, but I thought the most expeditious way would be to make bold and claim your aid direct. To come to the point then I have built a new chapel with an oriel window of three lights and a wheel. As I am scarce of funds at present I wish to have the smaller divisions only of stained glass merely as specimen. I would therefore like the colours and design to be good. Should you then enter into my views you will give a proper patern [sic] and design to a fit glass stainer who will execute the work and send the several pieces packed in a box addressed as under [Rev. W. McIntosh, Arisaig by Fort William]. There are several paterns [sic] enclosed each piece has a quarter of an inch of border as described on the circle. But that you may the better comprehend the plan I will enclose a plan of the whole window [the sketch elevation drawn by McIntosh on the back of the letter shows the wheel, which is comprised of eight sections around a circular centre, sitting on three lancets where the two side lancets are taller than the central one]. The sooner it can be got ready the better and I expect you to favour me with a few lines on receipt hereof that I may know what I am to expect regarding the business.' *McIntosh to Pugin*, 1849, May 5: 'You will remark that the small triangular piece is for the top of the window and is single and alone, whereas your letter seems to point it out as consisting of two pieces, one on each side of the wheel instead of one at the top [McIntosh's sketch in his previous letter implied that there were three such pieces, one at the top and, one (smaller piece) at each side of the wheel] The side spaces do not go quite through whereas the top space does [McIntosh's letter seems to suggest that nine of the eleven pieces recorded in the Day Book, included the eight sections of the wheel plus one triangular piece for the top perhaps the remaining two were for the circular centre of the wheel].' *McIntosh to Messrs Hardman & Co.*, 1849, Aug. 23: encloses a letter of credit for £7.12.6 and acknowledges: 'The glass arrived safe'.

INVERCLYDE, see STRATHCLYDE

LOTHIAN

212 Edinburgh, (Edinburgh UA), St Mary's Cathedral (RC)[81]
Client: W.F. Pitcairn, 19 Forth Street, Edinburgh. The church guide notes that the shallow sanctuary was extended backwards by three arched bays, and the new sanctuary opened in 1896. It also quotes the parish magazine of Jul. 1905, which says: 'that the window above the high altar is in Hardman and Company's best style, was the gift of Mrs. Oliver,

St. Edward's Murrayfield and bears the inscription "Pray for the soul of M.A., who died New Year's Day 1898 R.O.P." Presumably this window replaced the one recorded in 1849 in the First Glass Day Book.

Office records *Order Book*, undated, f. 49. *First Glass Day Book*, 1849, f. 65, Aug. 18: 'An East Window of / 3 Lights of 1 Centre Light 11'8" x 3'6"/2 Side Lights 11'0" x 2'7"/.../with Figures & c & c/.../£180/Subject of Window/The Transfiguration'. *Cartoon costs per ledger summary*: Powell £3.0.0, Hendren £1.6.8, Oliphant £34.7.0.

Letters. *HLRO 304: Pugin to Hardman*, letter no. 1000: 'I can send a rough sketch to Edinburgh – if you will send me the particulars something they cannot work from'. No. 995: 'I will send the sketch for Edinburgh tomorrow'. No. 998 Postmark 'NO 2 1848': 'I send you the sketch for the Edinburgh window I think it will show what I intend without being of any use except to the owner I think I would make a good job of it. [Included is a sketch headed (not in Pugin's hand) 'Broughton Street Church Edinburgh Chancel window.' It has three round-headed lights the dimensions close to those in the First Glass Day Book. The figures are very roughly sketched in so that only the subject matter of the centre light, the Transfiguration, can be identified]'. No. 990: 'Oliphant is coming down soon he is now doing the Edinburgh window I will attend to the cartoons as soon as I get the templates from you.' No. 140: 'Oliphant has brought down the cartoons for Edinburgh it will be a fine window.' No. 1032: 'Oliphant will make a splendid job of the Edinburgh Window it is now drawing in here under my eye'. No. 987: '4. Oliphant is getting very forward with the Scotch window'. No. 134: 'You will soon have the Stella window [Gaz.165] & the Edinburgh'. No. 169: 'The following cartoons go off tonight...a light of the Edinburgh window a very good job. Borders for do.' No. 54: 'I am delighted to say that Edinburgh window went off tonight'. No. 291: 'I think it would be a very good plan to diaper the large white mantles in the Edinburgh window'. *JHA: Pitcairn to Hardman*, 1848, Nov.: Confirms the order for the Altar window based on the sketch [see *HLRO 304, Pugin to J. Hardman*, letter no. 998 above] and the subject matter as: 'Our Lord in the Glory of his Transfiguration in the centre light, and Moses and Elias in the two side ones with the 3 disciples awakening out of sleep in the bottom parts, without undue prominence being given to these'. He also quotes from his architect's notes that: "There should be no canopy or niches of statuary represented. The window should be filled very much with figures and these of a large scale, the glass need not be dark.' *Oliphant to Hardman*, 1849, Mar. 9: 'I herewith enclose a `Hand' for the top of the centre compartment of the Transfiguration window for Scotland – and hope the cartoons for the said window were to your liking.'

Literature. Anon., 1989.

213 Edinburgh (Edinburgh UA), Chapel of St Margaret (RC).[82] Originally part of St Margaret's Convent: now part of the Gillis Centre

1849. Client: Rev. Dr Gillis, Greenhill College, Edinburgh.
A leaflet concerning the chapel notes that, 'The Windows above the nave depict King Malcolm and his seven children by St. Margaret; these were designed by A. W. Pugin'.[83] It appears, therefore, that the windows are extant. Sharples, 1985, includes an account of the commissioning of the windows, and, with illustrations, makes reference to their subject matter and style and expands on the alterations to them as mentioned in the letters below.[84]

Office records. *Order Book*, undated, f. 38. *First Glass Day Book*, 1849, f. 66, Aug 18: '8 Lights of Stained Glass/of Figures & c/Large Windows/7'3" x 2'7"/ £160/.../Designs of Early Saints'. *Pugin sketch*, BM & AG a. no. not allocated. *Cartoon costs per ledger summary*: Powell £6.0.0, Hendren £1.0.0.

Letters. *HLRO 304: Pugin to Hardman*, letter no. 634: 'I had Dr. Gillis with me all day – arranging about seven drawings – I told him that I had worked for nearly 10 years & never seen a Baubee[?] & it would not go on in which he agreed & his next 2 lower windows for St. Margarets.' No. 432: 'you have 8 windows for Dr. Gillis'. No. 995: '2. Dr. Gillis windows were £20 each you can send them down if you like first.' No. 414: alongside sketches showing required changes to the colours in some of the decorative detail are the comments: 'The only alterations in the glass for Dr. Gillis is Maud can have (Sancta); Mary (Maria de Bologne); David (Sanctus) Rex Scot; Edgar Rex Scot; Alexander Rex Scot; Edwardus – ; Etheldredus; His spear & key should be in the hands of King Malcolm – if it is not so, you must it [sic] put Sanctus Malcolm Rex.' *JHA: Gillis to Hardman*, 1849, Jul. 19: 'Pray don't forward the St. Margarets windows until you hear from Mr. Pugin about them, as they must include certain alterations before they leave.'

Literature. Sharples, 1985.

PERTH & KINROSS, see TAYSIDE

STRATHCLYDE
214 Greenock (Inverclyde UA), Cumbrae, The College (Episcopalian)
1851-3. Client: Hon. G.F. Boyle. Supervising architect: William Butterfield.

Office records. *Order Book,* 1851, f. 130, Apr. 18: 'window E. side chancel, subject the Resurrection'; *Order Book,* 1852, f. 175, Jun. 28 (chancel W window). *First Glass Day Book,* 1851, f. 117, May 26: 'A Stained Glass Window [E, see Butterfield's letter to Hardman, 1851, Jun. 25, below] of / 3 Lights and Tracery 5 pieces/£60/2 Side Lights, 8'0" x 1' 10½"/Centre Light 9'4" x 1'10½"'/1853 f. 203, Dec 31 'To A Stained Glass/ Window of 3 Lights & Tracery for Western/side of Chapel Chancel/Subject "The Crucifixion" /3 Lights 4'5" x 1' 3½" .../3 pieces of Tracery'.
Letters. *JHA: Butterfield to Hardman,* 1851, Jun. 25: 'I hear bad reports of the effect of the East Window at Cumbrae that it is hard, cold, blue & ineffective in its place. Has Mr. Boyle written to you? I can fancy there is truth in this and that it wants boldness in colour and outline.' *Letter Book, p. 181: Hardman to Butterfield,* 1853, Jul. 4: 'The Window for Cumbrae is quite ready for you to see, it has been painted exactly in the same way that the old glass was with flat smear shadow.'

TAYSIDE
215 Glenalmond (Perth & Kinross), Trinity College Chapel (chapel to independent school)
1853. Client: Warden of Trinity College, Glenalmond.

Office records. *Order Book,* 1851, f. 157, Oct. 27 (re-entered under same date in Order Book 2), subject matter given as: '1. Annunciation 2. Visions of Shepherds 3. Adoration of Magi 4. Birth 5. Our Lord among Doctors 6. Baptism 7. Transfiguration 8. Blessing little Children 9. Entry into Jerusalem 10. Last supper 11. Crucifixion 12 Agony 13 Betraid [sic] 14 Scourging 15. Taking down from the Cross 16. Burial 17. Women of Sepulchre 18. Resurrection appearance to Mary Magdalen 19. Appearance of the twelve & Thomas per John Xv19 20. Ascension [sic] 21 Penticost [sic]. [The subjects are set out in three rows, in columnar form with numbers 4, 11 and 18 marked as being in the centre]. The order is generly [sic] chronological but (3 & 4) are necessarily inserted and /12/13/14/ would of course properly preceed /11/.' *First Glass Day Book* 1853, f. 171, Jan 21: 'To A Stained Glass Window of 7 Lights & Tracery/7 Lights 17'0" x 2' 3½" .../52 pieces Tracery.../£480/Subjects "of Our Lords/Life & Death" for East/Window of College Chapel. [The *Letters* below show that Pugin was involved with the designs for the window, but that the finalizing of the designs and the production of the cartoons would have been done by J.H. Powell].'
Letters. *HLRO 304: Pugin to Hardman,* letter no. 491: 'The Glenalmond windows went off by this afternoons fast train.' *JHA: Barry to Hardman (copy letter),* 1850, Jun. 28: 'Not knowing the whereabouts of Pugin I send to you the enclosed account of a window of the Chapel of Trinity College near Perth and the requirements for filling it with painted glass I should be much obliged to you if you would by return of post if possible or able to answer as to time and cost of execution. As the enquiries are merely preliminary it will not be worth while to make any design - Each light would I suppose require three subjects on it figures of saints now adopted which has been thought of Each light would take two figures let me know the cost of adopting each mode of filling them. If there should be any difference. *Alfred Barry to Pugin,* 1851 (marked 1852 by Hardman's clerk), Jan. 26: 'I wrote to Hardman some months ago about a design for glass for an E. Window which he was to finish. I have heard nothing of it & knowing unfortunately that you are far from well and very busy for the 3rd at Westr [?] I did not like to press for it. But now I hope both these reasons are passing away and we are getting impatient to make some progress will you be kind enough to turn your attention to it as soon as may be? I should be loath to have the window which is very large & which will determine the whole effect of the chapel spoilt by being in another hand.' *Alfred Barry to Hardman,* 1852, Mar 30: 'The Warden has commissioned me to put the E. Window into your hands, to be treated with the three subjects in each light, and the estimate of 480£, which your letter gives... I enclose a sketch of the subjects by the Warden's desire, which does not I think differ materially from the one which you proposed... with regard to the sketch itself the thing I do not like is the great prominence of the horizontal lines, which mark the divisions between the subjects. Would it be in any way possible to obviate this, so as to make the three subjects of each light, panels as it were of one framework, by connection of the canopy work & c... Another point of great importance which both the Warden & I feel strongly is the dislike of the grotesque stiffness of drawing ("after the antique"!) which one sees so often in stained glass but which if I am not mistaken I have heard poor Mr Pugin treat with deserved contempt – I fancied that I noticed something of it in the sketch but that might be from its roughness. It seems to me simply absurd and I hope that it will be entirely banished from our window – a grave & monumental style is one thing, and the unnatural modern way which some seem to aim at quite another.'

WALES

CLWYD
216 Chirk (Wrexham UA), Chirk Castle
Client: Myddleton Biddulph.

Office records. Order Book, undated, f. 14. *First Glass Day Book*, 1846, f. 10, Dec. 10: 'Alterations in Windows/£9/7 Lights with Figures & Quarries/Old Shields used/1 Light with Figures & New/Shields'; 1848, f. 28, Mar. 20: '7 Old Lights Returned', f. 39, Aug. 8: 'Windows in Library .../£30/6 Lights with Centres & c & c/3'0" x 1' 6½'". *Cartoon costs per ledger summary*: the only entry in this summary is also dated Aug.8, 1848 and records Powell 6s.8d, Hendren 6s.8d. in respect of the dining room, not the library.

Letters. HLRO 304: letter no.?: Pugin to Hardman: '2. You must take out the Royal Shield [illustrates with a small sketch) altogether & substitute one that Powell will send you tomorrow.' *JHA: N. Myddleton to Hardman*, 1848, Jun. 8: 'The other drawing is sent by Mr. Pugin's direction. The drawing of the Arms may be addressed to me Brooks Club. St. James St. London.'

Literature. Country Life, Jul. 7, 1992, includes an illustration of a Pugin-designed heraldic window.[85] Wedgwood (Pugin's Diary): Pugin visits Chirk Castle, 1848, May 11.

217 Pantasaph (Flintshire), St David (RC)[86]
1852. Client: Viscount Feilding, Downing, Holywell. Supervising architect: T.H. Wyatt.

A brief history of the church is given by Rosemary Hill in an article for *True Principles*. It includes transcripts of four letters between Feilding and Pugin – one from Feilding and three from Pugi n. Extracts from the letters (below) show that by early Aug. 1851 Lusson[87] had produced designs for the chancel windows which Pugin was asked to look at, and if satisfied, arrange for the windows to be made. Pugin reported in the following October that he was unhappy with the designs and had suggested by way of a sketch a different approach. It would appear that Lusson was not persuaded by Pugin's views, for Wyatt's letter to Hardman in Mar. 1852 indicates the commission had been passed to Hardman's, except for the E window which seems to have been given to O'Connor. There is no record in the First Glass Day Book that Hardman's had made the chancel windows by the end of 1853 although those for the aisles (see below) were finished, (most likely without Pugin's involvement given that some four months elapsed between his becoming unfit for work and the completion of the windows), in Jul. 1852.

Office records. Order Book, 1852, f. 173, Mar. 12. *First Glass Day Book*, 1852, f. 150, Jul. 9: 'To 5 windows of Stained/ Glass of 2 lights each/for Aisles of Church/£87/2 lights ea window 6'2½" x 1'0½".../.../1 window of Stained/Glass of Tracery consisting/of 7 pieces/£6.15.0. Included alongside the entry is 'Charged £90.0.0. £18.0.0 each window'.

Letters. Private Collection: Feilding to Pugin, 1851, Aug. 9: 'It appears that Mr. ? Lusson has already made designs for the chancel windows and they are in Mr. Wyatt's possession. Will you look at them and if they are good see about the execution of them. I shall not do more than have the chancel and rose window filled with stained glass for the present.' *Pugin to Feilding*, [1851], Aug. 28: 'I will take an opportunity of seeing Mr. Lussons designs for the windows when I go to London. I suppose all the other windows will be glazed with plain quarries and there should be bars to all the windows to prevent the entrance of thieves.' [1851], Oct. 18: 'all I fear at present is the glass – Lusson has no idea of Date his design was a comparatively late style quite different from that of the church but I sent him a sketch of the sort of treatment I would recommend which I trust he will adopt [overleaf] in his designs the windows are so narrow they require a very simple design or they would appear crowded. Mr Wyatt quite agrees with me in this.' *JHA: Wyatt to Hardman*, 1852, Mar. 2: 'I should be glad to shew you O'Connor's[?] sketch for the East Window at Pantasa so that we may have a certain harmony between all those in the Chancel. I have desired Mr. Pary[?] to send you the templates for the side windows, which by this time he has probably done.' *The Tablet*, 8, 1852, p. 677: report of the opening of the church, with some details of the design but no mention of the stained glass. Wedgwood (Pugin's Diary): Pugin visits Pantasaph, 1851, May 8, Aug. 21, Nov. 29. Hill, 2008.

DYFED
218 Castlemartin (Pembrokeshire), Church[88]
1850-1. Client: Rev. J. Rodmell, 53 Trumpington Street, Cambridge (E window): Rev. J. Allen (S transept window).

Office records. Order Book, undated, f. 67 (E window), confirmation that the St James in the side light is St James the Greater: 1850, f. 125, Feb. 10 (S transept window). *First Glass Day Book*, 1850, f. 91, Jun. 1: 'A Stained Glass East Window/.../ of 3 Lights' 1 Centre 9'2" x 1'4½"/ 2 Side Lights 8'3" x 1'4½"/... /Sent to Revd. James Allen/ Vicar of Castle Martin.../ Figures of St. Peter, St. James & St. John/ £45'. f. 95, Jul. 29: '3 pieces of Copper Wire/Latticing for East Window sent/June 1 1850/£2.7.0'. 1851, f. 112, Feb. 10: 'A Stained Glass Window of 1 Light for South Transept/£30/7'0" x 2'4"/.../Memorial Window of John/Mirehouse Esq, Common Sergeant'. f. 115, Apr. 12: '4 Wrt Iron galvanized Bars/for Window sent Feby 10th'. f. 123, Sep. 8: '1 Piece Copper Wire Latticing/for window sent Feby 10th'. *Cartoon costs per ledger summary*: E, Powell £2.0.0, Oliphant £3. 15.0.

Letters. HLRO 304: *Pugin to Hardman*, letter no. 734: (probably for S transept window) '4. I send you the 3 sketches for Castlemartin but unfortunately I have drawn them wrong. I render[?] them in the scale 7 feet to the spring but I did not think it worth while to do them all over again driven as I am for time & I have figured them & you can calculate by the dummies[?]'. No. 791: 'I will try & do this Castle Martin window but if I remember right it is all full of groups.' No. 795: 'I have told Powell to start the Castle Martin Window if it is the Perpendicular one with 6 subjects as I imagine & it shall be done as soon as possible but these subject windows take Great time.' No. 211: 'Give me some idea of your plans of Running in cartoons. I see you say cannot you run in Castle Martin Window now as there are 6 subjects & all various groups how will we run them in ??? It is no use this Centre window will take time the only things that work [?] are Large images under canopies but how can we run groups except in a [?].' *JHA: Allan to Hardman*, 1849, Dec. 10: approves sketch for E window, 1851, Mar. 24: 'Your window has arrived'. Jul. 30: 'I enclose an order for £30.5.6 being the amount of your account for the window erected here by the family of the late Mr. Mirehouse ... I am happy to say the window gives great satisfaction. I think we are all reconciled to the insertion of the streaky ruby and most of us consider it a considerable improvement & will you tell me the intent of the introduction of the two weeping angels each holding a representation of the Sun ? I have an opinion as to what the object is, but I wish to have it confirmed by you.'

FLINTSHIRE, see CLWYD

GWENT
219 Abergavenny (Monmouthshire), Abergavenny Priory (CoE) Now Church in Wales
1847. Client: T.H. King.

Office records. First Glass Day Book, 1848, f. 27, Feb. 26: '4 Lights of Quarries, Centres /& Borders 2'0" x 1'1"/.../1 Small Tracery piece/£5.15.0'.

220 Newport (Newport U.A.) Coedkemen Church[89]
1853. Window designed by J.H. Powell.

Office records. Order Book 2, 1853, f. 76, Jul. 25; *Order Book 3*, 1853, f. 51, Jul. 25. *First Glass Day Book*, 1853, f. 202, Dec. 31: 'To An East Window of / Stained Glass of 3 Lancet Lights/ Centre Light 12'7" x 1'3½" / 2 Side do. 10'1" x 1'0½"'.

GWYNEDD
221 Merionethshire Church.[90]
1851. Client: R. Kyrke Penson, Oswestry.

Office records. Order Book, 1850, f. 106, Sep 3. *First Glass Day Book*, 1851, f. 113, Feb 20: 'A small Single Light Window with Figure 3'5" x/1'4½"/£5.15.0./.../for South Aisle of Chancel over the Sedilia.'

MONMOUTHSHIRE, see GWENT
NEWPORT, see GWENT
PEMBROKESHIRE, see DYFED
WREXHAM, see CLWYD

AUSTRALIA

222 Hobart, St Joseph (RC)[91]

1847. Client: Bishop Willson.

Office Records. *First Glass Day Book*, 1847, f. 21, Dec. 13: 'A Window for Church/of 2 Lights with Figures/and 3 Small Tracery pieces [no charge]'.

Literature. Atterbury & Wainwright (Andrews, 'Pugin in Australia'), 1994, p. 251 and plate 464 (glass still in place, subject matter – the Annunciation). Andrews, 2002, pp. 99-100.

223 Sydney, St Mark, Darling Point (Anglican)[92]

1850. Client. Acton Sillitoe, Sydney, New South Wales. Window no longer in place.

Office records. *Order Book*, undated, f. 62: 'centre light to have figure of St. Mark'. *First Glass Day Book*, 1850, f. 96, Aug 23: 'A Stained Glass Window/of 3 Lights1-/-13'4" x 1'6½" /2 Side do 11'2" x 1'3½" /£70'. *Pugin sketch*, BM & AG a. no. not allocated. *Cartoon costs per ledger summary*: Powell £5.0.0, Hendren £2.0.0.

Letter. *JHA: Sillitoe to Hardman*, written from London, 1849, Jul. 27: 'I enclose the dimensions received from Sydney please to take into consideration the district & the poor state of the Colony. Give me an estimate of a Nest plain windows, and one with a figure of St. Mark in the centre & a neat Centre in each of the side compartments & if I can with safety to myself give the order on my own responsibility without consulting my fellow Parishioners – Accept my sincere thanks for the many kindnesses I have received from you'.

Literature. Andrews, 2002, pp. 163, 200.

224 Sydney, St Patrick, Church Hill (RC)[93]

1849. Client: Archbishop Polding. The glass is no longer in place and is presumed lost or destroyed.

Office Records. *Order Book*, undated, f. 48: 'Large Round head Lights'. *First Glass Day Book*, 1849, f. 65, Jul. 25: 'To An East Window of/3 Lights of Stained Glass/£175/in Groups & Quarries set/in Iron Geometrical Frames/Centre Light 12'8" x 4'4"/2 Side Lights 10'8" x 3'0"/.../3 Large Iron galvanized/geometrical Frames for do/£30.10.0/.../Subject, Life of St. Patrick'. *Cartoon costs per ledger summary*: Powell £3.0.0, Hendren £1.6.8.

Letters. *HLRO 304: Pugin to Hardman*, letter no. 992: 'I am getting on well with the designs of all the windows you want – you will very soon have Sydney finished'. No. 820: '3. The Sydney window will be done & sent out this week'. No. 1038: 'I have got your letter – the window for Sydney you shall have tomorrow'. No. 370: 'The Sydney window & 2 Oscott lights [St Mary's College, Oscott, Gaz.182], go off tonight'. No. 1036': I send you the sketch of the window for Sydney there is a great deal of work in it I am sure 200 is not too much I quite [sic] sure if you can possibly make the Iron frames for the money they must be Iron frames I should charge the glass a little under 200 & make the Iron work extra there is 130 feet of glass hence you can judge as well as I can but that is my opinion it is no use losing by anything. I have kept a copy of the sketch to work the window by & shall get it in hand It will look a splendid job well worth the money'. No. 1037: 'I did not see anything about 2" of stonework for Sydney but it will be easy to contract the window that much in the cartoons. The iron work will have to be fitted into a rebate in the stone & secured by pins in the side [makes a small sketch to illustrate how this should be done]'. No. 987: 'Powell is doing the groups for Sydney so I think you will soon have a lot'. No. 950: 'St. Bridget for the Sydney window goes off tonight'. No. 140: 'another group for Sydney goes off tonight'. No. 993': 2 more subjects go off tonight for the Sydney window the rest will soon follow. No. 142: '4. 2 more side groups & the centre group go off tonight – for the Sydney window'. No. 134: '2. I have sent off the St. Patrick tonight & tomorrow the group of the asention [sic] which will complete the Sydney window'. No. 406: 'Powell gives me a most disturbing account of the Sydney window'. I am afraid your men are getting to Paint (as Myers men carve) all styles alike'. *JHA: Polding to Hardman*, 1848, Jul. 12: 'On the other side are the exact[?] dimensions of the Chancel window of St. Patrick's Church – I feel strongly inclined to leave the choice of subject to yourself and also the mode of treating The Patron Saint of the Church and St. Bridget must of course be introduced. Our saviour commissioning St. Peter and the other Apostles to preach the Gospel – Those three with such concomitant of yours from the Irish Church History or the circumstances from the life of St. Patrick which may be illustrative and edifying – will also I think afford ample matter to fill up a window which shall be creditable [sic] to all parties – As regards the price – I must leave that in perfect confidence to yourself to something less than £200. I presume it may be done - but really I

am not aware of the prices which run current in these matters. If it be thought fitting - in order to give strength to & to divide the spaces and to introduce stone tracery it can be done [sic] - we have left the entire space of the window lights unoccupied - that you may be uncontrolled in your design.' *W(?) V.M(?) Cormsly(?) to Hardman*, 1850, Jan. 21: 'I am directed by the most Reverend the Archbishop of Sydney to forward you the Enclosed set of Exchange for the sum of £210.18/- for the window of St. Patrick's Church – They came to hand quite safe and are now up.'
Literature. Andrews, 2002, pp. 161-2.

BELGIUM

225 Convent Chapel of Notre Dame, Rue Les Fosses, a Narres(?) (RC)
1853. Windows designed by J.H. Powell

Office Records. *Order Book 2*, 1853, ff. 87-8, Jun. 19: 'Joys. 1. Annunciation. 2. Visitation. 3. Birth of Our Lord. 4. Adoration of Magi. 5. Finding in Temple. 6. Resurrection. 7. Coronation of B.V.; Dolours. 1. Presentation of Our Lord. 2. Flight into Egypt. 3. Seeking in the Temple. 4. Meeting Our Lord on the Way of the Cross. 5. Crucifixion. 6. Descent from the Cross. 7. Burial of Our Lord.' *Order Book 3*, 1853, ff. 62-3, Jun. 19. *First Glass Day Book*, 1853, f. 196, Nov.: 'To 2 Windows of Stained/Glass, of geometrical/Tracery consisting ea./of 7 Circles & Tracery pieces. Subjects of/one Window/"The Joys of the B.Virgin"/of the other "The Dolours of the B.Virgin"/.../Each Window 10'5" x 3'11"'.

CANADA

226 Montreal, St Hilaire
1851. Client: Major Campbell, St Hilaire, Montreal. Ordered through Henry Sharples, 43 Sefton Street, Liverpool.

Office records. *Order Book*, 1851, f. 146, Dec. 13: 'Initials for simple windows T.E.C.'. *First Glass Day Book*, 1851, f. 146, May 25: 'To 4 Lights of Stained Glass/with Arms & Initials/for Dining Room/Each light 2'0" x 1'7½"/.../To 5 Lights of do./do./for/Drawing Room; Each Light 2'2" x 1'2"/.../ To 4 Lights of do./do./for/Drawing Room/£30/Each light 2'2" x 1'6"/.../To 6 Lights of Stained Glass /with Initials only/for Passage/£7.10.0/4 lights ea. 1'8" x 1'6"/.../& 2 lights ea. 1'6½" x 1'6"'.
Letter. *JHA: Sharples to Hardman*, 1851, Dec. 3: 'When the Major [Campbell] was with his regiment in Warwickshire he met Mr. Pugin & was also at your works & in fact you have been named to him for his stained glass.'

FRANCE

227 Paris, Monsieur Gerente
Office records. *First Glass Day Book*, 1847, f. 18, Oct. 19: ' ¼lb. Black Shadow Colour/7s 6d/ ½lb. Red Shadow do. 4s.0d/1lb Brown Shadow 8s.0d'.

ITALY

228 Rome, English College
Client: Francis Whitgreave, Radford, Stafford.

Office records. *Order Book*, 1850, f. 85, May 4: '2. shields to be introduced under St. George the Whitgreave arms under St. Amelia. Inscription & Arms to come on Brass Plate'. *First Glass Day Book*, 1853, f. 181, Jun. 4: 'To A Window of Stained/Glass of 2 Lights with/Figures of "St. George"/& "St. Amelia/£35/2 Lights 7'5" x 1'6" .../Forwarded by Rev. I Virtue/.../as directed'.
Letter. HLRO 304: *Pugin to Hardman*, letter no. 844, postmark 'MR17 1850', 'I send you the sketch for the English College Window. I have kept it in the Italian style of medieval glass'.

Endnotes

Introduction

1. *The Tablet*, 8, 1852, p. 618.

2. Harrison, 1980, p. 15.

3. Hill, 2007, pp. 10, 12 re Augustus; pp. 23, 24 re Catherine.

4. Ferrey, 1861, p. 33.

5. These categories are covered chapter by chapter in Atterbury & Wainwright, 1994. Alexandra Wedgwood's chapter, 'The Early Years' has provided me with much of the information on the first years of Pugin's life.

6. Champ, 1987, pp. 1-2: 'now the seminary of the Archdiocese of Birmingham and the main training centre for its priests it was the first English Catholic institution which attempted to blend secular and religious education'.

7. Wedgwood, 1985, p. 81, note 44.

8. Stanton, 1971, p. 10. A chronological list of 'Buildings and some other Work' is given on pp. 195-209. Hill, 2007, pp. 500-28, gives a more comprehensive and up-to-date list of works, by country, and locations within.

9. Atterbury & Wainwright, 1994 (Belcher, 'Pugin Writing'), p. 109.

10. Quoted in Trappes-Lomax, 1932, pp. 57-8.

11. Ibid., p. 103; Gwynn, 1946, p. xv.

12. Eastlake, 1872, reprinted with Introduction by J.M. Crook, 1970, p. 190.

13. Founded by students at Cambridge University in 1839, its stated objectives being: 'to promote the study of Ecclesiastical Architecture and Antiquities and the restoration of mutilated Architectural remains'. See White, 1962, pp. 36-40.

14. Bayliss, 1989, pp. 59-80; Harrison, 2004.

15. Ibid.

16. Pugin's first two remarks appear in Pugin, 1839, p. 33; the Hereford Cathedral window is described in Morgan revised by Penelope E. Morgan, 1979, pp. 21-3, and Pugin's comment on it in Belcher, 2001, p. 18, letter to William Osmond, 27 Oct. 1833.

17. Pugin, 1841, p. 1.

18. Cheshire, 2004, p. 12.

19. Pugin, 1839, p. 33.

20. Bayliss, 1989, chapters 1-5.

21. Harrison, 1980, pp. 15-17, and Harrison, 2004.

22. Bayliss, 1989, p. 234; Peover, 2004, pp. 90-6, 118-2.

23. Bayliss, 1989, pp. 237-9.

24. Bemden, Kerr, Opsomer, 1986, pp. 193-4.

25. Harvey & King, 1971, pp. 154-66; Harrison, 1980, p. 17; Bayliss, 1989, p. 243.

26. Harrison, 1980, p. 18.

27. *Gentlemen's Magazine*, 163, 1838, p. 171.

28. *London & Dublin Weekly Orthodox Journal*, 6, 1838, p. 90 (reprinted from the *Birmingham Journal*).

29. See note 16 re Belcher, 2001; Harrison, 1980, p. 18, suggests the 'Tree of Jesse' window, *c*.1522, at St Etienne, Beauvais, as a possible source.

30. See note 16 re Belcher, 2001.

31. Pugin, 1839, p. 30.

32. Ibid.

33. Harrison, 1980, pp. 17–18.
34. See Gaz.190, *Literature*.
35. See Gaz.126.
36. HLRO 304, letter no. 361.
37. HLRO 304, letter no. 908.
38. See Gaz.182, *Literature*.
39. The window is described by Pugin in his lecture to students at Oscott: see Pugin, 1839, p. 95.
40. See Gaz.151, *Letters,* Wedgwood, 1985.
41. Hill, 2007, p. 492, suggests syphilis contracted during the time he spent in the theatrical environment.
42. JHA, March 2, 1852.

Chapter 1. Pugin's Window-makers
1. Pugin to E.J. Willson, 17 Jul. 1835 (Belcher, 2001, p. 48).
2. See Gaz.192, *Literature,* Wedgwood. Alexandra Wedgwood (Atterbury & Wainwright, 1994 p. 45) has indicated that other windows of this period namely, those in the chapel of what was King Edward VI's School, Birmingham (the original school in the city centre was demolished in 1936 and the chapel recreated in 1952 in the new King Edward's School (Boys) located in Birmingham's Edgbaston district) were designed by Pugin. The windows are made up of diagonal Latin texts against yellow silver-stain patterned diamond quarry backgrounds. Pugin supplied the architect Charles Barry with drawings for decorative details and furniture for the school during 1835-6 (Stanton, 1971, p. 196).
3. See author's entry in *Oxford Dictionary of National Biography*, 2004.
4. *Birmingham Journal*, Jan. 16, 1838, reproduced in the *London & Dublin Weekly Orthodox Journal*, 6, 1838, pp. 90-1.
5. Warrington, 1848, p. 33 footnote.
6. 28 Aug. 1841 (Belcher, 2001, p. 269).
7. See Gaz.148, *Literature*.
8. See author's entry in *Oxford Dictionary of National Biography*, 2004.
9. For J.T. Trevanion's house, Caeshays, Cornwall.
10. Brown, 2006.
11. See Gaz.178.
12. 28 Aug. 1841 (Belcher, 2001, p. 268).
13. 24 Dec. 1841 (Belcher, 2001, p. 306).
14. See Cheshire, 2004, p. 40, for a suggestion that Willement had continued pricing in accordance with Regency precedents.
15. 13 Feb. 1842 (Belcher, 2001, p. 322).
16. Hall, 1982; Parry, 1996 (David O'Connor 'Pre-Raphaelite Stained Glass'), p. 40, quoting from Scott, 1892, vol. 1, pp. 188-91.
17. See note 16 and Harrison, 1980, p. 83, who notes that the 1851 census records Wailes as employing 76 workers.
18. Hall, 1982.
19. These included F.W. Oliphant, J. Sticks and J. Thompson Campbell; see Marshall Hall, 1982, pp. 130, 176 and 33 respectively.
20. See note 16.
21. *London & Dublin Weekly Orthodox Journal,* 12, 1841, pp. 347-8.
22. 4 Dec. 1840 (Belcher, 2001, p. 179).
23. MS86 BB 27 National Art Library, London. I am grateful to Alexandra Wedgwood for drawing my attention to this point.
24. According to Pugin's letters to Francis Amherst (see Gaz.168, *Letters*: the Birmingham Archdiocesan

Archives) the window at Kenilworth was close to completion by mid-Oct. 1841. On p. 1 of Louisa Amherst's diary (Birmingham Archdiocesan Archives P182/5/3 she writes: 'during our stay on the Continent, the East window was stained by Wailes at Newcastle on Tyne'.

25. In a letter to Dr Rock dated 25 Aug. 1841 (Belcher 2001, p. 267), Pugin wrote: 'I shall arrange to get down to you at Farrington when I go to Banbury where I am making several additions to the Church – in the shape of stained windows & c'.

26. For example, the arrangement of symbols or monograms in quatrefoils contained within roundels that are framed by cartouche – like quatrefoils, appear in the side lights at Kenilworth and in the side windows at Banbury, whilst the respective lights and windows are each made up of yellow silver stain – patterned white quarries albeit that the patterns are different in the two.

27. The buildings included: St Augustine, Kenilworth (Gaz.168); St Nicholas, Liverpool (Gaz.111); St John, Banbury (Gaz.131A); Jesus Chapel, Ackworth Grange, nr Pontefract (Gaz.191); St Oswald, Liverpool (Gaz.113); St Mary the Virgin, Oxford (Gaz.139); St George, Southwark (Gaz.63); Brigg (Gaz.84); The Grange, Ramsgate (Gaz.87); St John the Evangelist, Kirkham (Gaz.92); Ratcliffe College, Syston (Gaz.103); Oswaldcroft, Liverpool (Gaz.114); Sutton Chantry Chapel, Lynford (Gaz.118); St Felix, Northampton (Gaz.122); St Barnabas Cathedral, Nottingham (Gaz.131); St Bede, Rotherham (Gaz.144); Albury Chapel (Gaz.161); St Mary's, Newcastle upon Tyne (Gaz.164); St Mary, Brewood (Gaz.150); St Mary, Liverpool (Gaz.112); St Andrew, Cambridge (Gaz.11); St Mary, Wymeswold (Gaz.104); St Mary, (King's) Lynn (Gaz.119); Alton Towers (Gaz.117); St Giles, Cheadle (Gaz.151); St John the Baptist, Bishopstone (Gaz.193); and St Wilfrid, Hume (Gaz.67).

28. Letter to Lord Shrewsbury, 28 Nov. 1841 (Belcher, 2001, p. 290).

29. Letter to Lord Shrewsbury, date unknown (Belcher, 2003, p. 491).

30. See Gaz.40, *Letters*, HLRO 339, letter no. 124.

31. Atterbury & Wainwright (Eatwell & North, 'Metalwork'), 1994, p. 17.

32. Powell (ed. S. Timmins), 1866, p. 524.

33. JHA *Letters*, marked 1845 box.

34. JHA, glass invoices.

Chapter 2. Seeking the 'real thing'

1. HLRO 304, letter no. 406. According to his diary, Wedgwood, 1985, Pugin visited Rouen Aug. 29-30, 1849, and Evereux Aug. 31-Sep. 2, 1849.

2. HLRO 304, letter no. 394.

3. Pugin, 1839, pp. 17-34. A footnote on p. 21 mentions that large-scale transparencies were used and those mentioned in the text include: a pattern for Salisbury Cathedral (p. 21); a portion of a window of Chartres Cathedral (p. 22); a window from the choir of the Abbey of St Ouen, Rouen (p. 271), and a window from Great Malvern Abbey (p. 29).

4. Thomas Rickman, architect and author, in 1817 of *An Attempt to Discriminate the Styles of Architecture in England*. The dates are those quoted in Brooks, 1999, pp. 136-7.

5. See author's entry in *Oxford Dictionary of National Biography*, 2004.

6. *The Builder*, 3, 1845, p. 367.

7. *The Ecclesiologist*, 10, 1849, p. 91.

8. *The Building News*, 4, 1858, p. 393.

9. Harrison, 1980, p. 24.

10. *Illustrated London News*, Sep. 20, 1851, p. 362.

11. See note 7.

12. HLRO 304, letter no. 909.

13. See Gaz.41, *Letters*.

14. HLRO 304, letter no. 693.

15. HLRO 304, letter no. 769, *c.*early 1850.

16. HLRO 304, letter no. 913.

17. National Library of Scotland, MS 23204, f. 15. I am indebted to Margaret Belcher for alerting me as to the existence of a small group of letters from Pugin to Oliphant and to Rosemary Hill for letting me know that they were in the National Library of Scotland.

18. There is a suggestion here that Pugin experimented with painting on glass which he fired in his own furnace. No evidence has been uncovered that he carried out such experiments at Ramsgate.

19. HLRO 304, letter no 686, *c.*early 1850.

20. The organisation of the Hardman Glass Workshop is set out in Chapter 3.

21. HLRO 304, letter no. 986, *c.*1849.

22. HLRO 304, letter no. 109, *c.*1849.

23. See Gaz.162, *Letters:* HLRO 304, letter no. 466.

24. JHA glass invoices.

25. HLRO 339, letter no. 38.

26. Barry, 1868, p. 55.

27. See Gaz.40, *Letters,* HLRO 339, no. 124, Pugin to the Rev. Newsham.

28. HLRO 304, letter no. 982: JHA, glass invoice from Edward Rutter, 10 Rue Louis le Grand, dated September, 1849, for £16.13.4 in respect of the cost of the glass (£6.0.0) carriage and customs duty.

29. Much of what follows regarding glass manufacture in contained in Shepherd, 1997, pp. 1-10.

30. Winston, 1865, pp. 10-11, 182.

31. *The Ecclesiologist,* 14, 1853, p. 178.

32. Winston, 1865, p. 182.

33. Ibid., p. 10.

34. Winston, 1849, pp. 34-9.

35. HLRO 304, letter no. 986 (undated [*c.*end 1849]). St Joseph's Convent, Cheadle, see Fisher, 2002, p. 121, where the window is attributed to Hardman's. The sense of Pugin's letter suggests this is so although there is no record of it in the First Glass Day Book. I am grateful to Michael Fisher for giving me a photograph of the window which shows it to be of two lights with a single trefoil tracery-piece. Each light contains three geometrically patterned blue diaper, yellow-beaded-rimmed quatrefoils attached to each of which are four yellow *fleur-de-lis.* The rest of the lights are filled with yellow silver stain *fleur-de-lis*-patterned quarries. The borders are made up of white *fleur-de-lis* between which are alternately red and blue pieces of glass edged on the inside with strips of yellow-beaded glass. The tracery piece contains a yellow-rimmed, blue roundel patterned with a floriated letter M surrounded by geometrical patterns in blue yellow and green.

36. JHA, letter Hartley to Hardman, May 15, 1849.

37. JHA, letter Hartley to Hardman, May 18, 1849.

38. HLRO 304, letter no. 696, *c.*end 1849.

39. JHA, letter Hartley to Hardman, Jun. 5, 1849.

40. Winston, 1847, pp. 22-4.

41. HLRO 304, letter no. 779.

42. JHA, letter Hartley to Hardman, Dec. 27, 1849.

43. JHA, letter Hartley to Hardman, Jan. 8, 1850.

44. HLRO 304, letter no. 917.

45. JHA Letters.

46. Ibid.

47. JHA, letter Hartley to Hardman, Mar. 15, 1850.

48. *Archaeological Journal,* 7, 1850, p. 188. Referred to in Brown, 1997, p. 112. That Newcastle rather than Sunderland is mentioned is taken as being an error on Winston's part or a case of misreporting.

49. See note 45.

50. HLRO 304, letter no. 692, *c*.mid-1850.
51. HLRO 304, letter no. 690, *c*.mid-1850.
52. JHA, letters, Hartley to Hardman, May 13, Aug. 8 and Aug. 28, 1850.
53. JHA, letter Hartley to Hardman, Jun. 26, 1851.
54. See note 45
55. Winston, 1865, pp. 180-2.
56. Re the window St Mary the Virgin, Oxford, see Gaz.139, *Letters*, HLRO 304, letter no 187.
57. HLRO 304, letter no. 688.
58. Lyon Playfair (1819-98), British scientist, later Edinburgh chemistry professor 1850-68.
59. JHA, letter Hartley to Hardman, Sep. 25, 1851.
60. JHA, letter Hartley to Hardman, Oct. 8, 1851.
61. See note 45.
62. Ibid.
63. Ibid.
64. Ibid.
65. Harrison, 1980, p. 23.
66. *The Builder*, 19, 1861, p. 529.
67. Stokes, 1934, pp. 171-6.
68. *The Builder*, 15, 1857, p. 493.
69. Powell (ed. Wedgwood, 1988), p.184.
70. HLRO 304, letter no. 840, postmarked 'NO 8 1849'.
71. HLRO 304, letter no. 920, *c*.end 1849.
72. Ibid.
73. Ibid.
74. Ibid.
75. HLRO 304, letter no. 957.
76. HLRO 304, letter no. 437, post-marked 'JY25 1849'.
77. See note 70.

Chapter 3 The Hardman Glass Workshop

1. HLRO 304, letter no. 832.
2. Harman to Walter Blount, Dec. 14, 1846: see Gaz. 57, *Letters.*
3. Pugin, 1839, pp. 18-19.
4. HLRO 304, letter no. 792, *c*.early 1850.
5. HRLO 304, letter no. 833, postmark 'NO.4 1849.
6. HLRO 304, letter no. 405, *c*.late 1849.
7. JHA, Apr. 22, 1850.
8. HLRO 304, letter no. 700.
9. JHA, Letter Book, 17 May, 1850. It has been suggested that Hardman's description of the cartoons as being, 'all cut in pieces', meant that the workshop followed the French practice of, in effect, creating templates from which individual glass pieces could be cut rather than the nineteenth-century English practice of making separate 'cut-lines' to assist in the cutting of the glass. This seems unlikely for a number of reasons: Pugin's description of the process in his Oscott lecture suggests otherwise and so do a number of references in his letters to the drawing of the lead lines. Further his request for the Milton Abbey cartoons to be sent to assist in drawing those for St Paul, Brighton, implies that they were still in one piece. See Gaz 41, *Letters*, HLRO 304, letter no. 134. Possibly the cartoons for St Cuthbert's College were a one-off in this respect for the around 6,000 uncatalogued cartoons in the Hardman archive at the Birmingham Museum & Art Gallery seem to be whole. The collection is not open to the general public for inspection, although on occasions special searches

may be made. The extent to which those from the Pugin period survive is uncertain.

10. Powell (ed. S. Timmins), 1866, pp. 523-4.

11. JHA, glass invoices.

12. Powell (ed. Wedgwood, 1988), p.184, mentions William Tipping and a Frank Green as being members of the workforce, after Pugin's death.

13. Powell (ed. Wedgwood, 1988), p. 183.

14. Belcher, 2003, pp. 290-1; Powell (ed. Wedgwood, 1988), p. 171, the editor's introduction quotes HLRO 304, letter no. 80, postmarked Dec. 3, 1844, as requesting a bedstead to be sent at once before John Powell comes, see also Belcher, 2003, p. 292.

15. HLRO 304, letter no. 327.

16. Atterbury & Wainwright (Wedgwood, 'The New Palace of Westminster'), 1994, p. 224.

17. Powell (ed. Wedgwood, 1988), pp. 171-2.

18. HLRO 304, letter no. 865.

19. HLRO 304, letter no. 5, c.early 1847.

20. JHA, 1847 letters.

21. JHA, postmark SE 8 1847.

22. HLRO 304, letter no. 126.

23. HLRO 304, letter no. 738, c.mid-1849.

24. HLRO 304, letter no. 855, c.1st quarter 1850.

25. HLRO 304, letter no. 780, c.mid-1850.

26. HLRO 304, letter no. 576, c.Apr. 1851.

27. HLRO 304, letter no. 58, quoted in part in Stanton, 1950, p. 449.

28. Powell was born on Mar. 4, 1827 (obituary notice, *Birmingham Weekly Post*, Mar. 9, 1895). I am grateful to Ruth Gosling for this information.

29. HLRO 304, letter no. 431.

30. HLRO 304, letter no. 327.

31. Ibid.

32. HLRO 304, letter no. 431.

33. HLRO 304, letter no. 404.

34. See Gaz 166 *Letters*: HLRO 304, letter no. 393, and Gaz. 130, *Letters*, HLRO 304, letter no. 806.

35. HLRO 304, letter no. 431: 'he has been poisoned by others'; HLRO 304, letter no. 404: 'I know I think how he has been worked upon.'

36. HLRO 304, letter no. 404.

37. HLRO 304, letter no. 59, quoted in part in Stanton, 1950, p. 450.

38. After his marriage Powell moved into a house nearby, see Hill, 2007, p. 443.

39. The village of St Lawrence, now within the outskirts of Ramsgate, where Powell's house was situated.

40. HLRO 304, letter no. 725.

41. HLRO 304, letter no. 399: Pugin also writes of his readiness to take charge of the study, in HLRO 304, letters nos 726, 746.

42. HLRO 304, letter no. 576, c.Jul. 1851.

43. HLRO 304, letter no. 690, c.late 1850.

44. Scott, 1892, p. 188.

45. Fordyce, 1867, p. 200. I am grateful to Neil Moat for bringing this item to my attention.

46. The window is on loan in the Metalwork & Glass Decorative Art Department of the Liverpool Museum.

47. See, Gaz. 109, *Letters*, HLRO 304, letter no. 885.

48. HLRO 339, letter no. 15.

49. JHA, letter to Hardman dated Jun. 28, 1850 (copied into Hardman's Letter Book).

50. HLRO 304, letter no. 780.

51. These include: St Cuthbert's College, Ushaw (Gaz.40); Alton Towers (Gaz.147); St Wilfrid, Cotton (Gaz.152); Milton Abbey (Gaz.35); St Andrew, Wells Street (Gaz.61); Oswaldcroft (Gaz.114); St Margaret, Whalley Range (Gaz.70); St. John the Evangelist, Frieth (Gaz.5); St. Paul, Brighton (Gaz.41); St Margaret, Edinburgh (Gaz.213); Convent of Mercy, Nottingham (Gaz. 130); St Nicholas, Copperas Hill, Liverpool (Gaz.111); St Thomas & St Edmund of Canterbury, Erdington (Gaz.177); St Mary, Ottery St Mary (Gaz.29); Campden House, Glos (Gaz.44); St Stephen and All Martyrs, Lever Bridge (Gaz.68); Chester Cathedral (Gaz.14); Castlemartin Church (Gaz.218); St Mary, Beverley (Gaz.83); Stonyhurst College Church (Gaz.93); St Marie, Sheffield (Gaz.145); Magdalen College Chapel, Cambridge (Gaz.10); Holy Cross Abbey, Stapehill (Gaz.38); and St Chad's Cathedral, Birmingham (Gaz.176).
52. HLRO 304, letter no. 837.
53. HLRO 304, letter no. 930.
54. HLRO 304, letter no. 692.
55. HLRO 304, letter no. 54.
56. HLRO 304, letters nos 4, 325, 359, 365, 407, 686, 696, 699, 719, 732, 734, 769, 780, 816, 818, 819, 862, 874, 909, 938, 973.
57. HLRO 304, letter no. 909.
58. HLRO 304, letter no. 816.
59. HLRO 304, letter no. 719.
60. HLRO 304, letter no. 4.
61. HLRO 304, letter no. 699.
62. HLRO 304, letter no. 819.
63. HLRO 304, letter no. 769.
64. HLRO 304, letter no. 767.
65. HLRO 304, letter no. 768.
66. HLRO 304, letter no. 543.
67. JHA.
68. HLRO 304, letter no. 969.
69. HLRO 304, letter no. 784.
70. JHA, in 1847 bundles; £10 for time and expenses to cartoon is credited to Hendren on Nov. 2, 1847, in Pugin's cartoon account.
71. HLRO 304, letter no. 1032.
72. HLRO 304, letter no. 909.
73. HLRO 304, letters nos 920, 969, 973.
74. JHA.
75. HLRO 304, letter no. 637.
76. HLRO 304, letter no. 785.
77. HLRO 304, letter no. 789.
78. HLRO 304, letter no. 758.
79. JHA, undated Pugin letter marked 1845 box.
80. JHA, quoted, with illustration, in Stanton, 1971, pp. 174-5.
81. JHA, Early's letters.
82. HLRO 304, letter no. 987.
83. HLRO 304, letter no. 822, c.1849.
84. HLRO 304 letter no. 898, c.late 1849.
85. HLRO 304, letter no. 744.
86. HLRO 304, letter no. 179, c.mid 1850.
87. Hill, 2007, pp. 462-3.
88. Johann Friedrick Overbeck together with Franz Pforr (1788-1812) founded in 1809, in Vienna, a quasi-

order called 'The St. Luke Brothers' with the purpose of regenerating German religious art in imitation of the works of the late medieval and early Renaissance artists. They moved in 1810 to Rome and worked in the deserted monastery of Sant' Isidoro. They were joined by others, several of whom, including Overbeck, became Catholics. Due to their appearance and mode of life the group was sarcastically nicknamed the 'Nazarenes' (Murray, 1964, p. 223; Andrews, 1964, p. 29).

89. Vaughan, 1979, p. 42, but see St Oswald, Winwick (Gaz. 18), re letter to the Rev. Hornby in which Pugin claims the recommendation from Overbeck was directed to him.

90. JHA, undated letter marked 1847 box.

91. HLRO 304, letter no. 543.

92. See note 89.

93. HLRO 304, letter no. 467, c.late 1850.

94. HLRO 304, letter no. 821, c.Mar. 1850.

95. HLRO 304, letter no. 416.

96. HLRO 339, letter no. 122. In an earlier letter, HLRO 339, letter no. 124, date-stamped RAMSGATE AU 22 1847 Pugin agreed to send the designs of the Passion to the Rev. Newsham for inspection before they were executed.

97. HLRO 339, letter no. 122.

98. HLRO 339, letter no. 127.

99. These included: Burton Closes House, Bakewell (Gaz.23); Canford Manor, Dorset (Gaz.34); New Palace of Westminster (Gaz.64); The Grange, Ramsgate (Gaz.87); Dornden, Tunbridge Wells (Gaz.91); Oswaldcroft, Liverpool (Gaz.114); Oswestry School, Shropshire (Gaz.140); The Farm, Sheffield (Gaz.146); Alton Towers, Staffordshire (Gaz.147); Bilton Grange, Warwickshire (Gaz.166); Charles Iliffe, Birmingham (Gaz.173); Lander, Powell & Co. (Gaz.174); St Marie's Grange, Alderbury (Gaz.192); Lismore Castle, Ireland (Gaz.199); Chirk Castle, Wales (Gaz.216); St Hilaire, Montreal, Canada (Gaz.226), of which the most noteable were those for the New Palace of Westminster.

100. A list, with folio references to the First Glass Day Book, is given on p. 849 of my Ph.D thesis.

101. HLRO 304, letter no. 852.

102. JHA, marked 1845 box.

103. The amounts are given in sterling in the order book and rendered in code in the First Glass Day Book (the code used is an alphabetical one, D = 0; E = 1; F = 2; G = 3; H = 4; J = 5; K = 6; L = 7; M = 8; N = 9). Meara, 1991, p. 43, shows the same code was used for the metalwork side of the business.

104. JHA, dated Apr. 9, 1947.

105. JHA, Letter Book dated Jul. 19, 1850.

106. JHA, postmark MY 16 1849.

107. JHA, Letter Book, p. 61, to J.J. McCarthy dated Mar. 14, 1851.

108. JHA, Letter Book, p. 82, to W. Cunliff Brooks, Sep. 9, 1851.

109. HLRO 304, letter no. 236. In Atterbury & Wainwright, 1994, pp. 204-5, I incorrectly dated this letter c.1850-1, a time when the business was under pressure due to work for Westminster and the Great Exhibition.

110. Milton Abbey (see Gaz.35), *Letters*, JHA Pugin to Hardman, 1847, Oct. 1. Only the window for the S transept was completed.

111. HLRO 304, letter no. 41.

112. HLRO 304, letter no. 1035.

113. HLRO 304, letter no. 223.

114. HLRO 304, letter no. 183, postmark 'AU 26 1848' – possibly the windows were for St Andrew, Cambridge (Gaz.11), but there is no reference to them in the First Glass Day Book; perhaps the priest was mistaken when he said Hardman's stained them.

115. HLRO 304, letter no. 225.

116. John Gregory Crace (1809-89) who manufactured textiles and wallpapers from Pugin's designs.

117. HLRO 304, letter no. 432.

118. HLRO 304, letter no. 1038.

119. HLRO 304, letter no. 969.

120. HLRO 304, letter no. 911.

121. HLRO 304, letter no. 907, postmark 'DE 14 1849'.

122. HLRO 304, letter no. 922.

123. HLRO 304, letter no. 970, c.1850.

124. HLRO 304, letter no. 909.

125. HLRO 304, letter no. 149.

126. HLRO 304, letter no. 971.

127. HLRO 304, letter no. 724

128. HLRO 304, letter no. 651.

129. JHA, March 19, 1851 – see Gaz.128.

130. The First Glass Day Book f. 175 indicates that no charge was made.

131. *Aris's Birmingham Gazetter*, Oct. 1849.

132. HLRO 304, letter no. 847.

133. HLRO 304, letter no. 802.

134. HLRO 304, letter no. 159, c.Feb. 1851.

135. HLRO 304, letter no. 693.

136. HLRO 304, letter no. 456.

137. JHA, N.J. Cottingham to Hardman letter dated Feb. 17, 1851.

138. See note 136.

139. As described in the *Illustrated London News,* Sep. 20, 1851, p. 362.

140. See Gaz.9, *Letters*, JHA, J.S. Gammell to Hardman, Dec. 14, 1850.

141. See note 139.

142. *The Ecclesiologist*, 12, 1851 p.182.

143. Atterbury & Wainwright, (Wedgwood, 'The Medieval Court'), 1994, p. 238.

144. See note 139.

145. Ibid.

146. See note 142.

147. Ibid.

148. *Reports by the Juries on The Subjects in the Thirty Classes Into Which The Exhibition was Divided,* London, 1852, p. 695. The Report was in respect of J. Hardman & Co. of Birmingham (Class XXV, 532, p. 761), 'The figures after the Names (between parentheses) refer to the Exhibition Numbers and to the Pages in the Official Descriptive and Illustrated Catalogue'. The Report appeared under Class XXX Supplementary Report.

149. Atterbury & Wainwright, (Shepherd, 'Stained Glass'), 1994, p. 203.

150. HLRO 304, letter no. 855, c.early 1850.

151. See Gaz.188, *Letters,* JHA, Clifford to Hardman, Aug. 22, 1849.

152. JHA, Oct. 14, 1851.

153. HLRO 304, letter no. 819, c.early 1850.

154. JHA, Feb. 26, 1851.

155. JHA, Letter Book 1850 p. 57.

156. JHA, Mar. 1, 1851.

157. HLRO 304, letter no. 459.

158. JHA, Mar. 12, 1851.

159. JHA, Mar. 30, 1852.

160. HLRO 304, letter no. 837.

161. HLRO 304, letter no. 944, *c.*early 1850.

Chapter 4 Windows for Churches and Chapels

1. Pugin, 1839, p. 92.
2. Ibid., p. 91.
3. Ibid., pp. 91-2.
4. Ibid.
5. Reproduced in the *London & Dublin Weekly Orthodox Journal,* 6, 1838, pp. 382-3.
6. Pugin, May 1841, footnote p. 326.
7. *The Builder*, 5, 1847, p.508.
8. *London & Dublin Weekly Orthodox Journal*, 14, 1842, pp. 366.
9. Pugin, Feb. 1842, pp. 118-9.
10. Ibid., pp. 126-7.
11. Singleton, 1983, p. 36.
12. *The Tablet*, 7, 1846, p. 569.
13. Ibid.
14. The quoted paragraph appeared in the contributor's letter in *The Tablet*, 9, 1848, p. 467.
15. *The Tablet*, 9, 1848, p. 483.
16. Chadwick, 1848, pp. 11, 14.
17. Wickham, 1907, pp. 145-6.
18. *The Rambler*, 4, 1849, pp. 498-503.
19. *The Ecclesiologist*, 10, 1850, pp. 393-9; the report introduces the idea of 'constructional polychrome' not dealt with by Pugin, for which see Muthesius, 1972, pp. 18-22.
20. Quoted in Gwynn, 1946, p. 13.
21. 'The Artistic Merit of Mr. Pugin', *The Ecclesiologist*, 5, 1846, p. 10-16.
22. *The Tablet*, 7, 1846, p. 69.
23. Stanton, 1971, p. 109.
24. Belcher, 2001, Pugin to Lord Shrewsbury, p. 178.
25. Ibid., p. 381.
26. Stanton, 1950, Appendix VII.
27. See Gaz, 131, *Letters,* JHA, Cheadle to Hardman, 1849, JHA First Glass Day Book.
28. See Gaz. 151, *Letters,* JHA, Pugin to Hardman, 1846, JHA First Glass Day Book.
29. See Gaz.5, *Letters,* HLRO 304, letter no. 16.
30. *The Ecclesiologist,* 10, 1850, pp. 324-6.
31. *The Builder,* 3, 1845, p. 367.
32. Stanton, 1971, p. 140.

Chapter 5 Windows for Palaces, Country Houses and other Buildings

1. Pugin, 1839, p. 90.
2. Atterbury & Wainwright, (Wedgwood, 'The New Palace of Westminster'), 1994, Chapter 17.
3. Port (Christian, 'Stained Glass'), 1976, p. 246.
4. Ibid., p. 247 and illustration IX.
5. *The Builder*, 5, 1847, p. 153.
6. Ibid., p. 189.
7. See Gaz. 64 *Office Records*, JHA, First Glass Day Book.
8. Port (Christian, 'Stained Glass'), 1976, p. 253.
9. See Gaz. 64, *Letters,* JHA.
10. Ibid..

11. Ibid.

12. Birmingham Museums & Art Gallery.

13. Port (Christian, 'Stained Glass'), 1976, p. 253.

14. *The Ecclesiologist*, 10, 1849, footnote p. 89.

15. See Gaz.64 – opening comments.

16. Ibid .

17. Barry, 1867, p. 185.

18. Ibid., pp. 185-6.

19. Atterbury & Wainwright 1994 (Banham, 'Wallpaper'), p. 123.

20. Ibid., illustrations p. 229 of the Peers' Lobby and p. 217 of the Banqueting Hall.

21. Ibid., illustration p. 119.

22. See Gaz. 166, *Letters,* HLRO 304, letter no. 994.

23. Powell, (ed. Wedgwood, 1998), p. 175.

24. See note 1.

25. Ibid., pp. 90-1.

26. Atterbury & Wainwright (Wainwright, 'Not a Style but a Principle'), 1994, p. 1.

27. JHA.

28. Belcher, 2001, p. 276 Pugin to Lord Shrewsbury, 29 Sep. 1841.

29. Pugin, Feb. 1842, see Bishop's House Gaz.175 *Literature.*

30. See Gaz.138, *Letters,* JHA Letter Book, Sep. 5, 1851.

31. See Gaz.138, *Letters,* J.E. Millard to J. Hardman, Jul. 15, 1852.

32. See Gaz. 147, *Letters,* HLRO 304 letter no. 496.

33. See Gaz. 147, *Letters,* HLRO 304 letter no. 197.

34. Pugin, 1839, p. 91.

35. Powell (ed. Wedgwood, 1998), p. 175: Powell described the medieval medallions in the library as being set against foliage and martlets; presumably this was a lapse in memory which confused the grounds with those in the drawing room.

36. Ibid.

37. Of the undated roundels themselves, they are mostly non-pictorial, are closely connected to Pugin with their references to (according to Powell) his patron saints, to St Barbara's towers suggestive of architecture and to old churches of Thanet 'shewing [as Powell remarked] Pugin's desire to add another [St Augustine's, Ramsgate]'. Also they are neither apparently nor stated to be ancient. Given this and that the only stained glass Pugin would have had in his house would have been medieval or his own, it is tempting to speculate that they were the work of Pugin himself trying his hand at something different.

Chapter 6 Some Aspects of the Styles.

1. HLRO 304, letter no. 922, *c.*early 1850.

2. Winston, 1865, p. 173.

3. *Punch, or the London Charivari*, 1845, pp. 150, 238, quoted in Winston, 1847, pp. 278, 281, footnotes t and y respectively.

4. JHA. Among the glass invoices for 1848 is one from 'Richard Nicholls (Bookseller), 2 Bull Street, Birmingham' dated 1848 charging £1.11.6 for *Wilson on Stained Glass'.* The British Library Catalogue contains no record of such a book.

5. Winston, 1847, p. 285.

6. Ibid., pp. 269, 274.

7. Ibid., pp. 286-7.

8. Ibid., pp. 288-9.

9. Ibid., pp. 292-3.

10. *The Ecclesiologist*, 10, 1849, pp. 94–5.

11. Harrison, 1980, p. 23.

12. Ibid.

13. Articles and letters on the E window of St James appear in *The Builder*, 3, 1845, pp. 397, 415, 441; 4, 1846, pp. 331, 353, 363, 382–3.

14. See Chapter 3 p. 82.

15. Winston, 1847, p. 274 footnote q.

16. Pugin, 1839, p. 98.

17. HLRO 304, letter no. 230, *c*.1847–8, this extract invites comparison with a later comment on p. 96 of *The Ecclesiologist*, 10, 1849: 'If we ever had the good fortune to be consulted about decorating S. Pauls, London, we should go rather to Sens and Bourges, to Chartres and Canterbury, to Rheims and Troyes, than to Mr. Winston and his favourite Cinque-cento.'

18. HLRO 304, letter no. 862, *c*.April 1850.

19. See Chapter 2. pp. 41–2.

20. Winston, 1847, p. 78.

21. Ibid..

22. Ibid., p. 47.

23. *London & Dublin Orthodox Journal,* 6, 1838, pp. 227–8.

24. See note 22.

25. See note 20, p. 46.

26. *The Ecclesiologist*, 12, 1851, p. 324.

27. Jesus College, Cambridge, Archives.

28. HLRO 304, letter no.144, *c*.Mar. 1849.

29. HLRO 304, letter no. 46, *c*.Aug. 1849.

30. See note 26.

31. HLRO 304, letter no. 686.

32. See note 10, p. 93.

33. See note 27.

34. See Gaz. 75.

35. See Gaz.75, *Letters,* HLRO 304, letter no. 686.

36. N.J. Cottingham architect in charge of the restoration of Hereford Cathedral after the death of his father, L.N. Cottingham, in 1847.

37. HLRO 304, letter no. 820.

38. See Gaz.184 *Letters*, HLRO 304, letter no. 572.

39. Wedgwood, 1977.

40. Dr Megan Aldrich has kindly confirmed to me that Crace's did not make their own glass.

41. See Gaz.86, *Letters,* JHA, Webb to Pugin, Nov. 19 1849 and HLRO 304, letter no. 824.

42. See Gaz.76, *Letters,* JHA, Rev. Clive to Hardman, Mar. 9, 1849.

43. Alexander & Binski, 1987, catalogue entry 737 (illustrated), 'The overlapping of the vesica-shaped panels into the circular grisaille motifs is a characteristic feature of English late thirteenth-century glazing'. Pugin seems to have adapted the design to an earlier period.

44. See Chapter 2 pp. 47–50..

45. HLRO 304, letter no. 688: according to his diary (Wedgwood, 1985) Pugin visited Fairford on Jul. 29, 1850, starting out from Birmingham.

46. Wayment, 1984, pp. 85–9.

47. See Gaz. 10 *Letters,* HLRO 304, letter no. 692.

48. HLRO 304, letter no. 665, postmark 'NO. 20 1851' for the date of arrival in Birmingham.

49. Trappes-Lomax, 1932, p. 302.

50. HLRO 304, letter no. 985.

51. *Illustrated London News,* Sep. 20, 1851, p. 362.

52. *The Ecclesiologist*, 13, 1852, p. 245.

53. Ibid., 6, 1846, p. 46.

54. JHA, March 24, 1852.

55. *The Ecclesiologist*, 6, 1846, p. 38.

56. Winston, 1847, p. 148.

57. The sketch in the collection of the Birmingham Museums & Art Gallery could not be located for photographing. A photograph, unsuitable for publication, is contained in the author's Ph.D. thesis, held in the University of Birmingham Library.

Chapter 7 Subject Matter

1. See Gaz.9, *Letters,* Jesus College Archives, Pugin to 'Rev & Dear Sir' [late 1849(?)].

2. Ibid., Pugin to 'My dear Sir' Xmas Eve [1849(?)].

3. Marks, 1993, p. 72.

4. See Gaz.7, *Letters,* JHA, Scott Murray to Hardman, 'St. John's Day' 1847.

5. Ibid.

6. See Gaz.57, *Letters,* JHA Dec. 14, 1846.

7. See Gaz.16, *Letters,* JHA Pugin to Hardman, undated marked '1845 box'.

8. JHA, Pugin's letter is attached to one from T.A. Lister Marsden, dated Aug. 7, 1852.

9. Such as those at Chester Cathedral (Gaz.14), Bicton Mausoleum (Gaz.27), Our Lady, Upton Pyne (Gaz.31) and All Saints, West Haddon (Gaz.123).

10. See Gaz.93, *Letters,* HLRO 304, letter no. 773.

11. Mâle, 1961, p. 140.

12. Ibid.

13. Ibid.

14. See Gaz.145, *Letters,* HLRO 304, letter no. 863.

15. Ibid., HLRO 304, letter no. 862.

16. Isaiah 11, vv.1, 10.

17. Mâle, 1961, p. 168.

18. See Gaz.41, *Letters,* HLRO 304, letters nos 134, 1032.

19. See Gaz.37, *Letters,* JHA re wI, nVII–nX.

20. See Gaz.18, *Letters,* Rev. W.A. Wickham (1907), p. 152.

21. Marks, 1993, p. 85.

22. Ibid..

23. Ibid.

24. Pugin, 1839, p. 28.

25. Grodecki & Brisac, 1985, p. 24.

Chapter 8 Client Relationships

1. See Gaz. 5, *Letters,* HLRO 304, letter no. 172.

2. See Gaz.5, *Letters,* JHA, Ryder to Hardman.

3. See note 1.

4. Ferrey, 1861, pp. 188-9.

5. Scott, 1892, p. 190.

6. Could be the window for the Choir School (Gaz.138), but more likely that for Magdalene College Chapel, Cambridge (Gaz.10).

7. Powell (ed. Wedgwood, 1988), pp. 181-2.

8. See Gaz. 40, *Letters,* HLRO 304, letter no. 717.

9. See Gaz.40, *Letters,* JHA Newsham to Hardman, Aug. 24, 1850.

10. See Gaz. 12, *Letters,* HLRO 304, letter no. 504.

11. See Gaz.12, *Letters,* JHA, Sparke to Hardman, Mar. 17, 1851.

12. HLRO 304, letter no. 578.

13. See Gaz. 31, JHA *Letters,* Northcote to Hardman, 1850, May 3..

14. HLRO 304, letter no. 714.

15. See Gaz. 172, *Letters,* JHA, Lane to Hardman, 1851, Mar. 6.

16. JHA, undated in 1848 bundles.

17. JHA, E.M. Hartopp to Hardman, Mar. 30, 1851.

18. These included St Cuthbert's College, Ushaw (Gaz.40); St Peter, Marlow (Gaz.7); Our Lady of the Annunciation; Bishop Eton (Gaz.110); Nottingham Convent of Mercy (Gaz.130); and St Edmund's College, Ware (Gaz.82).

19. A convert to Catholicism, he commissioned the design and paid for the building of St Peter, Marlow (Wedgwood, 1985, p. 90, note 37).

20. JHA.

21. p. 139.

22. *The Ecclesiologist,* 10, 1849, p. 206.

23. I am grateful to Rev. M.K. O'Halloran, S.J. for this information.

24. St Chad's Cathedral, Birmingham, archive, item B2178, letter dated Apr. 18, 1851.

25. *The Ecclesiologist,* 12, 1851, p. 46.

26. See Gaz. 66.

27. JHA, letter dated Dec. 20, 1850.

28. Copy of reply written at bottom of W.L. Clowes' letter.

29. JHA, letter dated Jan. 30, 1851.

30. JHA, letter dated Feb. 3, 1851.

31. HLRO 304, letter no. 418, which seems to be a copy not in Pugin's hand. It is not clear that the original was ever sent, or, if it was, whether it was signed by Pugin or Hardman. I am grateful to Meriel Boyd for suggesting two alterations to my transcription of the letter and for letting me have the results of her researches on the St John, Broughton controversy including copies of the letters that appeared in the *Manchester Guardian.*

32. JHA, letter dated Aug. 12, 1851.

33. HLRO 304, letters, nos 264, 489, 824.

34. See Gaz. 9 *Letters,* C. Smyth to J. Hardman and vice versa.

35. Hill, 2008, p. 26; Atterbury & Wainwright (Wedgwood, 'The Medieval Court), 1994, p. 238.

36. *The Ecclesiologist,* 9, 1849, p.136. I am grateful to Meriel Boyd for bringing this to my attention.

37. See note 31 re Meriel Boyd's researches.

38. Atterbury & Wainwright, 1994, illustration on p. 239. A description of the rood cross is contained in the *Illustrated London News,* Sep. 20, 1851, p. 362.

39. Quoted in Atterbury & Wainwright, 1994 (Wedgwood, 'The Medieval Court), pp. 238-9.

40. Steegman, 1970, p. 209.

41. See note 39, p. 239.

42. See Gaz. 64, *Letters.*

43. See for instance Gaz. 64, *Letters,* HLRO 304, letter no. 462.

44. HLRO 304, letter no. 459.

45. See Gaz.34, *Letters,* JHA Oct. 2, 1850.

46. See Gaz.34, *Letters,* JHA Oct. 9, 1850.

47. See Gaz.34, *Letters,* JHA Oct. 2, 1850.

48. See Gaz.138, *Letters,* JHA Mar. 18, 1851.

49. See Gaz.138, *Letters*, JHA Letter Book, Sep. 5, 1851.

50. See Gaz.138, *Letters*, JHA, Sep. 5, 1851.

51. HLRO 304, letter no. 120.

52. HLRO 304, letter no. 692.

53. HLRO 304, letter no. 582.

54. HLRO 304, letter no. 214.

55. HLRO 304, letter no. 584 (see also no. 585), Butterfield was the intermediary for windows referred to in Gaz.4, 26, 29, 74, 186, 214.

56. HLRO 304, letter no. 795.

57. See Gaz. 186, *Letters*, JHA, April 2, 1852.

58. See Gaz. 186, *Letters*, HLRO 304, letter no. 732.

59. See Gaz. 29, *Letters*, undated letter at Chanters House.

60. HLRO 304, letter no. 908.

61. HLRO 304, letter no. 917.

62. HLRO 304, letter no. 836.

63. Eastlake, 1872, p. 223 – at that time the Society was known as the Cambridge Camden Society.

64. See Gaz. 41, *Letters*.

65. See Gaz. 41, *Letters*, JHA, Carpenter to Pugin, Sep. 20, 1851.

66. HLRO 304, letter no. 672.

67. JHA.

68. JHA. I am grateful to Martin Harrison for bringing this letter to my attention.

69. See Gaz. 37, *Letters*.

70. HLRO 304, letter no. 177.

71. HLRO 304, letter no. 672.

72. The E window completed in Apr. 1854 (JHA, cost sheet 18/1854) was ordered with the others for the chancel in Carpenter's letter to Pugin, (JHA, Sep. 20, 1851). As Carpenter requested a sketch for the window in 1853 (JHA, letter Jul. 17, 1853) the inference is that Pugin had made no progress and that the window was designed later by J.H. Powell.

73. The architects and buildings involved were: Matthew E. Hadfield – The Farm, Sheffield (Gaz.146); St Marie, Sheffield (Gaz.145); Charles F. Hansom – St Thomas & St Edmund of Canterbury (Gaz.177); Taunton Convent (Gaz.142); St. Catherine Convent, Clifton (Gaz.2); William W. Wardell – Our Lady Star of the Sea, Greenwich (Gaz.53); Our Lady of Victories, Clapham (Gaz.52); Henry Woodyer – Holy Innocents, Highnam (Gaz.48); St Peter, Pudleston (Gaz.78); Thomas H. Wyatt – St Martin, East Woodhay (Gaz.3); Pantasaph Church (Gaz.217); Nockalls J. Cottingham – Hereford Cathedral (Gaz.75); J. & C. Buckler – St Mary Magdalen Choir School, Oxford (Gaz.138); St. Leonard. Butleigh (Gaz.141); Fulljames & Waller – St Michael, Gloucester (Gaz.46); St Mary, Hasfield (Gaz.47); George G. Scott – St Mary, Melton Mowbray (Gaz.98); Banks & Barry – Dornden, Tunbridge Wells (Gaz.91); Bilsdale church (Gaz.125); Trinity College Chapel, Glenalmond (Gaz.215); J.J. McCarthy – Waterford Cathedral (Gaz.204)

74. JHA, Jan. 31, 1850.

75. HLRO 304, letter no. 329.

Chapter 9 After Pugin

1. Much of this chapter appeared in Shepherd, 2003.

2. Hill, 2007, pp. 483-90.

3. See Gaz. 71, *Letters*, JHA Hardman to Wells, Jul. 10, 1852.

4. JHA, Mar. 4, 1852.

5. See Gaz.156, *Letters*.

6. JHA, May 8, 1852.

7. HLRO 304, letter no. 58.
8. See Gaz.176, *Letters*, HLRO 304, letter no. 476.
9. HLRO 304, letter no. 640.
10. *The Builder*, 3, 1845, p. 367.
11. *The Builder*, 15, 1857, p. 493.
12. The window is on loan to the Stained Glass Museum, Ely Cathedral.
13. Harrison, 1980, p. 30.
14. Thompson, 1971, p. 463.
15. Ibid.
16. Harrison, 1980, p. 16.
17. Ibid., p. 26.
18. Ibid., p. 35.
19. Cheshire, 2004, p. 45.
20. *Oxford Dictionary of National Biography,* 2004, pp. 510-12.
21. Fisher, 2008, p. 170.
22. *Building News*, 4, 1858, p. 345.
23. Quoted in Robinson & Wildman, 1980, p. 38.
24. Harrison, 1980, p. 39.

Gazetteer

1. I am grateful to David O'Connor for his suggestion that the figure could be a nineteenth-century priest-donor of that name: this was confirmed from the *Catholic Directory*, 1845, p. 45, and 1846, p. 61, which refer to the Rev. Peter Coop, Great Marlow, Buckinghamshire.
2. This information was kindly given to me by the rector of Warrington, the Rev. J. O. Collings, who also showed me a photograph of window I prior to the bombing.
3. Referred to in the First Glass Day Book as 'Cockermouth Church': see *The Ecclesiologist*, 15, 1854, pp. 136-7, for a description of the window.
4. Recorded in the First Glass Day Book as 'Beaminster Church'. Identified with thanks, by Rupert Willoughby..
5. Kindly brought to my attention by the late Prof. Clive Wainwright.
6. As recorded in the First Glass Day Book. Possibly St Philip & St James (CoE): see *The Ecclesiologist*, 15, 1854, p. 214.
7. As recorded in the First Glass Day Book.
8. I am grateful to Martin Harrison for bringing this letter to my attention.
9. See for instance Frieth (Gaz.5) and Stonyhurst College Church (Gaz.93) where, although the figures are in separate lights, Pugin, in HLRO 304, letter no. 773 comments 'it is a window for 3 <u>subjects</u>'.
10. See Alfington (Gaz.26).
11. See Rampisham (Gaz. 36) and Stonyhurst College church (Gaz.93).
12. I am grateful to the Rev. G. R. O'Loughlin for this information.
13. As recorded in the First Glass Day Book.
14. I am grateful to Martin Harrison for bringing this letter to my attention.
15. As recorded in the First Glass Day Book. Probably St Mary, restored by Fulljames & Waller, 1849-52; see N. Pevsner, D. Verey & A. Brooks, *The Buildings of England: Gloucestershire 2: The Vale and the Forest of Dean*, New Haven & London, 2002, p. 581, which points to a: 'very good chancel S.W. window by Hardman, 1853'.
16. As recorded in the First Glass Day Book.
17. I am grateful to the Rev. Prebendary L.D. Mackenzie, vicar of St John's, for this information.
18. I am grateful to Martin Harrison for bringing this letter to my attention.

19. As recorded in the First Glass Day Book.
20. Information kindly supplied by Robin Morgan, churchwarden.
21. This publication was kindly brought to my attention by the late Prof. Clive Wainwright.
22. This publication was kindly brought to my attention by Mrs Jo Whitehead.
23. As recorded in the First Glass Day Book. Presumably the chapel of the almshouses endowed by F.R. Wegg Prosser in 1852, with R.C. Carpenter as the architect, as mentioned in N. Pevsner, *The Buildings of England: Herefordshire*, Harmondsworth, 1963, p. 72.
24. I am indebted to Canon Paul Iles for drawing my attention to the glass in the clerestory windows and for arranging to let me have photographs of them, as well as giving me a copy of his chapter that appeared in Aylmer & Tiller, 1999.
25. As recorded in the First Glass Day Book. Possibly the old church, now demolished, which according to N. Pevsner, *The Buildings of England: Worcestershire*, Harmondsworth, 1968, p. 218, 'stood close to the house [Madresfield Court]'
26. As recorded in the First Glass Day Book.
27. Ibid.
28. Ibid.
29. Atterbury & Wainwright, 1994 (Wedgwood, 'Domestic Architecture'), p. 59.
30. Powell, 1988, p. 195, note 16.
31. I am grateful to Fr John Sharp for bringing this letter to my attention.
32. There has never been a 'Lady Altar' below nIV but there is a statue of the Virgin in the immediate vicinity, and, while nIV is not next to the Willement window (nVII), as it is now placed, perhaps the latter was at one time at nIII which would have been a more logical position from the congregants' viewpoint for the first of their aisle windows; nIV is third in the aisle if the transept window is included in the count. I am grateful to Fr M.K. O' Halloran, S.J., for these observations.
33. As recorded in the First Glass Day Book. Probably St Mary (RC), 1852, which, according to N. Pevsner, *The Buildings of England: Lancashire: The North*, Harmondsworth, 1969, p. 267, was: 'Paid for by R.T. Gillow of Leighton Hall [who also commissioned the window]'.
34. Recorded in the First Glass Day Book as 'Melton Mowbray Church'.
35. As recorded in the First Glass Day Book.
36. I am grateful to Canon Eric Grimshaw for this information.
37. Recorded in the First Glass Day Book as 'Orphan House, Liverpool'.
38. I am grateful to Alyson Pollard for this information.
39. I am grateful to Mrs M. Aldred for the information regarding the rebuilding, and for a photograph of the N aisle E window. The assumption that this was Warrington's original E window is mine.
40. That this was so was kindly confirmed to me by Paul Atterbury during the course of his research for the V&A exhibition on Pugin in 1994.
41. As recorded in the First Glass Day Book.
42. Ibid.
43. Ibid. Probably St Hilda, 1851, which N. Pevsner, *The Buildings of England: Yorkshire, The North Riding*, Harmondsworth, 1966, p. 80, states as being by Banks & Barry.
44. This should be read in the context of the inscription in sII which suggests that J.G. Crace made them. Dr Megan Aldrich has kindly confirmed for me that the Craces did not make their own glass.
45. I am grateful to Paul Atterbury for letting me have a photograph of this window.
46. Recorded in the First Glass Day Book as 'Cuddesdon Church'.
47. Recorded in the First Glass Day Book as 'Culworth Church'.
48. Information kindly given to me by the Rev. S.E. Crawley.
49. Recorded in the First Glass Day Book as 'Clifton Church, Deddington'.
50. As recorded in the First Glass Day Book.

51. Information kindly given to me by Mrs J.B. Cottis, Archivist at Magdalen College, Oxford.

52. Some confusion has arisen as to the date and authorship of this window. N. Pevsner, *The Buildings of England: South and West Somerset*, 1958 p. 112, commented: 'E Window 1829 by Willement. This is specially interesting as no longer painted in the Georgian way, and not yet Victorian at all. Pugin does here in no essential way go beyond Willement'. Pevsner, no doubt, identified the window from Willement's entry in Willement, 1812 to 1865 which stated '1829 Butleight Co. Somerset a window for the church The Hon & Rev G. Neville Grenville,' Harrison, 1980, p.16, followed Pevsner's attribution noting that the window 'primitive as it is, does show the artist seriously attempting to achieve a convincingly medieval effect'. Cheshire, however, in his unpublished, 'Early Victorian Stained Glass', Ph.D thesis, Exeter University, 1998, p. 229, note 66, and in his book of 2004, p. 51, note 24, whilst continuing to accept the window as being by Willement, gave two sources, *Sir Stephen Glynne's Church Notes for Somerset*, Taunton: Somerset Record Society, 1994, pp. 62-3) and *The Ecclesiologist*, 14 (1853), p. 457, to suggest that it was new in the early 1850s and considered that the contradictory documentary evidence made sense; 'if Willement took out his old window and re-installed it including some new glass'. In fact, *The Ecclesiologist* report, which concentrated mainly on the architectural restoration Buckler had carried out, included the remark: 'the east window a new one of three lights, not very good, and fitted with stained glass by an amateur.' Martin Harrison has confirmed to me that he agrees with *The Ecclesiologist* regarding the stained glass and no longer believes the window to be by Willement. The window made by Willement in 1829 seems to be no longer extant: perhaps it was replaced by the current one, the design of which, to judge from his letter to Hardman, Buckler seems to have had a hand in or possibly it never occupied the east position at all. In any event the perception that it was a window in advance of Pugin's ideas is now no longer valid. As for the Pugin/Hardman window in the church – the subject of Gaz.141 – *The Ecclesiologist* report mentioned above, somewhat harshly observed; 'Mr Hardman has placed a window altogether unworthy of his reputation, on the South Side of the nave.'

53. As recorded in the First Glass Day Book.

54. As recorded in the First Glass Day Book. Possibly St John (CoE) where N. Pevsner, *The Buildings of England: South and West Somerset*, Harmondsworth, 1958, p. 355, notes that much of the stained glass is 'of *c*.1850'.

55. As recorded in the First Glass Day Book. No information as to the premises in question.

56. The ledger also gives details of the costs of packaging and carriage for the windows.

57. f. 191 of Hardman's Rough Day Book 34 for 1945-9 contains details of a charge of £650 made out to the Rev. John J. McDonald for:' inserting white glass in the backgrounds and borders where appropriate; repainting any fractured portions; releading, recementing; the ten windows of the aisles.' The entry was dated Jul. 14 1948, the work being done in three stages starting, apparently, on Oct. 29 1946.

58. I am most grateful to Fr Bede Walsh for drawing my attention to the survival of the glass and for giving me a copy of the Higham & Carson book. f. 254 of Hardman's Rough Day Book for 1933-7 contains details of two charges made out to the Rev. Bernard Manion, M.A.; one of £60 was for adapting four of the lights of the five-light E window to fit the four lights of the W window, making up the rest of the lights and tracery with plain diamond quarries of antique glass, relieved in the borders and traceries with pieces of coloured glass from the E window. The names beneath the figures were to be repainted. The fifth light, which contained the figure of St Benedict, was retained on Hardman's premises, Fr Manion having informed them that he had no use for it. The present whereabouts of the light, assuming it still exists, is not known. The second charge of £41 was in respect of adapting the glass from the three-light E window of the Lady Chapel, representing St Andrew, Our Lady & St Peter, to fit the second window from the E in the S aisle. The entry was dated Sep. 3 1936, the work, seemingly, having been put in hand on May 16 1936. A verbal order was made by Fr Manion on May 18 1936 to the effect that the three sanctuary windows, each of three lights and tracery, should be taken out packed in cases and stored in the belfry. The present whereabouts of the windows, assuming they still exist, is not known.

59. I am grateful to Michael Fisher for providing me with a photograph of the window and his reading of

the inscription.

60. Recorded in the First Glass Day Book as Longton Catholic church.

61. Information kindly given to me by Canon F. Brady.

62. As recorded in the First Glass Day Book. Probably St Nicholas (CoE): N. Pevsner, *The Buildings of England: Suffolk*, Harmondsworth, 1974 (rev. E. Radcliffe), p. 509, refers to 'Mrs Clissold the rector's wife who died in 1852'. The Very Rev. S. Clissold commissioned the window.

63. As recorded in the First Glass Day Book.

64. Information kindly given to me by Mr V.A. Bartley.

65. I am grateful to Rosemary Hill for bringing these letters to my attention.

66. I am grateful to Andy Foster for this information and for the *London & Dublin Orthodox Journal* reference quoted in the text.

67. As recorded in the First Glass Day Book.

68. I am grateful to Martin Harrison for pointing this out to me.

69. Recorded in the First Glass Day Book as 'Staplefield Crawley Church'.

70. The names refer to Rev. Clifford's parents: I am grateful to Mgr Basil Loftus for this information.

71. I am grateful to Stuart Muirhead for this information and the reference regarding Owen B. Carter's comments.

72. Information kindly given to me by the Rev. Philip Morgan.

73. As recorded in the First Glass Day Book.

74. I am much indebted to Lesley Whiteside for identifying the churches and house covered by the notes below and for supplying the information in respect of the glass therein.
As recorded in the First Glass Day Book. Probably St Patrick's RC church where the dimensions of the window tally with those given in the First Glass Day Book. A figure of St Patrick is in the centre light and the glass is certainly 19th-century.

75. The oratory at Tervoe House, Clarina, Co. Limerick, home of the Mansell family. It has not been ascertained if the window is still in place.

76. Recorded in the First Glass Day Book as 'Barntown Church'. The window is still in place.

77. Recorded in the First Glass Day Book as 'Enniscorthy Church'. The window is still in place.

78. As recorded in the First Glass Day Book.

79. Ibid.

80. Recorded in the First Glass Day Book as 'Arisaig, Nr. Fort William'.

81. Recorded in the First Glass Day Book as 'Broughton Street Church, Edinburgh'.

82. Recorded in the First Glass Day Book as 'St Margaret's Church, Edinburgh'.

83. Kindly sent to me by the Rev. Paul, administrator of the Gillis Centre.

84. I am grateful to Rosemary Hill for drawing my attention to this article.

85. I am grateful to the late Dom Bede Millard O.S.B. for bringing this to my attention.

86. Recorded in the First Glass Day Book as 'Pantasaph Church'.

87. Presumably A. Lusson who executed designs for Henri Gerente in the early 1840s, made windows for Ely Cathedral and worked in England with Gerente's brother, Alfred (Harrison, 1980, pp. 24-5). See also Gaz.188 regarding the Blessed Sacrament Chapel windows in St Edward, Clifford.

88. As recorded in the First Glass Day Book.

89. Ibid. Perhaps All Saints, Coedkernen, which J. Newman, *The Buildings of Wales: Gwent/Monmouthshire*, London, 2000, p. 193, notes was rebuilt in 1853-4 by W.G. & E. Habershon and has since been converted into a house.

90. As recorded in the First Glass Day Book. No information as to the church in question.

91. Recorded in the First Glass Day Book as 'Hobart Town'.

92. Recorded in the First Glass Day Book as 'Acton Sillitoe Esq'.

93. Recorded in the First Glass Day Book as 'Sydney, St. Patrick'.

APPENDIX 1

WINDOWS DESIGNED BY PUGIN IN DATE ORDER

	Gaz.		Made by
c.1835			
Alderbury, St Marie's Grange	192	2-light hallway window 3-light bedroom window	Unknown
1837			
Oscott, St Mary's College	182	I, nII, sII	William Warrington
c.1839			
Derby, St Mary	24	I, nII, sII	William Warrington
c.1840			
Dudley, Our Blessed Lady & St Thomas of Canterbury	181	nII	William Warrington
Southport, St Marie	116	N aisle E window	William Warrington
Alton Towers	147	7 lobby windows – Pugin designs(?)	William Warrington
Uttoxeter, St Mary	159	E and W windows	William Warrington(?)
c.1840–1			
Mount St Bernard	100	Chapter house windows – Pugin designs	William Warrington(?)
Birmingham, Handsworth, Convent of Our Lady of Mercy	178	3-light E window	Thomas Willement
c.1841			
Warwick Bridge, Our Lady & St Wilfrid	22	E window, aisle and W windows – Pugin designs(?)	William Warrington
1841			
Radford, Holy Trinity Chapel	139A	Windows over altar – Pugin designs(?)	William Warrington(?) or Thomas Willement(?)
Birmingham, St Chad's Cathedral	176	I, nII, sII	William Warrington
Alton Towers	147	Octagon-hall	Thomas Willement
Melton Mowbray, Thorpe End, St John the Baptist	99	3-light E window l – Pugin design(?)	Thomas Willement
Alton, Hospital of St John	148	E and side windows	Thomas Willement
Macclesfield, St Alban	16	I	William Warrington or William Wailes
Birmingham, Bishop's House	175	Chapel, hall, library and audience chamber windows.	William Warrington or William Wailes
Kenilworth, St Augustine	168	I	William Wailes
Liverpool, St Nicholas, Copperas Hill	111	E window	William Wailes

*c.*1842

Liverpool, Old Swan, St Oswald	113	E window	William Wailes
Banbury, St John, South Bar Street	131A	I, nII, sII	William Wailes(?)
Ackworth Grange, Jesus Chapel	191	Chancel, nave and chantry chapel windows	William Wailes

*c.*1843

Oxford, St Mary the Virgin	139	sVII	William Wailes

*c.*1844

The windows that follow, up to those made by Hardman, have been put in Gazetteer order within years, in the absence of more specific dates.

Southwark, St George's Cathedral	63	E and W windows	William Wailes
Brigg	84	Unidentified window	William Wailes
Ramsgate, The Grange	87	Chapel, library and drawing room windows	William Wailes
Kirkham, St John the Evangelist	92	I, nIII, sIII	William Wailes
Syston, Ratcliffe College	103	Chapel windows	William Wailes
Liverpool, Oswaldcroft	114	Hall, dining room, lounge windows	William Wailes
Lynford, Sutton Chantry Chapel	118	Unidentified windows	William Wailes
Northampton, St Felix	122	E window	William Wailes
Nottingham, St Barnabas Cathedral	131	Windows throughout building	William Wailes
Rotherham, St Bede	144	Windows(?)	William Wailes
Albury Chapel	161	Unidentified windows	William Wailes
Newcastle upon Tyne, St Mary's Cathedral	164	I, nII, sII and three others	William Wailes

1844

Brewood, St Mary	150	3 windows	William Wailes
Leigh, All Saints	153A	I	William Wailes

*c.*1844–5

Liverpool, St Mary, Edmund Street,	112	E window and E windows of aisles	William Wailes

*c.*1845

Cambridge, St Andrew	11	Unidentified window	William Wailes
Wymeswold, St Mary	104	I, wI, sIX, nVIII	William Wailes
Lynn, St Mary	119	E window	William Wailes
Alton Towers	147	Unidentified windows	William Wailes

Cheadle, St Giles	151	Windows throughout building	William Wailes
Princethorpe College Chapel	168A	I	William Wailes
Bishopstone, St John the Baptist	193	S transept S window	William Wailes

1845

Hulme, St Wilfrid	67	Chancel windows – Pugin designs(?)	William Wailes

*c.***1845-6** (designed by Pugin 1844)

Leeds, St Saviour	190	wI, sVI, nVI	Michael O'Connor

1853 (designed by Pugin 1850-2)

Bolton Abbey	126	sII–sVII	Unknown

Made by John Hardman, Birmingham – as recorded in the Hardman First Glass Day Book

1845

Ushaw, St Cuthbert's College	40	Nov. – cloister; Dec. – tracery
Warrington, St Elphin	17	Dec. – W circular window (part)
Wymeswold, St Mary	104	Dec. – sVIII, nIX and tracery for aisle windows

1846

Ushaw, St Cuthbert's College	40	Jan. – I tracery; Mar. & Apr. – nX; Jun. – sXII; Sep. – R nII–R nVIII, nII, nIII, wI (tracery), antechapel (W walls), sX; Dec. – cloister, sXI
Warrington, St Elphin	17	Feb. – W circular window (part), sIII, I (tracery)
Liverpool, St Catherine's Orphanage	109	Apr. – 2-light window
Liverpool, St Mary, Edmund Street	112	Apr. – S aisle window
Liverpool, Old Swan, St Oswald	113	Jun. – mortuary window
Great Marlow, St Peter	7	Jul. – I, sII, sIII, nII
Broughton, St John the Evangelist	66	Sep. – I (tracery), 3-light window
Kemerton, St Nicholas	49	Sep. – unidentified
Westminster, New Palace of	64	Sep. – single light
Ramsgate, St Augustine	88	Oct. – cloisters, OCH nII; Nov. – OCH sII, tower
Blithfield, St Leonard	149	Nov. – sVII
Southwark, St George's Cathedral	63	Nov. – confraternity window tracery
Macclesfield, St Alban	16	Dec. – sIII
Chirk Castle	216	Dec. – 1 new light
Liverpool, Bishop Eton, Our Lady of the Annunciation	110	Dec. – I, sV

1847

Broughton, St John the Evangelist	66	Jan. – tracery for chancel N and S windows; Nov. – I
Westminster, New Palace of	64	Mar. – Victoria Hall, Peers' Lobby, House of Lords
Knowsley, St Mary	108	Mar. – 3-light window
Nottingham, Convent of Mercy	130	Apr. – I; Jun – nII, nIV
Ushaw, St Cuthbert's College Chapel	40	May – I (lights); Sep. – wI (lights); Nov. – screen; Dec. – sII, sIII
Birmingham, Charles Iliffe	173	May – hall window
Birmingham, Handsworth, Convent of Our Lady of Mercy	178	Jun. – 3-light window; Dec. – E window centre light and tracery
Great Marlow, St Peter	7	Jul. – wI; Oct. – nIII, sIV; Dec. – nIV, sV
Rampisham, St Michael	36	Jul. – I (lights); Sep. – I (tracery); Dec. – sII, nII
Southwark, St George's Cathedral	63	Jul. – 1 light; Dec. – extra tracery for confraternity window
Rugby, St Marie	170	Jul. – E, Lady Chapel and tower windows
Rugby, Bilton Grange	166	Aug. – gallery, dining room; Oct. – entrance hall; Nov. – drawing room, library
Solihull, St Augustine	183	Sep. – 3-light window
Wasperton, St John the Baptist	172	Oct. – sVII
Old Hall Green, St Edmund's College	82	Oct. – I (tracery); Dec. – I (tracery)
Liverpool, St Mary, Edmund Street	112	Oct. – side window
Warrington, St Elphin	17	Nov. – I (lights)
London, St Andrew, Wells Street	61	Nov. – E window 1st light
Liverpool, Oswaldcroft	114	Nov. – shields and inscriptions
Bakewell, Burton Closes House	23	Nov. – dining room, drawing room, library; Dec. – entrance hall
Dunchurch, St Peter	167	Nov. – E window; Dec. – side window
Australia, Hobart Town	222	Dec. – 2-light window

1848

Birmingham, Bishop's House	175	Jan. – dining hall end window; Apr. – dining hall, side windows
Old Hall Green, St Edmund's College	82	Jan. – I (centre light); Mar. – I (six lights)
Wexford, Barntown Church	205	Feb. – 5-light window
Abergavenny Priory	219	Feb. – 4-light window
Rugby, Bilton Grange	166	Feb. – billiard room lights (CR sII, CR sIII[?]); Jun. – bedroom windows
Cotton, St Wilfrid	152	Mar. – tracery for E, Lady Chapel and sedilia windows; Jul. – E (lights); Sep. – Lady Chapel and sedilia lights; Nov. – quatrefoil
Cresswell, St Mary	153	Mar. – 2-light window

Nottingham, Convent of Mercy	130	Apr. – CRI; Jun. – cloister; Sep. – nII, sII, nV;
Southwark, St George's Cathedral	63	Apr. – 2 chancel windows (tracery); Jun. – tracery for confessional, 3 chancel side windows; Aug. – St Patrick window (centre light); Sep. – St Dominic window (tracery)
Ramsgate, St Augustine	88	Apr. – cloisters; Aug. – cloisters; Oct. – tracery for I, sII–sV
Oxford, St Mary the Virgin	139	Apr. – sIX
Broughton, St John the Evangelist	66	Apr. – nIV, sIII, sIV; Aug. – nII, sII
Wymeswold, St Mary	104	Apr. – nIV
Bakewell, Burton Closes House	23	Apr. – library window (lights)
Birmingham, St Chad's Cathedral	176	Apr. – sIII
Ushaw, St Cuthbert's College Chapel	40	May – lights for 5 upper N windows
Winwick, St Oswald	18	Jun. – I, nII, sIII, sIV
Oscott, St Mary's College	182	Jun. – RC 2; Dec. – RC 3
Alton Towers	147	Jun. – library window; Nov. – library window
Whalley, St Mary & All Saints	94	Jun. – sVIII
Warrington, St Elphin	17	Jul. – W circular window (part); Nov. – nII
Salisbury, St Osmund	198	Jul. – I, nII, another side chancel window, sII
Chirk Castle	216	Aug. – library windows
Kenilworth, St Augustine	168	Aug. – nIII
Clifford, St Edward	188	Aug. – nIII, nV
Liverpool, Bishop Eton, Our Lady of the Annunciation	110	Sep. – nVIII, nV
Birmingham, Handsworth, Hunters Lane	179	Oct. – drawing room window
Milton Abbey	35	Nov. – sXI
London, St Andrew, Wells Street	61	Nov. – E window 2nd light and tracery
Leadenham, St Swithin	107	Nov. – sII
Blithfield, St Leonard	149	Nov. – SV and side window
Liverpool, Old Swan, St Oswald	113	Nov. – 3-light window
Liverpool, Oswaldcroft	114	Nov. – oratory window
Cambridge, Jesus College Chapel	9	Dec. – rose window
Kirkham, The Willows, St John the Evangelist	92	Dec. – nVIII, sIX
Whalley Range, St Margaret	70	Dec. – tower and E windows
Birmingham, Handsworth, Convent of Our Lady of Mercy	178	Dec. – E window 4 lights

Westminster, New Palace of	64	Feb. – corridor; Apr.– Peers' Lobby screens, Peers' Library; May – 1st specimen Commons' Chamber, altered specimens Jul., Aug, Nov.; Jun. – 1st specimen Division Lobby, altered Aug.
Hammersmith, Convent of the Good Shepherd	54	Feb. – round window and tracery for choir windows
Southwark, St George's Cathedral	63	Feb. – windows for Petre Chantry
Oscott, St Mary's College	182	Feb. – window for picture gallery; Dec. – RC I
Birmingham, Handsworth, Convent of Our Lady of Mercy	178	Mar. – kitchen window; Apr. – N aisle window
Enniscorthy Church	206	Mar. – N and S aisle windows and tracery of E
Salford, St Stephen	69	Mar. – 3-light window
Ramsgate, St Augustine	88	Mar. – tracery for nIV and sII; Jun. – sacristy windows (plain) and tracery for I, sII–sV; Oct. – tracery for sVIII and sVI, stained light for sacristy and confessional windows, I (lights), sV; Dec.– tower window, organ chamber.
Cotton, St Wilfrid	152	Mar. – two 3-light side windows
Alton Towers	147	Mar. – 2-light window; Apr. – borders, picture gallery and passage windows
Sheffield, The Farm	145	Apr. – 3-light window
Stella, St Mary & St Thomas Acquinas	165	May – I, sII–sIV
Frieth, St John the Evangelist	5	May – I
Boulton Hall	105	May – 2-light window
Birmingham, Lander, Powell & Co	174	May – 3-light window
Blithfield, St Leonard	149	Jun. – SII and side window
Brighton, St Paul	41	Jun. – I; Oct – nII, sII–sIV
Broughton, St John the Evangelist	.66	Jul – nIII
Sydney, St Patrick	224	Jul. – 3-light E window
Arisaig Church	211	Jul. – tracery
Edinburgh, Broughton Street Church	212	Aug. – 3-light E window
Edinburgh, St Margaret	213	Aug. – 8 single-light windows
Beverley, St Mary	83	Aug. – wI (tracery); Dec. – wI (tracery)
Warrington, St Elphin	17	Sep. – sII
Nottingham, Convent of Mercy	130	Oct. – cloister window
Stoke upon Trent	157	Oct. – two 2-light windows
Liverpool, St Nicholas, Copperas Hill	111	Oct. – two 3-light side windows
Ushaw, St Cuthbert's College	40	Nov. – L wI, two 2-light windows for S side of exhibition hall and one tracery window for do.

London, St Andrew, Wells Street	61	Nov. – E window 3rd and 4th lights
Brastead, St Martin	86	Dec. – single-light window
West Tofts, St Mary	120	Dec. – nVIII–nXIII
Kilpeck, St Mary & St David	76	Dec. – I, nII, sII
Monkton Deverill, King Alfred	196	Dec. – two single-light windows
Birmingham, Erdington, St Thomas & St Edmund of Canterbury	177	Dec. – I, wI (tracery), sundry window

1850

Cambridge, Jesus College Chapel	9	Feb. – I
Ottery St Mary, St Mary	29	Feb. – nIV, sIV, NIII; Mar. – nVI, SIII; May – NII, SII
West Haddon, All Saints	123	Feb. – sIV
Birmingham, Northfield, St Laurence	180	Mar. – sII
Chipping Camden, Campden House	44	Mar. – E window of chapel
Birmingham, Bishop's House	175	Mar. – single-light side chapel window
Birmingham, Erdington, St Thomas & St Edmund of Canterbury	177	Mar. – SVII; Apr. – wI, SVII
Lever Bridge, St Stephens & All Martyrs	68	Mar. – nVII
Chester Cathedral	14	Apr. – sXXIV
Ramsgate, St Augustine	88	May – nII
Rugeley, St Joseph & St Etheldreda, Presbytery	155	May – single-light window
London, St Andrew, Wells Street	61	May – E window (6 lights)
Liverpool, Old Swan, St Oswald	113	Jun. – 3-light window
Dyfed, Castle Martin Church	218	Jun. – 3-light E window
Taunton Convent	142	Jun. – single-light window
Oscott, St Mary's College	182	Jun. – RC 4
Beverley, St Mary	83	Jun. – wI (lights)
Longton Catholic Church	154	Aug. – Lady Chapel 3-light window
Cork, Lismore Castle	199	Aug. – 9 lights
Woolwich, St Peter	65	Aug. – nII
Sydney, St Mark, Darling Point	223	Aug. – 3-light window
Sheffield, St Marie	145	Aug. – wI
Grazeley, Holy Trinity	4	Aug. – I

West Tofts, St Mary the Virgin	120	Sep. – sVI–sVIII
Cambridge, Magdalene College Chapel	10	Oct. – I
Oswestry School	140	Oct. – 2-light window
Clehonger, All Saints	74	Oct. – I
Stapehill, Holy Cross Abbey	38	Oct. – organ loft, chancel windows, I, wI, NC I
Greenwich, Our Lady Star of the Sea	53	Oct. – clerestory windows (tracery)
West Lavington, St Mary Magdalene	186	Oct. – I, wI
Brighton, St Paul	41	Nov. – nVIII
Clifton, Private Chapel	2	Nov. – tracery
Highnam, Holy Innocents	48	Nov. – sIII, sVI–sIX
East Woodhay, St Martin	3	Nov. – sIII
Stoke Canon, St Mary Magdalene	30	Nov. – sII
Rustall Church	90	Nov. – single-light window
Birmingham, St Chad's Cathedral	176	Dec. – sVI
Hereford Cathedral	75	Dec. – I (centre light)
Pudleston, St Peter	78	Dec. – aisle windows
Birmingham, Handsworth, Convent of Our Lady of Mercy	178	Dec. – S aisle window
Ushaw, St Cuthbert's College	40	Dec. – L I, L wI
Oxford, St George's Chapel, George Street	137	Dec. – 2-light window
Canford Manor	34	Dec. – I, nII, wI
Hillingdon, St John the Baptist	56	Dec. – 5-light E window

1851

Oxford, St Mary Magdalene, Choir School	138	Jan. – E window (2 lights); Dec. – do. (8 lights)
Dyfed, Castlemartin Church	218	Feb. – S transept single-light window
Merioneth Church	221	Feb. – single-light window
Westminster, New Palace of	64	Feb. – Commons Chamber; Oct. – Commons' Lobby; Dec. – Division Lobbies, writing room, waiting halls, corridor, cloisters, members' entrance, dressing rooms, washing rooms, skylights
Liverpool, St Francis Xavier, Salisbury Street	115	Mar. – Lady Chapel E window
Gloucester, St Michael	46	Apr. – 3-light E window
Skipton, St Stephen	128	Apr. – I
Clapham, Our Lady of Victories	52	Apr. – I, tracery for sII and side window; Lady Chapel E window

Ushaw, St Cuthbert's College Chapel	40	May – LS I, LS wI
Greenock, Cumbrae, The College	214	May – 3-light E window
Sherborne Abbey	37	Jun. – wI; Jul. – nVII–nX
Worsley, St Mark	72	Jul. – tracery for E windows
Appleton, St Bede	13	Aug. – sII, sIII
Melton Mowbray, St Mary	98	Aug. – sV
Bremhill, St Martin	194	Aug. – sIII
Butleigh, St Leonard	141	Aug. – sVI
Zeal Monochorum	32	Aug. – I
Tunbridge Wells, Dornden	91	Aug. – library and staircase windows
Little Dalby, St James	97	Aug. – nIV–nVI
Greenwich, Our Lady Star of the Sea	53	Sep. – I, sIII, sIV, sV, tracery for aisle and clerestory windows and others
Upton Pyne, Our Lady	31	Sep. – nII, nV
Stoneyhurst College Church	93	Oct. – nIV
Waterford Cathedral	204	Oct.– 3-light E window
London, St Mary Magdalene, Munster Square	59	Oct. – I
Alton Towers	147	Oct. – great dining hall (Talbot 5-light window)
Culworth Church	132	Oct. – 2-light memorial window
Cambridge, Jesus College Chapel	9	Oct. – sVI, sVII
Algarkirk, St Peter & St Paul	105	Nov. – I
Old Hall Green, St Edmund's College	82	Nov. – nVII
Ramsgate, St Augustine	88	Nov. – sIII, sIV, sVIII
Farnham, St Andrew	162	Dec. – I, nII, sII
Limerick, Tervoe	203	Dec. – 3-light oratory windows

1852

Bilsdale Church	125	Feb.– 3-lancet E window; Apr. – 5 single lancets
Shurdington Church	51	Feb. – 3 single lancets
Badsworth, St Mary the Virgin	187	Mar. – sIII
West Lavington, St Mary Magdalene	186	Mar. – chancel side and aisle windows
Ely Cathedral	12	Mar. – sXXIII
Blithfield, St Leonard	149	Apr. – nVII, nVIII(?)
Hasfield, St Mary	47	Apr. – I

Bicton Mausoleum	27	Apr. – I, wI
Algarkirk, St Peter & St Paul	105	Apr.– nII–nIV, sII–sV
Sherborne Abbey	37	Apr. – sX
Clapham, Our Lady of Victories	52	Apr. – sII and Lady Chapel side window
Alfington, St James & St Anne	26	Apr. – I
York, St George	129	May – I
Brighton, St Paul	41	May – sV; Nov. – sVI–sVIII (Pugin design(?)); Dec. – wI, (Pugin design(?)).
Montreal, St Hilaire	226	May – dining room, drawing room, passage windows
Hillingdon, St John the Baptist	56	May – 3-light E and side chancel windows.
Oxford, St Mary Magdalene, Choir School	138	May – 10-light W window
Ballyshannon Church	200	Jun. – 3-light window
Wasperton, St John the Baptist	172	Jun. – I
Castlewellan Church	208	Jun – 3 lancets
Gargrave, St Andrew	127	Aug(?) – 3-light E window, sV
Beaminster Church	33	Aug(?) – 2-light memorial window (Pugin design(?))
Wexford, Convent of Mercy & St Michael	207	Jul. – 3-light E window (Pugin design(?))
Chichester Cathedral	184	Jul. – sXII
London, St Andrew, Wells Street	61	Jul. – 2-light clerestory window (Pugin design (?))
Newbridge, St Corluth	202	Aug. – 3-light window (Pugin design (?))
Ottery St Mary, St Mary	29	Aug. – NIV, SIV (Pugin design (?))
Bamburgh Church	124	Aug. – 2-light window (Pugin design (?))
Bussage, St Michael & All Saints	43	Sep. – sII
Little Dalby, St James	97	Oct. – I (Pugin design (?))
Birmingham, St Chad's Cathedral	176	Nov. – nIX
Beverley, St Mary	83	Nov. – nXVI
Brighton, St Paul	41	Dec. – wI (Pugin design (?))
Staplefield Crawley Church	185	Dec. – triple-lancet E window
Westminster, New Palace of	64	Feb. to Dec. – various

1853

Glenalmond, Trinity College Chapel	215	Jan. – 7-light E window
Hambleden, St Mary	8	n design (?))
Grace Dieu	96	Feb. – nIII (Pugin design (?))

422

APPENDIX 2

PUGIN/HARDMAN WINDOWS

PERCENTAGE MARK-UP OF PRIME COST TO ACHIEVE SELLING PRICE

			Jun. 24 to Dec. 22 1848 %	Feb. 1 to Dec. 26 1849 %	Feb. 12 to Sep. 26 and Oct. 3 to Dec. 26 1850 %
Oscott, St Mary's College (Gaz.182)	Rector's Corridor	RC 2	9.7		
		RC 3	14.8		
		RC 1		32.7	
		RC 4			3.8
Alton Towers (Gaz.147)	Library window		18.1		
	Small window		80.0		
	2-light windows			39.6	
Whalley, St Mary & All Saints (Gaz.94)	S aisle E (sVIII)		61.0		
				42.7	
Southwark, St George's Cathedral (Gaz.63)	St Patrick window, centre light and tracery		69.0		
	Petre chantry, 3 windows			79.4	
Chirk Castle (Gaz.216),	Dining room window		107.3		
Kenilworth, St Augustine (Gaz.168)	N aisle window (nIII)		47.5		
Clifford, St Edward (Gaz.188)	N aisle windows (nIII, nV)		80.0		
Nottingham, Convent of Mercy, (Gaz.130)	N wall windows (nIV, nV, sII)		23.2		
	E window 4 lights		86.8		
	Cloister window			16.7	
Milton Abbey (Gaz.35)	S transept window (sXI)		40.3		
Warrington, St Elphin (Gaz.17)	Chancel N window (nII)		58.5		
	Chancel S window (sII)			25.8	
London, St Andrew, Wells Street (Gaz.61)	Transfiguration light and tracery		47.6		
	2 further lights			41.2	
	6 further lights				51.0
Leadenham, St Swithin (Gaz.107)	Chancel S window (sII)		50.8		
Blithfield, St Leonard (Gaz.149)	Clerestory and side window (SV and side)		137.9		
	Clerestory (SII)			24.4	
	Side window			30.7	
Liverpool, Oswaldcroft (Gaz.114)	Oratory window		16.3		
Cambridge, Jesus College Chapel (Gaz.9)	Rose window		73.7		
	E window, lights				47.6
Kirkham, St John the Evangelist (Gaz.92)	N and S aisles W windows		49.7		
Whalley Range, St Margaret (Gaz.70)	E window and tower window		56.4		
Overall Percentage:			51.4		

		Jun. 24 to Dec. 22 1848 %	Feb. 1 to Dec. 26 1849 %	Feb. 12 to Sep. 26 and Oct. 3 to Dec. 26 1850 %
Hammersmith, Convent of the Good Shepherd (Gaz.54)	Round window		70.6	
	Tracery for choir windows		33.3	
Enniscorthy church (Gaz.206)	2 windows		52.7	
	Tracery		40.8	
Salford, St Stephen (Gaz.69),	Window in frame		57.0	
Handsworth, Convent of Our Lady of Mercy, (Gaz.178)	N aisle window		10.0	
Boulton Hall (Gaz.106)	3 lights		21.0	
Stella, St Mary & St Thomas Aquinas (Gaz.165)	Chancel, E and S side windows (I, sII, sIII, sIV)		28.8	
Frieth, St John the Evangelist (Gaz.5)	E window		30.2	
Brighton, St Paul (Gaz.41)	E window		26.3	
	4 chancel windows (nII, sII–sIV)		78.2	
Broughton, St John the Evangelist, (Gaz.66)	Chancel N window (nIII)		88.8	
Sydney, St Patrick (Gaz.224)	E window		49.8	
Arisaig, nr Fort William (Gaz.211)	Tracery		19.4	
Edinburgh, St Mary's Cathedral, (Gaz.212)	E window		18.6	
Edinburgh, Chapel of St Margaret (Gaz.213)	8 lights		11.0	
Liverpool, St Nicholas, Copperas Hill (Gaz.88)	2 side windows		(3.1)	
Ramsgate, St Augustine (Gaz.88)	E window (I)		118.5	
	Chantry E window (sV)		51.2	
	Tower		107.2	
	N wall window			27.1
Ushaw, St Cuthbert's College (Gaz.40)	Refectory windows		33.6	
	4 lights exhibition hall		42.1	
West Tofts, St Mary the Virgin (Gaz.120)	N aisle E and W and 4 side windows (nVIII–nXIII)		32.7	
Kilpeck, St Mary & St David (Gaz.76)	3 apse windows (nII, I, sII)		35.3	
Erdington, St Thomas & St Edmund of Canterbury (Gaz.177)	E window (I)		23.9	
	S transept end (sVII)			27.4
	W window (wI)			22.8
	Tracery window (SVII)			38.6

Overall Percentage: 34.9

		Jun. 24 to Dec. 22 1848 %	Feb. 1 to Dec. 26 1849 %	Feb. 12 to Sep. 26 and Oct. 3 to Dec. 26 1850 %
Ottery St Mary, St Mary (Gaz.29)	4 small windows, (nIV, sIV, NVIII, SVIII)			56.3
	Clerestory (NII, SII)			25.8
	S transept E window (nVI)			25.2
	Clerestory (NIII, SIII)			35.1
West Haddon, All Saints (Gaz.123)	S aisle E window (sIV)			34.1
Birmingham, St Laurence (Gaz.180)	Chancel S window (sII)			15.5
Lever Bridge, St Stephen & All Martyrs (Gaz.68)	S transept W window (nVII)			10.1
Chester Cathedral (Gaz.14)	S aisle window			29.0
Liverpool, St Oswald, (Gaz.113)	3-light window			32.9
Castlemartin Church (Gaz.218)	E window			26.7
Taunton Convent (Gaz.142)	1-light window and tracery			49.4
Beverley, St Mary (Gaz.83)	W window (wI)			18.2
Stonyhurst College Church (Gaz.93)	Silence Gallery W window (SG wI)			(3.3)
Longton Catholic Church (Gaz.154)				16.8
Lismore Castle (Gaz.199)				23.3
Woolwich, St Peter (Gaz.65)	N aisle E window (nII)			25.0
Sydney, St Mark, Darling Point (Gaz.223)				40.7
Sheffield, St Marie (Gaz.145)	W window (wI)			19.1
Grazeley, Holy Trinity, (Gaz.4)	E window (I)			23.6
West Tofts, St Mary the Virgin (Gaz.120)				37.8

Overall percentage Feb. 12 – Sep. 26, 1850 — 27.4

Clehonger, All Saints (Gaz.74)	Chancel E window (I)			52.7
Staplehill, Holy Cross Abbey (Gaz.38)	Nave and nun's choir aisle windows			36.1
Highnam, Holy Innocents (Gaz.48)	2-light E window (sIII)			62.6
	S aisle windows (sVI, sVII, sIX)			44.8
East Woodhay, St Martin (Gaz.3)	Chancel S window (sIII)			42.0
Hereford Cathedral (Gaz.75)	E window			37.1
Pudleston, St Peter, (Gaz.78)	S aisle W window (sVIII)			62.6
	7 aisle windows			72.8
Oxford, St George's Chapel (Gaz.137)	Aisle window			48.9
Canford Manor (Gaz.34)	3 windows (I, nII, wI)			25.3

Overall percentage Oct. 3 to Dec. 26, 1850 — 40.0

Overall Percentage Full Year — 31.2

Sources

Alexander, J., & Binski, P., (eds), *Age of Chivalry: Art in Plantagenet England 1200-1400,* London, 1987.

Andrews, B., *Creating a Gothic Paradise: Pugin at the Antipodes,* Hobart, 2002.

Andrews, K., *The Nazarenes, A Brotherhood of German Painters in Rome,* Oxford, 1964.

Atterbury, P., ed., *A.W.N. Pugin: Master of Gothic Revival,* New Haven & London, 1995.

 & Wainwright, C., (eds), *Pugin: A Gothic Passion,* New Haven & London, 1994.

Anon., *The Priory Church of St. Mary and St. Cuthbert, Bolton Abbey,* Norwich, 1990.

 175 Years of St Mary's Cathedral in the Archdiocese of St. Andrews and Edinburgh 1814-1989, Edinburgh, 1989.

Aylmer, G., & Tiller, J., (eds), *Hereford Cathedral: A History,* Hambleden, 1999.

Barry, A., *The Life and Works of Sir Charles Barry R.A. FRS,* London, 1867.

 The Architect of the New Palace at Westminster: A Reply to a Pamphlet by E.W. Pugin, Esq., entitled 'Who was the Art-Architect of the Houses of Parliament?', London, 1868.

Bayliss, S.F., 'Glass-Painting in Britain *c.*1760-*c.*1840: A Revolution in Taste', unpublished Ph.D. thesis, Cambridge University, 1989.

Belcher, M., *A.W.N. Pugin, An Annotated Critical Bibliography,* London & New York, 1987.

 The Collected Letters of A.W.N. Pugin, 1, 1830 to 1842, Oxford, 2001.

 The Collected Letters of A.W.N. Pugin, 2, 1843 to 1845, Oxford, 2003.

Benden, Y.V., Kerr, J, & Opsomer, C., 'The Glass of Herkenrode Abbey', *Archaeologia,* 108, 1986, pp. 189-226.

Brooks, C., *The Gothic Revival,* London, 1999.

Brown, S., 'The Stained Glass of the Lady Chapel of Bristol Cathedral; Charles Winston (1814-64) and Stained Glass Restoration in the 19th Century', *British Archeological Association Conference Transactions,* 19, 1997, pp. 107-17.

 A History of the Stained Glass of St. George's Chapel, Windsor Castle, Historical Monograph relating to St George's Chapel, Windsor Castle, 18, Windsor, 2006.

Carr, M., *A Short History of Knowsley Church and the Derby Family,* 1981.

Chadwick, J., *Description of the College Chapel of St. Cuthbert, Ushaw,* Durham, 1848.

Champ, J.F., *Oscott,* Birmingham, 1987.

Cheshire, J., *Stained Glass and the Victorian Gothic Revival,* Manchester, 2004.

Eastlake, C.L., *A History of the Gothic Revival,* 1872 (ed. and introduction by J.M. Crook, Leicester, 1970).

Fenton, T.J., *A History and Guide to the Church of the Holy Innocents, Highnam, Gloucestershire,* 1985.

Ferrey, B., *Recollections of A.N. Welby Pugin and his Father, Augustus Pugin,* London, 1861 (reprint introduced by C. Wainwright, London, 1978).

Fisher, M.J., *Alton Towers: A Gothic Wonderland,* 2nd ed., Stafford, 2002.

 Pugin-Land, Stafford, 2002.

 Hardman of Birmingham: Goldsmith and Glasspainter, Ashbourne, 2008.

Fordyce, T., *Local Records or, Historical Register of Remarkable Events which have occurred in Northumberland and Durham, Newcastle upon Tyne, and Berwick-upon-Tweed,* Newcastle upon Tyne, 1867.

Gillow, H., *Chapels at Ushaw,* 1885.

Girouard, M., 'Alton Castle and Hospital, Staffordshire', *Country Life*, Nov. 1960, pp. 1226-9.

Goodhart-Rendel, H.S., 'Four Gothic Revival Casualties', *Architectural Review*, 91, 1942, pp. 27-32.

Greaney, W., *A Catalogue of Pictures, Wood-Carvings, Manuscripts and Other Works of Art and Antiquity in St. Mary's College Oscott*, Birmingham, 1880.

Grodecki, L., & Briscac, C., *Gothic Stained Glass: 1200-1300*, London, 1985.

Gwynn, D., *Lord Shrewsbury, Pugin and the Catholic Revival,* London, 1946.

Hall, M., *The Artists of Northumbria,* 2nd ed., Newcastle upon Tyne, 1982.

Harrison, M., *Victorian Stained Glass*, London, 1980.
 'Monumental, Spectacular and Gothick: Soane and Georgian Glass-painting', *Journal of Stained Glass,* 27, 2004, pp. 107-17.

Harvey, J.H., & King, D.G., 'Winchester College Stained Glass', *Archaeologia,* 103 (2nd ser., 53), 1971, pp. 149-68.

Haward, B., *Nineteenth Century Norfolk Stained Glass,* Norwich, 1984.

Higham, D., & Carson, P., *Pugin's Churches of the Second Spring,* Uttoxeter, 1997.

Hill, R., *God's Architect, Pugin & the Building of Romantic Britain,* London, 2007.
 'A.W.N. Pugin and Viscount Feilding', *True Principles*, 3:5, 2008, pp.25-31.

Hodgetts, M., *St. Chad's Cathedral,* Birmingham, 1987.

Leith, T.M., 'The Chronicle of St. Chad's Cathedral 1849-1880', *Birmingham Catholic Magazine*, 1914.

Mâle, E., *The Gothic Image,* London, 1961.

Marks, R., *Stained Glass in England during the Middle* Ages, London, 1993.

Meara, D., *A.W.N. Pugin and the Revival of Memorial Brasses,* London, 1991.

Meaton, E., *The Church of St. Augustine of England, Kenilworth, c.*1992.

Morgan, F.C., *Hereford Cathedral Church Glass,* 3rd ed. rev. Penelope Morgan, 1979.

Morgan, I. & G., *The Stones & Story of Jesus Chapel Cambridge,* Cambridge, 1914.

Murray, P. & L., *A Dictionary of Art and Artists*, Harmondsworth, reprint 1964.

Muthesius, S., *The High Victorian Movement in Architecture 1850-1870,* London & Boston, 1972.

Noonan, M.L., *The History and Ownership of the Alton Estates*, publisher and date unknown.

Norris, R., *The Stained Glass in Durham Cathedral*, Durham 1984, reprinted 1985.

O'Donnell, R., *The Pugins and the Catholic Midlands,* Leominster & Leamington Spa, 2002.

O'Loughlin, G., & Elleray, R., (eds), *St. Paul's, Brighton 150 Years: A Celebration,* Worthing, 2000.

Parry, L., ed., *Art and Kelmscott,* Occasional Papers of the Society of Antiquaries of London, 18, Woodbridge, 1996

Peover, M., 'Stained Glass in the Brocas Chapel of St James's Church, Bramley, and the Farebrother Sales Catalogues of 1802', and 'The Stained Glass in Sir John Soane's Museum – an Overview', *Journal of Stained Glass*, 27, 2004, pp. 90-106, 118-130.

Piper, J., 'St. Marie's Grange', *Architectural Review*, 98, 1945, pp. 91-3.

Port, M.H., ed., *The Houses of Parliament,* London, 1976.

Powell, J.H., 'On Stained Glass' (a paper read to the Worcester Diocesan and the Birmingham Architectural Society, on August 12, 1857), *Builder,* August 29, 1857, p. 493.
 'The Art of Stained Glass in Birmingham', *The Resources, Products and Industrial History of Birmingham and the Midland Hardware District: A Series of Reports Collected by the Local Industries Committee of the British Association at Birmingham in 1865* (ed. S. Timmins), London, 1866, pp. 521-5.

428

'Pugin in his Home' (ed. A. Wedgwood), *Architectural History*, 31, 1988, pp.171-205.

Pugin, A.W.N., 'Lectures on Ecclesiastical Architecture: Lecture the Third', *Catholic Magazine,* 3, 1839, pp. 17-34, 89-98.

'On the Present State of Ecclesiastical Architecture in England', *Dublin Review,* 10, 1841, pp. 301-49; 12, 1842, pp. 95-142.

The True Principles of Pointed or Christian Architecture, London, 1841.

Some Remarks on the Articles which have recently appeared in the 'Rambler' relative to Ecclesiastical Architecture and Decoration, London, 1850.

Purcell, E.S., & de Lisle, E., *Life and Letters of Ambrose Phillipps de Lisle,* vol.1, London, 1990.

Rickman, T., *An Attempt to Discriminate the Styles of Architecture in England,* Oxford, 1817.

Robinson, D. and Wildman, S., *Morris & Company in Cambridge,* Exhibition Catalogue, Fitzwilliam Museum, 1980.

Scott, W.B., *Autobiographical Notes of the Life of William Bell Scott M.S.A., LL.D. and Notices of his Artistic and Poetic Circle of Friends, 1830 to 1882* (ed. W. Minto) 2 vols, London, 1892.

Sharples, J., 'A.W. Pugin and the Patronage of Bishop James Gillis', *Architectural History*, 28, 1985, pp. 136- 58.

Shepherd, S.A., 'The West Window of Sherborne Abbey', *Journal of Stained Glass,* 19:3, 1994-5, pp. 315-22.

'The Stained Glass of A.W.N. Pugin *c.*1835-52', unpublished Ph.D thesis, Birmingham University, 1997.

'A.W.N. Pugin and the Making of Medieval-type Glass', *Journal of Stained Glass,* 21, 1997, pp. 1-10.

'Hardman's Stained Glass and the Transfer from Pugin to Powell', *True Principles,* 2:4, 2003, pp. 25-7.

Short, W.G., *Pugin's Gem: A Brief History of St. Giles Catholic Church, Cheadle, Staffordshire,* Stoke-on-Trent, 1981.

Singleton, F.J., *Mowbreck Hall and the Willows: A History of the Catholic Community in the Kirkham District of Lancashire,* Bolton, 1983.

Stanton, P., 'Welby Pugin and the Gothic Revival', unpublished Ph.D thesis, London University, 1950.

Pugin, London, 1971.

Steegman, J., *Victorian Taste: A Study of the Arts and Architecture from 1830-1870,* London, 1970.

Stokes, T., 'W.E. Chance and the Revised Manufacture of Coloured Glass', *Journal of the British Society of Master Glass Painters,* 5, 1934, pp. 171-6.

Thackray, D. & L., *A Brief History of St. Marie's Church 1844 to 1986,* Rugby, 1987.

Thompson, P., *William Butterfield,* London, 1971.

Trappes-Lomax, M., *Pugin: A Medieval Victorian,* London, 1932.

Tricker, R., *St. Mary's West Tofts Norfolk History & Guide,* 3rd ed., 1987.

Ullman, M.J., *St. Alban's Macclesfield,* Bolton, 1982.

Vaughan, W., *German Romanticism and English Art,* London, 1979.

Ward, B., *History of St. Edmund's Ware,* London, 1893.

Warrington, W., *History of Stained Glass,* London, 1848.

'A List of Some of the Principal Works in Stained Glass Done at 42 Berkeley St. West and 35 Connaught Terrace both in the Parish of Paddington, London', '*c.*1855(?)', MS 86 BB 27 National Art Library, V & A Museum, London.

Wayment, H.G., *The Stained Glass of the Church of St. Mary, Fairford, Gloucestershire,* 1984.

Webb, M.K., & Docker, F.A., *S. Andrew's Church, Wells Street, S. Marylebone 1847 to 1897,* London, 1897.

Wedgwood, A., *Catalogue of the Drawings Collection of the Royal Institute of British Architects, the Pugin Family,* Farnborough, 1977.

Catalogue of Drawings in the Victoria & Albert Museum, A.W.N. Pugin and the Pugin Family, London, 1985.

'A.W.N. Pugin and William Warrington at Oscott', *True Principles,* 3:2, 2005, pp. 7-17.

White, J.F., *The Cambridge Movement: The Ecclesiologists and the Gothic Revival,* Cambridge, 1962.

Wickham, W.A., 'Pugin and the re-building of Winwick Chancel', *Transactions of the Historical Society of Lancashire and Cheshire,* 59, n.s. 23, 1907, pp. 132-60.

Willement, T., 'A Chronological List of the Principal Works in Stained Glass & Designed and Executed by Thomas Willement of London F.S.A. from the year 1812 to 1865 inclusive.' Add. MSS 34871 to 34873, British Library, London.

'Ledger of Thomas Willement, 1841-1865', microfilm held at the Borthwick Institute of Historical Research, York (original in private ownership).

Willis, R., *The Architectural History of the University of Cambridge, and of the Colleges of Cambridge and Eton* (ed. J.W. Clark), 4 vols, Cambridge, 1886.

Winston, C., *An Inquiry into the Difference of Style Observable in Ancient Glass Painting especially in England with Hints on Glass Painting by an Amateur,* Oxford, 1847.

An Introduction to the Study of Painted Glass, Oxford, 1849.

Memoirs Illustrative of Glass Painting, London, 1865.

Index of Subject Matter in Pugn-Designed Windows

Pages and Gazetteer numbers are shown in light type while pages that include illustrations are shown in **bold**. Illustrations bound in the Gazetteer section commence with the number **10**.

432

Christ; Immaculate Conception **38,** Gaz.24, 53, 151, life of **89,** 156, **156, 163,** Gaz.112, Madonna della Misericordia Gaz.130, marriage Gaz.93, Nativity Gaz.17, 31, 40, 48, 53, 61, 88, 104, 126, 127, 130, 131, 177, **10.20,** Presentation in the Temple Gaz.48, 88, 130, Visitation Gaz.88, 93, 130, 131

St Mary Magdalene 155, Gaz.3, 10, 17, 52, 59, 97, 170 186, anointing the feet of Christ **133,** Gaz.126, 177, 186, at the feet of Christ Gaz.196, life of **72, 143,** Gaz.139, *Noli Me Tangere* Gaz.3, 14, 66, 126, 162, St Matthew Gaz.48, 61, 104, 149, 171, 182, 186, *see* also Apostles, and Evangelists; St Matthias Gaz.41, 68, 149, 177, election of, and martyrdom of Gaz.68, *see* also Apostles; St Michael Gaz.29, 46, 52, 61, 63, 66, 149, 176, 180, 186, 207; St Mildred Gaz.29, 151

St Nicholas **26, 27,** Gaz.41, 111, 148

St Osith **124,** 149, Gaz.7; St Osmund**,** Gaz.198, **10.38;** St Oswald Gaz.29, 40, 110, 113, **10.21a & b;** St Oswin Gaz.40

St Patrick Gaz.40, 52, 63, 111, 200 204, life of Gaz.224; St Paul **36, 37, 100,** Gaz.18, 26, 29, 32, 36, 41, 47, 61, 78, 82, 92, 98, 104, 112, 141, 151, 155A, 176, 177, 182, 190, 195, 198, **10.30,** life and martyrdom of Gaz.105, 184, *see* also Apostles, and Saul; St Peter **36, 100,** Gaz.6, 7, 26, 29, 32, 36, 47, 56, 59, 61, 78, 82, 87, 92, 97, 104, 112, 141, 149, 151, 152, 153A, 162, 176, 177, 178, 182, 190 198, 218, **10.30, 10.32,** life of Gaz.105, *see* also Apostles; St Philip Gaz.104, 149, 177, 182, **10.12,** *see* also Apostles; St Philip Neri Gaz.52

St Raphael Gaz.52; St Richard of Chichester Gaz.41

St Simon Gaz.149, 177, 182, *see* also Apostles; St Stanislaus Kostka Gaz.52; St Stephen Gaz.17, 29, 63, 104, 120, 149, 177, 190, **10.6,** martyrdom Gaz.29; St Swithin Gaz.41

St Thaddeus Gaz.182; St Theodore of Canterbury Gaz.40; St Theresa Gaz.130, 152; St Thomas **42,** 169, Gaz.82, 104, 176, 177, 178, 182, **10.35,** incredulity of Gaz.75, life of **142,** Gaz.139, *see* also Apostles; St

Thomas Aquinas 169, **10.8,** Gaz.40, 165; St Thomas of Canterbury **124,** 150, **166,** 167, Gaz.7, 29, 40, 52, 82, 122, 130, 168, 177, 182, 198, **10.25, 10.33, 10.38;** St Thomas of Hereford 149-50, Gaz.74; St Timothy Gaz.41; St Titus Gaz.41

Unidentified female saint Gaz.36, 190; unidentified male saint Gaz.29, 38, 190; unidentified saints Gaz.153A, 177; St Uriel Gaz.52

St Vincent of Paul Gaz.63, 178; St Vincent Deacon Gaz.178

St Werburg Gaz.24; St Wilfrid Gaz.152; St William of Bourges Gaz.92; St William of York **129,** Gaz.92, 130, **10.25,** life of Gaz.188; St Winefride Gaz.7, 178

Samuel Gaz.187, **10.36a-c,** *see* also David

Sarah Gaz.187, **10.36a**

Saul, the Crown of Saul brought by an Amalekite **157,** Gaz.12, *see* also David

Seraphim **32, 34, 35**

Simeon and Anna Gaz.48

Solomon Judgement of Gaz.40

Synagogue, personification of Gaz.40, allegory of Gaz.41, 145

Talbot, Great **90,** Gaz.147

Talbot, John, 16th earl of Shrewsbury Gaz.178

Te Deum 164, Gaz.37, 170

Transfiguration, *see* Jesus Christ

Turville, Isobel Gaz.168

Types and anti-types **91,** 157, **158,** 159, **159,** 163, Gaz.40, 48, 145, of the Virgin Mary 159, Gaz.40

Virgins, Wise and Foolish Gaz.17

Virtues and Vices Gaz.151

Wareing, George **65,** Gaz.176

Wedding at Cana, *see* Jesus Christ

Whitegreave, Thomas Gaz.168

General Index

Pages and gazetteer numbers are shown in light type while pages that include illustrations are shown in **bold.** Page numbers in italics refer to persons, buildings or events named in letters contained in the *Letters* sections of the Gazetteer. Illustrations bound in the Gazetteer section commence with the number **10**.